Looking at Art

Looking *at* A*rt*

A Visitor's Guide to Museum Collections

❦

Adelheid M. Gealt

R. R. BOWKER COMPANY New York & London, 1983

Dedicated to
my mother and father

Published by R. R. Bowker Company
1180 Avenue of the Americas, New York, NY 10036
Copyright © 1983 by Xerox Corporation
All rights reserved

Printed and bound in the United States of America

Library of Congress Cataloging in Publication Data

Gealt, Adelheid M.
 Looking at art.

 Bibliography: p.
 Includes index.
 1. Art—Collectors and collecting—History.
2. Art museums—History. 3. Art—History.
4. Art appreciation—History. I. Title.
N5200.G4 1983 709 83-6016
ISBN 0-8352-1730-2
ISBN 0-8352-1731-0 (pbk.)

The cover photograph by Ken Strothman shows
a gallery in the Indiana University Art Museum
and is reproduced by permission of the museum.

Contents

❦

Plates

Preface

❧

Art museums can make their visitors feel very inadequate. On a certain level, no factual knowledge is necessary to appreciate the beauty inherent in works of art. On another level, however, we can all appreciate better what artists have achieved if we learn and understand the context within which they worked.

Works of art on display in museums attract the visitor, but the labels accompanying these works usually assume a great deal of knowledge on the part of the viewer. The meanings of specialized terms, as well as a general background in art history, which enables the viewer to place an object in the enormous historical and visual context from which it emerged, are presumed to be known to the museum patron. Such knowledge, however, is usually the province of those few who have studied art history extensively. And because art history is increasingly a discipline of specialists, even many art historians may feel unprepared for a museum visit once they leave their area of specialization.

This general guide to art in museums is intended to provide basic information that would aid museum-goers, be they lay or specialist, in understanding what they see. The desire to make this guide portable enough to be carried on walking tours of museums imposed limits on the extent of detail that could be included; within these constraints, this books surveys the types of art produced by period, outlining the influences that are thought to have informed the artistic production of that age.

This guide is not intended as a general survey of the history of art and does not encompass the major art historical monuments; numerous worthwhile and important publications have already performed this service. Instead, this book explores the various changes in patronage, aesthetic tastes, and cultural and religious attitudes that have affected the arts of various periods. It focuses on those larger forces that shaped art and affected all artists' sensibilities in a given period or culture. All artists, great and minor, were subject to the same prevail-

ing conditions that determined for them not only the types of artwork they produced but the materials and subjects they chose. It was under these conditions that artists created until well into the nineteenth century, and only during this period did artists experience the freedom and subjectivity that is today so commonplace.

Thus, the approach that this guide to art takes can be said to be both sociohistorical and typological. It catalogs the artistic production of Western Europe from the ancient world to the twentieth century and identifies the types of artwork that developed out of these evolving social and cultural conditions, and that are today most likely to be found in art museums. For the main, the discussion of art in this guide falls on the smaller, more portable mediums of painting, smaller sculpture, drawings, prints, pottery, and occasional "minor" arts.

Such an approach is no less valid than that of traditional art historical surveys, which tend to single out the careers of influential artists whose work rose above the conventions and standards of an age and significantly affected the future course of artistic production. For the museum visitor, however, the traditional art historical survey may not be the most useful guide, for most museums do not have collections that consistently reflect the art historical developments described in such surveys. Rather, museums are heir to the vast body of artistic production that encompasses works of art by the renowned and the less well known, the celebrated and the never mentioned artists. In forming their collections, art museums either rely on gifts from private collections (which usually reflect the tastes of the individual collector) or they bring together the best available representative examples of the artistic output of an age. Those objects that share a common cultural origin are grouped together in museums according to chronological and geographic boundaries.

Because this volume is dedicated to art objects seen in museums, three introductory essays in Part I examine the context in which the visitor will encounter art. A brief history of art collecting in Chapter 1 enables the reader to understand how art museums evolved. Chapter 2 discusses the ways in which art museums build collections, and outlines the basic considerations involved in a hypothetical purchase. How museums are organized and staffed, and the functions they carry out, such as collection, preservation, and restoration, are the subjects of Chapter 3.

An important feature of Part II is the lists of artists and notable museum collections. For all periods in which artistic production can be reliably attributed to individuals, lists of known and important artists are supplied, providing such information as place and date of birth and death, mediums in which an artist worked, types of art created, affiliations with other artists active during the period, places traveled, and awards. Some artists are listed more than once, indicating an affiliation with a movement or even a nationality other than that which they are popularly connected with. The information contained in these lists can be extremely detailed, depending on the extent of documentation

available, especially with respect to the types of art an artist is known to have produced within a given medium. Under painting, for example, the types of painting an artist created are identified in somewhat abbreviated fashion: religious for paintings with religious themes, and so on for history, mythology, allegory, still-life, genre, landscape, and other painting. The inclusion of all listed artists' names in the index to this volume will enable the museum visitor, while on a gallery tour, to readily identify artists and place their work within the context in which they created.

The lists of notable museum collections that appear in all chapters in Part II identify major public museums in Europe, the United States, and Canada, and some in the Far East and Australia, in which substantial holdings of art of a given period are represented. These lists of museums were compiled from published sources and are also included in the index under the name by which they are officially known, with cross-references from popular names.

Maps, time lines, and diagrams are provided intermittently to enable the museum visitor to orient him- or herself to the geographic, chronological, and thematic contexts in which art was created. Sixteen plates, of which half are reproduced in color and half in black and white, offer representative and sometimes unsurpassed examples of painting from the Early Christian and Byzantine period to the twentieth century.

The reader is offered a few words of advice about going to art museums. First, it is essential that you learn to use your eyes and allow yourself a chance to look at an object before cluttering the mind with whatever information is provided on the museum label. Artists control what they create and permit to be seen in an infinite variety of ways. They make us see commonplace or obvious things in a completely new way and, in that sense, for the first time. Your enjoyment of art will be greatly enhanced as you learn to appreciate how artists do this, and you will learn through continual looking, thinking, and reacting. This guide does not deal with theories of style or elements of formal analysis. If viewers were to look at artworks, they would discover for themselves how artists compose and manipulate an image. Long dissertations on how to study a composition—by finding its horizontals and verticals, its diagonal or circular structure—will only burden with intellectual baggage the natural process of seeing and responding.

A final piece of advice: Do not go through a museum feeling obliged to look at everything. That is a tiring and unrewarding approach that can lead only to frustration and boredom. Instead, when entering a particular gallery or room, survey it and select a few images on which to concentrate your energies. Follow your own inclinations and spend some time looking closely. The next time you visit the museum, you will find that new images appeal to you and familiar ones look quite different. Nothing remains constant. As you change, what you see and how you see change as well.

Visiting museums to see art in the original is a wonderful experience. No

reproduction, however good, will ever replace first-hand exposure to original artworks. It is this unique experience to which art museums are dedicated, and this great service offers all who partake of it a lifetime of learning and pleasure.

Acknowledgments

The years spent on this project were shared with many people. My family, Berta and Terry Moore; Diemut and Walter Heller, Gustav and Rudolf Medicus; Elisabeth Butters; and Lois, Leonard, and Sylvia Gealt all took an interest in this venture from the start and to them I extend an affectionate thanks.

Gloria and the late Ulrich Middeldorf took an unfailing interest in this book. Professor Middeldorf's passing before this book could be placed in his hands leaves a great sorrow. Gerald and Penelope Stiebel are thanked for their support and many efforts on behalf of this publication. Peter and Julia Bondanella and Doreen Cole were sources of constant encouragement. Bruce Cole, who was present when the idea for the book was formed, inspired me throughout the project. He served as a willing and sympathetic sounding board for ideas and generously offered many valuable insights. For his knowledge and information, I owe him an everlasting debt of gratitude.

At Indiana University, many people provided assistance of all kinds. The Office of Research and Graduate Development provided both moral and financial support. Thomas T. Solley, Director of Indiana University Art Museum; Pamela Buell, Curator of Asian Art; and Constance Bowen, Curator of Modern Art, all graciously offered information and advice. I owe a special debt to Adriana Calinescu, Curator of Ancient Art, for her numerous answers to inquiries. Her generous gift of time and information are here gratefully acknowledged. All of the docents at the Indiana University Art Museum willingly served as guinea pigs as this book took shape and I thank them for their enthusiasm and encouragement. Virginia Berry Jackson, their director, was an unfailing source of energy and support.

Betty Jo Irvine, librarian, and Kate Siebert, assistant, generously provided me with books for extended periods of time. The office of the registrar, Diane Drisch, Terry Harley, and Kathy Henline, as well as Virgil Stephens, Jerry Bastin, and Dan Bell all generously assisted me with my many mailings, while Ken Strothman and Harvey Osterhoudt kindly provided photographs.

Brian Garvey and Susan and Jim Hull spent many hours providing the illustrations. Linda Baden deserves much thanks for her patient and careful editing. Katherine Schwende, Suzi Anderson, and Lois and Linda Baker all assisted in typing the manuscript. Patricia Harpring, Gustav Medicus, Terry Moran, Kate Siebert, and Nancy Smith all gave generously of their time to prepare lists. But a major share of this burden fell on the capable shoulders of Leslie Schwartz, whose dedication and meticulous work helped make this volume possible. I am deeply grateful to her.

At Bowker, I gratefully acknowledge the many efforts of Betty Sun. Her vital interest and enthusiasm for the project was a continual source of renewed energy. She supported the illustration of the book and gave the written material a consistent format. Her editing streamlined the the text and gave it a final polish. For her unstinting contribution of time, effort, and labor, she has my deepest thanks. I also wish to thank the production editor, Theresa Barry, for her painstaking work.

Finally, my husband Barry deserves much credit. His abiding and infectious love of art, which first opened up the pleasures of museum-going and pointed out to me the joys of Chardin and the miracles of Tiepolo, among many other artists, lies at the heart of this book. For his patience, understanding, and support during every stage of this project, I owe him an enduring debt that cannot be measured in words.

Adelheid M. Gealt

Bloomington, Indiana
May 1983

Introduction

꒰ܡ꒱

"Art is a lie that tells the truth," Picasso once said, alluding to the capacity of art to create meaning through pretense and illusion. In an artist's hands, pieces of stone, metal, or wood become animal or human forms or the embodiment of a spirit or idea. Raw materials are made to express or evoke emotions by the artist, who brings the inanimate to life through some powerful magic. Illusions of space or time are created. Colors blend to form images beyond our imagination, transporting us to uncharted regions of the mind or soul. Yet in oil, chalk, stone—whatever material is chosen—these illusions are convincingly real.

The human condition is a great paradox. We are flesh and fragile, transient and mortal beings, bound by and to our physical circumstances. Yet we have minds that perceive that which we are not: the immaterial, spiritual, infinite, and eternal. Throughout history, art has been used as a vehicle to create order and give material expression to the search for meaning. The most effective bridge between the world of the intellect, spirit, and soul and the world of bodily and material reality, art gives shape to our ideas, beliefs, feelings, longings, dreams, and hopes. Art is shaped by the culture that produced it and shapes it in return, forming one of the great forces through which civilization evolves and develops. As an expression of the human condition, art reminds us of the diversity of our civilization and the universality of our humanity.

Throughout history, art has been used to give form to the most important forces within a society. At the service of many religions, artists transformed innumerable deities into tangible, material entities. At the service of rulers, artists provided visible confirmation of the prestige, authority, and legitimacy of a governing power. At the service of other patrons, artists have mirrored the preoccupations, interests, values, and beliefs of their society.

The experience of art is, by its nature, somewhat paradoxical. Art can convey

the specific through the universal, and vice versa. Ideas specific to one person, culture, or period, once given aesthetic form, become accessible to all and take on universal significance. Through the medium of art, universal beliefs become concrete and can be transmitted to every member of society.

Art creates a symbiotic relationship between the real and the unreal, clearly charting paths in both directions, yet just as clearly lying somewhere in that magical realm between the two. A painting, for example, can evoke and deny nature all at the same time. Figures appear to be real yet exist in an imaginary space. A portrait can breathe life and reveal character, express a mood or emotion, and yet be composed of nothing but dabs of paint. In art, the impossible becomes possible. The most difficult yet most rewarding challenge of art is to accept contradiction and paradox within a single work. Only then can we see how artists exploit their skill at telling many lies in order to produce a more powerful truth.

Part I

CHAPTER 1

The History of Collecting and Growth of Art Museums

For nearly as long as Western art has been produced, there have been collectors who have sought to own these objects of material and aesthetic value. From the earliest known patrons of art in the ancient world to today's art museums, the assembling of artworks into private and, later, public collections has been an activity pursued with varying intensity by different members of society and for a wide range of reasons and motivations. The patterns of collecting that have been established over the centuries have wielded a profound influence on the history of artistic production itself and offer many valuable insights into the development of art forms. An institution of relatively recent origins, the art museum evolved out of certain patterns of private art collecting, and its functions today cannot be appreciated fully without some knowledge of the forces that led to its creation.

Thus, by providing a brief historical overview of art collecting through the ages, it is hoped that the reader will be able to appreciate the venerable traditions that have culminated in that now familiar institution, the art museum.

THE ANCIENT WORLD

For the Egyptians and Greeks, collections of art treasures constituted a vital element of their religious and economic life. Temples were repositories of the accumulated wealth of an entire society, and tombs, particularly in Egypt, were veritable treasuries. Egyptian pharaohs amassed not only implements that were considered necessary for the afterlife but had innumerable artworks buried with them as well. The tombs of the pharaohs have yielded many treasured collections, among which perhaps the best known today is King Tutankhamen's collection of walking sticks, which were found in an antechamber next to his tomb.

3

The Egyptians collected the charms, statuettes, and treasures of their ancestors and acquired fabulous goods from the Minoans, Nubians, and Asians.

Much Greek sculpture, which is so highly valued for its beautiful interpretation of human form and for its rarity, was originally produced for collections, or treasuries, that surrounded important Greek shrines. The Greek Muses (from whom the word "museum" is derived) were thought to preside over the arts—drama, dancing, poetry, music, and the visual arts. Shrines dedicated to the Muses were built on mountain- or hilltops in the shade of trees. Sculpture adorned the altars of these shrines, which soon developed into treasuries. The treasuries at Delphi and Olympia, for example, continuously received votive statues of athletes who had distinguished themselves at the Olympic Games. Under the guardianship of priests, Greek treasuries housed painted vases, occasional rare, natural objects, and vessels made from precious metals; the large treasuries had long, unroofed galleries that displayed votive statues. Also, the spoils of war were housed in these treasuries, which some scholars have compared to today's banks because they represented the accumulated wealth and economic security of Greek city-states.

Under Alexander the Great, Greek painting and sculpture were collected to demonstrate one's cultivation and civilization. The Alexandria library and museum, in Egypt, were among the seven wonders of the ancient world. It was described by the Greek geographer Strabo and later by Philo of Alexandria as a place where one could study and contemplate among the scrolls and inspiring sculptures and paintings.

As the Romans built their empire, they assembled a vast treasure of war booty and dedicated it to various temples to commemorate the greater glory of Rome and the victories of the Roman generals. Military leaders erected treasure houses or temples to display the spoils they brought back from battle. Most of the artwork commissioned by the Romans was dedicated to advancing state religion and the idea of the empire. After the Republican period, privately owned treasures became state property, and they could be found in various public buildings, including the great baths.

At the same time, such luxury goods as jewelry, decorative pieces, and furniture, as well as the instruments and utensils of daily life, were in great demand. Greek art, in particular its bronzes, was prized most highly, and the artifacts that survived the Roman siege of Corinth (146 B.C.) became the treasures of Roman collections. There was a flourishing market for Greek art in Rome. Entire sections of the city were filled with art dealers and booksellers, who sold real or fake artifacts, primarily of Greek antiquity. Roman artists worked almost entirely within the Greek artistic traditions and frequently made copies and occasional forgeries of original Greek works. Among others, Lucius Cornelius Sulla, Caius Verres, and Julius Caesar amassed stupendous private collections; Sulla's holdings were estimated (in 1948 U.S. dollars) to have been worth the equivalent of $10 million.

Some scholars speculate that the Roman treasures and vast art collections were destroyed by the descendants of barbarians who later occupied Italy, razing its cities and eradicating the learning and quality of life that had been achieved under the empire. A good portion of Greek and Roman sculpture, which had been tended by generations of Roman collectors, is said to have been lost under barbarian rule. Thousands of sculptures were thrown into lime kilns to produce fertilizer for the agrarian society that the barbarians imposed on Italy.

THE MIDDLE AGES

Riches and treasures were still amassed in the Middle Ages, but they served to proclaim or honor the greater glory of God, and not man or the state. Churches, hospitals, and monasteries accumulated wealth in a new society that, mindful of its sin and anxious to absolve its guilt, habitually donated precious objects to the church as a form of expiation. An abundance of material wealth was expended to create objects that expressed the spirit of God, Christ, the Virgin, and countless saints. Reliquaries were made of precious stones and metals to preserve and venerate the remains of saints. The most precious raw materials were used to represent the divine, as religious orders, churches, and monasteries began to accumulate treasures beyond compare. The most famous early collection of religious treasures was in the Abbey of St.-Denis, whose Abbot Suger compiled the now famous inventory of the abbey's holdings during the mid-twelfth century. Among the items recorded by Abbot Suger were a gem-encrusted crucifix, enamelled and gilded liturgical vessels, a golden altar and crucifix, porphyry vases, and sardonix chalices. Pieces from this collection are today housed in the Musée National du Louvre and in the Widener Collection of the National Gallery in Washington, D.C.

Other medieval treasuries were encyclopedic in scope, encompassing all manner of historical curiosities—rare stones, unusual animals, skins, teeth, coconuts, shells, and ostrich eggs. Anything that was considered rare or that demonstrated the rich and mysterious nature of God's creation was a potential item for a medieval treasury. Private collections followed the same broad approach to collecting. Princes and leaders and the educated and the wealthy built private treasuries of books, paintings, porcelain, gadgets, reliquaries, perfumes, spices, and much more. These assemblages are today called Wunderkämmer, or "chambers of wonders." Noted examples of Wunderkämmer belonged to Charlemagne, Frederick II, and the Dukes of Berry.

As the trade in art objects flourished, dealers emerged. Merchants of the late Middle Ages were an adventurous lot and risked all sorts of hazards—theft, storms, and pestilence—to send their goods great distances (from England to Italy, for example) in order to turn a marginal profit. Among the most famous

traders was the industrious Italian Francesco Marco Datini (1335–1410). His wealth was so substantial that he left an endowment upon his death to his native city of Prato, in Tuscany, so that its citizens would pray for his soul—as they continue to do to this day.

THE RENAISSANCE

During the fifteenth century, collecting began to take new directions. The humanistic philosophy of this age fundamentally altered the earlier medieval conceptions of the nature of man and his relationship to the world, and the "Renaissance man" emerged as one who was thought capable of shaping his own destiny. The classical ancient traditions were viewed with a renewed sense of appreciation during the Renaissance. In spite of the fact that the ancient Greeks and Romans were pagans, the beauty and cultivation they achieved in the arts came to be admired by Renaissance men of learning and wealth, who assembled the writings, sculptures, coins, and small treasures that survived the fall of Roman civilization.

The objects created by Renaissance artists were characterized as much by their aesthetic as by their functional value. Although religious and utilitarian objects were still produced, as the century wore on the increasing wealth of merchants and a certain secularization of the nobility led to the creation of art that was made purely for its own sake. Such art often took the form of small bronzes that emulated ancient models. By the sixteenth century, private collections included paintings and drawings that were appreciated purely as aesthetic objects.

The sixteenth century continued the idea of producing art for its own sake. Appreciated by collectors who were knowledgeable about art, including its classical ancient heritage, art came to be viewed as the product of genius and inspiration, and the role of the artist was reassessed. No longer merely an artisan or craftsman, the Renaissance artist endowed the works he created with those very qualities that were appreciated for their artistic merit. By the sixteenth century, not only small secular works but other types of objects, such as drawings and sketch models for sculptures (called bozzetti) were celebrated as works of art and were considered worthy of entry into a collector's studio.

During this century, the interest in natural phenomena, antiquity, and technological instruments continued. The wealthy and powerful developed wide-ranging collections of objects that included everything from rare geologic forms, shells, and sculptures to clocks and other devices. As a result of the collector's fascination with natural and man-made phenomena, certain categories of painting were developed. Early Dutch still-life paintings of flowers and shells, which frequently depicted insects or small reptiles, were collected as

much for their examples of natural specimens as for their intrinsic beauty. These paintings were housed in cabinets and were thus designated "cabinet pictures."

THE SEVENTEENTH CENTURY

The seventeenth century has been called the golden age of collecting. The ownership of an art collection was considered among members of the nobility to be a mark of prestige and cultivation. The love of paintings and other art objects became, in some countries, an attribute of the middle classes. Holland in the seventeenth century had an affluent merchant class whose interests and tastes in art fostered a new range of subject matter in painting, including landscapes, still-lifes, portraits, and genre scenes. While the noble of birth and the wealthy built up historic collections, private citizens in countries such as Holland also acquired a love of art and assembled collections that were modest by comparison to the monumental holdings of noble patrons.

Collecting was both a passion and an investment. Art objects were bought and sold continuously through dealers and at auction or directly from other collectors. Extant documents reveal that not only individual pieces but entire collections were amassed and then sold off. A good example of the ways in which art objects changed hands is demonstrated by the fate of the holdings of the Gonzaga family of Mantua, a city that was inhabited by some of seventeenth-century Europe's foremost art patrons and collectors. With Peter Paul Rubens as his adviser, Duke Vicenzo I Gonzaga (d. 1612) built an outstanding collection of Italian and Flemish masterpieces. In the year of his death, Vicenzo's collection was housed in a gallery created specifically for this purpose. The later decline of the Gonzaga family fortunes prompted the sale of a large part of this collection to Charles I of England in 1628. The English monarch's collection was, in turn, dispersed by the Commonwealth, whereupon Cardinal Mazarin of France, Philip IV of Spain, Leopold Wilhelm, governor of the Netherlands, and others eagerly snatched up its works. The prices paid for these transactions are noteworthy: Charles paid about £80,000 sterling for his purchase, which later brought the Commonwealth close to £118,080 sterling.

Archduke Leopold, regent of Belgium from 1646 to 1656, assembled an enormous personal collection of 1,397 paintings, 343 drawings, and 542 pieces of sculpture, all of which were primarily by Flemish and Italian artists. His vast collection required the services of a curator, and so he hired David Teniers the Younger. A painter, Teniers recorded the holdings of this collection in a number of paintings that were later depicted in drawings and in turn reproduced in engravings that were published in the *Theatrum pictorum* (1660).

Leopold's collection eventually came to Vienna, the archduke's home, where parts of it were contributed to the Kunsthistorisches Museum, which Marie Therese opened to the public in the eighteenth century.

In Spain, King Philip III (reigned 1598–1621) and his son Philip IV (reigned 1621–1665), commissioned the services of the painter Diego Rodríguez de Silva y Velázquez to seek out great works of art. Traveling to Italy, Velázquez was able to obtain the many wonderful paintings by Titian and Paolo Veronese that are today part of the Prado Museum's collection.

In Italy, Rome was the home of the premier collectors of the early seventeenth century. In particular, members of the papal court used their financial resources and sound aesthetic judgment to acquire works of art that expressed their prestige. Notable collectors included Cardinal Francesco Maria del Monte (1649–1727), who collected ancient art, as did others during this period, and who also developed a taste for the work of Caravaggio, Guercino, and Andrea Sacchi, among other painters active at the time. The marchese Vincenzo Guistiniani assembled collections of ancient art and the work of contemporary painters who were inspired by antique models, such as Domenichino, Albani, Guido Reni, and the circle of artists around Caravaggio. Cardinal Scipione Borghese was another enthusiastic patron of the arts and supported the work of Giovanni Bernini and amassed a wide-ranging collection of different styles by different artists.

As early as the seventeenth century, the papacy recognized the importance of art to the city of Rome and pressed for legislation to limit the exportation of artworks. Enforcement of this law was not always possible, however, as those who were anxious to acquire art sometimes resorted to extreme measures to obtain it. In 1630, the French invaded Mantua and carried off the contents of the Palazzo Ducale. This collection of art, which included works by Perugino, Andrea Mantegna, and Lorenzo Costa that Vicenzo I inherited from his ancestor Isabella d'Este, were transported to the Louvre, where they remain.

In addition to advising patrons on collecting, artists themselves also acquired notable collections, of which the two most famous belonged to Rubens and Rembrandt. When Rubens' estate was settled in 1641, his inventory of art objects included more than 300 paintings by such artists as Tintoretto, Titian, Veronese, Palma Vecchio (Jacopo Palma), van Eyck, Hugo van der Goes, Albrecht Dürer, Hans Holbein the younger, Quentin Metsys, Lucas van Leyden, Jan van Scorel, Perugino, Paul Bril, Jusepe Ribera, Hercules Seghers, Willem Heda, Adriaen Brouwer, and Frans Hals.

Rembrandt, a contemporary of Rubens, collected whenever he had the funds to do so. Successful and financially secure during his early career, Rembrandt regularly attended auctions, where he would sometimes make a point of bidding unusually high prices in order to demonstrate the value and importance of art. His inventory, which was compiled when he was forced into bankruptcy

later in life, included the works of an impressive list of painters: Brouwer, Jan Lievens, Seghers, Palma Vecchio, Giorgione, Pieter Lastman, Jan Porcellis, Jacopo Bassano, van Leyden, Raphael, and van Eyck. Rembrandt's studio frequently overflowed with pieces of armor, plaster casts, original antique sculptures, and album upon album of prints and drawings by the old masters and his own contemporaries.

The passions of the art collector fostered the publication of numerous guide-books to collections, as well as treatises on collecting. Guilio Mancini, an amateur collector and physician to Pope Urban VII, advised the readers of his *Considerazione sulla pittura* (c. 1620) on such matters as recognizing forgeries, establishing fair market prices, and displaying and restoring artworks. The collected artworks of Cardinal Federigo Borromeo were published in a catalog entitled *Musaeum* and were bequeathed in 1618 to a Milanese institution that later became the Accademia di Belle Arti.

THE EIGHTEENTH CENTURY

Because wealth was more widely distributed during the eighteenth century, more people collected and more diverse types of materials were available for collecting. By now, works of art had become objects of speculation, invest-ment, personal enjoyment, and decoration.

Collections became specialized. In France, the prevailing tastes among art collectors ran to contemporary French art and seventeenth-century Dutch art, which was credited for having inspired the French art of this period. The Comtesse de Verrue (d. 1736) and the Marquese de Pompadour (d. 1764) had notable collections of such material. The French also developed a fondness for porcelain and calling cards. Drawing collections flourished, notable examples being the holdings of Antoine Crozat (d. 1740) and Pierre Jean Mariette (d. 1774).

In England, thousands of Italian landscape paintings were imported, for the English had developed the habit of traveling to Italy to view its scenery. Classi-cal Greek and Roman art was sought enthusiastically, and the famous collec-tion of Greek vases accumulated by Sir William Hamilton (1730–1803) en-tered the British Museum (made open to the public in 1759) along with the vast collection of Charles Townsley. Lord Elgin's (Thomas Bruce, seventh earl of Elgin) fondness for Greek art prompted him, while he was a diplomatic envoy in Greece, to have the frieze sculptures of the Parthenon transferred to England, where they became part of the British Museum and were known then, as now, as the Elgin marbles. A major international financial disaster was precipitated with the bankruptcy of John Law, a Scottish financier and specula-tor, in 1720, whereupon many English and European nobles were forced to

sell their older art objects and replace them with less expensive, contemporary works.

German collectors of this period favored the work of native painters and the Italian masters. Elector Maximilian II (1662–1726) of Bavaria amassed a collection of paintings, numbering in the thousands, that included the works of Dürer, Lucas Cranach, and the Italian masters. In Vienna, the Hapsburg monarchy continued to expand its collections, acquiring the prints and drawings that today form the nucleus of the Albertina Museum.

In Russia, Catherine the Great built an art collection through the acquisition of the collections of Count Brühl (1769), the Parisian dealer Pierre Crozat (1772), and the Walpole Collection from Houghton Hall (1779). These eventually contributed to the formation of the Hermitage.

Constant market activity helped establish auction houses and galleries in France and England. James Christie the Elder held his first sale in 1766 and Sotheby and Company soon followed. Regular auctions were held in Paris in the Hôtel Aligre, the Hôtel des Americains, and in the Salle Lebrun. Paul Colnaghi opened his gallery in 1760.

As art markets flourished, so did the business of forgery, which has always plagued collectors. By the middle of the eighteenth century, forgeries of ancient art had become common. Because art was primarily an object of monetary speculation, it was also subject to periodic reevaluation. The eighteenth century witnessed a new appreciation for early Italian pre-Renaissance masterpieces referred to as the Italian primitives. The interest in early Italian painting spread during this time from Germany (Munich) to Great Britain and coincided in both countries with the Romantic movement's preoccupation with art of the past.

The eighteenth century was a watershed period in the history of art collecting, for it was during this century that the acquisition of artworks evolved from a largely private activity pursued by the few to a public concern. As the noble and wealthy classes came under the attack of a then prevailing democratic spirit that upheld the rights and cultural interests of all of society, private collections, by force or by free will, were transformed into museums for the public. In 1737, Maria Ludovica, the last Medici, left her family's great art collections to the state of Tuscany. The Medici treasures now form the collections of two of the world's great museums, the Galleria degli Uffizi and the Palazzo Pitti. By 1759, the British Museum had opened its doors to the public, and after the Revolution of 1789, the French Royal Collection, the forerunner of the Louvre, was nationalized and made accessible to the public. Part of the holdings of the Louvre were derived from Napoleon's siege of Europe, which resulted in the confiscation of treasures from innumerable churches and monasteries. After Napoleon's defeat, a good many objects (though not nearly all) were returned to their homelands for safekeeping in their original sites or in newly established national museums.

THE NINETEENTH CENTURY

The democratic spirit that was engendered by the previous century blossomed in the nineteenth century, which saw the establishment of some of our most renowned art museums. These include the Kaiser Friedrich Museum in Berlin (1797); the National Gallery in London (1824); the Musée de Cluny (1843); the Hermitage in St. Petersburg, now Leningrad (1852); the South Kensington Museum (1857), which was renamed the Victoria and Albert Museum in 1899; the Metropolitan Museum of Art in New York (1870); the Boston Museum of Fine Arts (1870); and the Philadelphia Museum of Art (1876).

In an atmosphere of public spirit, these museums were born of an age that was fascinated by history and that believed in education and assumed that education and cultivation were based on a firm knowledge of classical antiquity, literature, history, and the visual arts. From their very beginning, museums were intended both to instruct and delight the eye of their public, and they placed art within the more restricted context of culture.

What early museum visitors witnessed was vastly different from the holdings art museums display today. Following a tradition established in the seventeenth century, museums literally covered the walls of galleries with pictures, which could be hung high or low. An example of how a typical museum gallery then appeared is represented in the American painter and inventor Samuel B. Morse's *Louvre* (1833). Museums not only displayed paintings and watercolors but also featured large sculpture collections that, as often as not, included marbles and bronzes, as well as plaster casts of renowned sculptures from other collections. Not unlike private collectors, museums were both idiosyncratic and encyclopedic in their approach to collecting. They served the interests of their particular patrons and directors and also sought to represent, through original works or copies, important examples of past artistic traditions. Because the nineteenth century viewed itself as the spiritual heir of the Renaissance, the artistic traditions of the Renaissance and classical antiquity, as embodied in the genius of such artists as Leonardo da Vinci and Raphael, were especially valued.

During the nineteenth century, the museum was but one of the official institutions that patronized art and made it available to the public. The existing literature indicates that museums did acquire works on occasion and that they housed many award-winning creations. The Louvre, for example, received paintings that were produced by the recipients of the Grand Prix de Rome, an annual award conferred by the Royal Academy. By and large, however, the academies, which trained artists and regularly sponsored public exhibits (or salons, as they were called), were the principal means through which artists reached their public and established their potential clientele. Because only works that received official approval by the academy were displayed in the salons, many an artist's career depended on official sanction by the academy.

An artist who failed to gain such recognition, sometimes lost the prearranged sale of a work. Artists who were denied official recognition in the salons sometimes resorted to independent measures and rented or built their own exhibition galleries to display their works. In 1855, Gustave Courbet established his own private gallery and although his was a financial loss, later artists who charged admission to these galleries earned back their costs or even made a profit.

In addition to regularly sponsored salons, the nineteenth-century art public became the beneficiary of spectacular and ambitious exhibitions sponsored by the state. In 1851, England sponsored its famous display of the mechanical arts in the Crystal Palace, which was specially built to house the exhibit of the same name. Inspired by the interest this project generated, Napoleon III sponsored the Exposition Universelle in Paris in 1852, which assembled the arts and crafts of all nations in one extraordinary exhibition. The United States followed suit in 1853 with its own Crystal Palace exhibition in New York City. Such large-scale exhibitions continued throughout the nineteenth century, and important buildings were constructed to house them. France built the Palais des Beaux-Arts, and Germany constructed a hall opposite the Glyptothek in Munich that became the site of a monumental exhibition in 1858. These exhibitions helped foster the international character of art and exposed artists to a broad spectrum of styles and expressions, from which they derived inspiration for their own work. England's International Exposition of 1862 brought Japanese art to Europe's attention for the first time, and its effect is visible in a great deal of European printmaking and painting. International exhibitions also gave artists a wider audience. In the international exhibition in Paris in 1867, Frederic Church, an American painter, was awarded the gold medal for his painting *Niagara Falls*.

Art dealers, who had been important intermediaries between artists and the market since the seventeenth century, assumed an increasingly important role in the patronage of nineteenth-century artists. As the market expanded, the number of dealers and auction houses increased. Famous art dealers still known today established their enterprises in this century, including Georges Petit, Georges Wildenstein, Jacques Seligmann, Thomas Agnew, and Knoedler. Many nineteenth-century artists, perhaps because they espoused unconventional aesthetic views, were deprived of public or official support, and came to be patronized by dealers, many of whom had the independence of mind and foresight to recognize an artist's true value, in spite of prevailing artistic tastes. Paul Durand-Ruel (1831–1921), for example, patronized artists of the Barbizon school during the 1850s, when other dealers refused to handle their works. Later on, during the 1870s, when a market for the art of Barbizon school painters had already developed, Durand-Ruel was purchasing Impressionist paintings that were then still publicly scorned. Another notable dealer of this period was Ambroise Vollard, who collected and supported the work of the Post-Impressionists and Symbolists early on.

THE TWENTIETH CENTURY

The development of art museums in the twentieth century is ample proof that these institutions are ever changing, always reevaluating their holdings and methods of display. In the process of self-examination, museums have often been swayed by the interests or biases of their own time. In pre-World War I Berlin, for example, the directors of that city's museums resolved that certain artistic epochs reflected the then prevailing national ideals better than others. As a result, Egyptian, Romanesque, and Renaissance art was deemed highly valuable, but Hellenistic, Roman, and Dutch art were rejected as being inconsistent with the aspirations of the age. Such reevaluations have been ongoing, with varying results.

Museums in the twentieth century have participated more actively in the patronage of art. Responding to criticism that art museums were dedicated primarily to the art of the past, without the least regard for contemporary art, many museums have expanded their collections to include modern works. For example, in 1911, the Munich Pinakothek added a considerable body of contemporary German and French painting to its predominantly medieval and Renaissance art holdings. Museums today actively seek examples of contemporary art to balance their collections. Whereas in the nineteenth century modern art was generally considered the province of the private collector, some museums are now devoted exclusively to contemporary art, and many others make it a policy to acquire modern works of art and sponsor competitions. Although private collectors of all kinds still abound, art museums, which are often supported by state and federal government funds, have become increasingly important in the active patronage of contemporary art production. Through special exhibitions and acquisitions, art museums foster an awareness of modern art, and the prestige of some museums often brings success to many artists. The sale of a living artist's work to a renowned or reputable museum collection bolsters the sales potential of that artist on the open market. Consequently, the direction, subject matter, size, audience, and very often the price of contemporary works of art are geared to the scale of art museums and not to the individual collector.

Museums in this century espouse a different approach to collection development. Whereas in the past plaster casts of the world's great sculptural monuments were lovingly assembled for display, today they might be banished to storage rooms or destroyed, as museums determine that only original works should be displayed. If copies are deemed necessary objects of historical interest, nineteenth- and twentieth-century copies are not considered valuable unless they are exceptional examples of an artist's unique reinterpretation of past artistic traditions.

Art museums attempt not only to underscore the aesthetic merits of the objects they display but also to provide some context through which to convey

the original meaning or function of these objects. Often supplemental materials are provided to instruct and help viewers interpret the objects they encounter in a display. Maps, short information sheets, descriptive labels, and photographic reconstructions are among the many tools museums use to better explain individual works of art to their patrons.

Museums are increasingly conscious of their role as preservers of a precious and fragile visual heritage. Vast sums are expended to provide the necessary climate control and light conditions to ensure the maximum protection and longevity of an art object. Conservators, trained in the treatment and preservation of various types of artworks, are often part of regular museum staff. Usually each conservator will have a specialty, for example, works on paper, paintings, bronzes and clays, or textile and fiber creations.

Whereas in the past museums shared their exhibition functions with academies, salons, and galleries, today most exhibitions of artworks take place in either art museums or galleries. Academies and schools are training centers that may have small art museums as part of the training facility. And because most art galleries tend to be concentrated in large urban areas that are not accessible to all, most people experience art today by visiting art museums, which have become the great cultural treasuries of our age.

The art museum is the product of a paradox. At once democratic and elitist, the museum is open to all, yet it alone makes judgments about the artistic merits of an artwork and eliminates all but the best examples. In selecting a museum's holdings, the museum staff makes choices about artworks according to the artists' ability to resolve the formal, technical, and intellectual issues of the time. Unlike artists, who may select one medium or form of expression from many, museums attempt to assemble a broad range of exemplary works from a number of periods. In developing its collection, the art museum makes choices based on what may be considered elitist or esoteric knowledge in order to carry out its democratic mission of making art accessible to all.

How Museums Build Collections

The holdings of most museums are not, by and large, static. Rather, museums tend continually to refine their collections through the addition of new objects and disposal of others. Most acquisitions are obtained through gifts or bequests or through purchases. This chapter is devoted to a brief consideration of both methods of collection development and their significance to art museums. An example of how an art museum actually makes a purchase, including the considerations that must be made prior to buying, is described in a later section of this chapter.

GIFTS

Most art museums rely heavily on the generosity of donors in order to build their collections. Smaller bequests that entail perhaps a few pieces may literally come through the door, whereas large-scale donations generally require more elaborate preparation. Whatever the size of the gift, most donations are indistinguishable in terms of the philanthropic motivations that underlie them. The owners of art collections, large and small, often donate individual pieces or entire collections to museums so that these treasures may be shared by all.

Usually donations of any substantial size must be preceded by negotiation and prior agreement between the donor and recipient with regard to the maintenance and display of the collection. Some of the basic considerations might include the following: Must the collection remain together, or can parts of it be incorporated into the museum's overall collection? May items from the collection be made available for loan to other institutions for special exhibitions? Are the donors' names to be listed, or are they to remain anonymous?

If a donor wishes the collection to remain intact, a large-scale donation may

ultimately require the museum to create a great deal of new space. Thus, when the Metropolitan Museum of Art in New York acquired the fabulous Lehman Collection, it added a special wing and installed the collection in such a way that the final display was as it would have been in the Lehmans' own home. Thus, not only did unique and wonderful examples of painting, drawing, and decorative arts enrich the Metropolitan Museum's holdings but the display of the Lehman Collection, itself accumulated over years of careful selection, gave the public a rare glimpse into a family's lifelong enthusiasm for art.

Some museums, because of limited funds and space, cannot accept gifts with restrictions. Even though new materials may be actively sought by a museum, a donation may impose too great a burden on the museum's other resources if the individual collection must be kept intact. The arrangements that are made between donors and art museums vary, and each specific situation is probably unique.

Most museums are able to accept donations in part due to the tax laws that govern such bequests. In the United States, for example, the tax laws encourage donations to art museums by permitting the individual to declare current market value of the work rather than the original purchase price, which may have been much lower that the current assessment of value. This enlightened piece of legislation forms the basis for the continued growth and endurance of American art museums. A prospective gift is appraised by an independent source (usually a panel of experts selected from the American Association of Art Dealers), and this independent appraisal becomes the basis for the donor's tax credit.

Not all donations are made for tax reasons and, in fact, most museums do not accept unsolicited gifts. A donation is screened and approved by the museum's governing board, which considers the quality of the works to be donated, possible restrictions, the relevance of the proposed gift to the museum's other holdings, and the history of the gift.

In addition to outright gifts of artworks, many museums receive funds through private donations, membership fees, and entrance fees, all of which are used to purchase art to develop collections. These funds are placed in a purchase budget, and their expenditure is subject to the same screening and approval by the board as donations are.

PURCHASES

ART DEALERS

The purchase of artworks puts the museum in contact with a complex network of hundreds of individual and corporate dealers, whose knowledge and skill in locating and selling genuine works of art have brought them at least a comfortable and interesting living, if not a moderate or great degree of wealth. Such

legendary dealers of the past as James Henry and Joseph Duveen made their fortunes supplying such famous collectors as Isabella Stewart Gardner and Samuel H. Kress with masterpieces that have since become part of equally legendary public collections.

Successful dealers combine a good eye, sound judgment, and a gambling spirit with a solid knowledge of art and art history. Although dealers are often assisted in their efforts by the ablest scholars of the day, the distinction between dealer and scholar is sometimes fine, indeed. A good example is Sir J. D. Colnaghi, author of a basic reference tool on the biographies of Florentine painters which was published in 1928 and is still in use today, and proprietor of the famous Colnaghi Gallery in London. Today, dealers continue to make important contributions to the field of art history, in addition to buying and selling works of art.

Located in major cities across the world—such as New York, London, Paris, Zurich, and Rome—dealers may work independently or jointly in order to secure and advertise their offerings. Most dealers inform prospective clients of their available holdings by issuing periodic catalogs that provide basic information about an object, such as artist's name, title, medium, date, and publication information. They also advertise in major art journals, such as *Burlington Magazine*, *Art News*, or *Arts of Asia*, which any good library will stock.

Dealers offer a wealth of artworks, ranging from Impressionist oil paintings and African bronzes to Italian marbles. The sources that supply art dealers with their holdings are the many private art collectors who may be anxious to exchange goods for cash; institutions wishing to divest themselves of certain holdings in order to obtain others; and investment consortiums looking to turn a profit. Works of art change hands daily as collectors refine and reorient their collections, as museums fill gaps in their holdings, and as heirs to collections choose to sell the accumulated treasures of past generations.

A dealer's prospective clients, if they wish to examine an offering, will arrange for private appointments to view the object in question. The artwork, which has been kept in a special storage area, is displayed in the dealer's rooms, usually under special lighting. If a client shows interest in an object, the price and other detailed information are supplied by the dealer. A gentleman's agreement between the buyer and dealer usually establishes a "reserve," under which the dealer agrees not to sell the work for a specified amount of time, while the client proceeds to investigate further. A second reserve may be taken by another client in the hope that the first will lose interest.

Dealing can be a tricky business, and it presents its own unusual situations. Owners often wish to remain anonymous, opinions as to the authorship of an object may vary, or a collector may offer to sell or buy and then change his mind at the last minute. A successful dealer, however, offers his client the best and most complete information on a given object and restricts his profit to a respectable margin. A bad transaction is bad for business, so most dealers are

honest and offer their clients items that are backed by their good names and informed opinions.

A good dealer is also a valuable source of information. He provides the history of an object's ownership, or its provenance. A dealer's published catalogs may supply important information to scholars and students that enables them to study and locate works of art from various periods. These catalogs are frequently collected by museum libraries for further reference. Few special exhibitions are mounted without the assistance of dealers, who help locate potential loans and sometimes act as intermediaries between art museums and prospective lenders. Few students have been turned down by dealers when they have sought information about a piece that might have passed through the dealers' hands.

Often collectors themselves, dealers have contributed their materials and services for other worthwhile causes. They have helped assemble special exhibits to raise funds for the rescue of artwork and frequently donate works of art to institutions. In short, they are an important and valuable link between those who wish to obtain art and those who wish to divest themselves of it.

AUCTIONS AND AUCTION HOUSES

The alternative to selling or buying a work of art through a private dealer is to sell or buy it at auction. Currently, the auction business thrives on the thousands of artworks that pass through their houses annually. The largest and best known auction houses are Sotheby Parke Bernet and Christie's, both of which originated in England.

Staffed by experts in many areas of art, auction houses offer private collectors many services and will give opinions on the identities of art objects and estimate their potential sales prices at auction. Sellers sometimes prefer auctions to individual sales because the competitive bidding auctions entail may enable the seller to realize a higher price. The seller may then decide to establish a reserve, or base price, below which the work cannot be sold.

Once the offerings from one or more collections have been assembled, the auction house announces its forthcoming sale through advertisements, published catalogs, and fliers.

On the appointed day, buyers gather and the bidding begins. The atmosphere may be tense, but action is quiet and restrained. Unlike a country auction, in which bidders may wave their arms or shout, bidders at art auctions are a discreet lot who indicate their bids with a simple blink of the eye, a tug on a handkerchief, or a glance in a predetermined location. At auction, all buyers have an equal chance of obtaining a given work. Museum representatives, dealers, private collectors, and investment collectors are all present and compete against one another for the privilege of paying large sums of money for unique works of art. The bidding moves quickly and the last bid is final. A

buyer must be well informed in advance of his bid, for there is no time for last-minute research or a last-minute change of heart. If there is any risk involved, it is often worth taking because auctions make items available at somewhat lower cost, as no additional dealer's profit must be added to the auction price.

Auctions are increasingly popular and draw ever larger audiences, sometimes with stunning results. Recently, paintings by J. M. W. Turner, Frederic Church, and Dirk Bouts fetched record sums at auction. The astronomic prices these auctions produced are largely the result of a diminishing supply of works by the old masters, and there is fierce competition among buyers to obtain the few remaining examples. Such auctions make national headlines and draw attention to what ordinarily should be a minor consideration in the appreciation of works of art—their price.

THE ART MARKET

The forces of the marketplace are simple. Scarcity and quality drive prices up; availability and lower quality (relatively speaking) drive prices down. Most museums and collectors acknowledge that the art market has changed over the last decade. The works of such old masters as Michelangelo, Goya, and Rembrandt command astronomical prices at auction or simply are not available for purchase. Even the works of lesser known or less highly regarded artists fetch increasingly higher prices and may be infrequently available. Dealers who once routinely offered such items are now turning to other objects, such as decorative arts and drawings, and may only rarely make a masterpiece available, and then usually to a particular client.

Museums who wish to add to their collections can do so only at considerably higher cost today. In fact, the inflation of prices paid for artworks has given museums with greater financial resources a competitive edge over museums that are less well endowed and therefore perhaps in greater need to begin with.

As diminishing supply and increasing demand drive up the price of certain artworks, the effects are felt in other markets as well. A combination of rising prices, scarcity, and a general reevaluation of the medium has resulted in startling changes in the field of photography, for example. Until recently only the domain of a few enthusiasts and historians, photography has gained acceptance as an artistic medium, and works by recognized master photographers have either soared in value or become altogether unavailable. As photographs by nineteenth-century masters are being snapped up, museums that have responded more slowly to the increased public demand and appreciation for photography are now paying premium prices to add these works to their collections.

In addition to relative scarcity, taste also plays an important role in determining the prices individual artworks will obtain. Shifting trends in art appreciation cause the market value of artworks to fluctuate considerably over a period of

years and should sound a note of caution to prospective buyers of art only as an investment. In portraiture, for example, paintings by Sir Henry Raeburn sold in the 1920s for relatively high sums. Sales catalogs of that period list prices in the $20,000 to $30,000 range. Today, those same portraits are listed in sales catalogs at a fraction of their former price. Responding to changes in public taste, fewer private collectors find Raeburn's portraits compatible with their decor or lifestyle. The quality of Raeburn's portraits has not diminished, but the public's taste for these works has.

The results of escalating prices and scarcity are sometimes very unfortunate, such as the rampant theft and plundering of unprotected art. In Italy, for example, literally thousands of churches in cities and the countryside have been embellished by the work of generations of artists. Paintings and other precious relics are being stolen at an alarming rate. Many treasures now found in museums have been excavated from graves that were protected through the centuries by the burial practices of various cultures. These graves and other archaeological sites have also been plundered. The crime these vandals commit goes beyond the breaking of laws and actually causes damage to the artworks themselves. Pieces of pots are easier to smuggle than whole vessels, so often a beautiful vase or amphora that has survived over the centuries will be smashed and its pieces sold individually so that the object will be less easily traced.

Any country with archaeological sites is susceptible to such disruption, but countries with internal economic problems are particularly vulnerable. The wholesale pillaging of temples in India has brought fragments onto the open market. South America is teeming with hitherto unexplored sites that have since been spoiled by smugglers, who randomly cart off materials to eager collectors. Africa's treasures have been scattered in museums the world over. Art, the traditional booty of war, now supports a growing number of highly sophisticated thieves and smugglers.

Countermeasures in the form of protective legislation have been initiated by concerned governments, art dealers, and museums. Many countries have declared illegal the exportation of artworks considered to be national treasures. Each legally exported art object undergoes an elaborate review process, and the exporter must pay a tax. International cooperation has been fostered by the UNESCO Convention.* Interested groups have organized to make their particular plight public. Native Americans are struggling to preserve some of their sacred sites and to prevent plundering as well as scholarly excavation. The government of Cameroons, in Africa, is systematically tracking down and de-

*The United Nations Educational, Scientific, and Cultural Organization (UNESCO) is dedicated to education about art and the preservation of art on an international level. It is a moving force behind the sponsorship of international legislation preventing the removal of national art treasures from their country of origin.

manding the return of ancestral figures that are deemed critical to the preservation of the country's heritage and religion.

Most museums and dealers, mindful of these issues, are quite cautious about what they acquire. In most art museums, each acquisition is examined as an individual case, and certainly no museum today would intentionally acquire a stolen artwork or a national treasure. However, there is still some debate surrounding the question of whether museums and collectors may rightly obtain examples of art from countries that are too poor or incapable of protecting their own artistic resources. Unquestionably, it would be beneficial for all countries to cooperate in providing the funds necessary to enable each nation to protect and preserve its artistic heritage.

A SAMPLE PURCHASE

Bearing in mind the conditions and problems that the marketplace presents, this section discusses the procedures and considerations involved in the purchase of an art object for inclusion in a museum collection.

Let us assume that we are the curator of drawings and are trying to build up the drawing collection, which has suffered somewhat from neglect. The museum has a few, in terms of artistic quality, relatively minor Italian drawings, and we wish to add examples of other drawings that will show the range and quality of Italian draftsmanship. Our museum is modest and our means not unlimited. Even if we did have unlimited resources, we could most likely never acquire examples by the old masters, whose drawings have long since been acquired by the great museums of the world.

In order to locate a drawing that would be representative of the Italian output and that would enhance the collection as a whole, we would begin by scouring the sales and auction catalogs. Correspondence and visits with art dealers also give us a sense of what is available on the market.

An exquisite chalk drawing of a Madonna's head by the respected but not too well-known Italian master Federigo Barocci is announced for an upcoming auction. The estimated sales price of the drawing is checked in the back of the catalog. It seems to be in keeping with recent sales prices of other, similar drawings. The description of the drawing in the catalog offers some additional, interesting information. The drawing was previously unpublished, which means specialists in the field have not yet included this drawing in their publications on the subject. The drawing is also considered to have been a preparatory sketch for one of Barocci's most celebrated paintings, which was also reproduced by the artist as an etching. Our museum has an impression of this print in its collection. The addition of the head drawing would demonstrate the steps in the creative process, as an artist progresses from initial idea to sketches to the final painting and then translates the image into yet another

medium. Thus, the drawing not only fills a real gap in the drawing collection but offers many other features as well.

Having examined the drawing and reviewed our interest with the museum director, we research further. Using the library and our knowledge of Italian drawing, we locate two specialists on Barocci drawings and ask their opinion of the drawing. One informs us that, although she has not examined the drawing personally, it does look good in reproduction and appears to be genuine and in good condition. It is very likely, as reports indicate, the preparatory sketch for the Barocci painting in question. The other specialist has seen the drawing, concurs with the first expert on all points, and recommends purchase. Yet another specialist at the auction house is asked to examine the drawing first-hand. In the process, it is determined that the drawing was cut down on the sides by a collector, but that this only damaged the shape of the paper and does not impair the quality of the image. All parties agree with our initial reaction: The drawing is of good quality and rare, the price is reasonable, and the acquisition is desirable.

This background information is reviewed by our governing board, and a price ceiling for our bid is determined. A bidder is appointed to attend the auction. Finally, after much suspense, the word arrives that our museum has obtained the drawing at slightly under our ceiling.

The purchase of the Barocci drawing underscores the process art museums undergo in adding materials to their collections. In principle, many important considerations underlie the decisions museums make regarding acquisitions. The major concerns are described below.

Quality

The decision to purchase the Barocci drawing was based on the judgment that it demonstrated a significant artistic achievement and warranted inclusion in the museum's collection. Such an assessment is, of course, to some extent subjective. However, just as musicians reach various levels of proficiency by performing, so artists are judged for the degree of imagination and skill they demonstrate in their work. Curators, art historians, and museum directors, by virtue of their professional training and experience in both looking at and evaluating art, are able to judge such works with an informed eye.

Judgments concerning an object's quality are not always restricted to its aesthetic merits, although this concern is primary. In cases where a reproductive process has been used, as in printmaking, the work is also judged for the quality of a particular impression—in short, how well the ink registered from the plate to the paper. Good impressions are sharp and clear, and, on close examination, there is no breakdown or loss of ink due to excessive printing from the same plate.

The assessment of quality in relation to the collection will differ from one art museum to another. A small painting by an anonymous fourteenth-century

Italian master may be considered insignificant or of low quality by a museum with the standards of the Metropolitan Museum, in New York, which is filled with great masterpieces. But a small regional museum may be delighted to display the same work as an example of the art produced during the Middle Ages. Both museums are aware that the work is not the best of its type, but one museum's needs differ from those of the other.

Need and Relationship to the Collection

When a museum determines a need, it can define that need on many levels. Our primary need was to add drawings to our collection, as these had been particularly neglected. More specifically, Italian drawings were sought, especially because we owned good examples from other countries and periods. Sixteenth-century Italian drawings, in particular, were underrepresented, so the appearance of the Barocci drawing on the market was fortuitous.

The addition of this particular drawing to our collection brought with it a number of other benefits. The technique it demonstrated, chalk on paper, was an important one for European artists, and the Barocci sketch offered an example of that technique by an early experimenter in the medium. As a preparatory study for a painting, it was one of our few holdings to document the process by which an artist creates, as he moves from drawing to final painting. Our collection also happened to include a Barocci print related to the same painting, so the drawing would enable us to demonstrate by comparison how one artist works in two different mediums.

Barocci inspired a number of followers, among whom were Jacques Bellange and Hendrik Goltzius, whose work is also represented in our collection. The addition of the Barocci drawing would allow us to illustrate the nature of one artist's influence on others. Although each work of art is unique, the combination of examples we assembled would provide some insight into the artistic development of a given period.

No two museums' collections are the same, nor are their needs identical. However, each museum undergoes the same process in evaluating its strengths and weaknesses to determine what is needed. Each also inevitably discovers that every addition to the collection enhances its holdings on a number of levels. Most museums are likely to have needs they do not expect ever to fill, given the scarcity and price of some objects. And museums may wait for years before the opportunity will arise to fill a particular gap. When the opportunity does present itself, however, the strengthening of a museum's collection through new additions is among the most rewarding and enjoyable functions of museum work.

Price

The price of the Barocci drawing was also an important factor in its purchase. Although the drawing was desirable, it would not have been purchased had the

sales price gone beyond our estabished ceiling. The ceiling we set usually defines the price the museum can actually afford. However, had we been able to obtain additional funds for its purchase, we would probably still not have acquired the Barocci drawing. From our knowledge of the offerings available on the market, we might have felt that another object of equal value to the museum collection could have been found at a lower price. Beyond a certain price, the drawing would simply not have warranted the additional expenditure.

Clearly, museum budgets vary, and each purchase must be weighed in terms of a number of considerations—the importance of the work, its impact on the collection, and its estimated market value in the minds of other prospective buyers. It is in the context of all these factors, which must ultimately be balanced against each other, that prices for artworks must be viewed.

Condition

Another important consideration in any museum acquisition is the condition of a work of art: Is it in the same condition it was when created? If not, what are the changes, and how did they come about? Are they typical of what one would expect for works of art from this period? Is the condition unusually poor or good?

The passage of time, and frequently human intervention, have affected the state of works of art. Sculpture, for example, often survives only in a fragmented state. Arms, legs, and other extensions break easily. Wood sculpture is subject to rot and worm infestation. Stone sculpture may be abraded, broken, or sometimes, to counter aging, recut or overcleaned.

Paintings can lose paint flakes and are repainted. In rare instances, artists are known to have restored their own works, but in most cases, restorations have been done by others in later centuries. These alterations may distort a work's original appearance, but later additions are sometimes fascinating in themselves, for they reflect one period's reaction to the art of an earlier age. A thirteenth-century Madonna, for example, may have her face "modernized" by a fourteenth-century painter, or a nineteenth-century restorer may decide a face is too stern and retouch it. All of these alterations obscure the work's original appearance, and decisions regarding the condition of a work must often be based on how much of the original has been preserved.

Paintings are not only recoated but their shapes are often changed. Many European paintings on wood that were made from 1200 to 1700 were composed of sections. Later collectors of these paintings have frequently dismantled the sections, extracted pieces they liked, and discarded or dispersed the rest. Book illustrations suffered the same fate: Books were unbound, the pages sold piecemeal, and, in some instances, the decoration was cut out of a page.

Pottery is often found broken. Jewelry, metalwork, and clay and wood sculpture have frequently been "reconstructed," or assembled from newer, unrelated pieces that look similar. Textiles are treated similarly. Prints can be "intensi-

fied," that is, the loss of ink in printing corrected by the manual addition of ink. Drawings can be "freshened" or redrawn to alter their appearance or counter smudging. Painted sculptures often have had their colors renewed. In paintings, frames are falsified and signatures added.

Clearly, the condition of a work must be scrutinized prior to acquisition. The analysis of condition is undertaken with the help of experts and advanced technical equipment.

Forgery

A forgery is a deliberate misrepresentation. Forgeries can take any number of forms. They can be copies of an original work by a skilled imitator, or they can be, as is often the case, an amalgamation of various aspects of an artist's style, which the forger has learned to imitate. A cast that is taken from a sculpture and presented as the artist's original creation constitutes a forgery.

Some forgeries are obvious, but many are deceptively convincing. Some forgers developed such superb techniques that their fame was based on their ability to imitate successfully the style of a famous artist. The Dutchman Hans van Meegeren (1884–1947) established his place in history for his many remarkable forgeries that emulated Jan Vermeer and other seventeenth-century Dutch masters. The nineteenth-century forger G. F. Ioni produced scores of Italian Renaissance "masterpieces."

Technical and scientific processes help us to determine the authenticity of a work of art. Chemical analysis of paint reveals quickly whether a pigment is of modern manufacture or the product of an earlier period. A knowledgeable conservator can use microscopic examination to find out whether the cracking of paint on surfaces is genuine, whether it was artificially induced, or whether it was simply painted onto a slick surface to simulate the cracking that comes with age. The technical accomplishment of a work can reveal its true origins, for even good forgers are often incapable of the elaborate craftsmanship that characterized old master paintings or sculptures. Infrared reflectography is a relatively new process that permits painting beneath a paint surface to be detected. It frequently provides evidence of underdrawing, which was consistent with artistic practices in some periods. Pottery can be tested for age using carbon dating, thermoluminescence, and a highly sophisticated form of X-ray bombardment. Scientists can date the material of a piece of pottery with relative accuracy, to within 100 years of its likely date of creation.

Metal can be analyzed for its components. The manufacture of bronzes, for example, involved different quantities of trace metals, depending on the period and location in which the bronze was produced. Stone can also be analyzed. Samples are compared with others to determine the origin of the stone. If the age and origin of the stone are consistent with its appearance, then the combined evidence provides relative certainty of its authenticity.

Condition is also a factor. If a piece of African sculpture lacks patina or if the wood is in perfect condition, this evidence, along with a consideration of its artistic style, indicates that it is of recent manufacture and lacking in value as an example of art used in specific rituals. If a piece of Greek marble sculpture is perfect in every respect, it is suspect from the very start, as such works rarely survive 2,500 years intact.

These technical aids are indispensable but not always infallible. In the hands of an expert with a practiced and accurate eye, however, they are excellent tools in separating authentic works of art from their imitators.

Copies

At times, the distinction between a copy intended as a forgery and one that is intended as a work of art in itself is difficult to make. The practice of imitation, including copying, was an integral part of the art production of many cultures of the past. The Egyptians, for example, maintained their stylistic consistency through strict adherence to traditions, under which artists of one generation per-force emulated the working methods of their predecessors. This could be considered copying, and Egyptian art could be said to be lacking in originality because of its system of production. However, for the Egyptians, copying was an accepted and necessary practice. Students of Egyptian art must make highly refined distinctions in order to differentiate one phase of Egyptian art from another, but they accept the practice of copying as an integral part of Egyptian culture.

The replication of images was a necessary part of the function of art in other cultures as well. Roman emperors had replicas of their portraits placed in numerous cities across the empire. Medieval patrons, anxious to possess the magic powers that were thought to be inherent in certain religious works, would commission reproductions. Or a work of art may have been so famous in its day that artists, only sometimes compelled by patrons, were inspired to copy it.

For centuries, European and Asian artists were trained through the practice of copying works of older masters. It was acceptable and, indeed, even desirable to emulate an artist's style successfully. The contemporary notion of originality was alien to the workshop system, which was traditionally the most common method of art making in the past. Cooperative manufacture, in which more than one hand was involved in creating a final image, also encouraged the practice of copying. Shop practices, which included the production of large working drawings or models, could sometimes result in numerous versions of an image. The Barberini *Holy Family* by the Renaissance painter Andrea del Sarto, for example, has twenty-one documented copies, which were most likely based on just such a workshop cartoon that circulated within the shop.

To a greater or lesser degree, artists who made copies injected a subjectivity or their own personality into the reproduction. However, some copies are so

faithful to the original as to be almost indistinguishable, whereas others merely used the model as a point of departure for a very independent, idiosyncratic interpretation of the image.

Copies by unknown artists are frequently identified as "shop of———," "follower of———," "imitator of———," or "student of———." All of these designations indicate some relationship between the master who is being imitated and his copyists.

Misattribution

A work of art may be authentic, but its actual identity may be obscure or a matter of debate. The discussion regarding copies makes it evident that the distinction between the hand of the master and that of his student, follower, or shop assistant is often a matter of controversy. When there is no hard and fast evidence, such as a recorded document that clearly identifies the author of a work, then there is more than often room for dispute.

What is true for the authorship of a work is also true for its date and country of origin. For example, a follower of a particular master might have lived several generations later, and the date of a copy made by the follower might be later by as much as fifty to one hundred years. Often it is very difficult to specify which region produced a work, as stylistic influences were reciprocal among regions.

All of these considerations affect the relative importance of a work in a museum collection. For example, a newly purchased, signed and dated painting by Rembrandt would be considered a very major acquisition. But it is not unlikely that, as a result of continually improving techniques in scholarship, this Rembrandt painting would be discovered at a later date to have been produced by a gifted pupil who worked in the master's shop and used his signature, as was the common practice of most shops of that period. Because Rembrandt is generally considered the greatest artist of his day, obviously more value would have been placed on a work done by the master.

Nonetheless, an art museum would most likely still be happy to have the work by Rembrandt's pupil. The copy itself is evidence of the circumstances under which Rembrandt and his pupils worked and clarifies the relationship between the master and his circle of followers. Had the museum known the authorship of the painting prior to its acquisition, however, it might have reconsidered the purchase, and certainly it would have paid a different price. The contributions of Rembrandt's pupils were certainly less significant than those of the master, whose genius was responsible for the formulation of painterly images and compositions.

It was common practice in Rembrandt's time for students to execute the actual painting of images conceived by the master. A few of Rembrandt's patrons stipulated in their contracts with the artist that only his hand put brush

to canvas. The distinction between what was conceived and what was actually carried out by Rembrandt may not have been deemed significant in Rembrandt's time, but it is an important factor in our age and affects our appreciation of works of art.

Personal Taste

The ideal museum is one in which the underlying philosophy of its collection development is well conceived and supported by museum staff. There is no question that the individuals who work in art museums have personal tastes regarding art and that these subjective values have always played an important role in museum acquisitions.

Directors, curators, advisory committees, and benefactors all have personal likes and dislikes that are somehow reflected in a museum's holdings. A collection that is created simply out of the desire to obtain "correct" examples of art would be bereft of the joy and spirit that inspire the appreciation of certain art objects. Most museums try to achieve a happy medium between the needs of the collection and the preferences of its staff. Thus, the quality of a particular collection rests on how well these considerations are balanced.

Collection Size

So far, this discussion has been concerned with the process involved in acquiring works for a museum collection. Intrinsic to the process is the question of how large museum collections are or should be. No matter how large or small a museum is, its collections are usually so large that there would never be enough space in the museum to display everything at once. Therefore, a good portion of a museum's collection is often kept in storage. In many cases the material on display represents a mere fraction of the museum's holdings. Why do museums have so much material and why do they continue to grow? What measures are they taking to limit their growth?

Many factors necessitate the placement of materials in storage. If a museum accepts an entire collection, it may find that, given the quality or condition of that collection, only a portion can be shown at one time. Many museums accept certain items that are not of the requisite quality to be shown in the permanent collection but that are worthy of preservation as "study" material for students and specialists. Some museums inherit artists' estates and feel obliged to care for and preserve this material, even though they may not have room to display it all at once. Some materials are inherently fragile and cannot be displayed for long periods of time. Too much light or exposure to heat can damage some works, and so they are put on rotating display. Many museums believe that their permanent displays benefit from occasional changes, because their visitors can thus look forward to seeing new as well as familiar objects.

Such periodic and limited changes enable the museum to enliven its permanent collection without disrupting its continuity.

However, the question of unlimited growth is important and has been addressed by museums in a number of ways.

Deaccessioning A practice that is as common as it is controversial, deaccessioning entails the removal of a work from a museum's permanent collection for sale or exchange for other material. If, after a number of years, a museum finds it has obtained too many examples of a certain type of artwork, and thus seeks to fill gaps in other parts of its collection, it may regularly dispose of redundant material. As museums upgrade their collections, some pieces may no longer be considered vital to the collection and are also deaccessioned.

At best, deaccessioning is a rational, logical option that keeps a museum collection active, growing, and thriving. At worst, deaccessioning leads to controversy. Its practice discourages potential donors from leaving gifts to a museum's collections for fear these will not find a permanent home. It can deprive the public of the opportunity to see objects with which it has become familiar.

Deaccessioning also entails the sacrifice of certain parts of a collection for others. Much as personal tastes play a role in museum acquisitions, these subjective elements also figure in decisions to deaccession and generate disagreement regarding the wisdom of particular choices. However, as long as museums continue to add material and expand or upgrade their holdings, deaccessioning will remain a useful tool for collection development.

Long-Term Loans Some of the largest museums have instituted liberal policies regarding extended loans of their stored materials to other museums. This benefits smaller institutions, which could otherwise never obtain such objects for their own collections. Many museums make exchanges or long-term loans on a smaller scale. If one museum owns half of a pair of objects, for example, it may on occasion lend its half to the owner of the other half, so that the pieces can be rejoined, if only temporarily.

Size Limitation Some museums have simply chosen not to grow beyond a certain size. By either limiting the number of objects or limiting the physical space these objects occupy, they are able to hold their collection sizes within certain bounds. Other, large institutions choose not to restrict the scope of their materials because they are committed to fulfilling their roles as preservers of our cultural heritage. Smaller museums may serve a more limited geographic region and may consider their obligation to the public to have been fulfilled with less exhaustive holdings. Such institutions can purposely limit their collection and displays.

CHAPTER 3

The Functions and Organization of Art Museums

❧

Art museums perform a number of important functions. Their principal mission is the preservation and exhibition of artifacts of our artistic and cultural heritage. Museums with sufficient financial resources to do so will try to improve and refine their collections, and most museums research, catalog, and publish information about their collections in order to help the public better understand and appreciate their holdings.

This chapter is devoted to a discussion of the functions a museum performs, as well as the costs that are incurred in performing them. The requirements museums have in terms of staff and the functions of museum staff members are also analyzed. Finally, the nature of museum buildings is considered briefly.

MUSEUM FUNCTIONS

PRESERVATION

No matter what their origins, all art museums have a common purpose: the preservation of their holdings. The protection of collections for the benefit of future generations is the museum's primary obligation, and it mediates every other function. It affects how they display their materials; it influences their acquisitions; it determines the development of museum staff; and it dictates the nature of museum buildings and the organization of space within these structures.

In order to preserve their collections, art museums must be aware of certain dangers or potential harm that may fall to objects on display. Artworks on display risk being stolen or mutilated. Well-known masterpieces are generally immune from theft because they are too famous to be resold, but they are the

occasional victim of fanatics, as the attacks on Michelangelo's *Pietà* in Rome and Rembrandt's *Night Watch* in Amsterdam demonstrated. Other artworks can be unintentionally harmed by museum visitors who fail to understand the damage they can cause simply by touching an art object. Hands have oils and residues that permanently penetrate and alter the surfaces of objects. Marbles absorb these oils, bronze patinas change because of them, and the varnish on paintings is smudged by them.

For these reasons all art museums establish regulations for the public. Most museums post their regulations for visitors to read. Packages, briefcases, and coats must be checked, because they present a potential for damage—a flying coat can hit an object, a zipper can scratch a painting, an umbrella can poke through a canvas, a briefcase can suddenly drop. The risks involved in carrying packages or coats are simply too great for museums to take. Museums also do not permit smoking, eating, or drinking, for similar reasons.

Museums generally permit photography only when the camera is handheld and no flash is used. Flash produces sudden bursts of light that, over time, damage works of art. The museum visitor is advised to check with a guard before attempting to photograph an object.

In order to protect objects on public display, museums employ guards to watch visitors and guard rails or ropes to prevent people from getting too close to objects. The most vulnerable objects are put under glass or inside cases.

Every time an object is touched or moved, it is subject to risks. In order to minimize those risks, museums train their personnel in the proper care and handling of artworks. In these training sessions, they are taught how to handle and move paintings using carts or specially designed wagons. Instruction is given on the proper handling of works on paper, bronzes or other metal objects, which require the use of clean cotton gloves, and ceramics and other objects. These training sessions involve everyone who will handle artworks, and museum policies limit handling to those who have been properly trained.

In addition to theft or mishandling, artworks are vulnerable to many other factors, depending on the materials from which they are made. Atmospheric conditions affect all art objects. Fluctuations in temperature and humidity are severely detrimental to almost every kind of material. Cloth, fibers, paper, and especially wood respond to those fluctuations by expanding and contracting. Continual fluctuations in humidity will cause cracking, splitting, lifting of pigments, and warping. Humidity can also induce the growth of molds and mildew, which destroy surfaces. Environmental impurities or atmospheric pollution are other significant dangers. Marbles and bronzes suffer surface erosion caused by chemical impurities in the air.

Light is also detrimental. Photographs, watercolors, and drawings will fade under prolonged exposure to light. In order to preserve collections of works on paper, museums severely limit the light levels for rooms containing such materials. These objects are often displayed in windowless rooms with very low

light, or in rooms that are designed to light up only when a visitor is present. Museums are also experimenting with light-resistant acrylic glass, which limits the penetration of damaging ultraviolet rays.

Acidity can threaten works made of fibers or on paper. A drawing or print mounted on mat board that is not acid-free will, over a period of years, absorb that acidity and eventually deteriorate and crumble. The acid content of some adhesives used to mount textiles or fibers is also corrosive.

Art museums also design display and storage facilties to minimize potential and real dangers to their collection. Public areas must be large enough to accommodate the anticipated number of visitors and allow the public to move through display areas without crowding. Storage areas must be clean and should be large enough to hold all objects without overcrowding. Proper storage facilities must include such equipment as racks to hang framed works, drawers to hold works on paper, and protective cases, boxes, and containers for objects large or small. And, of course, such areas must be secure.

Display and storage areas must be environmentally stable, and temperature and humidity levels relatively constant. Between 65 and 70 degrees Fahrenheit and 50 percent relative humidity are the norm.

Laboratories dedicated to the treatment of paintings, works on paper, and other art objects are an important part of a museum's conservation efforts. Each laboratory is equipped to treat specialized types of materials.

To preserve their holdings, then, art museums have many special requirements. They must have buildings that are environmentally and physically secure. The must have storage spaces that can safely accommodate their holdings, and they must have the staff and facilities to handle and treat their collections properly. They must also have display areas that will allow artworks to be exhibited under proper protection while remaining accessible to the public.

DISPLAY

If preserving artworks is the primary aim of museums, certainly exhibiting them is a no less important second function. The display of objects requires time, energy, planning, and money. Before objects can be displayed they must be thoroughly examined by curators and conservators to determine that they are in proper condition. No painting that shows lifting of paint or that has a weakened support or that needs major restoration will be placed on exhibition. No bronze that shows signs of active corrosion or a mutilated surface can be displayed.

After examining objects to ensure they are in the right condition, the museum staff plans the display of related materials. Objects are assembled for exhibition according to the geographic regions and time periods in which they were produced. The display area is then designed with an eye to exhibiting each object to its best advantage and, at the same time, offering it the most protection.

Paintings are generally placed in chronological sequence on a wall, but they must be spaced so that each can be appreciated individually, with no one painting visually overpowering another. Special attention may be given to displaying an object as it was originally or historically seen. If a painting once decorated an altar or perhaps a ceiling, it may be placed higher up on a wall. If a painting was once part of the decoration for a piece of furniture, it might be placed much lower. In most instances, museums will consider the needs of their visitors. They hang pictures at a height that will suit the average visitor, in the hope that museum goers who are exceptionally tall or short will not be disturbed by this arrangement.

The size of materials to be displayed in an area help determine the size of the room. Large paintings and objects require much larger spaces than small images in order to be properly appreciated. The museum visitor must be able to step back to view large objects in their entirety, whereas smaller objects call for a more intimate environment to allow the visitor to view them more closely.

In order to accommodate exhibits of both large and small objects from a given country and time period, museums require display areas with flexible, movable walls and cases that can be rearranged to suit either large or small items. To work out the final arrangement of a particular display area, museum staff will often use small-scale models and miniature replicas of objects and pictures. These are then arranged and rearranged until an acceptable solution, one that satisfies all the criteria for a successful exhibition, has been achieved. The models allow the museum staff to iron out problems and prevent unnecessary wear of the objects intended for actual display.

The walls and cases of materials are chosen with an eye to their background color and texture. The most sumptuous arts of the Middle Ages and the Renaissance are often displayed against more lavish backdrops of velvet or brocade. Recent exhibition design for works of the Renaissance has become more restrictive, however, and tends to favor the use of single color, such as a muted orange or pale green for the background. Displays of tribal or pre-Columbian art require the selection of colors and textures that are visually compatible. Natural fibers and raw wood have been effectively used by various museums to display art of Africa or pre-Columbian South America.

In addition to considerations about room size, display height, and background materials, lighting is a critical factor. The choice of lighting is perhaps the one element of museum displays that has been most subject to change and diversity. Before World War II, museums most often employed various types of skylights to bring natural light into their exhibitions. Since then, museums have increasingly shifted to artificial light to allow for more control, because excessive light is considered detrimental to many kinds of artworks, including textiles, works on paper, and objects made of wood.

Natural light can be controlled through shades, tinted windows, and curtains, but artificial light can be controlled in more diverse ways. The kind of

artificial light ranges from flourescent to various types of incandescent bulbs. Flourescent light is least desirable because it radiates more ultraviolet rays. Incandescent light can be selected by wattage, and different filters can be placed on incandescent bulbs to diminish further their potential damage to works of art. Artificial light can be directed at an object or it can light an object indirectly. Finally, artificial light can be turned on and off at will, thus limiting the exposure time of an object to the few moments a museum visitor needs to view it. Not surprisingly, many newer museums have opted for the flexibility and control that artificial lighting offers.

The display of artworks in museums has undergone many changes since the eighteenth century. During the eighteenth and nineteenth centuries, it was common practice to crowd the walls high and low with pictures and to line spaces with sculptures and casts of all kinds. The twentieth century witnessed the development of a more purist approach to display. The number of pictures displayed is reduced to a single row along a wall, and the number of sculptures limited to works deemed to be original, which are now placed discreetly in well-chosen spots. More recently, museums have expressed a concern for historical authenticity in the design of displays. The Philadelphia Museum of Art, for example, now exhibits its eighteenth- and nineteenth-century art by hanging the pictures up and down the walls, as was the fashion of the time.

Many museums are concerned to display their objects in an historical context that will help the museum visitor understand the original function of these objects. Because function in large measure determined the size, shape, material, subject, and even color of a particular object, the viewer cannot fully appreciate it without historical background information. (In many cases, museums preserve only a fragment of an object and must therefore try to reconstruct its original appearance.) The materials that are necessary to provide the visitor such information—maps, photographic reconstructions, long explanatory labels, and other visual aids, such as filmstrips and slides—distract from the serene and aesthetic environment of the museum display. Museums must therefore incorporate their explanatory materials discreetly and carefully in order to maintain the aesthetic integrity of their exhibitions while providing the needed additional information.

Special Exhibitions

In addition to permanent exhibitions, most museums organize or display special temporary exhibitions as part of their activity. Special exhibitions, which commonly last from six to eight weeks, are a lively part of a museum's life. These exhibitions have a dual purpose. They bring together related materials from various collections (both public and private) and permit the visitor a rare opportunity to experience them all together. Special exhibition catalogs are

more permanent records of these displays and generally provide some new information on the objects that have been brought together.

Special exhibitions take many forms. They can be seen at one museum only or they can travel. They can be devoted to the work of a single artist, they can survey the art of a given period or region, or they can examine the diversity of artistic expression within a given medium. The recent Picasso retrospective, the *Treasures of Tutankhamen*, the *Search for Alexander*, the *Treasures from the Bronze Age of China*, and the *Treasures of the Vatican* are examples of the ambitious nature of some special exhibitions. *American Master Drawings and Watercolors*, an exhibition held in 1977 at the Whitney Museum of Art, in New York City, is an example of a special exhibition whose catalog (by Theodore Stebbins) has become the basic reference work for the history of American drawings and watercolors.

The costs of special exhibitions vary, depending on their size and the expense of bringing materials together. The exhibitions of Tutankhamen, Chinese bronzes, and Vatican treasures involved enormous expenditures for shipping. Priceless, irreplaceable objects had to be carefully wrapped, padded, boxed, and crated so that no damage would occur in transit. Arrangements for special handling also had to be made. Normal shipping was abandoned in favor of supervised moving, loading, and unloading of each crate by trained specialists. Usually such shipments are accompanied by appointed couriers and curators from the lending institutions, who carefully monitor the packing and unpacking of each object.

Despite the fact that objects involved in special exhibitions are priceless, they must be insured. The insurance costs for a large-scale special exhibition involving international shipments are so enormous that the expense is usually shared by all participating countries through a special treaty enacted by their governments. These treaties involve lengthy negotiations and also add to the cost of the final project.

Special exhibitions involve the creation of extra display equipment. In most instances, display equipment is not provided with the objects, so new stands and bases for statues or cases for objects, as well as special colors for walls, must be provided by the institution sponsoring the special exhibitions. Museums tend to charge lending fees to defray the cost of preparing their objects for loan. They may also charge the borrowing institution the cost of insurance for the exhibition, and both the lending and borrowing institutions incur the cost of time and paperwork involved in preparing a loan. Finally, the cost of special exhibition catalogs, posters, announcements, and invitations must be borne by the museum sponsoring the exhibit.

Shipping, packing, insurance, lending fees, display equipment, printing and publication, publicity fees—these costs constitute the basic expenses for any special exhibition, large or small. If the exhibition is small, these costs are relatively modest. A recent exhibition involving about seventy drawings, bor-

rowed only from collectors within the continental United States, cost roughly $25,000, which covered shipping, mounting, and publication of the catalog. A large and spectacular exhibition such as the *Treasures of the Vatican* costs millions to produce.

No art museum by itself has the financial resources to defray the cost of a special exhibition. Most special exhibits are funded through special agencies, such as the National Endowment for the Arts or the National Endowment for the Humanities. Other philanthropic organizations, such as the Ford Foundation, the Samuel H. Kress Foundation, and the Mellon Foundation, as well as contributions from the business community, help make special exhibits possible. Most special exhibitions are free to the public, but the larger, more ambitious projects charge entrance fees to help defray costs.

The organization, planning, and production of a special exhibition involves many talents. The idea for a project usually derives from a curator or art historian, who works alone or often collaborates with a number of specialists to develop a project and select the objects that will be assembled for display. A minimum of two years' lead time is required to plan an exhibition, negotiate the loans, and research and write the catalog. The more ambitious the project, the more time is necessary in advance to properly see the project to completion.

Not all loan requests are automatically approved. If the lender is another museum, the loan must be approved by that museum's governing board in conjunction with advice from the museum's curatorial and conservation staff and director. If the work is deemed too fragile or too important to the museum's own collection, or if the loan request involves the object's prolonged absence from the museum, the loan request may be denied. Conflicts may arise when one request is denied and another special loan request is made. If the lender is a private collector, he or she may not wish to have a prized object removed from his or her collection.

Once the negotiations for loans have been completed, more people become involved in the project. The museum registrar must be notified of a forthcoming special exhibit and is involved in the paperwork that formalizes the loan. A loan agreement must specify the terms that have been approved by both the borrower and lender; they include the details, restrictions, and other aspects of a transaction. Some works on loan cannot be photographed without permission; some cannot be removed from frames without permission; some cannot have the lender identified; others must identify the lender according to a specific format.

Once the loans are on their way, the museum registrar and curators often become involved in the mode of transportation from the lender. "Hand carriage," which means the object is carried by a museum staff member from one place to another, is a common practice. If the work must be trucked, it is often accompanied by special couriers.

When the object arrives, it must be unpacked by museum staff, inspected, and logged in, and its condition recorded. This procedure is followed again when the object is returned. When the object is hung, it is done by the exhibition curator(s) and museum staff together.

Labels identifying each object and posters announcing the exhibit must be printed along with the catalog. These preparations are made with the aid of editors, designers, and printers, as well as the exhibition curator(s) and the museum's education department.

The exhibition usually opens with a special celebration, to which all those involved with the project and special visitors are invited.

IDENTIFICATION AND DOCUMENTATION OF ART IN MUSEUMS

Museums use various systems to identify their objects and keep track of their collections. To give the reader an idea of the variety and purpose of these systems, a hypothetical object will be taken from its first entry into a museum to its final place on display and as part of the museum's collection catalog. Let us assume that the museum is considering the purchase of a statuette of a bull attributed to the late sixteenth-century Italo-Flemish sculptor Giambologna.

The museum director and curator have found this work in a gallery and, after some preliminary research, have requested the gallery to send this work to the museum for consideration as a purchase. The museum's registrar is notified to expect the bull and, in turn, works out the details of shipping with the gallery. Once the bull has arrived and is unpacked, the registrar assigns it a receipt number that records its vital statistics: artist's name, title of work, material from which it is made, approximate date of creation, measurements, name and address of the dealer from whom it has been borrowed, and its purchase price. Its condition upon arrival is noted, and preliminary photographs are taken to confirm this.

The bull will retain its assigned receipt number for the next several months while a museum curator researches it, consults experts on its authenticity, prepares a file on its history and on comparable material, and outlines a case for its purchase to the committee that will decide on the acquisition. If the committee decides against the purchase of the bull, it is returned to the dealer and no further records are made. If, however, the committee decides to purchase the bull, then the museum will make a number of additional records.

Once the purchase has been made, the registrar assigns an accession number that is specific to that piece. Every art museum has its own system, but, in general, accession numbers record the year an object was purchased and then a sequence number for the year of its acquisition. For example, if we bought the bull in 1982 and it was the thirtieth object we acquired that year, the accession

number for the bull would be 1982.30. If the bull was purchased that year and was the third in a lot of six objects purchased from one dealer, its number would be 1982.30.3.

The accession number is then affixed to the object in a discreet spot with a fairly stable but soluble paint. Fixing numbers to objects is a problem, as any permanent numbering could deface an object. On the other hand, should the number be lost, the record-keeping system would break down. Museum registrars are continually reviewing their numbering procedures, testing new application methods as they are developed.

The accession number is the primary item of information found on an accession card. This card is the single most important document of the object in the museum's filing system. The card records the name of the artist, date and title of the work, approximate date of the material from which the object is made, its measurements, condition, source, cost, former ownership, publication record (in some cases), and insurance information. The card is filed by its number in sequence, so the accession number becomes the easiest means to retrieve basic information about the object.

Museums also have a variety of cross-reference systems to locate information. The most basic cross-reference files include a system that identifies works by period, by country of origin within each period, by medium within each country, and then by artist within each medium. Our bull would fall in the category, 16th century Italy, Sculpture, Giambologna. Another form of cross-reference is the artist file, which identifies accession numbers of all objects by a given artist in a collection. Some museums have subject files, and most also keep a file by dealer or donor.

In the photography department, a record is made of the object's appearance. The bull is photographed from every angle, and perhaps details are recorded on film as well. The negatives are usually filed by accession number.

Meanwhile, the curator has developed a file on the bull. Photographs of casts or versions of the work are assembled. Published or written opinions on the object by various scholars are included. A record is made of all relevant publications and exhibitions in which the bull has been cited or included. If an early source or model for the work is known, this is documented as well. The condition reports are also filed. The curator's file may also contain a basic bibliography on the artist and as much information as is known on the history of the object's ownership since its creation. When all the information is complete, the work can be included in a museum publication. If it has been purchased since the guide to the museum's collections was published, museums will announce the purchase in a bulletin or other regular publication.

If the museum has an active curatorial staff and a fairly large collection, then a library becomes a necessity. Standard reference works that list artists' biographies and bibliographic references, dictionaries of art and artists, encyclopedias

of art, and books on collectors' marks and watermarks for works on paper are vital for a museum library. As museums accumulate dealers' and sales catalogs, these too become useful reference works. Publications and journals, museum catalogs, and scholarly works are needed for museum staff to perform their research properly. Libraries with the necessary funds also build up an invaluable library of photographs that, after the works of art themselves, become essential research tools.

ART MUSEUM BUDGETS

In a recent survey, 44 percent of the museums in the United States had annual operating budgets of less than $50,000 (excluding acquisition funds), and those with budgets over $500,000 constituted 5 percent. Only fourteen (of the 177) museums surveyed had operating budgets of more than $1 million, and about thirty-eight museums had budgets between $500,000 and $1 million.*

Even small art museums have complicated budgets, but larger art museums will sometimes require the services of a special administrator of budgets. In many instances, students who plan careers in museum management or administration will obtain one degree in art history or museum management and a second in business management, often a master's in business administration.

MUSEUM COSTS

The costs of operating art museums are considerable. First, there is investment in the physical plant. New buildings, including the Indiana University Art Museum in Bloomington, and new additions, such as the recent expansion of the Fogg Art Museum at Harvard University, have cost as much as $10 million each to construct. Once built, these museums incur running costs for the maintenance of temperature and humidity at strict levels, light and electricity, water, sewage, telephones, and the like—all of which add substantially to the annual budget.

The salaries of staff members constitute another portion of the budget. Museum directors earn roughly $30,000, to double or triple that amount in larger museums. Curators average salaries between $20,000 to $40,000 or more in larger museums. Expenses for the construction of new display equipment and supplies that are needed in the daily operation of the art museum also contribute to the budget, as do insurance premiums. The cost of special exhibitions,

*These figures are taken from a 1973 survey published in Sherman Lee, *On Understanding Art Museums* (Englewood Cliffs, NJ: Prentice-Hall, 1975), p. 68ff. Figures for 1983 will be considerably higher.

as described earlier in this chapter, is considerable, as are costs for publication, conservation, and other museum programs such as education.

Each art museum has some sort of acquisition budget with which to make purchases. Depending on the size of the museum, a purchase budget can range from thousands to millions of dollars.

What are the sources that supply funding for museums and their many operations? Public museums share a part of state and local tax revenues. Recent statistics from a survey of American museums have shown that only about 10 percent of art museums are fully supported by city, state, or federal resources. Nearly 70 percent of the art museums in the United States are funded through private philanthropy, which has contributed funds not only to construct museums and build their collections but to run and operate them as well. The remaining art museums are part of educational institutions and are funded by the resources of those institutions.

In order to supplement basic funding supplied by the sources described above, art museums rely on other resources. Many have fund or membership drives that are generally promoted through a "Friends of the Museum" group. Depending on the amount of the donation, museum membership generally entitles a participant to discounts at museum stores, advance viewing of special exhibitions, and invitations to special receptions. Larger museums request donations from all visitors, and some charge entry fees for special exhibitions.

Certain grant agencies, such as the National Endowment for the Arts and the National Endowment for the Humanities, and private organizations, such as the Ford Foundation, supply funds for such special projects as exhibitions, building improvement, and the addition of facilities, for example, conservation laboratories. Usually such grants are awarded with the requirement that the recipient match the gift with funds raised from other sources. Businesses and corporations also provide financial support for art museums. Business committees for the arts are increasingly active in promoting and supporting the many tangible and intangible advantages that the arts offer to their communities.

Of all the museum's activities, perhaps the most difficult to fund adequately is its day-to-day operation. Donors are quite pleased to give works of art as gifts or funds for the museum's other purchases. The results of such donations are concrete, beautiful, and rewarding. Others give willingly for special projects such as exhibitions, conservation, or the reinstallation of a gallery. Fewer patrons contribute funds to help the museum meet its operating costs. As a result, many art museums suffer chronically from lack of staff or from inadequate staff salaries. Quite often museum staff members will enter other, more lucrative careers as they find their options in the art museum world shrinking. Art museum organizations generally make pleas to the public for a better understanding of the vital role museums play in their communities, so that they can reward service through increased salaries.

MUSEUM STAFF

All art museums, regardless of size, require the talents of various staff members, ranging from administrators to guards. And, as in any organization, there must be a division of labor and responsibility. The structure of art museum staffs is discussed in the following sections.

BOARD OF DIRECTORS, OR POLICY COMMITTEE

Generally appointed by the president of the museum, the board of directors consists of men and women who have been selected on the basis of their distinguished position in the community and interest in the arts. The board is the ultimate source of museum policy and is the decision-making and governing body of the art museum. All major activities, such as fund drives, new building construction, acquisitions, and exhibitions are developed under the auspices of the board. Board meetings are held at regular intervals to conduct the business of the museum.

DIRECTOR

The director is the chief administrator of the art museum and enacts the policies established by the board. Every museum operation is supervised by the director, who usually delegates authority to various department heads, who answer directly to the director. The most public member of the art museum, the director is the link between the community and the museum, as well as between other professional organizations (including the National Organization of Museum Directors) and the museum. The director also is the primary liaison between the museum and donors or patrons. The director takes ultimate responsibility for the museum's acquisitions, its research and education programs, exhibitions, and publications.

The director sets standards for the museum. The role is a challenging and demanding one. It requires diplomatic and administrative skills, a broad and diversified knowledge of the arts, and a network of contacts in the business, art, and museum worlds.

CURATORS

Curators answer directly to the director and have primary responsibility for the proper care, display, research, cataloging, and publication of the objects within a given collection. The areas to which art museum curators may be assigned include prints and drawings, modern art, art from the Renaissance through the eighteenth century, Early Christian and Byzantine art, and ancient, Oriental, tribal, and decorative arts. In very large collections these categories may be

further subdivided into smaller areas of specialization; in smaller museums, the curator may have even broader areas of responsibility.

Curators are art historians whose emphasis and knowledge focus on the objects under his or her care. In that regard, they differ from other art historians, who tend to specialize in a given field. Curators must have detailed knowledge of specific objects in their collections and, because their areas of responsibility are sometimes quite large, they often must develop a broader area of concentration.

Curators usually work with scholars active in a given field, sharing and soliciting information about various objects. They must be familiar with the research methodology in a given field and conduct their research accordingly. Basic writing skills are necessary to enable the curator to compose reasonable summaries or analyses of data that have been collected.

Above all, curators must have a "good eye" and an excellent visual memory. By a good eye is meant a sensitivity to art that enables the curator to understand, appreciate, and judge a work of art for its beauty, quality, condition, and authenticity. Based on his or her knowledge of comparable works, the curator can judge a specific example on these various levels.

To develop that eye, the curator spends a lifetime looking at original artworks, thereby continually refining his or her sensitivity to nuances of style, technique, touch, and interpretations of subject matter that distinguish one artist from another in a given period. This pursuit offers immeasurable rewards, as countless images slowly yield their secrets, at once becoming unique in the mind of the beholder and finding their place in the visual repertoire of images the curator is always building.

REGISTRAR

Museums can function without many people. Conceivably, they could do without curators, conservators, photographers, public relations specialists, and education directors. But no art museum, no matter how small, can function without a registrar. The registrar is the central record keeper for the art museum, and his or her basic responsibility is to know the whereabouts of every object in the museum.

This is an overwhelming and at times frustrating responsibility, because artworks in museums are always changing location. They go on exhibition, or back to storage, or they are loaned to other institutions, or moved to conservation. Each time this happens, the registrar must make a record of it. Furthermore, other artworks are constantly moving in and out of the museum: objects being considered for purchase, temporary loans of all kinds. The registrar must oversee the packing and unpacking and arrange shipping and insurance, in addition to keeping the essential records by which a museum operates.

The registrar's organizational, managerial, and administrative skills are con-

tinually challenged. The scope of the registrar's responsibilities are broad, and may include museum security. Reporting to the museum director, the registrar has perhaps the most demanding and unrelenting job of any museum staff member.

CONSERVATORS

Conservators report to the director and work closely with the registrar and curators to preserve the works of art under their care.

Conservators have undergone rigorous training in chemistry, physics, and the technical aspects of treating and repairing works of art. Time and the environment are the enemies of all artworks. Metals corrode; pottery breaks; paper can discolor or develop mildew spots called "foxing," caused by acid inherent in the paper or present in the environment. Textiles can disintegrate. Paintings can lose the paint on their surfaces, or lose their supports (panels can split or be eaten by worms, canvas can deteriorate and lose its strength). In short, the problems are awesome.

Conservation is a continually growing and changing field as technological advances provide new tools for analyzing and treating works of art. If a museum has a trained conservator and a well-equipped lab, it has the two fundamental resources for the treatment of works of art. Conservators generally specialize in certain fields, such as painting, ceramics, and textiles. Paper conservators can control acidity and stop the growth of molds and mildews that can destroy paper. They clean prints and analyze the condition of drawings. Conservators can reconstruct such objects as an ancient vase out of a few fragments. They can stop the corrosion of bronze (called "bronze disease") and are skilled in repairing damaged wood and stone objects.

Painting conservators can reinforce the support of paintings, by stabilizing and recradling wood panels or relining paintings on canvas. They can clean paintings, readhere paint flakes to the surface of paintings, and, occasionally, repaint areas that have lost their original paint. Theories of "inpainting" vary, but current attitudes favor inpainting that makes paint losses less visually disturbing without actually imitating the style of the artist and thereby deceiving the viewer.

PHOTOGRAPHY

Photography is a vital aspect of museum operations. Any incoming object is photographed to record its condition and actual appearance. No verbal description, no matter how intricate, can match a photograph for accuracy and detail. If an object is acquired, the photographer must provide photographic documentation for the accession card and curatorial file. If the work is to be published, suitable photographs must be provided for this purpose. In case of

damage or theft, the photograph becomes an essential document for the reconstruction or recovery of the piece.

In general, black-and-white photography is in almost continual demand, but photographers are also called on to provide color slides and transparencies.

The museum photographer, who generally answers to the museum director, must have many skills. The challenge of properly photographing museum objects to best convey their aesthetic properties without reinterpreting them demands years of experience and understanding. Lighting techniques and the selection of cameras and lenses, film, and proper backgrounds for objects are among the many considerations a photographer must make before taking a picture.

PUBLIC RELATIONS

Larger museums have developed public relations departments to handle the many ways in which the museum comes to the public's attention. Most museums have regularly planned special activities, such as a speakers series or changing exhibitions (every two to three months). These activities require the attention and efforts of museum staff members who have a knowledge of art, the ability to write clearly (a background in journalism or English is very useful), and an interest in public relations. Occasional special events, such as a major acquisition or an outstanding donation, are also newsworthy and require the services of a public relations department. The planning of openings and events such as dinners or receptions for special exhibitions also must be arranged by the public relations department.

This department generally handles all regular museum calendars, news releases, and notices. They also plan publicity for major events to ensure maximum public awareness and museum attendance. The department staff members usually report to the museum director.

EDUCATION

Art museums have long been aware of their role as educators. Many have developed education programs to convey more effectively information about their holdings to the public. The education department of an art museum is charged with many responsibilities and generally reports to the museum director.

The problems that art musuems face in carrying out their role as educators are numerous. Often, information about the holdings of the museum must be conveyed through verbal description. These objects must be described in such a way that the reader can visualize them, but many defy adequate representation. Because the museum's potential audience is infinitely diverse and each segment has different needs and interests and asks different questions, the task of communicating effectively with all members of the public becomes that much more difficult.

Educational goals must be accomplished without distracting the viewer from the primary experience of the artwork itself. Thus, education departments continuously experiment with various types of communication tools. Films and slide shows, pamphlets, and special explanatory exhibitions are developed. Children are bused to museums and given guided tours, or artworks may be transported to schools to give children more firsthand exposure to original art.

If an art museum is part of a university complex, its educational role takes on another dimension. Art and art history students make frequent use of the museum to learn how to look at and appreciate diverse materials and styles of art. They learn the rudiments of researching an art object, from gathering information to evaluating the evidence that the object itself provides. Art museums are an essential resource for universities and are among the most precious cultural and educational resources in their communities.

WORKSHOP

No museum could function without the many talents of its workshop. Workshop staff members are professionals who are trained in the handling of priceless and irreplaceable works of art and who are routinely given responsibility for moving, packing, and unpacking artworks with an eye to protecting their inherent fragility. The hanging or installation of objects for display and their removal and proper storage are also responsibilities of the workshop.

In addition to moving works of art, preparators also try to design the most protective packaging for an artwork and devise the most effective display for a particular work. In a notable museum, one staff member has become something of an artist using acrylics, nonbreakable glasslike resins that can be adapted to the needs of countless situations. Acrylic tubing is used as an almost transparent support for a precious Byzantine cross. Acrylic rods invisibly hold up a vase whose base is as lovely as its rim. The contour of a Greek vase can be delicately suggested in clear acrylic, thus restoring the original context to a lovely handle, which may be the only fragment available or on display.

Carpenters, welders, painters, and many more workshop members are the dedicated craftsmen whose skills and hard work produce the singularly beautiful and imaginative exhibitions in our art museums.

GUARDS

No museum can open the doors of its galleries without a reliable security staff. Museums must preserve what they display, and without guards artworks would not survive. Many museum visitors are tempted by an irresistible urge to touch a work of art. Guards not only protect artworks from being handled by the public but also prevent theft and vandalism. Guards enforce visitor regulations established by the museum board and director. They must be alert to their

surroundings and routinely review the installations to ensure that nothing has changed or shows signs of wear. Guards must be patient, tactful, and reliable. Nothing is worse than an overzealous guard who remonstrates visitors sharply when no infraction of the rules has taken place—except perhaps a careless guard, whose negligence may lead to the damage or loss of an artwork.

VOLUNTEERS

Like other public service institutions, art museums have their share of volunteers who assist the museum in a variety of ways. Many are docents, or special volunteers, who work under the auspices of the education department and use their training or acquire training to give museum tours.

Other volunteers may assist with research, the planning of special exhibitions, or the cataloging of the collection. Others assist with special exhibits. Professional staff members are the foundation of a museum operation, but volunteers make a special contribution by generously donating their time and efforts.

REQUIREMENTS OF A MUSEUM BUILDING

A museum building must have both a public and a private side. It must have galleries to display its holdings to the public. These galleries must be large enough to display artworks adequately and accommodate the anticipated flow of traffic. Museums also must have large public areas through which visitors can pass from one section to another or in which they can leave packages and obtain information.

Museums also must have large private areas. These must accommodate office space for the director, curators, and other staff members; laboratory space for conservation; storage space, which usually includes a vault; shop areas in which exhibition designs can be executed and objects carted and unpacked; areas in which objects can be checked in and out; and a loading dock from which trucks and vehicles can pick up or leave off materials.

Traditional museum building design is adapted from European models, such as the Louvre and the Palazzo Pitti. Majestic and often featuring a classical façade, the traditional style is found in some of our most august institutions, including the Metropolitan Museum of Art, the National Gallery of Art, the Cleveland Museum of Art, the Toledo Museum of Art, and many more.

Gradually, museum design has changed as architects have experimented with plans to accommodate the visitor and regulate traffic flow. Frank Lloyd Wright used a circular spiral design for the Guggenheim Museum in New York, and the architect of the new Hirschhorn Museum in Washington, D.C., used a similar approach. Examples of other recent solutions to the problems of designing a

successful art museum can be found in the Mellon Center for British Art in New Haven, the Albright-Knox Art Gallery in Buffalo, the Herbert F. Johnson Museum at Cornell University in Ithaca, the Kimball Museum at Fort Worth, the Norton Simon Museum in Pasadena, the Munson-Williams-Proctor Institute in Utica, and the Indiana University Art Museum in Bloomington.

Part II

Art of the Ancient World

ᕙᗩᕗ

SOME NOTES ON ARCHAEOLOGY

The art museum visitor should bear in mind that much of what is seen from vanished civilizations is known to us only because these civilizations had the common practice of burying their dead. Those societies that buried treasures or personal belongings with the deceased have provided a small sampling of the output of their culture. From treasures that have been buried with the dead, scholars and archaeologists are able to deduce how these artifacts were used and, combining this knowledge with other evidence, such as the layout of an excavation site, can gain an understanding of the structure and organization of an ancient culture's life.

Scientific archaeology, which uses careful analytical methods and special dating techniques, such as radiocarbon dating, to excavate a site systematically, is a relatively young discipline. Its methods were rudimentarily laid down in the nineteenth century and have been continually refined since then. But the interest in history and physical evidence of earlier civilizations precedes modern archaeology by many centuries. In fact, one can assume that many have probably stumbled across remnants of their ancestors by happenstance, while plowing a field or digging a foundation. How they reacted to such a discovery we cannot know. A gold object might have been melted down, marble burned for its lime, and other objects discarded or saved, depending on the whim of their discoverer. How different these early "archaeologists" were from today's organized team of specialists, who map out an area, meticulously plan each descent into the soil, and record each precious fragment as it emerges from the silt that had covered it for centuries.

Throughout the world—Asia, South America, Africa, and Europe—archaeologists recover the buried remnants of lost civilizations, for time has literally

buried the past. Even cities not razed by conquering warriors gradually succumbed to the accumulated silt of the ages. There, in the soil, many types of objects lie protected and preserved, awaiting discovery through the efforts of archaeologists. Often, tombs, treasures, or occasional foundations or even walls of houses and temples and similar structures are found. Depending on the site, skeletal and other remains of the people who lived on these sites may also be uncovered.

Preservation through burial was a knowledge that many ancient civilizations had. Tombs and grave sites were commonly, though not always, placed below ground. Even those tombs placed in buildings or wall niches, or on particular sites, were considered special for they preserved the remains of ancestors, whose favored belongings and treasures commonly stayed with them. Although tomb robbing did take place throughout the ages, many tombs lay undisturbed for millennia until they became the "find" of archaeologists. Also, ancient people commonly buried their treasures during times of peril, such as the threat of war or invasion. A recent example of buried treasure rediscovered by chance went on display in 1981 at the Pinacoteca in Siena, where a group of four sixth-century silver chalices, a silver paten, and a silver spoon were dug up in a farmer's field in the countryside outside Siena.

Although archaeology as we know it is a fairly recent development, people have been fascinated with ancient history for far longer. Renaissance Europe became obsessed with classical antiquity and preserved and collected its treasures. The fourteenth-century Italians began to collect and annotate ancient manuscripts and, in Rome, surviving marbles began to hold new attractions. By 1471, when Sixtus IV became pope, he had already assembled a number of ancient sculptures in the Palazzo Campidoglio. In 1478, the humanist Giulio Pomponio Leto formed a kind of antiquarian society in Rome, which had its headquarters at the Quirinal Palace. The famous *Apollo Belvedere* was discovered in 1503.

During the sixteenth century, other important discoveries were also made. The Laocoön group was found in 1506. In 1553, the Etruscan bronze *Chimera* (today housed in the Museo Nazionale, Arezzo) was discovered and restored by Benvenuto Cellini. In Rome, the Farnese family undertook the study of Hadrian's villa and the Baths of Caracalla and consigned Pirro Ligorio (c. 1510–1583) to the official position of "archaeologist." Ligorio recorded the results of his excavation of Hadrian's villa outside Rome. Elsewhere, princes, kings, ecclesiastics, and others with money engaged agents to search out relics of antiquity. Traveling to Italy, where they collected mainly portable treasures, such as coins, small sculptures, gems, mosaics, and silver and bronze ware, these treasure seekers made no real attempt to record the sites, and their employers were none too interested in the relative chronology of the materials assembled. Antiquarians also began to examine the ancient sites in their own locales, searching for remnants of Roman and other civilizations.

Between the sixteenth and eighteenth centuries, interest in the past deepened and antiquarian societies were established in Britain and France. The English Society of Dilettanti began to publish its studies of ancient civilizations of Greece, the Near East, and Egypt, as the study of antiquity spread beyond Rome and its empire. Charles III of France supported the systematic excavation of Pompeii, a Roman city destroyed by an eruption of Vesuvius in 79 A.D. In 1748, the crust of ashes, volcanic debris, and soil was removed and the buried city uncovered, with many of its walls and possessions intact. Johann Winckelmann (1717–1768), the German archaeologist, made an exhaustive study of the discoveries at Pompeii and Herculaneum and published a comprehensive survey of art using as sources his studies of excavations and private collections of antiquity.

The systematic interest in archaeology was reflected in the work of many artists, notably the printmaker Giovanni Battista Piranesi (1720–1778), who from 1745 to 1756 recorded views of ancient Rome with an eye to archaeological accuracy. By then, antiquity had been the subject of much serious study as well as collecting, and it was felt that enough was known to make aesthetic judgments about various ancient civilizations. In fact, Piranesi debated the relative merits of Greece and Rome with Winckelmann, who staunchly upheld the excellence of Greece while Piranesi claimed the superiority of Rome.

During the nineteenth century, the interest in archaeology continued unabated. In 1806, Lord Elgin had bought the Parthenon sculptures from the Turks, brought them to England, and sold them to the British government in 1816. They now reside in the British Museum. By 1822, the French Egyptologist Jean François Champollion had deciphered the Egyptian hieroglyphs in the Rosetta Stone (now housed in the British Museum). Ancient cities previously known only through texts, such as the Bible or the *Illiad* and *Odyssey* of Homer, were discovered. Between 1870 and 1890, Heinrich Schliemann discovered the site of ancient Troy, and nine years later the German archaeologist Robert Koldewey (1855–1925) began his search for Babylon.

The interest in archaeology affected the arts, which began to copy the styles of Egyptian, Roman, or Greek artifacts. Conscious of the past, artists were concerned with accuracy and contributed to the demand' for publications on ancient civilizations. History paintings included not only traditional moral themes but also fascinating images of daily life in antiquity. For example, the English painter Sir Lawrence Alma-Tadema and the French academic painter Jean Léon Gérôme did a flourishing business in art that depicted the slave markets, homes, and pastimes, notably the gladiatorial combats and chariot races, of ancient Rome. An interest in the native past yielded the remains of indigenous cultures. The cultures of the Picts of Scotland, the Celts and Druids of Britain and Gaul, and the Vikings of Scandinavia were discovered beneath the soil.

Archaeology continues to be one of the most active and fascinating historical

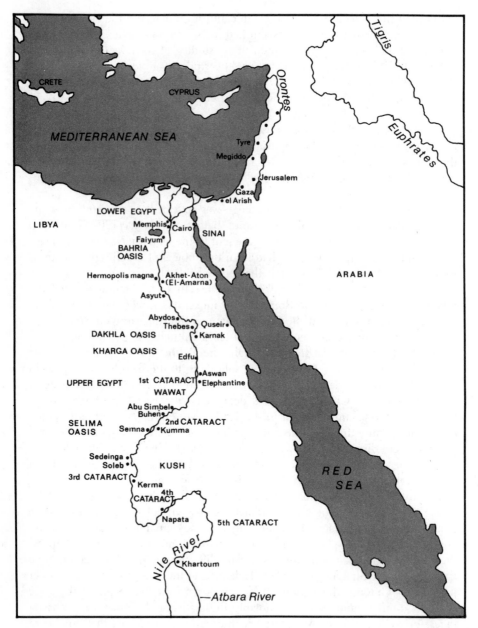

FIGURE 4-1.　Map of Egypt indicating major sites of Lower and Upper Egypt.

disciplines. The fundamental human urge to search for buried treasures has now been harnessed by scientific technology and discipline, providing us with exciting discoveries about the development of our own civilizations. The early amateurs and dilettantes who pursued this science have been replaced by trained professionals, who, armed with scientific methods and increasingly sophisticated instruments, extract important information about the lives and conditions of our long forgotten past.

EGYPTIAN ART

Much of the art of the ancient Egyptians was never intended to see the light of day; still less was it meant to be the object of public display as it now is in many a museum gallery. The Egyptians poured their energies and creative powers into the construction of temples for the gods and of tombs for themselves. Both were revered as holy places that occupied a special place in the Egyptian scheme of life, death, and the eternal afterlife.

Distinguished by the periodic, rhythmic changes that marked the days, seasons, and years, life was regarded by the Egyptian civilization as a brief journey toward a perfect afterlife. The dead were said to share a peaceful and eternal afterlife with the gods, who were worshiped in this life so that their magnanimity would ensure the stability of temporal existence. Between roughly 3000 B.C. and the birth of Christ, the Egyptians transformed the Nile Valley into a setting for one of the most grandiose architectural spectacles ever to be achieved. Great pyramids, massive temples, and sanctuaries—all physical embodiments of a firm belief in life and eternity—stretched from Abu Simbel to Alexandria to form the greatest religious shrine and burial site in history (see Figure 4-1).

Considered essential for the future well-being of the soul, proper burial was a complex process. From the moment of death, the deceased's name was preceded by that of Osiris, the god of death. The body was taken and washed by professional embalmers, the organs and brains removed and preserved in canopic jars. After soaking in natron salts, the body was dried for several months and then soaked in embalming fluids. A scarab, or beetle, symbolizing renewed life, would be placed over the heart, and other amulets or jewelry were added. The body was then wrapped in linen. In the burial procession, mourners accompanied the coffin in a barge down the Nile to the tomb. Servants brought along the food, clothes, and other necessities of life to ensure adequate provisions for the deceased in the next world. A sacred text called the Book of the Dead was often included to help the deceased during the final judgment.

The preservation of the body was considered vital to safeguard the soul or personality. This was further assured with images of the deceased, which in later periods evolved into highly convincing portraits that appeared on the

coffins. Effigies of the dead were made to provide permanent homes for the wandering *Ka,* or spirit. Often life-size figures, these effigies were sometimes placed in sealed chambers with slits cut into them at eye level, so that the statues could observe the offerings and rituals performed for them. The chambers of the coffin were covered with reliefs or paintings that magically recreated the images of the deceased's world, just as the effigy preserved the *Ka* of the deceased. The chamber, effigies, preservation of the body, rituals, and inscriptions interacted to resurrect the soul and were thus essential.

The society of ancient Egyptian civilization was highly stratified. The pharaoh, regarded as a god, was surrounded by a court of princes, courtiers, scribes, and others who were often relatives and who composed the first rank. The vast network of administrators—tax collectors, mayors, civil officials—made up the second rank, and laborers, craftsmen, and peasants composed the third. The proper burial of pharaohs included erecting shrines and temples, on which the rulers' unimaginable wealth and enormous resources were spent. One of the approximately sixty-seven pyramids dotting the desert around Cairo required two and a half million blocks of stone, which were quarried and set in place by more than 100,000 workers and slaves laboring more than twenty years.

Because the pharaohs were considered gods and their final resting places demanded the requisite luxuries, inconceivable treasures were sealed into the tombs. Coffins and shrines made of gold and precious stones housed statues, jewelry, jars, and elaborately carved and decorated effigies. Early in their history, the Egyptians also buried the entire court, whose servants and slaves renounced their earthly lives to continue their service of the pharaoh in the afterlife. Once the tomb was sealed, all witnesses were killed in order to protect the secret of the burial and preserve its treasures.

The rites of death and burial spawned an industry in the ancient Egyptian civilization. Mummifiers were needed to preserve bodies, textile makers to produce linen wrapping, metal- and goldsmiths to create jewels and coffins, and sculptors and stone carvers to make sarcophagi, wall reliefs, and statuary. Painters were called on to paint murals and to color statues and coffins. Craftsmen produced urns and other utensils, and architects designed buildings and temples for the tombs. Laborers and slaves built the sites, priests performed the services, and necropolis workers protected the remains.

For three millennia artists learned their craft from their predecessors and continually refined the process of producing timeless images of the fleeting experiences of life. Each generation of artists adopted subtle changes, although dramatic transformations are known to have taken place, such as during the Eighteenth Dynasty (see time line). Following a set of fixed and unchanging rules, Egyptian carvers chiselled rock knowing full well how the finished piece would look. Chance inspiration had no place in their working method, and everything had its place. These artists knew their material and constructed figures so that they would remain undamaged over time. Thus, arms were not

extended to invite premature breakage, and poses were created both to identify the social position of the sitter and to maintain the inherent strength of the material. Individuals in all stations of life and the deities had a prescribed format for representation. Designed to house the soul or represent a god for eternity, these sculptures were characterized by their rigidity, stability, and firmness. Endowed with the strength of stone and power of the spirit, the statues were everywhere surrounded by writing. The surfaces of tombs and temples were covered with inscriptions of chants, prayers, and rites that further clarified the role of the individual in the order of things. The portraits and statues of pharaohs, as well as portraits of various nobles, now found in museums can be identified frequently through inscriptions, and their social standing inferred through the manner and pose in which they are depicted.

To enter the Egyptian gallery in a museum is to find the scattered and disembodied relics from sacred shrines, tombs, or temples. The scattering of the possessions of the ancient Egyptians, if we believe their original function, means that the ancients are now bereft of their spiritual dwellings and belongings. Motionless stone statues and fragments of carved reliefs show people and animals rather stiffly engaged in various activities, some of which are still understandable, while others remain entirely mysterious. The following sections describe the types of art the museum visitor may expect to find in an Egyptian collection.

SCULPTURE IN THE ROUND

Most sculptures in the round were used in private tombs or mortuary temples. Tomb sculpture was thought to preserve the *Ka*, or spirit, whereas sculptures associated with mortuary temples were permanent, idealized representations of the deceased and played an important role in ceremonies honoring the dead. The practice of erecting temple sculpture emerged first in the Fifth Dynasty; tomb sculptures were known much earlier.

Both types of sculpture were believed to represent a person in body or spirit. Because tomb sculpture was meant to preserve the soul, patrons and artists sometimes went to great lengths to ensure their preservation, sometimes placing several sculptures of the same person in one tomb. Portraiture was also considered vital to these embodiments of people, and so faces were carved with an eye to achieving great likenesses. Sometimes only heads were sculpted, as, for example, during the Fourth Dynasty, when the tombs at Giza only had room for portrait heads within the burial chamber. Later, during the Eighteenth Dynasty, clay masks of uncertain function were produced.

In order to ensure the timelessness of these sculpted forms, artists used hard, indestructible materials, such as limestone, sandstone, granite and diorite. Remaining faithful to the concept of the block, these sculptors rendered an idealized, timeless representation of the individual. They carved from four sides—

front, top, back, and side—and the unneeded stone was chipped away until the four views met. Egyptian sculptors worked according to a predetermined formula that, to the minds of artists and society, best allowed the temporal to be rendered permanent.

Stone, which was expensive to quarry and time-consuming to carve, was generally reserved for nobles; sculptures of court and lesser officials were often made from cheaper materials, such as wood or clay. Each figure was represented in a manner that characterized his profession and station, but all ranks were endowed with dignity. Greater liberties of representation were often taken in the execution of statues of private individuals, which were not as idealized and represented the flaws and natural characteristics of their subjects.

Egyptian sculpture went through many changes during the various dynasties. In the Twelfth Dynasty, "block" statue evolved, reducing the body of the sculpted figure to a simple block that was often covered with inscriptions. The head, the most distinguishing feature of these forms, was rendered realistically and projected forth from the block. During the upheavals of the Eighteenth Dynasty, Ikhnaton (Amenhotep IV) introduced a brief revolution in religion that profoundly affected sculpture, rendering it more expressive and naturalistic for a short time.

SMALL-SCALE SCULPTURE

The Egyptians produced a wide variety of small-scale works that served a number of different purposes. During the First and Second Dynasties, small clay, ivory, faience, and stone figures were made of men, women, and children, as well as of animals, such as frogs, lions, falcons, peacocks, and hippopotamuses. Although their function is not known, it is thought that many were dedicated to sanctuaries or shrines and were produced for a broad spectrum of Egyptian society.

In the Fourth, Fifth, and Sixth Dynasties, the deceased were often buried with whole entourages of small-scale figures that represented or provided the necessities of life. Figures grinding corn, potters throwing vessels, brewers, butchers, cooks, and weavers were represented as the purveyors of amenities for the deceased in the afterlife. Gradually, these sculptures became doll-like and were frequently made from wood. They came to be placed inside miniature replicas representing scenes from life, including boating and military maneuvers. Scholars note that the high point of this type of sculpture was reached in the Eleventh Dynasty.

RELIEFS AND PAINTINGS

Wall reliefs and paintings are rarely found in art museums, and then only as fragments. These fragments once decorated the tombs of royal or private citizens

who could afford them. The earliest types of wall decorations were reliefs that depicted banquet scenes honoring the dead. By the Third and Fourth Dynasties, reliefs found in royal tombs tended to show funerary rituals, and those accompanying the tombs of officials and private citizens showed images of family and daily life. Painting in general was cheaper than relief carving and often substituted for the latter. Color was only gradually added to relief carvings.

During the Fifth Dynasty, sun worship was elevated to a state religion, and the ebb and flow of daily life, which the sun protected, became an increasingly important expression of the divine order in art. Tombs from this period illustrate a wide variety of images from daily life, ranging from scenes of hunting to dancing.

Painting flourished in its own right until the New Kingdom (c. 1570 B.C.). The extensive building activity during the New Kingdom precipitated a renewed use of relief carvings, which supplanted painting as the principal form of wall decoration.

MINOR ARTS

Egyptian tombs also contained the implements of daily life. These were very often items of pottery made on the wheel. An important industry, pottery was used to produce utilitarian, rather than luxury objects. In addition to the objects described below, tombs have yielded a vast array of other objects, including mirrors, razors, daggers, palettes for cosmetics, sandles, and various types of furniture. Stone vessels carved from alabaster, quartz, and rock crystal, used to store ointments, have also been found.

Faience

The Egyptians perfected a technique of firing and glazing terra-cotta to produce a luxurious and permanent material called faience. Most faience is blue or green, the colors thought to have been preferred because of their similarity to the most precious stones then known, lapis lazuli and malachite. From faience, beads, collarettes, jewelry, amulets, bowls, tiles, funerary statuettes, and small figurines were made.

Glass

Although the origins of glass are disputed, it is known that the Egyptians knew how to blow glass during the Middle and New Kingdoms.

Jewelry

Goldsmiths were among Egypt's most esteemed workers because they provided temples with golden statues of the gods and made the royal jewels. Gold was mined extensively in Nubia. Silver was even more precious because it was not

locally available. Jewelry was produced throughout Egypt's history, but the most highly esteemed examples date from the Twelfth Dynasty, when jewelry was unsurpassed in its elaboration, scale, and luxury.

Contemporary museum collections of Egyptian art represent remnants of a civilization that we can only reconstruct through the aid of scholars and archaeologists. These objects have survived the ravages of tomb robbing, which was commonplace from the time the first pharaoh was sealed in his grave. The defilement of tombs was so rampant that, by the Eighteenth Dynasty (c. 1570–1293 B.C.), pharaohs stopped using pyramids and had their coffins hidden in chambers carved into the cliffs and separated from the temples, where rituals were performed in their honor. Surviving records tell us that the ancient Egyptian priests resorted to desperate measures, including moving the coffins, sometimes more than once, themselves. Rameses III was reburied three times. Because of looting, we have only one example of a tomb that has eluded robbers—the now famous tomb of Tutankhamen, which was discovered intact by the British archaeologists Howard Carter and George Herbert, Fifth Earl of Carnarvon, in 1922. This minor king died suddenly and was interred in a grave prepared for another. This historic accident gives us our single glimpse into a mysterious and fabled world whose achievements produced wonderment among succeeding civilizations, from the Greeks and Romans to the early Christians. The Greek geographer Strabo recorded his impressions of this ancient civilization, and others of his compatriots managed to remove whole obelisks and transport them in triumph to Rome.

Fascination with Egyptian civilization continued long after its demise. The eighteenth century produced some of the most significant finds, including the discovery by Napoleon's army in 1799 of the Rosetta Stone. After Napoleon's defeat by the British, the stone made its way to the British Museum, and by 1822 it was used to decipher hieroglyphs by the genius Champollion. Innumerable expeditions recorded the ruins of ancient Egypt and took with them countless treasures that now form the great European collections of Egyptian art. It was not until 1858 that a museum was established in Egypt to house the legacy of this ancient culture. Today the Cairo Museum is unmatched for its splendid holdings.

By far the largest group of objects that have survived were decorations or artifacts for tombs. Burial customs evolved from early Egyptian civilization known as the Old Kingdom (see time line), and the general tendency was for sumptuous burial and the promise of afterlife to become the prerogative of an increasing segment of Egyptian society during the three millennia spanned by its civilization.

The passage from life to death was not feared by the ancient Egyptians; rather, it seems it was a welcome transition. The order and stability of this life was ensured as long as the innumerable gods that controlled its many aspects

were properly honored. In life, the gods were represented both in animal and plant form and were thus concrete manifestations of life-giving forces, such as the sun, the moon, and the darkness. The pantheon of Egyptian deities is listed in the appendix at the back of this book. Cows, dogs, cats, flowers, rams, and serpents represented deities and were often revered as such. Apis, the sacred bull, was worshiped in Memphis and received protection in temples and burial upon death. Huge sarcophagi carved from blocks of granite, each weighing 72 tons, have been discovered in great number. Other towns became burial sites for cats, crocodiles, and ibises, the gods who controlled human destiny. These gods were also depicted in sculpture, painting, and relief sculpture. Even at death, life was evoked in the images of celebrations, feasts and dances, and in the personal histories that were recalled.

Never meant to be seen by the afterworld, these silent, motionless, and inscrutable beings and images do not communicate with us physically or psychologically. Embodiments of an unwavering faith in an inevitable destiny, these treasures now reside in the world's museums, protected and watched over by guards, curators, and visitors, rather than priests and worshipers. Gazing at these creations, we are convinced of their truth and imbued with a sense of the 3,000-year civilization that produced them.

EGYPTIAN ART TIME LINE

THINITE PERIOD

c. 3100–2907
B.C. First Dynasty—union of Upper and Lower Egypt

c. 2907–2755
B.C. Second Dynasty

OLD KINGDOM

c. 2755–2680
B.C. Third Dynasty—center of political life shifts to Memphis, construction of Zoser's Step Pyramid.

c. 2680–2544
B.C. Fourth Dynasty—three pyramids constructed at Giza, including the Great Sphinx; Valley Temple and Funerary Temple of King Khafre constructed; the private tomb called *mastaba* ("bench") begins to appear.

c. 2544–2407
B.C. Fifth Dynasty—the cult of Ra, or sun religion, became the state religion and high priests and state officials gained impor-

tance; also the golden age of sculpture marked by the rise of
the noble class.

c. 2407–2255
B.C.

Sixth Dynasty—due to crisis and upheaval, the social order of
Egyptian society nearly disintegrated, reverting to a somewhat
more primitive culture.

────────── FIRST INTERMEDIATE PERIOD ──────────

c. 2255–2035
B.C.

Seventh through Tenth Dynasties—collapse of religious and
political systems of the Old Kingdom led to reduced output in
the arts. Few works of art survive, but literature abounded in
Lower Egypt. Collapse of state authority caused individual
nobles to gain prominence and power.

────────── THE MIDDLE KINGDOM ──────────

2134–1991
B.C.

Eleventh Dynasty—reunification of Egypt by Mentuhotep II.
Capital at Thebes.

1991–1784
B.C.

Twelfth Dynasty—battles between nobles for supremacy take
place until ascendancy of Seostris II. This period saw produc-
tion of strikingly spiritualized statues of kings as well as great
private portraits. The royal pyramids are built. The oldest
known example of an obelisk survives from this period.

1784–1668
B.C.

Thirteenth Dynasty—monarchy changes hands frequently,
and much construction is attributable to the innumerable
kings who reigned.

────────── SECOND INTERMEDIATE PERIOD ──────────

c. 1720–1570
B.C.

Fourteenth through Seventeenth Dynasties—the Fifteenth
Dynasty is called the Hyksos dynasty ruled by Asians who
resided in the northeast delta at Avaris. During the Sixteenth,
or Lesser Hyksos, Dynasty, Egypt is divided into several states
whose rulers revolted against the Hyksos. Thebes is established
as center of Egyptian civilization.

—————————————— NEW KINGDOM ——————————————

c. 1570–1293
 B.C. Eighteenth Dynasty—this dynasty brought down the power of Egypt, which nearly fell under Hittite rule, but was saved by Horemheb.

1293–1185
 B.C. Nineteenth Dynasty

1185–1070
 B.C. Twentieth Dynasty

——————————— THIRD INTERMEDIATE PERIOD ———————————

1070–712
 B.C. Twenty-first through Twenty-fourth Dynasties—Introduction of large scale bronge figures.

c. 767–656
 B.C. Twenty-fifth Dynasty (called the Ethiopian Dynasty)

c. 685–525
 B.C. Twenty-sixth Dynasty (called the Saite Dynasty)

525–404 B.C. Twenty-seventh Dynasty, first Persian period

404–399 B.C. Twenty-eighth Dynasty

399–381 B.C. Twenty-ninth Dynasty

381–343 B.C. Thirtieth Dynasty

343–332 B.C. Thirty-first Dynasty, second Persian period—in 332, Alexander the Great enters Memphis and is crowned king of Upper and Lower Egypt. In 331, Alexander laid the foundation stone of Alexandria, the city that still bears his name.

323–30 B.C. Ptolemaic Period—named after the general of Alexander, Ptolemy, who was the first ruler of the Macedonian Dynasty, this was the first period in which Alexandria became the cultural center of the ancient world. The Court of the Muses, the Museion, was founded by Arsinos II and housed the greatest spirits of the civilized world. The Alexandrian Library became the most important repository of knowledge and culture in all antiquity.

AEGEAN ART

Life and death, time and eternity, were strangely commingled in Egyptian civilization and compellingly embodied in its art. In contrast, during the

FIGURE 4-2. Map of the Aegean, showing the principal sites of Aegean, Greek, and
Etruscan civilizations. (1) Athens; (2) Knossos (Island of Crete); (3) Troy; (4) Lesbos; (5)
Pergamum; (6) Miletus; (7) Rhodes; (8) Antioch; (9) Damascus; (10) Venice; (11) Volterra;
(12) Vulci; (13) Tarquinii; (14) Veii; (15) Taranto; (16) Crotone; (17) Reggio; (18) Syracuse;
(19) Carthage; (20) Thessalonica; (21) Pella; (22) Delphi; (23) Olympia; (24) Mycenae; (25)
Corinth; and (26) Sparta.

Bronze Age (3000–1100 B.C.), life for the people of Aegean was as changeable as the sea, to be celebrated triumphantly and lived adventurously. The artifacts these heroic people left behind are vastly different in imagery and spirit from those of the Egyptians. In a sense, the art of the Aegean civilization offers a vital link with a heritage we recognize as an ancestor of our own.

The Cycladic, Minoan, and Mycenaean cultures of the Aegean (see map, Figure 4-2) were relatively brief, and the changes in their tastes and ideas were rapid and dramatic compared to the continuity of Egypt. For these seafarers, warriors who reveled in battle and its spoils, and merchants and traders, religion appears to have played a secondary role.

CYCLADIC ART

The oldest surviving artifacts of this world were created by a culture that existed on the Cyclades Islands in the Aegean Sea between roughly 2600 and 1100 B.C. Its trade routes extended to the French coast, and its economy seems to have been based on trade in obsidian, a volcanic substance similar in composition to granite, found on the islet of Yiali in the Dodecanese. Its minor stone tombs have yielded simple rough pottery and some weapons, primarily daggers and spears. Most notable are their marble, principally female, figures of unknown function, all depicted roughly the same way with crossed arms and schematic features. Depending on the sculptor's skill, these works could be crude or remarkably sophisticated distillations of the human form. Probably colored and likely laid flat in the tomb, these are great treasures in today's museums, which rarely have examples of intact figures.

The deceptively simple Cycladic forms are pleasing to the modern eye. Finely carved marble bowls and dishes are eagerly collected by museums. More elaborate shapes were evolved for specific functions: The kernos, a composite vessel of numerous small cups joined together, was made to hold fruit offerings; the rhyton was a libation cup, often taking the form of an animal's head and made of terra-cotta, alabaster, or metal; and the pyxis, made of ivory, pottery, stone, or wood with tight-fitting lids, probably served as a box for jewelry or for offerings.

MINOAN ART

By the beginning of the second millennium B.C., the Cyclades were under the influence of the thalassocracy (maritime rule) of the legendary King Minos of Crete. The origins of Minoan civilization can be traced to the settlement of the island of Crete, probably by refugees from Egypt, about 3500 B.C. Independent city-states developed, to be united under the kings of Knossos from 2000 B.C. until the fall of Knossos in 1400 B.C.

The towns of Knossos and Phaistos were sites of great palaces that lay buried

for ages, to be uncovered at the turn of the twentieth century by a group of British and Cretan archaeologists led by Sir Arthur Evans. Apparently destroyed in 1700 B.C., both cities were rebuilt in the Great Age of Crete, during the sixteenth century B.C., only to be destroyed again by 1450 B.C.

These unfortified palaces of the "merchant kings" have yielded a treasure of artifacts that provide us with clues to the Minoan civilization. Surviving fragments indicate that the palace walls were decorated with elegant, sprightly murals depicting processions, dancers, animals, and sea life. Their magazines were filled with pithoi, large, vivaciously decorated terra-cotta jars used to store wine, oil, and grain.

Minoan potters also turned out vases, jugs, cups, and pitchers, whose expansive forms harmonized with various kinds of decorations. Early pots had abstract designs, and at the height of the civilization, octopuses, fish, and other creatures were splashed on pottery surfaces, which were also enlivened by raised barbotine decoration. Metalsmiths produced bronze tools and weapons, cauldrons, bowls, ewers, hydriae, and lamps. Treasures made from gold included elaborate pendants, daggers, swords decorated or raised in relief (called repoussé), and ceremonial double axes. Semiprecious stones—agate, amethyst, jasper, and carnelian—as well as ivory, bone, and steatite, were carved into seals. Worn as personal identity disks, they were impressed in clay to seal documents and containers. Faience polychrome plaques representing houses were also found at Knossos; they tell us what Minoan buildings looked like.

Minoan sculpture was apparently limited to small figurines: wood, clay, or bronze figures of goddesses, acrobats, and worshipers. The portrayal of personality, even of rulers, is absent from this short-lived civilization.

The little we know of Minoan religion has been gleaned from the excavation of shrine rooms that contained offering tables imprinted with the double ax, offering jars, and human and animal figurines. Kamares pottery, a beautiful polychrome ware produced from about 1800 to 1600 B.C., takes its name from the sacred cave where it was placed with offerings of grain. Other caves were places of sanctuary for the Minoans, and mountaintop shrines from the earliest Minoan period dot summits all over the island of Crete.

It is known that the Minoans were first buried in communal circular tombs, later in pithoi and larnakes (oval clay chests), and, later still, in beautiful painted sarcophagi. Stone vessels and clay cups, jugs, and bowls, along with a few seal stones, ornaments, figurines, and bronze daggers have been uncovered in Minoan burial sites, which are surprisingly few in number.

Sometime around the middle of the fifteenth century B.C., the Minoan civilization was virtually destroyed by what most historians now believe was a natural catastrophe. Across the Aegean, at Mycenae on the Peloponnesus (the peninsula that forms the southern mainland of Greece), a vigorous civilization

had been developing since 1600 B.C. The Mycenaeans mingled with the Minoans through trading and quickly came to dominate the Aegean following the Minoan disaster.

MYCENAEAN ART

The Mycenaeans were the warrior heroes of Homer's epic poems, men of the sea who sailed the Mediterranean from Egypt to Troy. Syrian, Phoenician, and Egyptian influences are all to be found in Mycenaean art, and standard Mycenaean pottery shapes are found in Rhodes, Turkey, Egypt, Sicily, Taranto, Albania, and Sardinia.

Vigorous trade and widespread contacts did not preclude the making of war, and, unlike the Minoans, the Mycenaeans fortified their palaces. Although comparatively little remains of their buildings, we know the palace walls were carved and painted and that at the center of the palace was the megaron, or royal audience hall.

Burial customs were elaborate and most likely adapted from Egyptian practices that the Mycenaeans observed from their early contacts with the people of the Nile Valley. Ambitious beehive tombs sheltered the wrapped bodies of royal Mycenaeans, their faces covered with gold masks. The deceased were buried with their personal treasures in a manner similar to Egyptian practices. Mycenaean tombs have been the source of gold jewelry, diadems (crowns), fibulae (clasp or brooch), cups decorated with hunting scenes, caskets, alabaster bowls, inlaid daggers, and other treasures that have since entered museum collections.

Although Mycenaean burial customs were elaborate, little is known about the civilization's religion. Images of gods and remnants of temples are few. Some ivory carvings may depict deities, but their nature and function are uncertain. These ivories display a human likeness and exude a warmth that make them an important conceptual link with the art of the later Greeks.

Over time, the Mycenaeans tended to schematize and render abstract the repertoire of natural forms they had acquired. Painting on late thirteenth-century artifacts shows a mixture of shapes and geometrical forms that seem to be based less on the observation of nature than on pure decorative scheme. Mycenaean imagery and design appear not to have been inspired by ideology, religion, or magic, but rather adapted from nature, whose forms were pleasing and suitable to these heroic, aggressive people.

Mycenaean civilization ended between 1200 and 1100 B.C. Most scholars now assume that interstate war—raids by one city-state against another for material gain—brought about the destruction of the palace centers and thereby the demise of this homogeneous culture.

—————————— AEGEAN ART TIME LINE ——————————

c. 3500 B.C. Crete settled by refuges from Egypt(?).

c. 3000–2000

B.C. Early Bronze Age, so called because bronze was the chief metal.

—————————CYCLADIC CIVILIZATION——————————
c. 2600–1100 B.C.

c. 2100 B.C. Development of independent city-states.

—————————— MINOAN CIVILIZATION——————————
c. 2100–1450 B.C.

1930 B.C. First palaces of Crete are built. Crete develops wide links with other regions, including early settlements of Troy.

1700 B.C. Earthquakes destroy palaces and cities of Crete.

1600–1400

B.C. Rebuilding of palaces and cities of Crete. Palace of Minos at Knossos, later excavated by Sir Arthur Evans, belongs to this period.

1550 B.C. Approximate date of shaft graves excavated at Mycenae. Minoans form settlements abroad.

1500 B.C. Destruction of Thera.

—————————— MYCENAEAN EMPIRE——————————
c. 1450–1100 B.C.

1450 B.C. Destruction of various Minoan and Cycladic settlements.

1400 B.C. Mycenae and Tiryns replace Crete as power centers in the region. Destruction of the palaces of Knossos and Phaistos.

c. 1350 B.C. Mycenaeans and Achaeans begin their siege of Troy; the fall of Homeric Troy.

1200 B.C. Mycenaean settlements destroyed.

1200–1100

B.C. Dorian invasion of southwestern Greece, Crete, Aegean islands, and southwestern Asia Minor. Ionian invasion of northern Greece, central Aegean.

1100–800

B.C. Destruction of the Mycenaean world.

GREEK ART

The Greeks, who came into prominence after the fall of the Mycenaeans in roughly 1000 B.C., built a civilization that became the foundation of Western culture. Before the Romans finally annexed Greece and sacked Athens in 86 B.C., the Greeks had established the disciplines of modern history, philosophy, astronomy, poetry, and drama. The images of human perfection they left behind in clay, metal, stone, and paint were to remain the standards against which later accomplishments were measured. Few subsequent civilizations have reached the heights of Greek achievements, and none has surpassed them. It was no accident that these lovers of human perfection originated the Olympic Games, in 776 B.C., as the ultimate athletic challenge.

In many ways Greek life was similar to that of other ancient civilizations. Small cities developed, each with its own marketplace (agora), modest homes, and temples. Some cities evolved around special sanctuaries for the gods. These sanctuaries included temples, treasuries (special temples for storing gifts brought by pilgrims), theaters, and athletic arenas. So many Greek cities were built and destroyed that modern archaeologists are still excavating and trying to identify them all. (For a map indicating major Greek settlements, see Figure 4-2. Greek ruins have yielded innumerable pots, jewels, coins, mosaics, and the minutiae of everyday life. Many of these articles are no more distinguished than those uncovered from other civilizations that have come and gone.

And yet Greek civilization was unique. Even a brief encounter with Greek art shows something new. From the earliest examples of rather stiffly abstract human forms to late Hellenistic marbles unparalleled for their sense of movement and subtle emotion, Greek art was ever changing. Over time, the Greeks developed various schools of thought about politics and government, human nature, and history. Thus change was vital to this civilization and came dramatically, and it is in this context that Greek art should be viewed.

The parameters of our understanding of the development of Greek art have been defined as much by the loss of artifacts of this civilization as by any discoveries that have been made. A thousand years of painting has virtually vanished, and most of the sculpture has been lost as well. If one could imagine that Italian art were destroyed and that Michelangelo, Raphael, Titian, Tintoretto, and Tiepolo were names known only through descriptions or copies by later artists, then one would have an idea of how great the loss of Greek art is. Not a single temple survives intact, and not one large wall or easel painting. Many masterpieces of Greek sculpture are known only from Roman copies.

Out of the rubble of Greek cities scattered on the mainland, as well as in Italy and Asia Minor, remnants of this lost artistic heritage have emerged. Much of our understanding of Greek art is derived from surviving examples of its pottery, which has in large part been discovered in Etruscan tombs. The

Greeks traded extensively with the Etruscans, who buried treasures with their dead and thereby preserved many Greek as well as native artifacts.

POTTERY

The manufacture and decoration of pottery in Greece reached a level of accomplishment that was scarcely equaled in the history of art. The fire-baked hardness of Greek pottery ensured its survival over the centuries, if only in a fragmentary state. This is fortunate, as pottery painting gives us our primary clue to understanding Greek wall and easel painting.

The ancient Greeks, from their earliest beginnings, fashioned a great number of vessels from clay. Pottery was a necessity of everyday life and served many functions, notably as utensils for food storage, cooking, eating, and drinking. Pottery also figured in human burial and was used to store bodies or to mark graves. By 600 B.C., this industry was strong in a number of cities, including Corinth and the area around Athens, known as Attica.

Like most other industries, pottery manufacturing was a cooperative enterprise. Clay had to be worked to the right consistency, then thrown to the proper shape, often on a potter's wheel. After proper drying, a pot was fired once in a special oven to harden it, then refired after it had been decorated with mixtures of refined clays that yielded a limited range of colors.

Geometric Period Pottery

Measured, repetitive geometric patterns characterize the art of this earliest period of Greek art (1100–700 B.C.). Large pots used as grave markers and small, simple animal and human figurines made of terra-cotta and bronze are the oldest remnants of Greek civilization.

As the Mycenaean civilization declined (c. 800 B.C.), the Greeks began to consolidate their hold on the Aegean and beyond. They established colonies on the Black Sea, in western Asia Minor, southern Italy, Sicily, the French Mediterranean, and along the Spanish coast. Increasingly frequent contacts with ever more distant cultures offered a profusion of visual stimulation, and "foreign" ideas were quickly absorbed and assimilated into Greek art. Pottery experienced an "Oriental" phase marked by the use of curvilinear animal and human motifs. Corinth and Attica developed distinctly regional styles, and other towns responded in their own ways to the foreign influences on art.

Black-Figure Pottery (Archaic Period)

About 600 B.C., pottery makers in Corinth developed a technique known as "black-figure" that soon spread throughout the Greek world, taking root especially in Attica. Black-figure pottery was manufactured through an unusual

collective effort. The most interesting collaboration involved potters and painters. Potters were trained as painters and could very well make and decorate pottery themselves. However, perhaps because talents were diversified, the process often became somewhat specialized: A potter could throw one pot and paint another. For example, a potter who was good at making amphorae (storage jars) would throw the pot, and another, who was especially gifted at painting scenes associated with this shape, would decorate it. As in all industries, there was a certain amount of standardization, and pots were made for specific functions, which were determined by their shapes. Volute kraters were meant for mixing wine and water, oinochoes were wine jugs, hydriae held water, lekythoi were oil flasks; and so on. Vase shapes and their functions are described in Figure 4-3. Any number of hands might have been involved in pottery making, and so-called bilingual pots are distinguished by the fact that two painters shared the task of decoration, each perhaps one side, while a different person might have made the pot itself.

The images found on a pot often make some reference to its function. For example, pots that have to do with wine (kraters, kantharoi, kylikes, psykters) often depict mythological scenes of Dionysus, the god of wine, and aspects of his life. The stories themselves cannot always be precisely identified, but fortunately they, like the pottery shapes they adorn, were to some extent standardized and were often repeated according to formulas that allow us to recognize basic features of the story. See appendix for list of Greek mythological figures.

Red-Figure Pottery (Archaic Period)

Within two generations after the advent of black-figure pottery, the red-figure style developed around Attica. Just as black-figure pottery was so named because its beautiful, lithe figures were painted black (with red or white occasionally added) on a red background, so red-figure pottery told its stories in red against a black background.

The subtlety of artistic skills evident in red-figure pottery lies in its mastery of a limited range of color and its brilliant fusing of the shape of the pot and arrangement of forms in the painted image.

Hellenistic Period Pottery

During the last period of Greek art (c. 323–27 B.C.), pottery appears to have declined as the primary form of artistic expression. Under the increasing influence of wall and easel painting (of which no examples survive), pottery began

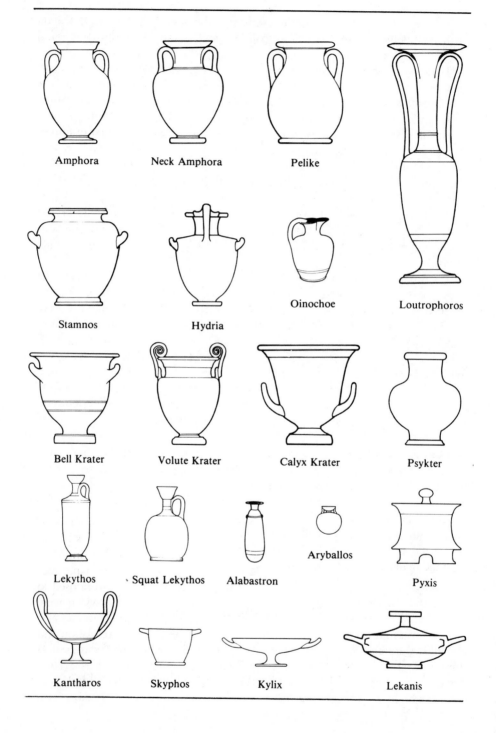

Amphora

Neck Amphora

Pelike

Stamnos

Hydria

Oinochoe

Loutrophoros

Bell Krater

Volute Krater

Calyx Krater

Psykter

Lekythos

Squat Lekythos

Alabastron

Aryballos

Pyxis

Kantharos

Skyphos

Kylix

Lekanis

to lose some of its earlier harmony between shape and imagery as Greek potters attempted to emulate painting and create the illusion of three dimensions on painted vase surfaces.

During this period lekythoi (oil flasks) were commonly used as funerary offerings. Featuring white backgrounds on which images were painted of a man or woman engaged in some mundane activity, these flasks were often exquisitely decorated. As with other pottery, however, the unity between the painted image and the surface and shape of the pot is not as great as in earlier examples of Greek pottery.

SCULPTURE

It is rare indeed that one will encounter an original Greek sculpture, or even a fragment. The few surviving pieces suggest the original splendor of Greek sculpture, which is known to us largely through Roman copies of Greek originals.

The Greeks regarded the making of sculpture as a gift of Daedalus, the first creator of divine images. Greek sculptures were offered by pilgrims as gifts to the gods in their sanctuaries, and were perhaps meant to represent the worshiper, albeit in an idealized form. Monumental kouros (youth) and kore (maiden) figures stood on pillars or columns surrounding temples and sometimes tombs. They represented deities, pilgrims, or athletes in their most perfect, unchanging states. From the initial types of figures, which were columnar and shown from a frontal view, these sculptures gradually evolved into moving, breathing entities who sported, fought, and died with ever greater realism. Small statues were made, too, as special funerary gifts and for use in domestic shrines.

For large sculpture, marble, wood, limestone, bronze, and sometimes gold,

FIGURE 4-3 The shapes of Greek vases were to a large extent determined by the different functions these vessels served. From left to right, top to bottom, these shapes are defined as follows: (top row) All amphorae (plural of amphora) and the pelike, a type of amphora, were used to transport liquids. The loutrophoros was a large, ritual amphora used to carry holy water for brides and to mark the graves of unmarried maidens; (second row) Stamnos and hydria were used to carry liquids, the latter commonly containing water, as its name suggests. The oinochoe was used as a wine jug; (third row) Kraters were used to mix liquids, such as water and wine, and so had wider mouths. Psykters were used to cool liquids; (fourth row) Lekythoi were used for oils and perfumes and were given as grave offerings at funerals in fifth century Athens. Alabastron and aryballos were also used to store oils and perfumes, and the pyxis was used to store various ointments; (bottom row) Kantharos (or cantharus) was a large drinking cup. The skyphos or styphos was a deeper vessel used as a bowl. The kylix or cylix was a shallow drinking cup, and the lekanis a lidded drinking cup.

silver, and ivory were used. Bathed in the bright Aegean sunlight under a pure blue sky, these sculptures stood in harmony with their architectural surroundings, for which they were specifically created. From fragments of original sculptures that were destroyed long ago, it is known that they were brightly colored in shades of white, blue, red, yellow, and pink. The vibrant colors that once enlivened Greek architecture and sculpture are now barely visible in the white skeletons of marble temples eroded by weather or bleached by the sun and in bits of pale marble sculpture now spotlighted in museums.

In addition to freestanding sculpture, relief sculptures were carved to embellish various parts of buildings and altars that were commissioned to commemorate special historical events, such as battle or sports victories. The creation of reliefs to fit pediments (the triangular shape formed by two sides of a roof) and friezes (the horizontal band between the roof and the walls of a building) challenged successive generations of sculptors, who devised ingenious solutions to these problems. Evolving from shallow reliefs that echoed the overall shape of the pediment or frieze to figures sculpted almost completely in the round, Greek sculpture produced innumerable masterpieces in relief. Also functioning as wall decoration, relief sculptures survive for the most part as fragments.

All of Greek sculpture, whether freestanding or relief, underwent important changes during the approximately 600 years that constituted the age of Greek art. The earliest monument kouroi were produced during the Archaic period (c. 600–480 B.C.). These early, rather stiff figures gave way to sculpture in the Classical period (c. 480–323 B.C.) that rendered complex movements and exhibited diverse emotions. Greek sculpture became further refined during the Hellenistic period (c. 323–27 B.C.), when it began to express specific emotions or specific moments in time and ranged in type from the ideal to the specific. Greek art of the Hellenistic period was infused with a pathos, feeling, and spirit not matched in art of the later centuries.

The subjects of sculpture included the human figure of all ages, and not simply youth in its physical perfection. The poses or actions displayed in Greek sculpture of this period varied and quite often depicted the transition between one movement and another, as between activity and repose, life and death, and consciousness and sleep.

The Greek interest in the specific gave rise to portraiture in its sculpture. The individual personalities of actors, writers, philosophers, rulers, and athletes were interpreted and immortalized in bronze and marble. At the same time, greater personal wealth among Greek citizens supported an increased production of small-scale sculpture. Made for private use as donations to shrines, these small works are frequently found in museum collections.

GREEK ART TIME LINE

GEOMETRIC PERIOD
c. 1000–700 B.C.

Large pots up to five feet tall are used as grave markers. Later pots begin to display simple human and animal forms. These forms also survive in terra-cotta and bronze figurines from roughly 800 B.C.

800–700 B.C. Greeks colonize areas around the Black Sea, southern Italy, and Sicily.

776 B.C. Founding of the Olympic Games.

c. 750 B.C. Greeks adapt Phoenician alphabet.

c. 750 B.C. Greeks set down oral tradition of the *Iliad* and *Odyssey*

c. 700 B.C. "Proto-Attic," "proto-Corinthian" pottery. Attica develops an emphasis on human forms for pottery decoration. Corinth remains more interested in animal shapes.

c. 650 B.C. Greek colonies spread over northern, western, and southern shores of the Black Sea and on to western Asia Minor, Aegean islands, Sicily, southern Italy, Cyrene in Libya, Marseilles, and along the Spanish coast.

ARCHAIC PERIOD
c. 600–480 B.C.

The first monumental kouroi were made.

600–580 B.C. Temple of Artemis at Corfu.

c. 600 B.C. Corinth develops black-figure pottery technique. It is later further developed by Attica.

c. 530 B.C. Red-figure style develops around Attica.

525 B.C. Treasury of Siphnians in the Sanctuary of Apollo at Delphi.

c. 500 B.C. Carved or painted stele replace pottery grave markers.

c. 500 B.C. Artists' names begin to appear on pottery, sculpture. Dynasties of sculptors are established.

c. 490–c. 429 B.C.
Age of Pericles

c. 490–459 B.C.
Persian Wars

490 B.C. Temple at Aegina constructed.

480 B.C. Persians destroy Acropolis in Athens.

CLASSICAL PERIOD
c. 480–c. 323 B.C.

Monumental sculpture achieves a greater unity of action and emotion.

525–456 B.C. Aeschylus, author of the *Oresteia*

c. 496–406 B.C.
Sophocles, author of *Oedipus Rex*

c. 484–c. 425 B.C.
Herodotus, historian and traveler, chronicles the Persian Wars.

c. 480–406 B.C.
Euripides, author of *Medea*

469–399 B.C. Socrates

c. 455–c. 399 B.C.
Thucydides, author of *History of the Peloponnesian War*

c. 448–c. 385 B.C.
Aristophanes, author of *The Birds*

448–432 B.C. Parthenon is built in Athens by Ictinus and Callicrates on the Acropolis.

437–432 B.C. Propylaea by Mnesicles is built on the Acropolis, Athens.

431–405 B.C. Peloponnesian War; Athens loses to Sparta.

428–347 B.C. Plato

421–405 B.C. Erectheum, built on Acropolis, Athens.

384–322 B.C. Aristotle

359–351 B.C. Mausoleum of Mausolus, at Halicarnassus.

338 B.C. Defeat of Athens by Philip II of Macedonia.

356–323 B.C. Alexander the Great and the Macedonian Empire

HELLENISTIC PERIOD
c. 323–c. 27 B.C.

Vase painting declines in importance as an art; mural and easel painting gain importance. Sculpture reaches a high point of sensuality and complexity of emotion.

341–270 B.C. Epicurus

c. 335–c. 262 B.C.
Zeno, founder of Stoicism

300 B.C. Euclid proposes his theories of geometry.

250 B.C.	Aristarchus, the astronomer, advances a refined heliocentric theory that is forgotten or ignored until the time of Copernicus.
240–200 B.C.	Altar of Zeus at Pergamon. The *Dying Gaul* known through copies.
212 B.C.	Sack of Syracuse by Romans.
190–144 B.C.	Roman dominions expand to include most of Greece.
180 B.C.	Victory altar of Pergamon (Berlin Staatliche Museen)
146 B.C.	Sack of Corinth and Carthage by Romans.
c. 100 B.C.	Greece is made a Roman province.
86 B.C.	Attack of Athens by Sulla.
27 B.C.	Foundation of Roman Empire.

ETRUSCAN ART

Very little is known about the Etruscans; their origins are mysterious and their language obscure. The Etruscans once extended throughout present-day Tuscany, southward almost to Rome and northward to the area around Volterra. The Etruscans preceded and then coexisted for a time with the Romans. Active as traders, they had contacts with the Greeks and Romans. From the height of their power in the seventh and sixth centuries B.C. to their gradual eclipse by the Romans, the Etruscans absorbed Greek and Roman influences in their art and influenced their neighbors in turn.

The Etruscans practiced subterranean burial. When a wealthy citizen died, he or she was either cremated or placed in a wooden log, and the remains were sealed in an underground tomb. Later burial practices involved placing the deceased in stone or clay sarcophagi. Important belongings, including pottery and metalware, were buried too. Among the artifacts retrieved from these tombs are some of our most celebrated Greek treasures, as well as numerous examples of Etruscan art.

The Etruscan cities of Volterra, Tarquinii, Vulci, Taranto, Crotone, and Veii (indicated on the map in Figure 4-2) have enormous importance for students of Greek, Roman, and Etruscan art. In themselves marvels of engineering and architecture, the cities were destroyed by the Roman expansion across Italy, which left only subterranean tombs relatively untouched. Thus, the tomb is once again the single greatest clue to this complex civilization.

CINERARY URNS AND SARCOPHAGI

Early Etruscan burials (c. 675–650 B.C.) either placed the body in a hollowed-out log or stored the ashes of the deceased in cinerary urns. These urns, in a

rudimentary way, resembled the shape of a human being, with a lid that took the form of a human head. Other urns resembled the small huts in which presumably the deceased once lived. By roughly 525 B.C., corpses were also sometimes interred in full-sized stone, marble, or terra-cotta sarcophagi, and cinerary urns took the form of small-scale sarcophagi. Full-length figures, thought to represent the deceased, recline on the lids of both types of sarcophagi.

The sides of sarcophagi and cinerary urns (especially in the north) were decorated with various funerary scenes, such as the deceased bidding farewell, the funeral procession, funeral orations, banquets and games, and the soul departing to the underworld. Certain mythological characters or tales associated with death or the deceased were depicted, such as the centaurs, Cupid, Medusa, Cadmus and the Serpent, the Judgment of Paris, Perseus and Andromeda, the Rape of Proserpina, Ulysses and the Sirens, gryphons, harpies, sea dragons, and demon. (For explanations of mythological characters, see the list of classical mythology in the appendix.)

The sarcophagi were set inside chambers below ground. Some of these chambers were decorated with murals depicting hunting and fishing scenes or images of other earthly pleasures. The most prized possessions of the deceased were also placed in the tombs.

POTTERY

The Etruscans manufactured their own pottery and also imported it. Among the most common Etruscan pottery types was bucchero, which had a characteristic black color that resulted from a particular firing technique. Manufactured in great quantities between around 600 and 500 B.C., bucchero cups, plates, amphorae, and other useful objects have been excavated. Human figures, similar to early Greek examples of pottery, are sometimes found perched on top of small clay or stone containers.

METALWARE

The Etruscans were master metalsmiths. They fashioned bronze figurines, vessels, armor, candelabra topped with dancing figures, censors, lamps, lampstands, and furniture, such as beds and chairs. Etruscan jewelry is of a high order, but its elegant mirrors are especially prized. These flat, highly polished bronze disks were silvered on one side for reflection and engraved on the other with subtle linear designs showing various mythological scenes. The draftsmanship evident in these designs is often of the highest quality.

SCULPTURE

Few large-scale Etruscan sculptures survive. The terra-cotta figures that once adorned Etruscan temples and the bronze statues that marked these hallowed

sites were vigorous interpretations of Greek models and influenced later Roman art.

ROMAN ART

The Egyptian belief in eternity and the Greek use of human form to express that which they most valued gave their respective art forms distinctive, important properties. The creation of the Roman Empire, the largest in Western civilization, and forged by well-organized warriors, adept administrators, and civic engineers, was made possible by the Roman conception of history, destiny, and the individual. These forces shaped Roman art as well and are the keys to understanding the remnants of Roman civilization that have survived.

Endless military campaigns, beginning about 750 B.C., continually expanded the empire until A.D. 177 (see map, Figure 4-4). Roman conquests were celebrated in triumphal processions replete with war booty, painted depictions of exploits, banners, insignias, chariots, and prisoners of war. The Roman belief in concrete, permanent symbols of victory prompted the creation of numerous triumphal, public monuments: vast arches decorated with reliefs depicting military exploits; triumphal columns, their stone surfaces carved with scenes of victory; bronze equestrian statues depicting the conqueror on horseback; the cuirass statue, showing the military leader in his armor. Victory itself was symbolized as a figure erected on temples and public buildings. Early in the empire, public emblems of power celebrated the personal heroic role of the victor; later, they express the concept of inevitable victory by the most invincible empire of the world.

As the Romans consolidated their power, they built new cities and transformed conquered ones into model Roman towns complete with the appropriate public monuments. Across the empire new towns were connected by an efficient highway system and buildings were designed to provide maximum personal comfort (including central heating and plumbing) through efficient planning and engineering. The Roman sense of organization, and their construction of practical, functional structures, resulted in well-ordered streets, houses, and public squares, where each public monument had its appointed spot. As they conquered their vast territory, the Romans imported arts, people, and ideas, and these in turn helped transform Roman culture into an amalgam of Greek, Etruscan, and numerous other influences.

Rome's ostentatious commemoration of military achievements probably will not come to mind as one tours a museum. These public emblems are too large to transfer into museum collections, although parts of a large monument (perhaps a relief of a battle victory or the portrait statue crowning a triumphal column) might be found. Nonetheless, even these fragments indicate that the viewer's response was vitally important to the makers and commissioners of

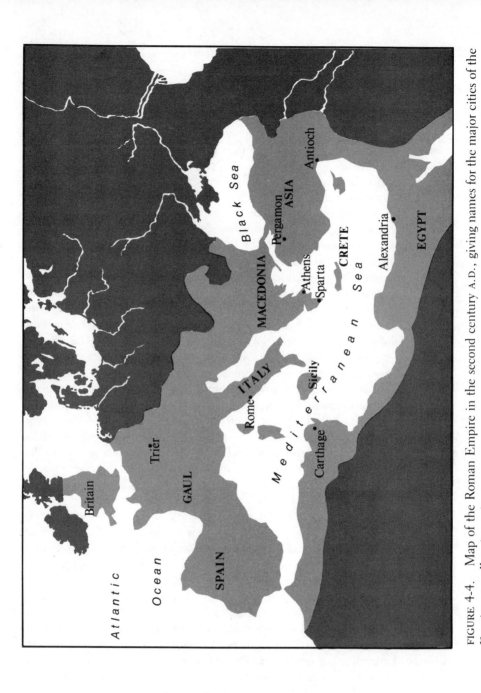

FIGURE 4-4. Map of the Roman Empire in the second century A.D., giving names for the major cities of the Empire as well as its regions.

Roman monuments. Their impact was considered so effective, and the construction of tangible historical monuments so important, that these powerful images were selectively destroyed in their own time. If an important figure fell out of public favor, the images commissioned in his or her honor were destroyed, the memory obliterated by the removal of tangible evidence.

With their love of decoration and their inveterate materialism, the Romans supported a vast industry, developing techniques that approached mass production. Indeed, many artifacts were shop-produced by anonymous craftsmen. In Roman times the demand outstripped the supply; thus, labor-saving devices such as mold casting, blown glass, stamping, and collective workshop production were the none too surprising results. The Roman capacity for large-scale production also helps explain the copying industry that evolved when not enough examples of original Greek artifacts existed to go around.

The Romans were enthusiastic collectors; they considered ownership of works of art a mark of distinction. They collected many objects that have been lost to us: easel paintings and drawings, as well as countless sculptures. They loved display, so decoration, the production of a beautiful façade, rose to prominence during the Roman Empire. After all, the Roman penchant for public displays—the triumphal marches, the laudatory pictures, the blare of trumpets, and the parade of virtuous heroes through permanent and many hastily erected monuments—also expressed their pride and belief in their glorious destiny. Most of the art of this civilization has fallen victim, like Rome itself, to the forces of history, which destroyed the empire and brought about the Dark Ages and a new phase in European culture.

SCULPTURE

Portraits

Self-consciousness and an awareness of the viewer underlie the creation of many Roman artworks. Perhaps the most important of these are the portraits. The characteristic most frequently lauded in the marble, clay, or bronze portraits of Roman men, women, and children is their unflinching realism, which captures even the physical imperfections that distinguish one individual from another. The realism of Roman portraiture is tempered by other considerations, however, that take into account the accepted values of society. Rather than presenting entirely unique characters, Roman portraits tend to underscore the individual's role in society. They are affirmations of status that would have been recognized by any viewer in Roman times. Showing a woman with her hand on her chin is not an accidental observance on the artist's part; it is a standard way of symbolizing a woman's modesty. A man's toga affirmed his status as a citizen. Each aspect of portraiture was governed by formulas that defined portraits into stock types. Portrait subjects also

wanted themselves to be rendered as certain types: the venerable sage, complete with deeply etched face lines; the respectable matron; the accomplished orator; the dutiful soldier.

Portraits were always seen as a means of immortalizing individuals in a permanent medium. They had many uses. Busts or full-length portraits were often found as part of tombs—on the sarcophagus, on the marker, or in a niche containing the ashes of the deceased, depending on the custom. Romans kept portraits of their ancestors in their homes, and they were sometimes carried in funeral processions when a member of the family died. And, of course, the rulers of Rome spread their images throughout the empire on coins, medals, public buildings, and the innumerable commemorative monuments such as triumphal arches. Each city kept abreast of changes in rulership and acknowledged them by placing portraits of new rulers in public squares.

Rulers are easily identified on the basis of surviving inscriptions. From the thousands of portraits that were made of each ruler, a good proportion survive and can be found in the world's museums. Any number of anonymous portraits have also survived, as fragments or whole.

The most common material used for portraits was marble quarried from Athens; Carrara, in northern Italy; and the island of Paros. Like the Greeks, the Romans colored their statues. In 1863, a statue of Augustus was discovered colored with reddish-browns, pinks, yellow, and blues. Bronze statues of emperors were richly gilded. In the first century B.C., colored marbles became popular. Variegated marbles were used to create colored drapery or to simulate metal. Heads, arms, and legs were sculpted from white marble. Red porphyry from Egypt became popular under Trajan.

Statues

The Romans had an insatiable appetite for sculpture of all kinds. Their interest in Greek sculpture was so intense that if an original could not be obtained, a copy was commissioned from a Roman artist, and that was enjoyed instead. We owe a great deal of our knowledge about lost original Greek sculpture to these many Roman copies.

In addition to full-length or bust portraits, sculptures were made to decorate temples, the gardens and courtyards of palaces and villas, and the niches and corners of public buildings in every Roman city. The public sculptures served commemorative and honorific purposes. The private ones honored ancestors if they were portraits or were collected simply for aesthetic enjoyment and the display of wealth.

Private sculptures ranged from life-size marbles and bronzes to small, exquisite statuettes in marble, bronze, clay, or, later, ivory.

Reliefs

The second most common form of Roman art was relief sculpture. To the Romans, stone surfaces were the natural fields on which to record the deeds of their heroes or relate stories from their mythology. (For a list of Roman mythological figures, see the appendix.) The dead were commemorated in carved reliefs on stelae (upright stone slabs or pillars), or later, when burial in tombs became popular, on the sides of sarcophagi. Thousands of whole or fragmented sarcophagi survive, and, like the portraits, their reliefs were carved for public commemoration of the dead.

Depictions in stone relief of battle victories were commonplace on the innumerable triumphal monuments the Romans erected. The surfaces of these monuments are alive with activity as thousands of figures reenact in minute detail the exploits of a victorious general or emperor.

The Roman sense of history was combined in these reliefs with a love of decoration. Over the centuries, the Romans acquired a great taste for ornament. Their homes and personal belongings were often extravagant and caused the creation of reactionary "sumptuary laws," which were intended to prevent excessive splendor. Nothing appears to have thwarted the Romans, however; they supported a vast network of workshops that manufactured an amazing variety of decorative arts. Examples of these artifacts form a good portion of today's collections of Roman art. As isolated examples, however, these objects cannot convey the total effect that completely assembled interiors, coordinated in their decorative schemes, would have produced.

MOSAICS

Floors were covered with elaborate patterns called mosaics that were made up of bits of colored stone. The earliest mosaics originated among the Greeks and were composed of pebbles. Later ones included colored glass, stone, and sometimes gold leaf fused between glass. The Republican period (510 B.C.–27 B.C.) favored simple designs of black and white. But, over the centuries, designs became intricate and colors bright. Fountains and grottoes were sometimes covered in mosaics, and many a wealthy Roman included such decoration in his villa, employing stones, colored glass, and shells for effect.

WALL PAINTING

Walls were painted with murals that served primarily decorative purposes. The best-preserved examples are found in Pompeii and Herculaneum, two cities buried under lava and volcanic ash in 79 A.D. and excavated in the eighteenth century. These paintings were embellishments for rooms and were often based on Greek models, and, in that sense, they were pictures of pictures. Often the

frame, because of its inherent decorative possibilities, became as important as the image itself in these wall decorations.

In general, wall paintings could contain simple, playful references to imaginary architecture, or they could depict views of landscapes or gardens, or consist of historic pictures or images of heroes assembled in one scene. Meant to delight the eye rather than stimulate the mind, these wall decorations were produced by special workshops.

STUCCOWORK

Both slow-setting and quick-drying plaster was used for making relief decorations on the ceilings and walls of Roman buildings. Plaster figures, stamped from molds or worked by hand, were surrounded by stamped ornamental frames. Sometimes left white, the stucco could also be painted.

Among the most delightful of the Roman arts, stuccowork most likely evolved in Italy in the first century B.C. and slowly became popular in the provinces.

METALWARE

For wealthy families, gifted craftsmen supplied dinner services made of silver and gold, and as many as 118 goblets, plates, and other utensils have been found in one home. Imperial courts likely had enormous collections. Bronze lamps and incense burners supplied light and sweet scent about the banqueters, who no doubt dressed in sumptuous, richly embroidered robes clasped with pins (fibulae) of gold and set with precious stones. On their fingers and around their necks, thighs, and arms, the affluent Romans wore bands of gold set with stones. Their hair and ears were also adorned. Even the moderately wealthy could afford such jewelry, as the vast collections in art museums reveal.

GLASS

Roman emperors and aristocrats considered glass a luxury item. High prices were paid for exceptional pieces, and special glass containers for wine and other fluids sparkled among the gold and silver pieces. Sets of glass tableware were preserved in Herculaneum and Pompeii.

By the first century B.C., glass blowing was invented, and this labor-saving technique made glass affordable for a larger segment of the population. Glass was etched using a cutter's wheel. A popular form of etched glass, called millefiori, or "thousand flowers," was made from multicolored glass rods cut and pieced together. By the first century A.D., the Romans also made window glass.

POTTERY

As painted pottery declined in the Greek culture, pottery had already become more closely associated with sculpture, and potters decorated their wares with relief patterns, much as metalsmiths and sculptors carved decorative reliefs in their respective mediums. The Romans continued the Greek tradition of colored pottery, attracting Greek and Asian artisans to Rome, where a thriving market awaited them. Many of these foreign potters settled in Arezzo, where they produced a fine pottery called Aretine ware.

Pottery colors varied with tastes and over time. The black pottery popular in earlier times gave way in the first century A.D. to red pottery, whose color was created by applying a red gloss onto a liquid clay that contained iron oxides. In the first century B.C., a glaze was manufactured in Asia Minor and northern Syria that used silicate with copper to produce a shade of green, or silicate with iron to produce a brown color.

Shapes and decorations varied by region. Most decorations were applied by stamping, cutting, or using molds, and many were erotic in nature.

Pottery was used as tableware for a large portion of the population. From the second century B.C., a good proportion of the lamps produced for general use were stamped from molds and made from clay.

MINTING

The Romans continued the Greek practice of coin making. Bronze coins appeared in roughly 300 B.C., about 280 B.C., silver was used, and by the Second Punic War (218–201 B.C.), gold was minted. Julius Caesar routinely minted gold coins. The vast empire demanded a massive minting process, and each emperor struck new coins with images of himself. Roman coins also bore images of monuments, notable persons, and events, and are valuable indicators of Rome's history.

ROMAN ART TIME LINE

753–519 B.C. Period of kings

519–27 B.C. The Republic

474 B.C. Roman victory over Etruscans at the Battle of Cumae

396 B.C. Fall of the city of Veii in Etruria

390–264 B.C. Roman expansion in Italy

264–133 B.C. Roman expansion in the Mediterranean regions (Punic Wars)

218–201 B.C. Second Punic War; Sicily is annexed

146 B.C. Greece conquered by Romans

133–31 B.C. Decline of the Republic; Rome inherits the kingdom of
Pergamon

―――――――――――― ROMAN EMPERORS ――――――――――――

27 B.C.–A.D.14	Augustus
14–37	Tiberius
37–41	Caligula
41–54	Claudius I
54–68	Nero
68–69	Galba, Otho, Vitellius
69–79	Vespasian
79–81	Titus
81–96	Domitian
96–98	Nerva
98–117	Trajan
117–138	Hadrian
138–161	Antonius Pius
161–180	Marcus Aurelius
180–192	Commodus
193–211	Septimius Severus
211–217	Caracalla
217–218	Macrinus
218–222	Elagabalus
222–235	Alexander Severus
235–238	Maximinus and Gordian I
244–249	Philip I, "The Arab"
248–251	Trajanus Decius
251–253	Trebonianus Gallus
238–244	Gordian III
253–268	Gallienus
268–270	Claudius Gothicus
270–275	Aurelian
275–276	Tacitus
276	Florian
276–282	Probus

282–284 Carus, Carinus, Numerianus (the tetrarchs)
284–305 Diocletian
305–312 Maxentius, defeated by Constantine 312
312–337 Constantine

ART OF THE ANCIENT WORLD: MAJOR COLLECTIONS

EGYPTIAN ART

Europe

Berlin
 Ägyptisches Museum
 Staatliche Museen
Bologna, Museo Civico Archeologico
Cairo
 Egyptian Museum
Grenoble, Musée des Peinture et de
 Sculpture
Leiden, Rijksmuseum van Oudhede
London
 British Museum
 Museum of the Department of
 Egyptology, University College,
 London
Munich,
 Staatliche Sammlung Ägyptischer
 Kunst
 Staatliche Antikensammlungen
 und Glyptothek

Oxford, Ashmolean Museum of Art
 and Archaeology
Paris, Musée National du Louvre
Rome, Musei Vaticani
Turin, Museo Egizio
Vienna, Kunsthistorisches Museum
Warsaw, National Museum

United States

Baltimore, Walters Art Gallery
Berkeley, Robert H. Lowie Museum
 of Anthropology, University of
 California
Boston, Museum of Fine Arts
New Haven, Yale University Art
 Gallery
New York
 Brooklyn Museum
 Metropolitan Museum of Art

AEGEAN ART

Europe

Amsterdam, Allard Pierson Museum
Athens, National Archaeological
 Museum
Berlin, Staatliche Museen
Copenhagen, Ny Carlsberg Glyptotek
Corinth, Corinth Museum
Delos, Archaeological Museum
Delphi, Archaeological Museum

Herakleion, Archaeological Museum
Istanbul, Archaeological Museums
Leiden, Rijksmuseum van Oudheden
London, British Museum
Oxford, Ashmolean Museum of Art
 and Archaeology
Paris
 Bibliothèque des Arts, Cabinet des
 Médailles
 Musée National du Louvre

Rhodes, Greece, Archaeological and Historical Institute of the Dodecanese
Stockholm, Nationalmuseet
Thasos, Greece, Thasos Archaeological Museum

United States

Boston, Museum of Fine Arts
New York
 Brooklyn Museum
 Metropolitan Museum of Art

ETRUSCAN ART

Europe

Arezzo, Museo Archeologico "Mecenate"
Basel, Antiken Museum
Berlin, Staatliche Museen
Bologna, Museo Civico Archeologico
Chieti, Museo Nazionale di Antichità
Chiusi, Museo Etrusco
Copenhagen, Ny Carlsberg Glyptotek
Florence, Museo Archeologico
Leningrad, Hermitage
London, British Museum
Munich, Staatliche Antikensammlungen und Glyptotek
Naples, Museo Archeologico Nazionale
Paris
 Bibliothèque Nationale
 Musée National du Louvre
Perugia, Museo Archeologico Nazional
Rome
 Musei Capitolino
 Museo della Antichità Etrusco-Italiche

Museo Nazionale di Villa Giulia
Musei Vaticani
Siena, Museo Archeologico
Tarquinia, Museo Nazionale
Vienna, Kunsthistorisches Museum
Volterra, Museo Etrusco Guranacci

United States

Baltimore, Walters Art Gallery
Boston, Museum of Fine Arts
Cambridge, Fogg Art Museum, Harvard University
Chapel Hill (NC), William Hayes Ackland Memorial Art Center
Cleveland, Cleveland Museum of Art
Detroit, Detroit Institute of Arts
Kansas City (MO), William Rockhill Nelson Gallery of Art and Mary Atkins Museum of Fine Arts
Malibu, J. Paul Getty Museum
New York
 Metropolitan Museum of Art
 Pierpont Morgan Library

GREEK ART

Europe

Amsterdam, Allard Pierson Museum
Argos, Greece, Archaeological Museum of Argos

Athens
 Acropolis Museum
 Agora Museum
 National Archaeological Museum
Berlin, Staatliche Museen

Brussels, Musées Royaux d'Art et d'Histoire
Cambridge, England, Fitzwilliam Museum
Chios, Greece, Archaeological Museum
Copenhagen
 Ny Carlsberg Glyptotek
 Nationalmuseet
 Thorwaldsen Museum
Corfu, Archaeological Museum
Delphi, Archaeological Museum
Herakleion, Herakleion Museum
Istanbul, Archaeological Museums
Leiden, Rijksmuseum van Oudheden
Leningrad, Hermitage
London, British Museum
Munich
 Staatliche Antikensammlungen und Glyptothek
Naples, Museo Archeologico Nazionale
Olympia, Greece, Olympia Museum
Oxford, Ashmolean Museum of Art and Archaeology
Paestum, Museo Archeologico Nazionale
Palermo, Museo Nazionale
Paris
 Bibliothèque des Arts, Cabinet des Médailles
 Musée National du Louvre
Reggio Calabria, Italy, Museo Nazionale
Rhodes, Greece, Museum of Rhodes
Rome
 Musei Capitolino
 Museo de Villa Albani

Musei del Laterano
Museo Nazionale di Villa Giulia
Museo Nazionale Romano
Musei Vaticani
Smyrna, Turkey, Smyrna Museum
Stockholm, National Museum
Syracuse, Sicily, Museo Archeologico
Taranto, Italy, Museo Nazionale di Taranto
Vathy, Greece, Archaeological Museum

United States

Baltimore, Walters Art Gallery
Boston, Museum of Fine Arts
Bloomington, Indiana University Art Museum
Cambridge, Fogg Art Museum, Harvard University
Chicago, Art Institute of Chicago
Cleveland, Cleveland Museum of Art
Malibu, J. Paul Getty Museum
New Haven, Yale University Art Gallery
New York
 Brooklyn Museum
 Metropolitan Museum of Art
Philadelphia, University Museum, University of Pennsylvania
Princeton, Art Museum, Princeton University
Richmond, Virginia Museum of Fine Arts
Toledo, Toledo Museum of Art
Washington, D. C., Dumbarton Oaks Research Library

ROMAN ART

Europe

Arles, Musee Réattu

Bath, Roman Baths Museum
Berlin, Staatliche Museen

Bonn, Rheinisches Landesmuseum
Brescia, Civico Museo Romano
Cambridge, Fitzwilliam Museum
Copenhagen, Ny Carlsberg Glyptothek
Florence, Museo Archeologico
Glasgow, Hunterian Museum and University Art Collections
Istanbul, Archaeological Museums
London, British Museum
Madrid, Museo Arqueológico Nacional
Mainz, Mittelreinisches Landesmuseum
Munich, Staatliche Antikensammlungen und Glyptothek
Nicosia, Cyprus Museum
Ostia, Museo Ostiense
Palestrina, Museo Archeologico Nazionale
Paris, Musée National du Louvre
Parma, Museo Nazionale di Antichità
Pisa, Camposanto
Ravenna, Museo Nazionale

Rome
 Galleria Borghese
 Museo Capitolino
 Musei del Laterano
 Museo Nazionale delle Terme
 Musei Vaticani
Trier, Rheinisches Landesmuseum
Tunis, Musee Alaoui
Vienna, Kunsthistorisches Museum

United States

Boston, Museum of Fine Arts
Cambridge, Fogg Art Museum, Harvard University
Cleveland, Cleveland Museum of Art
Detroit, Detroit Institute of Arts
Kansas City (MO), William Rockhill Nelson Gallery of Art and Mary Atkins Museum of Fine Arts
Malibu, J. Paul Getty Museum
New York, Metropolitan Museum of Art

CHAPTER 5

Early Christian and Byzantine Art

❦

Leaving behind the world of gladiators, soldiers, statesmen, and emperors who celebrated the power of their empire with monuments dedicated to Rome's glory, the visitor entering a gallery of early Christian art encounters a world in which the power of Rome has declined and the brute force of physical supremacy becomes subordinate to a new concern over the destiny of man's soul. The dominant spiritual force for nearly 2,000 years, Christianity brought about dramatic changes in both the cultural life and artistic development of European civilization.

If the Romans valued strength, valor, and courage and honored their generals and caesars above all else, the Christians ideally valued the renunciation of worldly pursuits and reserved their highest honors for frail, wraithlike ascetics whose self-control enabled them to refrain from normal human appetites. The early Christians fasted, meditated, prayed, had visions, preached, and renounced all but God. Their deeds are remembered and their remains accorded a reverence greater than that bestowed upon Caesar. The church became a new empire ruled by a pope whose power over the faithful of Western Europe went relatively unchallenged until the sixteenth century.

Christianity, the belief in eternal salvation through Jesus, Son of God, gradually gained preeminence over other religions. In 30 A.D., by modern reckoning, Jesus of Nazareth, a Jew, was probably crucified in Jerusalem on the hill of Golgotha by the Roman procurator, Pontius Pilate. Jesus' small band of followers spread the message of his life, death, and Resurrection throughout the Roman Empire and were eventually killed. St. Peter was crucified in 64 A.D. in Rome, where St. Paul was beheaded about the same time.

Martyrdom at the hands of pagan Romans did not stem the tide of conversion to Christianity. The early Christians were persecuted by the emperors Decius in 250–251, by Valarious in 257–260, and again during the Great

Persecution in 303–305 by the determined Diocletian, who hoped to rid the empire of Christians forever by throwing thousands to the lions. With this effort, imperial resolve seems to have weakened before the resolute throngs of Christians, of whom more than 40,000 lived in Rome by the fourth century. In 313, Christianity was made the state religion by the emperor Constantine, who then moved the capital of the empire to the city of Byzantium, now in modern-day Turkey, and renamed it Constantinople.

Even during periods of persecution, the Christians established a church and a dogma, founded monasteries, and laid the foundations for the cultural climate of medieval Europe. The church was administered by popes, who were considered spiritual descendants of St. Peter, to whom Christ had said, "Upon thee I will build my Church." Thus, St. Peter and St. Paul, the great writer and philosopher, were frequently represented in Christian art in images depicting Christ and his mother, Mary. The place of Mary in the religious pantheon rose after the Council of Ephesus in 431 officially proclaimed her the mother of God.

For the first four centuries, Christianity coexisted with older religions. By 350 A.D., pagan temples and Christian churches stood alongside one another in Rome, which still stood resplendent, its streets lined with marble statues, its palaces still sumptuously furnished, and its law schools a source of pride and learning. Later St. Ambrose, while bishop of Milan (then the Roman capital), helped issue the decree that closed pagan temples in 391. Shortly before that, St. Jerome went to Bethlehem to translate the Bible into Latin.

By 395, the empire was split in two: The Eastern, or Byzantine, Empire maintained its power, but the Western Empire fell to successive invasions of barbarians. In 410, Rome was sacked by the Goths. In 452, Pope Leo persuaded Attila the Hun to spare Rome, but the latter's invasion prompted the citizens of the northern city of Altinum to flee into the marshes, where they established Venice in the lagoons. The year in which the barbarian Odoacer captured Ravenna, 476, is traditionally accepted as the end of the Roman Empire.

Nearly a century before, the Christian empire split into two domains. The Western domain gradually disintegrated into the various regions and kingdoms of Europe. Its emperors, such as Charlemagne and Frederick I "Barbarossa," aspired to rule the "Holy Roman Empire," but their territories, though so named and quite expansive, were insignificant compared to the original boundaries of the ancient Roman Empire. The Eastern Empire, Byzantium, had Constantinople as its capitol. It also had a succession of emperors, including Theodosius I and Justinian (see the time line, later in chapter). Although Byzantium maintained its integrity for centuries, it continually suffered from encroachment. The forces of Islam seized Egypt, Syria, and northern Mesopotamia between 640 and 750 A.D.

The rest of Byzantine history is one of successive battles and skirmishes over

the empire's boundaries. Byzantium suffered a major setback in 1071, when the Seljuk Turks defeated the Byzantines at Mantziket, thereby gaining dominance over a large part of Asia Minor. In 1204, the Fourth Crusade, diverted from the goal of the Holy Land by the aged and blind Venetian doge Dandolo, laid siege to the fabled fortress of Constantinople and laid waste to the great Byzantine capital. Many of its treasures, including the famous four horses of San Marco, were spoils of this ignoble attack, and the Venetians claimed power over numerous Byzantine Greek colonies for centuries thereafter. By 1261, the Byzantines regained control over Constantinople, but the empire was slowly disintegrating. Its final collapse came with the fall of Constantinople to the Turks in 1453. To enable the reader to visualize the two regions under discussion, a map is provided that indicates the extent of the Byzantine Empire around 800 A.D. and the territories of Europe between 1000 and 1200 (Figure 5-1).

By the time of the fall of the Roman Empire, and the subsequent rise of Byzantium and the West, Christianity had already existed nearly five centuries, during which time it grew and struggled with questions of orthodoxy and image making. The fruits of these struggles and their impact on Western Europe are visible in galleries devoted to what is most often called Early Christian and/or Byzantine art and spans the period roughly from the death of Christ to the year 1200.

The difference in artistic expression between the early Christian and Roman periods is clear at a glance. Gone are the dignified portraits, and large-scale sculptures of any kind almost ceased to exist as the sense of mundane, pragmatic representation yielded to another form of expression. The human form in early Christian art takes on a spectral and insubstantial quality, and its earlier sense of individuality is lost as it becomes part of a highly complex system of symbols whose purpose is to direct one's thoughts away from the material world and toward the realm of the spirit.

The fear of idol worship transformed the imagery of early Christianity into representations of concepts. Symbols, concepts, and vast networks of intricately connected ideas predominate in Early Christian art. Never before, however, had such material splendor been used to create such an effect. For, as one traverses galleries containing art from the first twelve centuries of Christianity, one encounters an abundance of gold, silver, ivory, precious stones, well-wrought metals of every kind, sumptuous textiles, and delicate paints—all of which worked to create a physical manifestation of a higher spiritual order.

The Roman sense of history, the impulse behind the creation of so many monuments commemorating human triumph, is supplanted by the Christian view of history that begins, according to the Bible, with the creation of Adam and Eve and ends with the Last Judgment. Not the victories of conquest, but rather spiritual triumph, martyrdom, and mystical events and miracles worked by the holy are cataloged to become part of the vast network of saintly lore,

FIGURE 5-1. The early Christian and Byzantine empires from roughly 1000 to 1200 A.D. and 800 A.D., respectively. (1) Constantinople; (2) Nicaea; (3) Ephesus; (4) Antioch; (5) Dura Europos; (6) Damascus; (7) Nazareth; (8) Jerusalem; (9) Bethlehem; (10) Gaza; (11) Alexandria; (12) Athens; (13) Salonika; (14) Naples; (15) Rome; (16) Ravenna; (17) Venice; (18) Pavia; (19) Toledo; (20) Santiago de Compostela (21) Seville; (22) Valencia; (23) Toulouse; (24) Tours; (25) Paris; (26) St. Denis, (27) Rouen; (28) Reims; (29) Cluny; (30) Cologne; (31) Trier; (32) Mainz; (33) Fulda; (34) Lorsch; and (35) Strasbourg.

94

which, along with the Bible, becomes the primary source of imagery for Christian art. Art becomes the physical manifestation of faith, as the world of the senses is replaced by the world of faith.

From the first, the church played an important role. At times called a temple turned inside out, the church removed the faithful from the mundane world. The effect of its art—from the sacred symbols emblazoned on its stones, its altars, shrines, and walls resplendent with sacred images, to its tinted windows that transformed natural light and flickering lamps—was to evoke the power and glory of the divine.

Much of the early Christian art that is preserved in museums is small, precious, and portable, and a good portion of it was made for use in church services or by private citizens in their spiritual devotions. The abundance of various utensils preserved in museums gives the viewer an idea of how many objects were devoted to the performance of the rite of the Eucharist, the central rite of the early church. The smaller, more portable objects most likely to be found in museums include censers (incense burners), pyxes (containers for holding the Host), and chalices (goblets for wine). Made in the thousands for churches, these were turned out by skilled craftsmen in simple silver or gilt forms. For more elaborate tastes, chalices studded with precious stones or decorated with enamel were produced. Constantinople and, later, Limoges in France were among the centers that specialized in enamel and that produced splendid sets of liturgical objects that were then exported throughout the Christian world. From the fragments one encounters in museums, it is difficult to re-create or experience the vivid effect an entire set of liturgical objects must have had. The viewer can only imagine the awe, reverence, and pride with which these most sacred objects were held and beheld by the early Christians.

In addition to the objects already mentioned, a number of other beautifully crafted and fascinating examples of early Christian art may be found in museums. These are outlined below.

LITURGICAL OBJECTS

The implements used in the liturgy had a powerful symbolic, as well as practical, function. Each implement symbolized an event in Christ's life. The altar on which the Eucharist was performed was seen as Christ's tomb, and the ciborium, a canopy over the altar, symbolized the Crucifixion. The chalice represented the cup that collected Christ's blood at the Crucifixion, and the paten, or plate, that held the Eucharistic bread was the symbol for the hands of Joseph of Arimathea and Nicodemus, who removed Christ from the cross in the deposition. The events of Christ's life were thereby symbolically recounted during the Eucharist, and the vessels that represented these events were more highly venerated than images depicting Christ's life.

Because the events of Christ's life are of singular importance in understand-

1
2
3
4

5
6
7
8

9
10
11
12

13
14
15
16

17
18
19
20

ing the imagery and symbolism of Christian art, a chart is provided that recounts the most important events in Christ's life and depicts the compositions most commonly used to represent those events (Figure 5-2). All of these events are taken from the first four chapters of the New Testament: the Gospels of Matthew, Mark, Luke, and John. These four evangelists were also identified by certain symbols in the imagery of Christian art. The lion, representing power and dignity, symbolized Mark; the Winged Man, representing Christ's human aspect, stood for Matthew; the ox, a symbol of the sacrifice of Zacharias in Luke's gospel, represented Luke; and the eagle, representing divine inspiration, symbolized John. These evangelists and the Twelve Apostles are the second most important group of characters in Christian art. Figure 5-3 illustrates the symbols used to represent the Twelve Apostles, and a list of the Christian saints frequently depicted in art is provided in the appendix.

CROSSES

The most central and most commonly found symbol of the faith, the cross represented Christ's death and ultimate Resurrection, which were essential to human salvation. Crosses of many types and materials have survived through the ages. Large processional crosses were originally supported by long handles and used in religious processions. Made of ivory or sometimes silver, enameled or encrusted with precious stones, these crosses often bore figures of Christ in relief. Early examples show the Christ figure erect and staring triumphantly, and later examples (from roughly 1270 onward) show him suffering the agony of death. Other types of large crosses stood on altars; smaller ones, the prized

FIGURE 5-2. The most frequently represented events of Christ's life are listed here. The numbered figures are shown in the illustration in the forms most typically used to depict them: (1) the Annunciation to the Virgin; (2) the Visitation of Mary by Elizabeth, Mother of John the Baptist; (3) the Nativity; the Adoration of the Shepherds; (4) the Presentation in the Temple (the Circumcision); (5) the Adoration of the Magi; (6) the Flight into Egypt; the Massacre of the Innocents; (7) the Baptism of Christ; the Marriage at Cana— Christ Turns Water into Wine; (8) the Triumphal Entry into Jerusalem— Palm Sunday; (9) the Raising of Lazarus; Christ Washes His Disciples' Feet; (10) the Last Supper; the Agony in the Garden—Christ in the Garden of Gethsemane; (11) the Kiss of Judas; Christ before Ciaphas; Christ Presented to the People—the Ecce Homo; the Mocking of Christ; (12) the Flagellation of Christ; (13) the Crucifixion; (14) the Deposition; (15) the Lamentation—the Pieta; (16) the Entombment; (17) Christ's Descent into Limbo; (18) the Resurrection; (19) Christ Appears to Mary—the Noli Me Tangere; Christ Appears to His Disciples—the Doubting Thomas; (20) the Ascension; and Pentecost— the Descent of the Holy Ghost upon the Apostles.

personal possessions of the devout, were obtained on pilgrimages or given as gifts by prominent persons. They were worn on chains, and some contained bits of sacred relics.

RELIQUARIES

From the time of Christ's death and the earliest martyrs, the faithful revered the mortal remains and other possessions of the martyrs as holy relics. St.

FIGURE 5-3. The Twelve Apostles and their symbols: (1) Andrew, the transverse cross; (2) Bartholomew, the flaying knife; (3) St. James the Greater, pilgrim's hat; (4) St. James the Lesser, the club; (5) St. John, chalice with serpent; (6) St. Jude, halberd or lance; (7) St. Matthew, the purse; (8) St. Matthias, a lance; (9) St. Peter, the key or fish; (10) St. Philip, small cross or crozier; (11) St. Simon, the saw; and (12) St. Thomas, the builder's rule or spear.

Veronica's veil, the thorns of Christ, and fragments of the "true" cross were all venerated. By the time barbarians began invading Rome in the fifth century and robbing tombs for riches, the devout would preserve the bones of the saints by encasing them in special containers. To do so, they would sometimes break the bones into parts so that a hand, foot, arm, or even tongue could be encased in specially crafted containers, along with rock crystal, gold, silver, and all manner of enamels and jewels. Many relics were preserved in church treasuries; others were personal possessions bought at great expense, or gained as war booty. No church altar was without its relic, an item issued by a special office of the Holy See.

Canonization, the official declaration of sainthood, was awarded by the pope. The early martyrs, then the church's early popes and thinkers, were followed by a succession of men and women whose piety and adherence to rules of behavior set down by the Bible rendered them worthy of admiration and sanctity. Saints' bodies often became sites for altars and their tombs were giant reliquaries. Fragments were therefore housed in smaller reliquaries built to look like tombs and later, about 1250, to resemble a church. These treasures were taken out on feast days or were visited when a believer felt the need to associate with their special power.

The powers of these reliquaries increased with proximity. Like the holy figure, the mortal remains were considered magic, and relics were so enthusiastically collected that, in the year 1000, the peasants of Embria wanted to kill St. Romauld to be sure they would have his bones. When St. Elizabeth of Hungary died in 1231, her mourners did not hesitate to take what they could as she lay in state—strips of her clothing, her veil, hair, nails, and even her nipples. Reliquaries were thought to have magical healing powers by virtue of the holy remnants they contained. Such was their importance that Louis XI, king of France (1461–1483), spent fortunes on relics and received an emissary of the pope, who brought all types of holy oils, including the one used for coronation ceremonies, and the corporal of St. Peter.

SCULPTURE

The collapse of the Roman Empire brought about dramatic changes in sculpture. The need for large-scale sculpture in the form of triumphal arches, equestrian statues, massive monuments, and elaborate reliefs was gone. Even the portrait came into question. These forms disappeared from the cultural and artistic vocabularly of the Middle Ages. Burial customs changed, too, as the Christians rejected the pagan custom of burying treasures with the deceased and preferred burial near or inside a sacred place. Churches were thus transformed into cemeteries filled with tomb slabs on floors that gradually replaced the Roman sarcophagi.

Between 400 and 1150 A.D., freestanding sculpture virtually ceased to exist.

For reasons of function (the early church focused its decorative efforts on the interiors of churches), the external walls, capitals, and pillars of churches remained fairly barren. For fear of repeating pagan idol worship, the early Christians did not commission sculpted images of God, Christ, or Mary. Between 975 and 1000, large-scale crucifixes carved from wood began to appear, with the heads hollowed out to serve as a site for a relic. About that time, sculpted decorations in relief also began to appear outside churches. Fragments of these objects—a capital, part of a relief over a door, or part of a figure from a crucifix—can be found in museums today. Probably colored and part of a whole decorative and narrative scheme, these fragments remind us of a complex network of associations and beliefs that were meaningful for the onlooker of the time.

Metalwork

The making and casting of metals of all sorts—bronze, pewter, silver, and gold—continued to be an important art, and examples of medieval metalwork of all sorts are preserved in today's art museums. From Byzantium, imperial workshops produced elaborate silver services (much as the Romans had done) and the work thus made bore the stamp of the shop. Cups, spoons, forks (later imported in the West), and large dishes sometimes used as gifts can be found in museum collections.

Liturgical equipment—chalices, patens, flabella (fans), and paterae for the washing of priest's hands—was made from silver or bronze. Crosses, which were used to hold relics or worn around the neck, were also produced in silver. Gold or silver jewelry in the form of bracelets, belts, rings, and earrings, some of which contained enamels, have also come from this period.

The Byzantine bronze industries produced a great number of useful objects: lamps, both hanging and on stands, lamp stands, large and small candlesticks, and polycandelon (a chandelier that holds oil lamps or candles) hanging from chains, as well as incense burners and other instruments. Miscellaneous items included small animals that were probably used as votive offerings and plaques that were decorated in relief and attached to caskets and other containers.

Western metalworkers also excelled in silver, gold, and bronze. Processional crosses, crowns, portable altars (small, footed boxes) and altar frontals, book covers, and cult images of the madonna covered with gold survive in cathedral treasuries and in museums.

Ivories

Most art museums proudly display their ivories, which are among the most popular and beautiful artifacts of the early Christian and Byzantine eras. Ivory tusks came from Africa and Asia, whalebone from the ocean, and occasionally

a walrus tusk could be had. Thriving workshops in Constantinople, Rome, and Alexandria produced thousands of secular and sacred carved ivories. Elephant ivory was most prized for its gelatinous fluid, which gave the final surface a lustrous and smooth quality. By its nature, ivory limits the carver to a small, shallow surface that is conducive to precise carving. Ivory in larger sizes could only be created by piecing plaques together.

The Greeks and Romans used ivory for furniture and personal possessions, but most of these have perished. Little of the art produced from ivory before the fourth century has lasted; thereafter, however, a great number survive. Although some say this points to a revival of ivory carving, we do not know for certain.

The earliest carved ivories decorated small caskets (boxes for precious objects) and reliquaries. Many ivories were made into two hinged panels or plaques called diptychs. Pagan examples represent the commemoration of special events such as marriage or an appointment to a consulship or other seat of government. A number of consular diptychs survive that depict an image of the consul on one side; the inside of these diptychs was coated with wax to allow for inscriptions and contained the announcement of the appointment, which the consul then sent to friends and patrons.

Christian ivories were carved with sacred scenes and used in services or as private altars. Often colored, gilded, and set with stones, they were sometimes inscribed with the names of the living or deceased on whose behalf prayers were said. During the tenth and eleventh centuries, Constantinople produced a large number of small diptychs and triptychs (three panels), to be used as private shrines. Multiple diptychs, composed of five interlocking panels, once functioned as altars and were later reused as book covers. In fact, a good deal of ivory was carved for book covers by the painters who illustrated the manuscripts. The making and selling of holy images in ivory became an important industry in various parts of Europe, and, by 1250, Paris had become a notable center for the production of carved ivories.

Naturally, any object created from an assemblage of small plaques will very easily be dismembered over time. Therefore, the museum visitor may often see in the cases containing carved ivories only a fragment of a diptych or triptych or perhaps only the facing of a casket of chair. Often the color or gold will have worn off through use. Viewing a display of ivories in a museum gallery, one can only imagine the sense of personal satisfaction that must have come from having these delicate and intimate objects for the saying of prayers.

Steatites

Sometime after the eleventh century, the manufacture of ivories in the Byzantine Empire declined and the steatite plaque became more common. This pale green stone shared some of the same properties with ivory, including a smooth,

shiny surface but it was more brittle. It, too, was carved in shallow plaques that represented saints or holy figures and were often gilded. Affixed to wooden supports, steatite plaques became part of icons and caskets and were used for seals, crosses, and amulets. Some of these delicately carved relics have found their way into the world's museums.

TEXTILES

From this period, textiles of many kinds have survived—wool, linen, and the mixed colored borders of tapestries and altar covers made by Christian Egyptians called Copts. Silks woven with images of hunts, imaginary animals, and Christian symbols were used as hangings, altar cloths, throne hangings, and the like, and were exported from Constantinople throughout the West. Dry, stable climates have preserved fragments of the vast array of tapestries, drapes, and bedcovers produced centuries ago. Church treasuries and museums also preserve examples of liturgical clothing, including copes (bishops' mantles), gloves, helmets, and robes.

CERAMICS

A visit to certain art museums will expose you to some of the ceramic production that survives from the Western and Byzantine empires. Byzantium produced a wide array of ceramics, from dishes and cups with handles to tiles and plaques. A technique called sgraffito was developed there. It involved dipping a vessel into a glaze and then removing some of the glaze with a stylus to form a design. When fired, the design stands out darker against the lighter, fully glazed area.

MOSAICS

A technique popular with the Romans, mosaics were perfectly suited to decorate church walls. The interiors of churches of the Byzantine Empire are resplendent with reflections from colored glass that glistens in candlelight. The gold backgrounds, shimmering with reflected light, were ideal for depicting holy subjects. In many ways, mosaics were an alternative to painting, which they tended to resemble often more than they could be likened to assemblages of stone.

The technique of making mosaics became so refined by 1100 that Byzantine workshops were able to produce mosaics in miniature. These small, delicately worked images of saints and holy figures were no larger than the palm of one's hand. They are now scarce, found rarely in today's museums.

ENAMELS

By at least the ninth century, Western Europe was enthusiastically importing Byzantine "cloisonné" enamels, in which gold wire partitions separate sections of colored powdered glass that, when heated, become translucent. This was a finer technique than the "champlevé" or hollowed out technique used in Limoges, France at roughly the same time to make reliquaries, crosses, and other liturgical objects.

PILGRIM TOKENS

From the death of Christ to the early martyrs, Christians venerated certain sites: the tombs of Christ, the martyrs, and the saints. The devout often made special trips to pray at these sites and, over time, pilgrimages became an important activity for the early Christians. Pilgrimages were undertaken to expiate a sin, seek a cure, or look for adventure. By the eleventh century, they developed into the Crusades that sought to rid the Holy Land of infidels, who refused entry to the Christians by 1071.

Certain routes to Rome and other special sites (for example, Santiago in Spain) were well traveled, and churches and inns sprang up to accommodate the pilgrims. A burgeoning industry provided the pilgrim with mementoes, or tokens, of his journey. Of necessity small, cheap, portable, and mass-produced pilgrim tokens are now as scarce as they were once plentiful. For example, flasks that carried oil taken from lamps burning at holy sites now exist only in a few places. Among the other tokens produced during the time are clay or glass disks depicting stylites (ascetics who lived on top of pillars), small bronze crosses, and little glass vials that were bought at holy shrines and brought home as presents, offerings, or mementoes.

MANUSCRIPT ILLUMINATIONS

Every phase of liturgical activity—the saying of mass, the recitation of prayers, the singing of hymns, the selection of services, and numerous private devotions—was performed with the aid of written books that were often decorated with pictures or illuminations. In very early Christian times, papyrus rolls were replaced by parchment pages that were sewn together and placed between protective, decorated covers to form manuscript books.

Early books were laboriously transcribed by hand in monastic scriptoria. As the literacy rate dropped drastically after the fall of the Roman Empire, these scriptoria, which were usually found in monasteries, were the sole repositories of writing. To the monks we owe the preservation of the classical civilization that Christianity had supplanted.

The books reproduced by the scriptoria were many and served a variety of functions. Bibles were the most frequently transcribed books. The Epistles, the

twenty-one books of the New Testament; the Gospels, the first four books of the New Testament; and Genesis were transcribed separately. Missals charted the mass for the priest, and the Breviary instructed his daily devotions. Evangelaries and Sacramentaries contained prayers, and Lectionaries contained sections of the Gospels arranged by the calendar. Benedictionals contained blessings for the mass. Graduals and Antiphonaries recorded music sung during mass. Psalters, or private prayer books, were superseded in the thirteenth century by Books of Hours, which arranged prayers according to the times of day and year. Sermons and moral tales were collected in Homilaries and Legendaries.

All of these books offered ideal surfaces on which craftsmen applied their skills as decorators and illustrators. The process was slow, and, if a book were needed quickly and the workshops got along well, more than one artist contributed to the decorations. Some of the greatest painters of the day supplied manuscript illuminations, and the work of a great number of lesser artisans is distinguished only by shop and by region.

Beautifully decorated and carefully handwritten, these books were precious, costly, and hard to come by. Their sumptuously crafted covers were made of jewel-encrusted gold or silver or beautifully carved ivory. They were given as gifts by popes to various churches or princes and by dukes to their duchesses or to bishops to consecrate new churches. They were intended to be permanent, exquisite transcriptions of the Holy Word. Fortunately, many have survived. A good many, however, are not intact, having lost their covers or been dismembered. Quite often, the pages have been torn apart, leaving behind only the florid decorations that are now divested of their original purpose, which was to enhance a beautifully handwritten page. The nineteenth century was especially insensitive to manuscripts, and even as great an art lover as John Ruskin was guilty of cutting apart manuscripts to obtain the little details he liked.

PAINTING

Painters executed murals depicting holy scenes on church walls. The very few that have survived remain, along with their mosaic counterparts, on the original site.

Panel painting was also practiced. However, only a handful of small works on wood from before 1200 have survived. An example of these early paintings on wood is rare indeed and should be viewed closely and with the knowledge that its colors have very likely altered or been reapplied over the centuries and its overall condition likely to have been affected by the passage of time.

By 1250, the trickle of painting on wood becomes a steadier stream and the anonymity that marked so much of the artistic production between 100 and 1250 is no longer absolute, as we learn the names of various artists. Documents from 1250 onward begin to survive so that we can relate names to objects. Certain objects, especially paintings and sculptures, are signed so we can iden-

tify the artist. Stylistic idiosyncracies become pronounced to the extent that we can sort works of art not just according to the broad categories of geographic region and chronological sequence but by artist and school or circle as well. Sometimes enough evidence remains that an individual artist's development can be traced.

A good portion of the existing painting on wood survives from Italy. Early examples of painting from the cities of the old Roman Empire—notably the Coptic portrait heads—have survived, along with a few examples of painted icons from the Byzantine Empire. The making of painted crosses and various types of paintings, on either single or multisection panels, became commonplace in the thirteenth century. Although only a small fraction of what was originally produced survives (only 0.9 percent according to some scholars), enough has been passed down so that the museum visitor can expect to encounter at least one of these venerable early examples of large-scale paintings in many larger collections.

EARLY CHRISTIAN AND BYZANTINE EMPIRE TIME LINE

313	Christianity legalized by Constantine
324	Constantinople made capital of Roman Empire
340?–420	St. Jerome, noted for his translations of the Old Testament into Greek and Latin
354–430	St. Augustine of Hippo
395	Roman Empire is split into Eastern and Western empires with the death of Theodosius; Christianity becomes state religion

———————— EASTERN EMPIRE (BYZANTIUM) ————————

527–565	Emperor Justinian I
650–750	Arabs convert to Islam and capture Egypt, Syria, and northern Mesopotamia
726–813	Iconoclastic government of Byzantium, destroys many artworks
787	Council of Nicaea reinstates the use of religious images in art
867–1065	Macedonian Dynasty
1054	Separation of Roman Catholic Church from Greek Orthodox Church
1071	Victory of Seljuk Turks over Asia Minor region of Byzantium

1185–1204	Angelus Dynasty
1204	Constantinople attacked by Fourth Crusade
1261	Byzantium regains control over Constantinople
1291	Moslems attack Acre, thereby further consolidating their hold over the Holy Land (Palestine)
1350–1402	Turks conquer Byzantine area of Balkans and Asia Minor
1453	Turks conquer Constantinople, ending the Byzantine Empire

WESTERN EMPIRE

410	Rome attacked by the Visigoths
461	St. Patrick dies; established Celtic church in Ireland
543	St. Benedict dies; established Benedictine order
568	Lombard invasion of Italy

496–752 *Merovingian Period*

Founded by Merovech, this is the earliest Frankish Dynasty and marks the beginning of the feudal period, which is characterized by the fidelity between man, who provides service in war and agriculture, and his lord, who provides protection and maintenance.

481	Clovis, grandson of Merovech, becomes the sole ruler of the Franks
752	Merovingian Dynasty falls as Pepin the Short establishes the Carolingian Dynasty

752–962 *Carolingian Dynasty*

768–814	Rule of Charlemagne
800	Charlemagne crowned Holy Roman Emperor by Pope Leo III.
843	Treaty of Verdun splits Carolingian Empire into three districts ruled by Charles the Bald of France, Louis of Germany, and Lothair of Lorraine
870	Lorraine is divided between France and Germany

962–c. 1050 *Ottonian Period*

962	Otto I crowned emperor by Pope John XII
1016	Norman invasion of Italy

c. 1050–c. 1200 Romanesque Period

1066	Battle of Hastings, Norman conquest of England
1095	First Crusade
1098	Cistercian order founded
1152–1190	Frederick I "Barbarossa"

1200–1300 Early Gothic Period

1202–1204	The Fourth Crusade conquers Constantinople and destroys the Byzantine capital; many art treasures are taken to Venice
1170–1221	St. Dominic, founder of the Dominican order
1205	*Nibelungenlied* written
1226	Death of St. Francis of Assisi; canonized 1228
1274	St. Thomas Aquinas dies
c. 1266–1283	The *Golden Legend*, an assembly of holy stories by Jacobus de Voragine, written
1275–1293	Marco Polo travels to China

1300–1400 Late Gothic Period

c. 1306	*Divine Comedy* written by Dante Alighieri (1265–1321)
1309–1376	Papal schism, when the seat of papal rule moved from Rome to Avignon
1337	One Hundred Years War between France and England
1348	The Black Plague strikes Europe, eradicating from one-half to one-third of the population of European cities and towns
c. 1349–1350	The *Decameron* written by Giovanni Boccaccio (1313–1375)
c. 1387	*Canterbury Tales* written by Geoffrey Chaucer

EARLY CHRISTIAN AND BYZANTINE ART: MAJOR COLLECTIONS

Europe

Athens
 Benaki Museum
 Byzantine Museum
 National Library
Autun, Musée Rolin
Bamberg, Staatsbibliothek

Barcelona, Museo de Bellas Artes de
 Cataluña
Bayonne, Musée Léon Bonnat
Beauvais, Trésor de la Cathédrale de
 Beauvais
Berlin
 Kupferstichkabinett
 Staatliche Museen

Bonn, Rheinisches Landesmuseum
Brussels
 Bibliothèque Royale
 Musées Royaux d'Art et d'Histoire
Burgos, Museo Arqueológico
Chantilly, Musée Condé
Chartres, Musée des Beaux-Arts
Cologne, Schnütgen-Museum
Copenhagen, Nationalmuseet
Darmstadt, Hessische Landes- und
 Hochschulbibliothek
Dijon, Musée des Beaux-Arts
Florence
 Museo Nazionale del Bargello
 Biblioteca Medicea Laurenziana
 Galleria dell'Accademia
 Galleria degli Uffizi
Frankfurt, Liebieghaus
Freiburg, Augustiner Museum
Fulda, Landesbibliothek
Hamburg, Museum für Kunst und
 Gewerbe
Hannover, Kestner-Museum
Heidelberg, Universitätsbibliothek
Istanbul, Archaeological Museums
Karlsruhe, Badisches Landesmuseum
London
 British Museum
 Victoria and Albert Museum
Lucca, Pinacoteca Civico
Madrid, Museo Arqueológico
 Nacional
Mainz, Cathedral Museum
Moscow, Museum of Fine Arts
Munich, Bayerisches Nationalmu-
 seum
Oxford
 Ashmolean Museum of Art and
 Archaeology
 Bodleian Library
Paderborn, Erzbischöfliches
 Diözesanmuseum

Paris
 Bibliothèque des Arts, cabinet des
 Médailles
 Musée de Cluny
 Musée National du Louvre
Rome, Biblioteca Vaticana
Rouen, Musée Départmental des
 Antiquités de la Seine-Maritime
St. Omer
 Musée-Sandelin
Stockholm, Riksantikvarieämbetet
 och Statens Historiska Museum
Strasbourg, Musée de l'Oeuvre
 Notre-Dame
Thessaloniki, Archaeological
 Museum
Toulouse, Musée des Augustins
Trier
 Bischöfliches Dom-und
 Diözesanmuseum
 Domschatz
Urbino, Galleria Nazionale delle
 Marche
Vienna, Kunsthistorisches Museum
Zurich
 Landesmuseum
 Zentralbibliothek

United States and Canada

Baltimore, Walters Art Gallery
Boston, Museum of Fine Arts
Cleveland, Cleveland Museum of
 Art
New York
 Cloisters
 Metropolitan Museum of Art
 Pierpont Morgan Library
Washington, D.C.
 Dumbarton Oaks Research Library
 and Collection
 National Gallery of Art

CHAPTER 6

Medieval Art, 1250–1400

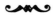

The period from 1250 to 1400 has been described as the age of Europe's reawakening. Dramatic growth in population, increased mobility, greater political security, and economic stability are the hallmarks of the thirteenth and fourteenth centuries. With the resurgence of productivity in Europe, artistic activity also experienced a renewal. But, like other aspects of this period, artistic production maintained traditions established in preceding centuries. Many of the forces that underlay the production of art remained the same, for Christianity continued to represent a spiritual and institutional force that dominated the social and political life, thinking, and artistic output of this period.

As European cities developed, they acquired a larger economic base. The manufacture of goods, trading, and banking (notably in Italy) fostered the emergence of an increasingly wealthy merchant class that rivaled the nobility in financial resources. In fact, the Italian banking families, such as the Peruzzi, were the bankers of Europe. Thus emerged a broad basis for the patronage of the arts. The cities in which these wealthy citizens lived not only competed with each other politically and economically but culturally as well, and their civic pride was expressed in the artistic embellishments they commissioned. Throughout Europe, cities tried to outdo each other in the splendor of their cathedrals and the magnificence of their town halls.

As more and more churches were built in response to a growing population, art produced in the service of religion also flourished. What had earlier been a trickle of painting became a virtual flood, sculpture was more actively produced and liturgical objects were turned out in ever greater numbers. Because more of everything was created, more remains, and museum collections consequently offer a broader sampling of the surviving artwork.

Even art produced outside the church was generally religious in character. There was, in fact, no real distinction between the sacred and the secular.

Town halls, homes, and public monuments were decorated with holy images because these were often believed to have magical or other salutary powers. For every illness or disaster there was a saint from whom one could seek protection or deliverance. For every sin there was a concrete act that might absolve it—an important notion, especially in Italy, for many merchants guilty of usury commissioned artworks by way of expiation.

The citizens of Europe's cities belonged to various organizations. In republican cities, there were governing bodies. Every skilled laborer had to belong to a guild, and there was a guild for every conceivable trade—textiles, tannery, carpentry, medicine, armories, and so on. Civic organizations dedicated to the communal welfare sponsored hospitals, orphanages, and ambulance services and gave alms to the poor. These charitable groups also competed with each other in expressing their civic consciousness by commissioning artworks. By embellishing a church door, erecting a statue of their patron saints (and every organization had its own), or commissioning a building and its decoration, the civic-minded displayed their goodwill and Christian spirit.

As a social unit, the family played an important role in defining the position, consciousness, and aspirations of its individual members within the larger context of society. A family's prestige and power were highly valued and were thought to be enhanced by its role as patron of the arts. Families proclaimed their prominence in society by having their own chapels built within churches, decorating these with altarpieces and other embellishments, and commissioning tombs for their relatives.

Women gained new prominence during this period and many emerged as leaders (Eleanor of Aquitaine, 1122?–1204), saints (Saint Clare, 1194–1253, and St. Catherine of Siena, 1347–1380), and writers (Saint Bridget of Sweden, 1303–1373, author of the *Revelations*). Women became the objects of an idealized romantic love that formed the basis for a code of chivalry and that inspired innumerable romantic ballads and poems. They also came to embody a type of candid sensuality that was celebrated in a new and vibrant vernacular literature, which included the likes of Giovanni Boccaccio's *Decameron*.

The feminine principle found religious expression in the cult of the Virgin Mary, which flourished throughout Europe. The role of the Virgin as intercessor on behalf of the faithful, her compassion, humanity, and motherhood were celebrated. Entire cities, such as Siena, were dedicated to her, as were countless cathedrals. Her life was recounted in numerous picture and sculpture cycles that began with her birth and ended with her death, assumption to heaven, and subsequent coronation as Queen. The protectress of humanity, she embodied a feminine ideal that was to be venerated for centuries to come.

Between 1200 and 1400, religion had two great exponents who helped shape the cultural and spiritual climate of the age. St. Francis of Assisi (1182–1226) sought to bring religion closer to the individual by preaching Christ's humanity and compassion, which were so great that he suffered and died for man's sins.

As the Franciscan movement swept across Europe, St. Dominic (c. 1170–1221) founded the equally influential Dominican order. Devoted to the teaching of orthodox Christian faith, the Dominicans sought to weed out heretics through the Inquisition. Through love and fear, it was thought, religion could continue to hold man in its grip.

It was this period that saw universities emerge as centers for higher learning and the establishment of the now famous academic institutions at Bologna, Padua, Oxford, and Paris. The academic curriculum included such disciplines as theology, mathematics, astronomy, music, grammar, logic, law, and medicine. Theology was taught and learned through reasoned argument and disputation, a method called Scholasticism that perhaps found its greatest proponent in St. Thomas Aquinas (1225–1274), a Dominican and professor at the University of Paris. His *Summa Theologica* (1266–1273) exemplifies the highest achievement of the Scholastic method, for it defined every element of theology in terms of the unified, systematic framework of rational thought. These thought processes were to influence more than mere academic debate, however, for they also determined the construction of medieval cathedrals, regarded as material expressions of systematic order defined by the rules of logic.

Museums preserve objects that were not regarded in their own time as mere works of art, but as practical objects that specifically helped ensure the physical and spiritual well-being of both the art patron and the viewer. Many sacred objects, in fact, were considered to have magical powers. Banners with painted images of saints or sculpted figures of Christ were frequently carried through the streets in times of pestilence to ward off disease. Images that were believed to have performed miracles were highly esteemed and frequently copied, in the hope that some of the power of the original might be transferred to the copy. Direct copies were common, but, as copies proliferated and spread to various regions, their resemblance to the original model became less distinct. Because the practice of copying was common during this period, scholars, in their search for original works, sometimes have had to trace hundreds of copies in order to arrive at a single, miraculous original.

Because many objects survive from the medieval period, it is possible to distinguish regional differences in styles of art. Although the birth of modern European nations was still centuries away, by 1250 certain stylistic boundaries had been clearly delineated, and the art of Europe from this time forth generally reflects these geographic divisions. Because of its unique development and its impact on future centuries, the art of the Italian peninsula is distinguished from that of the rest of Europe. The roots of this distinction lie in the diverse origins of Italian and northern European cultures, which remained bound only by a common religion. History, climate, demographics, geography, and artistic and cultural traditions led to differences between Italy and the north both in their aesthetic tastes and art production. For these reasons, Italy and Northern Europe are discussed separately.

ITALIAN ART

As in the rest of Europe, Italy's artistic production was primarily religious in function during the medieval period. Churches were lavishly decorated with vast picture cycles painted on walls and were divided by chapels whose altars were adorned with panel paintings. Every part of an Italian church delighted the eye and inspired the heart. Floors were decorated with elaborate marble inlay patterns that often had symbolic meanings. Ceilings had gaily patterned wooden beams or were often painted with images of various saints. Fanciful wrought-iron gateways closed off private chapels. Choir stalls were decorated with inlaid wood representations of saints or religious symbols. The floors and walls of churches were also punctuated here and there by tombs, and rood screens and pulpits were further adorned with sculpture. Light passing through windows set with colored glass illuminated the splendor of long walls painted with picture cycles of every description. The total effect of these thirteenth- and fourteenth-century churches is almost impossible to imagine, now that they have suffered the vicissitudes of time and taste. Few Italian churches survive in anything resembling their original splendor.

PAINTING

From the description provided above, it should be clear that the church was the primary setting for painting, and that painting was especially near to the hearts of Italians. From its vast mural cycles to its delicate miniatures, Italian painting has an extensive tradition in both quality and quantity that is unrivaled in European history. Fostering generation after generation of genial painters, Italian art developed in numerous cities and regions that were distinguished by their own unique characteristics and styles. Due partly to the fact that Italy did not become a unified nation until the nineteenth century, the regional differences in Italian art remained important throughout the country's history and were even reinforced through vigorous competition among cities and towns struggling to maintain their independence. The map of Italy (Figure 6–1) identifies the important art-producing regions and cities which include Florence, Siena, and Venice. These schools of painting are described briefly.

Central Italian Painters

Central Italy includes many distinct regions: the Marches, Emilia-Romagna, Umbria, and Tuscany. Within Tuscany, many distinctive schools of painting evolved during the fourteenth century, among which Pisa and Lucca were the oldest and Florence and Siena the best known and most celebrated. Because Florence and Siena are so distinct, their painters are discussed separately.

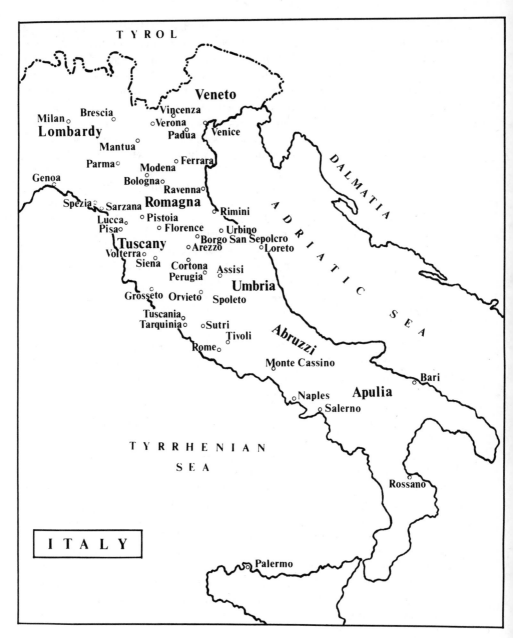

FIGURE 6-1. Map of Italy indicating major regions and important cities.

Florence The Florentine school owed a fundamental debt to the genius of
Giotto di Bondone, who radically altered the symbolic, nonillusionistic tradi-
tions of Italian painting of that time. Giotto's monumental and daring reinter-
pretation of divine images made them more human and physically and psycho-
logically more accessible to their beholders. In his own time, Giotto's majestic
and breathtaking realism must have been awesome. His talent as a storyteller
was unmatched. Biblical stories were infused with an emotional intensity,
dignity, and seriousness that remain unparalleled in the history of painting.
Certainly all Florentine painters and most schools elsewhere, with the excep-
tion of the Sienese, were influenced by Giotto's example.

The history of later fourteenth-century Florentine painting reveals how
Giotto's artistic heirs reconciled the new realism in painterly representations
with the traditional functions of religious art. No painter could ignore the
tensions this dual heritage brought, but each resolved them in his own dis-
tinctive manner. No painter after Giotto pursued purely realistic painting, and
none attempted to create the purely symbolic images that had characterized
early Italian religious art. Florentine painters bridged both traditions until
midcentury, when spatial illusionism was abandoned, if only temporarily, in
favor of a flat, decorative style.

Siena The fourteenth-century Sienese school produced some of the most
original and independent painters ever to have assembled in one city. Duccio
di Buoninsegna, Simone Martini, and Pietro and Ambrogio Lorenzetti, to
name the best known, were supremely talented and inventive artists. Yet,
paradoxically, these painters adhered consistently to their school's own estab-
lished traditions and remained almost impervious to outside influences.

Because the religious function of much of fourteenth-century Italian painting
imposed many restrictions on artists in terms of technique, format, subject
matter, composition, and even choices of color, it is often hard to appreciate
the inventiveness of the Sienese school. In spite of these constraints, the origi-
nality of the Sienese painters is unquestionable. Ambrogio Lorenzetti, for ex-
ample, reinvented a subject every time he painted it, and no two images of a
Madonna and Child by him are identical. Furthermore, the Sienese school
invented new subjects. Its artists appear to have been the first to make the
Annunciation the main theme of altar painting. Simone Martini's *Annuncia-
tion* (1333), now in the Galleria degli Uffizi in Florence, is a notable example.
The Sienese also introduced the Madonna of Humility, a variant of the Ma-
donna and Child that shows the Virgin not on the traditional throne, but rather
seated on the ground.

Whereas Florentine painting is monumental, Sienese painting is elegant and
courtly, depicting a world of refined and often aloof beings whose grace and
bearing place them far above mere mortals. The Sienese never succumbed to
the temptation to make their religious images realistic. In fact, they endowed

these images with a richness and splendor that raised them above the limited experience of human beings. In addition to incorporating natural observations and incidental narrative details, Sienese painting balances reality and illusion effortlessly. The link between these two spheres is often achieved through a brilliant use of line to describe a figure and its contours as it forms a beautiful, flat arabesque across the picture plane. Sienese painting evokes a glowing, transcendent realm that is inhabited by celestial beings. If Florentine painters give the Divine an earthly grounding, then Sienese painting allows us a glimpse into heaven itself.

Venice

On the edge of the Adriatic, facing Turkey and the Byzantine Empire, Venice traditionally had more contacts with the art of Byzantium. The Byzantine influence on fourteenth-century Venetian painting is readily apparent, for it relied on a system for structuring images that was part of the Byzantine artistic heritage. Characteristic of the Venetian school of painting were its densely constructed, crowded, and colorful images and its use of a system of parallel gold lines to define folds within drapery. The beauty of Venetian painting lay in its artists' ability to control many elements and fuse them into a splendid yet intricate design.

No museum will display outstanding examples from every area of Italy, nor is it likely that a single collection will have more than one or two paintings by a single master, unless one is visiting the cities that produced these masters. Few painted panels survive in relation to what is estimated to have been produced. Nevertheless, a visit to any museum that displays early Italian painting is an encounter with the beginning of a centuries-long tradition of artistic excellence.

The earliest examples of Italian painting approached their subjects in symbolic terms. The Deity and saints could not be and were not rendered in human terms. The first representations of Christ, the Virgin, and other sacred figures in paintings depict them in such a way that they remain remote from the viewer, both physically and psychologically. Their bodies defy material substance and are but glorious blazes of color set before a magical and reflective material—gold. Their faces and eyes do not communicate with the viewer or meet his glance. Earlier artists faced the challenge of giving ephemeral spirits material representation without reducing these to mere human terms. They chose a solution that was materially splendid and aesthetically sophisticated, but that completely removed art from human experience.

Toward the end of the thirteenth century, a new, more humanistic interpretation of the Divine emerged that stressed the personal relationship and affinity between man and his maker. St. Francis of Assisi preached the compassion and humanity of Christ and the beauty of God's creations. Gradually responding to

this change in conceptions of the Deity, Italian paintings began to depict the Divine in more human terms and in a more natural context. After roughly 1300, paintings of holy figures take on a more physical substance, and, in many instances, these subjects communicate with the viewer directly by their gazes. Furthermore, the representation of space in painting becomes more believable as perspective and incidental details are added to expressions and settings to reinforce the bond between the image represented and the onlooker.

Italian painters from roughly 1300 to 1400 faced considerable challenges and produced innumerable solutions to one principal problem: How could art represent the elevated status of its subject in a more human context? The responses were diverse and complex. For example, figures could be given dimensionality and human expression, but were then also idealized and endowed with a beauty and splendor that placed them clearly beyond the realm of mere mortals. Or they were placed in a setting that denied the very dimensionality suggested by their physical forms, thereby giving the image a context that is not consistent with the viewer's own reality. Working with traditional constraints in available materials, subject matter, composition, and narrative, Italian painters from this period were able to arrive at unique and original conceptions that were remarkable in light of such limitations.

Not all types of paintings produced during this era are in museums, but those types that are commonly found in collections are described below.

Panel Painting

Despite some problems with their condition, restoration, and preservation, Italian panel paintings are in many ways the most fortunate survivors of the thirteenth and fourteenth centuries. Because paintings on panels were always meant to be discrete and therefore were not chemically bonded to walls, as were frescoes, and because they did not depend physically and psychologically on their architectural surroundings, as did most sculpture, they have often been removed from their original sites. Today, many are housed in museum collections.

Most surviving panel paintings originally were altar decorations for large churches or small private altars in homes, monasteries, or palaces. They could take many shapes, depending on the time in which they were made or the altar they were meant to embellish. Early church altarpieces from about 1250 to 1300 were large and simple; later examples from about 1330 onward were elaborate and composed of many sections. A central image flanked by wings, pinnacles, and predellas was contained within a beautifully carved and gilded frame that often cost more than the painting itself. Private altars were generally smaller and also portable. A description of various panel shapes and their functions is provided in Figure 6-2. A superb example of a private devotional altar can be found in Plate 1. By Duccio, the great founder of the Sienese school, this painting represents a brilliant fusion of real with fictive, of narrative

and functional considerations that were to affect Sienese school painting profoundly for centuries to come. After opening the wings, the viewer encounters an exquisitely yet dramatically rendered Crucifixion, and the images of two saints (perhaps name or patron saints), one on each wing, bless the viewer as he performs his devotions.

Panel painting involved painstaking, laborious processes. Wood planks were joined, covered with gesso (gypsum or plaster of paris prepared with glue), and polished smooth with special tools. On this perfect surface, the artist would sketch out a composition with chalk, redefine it with inks, and then begin the deliberate process of applying thin layers of egg tempera paint (egg yolk in which pigments are suspended) with small brushes. The successive layering of these meticulously applied paints produced the final, translucent colors.

Backgrounds and halos of gold were made by carefully applying sheets of gold leaf first and then embellishing by punching the gold with a metal rod on which a pattern was embossed, for decoration. Every step in the process, from cutting the wood to applying the gesso and gilding and painting, was slow and deliberate. The quick-drying tempera demanded that the artist know exactly where each stroke be placed before the brush met the panel, and it required the use of fine brushes. It was, therefore, an ideal technique for emphasizing hard linear edges and pure, fine areas of color that were so much a part of the overall aesthetic of these images. The notion that an artist could or would dash off an idea in a fit of spontaneous inspiration was completely alien to these deliberately produced works.

Furthermore, these paintings were so time-consuming that they demanded assistance. All such work was done by collective enterprise in the workshop. The painter or master whose name is on a museum label may have designed the work and overseen its production, but it is highly unlikely that his hand applied every stroke of the brush. Rather, he probably had numerous assistants who learned to imitate his style and who applied the paint under his direction. The carpenter's shop likely provided the frame and perhaps supplied the panel, and yet another shop supplied the gold. Thus, not only many hands but many shops were involved in the final product.

Although many examples of Italian panel paintings have survived, they have not weathered the passage of the time unscathed. Originally formed of sections that were hinged together and often painted front and back, many altarpieces have been taken apart in the intervening centuries, and at times the fronts and backs have been sawed apart. A museum may preserve only a predella or wing from a much larger work that formed the context for and gave meaning to that fragment. Also, original frames are often missing, having been removed for their gilding, which could be salvaged by burning the frame. Thus, the museum visitor may think he is seeing an altarpiece complete with original frame, when, in fact, the frame is but a gaudy, nineteenth-century imitation or later replica.

Inscriptions, dates, and signatures on altarpieces are sometimes later addi-

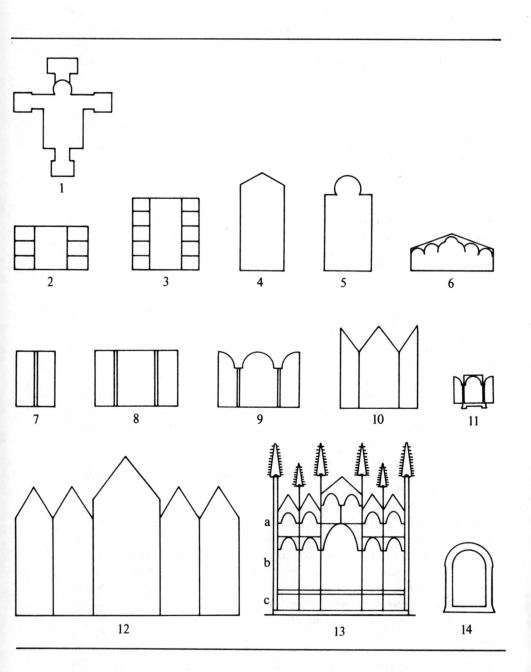

tions. Specialists in Italian art are always wary of accepting a signature as evidence of authorship until all of the evidence—including composition, over-all design, narrative interpretation, and construction of the individual figures—has been examined. False signatures can be detected by various technical examinations as well.

Even in the rare instances where human efforts have not tampered with original altarpieces, nature has taken its toll over the 600 to 700 years that have

FIGURE 6-2. The most common thirteenth- and fourteenth-century panel shapes are: (1) the crucifix, which was often quite large and generally hung over the main altar; (2) and (3) rectangular panel shapes with subdivisions. Common during the late thirteenth and early fourteenth centuries, both shapes generally depicted saints in the central panel, while subdivided side panels showed scenes of the saint's life. The horizontal format depicted saints seated whereas the vertical format showed them standing. This panel type was placed at the back of the altar, along with all the altar decorations; (4) gabled panels, which showed a saint or other holy figure standing or enthroned. These exceptionally large panels were used to decorate the main altar of churches and became popular in the early fourteenth century; (5) a variant of the gabled panel, this type featured a circular shape on top, in which the halo of the holy figure was contained; (6) panels of this type frequently depicted half-length images of the Madonna in the center surrounded by half-length images of various saints. Gaining currency during the late thirteenth and early fourteenth centuries, this panel shape underwent many transformations; (7) diptych panels (comprising two wings) could be large but were frequently small enough to be held in one's hand for private devotions; (8, 9, 10, 11) consisting of three parts, triptychs came in various sizes and shapes and were popular in the early fourteenth century. Generally a holy image or scene was depicted in the central panel and subsidiary scenes or images of saints decorated the wings. Number 11 illustrates one of the most popular fourteenth century panel types, the portable triptych, which was small enough to be carried and had movable wings that could be closed over the central image when the triptych was not in use. Whole or fragmentary triptychs are frequently found in museums; (12) polyptychs, or altarpieces with more than three sections, featured a holy image in the central panel and images of various saints in the wings; (13) increasingly popular during the fourteenth century, elaborate polyptychs of this type depicted a holy image or the saints in the central panel, and other saints and prophets in the pinnacle (a) and wings (b), and illustrations of the lives of the saints in the predella or images from the episodes of Christ's life (c); and (14) bier head, which decorated the ends of a bier on which a coffin or body was carried during funeral processions. Christian subjects related to burial, such as the lamentation over Christ, were commonly depicted on bier heads.

passed since these paintings were made. Wood expands and contracts with climatic changes and thus the panels may have lost some of the surface paint or suffered numerous cracks in the paint surface. Worms may have bored through the wood into the paint surface. Oxidation, the natural binding of atmospheric oxygen with surface pigments, will have changed the appearance of certain colors: Blue robes will often appear black, green underpaint in flesh tones will sometimes show through the surface, or the surface will have been worn down to the underpaint. The accumulation of soot from candles and lamps burning at the altar would be cleaned off regularly, leaving the paint surface marred, scratched, and abraded.

Restoration, the replacement of lost paint or alteration of existing paint, has been almost inevitable for many altar paintings from this period. Not all restoration is of recent date, either. A thirteenth-century Madonna may have been given a fourteenth-century face to modernize the image. A fifteenth-century Madonna may wear a sweeter expression that was supplied by a nineteenth-century restorer in an attempt to make the original image conform to the then prevailing tastes. In their zealous search for only "original" paint, modern restorers have bereft many old panel paintings of all pigment but the gesso or first undercoating layers. They used chemicals that were believed to be useful in detecting differences between old and newer pigments, but these abrasives also corroded original paints in the process.

Other Types of Painting

From records such as commissions, contracts, and inventories, it is known that painters produced a great deal more than murals and altarpieces. Banners, coaches, saddles, shields, and probably furniture were painted by artists for their patrons. Greatly worn by use, these artifacts have been lost. Only a few banners painted on linen or an occasional shield survive to remind us of the many other types of painting that were produced during the medieval period.

Furniture, such as chests (cassoni), birth trays (deschi da parto), beds, and benches, and such painted surfaces as book covers, were most likely produced in great numbers but very few from this period survive. Tax book covers (gabello) can be found in some Sienese museums.

Illuminated manuscripts were extensively produced, continuing traditions discussed in the previous chapter. Specialists in painting miniatures often worked in monastic scriptoria, and painters who ran shops in the cities also undertook painting in miniature as the century progressed.

SCULPTURE

The 150-year period from 1250 to 1400 saw rapid changes in Italian sculpture. In contrast to the small-scale sculpture that had been predominant until 1150, large-scale works began to make their appearance once again.

As with painting, the surviving sculpture from this period was created for

churches or religious services. In fact, throughout Europe many museums today are located adjacent to important churches and house the precious fragments of sculpture that once adorned church exteriors and interiors. Certain locations in churches were important or ideal for sculpture. The horizontal spaces over church doors, called lintels, were often adorned with relief sculpture. Images of the Last Judgment or the Virgin and Child were placed in lintels to remind those who entered through the doors of their ultimate destiny or the source of their protection. Church doors themselves were ornamented. Early wooden doors were carved with relief scenes; later bronze-cast doors showed scenes from the Bible.

Church walls were often punctuated outside and inside by columns or pillars whose capitals, or crowns, were carved with miniature images that frequently had sequential relationships. Favored subjects included the twelve months, the seasons, the signs of the zodiac, episodes of biblical or church history, personifications of the virtues (faith, hope, charity), and the like.

The outside walls of churches, sometimes scalloped with niches or punctuated by projecting pillars, were sites for large-scale figures. Usually depicting characters from church history, these sculptures portrayed prophets from the Old Testament and sibyls, considered presagers of Christ's coming. Large in scale to match the size of their architectural surroundings, these sculptures may be found intact or as fragments in church and other museum collections.

Next to major churches in Italy were special buildings called baptistries in which infants were baptized. These, too, were decorated with sculpture and mural paintings, which commonly featured themes from the life of John the Baptist, to whom most baptistries were dedicated.

Sculptures were usually components of a larger framework. Thus, to see an isolated figure or relief is probably to witness a fragment of what was once a larger whole. Like the components of altarpieces, the individual sculptural components of tombs, altars, pulpits, and the like often separate very easily and are thus studied and displayed as discrete entities. Only when the fragmentation is obvious—when a head is broken off from a body, or a torso is limbless, or a panel is broken—is the viewer likely to be conscious of dismemberment. Because sculpture generally remained part of a vast decorative scheme, it is important to remember that museums preserve only fragments whose reconstruction may often be disputed and whose original context and location are sometimes purely a matter of speculation.

The following discussion will treat types of sculpture that may be found, whether intact or, as is more common, as fragments, in museum collections.

Columns, Capitals, and Bases

Decorated with various symbolic images, columns and capitals of stone, marble, or wood were frequently produced during this period. Not only did they appear next to interior and exterior walls but they also served to separate

aisles within churches. Smaller columns became components of altarpieces, pulpits, tombs, and screens.

It was not uncommon for the bases of columns to represent a symbolic animal form. Thus, at the base of columns flanking church doorways or supporting pulpits and the like, lions were frequently shown resting. This particular animal motif remained popular until about the fourteenth century.

Cult Figures

Painted or gilded wooden statues of the seated Virgin and Child are the earliest surviving type of medieval sculpture and the earliest forerunner of freestanding sculpture from this period. These highly venerated statues were kept in churches and carried in processions during special holidays. Many have been damaged and fragmented from repeated use.

Standing Virgin and Child

The cult of the Virgin gained popularity between 1250 and 1400. Statues of the Virgin holding Christ were first placed on trumeaux, or doorposts of churches, and gradually became freestanding sculptures that adorned altars. Mounted on bases, they were also placed in streetcorner shrines. Smaller versions were used in private devotions.

Larger sculptures of the Virgin and Child were generally carved from limestone, marble, alabaster, or wood and were frequently painted and gilded; smaller figures were carved from ivory or made from precious metals.

Crucifixes

Examples of the large, sometimes life-size wooden sculptures of the Crucifixion of Christ date from as early as 900 A.D., although later works are more prevalent in museum collections. Some crucifixes show a Christ figure with moveable arms that are outstretched; others depict Christ dead, with arms resting at his sides. Painted details make these images more lifelike and compelling. They were used in festivals celebrating the various stages of Christ's Passion and were carried in processions. Others were hung on choir screens, flanked by wooden sculptures of the mourning Virgin and John the Evangelist.

Angels

Large or life-size, as well as small-scale, sculptures of angels were commonly carved to serve a number of purposes. Pairs of angels were placed at altars to hold candles. The Angel Gabriel was often placed opposite his counterpart, the Annuciate Virgin, in entrances to chapels or over church doors. Smaller ver-

sions were frequently part of the overall sculptural ornamentation of a tomb or carved altar. Wood, stone, marble, or alabaster were the most commonly used materials for these sculptures.

Pulpits

The raised stone or wooden platforms from which priests preached their sermons had flat sides that were ideal for many types of sculpted decorations. The earliest stone pulpits were inlaid with bits of colored stone (intarsia) and later were decorated with relief sculpture. Much of the relief imagery depicted scenes from Christ's life, and additional meaning was supplied through representations of the prophets, the virtues, or other symbols. Although many pulpits have vanished, some remnants have entered museum collections and several notable examples by the Pisani (see list of artists, at end of chapter) still remain in the various cathedrals of Siena and Pisa that originally commissioned them.

Tombs

A great deal of artistic energy went into the production of tombs. Kings, emperors, nobles, important church leaders, prominent citizens, merchants, bankers, professors, and warriors were commemorated after death through their tombs, which may or may not actually have contained the remains of the deceased. Tombs took many forms. The simplest consisted of slabs of marble, stone, or bronze on which an effigy was carved in shallow relief. Tomb slabs were placed on church floors, beneath which the dead were buried. During the late thirteenth and fourteenth centuries, tombs became more complex. These later examples, for the most part, have been dismantled and subsequently reconstructed. Although there is much debate about their proper reconstruction, the size and complexity of some tombs involved a great deal of sculpture. An example of what is generally regarded as a well-reconstructed tomb is illustrated in Figure 6-3.

Located along church walls, within chapels, as slabs in floors, or as free-standing works, tombs proclaimed the history, social and political stature, and often the deeds of the deceased. Thus, medieval Italian tombs continue the Roman tradition of public display, giving visible testimony to an individual's importance while affirming the Christian belief in an afterlife by depicting the holy intercessors who aid the salvation of the soul. Tombs were permanent reminders of the deceased and were the site of special prayers and masses held on the anniversary of a person's death. Given the social structure of medieval Italy, tombs of prominent men were more common than those of women.

Wellheads

Sources of precious water, wells were capped by stone or marble tops that
sculptors were often commissioned to carve. Some of these wellheads are
masterpieces, and an occasional example may be found in museums.

Fountains

Fountains made of stone, marble, or bronze were common civic adornments
and sources for public water. Many great sculptors of the day transformed
fountains from simple outlets for water into marvelous works of art that used
basins to catch water and various ingenious forms for waterspouts. Fountain
basins frequently had relief carvings, and at times, freestanding figures served as
spouts or supported them.

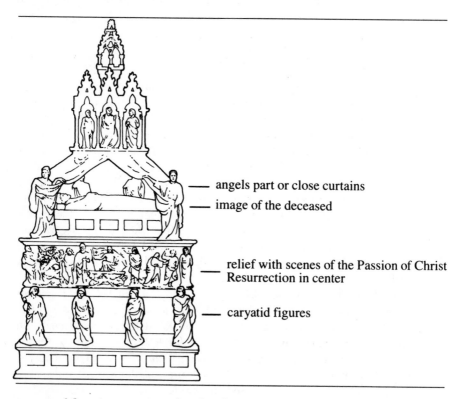

angels part or close curtains
image of the deceased

relief with scenes of the Passion of Christ
Resurrection in center

caryatid figures

FIGURE 6-3. A rare example of a fourteenth-century wall tomb. The one
illustrated here is by Tino da Camaino, and is found intact at the cathedral at
Siena.

Decorative Metalware

Door knockers, wrought-iron sign and torch holders, screens, hinges, locks, and scissor hinges were made in large numbers. Like other forms of sculpture, they gave the artist an opportunity to transform a functional object into one of beauty and imagination. Combining animal, vegetable, and plant forms, a screen could become a beautiful network of intricate designs that attracted the eye while repelling one's entry into a chapel. A torch holder might take the form of a monster whose paws gripped the torch; a door knocker could assume any number of animal or figurative forms.

Ivories

Italy also had its share of ivory carvers. Beautiful examples of the Virgin and Child carved from ivory tusks, as well as figures of the Crucifixion of Christ, have survived from this period. Small caskets were decorated with panels of bone or ivory that were joined together in uniformly sized segments and carved in relief with various images. Other luxury items, such as mirrors, were framed in ivory.

Venice was an important center for the production of small caskets, and the most notable workshop to produce such goods was that of Baldassarre di Simone d'Aliotto degli Embriachi (or Ubbriachi), a Florentine active in Venice from about 1389 to 1409.

DRAWING

From contemporary books and treatises, it is known that artists drew constantly to practice their skills. Artists working between 1250 and 1400 apparently drew on wax-covered wood or slate or on gessoed tablets, copying extant works in sculpture or painting, and then erased the surface and redrew, using this method to perfect their technique. It is also known that artists sketched their ideas for panel and mural paintings directly on the wall or panel surface.

The few drawings on parchment that survive from this period are largely copies of then existing works and were used to supply ideas or motifs for an altar painting or mural. These drawings on paper were not done as sketches for a composition, as these were drawn directly onto the painting surface. Only later do drawings on paper become the first step in a more complex process of developing an idea for a final painting. The drawings known from this period are fragments derived from shop books, and display several types of mediums.

Pen and Ink Drawings

Marsh reed stalks and bird quills held ink that was derived from cuttlefish, gall nuts, or wood ash (which produced a brown pigment called bistre), and that

was commonly applied to parchment. With the passage of time, however, many inks have faded from black to brown in color.

Silverpoint

A silver stylus is moved over a fine, gesso-coated paper, leaving a trace of silver that tarnishes to a brown-red color over time. The fine and delicate marks made by silverpoint are a perfect counterpart to the exacting process of painting with egg tempera. The meticulous silverpoint technique ensured the permanence of these drawings and permitted them to be passed down from one master to the next.

NORTHERN EUROPEAN ART

In northern Europe, as in Italy, the thirteenth century witnessed a renewal that was best expressed in the great number of churches that were built between 1250 and 1400. Churches rose along pilgrimage routes, serving as shrines for precious relics and as sites for worship within newly created towns. Thousands of churches dotted the northern European landscape but, as in Italy, succeeding centuries produced many changes in Europe's religious, philosophical, and political outlook so that much of what was then built has since been destroyed. The Reformation wrought the wholesale destruction of churches. Changes in taste during the seventeenth and eighteenth centuries caused church interiors to be remodeled and the old-fashioned altars to be dismantled. Later, wars, revolutions, and Napoleon's repression of religion reduced the once-splendid church decorations to the paltry fragments that are now preserved in today's museums or in a few rare, undisturbed churches.

Italian churches were riotous panoplies of color and decoration meant to dazzle the eye and excite the mind. The towering Gothic cathedrals of northern Europe, with their glowing stained glass and solemn stone figures, were hallowed vessels built to inspire awe and stimulate contemplation of the transcendent spirit they sheltered. Because sculpture was the primary form of artistic expression in the north, the discussion that follows will deal first with this medium.

SCULPTURE

It is impossible to say with certainty why the creative energy of the north was channeled into sculpture, while, in Italy, the vigor of artists was poured into painting. However, sculpture and stained glass, seemed particularly well suited to the northern artistic and cultural milieu. Throughout northern Europe, sculpture developed with an intensity and fresh energy during the Romanesque period (c. 1050–1200, see time line from previous chapter) and flourished

continually thereafter. The extensive use of stone and glass to shape northern Europe's cathedrals transformed them into virtual membranes of glass supported by mere skeletons of stone. These stone supports then became increasingly disguised by sculpted figures that hid or supplanted them. Embodying a network of religious symbols, ideas, and personages, these sculptures were the foundation and fabric of the cathedral itself.

The development of large-scale stone sculpture was intimately connected to the development of cathedrals. The increasing use of stone as a building material first allowed the tympana (areas over the doors) of Romanesque cathedrals to bear carved images. This rather modest beginning was to be followed by entire, complex schemes of sculptural decorations in succeeding centuries. Because sculpture is so closely tied to its context, the accompanying diagram (Figure 6-4) of a northern European cathedral is intended to aid in the understanding of how and where various types of sculpture were used.

Usually consisting of a nave, cross arm, and choir, cathedrals had several entrances, including a main entrance at the end of the nave and various side entrances. The interior and exterior of the church were punctuated by columns and pillars that served as the background for or were themselves transformed into various kinds of figures. The tympana depicted such scenes as the Last Judgment or Christ in Majesty over the main entrance and various other subjects over the side doors.

Side entrances for churches were often given special designations, such as the Mary Portal or the Virgin's Portal. The tympanum over the portal would depict an episode from Mary's life—her death, assumption into heaven, or coronation as Queen of heaven by Christ. A statue of the Virgin was generally prominently placed over one door. Symbols of both a beginning and ending (or entrance and exit), doors were logical locations for sculpture that recounted tales of beginnings (the Annunciation) or endings, such as the Last Judgment.

The windows, frames, capitals, pillars, and other architectural components of churches were also adorned with sculpture. Beautiful intricately wrought mythological animals, cycles of the seasons, episodes from the Old Testament, and all sorts of moralizing tales were carved. Together, these sculptural embellishments contributed to the visual appeal of the moral, religious, and historical context in which the medieval worshiper practiced his faith.

Each church developed its own decorative program of sculptures for the exterior of the church. Exterior embellishments were regarded as particularly significant, for they depicted for public viewing those figures who were important in the history of the world and thus in the history of a specific town or city.

Sculpture was integral to the architectural conception of a church and served specific, significant functions that generally dictated its size, material, posture, expression, overall appearance, and relationship to other sculpture. Thus, museums that exhibit examples of this sculpture do so without the benefit of the original aesthetic and material context in which these objects were placed.

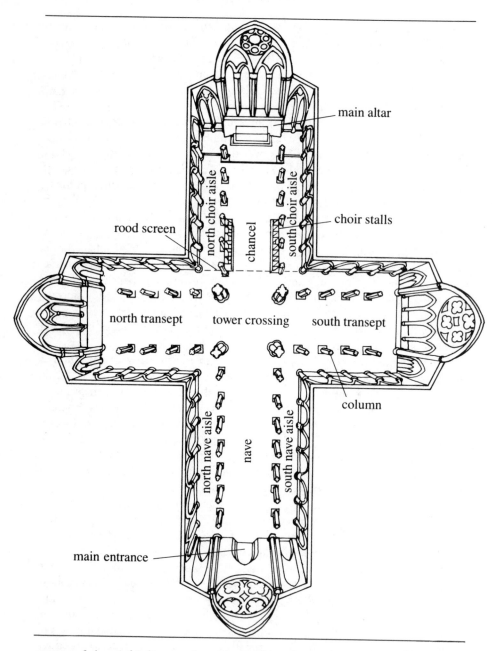

FIGURE 6-4. A bird's eye view of a Gothic cathedral of the cruciform (in the shape of a cross) plan. The chancel was frequently separated from the transept by a rood screen that stretched between the two main pillars. (For an example of a rood screen, see Figure 6-5.)

By virtue of its size and material, sculpture had the power physically to embody religious, political, and civic ideals. Because these ideals were subject to change, sculpture, more often than painting, suffered destruction as new beliefs supplanted old ones and hostility against outmoded ideas was vented against the works that manifested them. Civic monuments, religious sculptures, and tombs were often quickly dismantled and the fragments scattered or destroyed. Only today's archaeological interest in understanding the original contexts for art has induced scholars to grapple with the perplexing problems of reconstruction. Using careful measurements and photographic data, and guided by a few surviving monuments considered to be intact, scholars are gradually able to reassemble sculpted monuments and identify their original context.

Furthermore, sculpture has endured many other changes that can fundamentally alter its proper appreciation. Over the centuries, the delicate surfaces of wood or stone have been subject to erosion, breakage, or changes in taste. For example, in order to "freshen" a work or to change its appearance, later artists would recut the surface of a work, following or even changing the original surface pattern. Thus, it is often difficult to know how much of the original appearance of a sculpture has been preserved.

Much of the sculpture produced during this period was colored. There is much debate about the extent and nature of coloration used in original sculptures, for many have been altered by the removal of color or additions of new color. Numerous examples of surviving wooden or stone sculpture show that successive layers of polychromy were applied over the centuries to make a particular sculpture conform to the tastes of later times. Determining the original paint is a problem that is not easy to solve. Some works have suffered from overzealous cleaning that has completely stripped both the original and later colors.

With these cautionary notes in mind, the discussion will now turn to the various types of sculpture that are most likely to be found in museum collections.

Reliquary Sculpture

Large, almost life-size wooden statues of various figures, such as the Madonna holding her Child, began to appear after about 1160. These sculpted figures were meant to preserve and embody the power and meaning of the relics that were placed inside them. Some early reliquary sculptures were covered with gold leaf to signify their precious nature, and others were painted. As in Italy, these early cult images were the precursors of freestanding sculpture.

The production of other reliquary vessels continued unabated. (For a more complete discussion of relics, see Chapter 5.

Devotional Images

A great deal of prayer and devotional exercises centered around the suffering of Christ, his death on the cross, and the sorrow endured by the Virgin at her Son's death. The Crucifixion of Christ was, to the minds of medieval believers, the key to their own salvation. As a result, numerous sculptural groups came to serve as the focus for devotion and were based on the themes of the Crucifixion, the Pietà, and the Entombment, and included figures of Christ and John, among others. The cult of the Virgin produced numerous devotional images as well.

The Crucifix The emaciated body of Christ was shown with graphic details of his wounds and blood. This image was intended to stir an almost turbulent feeling of religious fervor and fear in the hearts of its observers.

Large crucifixes formed the central image of the rood screen, the ornamental partition between the nave and chancel, or choir, of a church that separated the laity from the clergy. Rood screens most commonly showed a carved and painted wooden figure of Christ, flanked by figures of the mourning Virgin and John the Evangelist. For an example of a rood screen, see Figure 6-5. Other crucifixes were paraded about during times of plague or in processions dedicated to the reenactment of Christ's Passion.

The Pietà or Vesperbild The term "Vesperbild" derives from the fact that prayers for Mary's lament over her dead Son often occurred in cloisters at Vespers. The same image is known in Italy as the Pietà, which literally means "pity." The Versperbild is believed to have originated in Germany in the fourteenth century, and many examples of all sizes have survived. The large Pietàs were made for church altars, and smaller ones were used for private devotions. Carved from walnut or from limestone or soapstone or molded in terra-cotta, all of these images were painted; they gained popularity in many areas of northern Europe.

The Entombment Christ's burial was depicted in sculptural decoration in many church altars, as well as in relief decorations on tomb panels. Large, freestanding sculptures of the entombment are rare, but reliefs from tombs are more commonly found in museums.

Christ and John Groups Christ shown affectionately touching John the Evangelist, who would care for Mary after Christ's death, was a devotional image often used in place of the Pietà. Now rarely found in museums, this figure group is represented by a notable example at the Liebighaus in Frankfurt.

Standing Madonna holding her Child Perhaps more common than any other medieval devotional image was the freestanding statue of the Madonna holding her Child. This subject gave sculptors an opportunity to explore the many nuances that made one depiction of the theme of Mary and her son distinct from another. The Madonna came to embody an ideal of feminine beauty that earned this figure the designation of Beautiful Madonna or *Schöne Madonna*. The subject itself was more justification for the sculpted image than the presence of any relic that might have been stored inside it. The tradition of reliquary statues was continued in this period, however, as evidenced by the French *Viergée Ouvrant*, which opened to reveal the image of the Trinity inside.

During the thirteenth and fourteenth centuries, as the Madonna image became increasingly popular and more natural in appearance, artists faced the

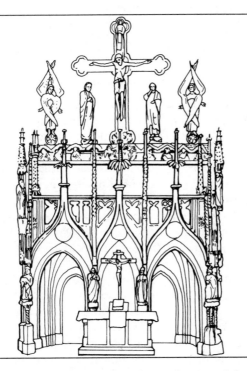

FIGURE 6-5. A rood or choir screen. This architectural framework separated the clergy from the laity during worship services. It also functioned as a vehicle for the display of religious sculpture, such as relics. Sculptures of various holy figures often adorned the pillars, or an altar was placed in front of the screen. In this example, a crucifixion group, consisting of Christ, Mary, and John the Evangelist flanked by angels (seraphim) is mounted above the screen. Most screens were torn down during the sixteenth century.

challenge of preserving the elevated status of the subject. Early examples show that the problem was solved by using precious materials and stones that encased the Virgin in a splendor far beyond the ordinary. By the late fourteenth century, this method was supplanted by exaggeration of form and refinement of type that is called aesthetic excess.

No matter what the solution, the Virgin captured the public imagination because she embodied a number of important religious and spiritual ideas. She was the intercessor between man and God, the protector of humanity, the model of feminine beauty, an expression of fertility, the symbol of motherhood, and Queen of heaven and earth. As such, she served many functions, and her image was therefore placed in many locations. Larger-than-life examples guarded the entrances to churches and blessed the faithful. Other examples graced columns within churches or hung suspended over the congregation. Still others were placed on altars, both in churches and homes. Larger sculptures of the Madonna were carved from wood and stone and were splendidly painted; smaller versions were carved from ivory.

Carved Altars

In addition to three-dimensional sculpture, carved altarpieces became the focus of devotions in northern Europe. Given the strong northern inclination to sculpture and the northern affinity for wood and stone, this development is not hard to understand. Few early examples survive compared to what has been passed down from later medieval periods, but it is quite clear that carved altarpieces of fairly large dimensions were quite popular in northern Europe by about 1300.

Most carved altars involved a central image that was flanked by removable wings. The central image often depicted either a single figure, such as the Madonna and Child, or an individual scene, such as the Crucifixion. Other subjects generally portrayed in these altars included scenes from the life of Christ or the lives of the saints. The wings, which were carved or painted, amplified the meaning of the central panel by illustrating thematically related or subsidiary episodes. When the altar was not in use, the wings could be folded over to protect the central image.

Generally carved from wood and occasionally from stone, such as alabaster, these altars were contained within a framework that imitated its architectural surroundings. A kind of theater in miniature, these altarpieces were also painted to create an effect that captured the imagination of northern Europe in the fifteenth century.

Ivories

Ivories were extensively produced in northern Europe between 1250 and 1400. Their quality varied, depending on the center that produced them. Regarded as

the source for the finest ivory carvings, Paris served the French court during the fourteenth century and thereby developed a special skill in the production of luxury arts, including carved ivories. Parisian ivories are notable not only for the technical virtuosity of their carving but also for the aristocratic, elegant, and graceful deportment of their carved figures. What these carvings gained in refinement they may have lost in emotional power, but the highest achievements of Parisian ivory carvers were unsurpassed for their decorative effect.

Early French ivories, from roughly 1260 to 1290, included crucifixes and large groups of figures that were probably used as altarpieces in churches. An example of these large-scale ivories is rarely found in museum collections.

Parisian ivories were exported throughout Europe, but ivory carving was practiced throughout the fourteenth century in England, Germany, and the Low Countries. Figures in the round of the standing or seated Virgin were also common and found their way into private chapels, church treasuries, and personal collections of wealthy medieval noblemen. After roughly 1300, ivories were no longer carved as book covers or reliquary reliefs, as had been the practice. Rather, ivory came to be used to create carved, portable diptych or triptych shrines that depicted a holy subject, such as the Madonna and Child and that were surrounded by frames. Also, many secular objects, such as caskets, mirror cases, combs, and tablets, were produced from ivory and were sold to an expanding market for luxury goods.

Most ivories were colored, but the nature and extent of their coloring is still a subject of debate.

Tombs

In northern Europe, as in Italy, people sought to be buried inside the church in order to obtain the benefits and status that burial in that hallowed place, with all its saints and holy relics, would endow. Thus, old regulations prohibiting burial within the church were often ignored so that laymen, clerics, and those of rank could obtain salvation guaranteed through burial in sacred sites. Churches charged for this favor and, recognizing the potential for profit, began to compete with one another for the privilege of burying members of ranking wealthy families. Because finances, rather than status, were decisive, even some affluent members of the middle class could afford the fees and were buried in churches.

As final resting places, tombs were fascinating fusions of the earthly and the spiritual. Because the central subject of the tomb was the deceased, tomb portraiture emerged by the late thirteenth century. The deceased could be represented on a slab that was placed on the ground or raised above ground and that was surrounded by various types of scenes. Freestanding figures representing mourners were sometimes placed around the effigy in a perpetual reenactment of the funeral.

By the fourteenth century, the now familiar epitaph was created. A vertical slab often made of stone, the epitaph was not located at the actual burial site, but rather would be placed in the church of the deceased's parish. Intended to proclaim publicly the stature and accomplishments of the deceased and his family, epitaphs commonly bore images of the deceased worshiping a devotional image, but could also depict a family's coat of arms. The fact that the coats of arms were represented indicates that families were motivated as much by pride as by religiosity in commissioning epitaphs.

Metalwork

Among the most commonly found metal objects from this period are the so-called aquamaniles, or pouring vessels, used to wash hands in both sacred and secular contexts. Often taking the form of lions or mythical animals, aquamaniles were particularly favored in Germany.

PAINTING

Most collections of northern European art from 1250 to 1400 will likely contain a greater number of sculptures than paintings. The reasons for this are complex, and scholars debate whether this tendency reflects a lower survival rate of paintings or whether, as seems more likely, it indicates less production of paintings to begin with. Important churches, such as cathedrals in cities and those along pilgrimage routes, had the money to purchase the embellishments provided by stone masons, wood carvers, and gold- and silversmiths. Because painting was a less expensive medium it might have been commissioned less often because churches could afford more costly decorations.

Altar Painting

The building of smaller churches, parishes, and abbeys stimulated a demand for painted altars and crosses but, by comparison to Italy, fewer of these were commissioned in the north. More examples of paintings survive from Germany than from France, the Netherlands, or England.

Often, artists' names are not known, in which case museum labels identify only the country, date, and subject of a painting. Possibly the name of a specific master is cited, based on a style or manner that is recognized from other work.

Paintings that have survived from this period are likely to have experienced some alteration. Paint surfaces have probably suffered losses and undergone some repainting. Originally, painted panels were frequently contained in ornate frames that were carved with delicate designs that repeated in miniature the architectual motifs of the church setting. These frames have been lost in

most instances, making the painted image appear far starker and simpler than it must have been in its original context. Quite often, altar paintings were composed of parts and formed diptychs, triptychs, and other folding altarpieces. The intervening centuries have resulted in the separation of many panels.

Manuscript Illumination

In the north, and particularly in France, the making of books that were largely religious in nature remained a major outlet for painterly expression. Most painters were in the service of the royal courts, monasteries, and wealthy classes. Unlike some artists who worked solely in monastic scriptoria, many painters became independent during this period and served a patron or established a shop.

A great proportion of book production (approximately 80 percent, according to some scholars) was devoted to making Books of Hours. Combining Psalter and prayers from the offices of the Virgin, these highly personal books often included a church calendar and were written in both the vernacular and in Latin. Richly illustrated and sumptuously bound, they were the objects of pride in ownership as much as in devotion.

Monks were no longer the only scribes; professional scribes also worked within guilds. Licensed to copy, they produced books for an audience that by now included the rich bourgeoisie and a merchant class that was fond of poetry, history, chronicles, romances, travelogs, bawdy tales, and devotional texts. The ownership of books was a mark of one's cultivation, and books were enjoyed by groups of people, much as music, theater, or church services were attended in groups.

MEDIEVAL ARTISTS, 1250–1400

ITALIAN PAINTERS

The names and dates given in this list are not the only ones that are known. Italian archives have yielded hundreds of artists' names as well as accounts of their residences, the taxes they paid, and sometimes even the contracts they made with clients to undertake productions of paintings. However, because few works have survived in place and because artists seldom dated or signed their paintings, many works cannot be attributed with certainty to their creators. Art historians may devote an entire lifetime trying to assemble related images, and only rarely have they been able to assign a particular artist's name to a specific work.

The abbreviation "doc." is used here and in the next chapter to signify that some documentation is extant, whether it pertains to the artist's birth or death

dates, active years, years of residence in a particular place, contracts, or the like.

Central Italy

Cecco di Pietro, doc. 1370–1381. Pisa.
Deodato Orlandi, active c. 1280–1310. Lucca.
Francescuzzo Ghissi, active c. 1359–c. 1395. Marches. Pupil of Allegretto Nuzi.
Giovanni di Nicola, doc. 1326–1360. Pisa.
Guido di Palmeruccio, active 1313–1349. Gubbio.
Jacopo di Michele (called Gera), active 1371–1395. Pisa.
Lippo Dalmasio de'Scannabecchi, doc. 1384–1410. Bologna.
Allegretto Nuzi, active c. 1315–1373. Marches, Fabriano.
Francesco Traini, active c. 1321-1350/75. Pisa.
Vitale da Bologna, active c. 1330–1353. Bologna.

Florence

Andrea da Firenze, active c. 1343–1377.
Antonio Veneziano, active c. 1369–c. 1414.
Giovanni Bonsi, doc. 1351–1371.
Cenni di Francesco di Ser Cenni, active c. 1375–1415.
Cimabue, active c. 1272–1302.
Jacopo di Cione, doc. 1365–1398. Brother of Andrea (Orcagna) and Nardo di Cione.
Nardo di Cione, active c. 1343–1366. Brother of Andrea (Orcagna) and Jacopo di Cione.
Bernardo Daddi, active c. 1312–1348.
Agnolo Gaddi, doc. 1369–1396. Son of Taddeo Gaddi.
Taddeo Gaddi (died c. 1366). Principal pupil of Giotto.
Giotto di Bondone, c. 1267–1337. Most famous Florentine painter and profoundly influential.
Giovanni da Milano, doc. 1346–1369.
Giovanni del Biondo dal Casentino, active c. 1350–1400.
Giovanni di Bartolommeo Cristiani, active c. 1350–1400.
Jacopo del Casentino, died 1349 (or 1358).
Lippo di Benvieni, doc. 1296–1353.
Lorenzo di Niccolò, doc. 1391–1411. Pupil and assistant of Niccolò di Pietro Gerini.
Maso di Banco, active c. 1325–1350. Pupil of Giotto.
Master of the Saint Cecilia Altarpiece, active c. 1300–1330.
Niccolò di Pietro Gerini, active c. 1368–1415.
Niccolò di Tommaso, active c. 1343–1376.

Orcagna (Andrea di Cione), active c. 1343–1368.
Pacino da Bonaguida, doc. 1303–1339.
Puccio di Simone, active mid-14th century.
Spinello Aretino, active c. 1370–1410.

Siena

Barna da Siena, active c. 1330–c. 1360. Follower of Duccio and Simone Martini.
Bartolo di Fredi, active 1353–1410. Occasional partner of A. Vanni.
Naddo Ceccarelli, active mid 14th century. Pupil of Lippo Memmi.
Duccio di Buoninsegna, active 1279–c. 1318. Founder of Sienese school.
Paolo da Giovanni Fei, active 1372–1410. Pupil of Bartolo di Fredi and Andrea Vanni.
Francesco di Vannuccio, active mid-late 14th century.
Ambrogio Lorenzetti, active 1319–1347. Brother of Pietro Lorenzetti.
Pietro Lorenzetti, active 1320–1344.
Luca di Tommé, active c. 1356–1399.
Master of Città di Castello, active early 14th century.
Master of the Codex of St. George, active c. 1325–1349.
Master of the Panzano Triptych, active late 14th century.
Lippo Memmi, active 1317–1357. Pupil of father, Memmo?
Meo da Siena, active early 14th century.
Niccolò di Buonaccorso (1348–1388).
Niccolò di Segna, doc. 1331–1346. Pupil of father, Segna di Bonaventura.
Giacomo di Mino del Pellicciao, active 1344–1389.
Segna di Bonaventura, active 1298–1333. Pupil of Duccio.
Simone Martini (Siena 1284–Avignon 1344). Pupil of Duccio.
Niccolò di ser Sozzo Tegliacci (died 1363), active mid-14th century. Pupil of Lorenzetti.
"Ugolino Lorenzetti," (perhaps Bartolomeo Bulgarini)—an unknown artist whose work is related to Ugolino di Nerio and the Lorenzettis.
Ugolino da Siena (Ugolino de Neri) doc. 1295–c. 1339.
Andrea Vanni, c. 1332–1414. Pupil of Lippo Memmi?
Lippo Vanni, (died 1375), doc. 1341–1345, 1373.

Northern Italy

Altichiero (c. 1320–c. 1385). Founder of Veronese School.
Barnaba da Modena, active 1362–1383. Modena.
Giusto di Giovanni de' Menabuoi (1340–1393). Padua, Milan.
Guariento (c. 1338–1370). Padua.
Matteo Giovanetti da Viterbo (1300–c. 1368).
Tommaso da Modena (c. 1325–1368). Modena.

Venice

Giovanni da Bologna, active 1360–1390. From Bologna.
Catarino Veneziano, recorded 1362–1382.
Lorenzo Veneziano, active, c. 1356–1372. Probably pupil of Paolo Veneziano.
Paolo Veneziano, active 1324–1362.
Nicoletto Semitecolo, active 1353–1370.
Stefano (Plebanus) di S. Agnese (Stefano Veneziano), probably active 1353–1385.

———————————— ITALIAN SCULPTORS ————————————

Andrea Pisano (c. 1290–c. 1348) Florence, Orvieto. Father of Nino
Arnolfo di Cambio (c. 1245–c. 1310). Florence.
Giovanni Pisano (c. 1248–c. 1314). Pisa.
Lorenzo Maitani (c. 1270–1330). Siena, Orvieto, Perugia.
Nicola Pisano, active 1258–1278. Founder of Pisan school of sculptors.
Nino Pisano (c. 1315–c. 1368). Orvieto, Florence, Pisa. Son of Andrea.
Orcagna Andrea (Andrea di Cione), active 1343–1368. Florence, Orvieto.
Tino di Camaino (1285–1337). Siena. Pupil of Giovanni Pisano.

MEDIEVAL ART, 1250–1400: MAJOR COLLECTIONS
———————————— ITALIAN PAINTING ————————————

Europe

Altenburg, Staatliches Lindenau-
 Museum
Avignon, Musée du Palais des Papes
Asciano, Museo d'Arte Sacra
Berlin-Dahlem, Staatliche Museen
Budapest, Museum of Fine Arts
Cambridge, Fitzwilliam Museum
Ferrara, Pinacoteca Nazionale
Florence
 Fondazione Horne
 Galleria degli Uffizi
 Galleria dell'Accademia
 Museo del Bigallo
Frankfurt Städelsches Kunstinstitut
London

National Gallery
Victoria & Albert Museum
Munich,
 Bayerische Staatsgemäldesamm-
 lungen, Alte Pinakothek
Milan, Brera, Museo Poldi Pezzoli
Modena, Galleria e Museo Estense
Montalcino, Museo Civico—Museo
 Archeologico
Oxford
 Ashmolean Museum of Art and
 Archaeology
 Picture Gallery, Christ Church
Paris, Musée National du Louvre
Perugia, Galleria Nazionale dell'-
 Umbria
Pisa, Museo Nazionale di S. Matteo

Rome, Pinacoteca Vaticana
San Gimignano, Pinacoteca Civico
Siena
 Pinacoteca Nazionale
 Museo dell'Opera Metropolitana
Turin, Galleria Sabauda
Urbino, Galleria Nazionale delle
 Marche
Venice
 Fondazione Giorgio Cini
 Galleria dell'Accademia
Verona, Pinacoteca Comunale

United States

Baltimore, Walters Art Gallery
Cambridge, Fogg Art Museum, Harvard University
Cleveland, Cleveland Museum of Art
New Haven, Yale University Art Gallery
New York, Metropolitan Museum of Art
Philadelphia, Philadelphia Museum of Art
Washington, D.C., National Gallery of Art

ITALIAN DRAWING

Europe

Bergamo, Biblioteca Civica
Florence, Galleria degli Uffizi
London
 Victoria and Albert Museum
 National Gallery
Vienna, Graphische Sammlung Albertina

United States

Cambridge, Fogg Art Museum, Harvard University
Cleveland, Cleveland Museum of Art
New York
 Metropolitan Museum of Art
 Pierpont Morgan Library

ITALIAN SCULPTURE

Europe

Berlin, Staatliche Museen
Bologna, Museo Civico Archeologico
Empoli, Museo Diocesano
Florence
 Museo Nazionale del Bargello
 Museo dell'Opera del Duomo
Frankfurt, Liebighaus
London, Victoria and Albert Museum
Milan
 Biblioteca d'arte, Castello Sforzesco
 Museo Civico

Naples, Museo Nazionale di San Martino
Orvieto, Museo dell'Opera del Duomo
Paris, Musée National du Louvre
Perugia, Galleria Nazionale dell'Umbria
Pisa
 Museo Civico
 Museo dell'Opera del Duomo
 Museo Nazionale di San Matteo
Siena, Museo dell'Opera Metropolitana
Turin, Museo Civico
Venice, Gallerie dell'Accademia

United States

Boston, Museum of Fine Arts
Cambridge, Fogg Art Museum, Harvard University
New York, Metropolitan Museum of Art

Princeton, Art Museum, Princeton University
Washington, D.C., National Gallery of Art

———————— NORTHERN EUROPEAN ART ————————

Europe

Amsterdam, Rijksmuseum
Antwerp, Musée Royal des Beaux-Arts
Berlin, Staatliche Museen
Brussels, Bibliothèque Royale Albert Ier
Chantilly, Musée Condé
Cologne, Wallraf-Richartz-Museum
Dijon, École Nationale des Beaux-Arts
Florence, Museo Nazionale del Bargello
Hamburg, Hamburger Kunsthalle
London
 British Museum
 National Gallery
 Victoria and Albert Museum
Munich, Bayerisches Nationalmuseum
Nuremberg, Germanisches Museum
Oxford, Ashmolean Museum
Paris
 Bibliothèque Nationale
 Musée de Cluny
 Musée National du Louvre

Prague, National Gallery
Vienna, Kunsthistorisches Museum

United States

Baltimore, Walters Art Gallery
Chicago, Art Institute of Chicago
Cleveland, Cleveland Museum of Art
New York
 Cloisters
 Metropolitan Museum of Art
 Pierpont Morgan Library
Philadelphia, Philadelphia Museum of Art
Princeton, Art Museum, Princeton University
Providence, Museum of Art, Rhode Island School of Design
St. Louis, City Art Museum of St. Louis
Toledo, Toledo Museum of Art
Washington, D.C.
 Dumbarton Oaks Research Library and Collection
 National Gallery of Art

CHAPTER 7

Renaissance Art
1400–1600

ᥰᴧᴧ᭬

THE FIFTEENTH CENTURY

During the fourteenth century, Europe became urbanized, its economy began
to develop, and centers for learning were established. In this fertile cultural
soil, the seeds were sown for the development of a new civilization whose fruits
were reaped in the following century.

During the fifteenth century, a new view of humanity was born. The con-
cept emerged of the individual as an important being with unlimited potential
for growth and self-development. Those who embraced this humanistic attitude
proceeded to pursue interests in science, philosophy, politics, and, above all,
the arts, which experienced an unparalleled flowering.

This philosophical orientation developed haltingly, slowly, and unevenly.
Northern Europe remained bound to the medieval values of chivalry, ro-
mance, religion, and superstition. Even though some of these values lost their
practical efficacy, they persisted as ideals for this society. The widening gulf
between ideals and actuality created a sense of decline and decay, and pessim-
ism permeated the society of fifteenth-century northern Europe. For the north,
it was a time of anxiety and despair.

Italy, on the other hand, witnessed the cultural resurgence we have come to
call the Renaissance. Vital new forces made themselves felt in the cultural
environment. These forces did not entirely supplant tradition, but rather joined
it to give human life a new dimension. Viewed as one of the most important
periods in the history of Western civilization and as the ancestor of the modern
age, the Renaissance gave us our concept of the individual. To it we owe our
sense of history and preoccupation with things of this world, as well as our
understanding of politics and government. The Renaissance forged the modern
tools of diplomacy and accounting. The earliest scientific inquiries were per-

formed during the Renaissance, and even our interest in gardening and fashion can be traced back to this heritage.

Fifteenth-century Italy witnessed a number of important and far-reaching changes. Before 1400, books were laboriously transcribed by hand, and their ownership was limited to the very wealthy; by 1500, 250 European cities had printing presses that were issuing books of all sorts. Before 1400, very few people could read, and only scholars could read Latin or Greek; by 1500, the literacy rate among the populace was rising, and thousands of people could read Greek. Time was viewed by the medieval man as a continuum that originated with the Creation and headed ominously toward the Last Judgment. The Renaissance gave rise to a historical perspective that viewed the past as distinct epochs, separate from the vastly different present. Before 1400, writers were preoccupied with theological or Scholastic problems, saintly visions or human weaknesses. By 1496, the philosopher Giovanni Pico della Mirandola (1463–1494) wrote his famous *Oration on the Dignity of Man*, which reaffirmed man's special place in the center of the universe, midway between God and matter. Man's role as participant in both worlds was upheld, and his capacity to achieve his fullest potential through self-discipline and self-improvement was underscored. The art of the Middle Ages was made almost exclusively to serve religion, but by 1500, secular art of many kinds was routinely commissioned for private enjoyment.

The church still served as an anchor for Renaissance life: Babies were baptized in its hallowed chapels, confessions were still heard, and marriages were still proclaimed by its authority. Religious images still protected the living from harm and ensured the dead salvation in the afterlife. Religious institutions still cared for the ill, aided the dying, and sheltered orphans and spinsters in homes and convents.

At the same time, however, a secular spirit emerged. The humanists, who had collected and translated Greek manuscripts in the fourteenth century and dedicated themselves to well-rounded education that endowed them with wisdom and eloquence, reaped the benefits of their efforts in the fifteenth century. The church and Scholasticism no longer had a monopoly on the education of the young. Nor was the complex network of ideas and values propagated by the church the only guiding norms or systems of thought. The thinkers of the Renaissance searched for new paths to understanding. Antiquity, the age of classical Greece and Rome, became a model for the Renaissance of an idealized and perfect humanity.

How and when the Renaissance evolved in various Italian centers are questions still subject to debate. Certainly the interest in antiquity was not universally shared by every part of society. Florence, long regarded as an important center of Renaissance humanism, witnessed some of the most dramatic expressions of the Renaissance. Elsewhere—in Siena, Mantua, Venice, and

Naples—the interest in antiquity was generally limited to princely or ruling circles and the artists and writers who were in their employ. Nevertheless, the vital ideas born in these noble circles gradually penetrated other levels of society and affected the production of art, the building of collections, and the general cultural climate of the age.

In the north, the tension between older ideals and current realities persisted, but newer, more positive ideals were slower to appear. Hence, the society of northern Europe witnessed the decline of traditional values without the healing effect of new ones. As the social code of chivalry became ineffectual, its form was increasingly celebrated in courtly literature and music. Artifice and extravagance took the place of value and substance, as the age of chivalry came to be regarded somewhat nostalgically.

At the same time, a morbid fascination with death and decay emerged in fifteenth-century northern Europe. Nearly 150 years after Europe was decimated by the Great Plague of 1348, the *Nuremberg Chronicle*, of 1493, depicted the *Dance of Death*, a theme that became common currency in literature and the visual arts throughout the fifteenth century. Rather than warning of the brevity of earthly existence, many such images presented an almost obsessive attachment to life and a dissatisfaction with religion as a source of comfort. Stripped of the consolation that religion afforded, the evils of this world seemed even more threatening.

This period was also marked by an obsession with demons and the devil. Scholars seriously debated about the nature of witches, and scores of witch trials were held (notably in Arras, France, in 1460) in which people were accused of honoring the devil, having intercourse with him, or participating in witches' Sabbaths.

Some scholars argue that religion lost power and effectiveness as its adherents sought expressions of it in continually specific and realistic terms. Religious images were depicted in detail with an eye to their physical rather than spiritual essence. Relics gained increasing usage and often were commercially bought and sold, but they were often less than authentic.

Almost imperceptibly at first but most certainly, the shroud of darkness over the north was lifting. Northern Europe was coalescing into distinct regions, each responding in its own way to the religious and cultural issues of the day. The Netherlands, Flanders, and Germany emerged as significant centers of artistic production and culture. During this century, Dutch art was characteristically less severe and morbid than the art of Germany, but all regions were responding to new impulses.

New forces within fifteenth-century society were to shape the events of the sixteenth. The seeds of a religious movement among the laity had been sown in the fourteenth century and came to fruition during the fifteenth and the following centuries. Based on the belief that God was greater than any dogma and

could be approached only through personal love and devotion, the faith of the laity stressed humility and laid the foundation for the later rejection of the papacy and all its churchly splendors.

The resourcefulness and practicality of the north found expression in the achievements of Johann Gutenberg of Mainz, who in 1455 printed a Bible using movable type. This single event signaled a revolution in written communication, and made books and literature available to a much broader spectrum of society.

Finally, the devotion to faith, which found its greatest expression in the arts in northern Europe, left behind a legacy of artistic achievement whose impact was felt throughout Europe and Italy. Mirroring this world, rather than the afterlife, these works helped shape our understanding of the Renaissance.

FIFTEENTH-CENTURY ITALIAN ART

The Italian peninsula was, in the fifteenth century, blessed with relative prosperity and security, with fertile soil and vigorous people, with a rich past and the promise of a bright future. Whereas the preceding age saw the tender unfolding of a new sense of humankind, the fifteenth century experienced its full blossoming under the protective umbrella of religion. The consuming need to understand, evoke, and communicate with God that was so keenly and at times painfully felt by the devout of earlier centuries was now commingled with a curiosity about the nature of man and his capabilities. Art came to be motivated by the need to explore the human realm and physical world and by an urge for self-aggrandizement that gradually supplanted the deep sense of need, fear, and guilt that were formerly the impetus for the creation of art.

Artists found new ways to represent the Deity realistically, yet without calling the elevated status of the Divine into question. The methods artists used varied according to the schools to which they belonged (discussed below in detail). As man became a subject of art, his image became increasingly important, both in terms of size and in relative prominence in religious works of art. Many individuals became a subject worthy of independent representation, as evidenced by the many portraits that survive in painting, sculpture, and drawing. The human environment or landscape appears with greater frequency as backgrounds in paintings and numerous drawings.

All Italian artists of this period—painters, sculptors, and printmakers—sought to bring a degree of beauty to their work. Earlier artists had had similar aspirations, but had subordinated beauty to the expression of spirituality. During the fifteenth century, beauty became an end in itself. Thus, artists did not merely imitate nature, but used its forms and models provided by classical antiquity to create a wide range of images that idealized nature or took it as a point of departure in order to evoke another, more perfect realm. Even portraits tended

to be idealized and presented their subjects in their most composed or noble state. The traditional emphasis on evoking images of spiritual perfection in art was now tempered by a concern with images of human perfection, which were often modeled after classical examples. Art became a mirror that reflected an idealized version of humanity.

The Italian conception of beauty as expressed in art had distinctive characteristics. Specificity was always moderated by generalized forms. Natural or spontaneous movements and gestures were always placed in the context of deliberate compositions that allowed the viewer to understand and appreciate the image for its artistic merits as well as its meaning. In general, Italian artists strove for harmony, balance, and stability. And all Italian artists shared an unshakable belief in their own ability to give their visions concrete form and expression. If any one element could be said to characterize fifteenth-century Italian art, it is the sheer optimism that underlay it.

PAINTING

Fifteenth-century Italian painting represents a highpoint in the history of art. Many regions—Florence, Siena, Venice, and Umbria, to name only the most celebrated—produced scores of painters, many of whom were exceptionally talented and fulfilled the aspirations of the age with unparalleled mastery.

Changes in technique may have helped these painters express their ideas with greater flexibility. Although many paintings were still done on panels, canvas was increasingly utilized, especially in Venice, where frescoes and panels suffered from the dampness of the Venetian climate. An oil-based paint came to be used, with tempera or alone, and enabled artists to achieve a broader range of effects. The luminous property of oil permitted greater shades of light and texture to be rendered, and the viscosity of oil paints allowed for a greater range of brush strokes, from the most refined to the broadest and most vigorous.

All cities in Italy required the services of painters. Many cities imported painters from other areas. Rome, for example, hired the services of notable Florentine painters, and Naples did the same. Lucca and Pisa, whose earlier masters helped to establish a native Italian school of painters, lost their former preeminence to Florence and Siena and produced no painters of note in the fifteenth century. The most esteemed schools of painters were centered in Florence, Siena, Venice, and Umbria.

The Florentine School

The Florentine school, under the patronage of various churches as well as merchants and bankers—most notably Cosimo I and Lorenzo de Medici—produced remarkable painters. All of the artists mentioned in the lists at the

end of this chapter are noteworthy. Among them, Masaccio is considered the most revolutionary, standing apart even in his own time. Fra Angelico, Paolo Uccello, Andrea del Castagno, Fra Filippo Lippi, Pollaiuolo, and Pesellino represent the major figures of the early century; Sandro Botticelli, Andrea del Verrocchio, Domenico Ghirlandaio, and Filippino Lippi are among the outstanding talents of the later century.

Florentine painting, on the whole, represented an idealized, harmonious image of the natural world. The flaws of nature were overlooked in such a way that images are convincing representations of nature, yet perfect in a way that nature simply is not. The Florentine interest in nature induced artists to replace the gold backgrounds of their religious paintings with landscapes or architectural settings. They also developed systems for representing figures, landscape, and architecture as spatial extensions of the viewer's own reality. Mathematical perspective gives Florentine painting a rational, systematic air. But all of these systems were employed to create a harmonious image.

Florentine painters were superb craftsmen and gifted draftsmen who had a special sense for creating images that were serene. The figures depicted in Florentine paintings seem relaxed and spontaneous. They exist in an evenly sunlit world and exude a sense of well-being that infuses the viewer with calm, confidence, and contentment.

The Sienese School

The tradition of otherworldly painting that characterized earlier Sienese art remained largely unaltered in the fifteenth century. However, generations of original artists transformed that tradition into their own unique expressions. Sassetta, Giovanni di Paolo, Neroccio di Landi, Francesco di Giorgio, and Vecchietta created paintings with a spectral, phantasmagoric nature that were in no way simply imitative of the past. Although Sienese painting did not exhibit the taste for secular subjects that had developed in Florence, its traditional religious imagery was rendered in entirely original ways. Sienese painters attempted to make their religious subjects both more and less real, and therefore more haunting, than they had been earlier. Images of the Virgin by Giovanni di Paolo, for example, are at once stranger and more compelling than anything that preceded them. These images exist in a vast, disconnected space that is not even remotely connected to the viewer's reality.

Some Sienese painters responded to the influence of Florentine art and created images in which the Florentine balance between reality and ideality was mixed with strangely disconcerting elements of fantasy. Sienese painting cannot be judged by Florentine standards, however, because it was not meant to appeal to reason but rather to the irrational and subconscious elements of the human imagination, in which faith—not reason—resides.

The Venetian School

Fifteenth-century Venice, like Siena, developed an independent and original school of painters whose work moved in many stylistic directions. The art of the Vivarini and Crivelli families (see list of artists at end of chapter) adopted a new, realistic interpretation of Divine images. They gave their figures a greater sense of corporality, dimension, and physicality. These accessible forms are, however, surrounded with material splendor through the use of color, gold, decorative details, and ornate settings that elevate the divine. A haunting example of Carlo Crivelli's interpretation of a religious image in his *Pietà* (Plate 2).

The work of Andrea Mantegna and of Jacopo, Gentile, and Giovanni Bellini expanded the painterly vocabulary to include natural settings and a broader range of emotional expression. The introduction of oil paint into Venice (probably by Antonello da Messina) provided a vehicle through which naturalism could be further explored and through which painting could be endowed with a greater unity of emotion, setting, and expression. The religious nature of much of fifteenth-century Italian painting challenged the artists to achieve a synthesis of religious meaning and realistic aims. Anticipating many later developments in seventeenth-century art, this synthesis was produced by infusing religious images with a transcendental mood that suspends time and the very reality the artist has created.

Secular paintings by the Venetian school, such as large-scale narrative works or portraits, are notable for their accuracy and attention to detail.

The Umbrian School

The region of Umbria, notably in Urbino, developed a unique and influential school of painters during the fifteenth century. Perugino and Pintoricchio created a type of imagery that was ideally suited to the primarily religious nature of their commissions. The figures that inhabit their images exhibit such grace, delicacy, and refinement that they are far beyond the appearance of any ordinary mortal. The sweet and transcendent expressions of these figures were to find special favor in the nineteenth century, which is notable for its sentimental inclinations.

Quiet, harmony, beatific calm, and a mystical state of mind characterize the idealized religious imagery of Umbrian painting, in which the tranquil landscape serves as an evocative setting that perfectly complements the elegaic and poetic spirit of the figures. This quality was to later influence Sienese and Florentine painting.

The types of paintings artists produced varied in this century more than in the previous. Religious painting still predominated, but other types, namely secular works, evolved as well.

RELIGIOUS PAINTING

The Altarpiece

The altarpiece remained the predominant form of painting, but underwent many changes in the fifteenth century. From the discussion of the various schools, it is clear that many religious images were characterized by a greater naturalism and a more human appearance. Many holy images, such as scenes from the Bible or saints' lives, not only depicted religious figures but also included the patrons who commissioned the work, shown on the same scale as the other figures and often in prominent positions.

As Renaissance architects changed their conceptions of church interiors, they often deemphasized mural painting and called instead for unadorned walls, so that chapel decorations focused on a single altar painting. Although some areas still favored the traditional sectioned altarpieces, painted panels were being reduced to simpler shapes—for example, the circles (tondos), rectangles, and squares that predominated in Tuscan painting. The various fifteenth-century panel types are illustrated in Figure 7-1.

Certain types of religious subjects lost popularity. Large crucifixes were less frequently painted. Subjects such as the Annunciation, the Nativity and the Adoration of the Magi, which were often secondary narrative elements in fourteenth-century panels, became the main themes of independent panels that combined narrative and altar decoration into one cohesive image. The joy, pageantry, and opulence of such scenes reflect the optimism of Renaissance society.

Among the newly developed subjects in altar painting was the representation of the Madonna, who is kneeling, adoring her Child and surrounded by such symbolic elements as flowers, trees, animals, and plants, all of which represent a particular element in the network of religious symbolism. Although symbols were used in all religious images, this particular type emphasized the symbols and made them more discrete and perceptible to the viewer.

Private Devotional Images

Portable triptychs, which had been so common in the fourteenth century, were less frequently produced in the fifteenth. Though still common in such tradition-oriented areas as Siena, the portable triptych was replaced in Florence by a single panel type that depicted the Madonna and Child enthroned, or showed a half-length image of the Madonna holding the Child as had been popular in the previous century.

SECULAR PAINTING

During the fifteenth century, secular art emerged. Paintings that were commissioned for private or public viewing and that depicted nonreligious subjects

became common. Some of these paintings (portraits, for example) also had a function, but many can be regarded as the earliest examples of painting that had only an aesthetic function. These early secular images are as comfortable in museum collections as they were in their original settings because they were always meant to be displayed and enjoyed on their own.

Portraits

Independent portraits, commissioned to commemorate or preserve the likeness of an individual, appear with greater frequency in the fifteenth century. The earliest form of portraiture depicted the sitter in profile. Later Italian portraits emulate Dutch art, with the sitter in three-quarter or full-face poses. Produced in abundance, portraits could be almost purely decorative images that stressed hair, clothing, and ornament (this type most frequently depicted women), or they could be penetrating character studies. Because portraits were public images, and their subjects were well aware of that fact, they generally depicted sitters as aloof, reserved characters. The likenesses of nobles, merchants, clergy, artists, and occasionally children are preserved in these early portraits. Husbands and wives are sometimes shown in pairs. Because portraiture was intended for display or to commemorate public figures, their subjects remain psychologically distant from their viewer.

Nudes, Battle Scenes, Mythological and Historical Scenes

Often derived from traditions established by painted cassoni (marriage chests) or decorative tapestries, these diverse themes were frequently used as subjects for decorative paintings, especially in Florence and Venice. Nudes, sometimes erotic elements on cassone panels, would be represented as Venus or some other goddess. Battle scenes, whether real or imaginary also served as painterly subjects. Grand processions of triumph, which were themes derived from the ancient Roman custom of bestowing honor upon a victorious general, were depicted in Renaissance painting as a means to honor princes or to celebrate the gods of antiquity. The triumphal car, bearing a personification of an idea or a god, and followed by its attribute, became a popular motif in Renaissance painting, depicting such themes as the triumph of love, chastity, death, fame, time, or eternity.

Some of these images are difficult or impossible to interpret, and the meanings of certain subjects are not always specific. In Venice, a tradition was established for paintings that depicted evocative images with poetic overtones. These images were meant to stir contemplation and stimulate the viewer's fantasy. The panel shapes that were often used for such images are shown in Figure 7-1.

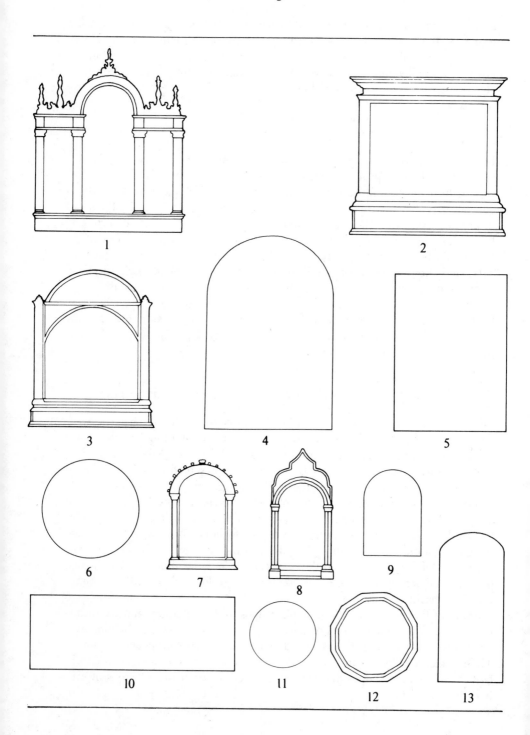

Marriage Chests (Cassone)

Cassoni were commissioned, often in pairs, as wedding gifts. They were decorated inside and out with moral, historical, mythological, and sometimes erotic themes. Virtues such as chastity, fidelity, and fertility were emphasized. Painted chests were produced in the thousands and some shops specialized in them. Today, very few survive intact. (The Metropolitan Museum of Art preserves one of the rare known examples.) Usually, only a fragment, such as the front painted panel or a lid with the painted element set into a new frame, has survived.

Deschi da Parto

Births were celebrated with painted wooden birth trays that were laden with gifts and given to the mother. These trays, called *deschi da parto*, were decorated with symbolic references to love and fertility. They sometimes depicted fanciful portraits, emblems of children, or the family coat of arms.

DRAWING

Compared to the number of drawings that must have been made between 1400 and 1500, relatively few survive. But because paper became more available and

FIGURE 7-1. Commonly found fifteenth- and sixteenth-century panel shapes, including: (1) triptych type often found in Northern Italy; (2) rectangular panel whose base included small narrative images. This type was commonly found in Tuscany; (3) rectangular panel frequently found in Siena. The arched shape above is called a lunette and commonly depicted such scenes as the Lamentation or the Nativity. The base also depicted narrative scenes; (4) and (5) these large shapes were often used for altar painting in the late fifteenth and sixteenth centuries, both on canvas and on the more traditional material, wood; (6) circular tondo shape became increasingly common in the late fifteenth and early sixteenth century; (7) and (8) panel types typically used for private devotions. Most frequently depicted on such panel shapes were half-length images of the Madonna and Child; (9) beir heads were still commonly used in the fifteenth and sixteenth centuries; (10) long, horizontal panels used for private decoration as well. Smaller panels of this type were often fragments of "cassoni," or marriage chests, whereas larger panels were independent pictures or fragments from painted beds, and depicted secular subjects, such as battle scenes, mythologies, and nudes; (11) and (12) these two shapes were most common for birth trays or "deschi da parto"; and (13) tall, arched panels of this type were sometimes used to depict series of images, for example, of famous men and women in history, and decorated many fifteenth-century Italian palaces.

was used more often, more drawings are preserved from this period than from the previous century.

Drawing was the basis of any artist's training. The apprentice practiced on slate or wax tablets and then tried his hand at paper. Surviving drawings reveal a great deal about the training process. Apprentices copied the master's drawings and prints and then copied paintings and sculpture as well.

When apprentices became masters themselves, they drew for many reasons and used several types of materials. The earliest drawings were made for model books. They contained any number of studies that could be used by apprentices or the master, and that were sometimes borrowed by other artists for paintings. Model books were sometimes systematically arranged, with two to three drawings to a page, and contained careful studies of figures or animals. These were particularly popular in the north of Italy. Model books were passed down from the master to his descendants and were used for generations.

A more informal type of drawing was collected in the sketchbook, in which an artist would record whatever caught his eye in his travels, be it another artist's painting, a head, a hand, or an animal. These drawings were sometimes jumbled together casually. The earliest Italian landscape drawings appear in these artists' sketchbooks, as one might expect, as the traveling artist was continually exposed to views of nature. Artists used these books not only to record images they encountered but also to invent, create, or develop a visual theme that had captured their imagination.

Some scholars identify a third category of drawings, namely, pattern books, which contained individual sketches of a particular subject. Drawings of nude males seen from many viewpoints, for example, would be compiled into a pattern book, and sometimes such studies would be loaned to other masters. Given the collaborative nature of art making of the time, it would not be surprising that this should have happened quite often. An artist who was gifted at rendering the human anatomy, for example, could share his expertise with another artist who needed this information. Thus, pattern book sketches functioned in much the same way as did the earlier model books.

Artists often had to present a finished drawing of a proposed commissioned to their patrons. "Presentation drawings," which were shown to the patron for approval or served to bind the artist to a specific format, were no doubt commonplace (as records of contracts suggest) but few such drawings survive.

After roughly 1450, cartoons, or huge drawings the size of the final mural or large painting, were made. Often pieced together from many sheets of paper, the cartoon gave the basic outlines of a composition that could then be traced onto the actual painting surface. This was very convenient for the painter. In the process, cartoons must have suffered considerable wear and many were probably repulped for paper. Thus, only a few partial examples survive.

Although some scholars debate the function of some drawings, and it is not

always clear whether they were intended for a model book, sketchbook, or the like, surviving drawings clearly indicate the subjects that intrigued artists. Animal studies, compositional studies, landscapes, portraits, and views of various parts of the world preoccupied the northern Italians especially. The human figure, particularly the male nude in action, was a principal subject of interest to artists from central Italy. After 1450, artists throughout Italy made exhaustive portrait studies, which were often to be used in murals. Detailed drapery and anatomy studies and drawings from sculpture, as well as nude models in the studio, were common in Tuscany.

Pen and Ink

In addition to silverpoint (see previous chapter), the fifteenth-century draftsmen commonly used the goosequill pen for its flexibility and responsiveness to the slightest shifts in pressure and movement. Unlike the rigid stylus of silverpoint, the pen could make minute strokes to define a form in detail, or it could pull a long fluid line. Shading could be achieved by a complex network of strokes or by flooding or, "washing," an area with a puddle of ink that was applied with a pen edge or a brush.

Brush drawings

The use of brushes and inks alone became an independent technique toward the end of the fifteenth century. It was especially favored in northern Italy.

Chalks

Chalks were not extensively used, so far as we know, until about the mid-fifteenth century. Because chalk could make a line and also be rubbed to create subtle transitions of light to dark, it became the ideal medium for artists to explore the details of human musculature and individual facial features that so absorbed them. The interest in rendering the human subject, as well as the availability of colored, especially blue, paper, may have helped promote chalk as a favorite material. Because several additional colors were made available in chalk, and because it could be more easily corrected than pen and ink, chalk became the principal medium for portrait drawings, which flourished in northern Italy.

In the fifteenth century, black chalks were commonly used alone or occasionally with white chalks. Red chalk, which is harder and more conducive to rendering minute details, came into use toward the end of the fifteenth century.

PRINTMAKING

The study of Italian prints is fraught with ironies and paradoxes. Although prints were so popular in the fifteenth century that they were produced in greater abundance than paintings, sculpture, or drawings, only a very few examples of woodcuts and engravings from this period survive. More cavalier than their northern counterparts, Italian printmakers printed until their plates were nearly worn out. As a result, surviving examples are often weak, late impressions that appear battered and faded and that only hint at the original splendor of the best of the edition. Yet because so much was lost, even the feeblest impressions are today rare and highly prized.

Prints were the most influential art form. Produced in great numbers on paper, they were highly portable and traveled far and wide, beyond the boundaries of a single city, region, or country. Yet most of these images were produced by artists who remain anonymous and whose ideas were often based on a model drawing, painting, or sculpture by yet another artist. It is often difficult to trace an image in print to its source, and find the many links in a visual chain.

Many steps and hands were involved in producing a final image. A professional woodcutter or engraver would obtain a design, usually a drawing, from an artist. Sometimes the artist was paid for the design, and sometimes the profits of the production were shared by the printmaker, who often kept the copyright for the print, and the artist. The printmaker transferred the artist's design onto the wood block or metal plate from which it would be printed. The printing process itself involved inking, wiping, and pressing the plates and necessitated certain equipment: cutting tools, inks, papers, and press. This meant that the printmaker had to make considerable investment, so it is not surprising that once he was set up, the printmaker produced prints from many artists' works and often kept all of the proceeds from the sale.

Even when artists themselves are credited with the actual cutting of a block or engraving of a plate, it is thought that they then employed the services of a professional to print their images. Museum labels may identify only the printmaker or the designer/artist, so that the viewer is left unenlightened about the collaborative nature of the process.

Another paradox regarding Italian prints is that, despite their proliferation, the artists known to have produced prints are few, relative to the great numbers of known painters and sculptors. And even though prints were produced in abundance, their number is finite; all surviving Italian prints from this period are known and have been identified in various standard texts. It is highly unlikely that a previously unknown print by a fifteenth- or sixteenth-century master would surface today.

Printmaking is often defined as a single category, when, in fact, each printmaking technique has its own challenges and properties. Art museums tend to group their collections into woodcuts, engravings, nielli, and so on. Curators

then arrange the material by region and in chronological sequence, and then by artist if he is known. Although these arrangements help us understand and organize the material, they artificially separate prints from their artistic context. Prints can be fully appreciated only when the viewer is armed with a great deal of information about that context.

A discussion of the general techniques of printmaking that emerged in the fifteenth and sixteenth centuries can be found in the section on German printmaking.

Woodcuts

The woodcut was probably the earliest form of printmaking in Italy. Mechanically reproduced religious images were acquired by a broad spectrum of the population. The religious festivals, private devotions, and cults dedicated to individual saints contributed to the proliferation of many kinds of religious prints. Most were done by anonymous craftsmen.

Woodcuts were used to create many secular objects as well, including playing cards and the famous tarot cards, which were illustrated with various subjects not found in other mediums. Single-sheet woodcuts were printed with patterns or images, such as profile portraits, designs, erotic subjects, and the like, and were pasted in boxes or given as gifts.

Woodcuts were used to illustrate the earliest printed books. By 1465, the first books produced with movable type appeared and covered a broad range of religious, military, and literary subjects. These early texts included woodcut illustrations. By the late fifteenth century, Italian book publication was centered in Venice, where *Triumphs of Petrarch* (1488), Dante's *Divine Comedy* (1491), Boccaccio's *Decameron* (1492), Herodotus' *Histories* (1494), and the famous *Hypnerotomachia Poliphili* (the Dream of Poliphili) by Francesco Colonna (1499) were published.

Any idea could be proliferated more easily through prints, and prints entered the realm of politics quickly. Florence issued a series of political pamphlets illustrated with woodcuts that can be called the earliest political cartoons. Examples of these cartoons are only rarely found in collections today.

By the mid-fifteenth century, if not before, woodcuts were used to reproduce images from other mediums, notably sculpture and painting.

Niello

Engravings seem to have arisen out of the goldsmiths' trade. Goldsmiths often made designs into metal surfaces with a burin, and filled the grooves with a sulfurous mixture that turned black and contrasted with the shining metal. These designs, sometimes printed on paper to record the design, are called nielli. Independent engraving is thought to have developed from this practice of

printing designs. History tells us that the Florentine Maso Finiguerra was the first to make independent engravings, but no examples survive and his invention cannot be proved with certainty. Niello prints are scarce now and very costly; they are only occasionally seen in print cabinets.

Engraving

Engraving techniques appeared between 1460 and 1470 in Italy. Although northern Europe had established and used engraving processes by this time, the technique used in Italy may have originated from niello, and was probably not imported from the north.

Engraving techniques were used to create devotional images for church festivals, block books that combined sacred images with lettered text (often a prayer), and prints of secular subjects such as portraits and designs.

In many cases, engravers were associated with one or more master painters and used their designs or paintings as sources for print imagery. Pollaiuolo and Botticelli were important sources for Florentine printmakers; Mantegna and Giovanni Bellini supplied images for northern Italian engravers.

Engraved plates wore out faster than woodcuts and were more expensive to make and print. In comparison to woodcuts, they were a luxury item, but shared the same general functions that woodcuts had.

SCULPTURE

It is far more difficult to gain a full appreciation of fifteenth-century Italian sculpture by visiting museums than it is to experience paintings from the same period. Sculpture had many more functions and could take the form of public and civic monuments or intimate personal objects. Changes in customs and tastes resulted in the later dismemberment and destruction of much sculpture. By virtue of its size, public sculpture less frequently appears in museums. Despite these limitations, however, there is much to be seen and appreciated in collections of fifteenth-century Italian sculpture.

Although traditional religious sculptures were still commissioned, secular art represented a larger part of the output of sculpture during this century. Different materials became popular: Marble, clay, and wood remained important, while bronze and glazed terra-cotta were more frequently used. The Renaissance interest in antiquity profoundly affected sculpture both in type and subject matter, as new types of sculpture, including portrait busts, medals, and statuettes often inspired by Roman examples reflected a rising interest in portraiture. Large freestanding sculpture, designed to be seen and appreciated from numerous vantage points, decorated courtyards and fountains, and smaller versions were enthusiastically collected as well.

RELIGIOUS SCULPTURE

Carved Altarpieces

Carved altars were made from wood, marble, or bronze and contained images of the Deity or the Virgin with saints. Though extremely popular in the north, sculpted altarpieces were less frequently produced in Italy. Fragments of such altars are sometimes found, but they do not survive in great numbers.

Standing Madonnas

Standing Madonnas remained in demand in the more conservative regions of Naples and Sicily, but in the more cosmopolitan centers of Florence, Rome, and Venice, the image was superseded in the fifteenth century by a new type, the half-length Madonna.

Half-Length Madonna Holding Her Child

The half-length image of the Madonna that had been so popular since the Byzantine period captured the imagination of Italian patrons and sculptors in the fifteenth century. Half-length Madonnas in stone, marble, glazed terra-cotta, bronze, and wood, as well as painted casts made from plaster and cement mixtures, were produced by the hundreds. Depicting the intimate and affectionate relationship between mother and child, the sculpted images had many uses; and, although our knowledge incomplete, we can surmise that they were placed in many settings. Displayed in outdoor tabernacles, on streetcorners, or in special locations such as on domestic altars, over doorways, or in courtyards, these objects of devotion provided comfort and protection to the onlooker. They could be carved almost fully in the round, or they could be flat, finely incised reliefs; they could be life-sized images or small-scale pieces, which were likely intended for domestic use.

Very small medals of the half-length Madonna, about the size of one's hand, were also produced. These were to be pinned or sewn on bed curtains to guard the owner during his or her sleep.

Altar Reliefs

Polychrome glazed terra-cotta altarpieces that depicted sacred subjects and were similar to large, single-panel paintings were produced by several generations of the della Robbia family, and were used to decorate outdoor and indoor altars. In many cases these ornate works have been extraordinarily well preserved and have found their way into museum collections.

Full-Length Statues of Saints

Occasionally an isolated example of this very popular fifteenth-century sculpture type can be found in museums. Cast in bronze or cut from stone, these saints were often placed in niches in the walls or on the facades of churches. Often commissioned by a guild or fraternity, these statues were regarded as holy patrons, protectors, and symbols. Large wooden statues of saints, often painted, were also produced in great number and were placed on church altars and in chapels dedicated to that saint. On special festivals these statues were sometimes carried in processions.

Annunciation Groups

Life-size or larger than life-size statues of the Virgin and the annunciate angel were another popular form of sculptural expression. Carved most often from wood and sometimes from stone, their light weight and independence of their architectural surroundings made these groups especially susceptible to removal from churches, for which they were made.

It is rare to find statues of both angel and Virgin together in a museum. Such a rare encounter allows the viewer to appreciate the beautiful interaction and the silent duet the two perform as they engage in a mystical ritual that captured the imaginations of artists for centuries. Very few Annunciation groups remain in situ; most have been removed to church museums, so our knowledge of their function is fragmentary. It seems likely, however, that, given the symbolic nature of the Annunciation, the group would have been placed at entrances to chapels, in church doorways, and flanking main altars.

Wooden Crucifixions, with or without Attendant Figures

The painted crucifix, which generally hung over the main altar of churches, tended to be supplanted in the fifteenth century by a type that was wooden, carved, and usually painted. Carved crucifixes are usually displayed in museums separately from the attendant figures of Mary and John the Evangelist, so it is difficult to know if the crucifix was meant to be alone or if the attendant figures were simply lost.

Busts of Saints and Deities

Busts of saints and sometimes Christ were produced in terra-cotta, bronze, or other metals. Sometimes made for reliquaries, these busts may have had other, less well understood functions. It has been suggested that busts were used as protective images over doorways. At various times of religious fervor (such as Girolamo Savanarola's declaration of Christ as the king of Florence in 1494), busts of Christ were placed over doorways of houses.

SECULAR SCULPTURE
The Portrait

The interest in the individual that so characterizes the Renaissance was best expressed in the proliferation of various types of portrait sculpture ranging from the bust in the round to the small relief medal. All were occasionally produced in the preceding century, but were in demand and abundant in the fifteenth century.

The Portrait Bust A revival of the earlier practice of including portrait busts in church decoration, coupled with the reawakening of interest in antiquity, led to the commission of hundreds of busts in marble, clay, and bronze. Sometimes based on life or death masks, these portraits varied in approach from highly detailed topographical renderings of features to almost abstract, idealized forms. In most cases, the sitter is shown animated in mind and soul but disciplined, aloof, dignified, and enigmatic. Usually finished in the round, busts were treated in various ways: They could be cut off horizontally across the chest, or cut off below the neck (emulating Roman busts), or shown with the torso intact with arms and hands adding movement and animation to the form. Few busts survive with their original bases, and their original placement and use remains unclear because of the scarcity of busts that have survived in situ.

Certainly, all portrait busts had some sort of commemorative function. Funeral monuments occasionally used busts in the tombstone. If Roman practices were followed, then busts were also placed in architectural settings such as courtyards, over doorways (in some sort of niche), in almost any interior room of a palazzo or villa, and occasionally over an exterior door. Toward the end of the fifteenth century, it is thought that busts were displayed on bases that permitted them to be seen from any view. It is likely that they were collected and commissioned by family members to commemorate a special event or to honor an important relative. The busts were to remind and exhort the descendants of their illustratious heritage.

The Portrait Relief Often depicting the sitter life-size and generally in profile, portrait reliefs were carved in marble and stone during the fifteenth century. Their function is not always clear, but commemoration of some important event—the conferring of a title or rank, a marriage, or the like—might have prompted the commission. Some reliefs appear to be donor portraits that have been excised from dismembered carved altars; others were parts of wall monuments that displayed both life and death masks.

Medals Among the most highly prized, artistically refined, and personal forms of portraiture was the medal. Produced throughout the century, the greatest examples are considered to come from Verona and Florence. Early medals depicted princes, and later ones included men and women of various

ranks, including artists. Medals were a perfect format in which to express the Renaissance interest in ideal character. A profile likeness was accompanied by a personal device (a symbolic image usually derived from a classical antique source or model) and a motto lettered on a bronze disk usually no larger than the palm of a hand. Medals were a blending of the public and private, the real and the ideal. Many have holes, indicating that they were worn on chains, and others were sewn onto hats, displayed on armbands, or used as harness decorations. Medals were likely cast to commemorate special events such as betrothals and marriages, as well as important state and civic occasions. A fusion of portraiture, lettering, design, and invention on a small scale, the finest medals relied on the artist's accuracy of observation and his sense of design. They were enthusiastically collected from the beginning, resulting in collections that are the nucleus of today's great medal cabinets.

Coats of Arms

Prominent families identified themselves with coats of arms that were proudly displayed throughout the palazzo or villa. Large versions were placed on exterior corners of the building or over doors. Ruling families had their insignias placed inside buildings that were seats of government.

As the fortunes of families rose and fell, these coats suffered many changes, and occasionally fell into the hands of collectors who preserved them for their fine sculptural and decorative qualities, as well as for their historical interest. Carved in durable materials such as stone or marble, fifteenth-century coats of arms also were made from glazed terra-cotta.

Freestanding Sculpture

One of the important developments in fifteenth-century sculpture was the increasing interest in sculpture in the round. Both sacred and secular sculpture shared this development, although many more examples of secular images, which graced doorways, fountains, courtyards, or gardens, have found their way into museums. Biblical and ancient heroes were the subjects of most freestanding sculpture, and for the first time they were depicted as idealized human forms, often in the nude. These commissions challenged the sculptor's understanding of anatomy, composition, pose, proportion, gesture, scale, and expression. The concern with formal considerations brought this type of sculpture emphatically into the realm of art and distinguished it from earlier sculpture types in which function took precedence over aesthetics.

Ancient sculpture, which was being excavated or studied with revived interest during this period, provided many models for artists in their quest to deal with the idealized nude human form. Wood, stone, and marble were frequently used, but the fifteenth century also saw a rise in bronze casting.

The Statuette

Most museums that represent fifteenth-century Italian statuettes display them tucked away in a vitrine case. These bronzes were originally made for private owners who held them in their hands or displayed them on cabinets, tables, and desks. These statuettes can only be fully appreciated by viewers who know about the intimate, sumptuous personal settings for which they were originally intended.

Fifteenth-century patrons, partly out of a desire to emulate the Romans and express their interest in antiquity and partly out of an interest in forming personal art collections, began to accumulate bronze statuettes. Many statuettes were directly or indirectly related to antique examples. Classical subjects, such as gods, goddesses, heroes, satyrs, nymphs, and Pans, were treated as individual figures or in groups by bronze casters, who sometimes made small-scale copies of known antique examples. Other artists developed original versions of subjects that had been handed down from antiquity. Animal figurines, lamps, inkstands, and other bronze utensils tested the imaginations and casting skills of their makers. A good portion of these statuettes had erotic overtones and were the stuff of private sensuous enjoyment. Nobles, wealthy, educated merchants, and humanists, who pursued an interest in the revival of classical literature, amassed extensive collections. Many of their statuettes escaped the destruction that befell so much of the large-scale sculpture of this period.

Florence, Padua, Siena, Rome, Venice, Naples—the major cities and principalities of Italy—had collectors who eagerly patronzied bronze casters. Some sculptors only made several statuettes in their careers, whereas others produced almost nothing else. Intended to delight the owner with the skill of their execution, the originality of their conception, and the variety of their surface treatment, bronze statuettes are sometimes accented with gilding or silvering. Some have rather rough surfaces, and others dispay a highly finished and polished surface. Now typically locked inside a case in a museum display, statuettes must be held with the eyes, and the viewer must imagine the weight and texture they would have in his hands.

FIFTEENTH-CENTURY FLEMISH AND DUTCH ART

Holland and Flanders had, by the fifteenth century, developed a rich tradition in the arts. They attained extraordinarily high levels of artistic accomplishment in sculpture, printmaking, and painting. Their sculptural output fell victim to the changes wrought by the Reformation and is therefore difficult to find to any great extent in most art museums. Holland and Flanders shared with Germany the great exploration of the new medium of printmaking. (The discussion of printmaking is detailed in the section on German art.) The Flemish and Dutch

are universally acknowledged as the founders of and moving force behind most fifteenth-century northern European painting. Therefore, this section concentrates on a discussion of painting and its related mediums, manuscript illumination and drawing.

PAINTING

The primary impetus for painting in Holland and Flanders was religion. The creation of altarpieces consumed the painter's time and energy. Churches and the devout laity sought images that would make the mysteries of religion visible and comprehensible. In Holland and Flanders this was achieved by placing images of the Virgin and Christ in surroundings that were, for the most part, recognizable to the citizens. The Virgin would receive the Archangel Gabriel in a comfortable room, whose windows, benches, and other accoutrements were depicted in specific detail, or she would stand in the center of the interior of a vast cathedral, whose every element was reproduced. A scene of the Adoration of the Magi might take place outside a medieval city, whose bustling populace would be featured in the background to give a contemporary setting to a sacred event.

With abilities bordering on the magical, these Dutch and Flemish painters provided an astounding record of natural scenery: Landscapes, interiors, objects, people, clothing, fur, hair and skin, flowers, grass and trees—all were rendered in the most minute detail. Nature was depicted as though seen through a microscope, and no aspect was considered too insignificant to include in the painter's vision. The effects of light and texture and the infinite gradations of color reflected in a piece of cloth turned to the light are captured in the medium of paint. In this century, painters celebrated the material and specific substances of this world and, in so doing, profoundly affected Dutch and Flemish art and culture for centuries to come.

Vital to the development of naturalism in painting was the discovery of oil paint. Tempera, the medium most commonly used, was quick to dry and therefore dictated that colors be applied in flat, hard-edged, and generally opaque layers. Flemish painters discovered that pigments suspended in oil, rather than egg, base were slower-drying and produced a variety of effects that were impossible to achieve in tempera. Deep, rich opaque colors and translucent washes were now possible, as were small, delicate strokes of the brush and more vivacious sweeps. The versatility of oil paints fundamentally changed the direction of painting and helped artists to achieve an illusion of reality that had previously been unattainable.

With the ability to render nature convincingly came the challenge that all artists of the preceding century faced—how art could give sacred concepts physical substance without making the sacred profane. The northern painter's task was slightly different and perhaps more formidable, for the influence of

religion in northern Europe declined as a new world view emerged in which the individual and objects of the human world came to be seen as manifestations of God. Man and the natural world were equally God's creations, and it became the painter's duty to render these accurately, leaving out no detail. This was a task that the Flemish and Dutch fulfilled splendidly.

The images that these Flemish and Dutch painters created have many layers of meaning. Nothing was random, and each element had its place in the vast complex of pictorial religious symbolism that had developed by the fifteenth century. Flowers, vessels, candles, smoke, windows, books, and furniture—all had symbolic meaning. Flowers could be symbols for virginity, blood, sorrow, or rebirth; windows and light could symbolize the Virgin Birth. Today's viewer's understanding of the network of religious symbols is limited, and most art museums identify only the vital statistics: name of the artist, if known; country of origin; the title of the work; and its approximate date of creation; and materials used. It is up to the viewer to learn more. However obscure the layers of meaning embedded in these paintings may have become, these precious works continue to enchant the viewer because of the conviction with which they represent reality.

As in other countries, various types of paintings were made, but the most important and most common are altarpieces and portraits.

RELIGIOUS PAINTING

Altarpieces

The fifteenth century has been called the century of easel painting in the north. Although it is true that these paintings were probably painted using an easel, they were not not meant to be domestic ornaments; rather, they were destined to be the chief altar decoration for churches. The Protestant Reformation of the sixteenth century spawned periodic bursts of iconoclasm that resulted in the destruction of many altar decorations in northern Europe. Therefore, the exact location of some altarpieces may not be known, nor is it always possible to reconstruct fragments that have survived. Like their Italian counterparts, northern European altars were often composed of many parts, and generally consisted of a central panel, wings, and a base. A reconstructed fifteenth-century Flemish altar is illustrated in Figure 7-2.

The subjects of altarpieces, as well as the placement of one subject relative to another, were determined by the original format of the altarpiece. Very often northern altar panels were enclosed in carved wooden frames. (Frequently, these frames have been lost by the time a work enters a museum.) The wood-framed altarpiece was then enclosed in a second frame made of stone. These altarpieces formed the nucleus of a decorative scheme that extended into the church by virtue of its wooden and stone frameworks.

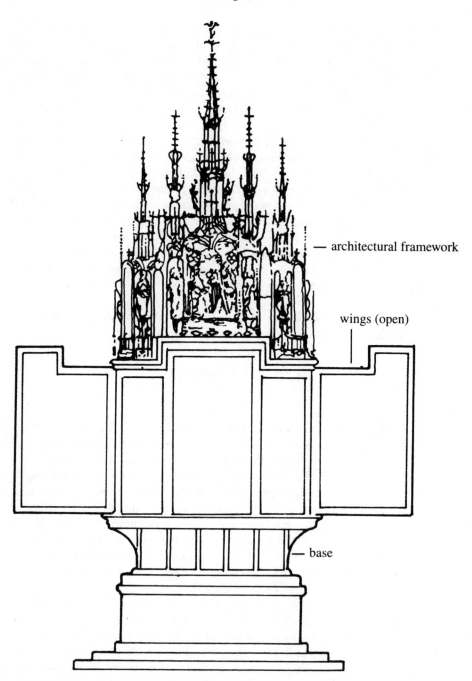

— architectural framework

wings (open)

— base

FIGURE 7-2. A reconstructed painted altar, depicting an ornate carved frame.

Supported by a pedestal (now often absent) that may have been carved and/or painted, the altar may have contained a holy relic. The superstructure surrounding the painting might also have been painted. Unlike most fifteenth-century Italian altarpieces, which are commonly composed of various stationary sections, many northern altarpieces had movable wings painted on both sides that allowed various stages of meaning to be expressed as the altar was opened and closed. Operated manually or mechanically, and sometimes accompanied by music and the ritual of the Sacrament, the altar was a spectacle in itself, not unlike a theater performance.

The altar painting expressed various levels of reality. The wings echoed the altar's sculptural surroundings, and the central panel generally expressed a more independent image. Thus, when the wings were closed, the altar painting conformed to its sculptural surroundings most fully; when opened, however, it revealed a different and magically compelling world.

These painted altarpieces were a sort of mystery show. Various stories from the Bible were recounted, often beginning with Adam and Eve and ending with the Last Judgment, with perhaps episodes of Christ's Crucifixion and the Resurrection in between. It is recorded that those who were willing to pay a fee could have the altar opened to reveal its successive tales. Usually the altar was closed, but on certain sacred holidays, people would crowd into the church to witness the spectacle of its unfolding.

A fusion of architecture, sculpture, painting, music, theater, and religious rite, the altar painting, now bereft of its original function and surroundings, only suggests part of the experience it once provided its viewer. Not a single altarpiece survives intact in a museum collection. Only a visit to churches that were spared the excesses of the Reformation can give the viewer a clue to the appearance of these altarpieces in something resembling their original setting.

A good many altarpieces now preserved in museums depict figures kneeling in prayer on the wings of an altar. These figures represent the patrons who commissioned the painting and who probably had it placed in a family chapel or on a main or high altar.

Private Devotional Paintings

Those who could afford large altar paintings probably also owned smaller devotional paintings, which are frequently found in museums. Generally of modest dimensions, the average being around 11 inches by 16 inches, private devotional images usually showed only a single subject, such as the Virgin holding her Child. These smaller panels were not fragments of a larger complex, but were hung in homes where their owners could peform their private devotions.

SECULAR PAINTING

Portraiture

The same skills that enabled Flemish and Dutch painters to render images of nature so well inclined them naturally to portraiture. Some of the resulting portraits were accurate portrayals of physical features; others became penetrating personality and character studies.

A private devotional painting could have a second panel that depicted its owner engaged in prayer. Other surviving portrait types recorded the likeness of individuals and married couples. Portrait sizes varied from bust-length images showing a three-quarter view of the face to full-length portraits. Larger paintings must have been more expensive and were probably commissioned by the few wealthy burghers or nobles who could afford them.

Flemish and Dutch portraits are a wonderful expression of an age that had both spiritual and worldly aspirations. It was an age that espoused with conviction the view that man was God's most important creation and that human life on this earth was brief. As a result, portraits were important expressions of this conviction, for they preserved the features of a few northern citizens for posterity.

Manuscript Illumination

In the fifteenth century, several Flemish centers produced manuscripts for export, mainly to France. The towns of Ghent and Bruges produced an abundance of religious books: Books of hours, chronicles, and love stories were painted, transcribed, and decorated with lovely historiated initials, full-page miniatures, and beautiful borders of fruit, vegetable, flower, animal, and mythical imagery. Most of the artists responsible for this work remain anonymous.

In Holland, the Utrecht region was also active in manuscript production, although scholars consider Dutch work to be more conservative and routine compared to manuscripts from Flanders. Grisaille, a painting technique that uses only gray (as the name suggests) tints and gives the effect of relief sculpture, was practiced in Delft. Several important Dutch panel painters also produced illuminations or influenced their design.

The second half of the fifteenth century is considered the finest period of the Flemish school. Most of its production consisted of books of hours manufactured for export, whereby they found their way into princes' collections in Italy and France. Between about 1450 and 1480, huge illuminated books (the *Biblia Historiale*, histories, and romances) became fashionable. By the last two decades of the fifteenth century their popularity had waned, and only private devotional books, breviaries, and books of hours with small and large size lettering were produced. Popular forms of decoration included illusionistically painted flowers, fruits, insects, and birds, which were shown as though floating above the page.

DRAWING

Many early Flemish and Dutch drawings have been lost. Of the techniques available to artists, the most popular appears to have been silverpoint on paper coated with a white ground to simulate parchment. Pages from sketchbooks (using both sides of the sheet), a few portrait drawings, and some copies of motifs from known paintings have survived. Little of this small sampling is regarded as original work by today's scholars. But because sketchbooks were used by students and apprentices as practice tools, and by most masters to record their own ideas or impressions, the concept of originality must be given a broader meaning when applied to drawing.

FIFTEENTH- AND SIXTEENTH-CENTURY GERMAN ART

The area we now call Germany was a land of many art-producing regions. Outstanding schools were located in Cologne, Nuremberg, Augsburg, and the region along the Danube River that includes Regénsburg (see map, Figure 7-3). These and other cities, as well as churches, courts, and burghers, commissioned many of the same kinds of objects that were then being produced in other European cultures. Churches needed altarpieces, tombs, monuments, and other embellishments. Courtiers and burghers were interested in portraits, paintings, and objects such as sumptuous metalware that were intended for private enjoyment.

One of the great developments in fifteenth- and sixteenth-century German art was the evolution of a printmaking industry, which began to flourish in the early fifteenth century and continued unabated throughout the sixteenth century. Many of Germany's greatest contributions were made in this medium and particularly in the art of wood carving, for which German artists are best known today.

During the fifteenth century, German art borrowed heavily from Dutch traditions, but by the sixteenth century, a number of important original talents emerged. These artists rank with the world's great masters, and made unmatched contributions, especially as engravers and wood carvers. Some artists took inspiration from Italian and some from northern European art; others turned to their own imaginations to produce an art of deep psychological intensity.

All German art, no matter what its sources, tends toward a great intensity of expression. Some scholars have denounced it as hysterical, while others have recognized its unusual penetration into the world of the psyche. The tradition of and means for exploring the natural appearances of things was borrowed from the Dutch, but was adapted by German artists to suit very different needs. It was not nature's splendor, but its mystery, that captivated German artists,

FIGURE 7-3. The major cities and regions of Germany during the fifteenth and sixteenth centuries.

who expressed the mystical forces of nature in supernatural, hallucinatory, or dreamlike visions that reflected a highly personal interpretation. These dreams were often threatening, nightmarish explorations of the human mind. Artists often viewed their subjects in terms of stark contrasts: Behind health lurked illness, behind life death; beauty invoked vanity; self-confidence smacked of pride. Even an idyllic pastoral landscape, no matter how inviting, could easily become the domain of witches and demons. The German artist, and those who saw his work, understood the world as a threatening place, full of evil, death, and corruption.

This great flowering of German art was interrupted by the violence of revolts,

wars, and economic upheavals that were brought on in part by the Reformation in the mid-sixteenth century. For this reason, and because German art was never as eagerly collected outside its own borders as Italian and Dutch art was, fewer examples of German art are found outside Europe.

RELIGIOUS PAINTING

German painting from this period may shock the viewer at first. It does not, for the most part, conform to our notions of beauty, but presents a rather unsparing view of nature that is not in any way sweetened or embellished. Beauty, in fact, was not the German painter's principal concern. Instead, he sought to arouse, often successfully, a response of unease, fear, guilt, or pain in the viewer. These feelings were aroused by gruesomely rendered scenes of the Crucifixion, martyrdoms, visions, and massacres. The only salvation to be had from such a harsh reality was to maintain faith in divine intervention. The German artist did not wish to lull the viewer into complacency by presenting a restfully beautiful vision that might never take the viewer's thoughts beyond the image itself. Instead, he reminded the viewer, often quite bluntly, of harsh realities from which only faith could protect him.

German painters explored a whole range of painting types, which are described below. Not included in this description are illuminated manuscripts, which continued to be produced, but were gradually superseded by prints.

Altar Painting

Altar paintings were usually four to five feet high and six to eight feet wide, although they frequently exceeded twice that size. Painters often worked with sculptors to create these altars, which were a supreme test of the painter's skills as narrator and composer. Set against a church wall and opened only on special holidays (or at times on payment of a fee), an altar could have up to three pairs of wings. Each wing section was used to recount an episode of a holy figure's life. The center section of the altar was frequently carved, but the outside wings were invariably reserved for painting. The altar combined painting, frame, and sculpture in a unit that offered its viewer a kind of theater in which well-known stories could be dramatically staged, using many levels of reality at once. For a fuller discussion, see Chapter 6.

It is difficult to estimate how many altars were destroyed during the Reformation. Few have entered museums intact, although complete examples can be found gracing the walls of some European churches. Museums most often have fragments, such as a wing, a center panel, or a predella. The elaborate frames that crowned many of these altars are seldom preserved, thus giving a false impression of simplicity to pieces that once belonged to a highly decorative and ornate whole.

In the sixteenth century, painting still conformed to traditional themes and formats. The conception of figures and their relationship to their surroundings gradually changed in altar paintings. Artists became aware of rendering the effects of light and atmosphere, and had a better understanding of the principles of drawing and perspective, through which they could make figures and objects appear more convincingly to exist in a three-dimensional state. Thus, whether artists chose to depict religious episodes within an architectural framework or a landscape, the final image was more cohesive and details were more selective. Not everything was rendered with equal intensity, as had been the case in the previous century. By diminishing some things and emphasizing others, a more naturalistic effect was achieved.

Private Devotional Pictures

Small, single or paired panels were produced extensively in Germany for private altars and personal use by the wealthy. Generally these private images focused on a single episode from Christ's or Mary's life, and depicted the episode in more human, often intensely emotional terms. Because these altars were meant to aid in private devotions which did not benefit from the assistance of priests, congregation, and assorted rituals, such intensity may have been important to the worshiper to enable him to reach the proper emotional state.

SECULAR PAINTING

Independent portraiture became prevalent in Germany as elsewhere beginning in the fifteenth century. Until then, the portrait was rooted in the religious tradition of donor portraits, in which the sitter was sometimes shown facing a religious image. Individuals often had themselves depicted in settings that had religious overtones.

Full-length and half-length portraits were commonplace, and their subjects were scrutinized and depicted with unsparing honesty. Some of Germany's greatest contributions came in the field of portraiture in the sixteenth century. Middle-class patrons, eager to emulate those of the court and clergy, commissioned portraits. These individuals are shown to be reflective, self-perceptive, and conscious of the spectator. Individuals, couples, and sometimes groups were portrayed in fairly standard poses. The best German portraits combine a thoughtful study of subject with a skilled understanding of composition.

Landscape

The areas along the Danube—Regensburg, Passau, and Vienna—offered some of the most beautiful natural scenery in Europe. During the first three decades

of the sixteenth century, a number of German painters from this region were inspired to produce the first independent landscape paintings in the history of art. The artists who demonstrated this interest in nature were given the designation Danube school.

These early landscapes saw nature as a vast, dynamic entity, a fusion of air, clouds, mountains, trees, valleys, and water. By contrast, the human figure was insignificant, overpowered by vast distances and the grandiose scale of nature. Landscape became an increasingly important backdrop for other types of paintings as well, for example, battle scenes and religious images.

The Nude

The courts and royal houses continued to patronize many artists and revived the interest in the female nude in the sixteenth century. Beautiful, sensuous, and at times provocative, images of ideal feminine beauty were presented in the guise of Venus, the Three Graces, allegories of time and vanity, the Judgment of Paris, and biblical figures, such as Lot and his daughters and Adam and Eve. All these images emphasized their real subject, which was invariably either the standing or reclining nude. The poses in which these female nudes were shown were largely derived from Italian painting and classical antique models.

SCULPTURE

No new types appeared in fifteenth- and sixteenth-century German religious sculpture. Altars, crucifixes, tombs, and other religiously inspired sculptural works continued to be produced until the Reformation began to question the use of religious imagery.

German sculptors were trained in the art of carving limestone or occasionally marble, ivory, or alabaster. Today, however, they are regarded primarily as woodcarvers. Certainly, they excelled in carving wood, which was in more abundant supply than marble or stones. The great hardwood forests of Germany provided limewood (linden), walnut, boxwood, and oak. Once cut and dried, a log was transported to the carver's shop, and there the experienced carver set about chipping away unneeded parts to expose his desired form. Then he would add color, which was an integral part of sculpture until the end of the fifteenth century.

A major change was introduced to sculpture between 1400 and 1600 as a result of the rise in secular patronage. By the sixteenth century, those of wealth and the inclination avidly began to collect objects for private enjoyment. Small sculptures in wood, ivory, and bronze began to find their way into northern private collections.

Carved Altarpieces

By the mid-fifteenth century and into the sixteenth century, German carvers ranked among the leading sculptors of northern Europe. Much of their finest work was devoted to the production of carved altars. As discussed earlier, the carved altar had a long history in northern Europe, and between 1400 and 1525 it became increasingly important in Germany.

The carved altar was the product of a union of sculpture, architecture, painting, and decoration. It combined elements of theater, narrative, religious dogma, and worship, serving the needs of a religious society that loved spectacle and drama and that sought to make its belief more palpable. The carved altar was an ideal medium: It was more accessible than painting because of its material substance and plasticity, and it made sculpture even more realistic by adding color. German sculptors created a variety of appropriate facial expressions for the various figures they carved and depicted religious events with an eye to spectacle by creating scenes with casts of thousands.

On the small, or at times rather large, stage that the altar provided, familiar episodes from the life of Christ, Mary, or various saints would be presented. The central panel focused on a primary image, and the wings recounted related episodes. Although each altar was unique, the format tended to be fairly consistent.

Natural light and candlelight produced shadows and highlights in these carved forms, which no doubt must have taken on a quality of reality and movement in their original setting. The dramatic gesture, detailed execution of forms, and added element of color must have made these altars magical and extraordinarily real. In the hands of master German woodcutters, these altars became extraordinary feats of carving, craftsmanship, and design. By the late fifteenth century, wood carvers produced results that one would have thought impossible: Forms appeared to move; legs, arms, and draperies extended beyond the believable circumference of a single log; and drapes looped, swirled, and fluttered, defying gravity as they were blown upward by unseen winds.

Hardwood was a suitable, yet challenging material. Although subject to cracking, splitting, worm infestation, and rot, wood was also light and strong. Large volumes could be supported by relatively small bases. An infinite array of sizes and forms could be obtained. Wood could be sliced to almost knife-blade thinness or left as broad, grand forms. Minute details could be articulated in the fine grained wood. Ever sensitive to the structure of the wood, the carver learned to work with its unique properties, and to follow its contours to find its intrinsic forms. As carvers grew more concerned with the aesthetic purposes of their production, they grew perhaps less inclined to disguise their efforts under layers of paint. Whether this is the reason for the development of simple, varnished, unpainted carvings toward the end of the fifteenth century, or

whether these carvings developed as a result of changing tastes, cannot be known for certain.

It is difficult to determine whether surviving sculpture from this period is devoid of color because such was the original intention of the sculptor, or because the efforts of some overzealous restorer removed all traces of pigment. Whatever the reason, the taste for uncolored images was to affect the numerous small carvings that were made for private devotion or enjoyment in the sixteenth century.

The Statuette

Made of pearwood, boxwood, limestone, bronze, marble, or ivory, and meant for private delectation and therefore often sensuous in subject matter, the statuette became popular in the sixteenth century. In the guise of portraying such themes as the Judgment of Paris, Adam and Eve, or Susannah and the Elders, nudes were a favorite subject of statuettes made for personal collections. Often kept in cabinets and enjoyed in privacy, these statuettes were intended purely for enjoyment, and grew in popularity as religious imagery became less common in areas most affected by the Reformation.

Bronze Statuettes Bronze casting was introduced to Germany before the fifteenth century and was used primarily to produce functional objects, such as water holders called aquamaniles that took the shape of fanciful animals from whose mouths liquid poured forth. In the sixteenth century, however, private collectors began to take an interest in bronze statuettes that were similar to those carved from wood.

Wood could be called the principal material of bronze casters, simply because wood carvers often supplied wooden models from which the founder made his mold. The professional founder would sign the bronze, but it was the sculptor, who generally remained unknown, who made the model. Given the origins of these small statues, the interest in the inherent properties of bronze, which so preoccupied Italian artists and collectors, was less prevalent in Germany. What is now Bavaria was the center for bronze casters, and the leading workshop was that of the Vischer family in Nuremberg. Along with many other casters in such centers as Augsburg, which rose to prominence about 1530, the workshops produced a whole range of bronze objects, including figures taken from classical antiquity and/or copied from Italian models, as well as small figures of animals or children.

These statuettes were fashioned into independent table sculptures or were used to make such things as fountains (by far the most popular), inkwells, lamps, and other functional objects. Table fountains as well as larger fountains intended for public squares or private gardens were generally composed of

groups of figures and animals that derived their meaning from biblical or classical texts.

By the second half of the sixteenth century, genre figures came into vogue among German collectors. Statuettes of hunters and peasants and acrobats and children were cast to delight wealthy patrons, who enjoyed these images of lower-class life.

Other types of bronzes, including medals and plaquettes, were inspired by Italian prototypes and were sought after by German collectors. Functional objects, such as mortars, scales, and caskets (small boxes for holding things like jewelry) were also extensively produced, and are sometimes of such an artistic quality that they are sought by museums and collectors today. By the sixteenth century, wonderfully wrought lockets were made with exquisite relief designs and were often used to hold wax miniature portraits. Small bronze reliefs used for garment ornaments were also produced.

In addition to secular bronze statuettes, a small industry in Germany did produce devotional art objects in bronze. Small crucifixes with accompanying mourning figures and plaquettes with religious subjects were often used for private devotions. Because they were often dismembered or detached from their original surroundings, these small bronzes had functions that remain unknown. However, they are thought to have served many of the functions that earlier ivories had in private devotions.

PRINTMAKING

Printmaking, which gave artists the ability to reproduce an image on paper exactly and in many copies, was a profoundly influential invention. It helped disseminate all sorts of information, ranging from religious, political, and artistic, to technical ideas. It helped raise the general educational level and played a very special role in the development of art. Through printmaking, the ideas of painters, draftsmen, sculptors, metalsmiths, tapestry and embroidery makers, book illustrators, and publishers were shared and widely transmitted through small, easily transported images. By studying prints we can learn a great deal about all areas of art and gain an appreciation for a much broader range of the artistic output of a given culture.

Prints have a relatively recent history. The first important contributions were made in late fourteenth-century Germany and Holland. These countries led the way throughout the fifteenth and sixteenth centuries. Once developed, the fundamental techniques and principles of printmaking spread throughout Europe.

Several conditions contributed to the emergence of printmaking as an important art form in the early fifteenth century. First, printmaking depended on the availability of large amounts of cheap paper on which to print. Paper became abundant and cheap toward the end of the fourteenth century. Printmaking also depended on a broader base of patrons to support certain kinds of

images. By the late fourteenth century, many cities had large middle-class populations who could afford and actively bought images. The images these middle-class patrons demanded were, at least initially, religious. But images made for recreation, such as playing cards, were later to be in great demand, and printmakers were able to produce a ready supply of all images, religious and secular. By the fifteenth century, the average citizen could say his prayers before an image of the Madonna, look to St. Christopher for protection, or while away the hours playing cards that, along with other images, were the products of the industrious printmaker. Prints became a popular form of art because they were affordable to many more people than were paintings or sculpture.

In very short order, the potential that prints had for being cheaper substitutes for all kinds of painting was realized. Prints were used to illustrate books and gradually superseded the more expensive and tedious process of hand illumination. Prints were sold in all sorts of ways. Monasteries sometimes made and sold religious prints to pilgrims, churches (which, in turn, resold them), and religious societies. Artists also sold prints at special fairs or festivals or from their shops. In time, book publishers became an important source for prints. Independent print dealers, who engaged in buying and selling prints to the general public, later arrived on the scene.

Because many prints were functional, and existing records indicate that not many attempts were made to preserve them, a vast proportion of the early print production has been lost through use. Only a few scraps, pasted into a traveler's box here or to a book binding there, indicate what kinds of prints were made and how they were used. Only later were prints collected for their aesthetic merits and preserved in albums as special treasures.

Because most prints were not commissioned, but rather were geared to the tastes of the general public, artists devised ingenious concepts and designs that both appealed to their buyers and still remained true to their own artistic inclinations. This aspect of printmaking anticipates later conditions that were to prevail in painting and sculpture, as artists worked less on commission and produced more often for a general art-buying public.

Prints were the ideal medium to express the many interests of the fifteenth- and sixteenth-century German. Much of his thought was philosophical and religious in nature. The condition of man and the great issues of good and evil, and life and death are themes that run through many prints. These grand preoccupations were coupled with a vital interest in the appearance, function, and underlying structure of all natural phenomena.

German prints from this period are distinguished by their narrative complexity. Conceived for viewers accustomed to seeing layers of meaning in a single image, these prints told their stories in complex ways and combined numerous elements. The stories themselves were derived from traditional sources, including the Bible and ancient literature, as well as from contemporary writers.

Filtered through the imagination of the printmaker, these stories were told and retold in endless variation.

Almost invariably, these stories recount the experience of a single individual, be it a bewitched groom or a St. Anthony plagued by devils. The fate or condition of the individual, faced with certain, usually difficult circumstances, is a common theme in German prints. It is a theme that enabled the viewer to draw a general moral principle or lesson based on the character of the drama, who represented a general, rather than a specific, figure. In general, German prints deal with universal concerns and view their subjects with an eye to passing moral judgment. The judgment is often harsh and the view of humanity frequently pessimistic.

The concern with narrative resulted in the use of prints to tell stories in a sequence of independent but related episodes that formed a print series. Sometimes these series were bound into books. Frequently, buyers would purchase several images in a narrative sequence in order to have a complete story.

Over time, prints developed a wide range of uses. In addition to decorating playing cards, reproducing religious images, or illustrating well-known stories from the Bible or classical mythology, occasional prints depicted images related to contemporary life. Portraits of individuals also gained currency in print form. The frequent appearance of nudes in the guise of various mythological or biblical subjects indicates that some prints were made for and collected by patrons who sought only the private enjoyment of sensuous imagery. Prints of this type take their place with statuettes as artworks created strictly for private enjoyment.

All sorts of natural phenomena—freaks of nature, beached whales, rare animals—were recorded in prints. Landscapes, in particular visions of the regions of the Danube, made their first appearance in the sixteenth century in engravings and an occasional etching, along with views of towns and other worthwhile sights.

Images from the lives of peasants were sought and produced in a steady supply of prints that showed peasants dancing, courting, or selling their wares. Scenes of violence or battle, images of soldiers, mercenaries, and their retinue, especially standard bearers, were the subjects of prints as well. Scenes of courtly life, costume studies, coats of arms, allegories of the seasons or the months, and the zodiac were illustrated in prints, as were satires of human weaknesses—gluttony, sensuality, wickedness, and the love of flattery.

For artists and artisans, prints were a bonanza. Paintings could be replicated; decorative motifs and figure studies could be passed from one shop to another. All sorts of ornamental designs, copied from decorative reliefs in stone, metal, or wood, were preserved and passed on through prints. In general, German printmaking developed from rather large, simple forms in the fifteenth century to more complex, spatially convincing and detailed images in the sixteenth century. Employing dark, rich inks, white paper, and the static, rigid qualities

of the material, the great masters exploited the inherent properties of printmaking to produce effects that were not possible in other mediums. Printmaking was raised to the level of a fine art, where it has remained to this day.

Woodcuts

During the fifteenth and sixteenth centuries, several techniques for prints developed, each producing its own distinct appearance. The earliest technique produced relief prints, in which the raised printing surface is inked and paper pressed against it to produce the image.

Woodcuts were the earliest relief prints. They were made by chipping away bits of wood from a block to leave the desired pattern raised in relief. The raised surface was then smeared with ink and produced a mirror image of itself on paper. Woodcuts were later often hand-colored with watercolors or tempera.

Woodcuts were used to make inexpensive religious images, playing cards, occasional portraits, and book illustrations. Bibles, for example, the *Biblia Pauperum*, or Bible of the Poor, were printed extensively in the fifteenth century. Books printed from single blocks that contained both image and text were called block books, among which the *Ars Moriendi*, or *Art of Dying*, is a famous example.

About 1465, in Augsburg or Haarlem, publishers began to use movable type in conjunction with separate woodblocks that contained illustrations. With this innovation, the book publishing industry flourished throughout Germany and the Netherlands. The woodblock became more independent of the text and generally larger. All sorts of religious and secular works were published, including travelers' books; histories, for example, the famous *Nuremberg Chronicle*; herbal, plant, and animal studies; and contemporary literature, for example, Sebastian Brant's *Narrenschiff* and the *Ritter vom Turm*. One of the most famous woodblocks is Hans Holbein's illustration of the *Dance of Death*.

The publishing industry employed the talents of the publisher, designer, woodblock carver, printer, and designer and carver of letters, as well as the author. Few of the products of this burgeoning industry have survived intact. Museum and private collections are full of individual sheets that are fragments from large and now dismantled books. Books that have remained intact are highly prized.

Some of the blocks from which woodcuts were printed have survived. Because they were printed and reprinted many times, the blocks have suffered from wear, and after numerous printings, the images they produce stray farther and farther from the artist's intention. For this reason, museums and collectors strive to obtain early impressions that were taken from the block when it was fresh. Impressions taken before the edition, or complete run of a print, is made are called proofs. Proofs were used by the artist to check the quality of his prints and are especially prized by collectors.

Chiaroscuro Woodcuts The desire to add color and the illusion of depth to an essentially monochromatic medium resulted in experiments with printing with more than one block. A different color was applied to each block to achieve greater effects of color and shading. Lucas Cranach and Hans Burgkmair are variously credited with perfecting this technique.

White Line Woodcuts These reversed the general appearance of dark lines on a white page, creating dark images that were defined in large measure by white lines. All woodcuts produce an evenly printed line that is fairly thick and cannot record the nuance and subtlety of touch that a drawing or painting can. Great printmakers exploited this property of woodcuts to produce bold forms, in which a fine balance is struck between the image itself and the lines from which it is made.

Intaglio Prints

In contrast to relief prints, in which the raised surface carries the ink and leaves the impression, intaglio prints involve cutting, carving, engraving, and incising or etching lines into a plate. These lines, below the surface, carry the ink. Engraving, which uses a sharpened tool (generally made of steel) to cut into a soft (generally copper, sometimes iron) plate, originated with goldsmiths and armorers. They would preserve a design that had been worked into a piece of armor or ornament by inking it and pressing it onto paper. By the 1430s, engraving became an independent medium that was used to reproduce images purchased by a wide public. Scholars tell us the buyers of engravings were a bit more sophisticated, and consequently less numerous, than those who bought woodcuts. Nonetheless, the making of engravings flourished, and German engravers rank among the foremost practitioners of the technique.

Another technique related to engraving is called drypoint, in which a steel needle is used somewhat like a silverpoint drawing tool. Sometimes used together, engraving and drypoint are inherently conducive to the meticulous rendering of minute detail. Each mark must be made slowly and deliberately, as mistakes are difficult, if not impossible, to correct. Lines cut into resistant metal are short, and many strokes must therefore be taken to create a long line. Thus, the final image is the product of an infinite number of accumulated small marks that have been laboriously worked into the surface of the plate. The marks, their spacing, and inking contributed to the final effect and overall tonality.

The aesthetic of engraving thus depended on detail and on the artist's ability to create infinite variations of dark to light tones on paper using a primarily black and white medium. Engravers, challenged by this medium, strove to create the illusion of volume through tone. By the late fifteenth century, great strides had been made in this direction, with some of the most outstanding

contributions having been made by Martin Schongauer. By manipulating the intensity, length, spacing, and direction of his burin marks, Schongauer produced remarkable, imaginative images in which the rigidity of the burin mark is offset by an image that is full of action and swelling forms.

Like woodcutting, the engraving process was slow and laborious. But, unlike woodcuts, which almost always involved collaboration between professional cutters and printers, engravings were frequently (but not always) designed first as a drawing and then executed by the same hand. Hence, the names of many engravers are known from the inception of engraving, while many carvers of woodcuts remain anonymous.

German engravers also had a mechanical advantage: They had a roller press that printed their images evenly and richly. Other (notably Italian) prints of the period lack such qualities.

Dotted Metalcuts By using a metal plate (commonly of lead, pewter, or copper) and working from the back with the punching, stamping, and cutting tools of a metalsmith, dotted metalcuts were worked on the surface to create often intricate and decorative designs. The dotted metalcut was also hand-colored and was most popular between roughly 1450 and 1500 in Germany and the Netherlands.

Etching Etching, which involves the use of acid to eat into metal, was known in the sixteenth century, but was used only experimentally. The artistic sensibility of the times found engraving a more satisfying medium. When copper plates replaced iron ones, etching and engraving methods could be used together on the same plate.

DRAWING

By the sixteenth century, artists drew more on paper and more of their production has survived. Like their Dutch, French, and Italian counterparts, German artists drew for various reasons: to prepare or develop an idea or element for a painter, sculpture, or print; to record for their notebooks images they encountered while traveling; or to practice the formal aspects of draftsmanship in the form of model studies. The first nude model studies date from the sixteenth century. Pen and ink, watercolor, charcoal, and chalk were used; silverpoint was also still common.

Because drawings were the most private and intimate medium for the artist, a range and type of subject matter are specific to drawing and are entirely absent in the more public mediums of painting, sculpture, and prints. Observations were recorded by the artist in myriad drawings of pure landscapes, views, animals, and all sorts of natural phenomena. Portrait drawings of family mem-

bers, sketches of an idea, methodical model studies—these subjects are unique to this medium.

Drawings were also regarded as teaching, learning, and reference tools, to be seen and used by only shop members of the artist. Only in certain cases, such as when a painting or sculpture was commissioned, did an artist prepare a drawing (which was then usually highly finished) to present to a patron. On other occasions, when specifically commissioned by the patron, finished portrait drawings were made to substitute for the more expensive and less quickly produced portrait paintings.

THE SIXTEENTH CENTURY

During the fifteenth century, the concept of the individual was affirmed and given new expression in the visual arts and literature, which in turn gave further positive impetus to the celebration of humanity. Man had become the measure of all things, and art was slowly coming to reflect man's preoccupation with the physical environment and his desire for physical and intellectual perfection.

Individuals began to play an increasingly important role in shaping the course of history. By assuming such power, however, they set into motion forces that were ultimately beyond the control of any one individual. The sixteenth century experienced the gradual transformation of an age of optimism into one of disillusionment and ineffectualness.

The stage was set in the late fifteenth century for new and important changes in Europe's economic and cultural life. Northern Europe had begun to prosper. Exploration and the exploitation of riches from the New World brought unimaginable wealth to Spain and Charles V (1516–1566), ruler of the Holy Roman Empire, which by then encompassed parts of Germany, the Netherlands, Flanders, and the kingdom of Naples. Europe's cities nearly doubled their populations from the previous century, and the humanistic spirit that had originated in Italy fostered new intellectual vibrancy in the north.

Erasmus of Rotterdam (c. 1466–1536) and Thomas More of England (1478–1535) exemplified the educated, literate men who turned their attention to the issues of the day. Applying their high moral and intellectual standards, they rejected Scholasticism and the hidebound dogmatism of many theologians. The corruption of the church aroused their indignation and criticism. The climate was thus ripe for reform. The church had become a sprawling network of institutions that required an extensive managerial bureaucracy. Parishes in various districts were given as sinecures; they were choice positions that offered members of the clergy financial and material security. Many such positions were held by individuals whose greed and cynicism overshadowed their commitment to the original precepts of the church. To raise money for their buildings and other costs, the church routinely sold indulgences, or guarantees

of reduced time in purgatory, in exchange for monetary donations. The pious laity of northern Europe, barred from direct access to the Deity by the system of spiritual intercessors in the form of priests, grew increasingly intolerant of the established practices of religion.

This dissatisfaction was crystallized in the writings of Erasmus, whose *Praise of Folly* (1509) criticized Scholastics, urged the translation of the Bible into the vernacular, and called for the reform of the clergy. The clergy was the subject of numerous barbs in the works of the satirist François Rabelais (c. 1494–1553), including his famed *Gargantua* (1532) and *Pantagruel* (1532 or 1533). The most effective champion of the Reformation was Martin Luther (1483–1546), whose objection to the sale of indulgences was set down in his famous ninety-five theses, which he nailed in protest to the door of Wittenberg Cathedral in 1517. In 1521, the church declared him a heretic, and Charles V issued an order for his arrest. That year also witnessed the first of many outbursts staged by reformers, who swept through churches and vented their hatred by smashing and burning sculptures and paintings.

The Reformation rejected papal authority and with it the power of priests. Rejected too were the notions of purgatory, transubstantiation (in which the Host miraculously assumes the body of Christ during the Mass), confession, and the use of religious images. The reformers relied on the Bible and translated it into languages that all could read as a source of inspiration. The reformers based their religion on the belief that faith alone brought the worshiper in contact with God.

With the Reformation, Europe was swept up in a period of turmoil and upheaval. Wars, economic fluctuations, revolts, and dissent eroded confidence and stability, ruptured the cohesion of institutions, and plummeted northern Europe into a period of imbalance and cross purposes that were so complex that no individual could effectively control or understand them. Charles V abdicated the Spanish throne in 1556 and retreated to a monastery. Erasmus retired to Basel and spent his last years trying to mend the breach within the church. Thomas More, who had envisioned in his *Utopia* (c. 1515) an ideal world in which men were equal and ruled by reason, refused to compromise his faith and was beheaded in 1535. Having broken with Erasmus, Martin Luther died deeply disappointed by the moral laxity of his contemporaries, the disunity of the Protestant movement, and the apparent recovery of the Catholic Church.

The effects of these developments on the arts of northern Europe were in many respects disastrous. The Reformation ended the production of images of the Deity in pictorial or sculptural form, and its followers destroyed hundreds of thousands of examples of what they deemed to be sacrilege. By removing imagery from the church, the Reformation also ended a practice that had provided sustenance for generations of artists and turned its back on a cultural legacy that today can only be partially understood due to its wholesale destruction by overzealous reformers.

The patronage of northern European artists in the sixteenth century therefore underwent some transformations. The courts remained a dependable source for commissions. We owe much of what we know about sixteenth-century French art to the patronage of Francis I (1515–1547). A good deal of German art was supported by Maximilian I (1493–1519) and later by Charles V. The courtly circles included learned scholars and writers, whose tastes ran to antique and literary subjects and who were to affect the artistic production of this and subsequent centuries.

The Reformation also affected the arts of northern Europe in a more subtly positive way. The Reformation was fostered by a spirit of intellectual curiosity that rejected old systems of thought and approached problems in a new, independent way. That same inquisitive spirit came increasingly to be directed toward natural phenomena and the physical world. Science, the study of physical reality, tentatively emerged from centuries of neglect and banishment. Thus, the secrets of nature began to lure men to scientific pursuits. An eclipse of the sun induced the Danish astromer Tycho Brahe (1546–1601) to abandon his study of rhetoric to take up astronomy, following the lead of the Polish astronomer Nicolaus Copernicus (1473–1543) in this pursuit. Medieval thought and religious dogma still imposed great restraints on scientific inquiry; Copernicus only permitted his *On the Revolution of the Heavenly Bodies* to be published posthumously. And Brahe's findings were less important than his contribution to the development of the young Johannes Kepler (1571–1630), the German astronomer, whose discoveries were made in the next century.

Although science lacked system, the interest in it permeated many levels of society, including artists. Albrecht Dürer's watercolor studies of clumps of grass and animals are paradigms of objective scientific observation. His inveterate curiosity proved to be his undoing, for he died from a chill caught while watching a beached whale in a rainstorm. It is also no coincidence that landscape emerges as an independent subject among Danube school painters, for the entry of landscape into the language of painting marks the extension of a scientifically inspired interest in the surrounding world into the realm of art.

The flowering of the Renaissance in Italy in the previous century offered inspiration and prototypes for northern European artists, who sought not only to represent objective reality but to render an idealized interpretation of it. In Italy, classical antiquity was a continual source of models for northern European artists who traveled to Italy or studied the prints, drawings, and Italian paintings that had been imported to the north.

Italy was disrupted less by the forces of the Reformation. Nevertheless, its cultural climate and artistic production underwent transformations during the sixteenth century. The celebration of the individual that characterized the Renaissance came to include the artist, who was now sometimes viewed as an embodiment of genius, a creative force that was something like the Divine. The beginnings of a cult of genius signaled a radical departure from earlier

attitudes toward artists, who had been regarded as craftsmen whose trade was like that of others who worked with their hands and applied industry, training, and skill to the production of their goods. A new understanding of art as the product of talent and inspiration found greater credence in Italy than in northern Europe and helped sever some artists' reliance on traditional forms of patronage. The secular spirit of the day perhaps even affected artists who worked on religious images, who might have done so with less conviction than had been the case earlier.

The cult of the artist also manifested its darker underside in the form of personal crisis, nervous failure, and doubt, which caused some sixteenth-century Italian artists to abandon projects. Artists began to follow the elusive phantom of their creative inspiration and continually lamented their inability to translate their visions into concrete form.

The character of art patronage underwent changes during this period as those who commissioned art sought works that would glorify their achievements and rejected proposals that did not suit their requirements. Among the most demanding patrons were nobility. The sixteenth century witnessed the emergence of powerful rulers who embodied and fulfilled the best qualities of man: intelligence, education, cultivation, morality, judgment, reflectiveness, courage, and action. The Italian peninsula was dotted with principalities whose rulers saw new possibilities for their own glorification through art. The Montefeltro family of Urbino and the Gonzaga family of Mantua had fabled collections of art, and these cities became famous as educational centers for young gentlemen. The Medici family, whose patronage of art exalted Florence during the fifteenth century, had quietly gained control of the city under the guise of republican rule. The Medicis became the Grand Dukes of Tuscany in the sixteenth century, and their patronage of such artists as Cellini, Bronzino, and Giorgio Vasari was now inspired by the need to celebrate their own imperial claim to power.

Unlike many northern European artists, Italian artists were still extensively patronized by the church. In fact, the spirit of learning and cultivation within the secular courts extended to the papal court, and the popes of this century (see table listing popes) included Julius II, Leo X, Clement VII, and Paul III, all of whom were important and influential art patrons as well as private collectors. Many artists were considered the equals of their papal and other patrons in terms of intellectual abilities and cultivation. Raphael, Michelangelo, Titian, and Leonardo, in addition to being celebrated artists, were treated with respect and high regard by their patrons.

Italian artists provided a broad range of art objects for their patrons, ranging from small, intimate, and intellectually inspired works for collectors' studioli (studies) to large, public, and tradition-oriented works for the church. During the sixteenth century, artists produced art for its own aesthetic merits. Artistic styles began to emphasize elements that clearly belonged to the substance of

THE PAPACY FROM 1492 to 1800

1492–1503	Alexander VI
1503 (Sept.–Oct.)	Pius III
1503–13	Julius II
1513–21	Leo X
1522–23	Adrian VI
1523–34	Clement VII
1534–49	Paul III
1550–55	Julius III
1555 (April)	Marcellus II
1555–59	Paul IV
1559–65	Pius IV
1566–72	Pius V
1572–85	Gregory XIII
1585–90	Sixtus V
1590 (Sept.)	Urban VII
1590–91	Gregory XIV
1591 (Oct.–Dec.)	Innocent IX
1592–1605	Clement VIII
1605 (April)	Leo XI
1605–21	Paul V
1621–23	Gregory XV
1623–44	Urban VIII
1644–55	Innocent X
1655–67	Alexander VII
1667–69	Clement IX
1670–76	Clement X
1676–89	Innocent XI
1689–91	Alexander VIII
1691–1700	Innocent XII
1700–21	Clement XI
1721–24	Innocent XIII
1724–30	Benedict XIII
1730–40	Clement XII
1740–58	Benedict XIV
1758–69	Clement XIII
1769–74	Clement XIV
1775–99	Pius VI (d. in exile)

art—composition, draftsmanship, line, proportion, and color. The scales that had been so carefully balanced between function and aesthetic in the last century were tipped in this century in favor of the latter. Artists began to work in ways that neither imitated nature nor sought to idealize it, but that allowed the artist to impose his will on the subject, which he could distort, exaggerate, or refine as he saw fit. The role of the artist in the making of images became primary, and art came to express more and more the personality and idiosyncracies of its creator.

Artists and their accomplishments were celebrated in a famous biography of artists by Giorgio Vasari, which traced the history of Italian art from the time of Giotto to the middle of the sixteenth century. Vasari's *Lives* (*Vite de' più eccellenti architetti, pittori e scultori italiani*) was first published in 1550 and is still the basis for much of our knowledge about Italian art, despite his clear bias in favor of the Florentine school. Shortly thereafter, Benvenuto Cellini composed his autobiography (1558–1562), which records with pride and arrogance his struggles, achievements, and rivalry and intrigues with other artists over patrons. Both works are fundamental barometers of their age and reveal the value that came to be placed on individual accomplishment and the uniquely creative efforts of artists.

SIXTEENTH-CENTURY ITALIAN ART

PAINTING

The clear, sunlit, rational world of fifteenth-century Italian painting fashioned animals, plants, and human figures into ideals of perfection. This bright, optimistic vision of reality was to become clouded in the sixteenth century by vagueness and shadow. The calm, aloof figures that moved with decorum and propriety through an ordered world in fifteenth-century painting are supplanted by strange, haunted, and anonymous creatures who move and interact in ways that are sometimes alien to our understanding. These paintings are not expressions of a universally accepted ideal, but rather the personal, often tormented visions of individual artists. As painters began to translate their private thoughts into the medium of paint, the communal, archetypal, and communicative quality of their images was correspondingly diminished.

Sixteenth-century painters still made religious images, but their self-perceptions and their role in society were undergoing gradual change. Patronage was also shifting hands, as more and more often the traditional public commissions from churches and civic and monastic groups were augmented by commissions from private patrons. In all of their images, painters stressed such elements as composition, color, and design, which defined their work primarily as art. They often exaggerated these elements and combined them with extremes of

emotion, gesture, action, and lighting. The confident, moderate world of fifteenth-century art evolved in this century into one of excess.

In order to please their patrons, painters created images that were passionately mystical, extravagantly sensual, supremely heroic, or intensely ascetic. Differences in the appearance of paintings were based not only on traditional regional styles of the past but on the philosophical attitude each region and artist held toward the making of art.

Florentine School

Leonardo, Michelangelo, Fra Bartolommeo, Andrea del Sarto, and Pontormo are among the major geniuses of the Florentine school. Their fame stretched far and wide and was noted for posterity by the Florentine biographer Vasari, whose biases placed Florentine school painting above all others and whose attitudes have been reflected in scholarship ever since.

Serving as the link between the eye and the spirit, each artist solved the challenge each type of painting posed in his own distinctive way. For example, the spiritual nature of religious art was expressed through mystery and pictorial perfection. Religious images do not communicate directly with the viewer. They represent a world that appears to be an extension of the viewer's reality but that remains wholly inaccessible. Religious emotions and thoughts are turned inward and express a profundity and grandeur beyond the human potential. Anxiety and tension are expressed to an ever greater degree in religious art during the sixteenth century and take the form of a seriousness and tragedy reflected on the faces of religious characters.

Secular painting in the form of frescoes or an occasional canvas or panel features mythological themes. Portraits depict their subjects as aloof and distant beings. The human figure became, in Florentine painting, the principal vehicle for the expression of ideas. Monumental conceptions and a preoccupation with the human form are inspired by antique models. Florentine artists emphasized line, composition, and masterful drawing as the most important elements of painting.

The Sienese School

As in previous generations, Sienese painting followed an independent course in the sixteenth century. Imagination, fantasy, the hallucinatory, and the real are commingled in the painting of this period, which is best exemplified in the work of Domenico di Pace Beccafumi. Light, dark, structure, and volume coexist with voids, and ephemeral substances dissolve into a luminous vapor. The spiritual world as depicted in religious painting is one in which neither its inhabitants nor the milieu seem connected with the human sphere.

The Venetian School

A number of unparalleled geniuses belong to the sixteenth-century Venetian school—Giorgione, Titian, Sebastiano del Piombo, Paolo Veronese, and Tintoretto. The sacred paintings of these artists assume a secular opulence. Emphasis was on the grandeur of the painter's conception. Larger in scale, these images incorporate secular elements in the form of setting; attendant figures of donors, a sense of light and air, and incidental detail are all grander, loftier, and more dignified than anything possible in the real world.

Secular painting of nudes, landscapes, and mythological scenes are transformed by Venetian painters into poetic and sensuous visions. Known literary themes are rarely depicted; instead, specific objects and subjects have associative meanings and an enigmatic quality that suggest the mystery of the artist's personality. In portraiture, Venetian painters conveyed the inner character of their sitters in a manner rarely before attempted or realized. Portraits, like other forms of painting, are veiled in mystery and endowed with a poetic quality.

Technically, oil paint was exploited to the fullest. During this century, Venetian painters used oil paint to convey the effects of light, texture, atmosphere, color, and the subtle nuances of shadow. Paint and color are the means through which the mystery of Venetian painting is achieved. Venetian artists' use of both paint and color fundamentally influenced European artists of later centuries.

Although Venice and Florence were still important centers for art, Rome and the papal court became increasingly significant as many artists were called there from other centers to satisfy the demand for artworks.

RELIGIOUS PAINTING

Altarpieces were still in great demand, but their appearance was again changing. The scale and grandeur of sixteenth-century architecture seemed to require enormous altarpieces of an equally grand scale. Compartmentalized altarpieces were still popular in northern Italy, but there was a general tendency to condense the altarpiece into one large painted panel with no additional predellas, wings, or pinnacles.

The subjects of religious painting also gradually changed. The Madonna was more often shown absorbed in private, silent communication with her Child or with saints who accompanied her, to the exclusion of the viewer. Subjects that had powerful emotional or mystical content, such as the visions of saints, the sufferings of Christ, his transfiguration, and the Virgin's assumption, gained popularity.

Private altarpieces now tended to be single panels and most often represented images of the Virgin holding the Child and sometimes accompanied by St. John. These images showed the Madonna only from the waist up (the half-length version), as had been the tradition for the previous centuries.

SECULAR PAINTING

Portraits

These were made in great numbers and were commissioned by many, including doctors, professors, musicians, writers, and artists, as well as princes, popes, clerics, and their families. Portraits came to be viewed as a means through which an individual could achieve immortality. The traditional bust- or shoulder-length portrait gave way to full- or waist-length portraits.

Artists came to interpret portraits in a variety of ways. Some simply recorded facial features, thereby often revealing an aloof or disdainful sitter; others were penetrating character studies. The most accomplished group portraits from this period are narrative in character. More painted than sculpted portraits survive, probably because the former were cheaper to produce.

Nudes

Images of nudes became increasingly popular among private collectors. Subjects such as Adam and Eve, Susannah and the Elders, or Joseph and Potipher's Wife became pretexts for depicting sensual male and female nudity. Classical figures, such as Jupiter, were shown in numerous guises and with numerous paramours (Danäe, Io, Leda). Such paintings satisfied both the interest in classical antiquity and the love of erotic imagery. Scores of ripe and voluptuous Venuses were painted as they stepped from the sea or reclined with self-conscious, feigned modesty on accommodating couches. Diana, the nymphs, and the satyrs reappear in the repertoire of imagery commanded by the sixteenth-century artist, who was often anxious to please his patron with skilled depictions of the nude human form. A notable example of this type of painting is *Venus with a Mirror* by Titian (see Plate 3).

New Subjects

As private collectors became more numerous, artists began to define new subjects in painting in the hope that these would induce patrons to part with their money. No longer meant to appeal to the viewer's religious or moral impulses alone, these new images spoke to other human attributes, such as pride, sensuality, or intellect. Painters often used images to stimulate the other senses, and relished their ability to deceive the viewer's eyes by creating illusions and by making one thing appear like another. Artists sometimes relied on either printed texts (for example, Ripa's *Iconologia*) to supply the correct meaning of symbols and emblems, or on other sources, including the patron's personal ideas, to create complex images that were layered with meaning and that appealed to the intelligence of the patron. In the process, a whole new range of painterly subjects was born.

Battle and Rape Scenes Formerly found on tapestries, cassoni, or bedroom furniture (spalliere), these images were now frequently the subjects of numerous independent paintings.

Female Beauties As an extension of portraiture, there developed, in Venice in particular, the love of depicting beautiful, voluptuous women in the guise of legendary prototypes, such as the Magdalen or Judith. Sometimes painted as portraits, these were frequently bought for the beauty and sensuality they added to the buyer's collection.

Concerts Music had always been an important subject in religious painting. Scores of religious images show angels playing instruments at the foot of the Madonna's throne. In newer interpretations of the theme of music, musicians are featured in groups or as individuals independent of any other context, playing and listening to their instruments. These paintings engage the viewer's imagination by appealing through his sight to his sense of hearing.

Still-Lifes A traditional subject of wood inlays, still-life imagery, or depictions of artfully arranged animals, vegetables, flowers, or fruits, found its way into the painter's repertoire. This painting type became increasingly popular by the end of the century.

Ceiling Painting The sixteenth century saw a growing interest in decorating church and palace ceilings with various decorative schemes. Painted as frescoes and occasionally on canvas, these decorations challenged the artist's ability to make objects and figures appear as though they were seen from below. Examples of detached painted canvas decorations are sometimes found in museums today.

Fantasy Images Meant to showcase an artist's virtuosity, these were popularly collected paintings in which fruits, trees, vegetables, and other objects were skillfully arranged to appear like faces. Even portraits became popular, and the style took its name from one of its most prominent exponents, Archimboldo.

Genre Painting Genre paintings made their appearance at the end of the sixteenth century. Subjects from everyday life—fishmongers, butcher shops, peasants, and rustic pastimes—offered alternatives to the idealized, rarified world of religious and allegorical painting. Bassano (a region near Venice) and Bologna in particular had painters whose work and patrons reflected an interest in genre imagery.

SCULPTURE

Sculptors in sixteenth-century Italy were employed by ruling families, civic governments, and churches to make large-scale sculpture for buildings, public squares, courtyards, gardens, and palaces. These sites were embellished with larger-than-life-size figures, groups, and fountains. Though an important part of the sculptural production of this period, these monumental pieces are far too massive to be preserved in most museums. Churches required sculpted altars, tombs, and monuments. These large-scale sculptures, or sculpted complexes, likewise rarely enter museum collections. When they do, they usually arrive in a fragmented state and have been wrenched from the physical context that gave them meaning and scale. Because most such sculpture has been stripped of its original visual surroundings, it is helpful to have an understanding of the context in which these fragments first existed.

In sixteenth-century Italy, the human figure was still the major motif of the sculptor. Traditional materials, such as marble, bronze, wood, and clay, were used. Ancient mythological gods and heroes, and saints and holy figures from the Bible remained the most common subjects. The treatment of these traditional subjects changed during the sixteenth century. A general tendency evolved for artists to idealize the human figure and to remove it from the realm of the spectator. By making it larger than life (many large-scale sculptures were two or three times life-size, and were called colossi), by making the human form more beautiful in art, and by endowing it with a perfection not attainable by mere mortals, artists moved the work psychologically and physically out of the realm of the spectator. Facial expressions emulated antique models and were muted or aloof.

Sculptors were challenged by their calling. They produced sculptures that they hoped would outdo a rival, and their highest hopes were to match or surpass their antique models. Sculpture was conceived as a test of skill and artistry; questions of composition, figure grouping, fineness of execution, and mastery of the human form were foremost. Although the previous century witnessed the emergence of the self-conscious artist, many gifted sculptors in the sixteenth century viewed themselves even more emphatically as artists rather than craftsman. Whether the sculptor worked in the service of a family, ruler, king, emperor, or the church, he aspired to refinement and perfection and expressed concepts such as heroism, spirituality, and power in a manner that was either grander or more decorative than anything that could be found in the natural world or that had been attempted in the previous century.

Much of the inspiration for sixteenth-century sculptural form was derived from Greek and Roman art. Not only did sculptors use already available antique models but they watched and responded with enthusiasm as collections of ancient sculptures were formed and new examples were found. In 1506, the Làocoön group was discovered in Rome, and was considered in its time the

greatest piece of sculpture ever made. Artists copied the individual figures and used them in countless compositions. They also made copies of the whole group, as well as of other antique works.

One of the principal sources of inspiration for sixteenth-century sculptors was the Vatican sculpture garden, which contained the *Torso Belvedere*, the *Hercules and Anteus*, the *Cleopatra*, the *Tiber*, the *Laocoön*, and the *Apollo Belvedere*—all of which were present in the garden by 1512. These works provided canons or guidelines for sculptors who wished to depict the human figure, whether nude or clothed, in movement or in repose.

Private collectors also assembled small-scale antique works in the form of gems, cameos, medals, coins, and statuettes, which they made available to artists for copying or drawing. The degree to which antiquity affected style varied with each artist, but the profound enthusiasm for antiquity was shared by patrons, collectors, and sculptors alike.

Classical antique style, as expressed by proportions, facial expressions, surface modeling, poses, and gestures, was imitated, as were antique types of sculpture, such as statuettes, medals, coins, and small reliefs. Originally collected for private enjoyment, these small-scale works are extensively displayed in museums and form a great part of modern collections of sixteenth-century Italian sculpture.

Much of the sculpture of this period was made of cast bronze. Because bronze sculptures were made from molds, from which casts could be obtained, examples of the same sculpture may be found in different museums. The popularity of some works led to repeated casting over long periods of time, a practice that makes it difficult to identify the actual date of a specific example or determine its relationship to the date of the creation of the mold. Such questions are always matters of speculation.

The concept of originality in sixteenth-century Italy was quite different from our own. The fact that various casts existed did not prevent the owners of such bronzes from enjoying their particular version. They were much more concerned with the visual and intellectual enjoyment their object provided. That enjoyment was contingent not only on the subject matter and the formal configuration, but was also affected by surface treatment or patina. The finishing of raw bronze, which involved cleaning the surface, polishing rough places, working details out with tools, and applying a chemical such as lacquer or gilding as the final surface, challenged the artist's craftmanship. His solutions, like many other aspects of his work, were often found by referring to antique examples.

RELIGIOUS SCULPTURE

Religious sculpture is a smaller component of museum collections for a number of reasons. Most tombs, altars, and large-scale statues made during this

period were either destroyed or remain in situ. Relative to the number of secular works that passed from one collection to another, religious sculpture was not extensively moved.

Sculpted Altarpieces

Sculpted altars remained common in sixteenth-century Italy and were produced in Florence, Siena, and especially Rome and Venice. Each region used its own type of subject matter, style, materials, and scale for its altarpieces. The most common in today's museum collections are the glazed terra-cotta altarpieces or religious reliefs that were produced in massive quantities by the descendants of the della Robbia family.

Half-Length Madonna Holding Her Child

This sculpture type declined by the sixteenth century. Occasional reliefs of related themes can be found, but religious sculpture with this particular theme is relatively rare.

Crucifix

The carved crucifix was still a common motif for altar decoration in churches and private chapels. It became an ideal vehicle for the artist to express his skill at depicting human musculature and anatomy.

Lamentation or Pietà Groups

This theme still captured the imagination of many sixteenth-century artists. The subject was ideal for tomb decoration, and numerous surviving examples must have been used for that purpose.

SECULAR SCULPTURE

The Portrait

Early in the century, portraiture followed many of the conventions that had been established in the previous century. But a gradual transformation occurred as artists began to focus on the dynamic, heroic qualities of their subjects. Sculptors tried to underscore the dignity and power of the individual, and the resulting portraits are much more self-conscious and ostentatious than those of the fifteenth century. Many artists took imperial, rather than civic, Roman portraits as their models. Even the portrait bust takes on a more self-conscious attitude, as the sitter appears to be striking a pose for the viewer.

Profile portraits, portrait busts, and occasional full-length portraits were produced. Portraits of men often show beards, emulating the Roman imperial style of bearded faces.

The Statue

Cities, churches, and wealthy (often noble) patrons supplied the funds for the production of numerous large-scale statues. In Florence, for example, the city hall, Palazzo Vecchio, collected an array of statues throughout the fifteenth century, and by the sixteenth century, other figures were added occasionally.

Sculptors became concerned with the problems of modeling, proportion, gesture, pose, material, and large-scale stone carving or bronze casting. The challenge was not always well met by the talents of individual sculptors, but it was considered a test of their artistic gifts. If the figure was to be freestanding, it was considered necessary that the work satisfy the beholder by providing beautiful views from at least four to eight vantage points.

The interest in large-scale sculpture spread from Florence to Rome and Venice. These large-scale works obviously had important civic or propagandistic overtones, and were often used to glorify an idea, a city, or a person, either through direct or symbolic representation.

Secular subjects were derived from many sources: Some were biblical and some came from classical history or mythology, but all had in common an emphasis on heroic or spiritual virtues that were expressed through physical strength. David, Hercules, Neptune, Perseus, Samson, and Mercury embodied the common themes of victory, triumph, and conquest of one's opponents. Their statues showed them at the height of their powers, as the victor triumphing over the conquered. Like their predecessors, sixteenth-century Italian sculptors strove for ideal beauty, but discovered in the perfect male anatomy a vehicle for expressing strength, valor, and beauty. Often inspired by Roman antique models, these sculptures depict tautly muscled, ideally proportioned men at their physical peak. Sometimes their proportions are exaggerated or attenuated.

Statues of mythological women were also made: Leda and Diana were frequently represented in small-scale sculptures meant for private enjoyment. But public fountains, equestrian monuments, or civic sculptures were set high on large bases and were generally not considered a place for such feminine subjects.

The Statuette

In the sixteenth century, there was no dramatic change in the making of statuettes, which continued to be popular. In general, their surface treatment became more refined and elegant, and their poses a bit more complex.

The nude female statuette played an important role. Some are overtly sensuous, and others are studies of almost abstract form. Sculptors also depicted male nudes, wrestlers, heroes, various animals (horses, lions, panthers), and figures on horseback. Sculpted designs that had practical functions, such as door knockers, inkwells, writing boxes, candlesticks, and oil lamps in numerous fanciful shapes, continued to be produced. Inkwells and oil lamps that were sculpted in the form of goats, satyrs, turtles, shells, and other natural forms gave their collectors great visual pleasure.

Artist's Models (Bozzetti) Although earlier artists probably worked mostly from small studies, more examples of these models, or bozzetti, survive from the sixteenth-century, which suggests they were also in greater use. Anatomical studies, experiments with individual figures and poses, as well as studies of the relationships between numerous figures in large-scale compositions, were commonly done in wax or clay. Based on model studies or existing works by other artists, or simply on the artist's imagination, these bozzetti have an immediacy and energy that make them valuable as works of art, independent of the fact that they were often preliminary studies or presentation pieces.

Medals

The same principles that applied to the production of fifteenth-century medals underlay the manufacture of medals in the sixteenth century. One technical development deserves mention: About 1550, it became common in Florence and Rome to strike the heated metal with a die or hard mold so that the design would be stamped into the medal. Called "striking," this mechanical process reduced the artistic value of medals for many collectors and scholars. Cast medals continued to be made in other regions, notably Siena.

Portrait Reliefs

In addition to portraits done as medals, the sixteenth-century Italian patron commissioned portraits in other materials. Wax reliefs on glass, though less common than bronze medals, were made and worn in lockets around the neck.

Plaquettes

Most commonly cast in bronze from a mold, plaquettes continued to be a popular form of sculpture. These small reliefs depicted sacred, classical, and philosophical themes that reflected the sophisticated literary interests of Italian collectors. In a sense, these plaquettes are a kind of visual poetry that uses the human form in infinite nuances of relief to evoke a subject derived from poetry, literature, history, or scripture. Some plaquettes might have been adornments for weapons, furniture, personal toiletry, or writing objects. Others

might have been used as engravings to record and transmit an artistic idea, and like prints, many plaquettes were made in large editions.

Plaquettes were owned by artists who collected and by private collectors. They formed part of the "cabinet" of amusing and pleasing personal objects that included all sorts of flora and fauna, as well as works of art. Generally, there is no real distinction between fifteenth- and sixteenth-century plaquettes.

DRAWING

During the sixteenth century, collectors began to preserve drawings, and many stories recount that artists collected examples by other artists. Because artists and collectors held drawings in higher regard, it makes sense that a greater number of them are preserved. Surviving examples include a wide range of drawings, from brief studies and compositional sketches to finished sheets. Sixteenth-century drawing indicates some significant changes from the previous century. Many more personal idiosyncracies are apparent in chalk or pen drawings. Drawings are bolder and are composed of marks that are more assured and dynamic. Figure and drapery studies, landscapes, and head drawings vibrate with life. Subjects are shown in movement or in thought, breathing and gripped by emotion.

Because artists were extraordinarily conscious of their own creative powers, skills, and personalities, and because drawing was still the first medium in which a creative concept for another medium was expressed, drawings became more energetic, personal, and vivacious. Artists also felt freer to experiment, and numerous artists mixed mediums, combining different chalks and applying their materials in less conventional ways. The sixteenth century was an age of unprecedented achievement in draftsmanship, and some of the greatest drawings in the history of art derive from this era.

Chalks, which had grown popular toward the end of the fifteenth century, continued to be the most important material for artists in drawing the human face or figure. Pen and ink were also extensively used, while silverpoint, that meticulous and demanding medium, fell into disuse.

PRINTMAKING

The woodcut continued to proliferate during the sixteenth century. Artists continued to use it for book illustration. Woodcuts were also involved in a fascinating experiment with its use in large-scale decorations that were to be a cheaper substitute for wall painting. Maps and battle scenes are known to have been printed from large numbers of blocks, but few have survived.

As in the north, the chiaroscuro woodcut came into use for its potential in creating light and shadow as well as color. White line woodcuts were also made on occasion.

Engraving

Images from other mediums were often reproduced as engravings. Artists recognized the potential profits from sales of their engravings, and successful collaborations ensued. Raphael was the first known painter to employ an engraver, Marcantonio Raimondi, and to profit from selling prints. This collaboration helped establish an engraving industry in Rome that survived for several centuries. Inasmuch as Rome was an international city with numerous tourists, one can suppose that its engraving industry anticipated similar, later developments in Venice, which experienced an expanding tourist trade as well.

The nature of the creative collaboration in Italian engraving is not thoroughly understood. According to some scholars, Italian engravers rarely had more than an artist's sketch as a model, whereas northern engravers worked with more finished images and were thus more attentive to detail and more faithful to the model. It has been said that Italian engraving is part copying and part invention. Few engravers' models actually survive for study, so this question remains open to debate.

Technically, many advances were made by engravers during the sixteenth century. Challenged to reproduce the effects of volume and shading that were attainable in paintings and drawings, engravers experimented with crosshatching, curving lines, broken lines, and dots to achieve various color and light effects. The artists Ghisi and Cornelis Cort are remembered for their contributions to engraving technique, and both were employed at one point or another by Europe's most influential sixteenth-century publisher, Hieronymous Cock.

The printing industry flourished, producing everything from book illustrations, portraits, ornaments, prints, and maps to religious images. Toward the end of the sixteenth century, the center for printmaking shifted to Bologna, where the leaders of the Carracci Academy successfully achieved in prints the lightness, vivacity, and spontaneity that are characteristic of drawing.

Etching

Sometime after 1510, artists began to experiment with etching. This technique entailed copper plates with an acid-resistant ground (often a combination of waxes and resins) and incising the plate surface with needles. The worked plate was then bathed in acid. The ground resisted the acid except where it had been scored by the needle. Here, the exposed copper was etched. The plate was wiped and then inked and printed. It was a difficult process to control. Etching did not really flower until the seventeenth century, but certain artists, notably Parmigianino, recognized the potential in the etching process and experimented with it continuously. The fluidity that the etching process made possible brought it closest to drawing and gave artists freedom to be inventive.

The knowledge of techniques, mixtures of grounds and tool designs were

passed from one shop to another. It was an erratic process that is almost impossible to retrace.

SIXTEENTH-CENTURY FLEMISH AND DUTCH ART

PAINTING

The sixteenth century was a watershed period for Flemish and Dutch painting. Flanders and the Netherlands, which had formerly shared a common religious, cultural, artistic, and political heritage, grew apart in all areas during this century. The change was sometimes gradual, but finally abrupt. By 1579, after years of religious revolts and wars, Flanders emerged as a distinct region. Catholic in religion and under Spanish Hapsburg rule politically, Flanders tended artistically toward the traditions of Italy. Holland emerged as Protestant nation, under republican rule, and was artistically somewhat less inclined to follow the Italian example. The Dutch Protestants disallowed religious imagery in churches, and Italian models of religious (Catholic) art were therefore less relevant to a Protestant culture, but remained important to Catholic Flanders.

As traditional church patronage declined here and there, artists turned to new markets to make a living. The emerging secular spirit among patrons helped establish new subjects for painting. Traditional types, such as portraits, remained important, but other subjects such as landscape, mythology, and genre also emerged. For a largely urban culture, peasant or farm life was regarded with nostalgia or amusement.

Artists no longer worked solely on contract, but created images that would be sold on the open market. They also no longer painted everything, but tended to specialize in certain subjects to hone their skills and ensure a higher production rate. In this century, the artist also assumed a new relationship to his subject matter. The artist often became a social critic or satirist and endowed his images with moral commentary.

Like their Italian counterparts, sixteenth-century Flemish and Dutch painters increasingly conceived of themselves as artists rather than craftsmen. To their minds, artistic invention took precedence over subject matter, with the result that many paintings look contrived. The quiet, sober, and earnest devotion to nature and religion that underlay the genial production of the previous century gave way to images that are agitated, often angular, turbulent, and highly stylized. The artist demonstrated his abilities by achieving all sorts of effects: the sensation of movement, illusions of space, or masterful strokes of draftsmanship. Artists went to many extremes to achieve their aims, and the results are often strident, self-conscious, and, to many modern eyes, less appealing than paintings from earlier times.

In this hundred-year span there seem to have been greater extremes of

approaches. Some artists were idiosyncratic and original, others far more conventional. Out of this period of artistic liberation and experiment grew the great accomplishments of painters in the subsequent century.

Manuscript Illumination

The sixteenth century continued many of the styles and trends that were typical of fifteenth-century manuscript illumination. Bruges, a large commercial center with an international clientele of merchants, maintained its position as the most important center of Flemish illumination. Yet only a few artists' names are associated with its enormous production. Although religious manuscripts were more commonly illuminated, poems, histories, chronicles, scientific writings, and translations of classical literature were occasionally illuminated for some discerning patrons.

PRINTMAKING

Woodcuts and engravings continued to be the principal mediums in printmaking in sixteenth-century Holland. Like other craftsmen, engravers and woodcutters continued to rely on artists of superior talent to supply the designs on which they based their prints. Leading artists of the day could take their designs to engraving shops and have them engraved and printed. In other cases and in other countries (notably Germany), the artist himself undertook his own printmaking, both for personal profit and greater artistic control.

Images of great intimacy and narrative richness were developed. Biblical stories were, of course, quite popular. But prints provided a market for images that were not always found in painting. Illustrations of new and fascinating subjects emerged: The lives of Turks were examined in one print series, and scenes from daily life in another; imagery derived from moralizing tales, classical stories, and histories was also produced and purchased in great numbers.

A special interest in observation is characteristic of sixteenth-century Dutch and Flemish art. It sets the stage for the development of narrative that was to remain important in European, and especially Dutch, art through the nineteenth century.

DRAWING

Drawing was a medium in which artists could explore their personal ideas more freely and without the restrictions of the marketplace, whose conventions and tastes held the more public commercial arts in sway. As a result, drawings often anticipated later developments in paintings. The earliest pure landscapes, for example, are taken from sketchbooks that recorded artists' impressions during their travels or, as in some instances, on their way to Italy.

Portraits, nature studies, scenes of daily life, and the hustle and bustle of human activity are portrayed independently or are used as foils for recounting a moralizing tale. Well-known themes could be given unusual, almost dreamlike interpretations by imaginative artists who sought to infuse their own personality or viewpoint into conventional subjects.

Silverpoint was gradually superseded by pen and ink as the predominant medium. Watercolors emerged at the end of the century. Apparently following the lead of Italian artists, Dutch draftsmen began to use red and other colored chalks (pastels) toward the latter part of the sixteenth century. Mixtures, for example, pen and ink used with washes of color on prepared or tinted paper, were also common in the sixteenth century.

SIXTEENTH-CENTURY FRENCH ART

Most of the sixteenth-century French art production that is known today was supported by court patronage. The creation of new fashions, which in turn greatly affected courtly art, can be attributed to the French kings and the royal court. Court activity was centered at the royal palace in Fontainebleau, which was constructed beginning in 1528. Italian art was so esteemed by the French court that many Italian masters were invited to provide painted and sculpted decorations. Leonardo, Andrea del Sarto, Rosso, and Francesco Primaticcio were among the artists who decorated the palace walls and gardens with master-pieces. French artists emulated many of the Italian models. Because many of the French artists who worked at the court are unknown, much of sixteenth-century French art that was produced for the court is designated by the school name of Fontainebleau, after the source of its style. Museums tend to have more paintings and drawings from this period because sculpture, with the exception of small statuettes, is less portable.

Because they worked for a sophisticated audience that was knowledgeable about literary and classical meanings, artists produced images that were replete with symbolic allusions. These were often quite sensual despite their elegant, refined, and artificial style, which tended either to idealize reality or defy it altogether. Again, this style owed much of its appearance to the influence of Italian art.

PORTRAITS

Francis I established the custom of summoning an artist to his court for a portrait drawing. That drawing was later used as the basis for an oil painting or was recopied in other drawings. A custom was established of keeping the drawn portraits in albums, with the result that many hundreds of portrait drawings have survived within their protective covers and are today housed in the world's museums.

Those albums contained portraits of nearly everyone connected with the French court. The court's habit of imitating everything the king did has afforded us a rare glimpse into the past. The likenesses of most sixteenth-century French nobles have been preserved and cryptic notes on drawings even indicate something about their personalities. Drawings concentrate mainly on the face and rarely attempt to penetrate into the psychology or character of the sitter, who remains aloof.

Portraits of court favorites or mistresses show them provocatively disrobed and sometimes in the guise of a goddess or biblical heroine. Surrounding their subjects with luxurious and symbolic objects, these paintings fuse reality, allegory, and sensuality in images that were meant to please the mind, eye, and senses of the patron.

The chief occupation of court painters, portraits were useful diplomatic tools or expressions of the prestige and position of the subjects. They could commemorate, idealize, symbolize, and elevate the subject or they could simply preserve a likeness. Portraits could be given as gifts or exchanged as tokens of friendship.

RENAISSANCE ARTISTS, 1400–1600*

———— FIFTEENTH-CENTURY ITALIAN PAINTERS ————

Central Italy

Antoniazzo Romano, doc. 1461–1510. Umbria.

Antonio da Fabriano, active 1451–1489. Marches.

Antonio Massari da Viterbo (Pastura), doc. 1478–1509. Viterbo, Rome, Orvieto.

Archangelo di Cola da Camerino, doc. 1416–1428. Marches.

Bartolommeo di Tommaso da Foligno, doc. 1425–1455. Marches?

Francesco Bianchi Ferrari (1457–1510). Modena.

Giovanni Boccati da Camerino, doc. 1445–1480. Perugia.

Bartolommeo Caporali (c. 1420–1509). Perugia.

Francesco di Gentile da Fabriano, active c.1450–c.1500. Marches.

Francia (Francesco Raibolini) (c. 1450–1517). Bologna.

Gentile da Fabriano (c. 1370–1427). Marches.

Perugino (Pietro di Cristoforo Vannucci) (1445–1523). Perugia. Influenced by Verocchio.

Piero della Francesca (Borgo San Sepolcro c.1416–1492). Pupil of Domenico Veneziano. Considered one of the great Italian painters.

*The use of the term "doc." in these lists signifies that documentation is extant, and may pertain to the artist's birth and death dates, years active, years of residence in a particular place, contracts, or the like.

Pintoricchio (Bernardino di Betto) (Perugia 1454–Siena 1513).
Giovanni Santi (c. 1430–1494). Urbino. Father of Raphael.
Ludovico da San Severino Urbani, doc. 1460–1493. Marches.

Florence

Andrea di Giusto (c. 1400–1455).
Andrea di Giusto Manzini (c. 1440–1496). Assistant to Neri di Bicci, Filippo Lippi, Benozzo Gozzoli
Fra Angelico (Frate Giovanni da Fiesole) (c. 1387–1455).
Apollonio di Giovanni, active 1446–1465. Head of a cassoni workshop.
Alesso Baldovinetti (c. 1426–1499).
Bartolommeo di Giovanni, active 1480–c.1500.
Bicci di Lorenzo (1373–1452).
Sandro Botticelli (c. 1445–1510). Pupil of F. Lippi; influenced by Pollaiuolo, Castagno, Verrocchio.
Francesco Botticini (1446–1498). Pupil of Neri di Bicci; influenced by Castagno, Cosimo Rosselli; worked with Verrocchio.
Andrea del Castagno (c. 1421–1457).
Fra Diamante (1430–after 1498). Pupil of Filippo Lippi.
Domenico di Michelino (1417–1491). Influenced by Fra Angelico.
Domenico Veneziano (c. 1400–1461).
Francesco di Antonio di Angeluccio (1394–1463), active c. 1433. Pupil of Lorenzo Monaco.
Benedetto di Tommaso Ghirlandaio (1458–1497). Assistant to brother Domenico.
Davide Ghirlandaio (1452–1525). Assistant to brother Domenico.
Domenico Ghirlandaio (1449–1494). Pupil of Baldovinetti.
Giovanni di Francesco del Cervelliera, doc. 1459. Pupil of Uccello?
Giovanni del Ponte (1385–1437). Pupil of Spinello Aretino?
Benozzo Gozzoli (1420–1497). Assistant to Fra Angelico.
Filippino Lippi (Prato 1457–Florence 1504). Pupil of Botticelli.
Fra Filippo Lippi (c. 1406–1469). Pupil of Lorenzo Monaco.
Lorenzo Monaco (c.1370–1425). Pupil of Niccolò di Pietro Gerini?
Lorenzo di Niccolò Gerini, doc. 1391–1411. Pupil of Gerini.
Zanobi Machiavelli (1418–1479). Assistant to Benozzo Gozzoli.
Mariotto di Cristofano (1393–1457). Brother-in-law of Masaccio.
Mariotto di Nardo, doc. 1394–1431. Follower of Niccolò di Pietro Gerini and Lorenzo Monaco.
Masaccio (Tommaso di Ser Giovanni di Mone) (1401–1428). Influenced by Donatello.
Masolino (Maso di Cristofano Fini) (1383–c. 1435). Influenced by Lorenzo Monaco.
Master of the Bambino Vispo, active early 15th century. Influenced by Lorenzo Monaco.

Master of the Barberini Panels, active mid-15th century?

Master of the Castello Nativity, active mid-15th century.

Master of the San Miniato Altarpiece, active mid- to late 15th century. Influenced by Lippi, Botticelli.

Neri di Bicci (Florence c. 1419–c. 1491). Pupil of father, Bicci di Lorenzo.

Paolo di Stefano (Lo Schiavo) (1397–1478). Pupil of Masolino.

Parri Spinelli (1387–1453). Arezzo. Pupil of father Spinello Aretino.

Francesco Pesellino (Francesco di Stefano) (1422–1452). Influenced by F. Lippi.

Pier Francesco Fiorentino, active 1474–1497. Influenced by Benozzo Gozzoli.

Pseudo Pier Francesco Fiorentino, now called the Lippi-Pesellino Imitators, group or individual influenced by and copiers of Lippi and Pesellino.

Antonio del Pollaiuolo (Antonio di Jacopo d'Antonio Benci) (c. 1431–Rome 1498). Sculptor, goldsmith, and painter.

Piero del Pollaiuolo (Florence c. 1443–Rome c. 1496). Brother and follower of Antonio.

Cosimo Rosselli (Florence 1439–1507). Pupil of Neri di Bicci.

Rosello di Jacopo Franchi (c. 1376–1456). Pupil of Mariotto di Nardo?

Jacopo del Sellaio (c. 1441–1493). Pupil of Filippo Lippi.

Zanobi Strozzi (Florence 1412–1468). Painter and miniaturist.

Paolo Uccello (Pratovecchio 1397–Florence 1475). Pupil of Ghiberti.

(Utile) da Faenza, doc. 1476–1483, 1504. Influenced by Verrocchio and Ghirlandaio.

Andrea del Verrocchio (Florence 1435–Venice 1488). Painter and sculptor. Pupil of Donatello and Baldovinetti.

Northern Italy

Baldassarre d'Este (or da Reggio) (1441–1504). Painter and medallist. Milan, Ferrara.

Bartolommeo di Tommaso da Foligno, active 1425–1455. Ancona, Foligno.

Francesco Benaglio (Verona 1432–c. 1492?). Verona.

Ambrogio da Fossano Bergognone, active c. 1481–c. 1523. Milan.

Francesco Bonsignori (c. 1445–c. 1519). Verona.

Lodovico Brea (c. 1443–c. 1523). Genoa, Nizza.

Bernardino Butinone, active 1484–1507. Milan.

Francesco del Cossa (c. 1435–c. 1477). Ferrara, Bologna.

Vincenzo Foppa (c.1427/30–1515/16). Milan.

Francesco dai Libri (il Vecchio) (c.1451–1502/1514). Verona.

Francia (Francesco Raibolini) (died 1517), active c. 1482. Bologna.

Girolamo da Cremona, active c. 1467–1475. Miniaturist. Cremona.

Girolamo di Giovanni da Camerino, active last half of the 15th century. Padua.

Liberale da Verona (c. 1445–c. 1526/29). Verona, Siena, Venice.
Macrino d'Alba (1494–1508). Piedmont.
Gianfrancesco Maineri, active 1489–1505. Parma.
Andrea Mantegna (1431–1506). Padua, Mantua, Verona.
Giovanni Massone (Mazone, Masone) 1453–1510. Piedmont.
Ludovico Mazzolino, active 1504–1528. Ferrara.
Domenico Morone (1442–after 1517). Verona.
Francesco Morone (1471–1529). Verona. Son of Domenico.
Ercole de'Roberti (c. 1450–1496). Bologna, Venice, Mantua.
Francesco Squarcione (1397–c. 1468). Padua.
Stefano (1375–c. 1451). Verona.
Cosimo Tura (c. 1430–1495). Ferrara. Padua.
Marco Zoppo (near Venice 1433– Venice 1478). Padua, Bologna, Venice.

Siena

Pietro di Giovanni di Ambrosi (1410–1449). Follower of Sassetta.
Andrea di Bartolo, doc. 1389–1428. Pupil of father, Bartolo di Fredi.
Andrea di Niccolò di Giacomo, doc. 1470–1512. Pupil of Vecchietta?
Bartolommeo della Gatta (1448–1502). Florentine; influenced by Sienese, active in Arezzo.
Benvenuto di Giovanni (1436–c.1518). Pupil of Vecchietta.
Guidoccio di Giovanni Cozzarelli, active 1450–1516. Assistant to Matteo di Giovanni.
Domenico di Bartolo Ghezzi (c. 1400–c. 1447). Pupil of Taddeo di Bartolo?
Paolo da Giovanni Fei, active 1372–1410. Pupil of Bartolo di Fredi.
Francesco di Giorgio (1439–1501). Architect, painter, sculptor, miniaturist. Pupil of Vecchietta.
Giovanni di Paolo (1403–1483). Pupil of Paolo di Giovanni Fei?
Gregorio di Cecco di Luca, doc. 1389–1423. Pupil of Taddeo di Bartolo.
Gualtieri di Giovanni da Pisa, active c. 1389–c. 1445.
Lorenzo di Pietro (Vecchietta) (c. 1412–1480). Painter and sculptor. Pupil of Sassetta.
Martino di Bartolommeo di Biago, doc. 1389–1434/5. Pupil of Jacopo di Mino.
Master of the Osservanza Triptych (sometimes called early phase of Sano di Pietro).
Matteo di Giovanni (c.1435–1495). Pupil of Domenico di Bartolo?
Neroccio di Bartolommeo Landi (1447–1500). Painter and sculptor. Pupil of Vecchietta; partner of Francesco di Giorgio.
Pietro di Domenico (1457–1506 or 1533). Influenced by Matteo di Giovanni.
Sano di Pietro (1406–1481). Pupil of Sassetta.
Pisanello (Antonio Pisano) (Pisa c. 1395–Verona? c. 1455). Major painter and medallist.

Sassetta (1395–1450). Pupil of Paolo di Giovanni Fei.
Taddeo di Bartolo (c. 1362–1422). Pupil of Giacomo Mino del Pelliccaio?

Venice

Pietro Alamanno, active 1471–1498. Marches.
Andrea da Murano, doc. 1462–1507. Venice.
Antonello da Messina (c. 1430–1479). Mature period in Venice.
Lazzaro Bastiani (c. 1430–1512). Pupil of B. Vivarini.
Gentile Bellini (1429–1507). Pupil of father, Jacopo Bellini
Giovanni Bellini (c. 1430–1516). Pupil of father, Jacopo Bellini
Jacopo Bellini (c. 1400–1470).
Marco di Giorgio Bello (1470–1523).
Andrea da San Vito (called Bellunello) (c. 1430–1494). Friulia.
Leonardo Boldrini, doc. 1454–1498.
Donato Bragadin, doc. 1438–1473.
Vittore Carpaccio (c. 1465–1525/26). Pupil of Gentile Bellini.
Giovanni Battista Cima (Cima da Conegliano) (c. 1459–1517). Pupil of A.
 Vivarini?
Carlo Crivelli, active 1457–1495. Venetian, active in Marches.
Vittorio Crivelli, doc. 1481–1501/2. Pupil of Brother Carlo Crivelli.
Dario da Treviso, c. 1420–1498. Pupil of Squarcione.
Bartolommeo Diana (Benedetto Rusconi), active 1482–1525. Pupil of Lazzaro
 Bastiani.
Francesco de' Franceschi, active c. 1447–1467.
Michele Giambono, active 1420–1462.
Gianfresco da Tolmezzo (c. 1450–1510).
Giovanni di Francia, doc. 1429–1439.
Jacobello del Fiore, doc. 1394–1439.
Jacopo da Valenza, active 1485–1509. Assistant to Alvise Vivarini.
Filippo Mazzola, active 1460–1505. From Parma. Father of Parmigianino.
Girolamo Mocetto (c. 1458–c. 1531).
Bartolemmeo Montagna (c. 1450–1523).
Jacopo da Montagnana (c. 1443–c. 1499). Padua.
Nicola di Maestro Antonio, active late 15th century. Marches.
Niccolò di Pietro, active 1394–1430.
Pasqualino di Niccolò, doc. 1463–1530.
Quirizio da Murano, doc. 1461–1478.
Antonio da Cadore (Rosso) (c. 1440–1509).
Alvise Vivarini (1445/6–1503/5). Pupil of father Antonio Vivarini.
Antonio Vivarini (c. 1415/20–1476/84).
Bartolommeo Vivarini, active 1450–1491. Pupil of brother Antonio.
Zannino di Pietro, early 15th century.

—————— SIXTEENTH-CENTURY ITALIAN PAINTERS ——————

Central and Northern Italy

Andrea Sabatini (Andrea da Salerno) (c. 1480–1530). Influenced by Umbrians.

Sofonisba Anguissola (1527–1625). From Cremona. Pupil of Bernardino Campi. Woman artist.

Guiseppe Archimboldo (Milan 1530–1593). Fantasy portraits. Court painter to the Hapsburgs.

Amico Aspertini Bologna (1474/5–1552). Pupil of Ercole de' Roberti da Ferrara.

Antonio Badile (1518–1560). Verona. Pupil of Caroto.

Matteo Balducci, active 1509–1555. Pupil of Pacchiarotto.

Bartolommeo di Maestro Gentile (c. 1470–1534). Urbino. Pupil of Giovanni Santi.

Ambrogio da Fossano Bergognone, active 1481–1523. Milan. Pupil of Foppa.

Luca Cambiaso (near Genoa 1527–Madrid 1585). Painter, draftsman.

Bernardino de' Conti (c. 1490–1522). Milan. Pupil of Zenale?

Bernardino di Mariotto dello Stagno (c. 1478–1566). Umbria. Pupil of Fiorenzo di Lorenzo.

Caracciolo Giovan Battista Bertucci, active 1503–1516. Umbro-Romagnol.

Boccaccio Boccaccino (c. 1465–1524/5). Cremona.

Giovanni Antonio Boltraffio (c. 1467–1516). Imitator of Leonardo. Milan.

Bramantino (c. 1465–1530). Milan. Pupil of Butinone?

Domenico Brusasorci (c. 1516–1567). Pupil of Caroto. Verona.

Galeazzo Campi (1477–1536). Cremona.

Giulio Campi (c. 1500–1572). Pupil of Romanino. Cremona.

Giovanni Caroto (1488–c. 1566?). Verona. Brother of Giovanni Francesco Caroto, whose style is very similar.

Giovanni Francesco Caroto (c. 1478–1555). Verona. Pupil of Liberale.

Paolo Morando Cavazzola (1486–1522). Verona. Pupil of Domenico Morone.

Cesare Magni, active early 16th century. Milan. Pupil of Bergognone.

Vincenzo Civerchio (c. 1470–1544). Crema. Pupil of Foppa.

Cola delle Amatrice (c. 1489–1550). Pupil of Pietro Alamanno?

Correggio (Antonio Allegri) (1484 c.–1534). Parma. Pupil of Bianchi Ferrari.

Lorenzo Costa (c. 1460–1535). Northern Italy. Pupil of Francesco del Cossa and Ercole de'Roberti.

Defendente Ferrari, c. 1501–1535. Northern Italy.

Dosso (Giovanni Luteri) (c. 1490–1542). Ferrara. Influenced by Venetians.

Battista del Dosso, active c. 1517–1548. Ferrara. Assistant to brother Dosso.

Eusebio di San Giorgio, active 1492–1540. Perugia. Pupil of Perugino.

Paolo Farinati (1524–1606). Verona. Pupil of Giolfino.

Fiorenzo di Lorenzo (1440–c. 1522). Perugia.

Francesco Napoletano, active early 16th century. Northern Italy. Pupil of Ambrogio de Predis?

Francesco da Tolentino (c. 1500–1535). Marches.

Garofalo (Benvenuto Tisi) (1481–1559). Ferrara. Pupil of Panetti.

Gaudenzio Ferrari (c. 1480–1546). Northern Italy.

Girolamo Genga (Urbino 1476–1551). Pupil of Signorelli.

Giampietrino, active early 16th century. Milan. Imitator of Leonardo.

Niccolò Giolfino (1476–1555). Verona. Pupil of Liberale da Verona.

Giovanni Agostino da Lodi, early 16th century. Lombardy.

Girolamo Giovenone (c. 1490–1555). Vercelli. Pupil of Gaudenzio Ferrari.

Girolamo da Carpi (1501–1556). Ferrara. Pupil of Garofalo.

Bernardino Lanino (c. 1511–1581/2). Vercelli. Pupil of Gaudenzio Ferrari.

Girolamo dai Libri (1474–1555). Verona. Son of Francesco. Pupil of Morone.

Bernardino Luini (c. 1480/90–1532). Milan. Pupil of Bergogone?

Macrino d'Alba, doc. 1494–1508. Vercelli.

Marco d'Oggiono (c. 1475–1530). Northern Italy. Imitator of Leonardo.

Michele da Verona (died after 1536). Pupil of Domenico Morone.

Moretto da Brescia (Alessandro Bonvicino) (1498–1554). Brescia. Follower of Savoldo and Titian.

Giambattista Moroni (c. 1520–1578). Bergamo. Pupil of Moretto.

Ortolano (Giovanni Battista Benvenuti) (c. 1488– died later than 1526). Active 1512–1524. Ferrara. Follower of Dosso.

Vincenzo Pagani (c. 1490–1530). Marches.

Marco Palmezzano (1459–after 1543). Romagna. Pupil of Melozzo da Forli.

Parmigianino (Francesco Mazzola) (1504–1540). Parma. Follower of Correggio, Raphael, Michelangelo.

Albertino and Martino Piazza, active early 16th century. Lodi. Brothers who worked in styles influenced by Boltraffio, Perugino, Raphael.

Calisto Piazza (c. 1500–1562). Lodi. Son of Martino.

Francesco Primaticcio (Bologna c. 1504–Fontainebleau 1570). Considered founder of School of Fontainebleau.

Raphael (Raffaello Santi or Sanzio) (1483–1520). Urbino. Son of Giovanni Santi. Influenced by Perugino, Leonardo, Michelangelo.

Girolamo Romanino (1484–1559). Brescia. Influenced by Venetian painting.

Giulio Romano (c. 1499–1546). Mantua. Pupil of Raphael.

Lo Scarsellino (Ippolito Scarsella) (1551–1620). Ferrara. Influenced by Venetian painting.

Cesare da Sesto (1477–1523). Milan. Imitator of Leonardo.

Luca Signorelli (c. 1450–1523). Cortona. Pupil of Piero della Francesca.

Andrea Solario (c. 1465–1524). Milan. Influenced by Northern Italian art.

Lo Spagna (Giovanni di Pietro) (died 1528). Pupil of Perugino.

Giovanni Martino Spanzotti, doc. 1480–1526. Vercelli. Influenced by Northern Italian Painting.

Tiberio d'Assisi (c. 1470–1524). Umbria. Influenced by Pinturicchio and Perugino.

Francesco Torbido (Il Moro) (c. 1482–1561). Venice, Verona. Influenced by Venetian painting.

Perino del Vaga (Pietro Buonaccorsi) (1501–1547). Florence, Rome. Influenced by Michelangelo.

Timoteo Viti (1467–1523). Urbino. Influenced by Umbrian art.

Francesco Zaganelli (c. 1480–1531) Romagnol. Partner with brother Bernardino.

Bernardino Zaganelli, active until c. 1514. Romagnol.

Bernardino Zenale (1436–1526). Milan. Influenced by Leonardo.

Florence

Mariotto Albertinelli (1474–1515). Pupil of Cosimo Rosselli and Piero di Cosimo.

Bacchiacca (Francesco d'Ubertino) (1494–1557). Pupil of Perugino.

Fra Bartolommeo (Baccio della Porta) (1475–1517). Pupil of Cosimo Rosselli and Piero di Cosimo.

Agnolo Bronzino (Angolo di Cosimo di Mariano) (1503–1572). Pupil of Pontormo.

Giuliano Bugiardini (1475–1554). Pupil of Domenico Ghirlandaio, Piero di Cosimo.

Lorenzo di Credi (c. 1459–1537). Assistant to Verrocchio.

Franciabigio (c. 1482–1525). Pupil of Piero di Cosimo and Mariotto Albertinelli.

Ridolfo Ghirlandaio (1483–1561). Son of Domenico Ghirlandaio; pupil of Fra Bartolommeo, Piero di Cosimo, and Grannacci.

Francesco Granacci (c. 1468–1543). Pupil of Lorenzi di Credi and Domenico Ghirlandaio.

Leonardo da Pistoia (1483–c. 1518). Influenced by Fra Bartolommeo and Raphael.

Leonardo da Vinci (1452–1519). Florence, Milan. Pupil of Verrocchio.

Sebastiano Mainardi (c. 1460–1513). Pupil of Domenico Ghirlandaio.

Michelangelo Buonarroti (1475–1564). Pupil of Ghirlandaio and Bertoldo; influenced by Donatello and Signorelli. One of the geniuses of Western art.

Michele di Ridolfo (1503–1577). Pupil of Lorenzo di Credi.

Fra Paolino (c. 1490–1547). Pupil of Fra Bartolommeo.

Piero di Cosimo (1462–1521). Pupil of Cosimo Rosselli.

Pontormo (Jacopo Carucci) (1494–1556). Pupil of Andrea del Sarto.

Domenico Puligo (1492–1527). Pupil of Ridolfo Ghirlandaio.

Raffaellino del Garbo (c. 1466–1524). Pupil of Botticelli.

Rosso Fiorentino (Giovanni Battista di Jacopo) (1494–1540). Pupil of Andrea del Sarto.

Francesco Salviati (Francesco de'Rossi). (1410–1563). Pupil of Bugiardini, Andrea del Sarto.

Santi di Tito (1536–1603). Pupil of Bronzino.

Andrea del Sarto (1486–1530). Pupil of Piero de Cosimo.

Giovanni Antonio Sogliani (1492–1544). Pupil of Lorenzo di Credi; influenced by Andrea del Sarto.

Tommaso. Name given to artist close to Lorenzo di Credi, by B. Berenson.

Tommaso di Stefano Lunetti (c. 1490–1564). Pupil of Lorenzo di Credi.

Utile da Faenza (Utili), active late 15th–early 16th centuries). Name given to artist close to Verrocchio and Ghirlandaio by B. Berenson.

Giorgio Vasari (1511–1574). Painter and draftsman. Best known for biography of artists, *Lives*, published in Florence, 1550.

Siena

Domenico Beccafumi (1486–1551). Printmaker, sculptor, painter. Pupil of Pacchiarotto.

Andrea del Brescianino, active c. 1507–1525. Pupil of Pacchia?

Bernardino Fungai (1460–1516). Influenced by Benvenuto di Giovanni, Francesco di Giorgio.

Girolamo di Benvenuto (1470–1524). Son and Pupil of Benvenuto di Giovanni. Influenced by Northern European painting?

Girolamo del Pacchia (1477–1535). Pupil of Fungai.

Giacomo Pacchiarotto (1474–1540). Pupil of Matteo di Giovanni.

Baldassare Peruzzi (1481–1536). Siena, Rome. Also architect.

Sodoma (Giovanni Antonio Bazzi) (1477–1549). Influenced by Florentine painting.

Venice

Pietro Paolo Agapiti (c. 1470–1540).

Antonello de Saliba (c. 1466–c. 1535). Influenced by Antonello de Messina, Bellini, and Cima.

Jacopo de'Barbari (died c. 1516). Influenced by Northern European painting.

Bartolommeo Veneto, active 1502–c. 1530. Pupil of Bellini.

Marco Basaiti (c. 1470–c. 1530). Pupil of Alvise Vivarini. Influenced by Bellini, Giorgione, and Catena.

Francesco Bassano (Da Ponte) (c. 1470–1539).

Jacopo Bassano (c. 1510–1592). Pupil of his father Francesco and of other Venetian painters.

Leandro Bassano (1557–1622). Pupil of father Jacopo. Religious and genre painting.

Francesco Beccaruzzi (c. 1492–1562). Influenced by Titian and Palma.

Francesco Bissolo, active 1492–1554. Pupil of Giovanni Bellini.

Paris Bordone (1500–1571). Pupil of Titian.

Bonifazio de'Pitati (called Veronese) (1487–1553). Pupil of Palma Vecchio.

Domenico Campagnola (1500–c. 1581). Influenced by Titian. Noted draftsman and printmaker.

Domenico Caprioli (1494–1528). Follower of Giorgione and Palma Vecchio.

Giovanni Cariani (Giovanni de'Busi) (c. 1480–1548). Pupil of Giovanni Bellini.

Benedetto Carpaccio (c. 1500–1560). Son and pupil of Vittore Carpaccio.

Cristoforo Caselli (died 1521). Active from 1488.

Vicenzo Catena (c. 1480–1531). Influenced by Bellini and Giorgione.

Filippo da Verona, active early 16th century. Influenced by Cima and Giovanni Bellini.

Marcello Fogolino, active c. 1510–1548. Influenced by Montagna, Romanino, and Dosso.

Stefano Folchetti, doc. 1492–1513. Influenced by Crivelli.

Giorgione (Giorgio di Castelfranco) (c. 1477–1510). Pupil of Giovanni Bellini; noted and innovative Venetian painter.

Giovanni da Brescia (and Bernardino). Father and son. Active first half of 16th century. Influenced by Venetian painting.

Pietro degli Ingannati (first half of 16th century). Influenced by Bellini and Palma Vecchio.

Lattanzio da Rimini, active 1492–1505. Pupil of Giovanni Bellini.

Bernardino Licinio (c. 1489–1560). Pupil of Pordenone.

Lorenzo Lotto (1480–1556). Pupil of Alvise Vivarini; innovative follower of Bellini and Titian.

Domenico Mancini, active 1510–1520. Follower of Giorgione and Titian.

Giovanni Mansueti, doc. 1485–1527. Pupil of Gentile Bellini.

Rocco Marconi, doc. 1504–1529. Pupil of Giovanni Bellini.

Pietro de Marisc alchi (called Lo Spada) (c. 1520–c. 1584). Pupil of Titian.

Giovanni di Martini (c. 1453–1535). Influenced by Cima and Pordenone.

Francesco Montemezzano (died c. 1600). Influenced late Veronese.

Alessandro Oliverio, c. 1500–1549. Influenced by Giovanni Bellini, Giorgione, Palma Vecchio.

Jacopo d'Antonio Nigretti Palma (Palma Vecchio) (1480–1528). Influenced by Bellini, Giorgione, and Titian.

Polidoro da Lanciano (1514–1565). Influenced primarily by Titian.

Giovanni Antonio de'Sacchi Pordenone (c. 1483–1539). Influenced by Giovanni Bellini, Giorgione, Palma Vecchio, and Titian.

Andrea Previtali (died 1528), active 1502. Pupil of Giovanni Bellini.

Francesco da Santacroce, doc. 1492–1508.

Francesco Rizzo da Santacroce (died c. 1524), active 1508. Heir and follower of Francesco da Santacroce.

Girolamo da Santacroce, active 1503–1556. Copied works by major Venetian painters.

Giovanni Girolamo Savoldo (c. 1480–1548). Influenced by Venetian painters.

Andrea Schiavone (Andrea Meldolla) (c. 1522–c. 1563). Influenced by later Venetian painters.

Sebastiano del Piombo (Sebastiano Luciani) (c. 1485–1547). Venice, Rome. Influenced by Giovanni Bellini, Giorgione, and Michelangelo.

Antonio Solario (Lo Zingaro), active c. 1495–c. 1515. Marches.

Giovanni Speranza (1480–1536). Pupil of B. Montagna.

Lambert Sustris (1515/20–c. 1595). Dutch. Pupil of Titian.

Tintoretto (Jacopo Robusti) (1518–1594). Influenced by Titian and Michelangelo.

Titian (Tiziano Vecellio) (c. 1480–1576). Pupil of Giovanni Bellini.

Francesco Vecellio (c. 1475–1559/60). Younger brother of Titian, pupil of Giovanni Bellini.

Francesco Verla, doc. 1512–1520. Influenced by Montagna.

Paolo Veronese (Caliari) (1528–1588). Influenced by Titian.

Giambattista Zelotti (1526–1578). Pupil of Badile.

FIFTEENTH CENTURY ITALIAN PRINTMAKERS

Baccio Baldini (died 1487). Florence. Goldsmith, niellist, engraver, draftsman.

Giovanni Pietro Birago, active c. 1470–c. 1513. Milan. Engraver.

Maso Finiguerra (1426–1464). Florence. Goldsmith, niellist, designer.

Andrea Mantegna (1431–1506). Mantua. Painter, engraver, designer.

Antonio del Pollaiuolo (1431/32–1498) Florence, Rome. Painter, sculptor, goldsmith, engraver, designer.

Francesco Rosselli (1448–1513). Florence. Painter, miniaturist, engraver, cartographer.

Andrea Zoan, active c. 1475–1519. Milan. Painter, engraver.

SIXTEENTH CENTURY ITALIAN PRINTMAKERS

Antonio da Trento, active c. 1508–1550. Woodcut designer.

Jacopo de' Barbari (c. 1460/70–c. 1516). Venice, Malines? Brussels? Painter, engraver, woodcut designer.

Nicolas Beatrizet (c. 1515–c. 1560). Place unknown. Engraver.

Giulio Bonasone (c. 1498–c. 1580). Place unknown. Engraver.

Domenico Campagnola (1500–c. 1581). Padua. Painter, engraver, woodcut designer.

Giulio Campagnola (c. 1482–c. 1515). Venice. Painter, miniaturist, engraver, gem cutter.

Giovanni Antonio da Brescia, active c. 1490–after 1525. Brescia. Engraver.

Giovanni Jacopo Caraglio (Verona c. 1500–Cracow c. 1570). Parma. Engraver.

Ugo da Carpi (c. 1480–1532). Venice, Rome. Woodcut designer, maker of chiaroscuro woodcuts.

Lorenzo Costa (1460–1535). Ferrara, Mantua. Painter, engraver.

Marco Dente da Ravenna (died 1527). Ravenna, Rome. Engraver.

Jacopo Francia (c. 1486–1557). Bologna. Painter, engraver, goldsmith.

Giorgio Ghisi (1520–1582). Mantua. Engraver.

Girolamo Mocetto (c. 1454/58–c. 1531). Murano. Painter, engraver.

Benedetto Montagna (c. 1480–c. 1555/58). Venice. Painter, engraver.

Agostino dei Musi (Agostino Veneziano) (Venice c. 1490–Rome c. 1540). Rome. Engraver.

Giovanni Battista Palumba, active c. 1500–1525. Painter, engraver, woodcut designer.

Parmigianino (Francesco Mazzola) (1503–1540). Parma, Casal Maggiore. Painter, etcher.

Marcantonio Raimondi (c. 1480–c. 1534). Bologna, Rome. Engraver.

Cristofano Robetta (1462–c. 1535). Florence. Goldsmith, engraver.

Andrea Schiavone (Andrea Meldolla) (c. 1522–c. 1563). Venice. Engraver.

Aenea Vico (Parma 1523–1567). Ferrara. Engraver.

———— FIFTEENTH CENTURY ITALIAN SCULPTORS ————

Baccio d'Agnolo (Florence 1462–1543). Choir stalls, decoration for municipal festivities, wood sculptures. Also architect.

Agostino di Duccio (Florence 1418–Perusa c. 1481). Tombs, façades, marble, and terra-cotta sculptures. Architect.

Benedetto Bugliono (1461–1521).

Desiderio da Settignano (Settignano c. 1430–1464). Reliefs, altars, monuments, portrait busts.

Donatello (Donato di Niccolò Bardi) (Florence 1386–1466). Marble statues, terra-cotta busts, bronze tomb slabs, carvings, stained glass windows, wood sculptures.

Francesco di Simone Ferrucci (Fiesole 1437–Florence 1493). Funeral monuments, columns for an altar. Traveled Fiesole, Florence, Bologna, Rome, Venice.

Lorenzo Ghiberti (Florence 1378–1455). Goldsmith, goldcaster.

Giuliano da Sangallo (Florence 1445–1516).

Leonardo di Chimenti Tasso (Florence 1466–c. 1500?) Altarpieces.

Benedetto da Maiano (Florence 1442–1497). Altarpieces, tombs, monuments, friezes, terra-cotta sketch models.

Michelozzo di Bartolommeo (Florence 1396–1472). Bronze façades, monuments, marble sculptures.

Michele da Firenze, doc. 1436–1441.

Mino da Fiesole (Poppi 1429–Florence 1484). Busts, pulpit reliefs, tombs, monuments.

Antonio del Pollaiuolo (Florence 1432/33–Rome 1498). Mythological statues, bas-reliefs. Goldsmith.

Andrea della Robbia (Florence 1435–1525). Bas-reliefs, doors, friezes, medallions, busts, enamels. Ceramicist.

Giovanni della Robbia (1469–1529/30). Bas-reliefs, fountains. Ceramicist.

Luca della Robbia (1399/1400–1482). Reliefs, bronze doors, enameled terra-
cotta lunettes, marble and bronze sculptures.
Domenico Rosselli (near Pistoia 1439–Fossombrone 1497/98). Reliefs of the
Virgin.
Antonio Rossellino (Settignano 1427–Florence 1479). Tombs, busts of chil-
dren, reliefs.
Andrea del Verrocchio (Florence 1435–Venice 1488). Lavabos, tombs, bronze
and terra-cotta sculptures. Trained as a goldsmith. Student of Rossellino.

Mantua

Pier Jacopo Alari-Bonacolsi (Antico) (Mantua c. 1460–Bozzalo 1528). Statu-
ettes, vases, mythological. Goldsmith, metalworker.

Padua

Gregorio di Allegreto, active 1442–1476.
Bellano Bartolommeo (b. Padua 1434–1496/97). Bronze reliefs, funeral monu-
ments. Student of Donatello.
Andrea Briosco (Il Riccio) (Padua c. 1471–1532). Small bronzes.

Venice

Bartolommeo Buono (Venice 1374–1464/67). Saint statues, exterior and inte-
rior relief of Ca d'Oro.
Antonio Lombardo (c. 1458–c. 1516). Altarpieces, relief, mythological carv-
ings.
Pietro Lombardo (c. 1435–1515). Padua, Venice. Bas-reliefs, biblical statues,
tombs, busts.
Antonia Rizzo (Antonio Bregno) (died 1499/1500), active from 1465. Doorway
relief sculptures.

Lombardy

Giovanni Antonio Amadeo (Pavia 1447–Milan 1522). Bas-relief facades, terra-
cotta decorations. Also architect.
Cristoforo Mantegazza (died 1482). Church façades, large statues, terra-cotta
decorations.

Liguria

Michele and Antonio Carlone, active 1489–1519. Both architects and sculp-
tors. Portals, altars.
Giovanni Gaggini (Bissone?–Mendrisio 1517). Genoa. Portals, bas-reliefs.
Pace Gaggini, active 1493–1522. Pavia, Genoa, Rivarolo, France. Church
portals, columns, statues.

Siena

Neroccio di Bartolommeo Landi (Siena 1447–1500). Large sculptures, wood sculptures. Student of Vecchietta.

Francesco di Giorgio (Martini) (1439–1501). Large sculptures, wood sculptures, bronze reliefs.

Lorenzo di Pietro Vecchietta (Castiglione d'Orcia c. 1412–1480). Bronze castings, large sculptures. Painter of frescoes at Baptistry of San Giovanni.

Urbano da Cortona (Cortona 1426–Siena 1504). Sculptures for cathedrals and churches, stucco reliefs. Student of Donatello.

———— SIXTEENTH CENTURY ITALIAN SCULPTORS ————

Bartolommeo Ammanati (Settignano 1511–Florence 1592). Civic sculptures, fountains, tombs.

Tiziano Aspetti (Padua 1565–Pisa 1607). Portrait busts, statuettes, functional objects, altars, bas-reliefs, figures.

Baccio Bandinelli (Florence 1493–Florence 1560). Large-scale religious and secular works, portraits, statuettes.

Giovanni Antonio de' Rossi (Milan 1517–Rome, after 1575). Active Venice, Rome, Florence. Medals.

Giovanni Bandini (Florence 1540–1599). Tomb figures, altar reliefs, portraits, secular figures.

Valerio Belli (c. 1468–1546). Bronze castings, plaquettes.

Giovanni Bologna (Douai, Belgium 1529–Florence 1608). Statuettes, altar and tomb sculptures, equestrian monuments. Architect.

Michelangelo Buonarroti (Caprese 1475–Rome 1564). Tombs, large-scale statues, reliefs, religious works (pietàs). Architect, painter. One of the great artists of history.

Girolamo Campagna (Verona 1550–after 1623). Religious sculptures, tombs, plaquettes.

Giovanni Jacopo Caraglio (Verona c. 1500–Cracow 1565). Plaquettes, medals. Goldsmith, architect, engraver.

Danese di Mechele Cattaneo (Colonnata near Carrara c. 1509–Padua 1573). Tombs, religious sculptures, fountains, statuettes, portraits. Poet. Pupil of Jacopo Sansovino.

Giovanni dal Cavino (Padua 1500–1570). Bronze castings, medals.

Benvenuto Cellini (Florence 1500–1571). Large-scale secular sculptures, statuettes. Medallist, draftsman.

Vincenzio Danti (Perugia 1530–1576). Large-scale religious sculptures, secular sculptures.

Desiderio da Firenze, active 1532–1545. Candlesticks, boxes, lamps, statuettes.

Gian Francesco Enzola (Parmensis) (1450–1478).

Annibale Fontana (Milan 1540–1587). Religious works, statuettes, functional objects. Medalist.

Pietro Francavilla (Cambrai 1548–Paris 1615). Large-scale religious and secular sculptures.

Vittore di Antonio Gambello (Camelio) (Venice c. 1455/60–Venice 1537). Statuettes.

Leone Leoni (Menaggio 1509–Milan 1590). Plaquettes, statuettes. Medalist, portraitist, goldsmith.

Pompeo Leoni (Pavia c. 1533–Madrid 1608). Tomb sculptures, bronze statues, busts.

Tullio Lombardo (Venice c. 1455–1532). Statuettes, tombs.

Lorenzetto (Lorenzo di Ludovico di Guglielmo) Lotti (Florence 1490–Rome 1541). Tombs.

Stefano Maderno (Bissone c. 1576–Rome 1636). Statuettes, mythological subjects.

Moderno, active late 15th–early 16th century in Northern Italy. Plaquettes.

Giovanni Angelo Montorsoli (Montorsoli near Florence 1507–Florence 1563). Fountains, marble, wood and stucco sculptures.

Giovanni da Nola (Marigliano) (Nola c. 1488–Naples 1558). Tombs, altar sculptures, woodcuts.

Guglielmo della Porta (Porlezza c. 1490–Rome 1577). Altar and tomb sculptures, portraits, plaquettes, statuettes.

Niccolò Roccatagliata (Genoa before 1539–Venice 1636). Statuettes, decorative appliques, candlesticks.

Angelo de Rossi, active late 16th century in Verona. Statuettes.

Giovanni Francesco Rustici (Florence 1474–Tours 1554). Large-scale sculptures, statuettes, bronze sculptures.

Francesco da Sangallo (1494–1576). Worked in Florence. Tombs.

Andrea Sansovino (near Monte Sansavino 1460/67–1529). Large-scale sculptures, tombs, reliefs, altar sculptures.

Il Sansovino (Jacopo Tatti) (Florence 1486–Venice 1570). Statuettes, reliefs, bronze doors, altar reliefs, large-scale religious sculptures, secular sculptures, tombs.

Girolamo da Santacroce (c. 1502–1537). Worked in Naples. Altar sculptures.

Severo da Ravenna, active c. 1500 in Padua. Bronze caster. Inkwells, caskets, religious statuettes, candlesticks.

Prospero Spani (Il Clemente, Sogario) (Reggio Emilia 1516–1584). Plaquettes, statues, statuettes. Architect, goldsmith.

Pietro Tacca (Carrara 1577–near Florence 1640). Busts, statues.

Bastiano Torrigiani (Bologna-Rome 1596) Altar sculpture, colossal religious figures, portrait busts.

Pietro Torrigiano (Florence 1472–Seville 1528). Portraits, tombs.

Niccolò Tribolo (Florence 1500–1550). Religious, fountains, large-scale tomb figures, statuettes.

Pierino da Vinci (Vinci c. 1530–Pisa 1553). Large-scale religious and secular works, portraits.

Alessandro Vittoria (Trent 1525–Venice 1608). Portraits, large-scale altar sculptures, statuettes, plaquettes.

FIFTEENTH- AND SIXTEENTH-
_____ CENTURY DUTCH AND FLEMISH PAINTING _____

Pieter Aertsen (Amsterdam 1507/08–Amsterdam 1575). Genre and religious scenes.

Joachim Beuckelaer (Antwerp c. 1530–1573). Religious history, still-lifes, portraits. Student of uncle, Pieter Aertsen.

Herri met de Bles (Bouvignes c. 1480 or 1500–after 1550) Landscapes, religious, portraits.

Hieronymus Bosch (Jerome van Aeken) (Hertzogenbosch, Bois-le-Duc c. 1450–1516). Religious. Engraver.

Dirk Bouts (Haarlem c. 1415–Louvain 1475). Religious.

Pieter Brueghel the Elder (c. 1525–Brussels 1569). Religious scenes, landscapes, genre scenes, still-lifes.

Robert Campin (Master of Flemalle) (Valenciennes c. 1375/78–Tournai 1444). Religious, portraits.

Petrus Christus (died Bruges 1472), active c. 1444. Religious scenes.

Joos van Cleve (Master of the Death of the Virgin) (Cleves ? c. 1485–Antwerp 1540/41). Religious.

Hieronymus Cock (Kock) (c. 1507–Antwerp or Rome 1570). Genre, landscapes. Engraver, art dealer, watercolorist.

Jan (de) Cock (Wellens) (Leiden c. 1480–Antwerp c. 1526). Religious scenes. Father of Hieronymus.

Pieter Coecke (Pieter Coecke van Aelst) (Alost 1502/07–Brussels 1550). Religious, portraits. Sculptor, architect, cartoonist of tapestries, writer.

Jacob van Oostsanen Cornelisz (Oostsanen before 1477–Amsterdam before 1533). Portraits, religious scenes. Draftsman.

Jacques Daret (c. 1404–Tournai after 1468). Religious and historical tapestry cartoons, religious themes, some portraits. Pupil of Robert Campin.

Gerard David (Oudewater, The Netherlands 1460–Bruges 1523). Altarpieces, religious. Traveled Bruges, Geneva, Antwerp.

Cornelis Engebrechtsz (Engelbrectsz) (Leiden c. 1488–1533). Religious history.

Geertgen Tot Sint Jans (Gérard de Saint-Jean) (Leiden c. 1465–c. 1495) Religious. Pupil of Albert van Ouwater.

Hugo van der Goes (Ghent c. 1440–near Soignies 1482). Religious, miniatures, portraits.

Jan Gossaert (Mabuse) (c. 1478–Middelburg c. 1536). Religious history, portraits, mythological, miniatures.

Maerten van Heemskerk (Veen) (Heemskerck near Haarlem 1498–Haarlem 1574). Religious history, mythological, portraits. Glassmaker, engraver.

Jan Sanders van Hemessen (Hemixem near Antwerp c. 1504–Haarlem before
 1566). Genre, mythological, religious.
Pieter Huys (Antwerp c. 1519–1584). Genre, religious. Engraver, illustrator.
Adriaen Isenbrandt (Ysenbrand) (c. 1490–Bruges 1551). Landscapes, religious.
Jan Joost (von Kalkar) (Kalcar 1460–Haarlem 1519). Religious history, still-
 lifes. Traveled, Cologne, Genoa, Naples.
Justus of Ghent (Joos van Ghent, Joos van Wassenhove) (c. 1435–c. 1480)
 Worked in Urbino, Antwerp, Ghent, Rome. Religious, some portraits.
Lucas van Leyden (Leiden 1489/94–1533). Historical, genre, landscapes, por-
 traits. Engraver. Pupil of Engebrechtsz.
Lambert Lombard (Liège 1506–1566). Religious history, genre, portraits, ar-
 chitecture. Traveled Germany, Rome.
Cornelis Metsys (Massys) (Antwerp before 1508–after 1550) Landscapes, pano-
 ramic views. Son of Quentin.
Quentin Metsys (Massys) (Louvain c. 1466–Antwerp 1530). Religious history,
 portraits, genre.
Master of Frankfurt, active second half of 15th century in Antwerp. Religious,
 altarpieces, portraits.
Master of Flemalle. See Robert Campin.
Master of the Female Half-Lengths, active early 16th century in Antwerp.
 Religious, busts of women, paintings of musicians.
Master of the Virgo inter Virgines, active c. 1450–1475 in Delft. Religious.
Hans Memling (Memlinc) (Mëmlingen c. 1425/40–Bruges 1494). Religious
 history, portraits.
Anthonis Mor (Utrecht c. 1517–Antwerp 1575). Court portraits, historical and
 religious scenes. Pupil of Jan Schoreel. Traveled Spain, Belgium.
Gillis Mostaert the Elder (near Antwerp c. 1534–Antwerp 1598). Landscapes,
 panoramic views of villages, fairs and festivals, genre scenes of snow and
 nighttime, historical scenes.
Albert van Ouwater, active mid-15th century in Haarlem. Religious.
Joachim Patinir (Patiniero) (Dinant or Bouvignes c. 1485–Antwerp 1524).
 Landscapes, religious. Traveled Bruges.
Jan Provost (Prevost) (Mons 1462/65–Bruges 1529). Religious, portraits.
Marinus van Reymerswaele (Seeland c. 1493–after 1567). Religious.
Jan van Scorel (Master of the Death of the Virgin) (Scorel 1495–Utrecht 1562).
 Religious history, portraits. Engineer, architect. Traveled Cologne, Stras-
 bourg, Basel, Rome.
Bartholomeus Spranger (Antwerp 1546–Prague 1611). Mythological, some re-
 ligious. Etcher. Traveled Paris, Lyon, Cologne, Milan, Rome, Parma.
Jan van Eyck (c. 1390–Bruges 1441). Religious, portraits, mythological.
Jan Cornelisz Vermeijen (Vermeyen) (Beverwyck near Haarlem c. 1500–Brus-
 sels 1559). Religious history, tapestry cartoons, portraits. Engraver.
Rogier van der Weyden (Tournai 1390/1400–Brussels 1464). Religious history.
 Pupil of Robert Campin.

_____ FIFTEENTH-CENTURY GERMAN PAINTERS _____

Rueland Frueauf the Elder (c. 1440–Passau 1507). Religious, portraits.

Friedrich Herlin (Rothenburg c. 1435–Nördlingen c. 1500), active in Nordlingen c. 1459–c. 1499. Historical, religious, genre.

Wolf Huber (Feldkirch c. 1490–Passau 1553). Portraits, landscapes. Woodcuts.

Caspar Isenmann (died Colmar, c. 1472), active 1433 in Colmar. Religious, genre.

Johann Koerbecke, active c. 1446–1491 in Münster. Religious themes, altarpieces.

Stephan Lochner (Meersburg c. 1405/1415–Cologne 1451). Religious.

Nicolaus Alexander Mair (von Landshut) (died probably 1520), active 1492–1514 in Landshut. Religious.

Master E. S., active 1450–1470. Engraver, goldsmith.

Master of the Amsterdam Cabinet, active late 15th century in Southern Germany. Engraver.

Master of the Holy Kinship the Younger, active 1480–1520, Cologne School. Religious.

Master of the Life of Mary, active 1463–1480 in Cologne. Religious.

Master of the Saint Bartholomew Altarpiece (c. 1450–c. 1510/20). Cologne. Religious. Illustrator.

Master of Saint Severin, active 1480–1510 in Cologne. Religious themes, woodcuts.

Israel van Meckenem (died Bocholt 1503 or after 1517), active c. 1445–1503. Painter, engraver, goldsmith.

Lukas Moser (Weilderstadt, early 15th century), active 1431. Religious, historical.

Hans Multscher (Reichenhofen near Leutkirch c. 1400–Ulm 1469). History, religious, altarpieces, wood sculptures.

Michael Pacher (Neufstift c. 1435–Salzburg 1498). Religious altarpieces. Sculptor.

Hans Pleydenwurff, active c. 1451–1472 in Nuremberg.

Hermen Rode (c. 1468–1504), active in Lübeck 1485–1504. Religious, altarpieces, some portraits.

Martin Schongauer (Colmar c. 1430/50–Breisach 1491). Religious, some portraits. Engraver.

Hans Schüchlin (Ulm c. 1440–c. 1505) Religious, portraits. Pupil of Michael Wolgemuth.

Konrad Witz (Rottweil c. 1400/1410–Basel or Geneva 1444/46). Historical, religious.

Michael Wolgemut (Nuremberg 1434–1519). Religious, portraits. Woodcut designer, draftsman.

───── FIFTEENTH-CENTURY GERMAN SCULPTORS ─────

Gregor Erhart (Ulm c. 1465–1540). Altarpieces, wood statues.

Michael Erhart of Ulm, active 1469–1518. Ulm. Wood sculptures, altars.

Nikolaus Gerhard (Nicolaus von Leyden; Nicolas Gerhaert von Leyden; Nicolaus Lerch) (died Vienna-Neustadt 1473 or 1493), active c. 1462–1473, in Strasburg. Busts, choir stalls, tombs.

Adam Kraft (c. 1460–c. 1508), active 1490–1509. Nuremberg. Tombs, bas-reliefs.

Hans Multscher (Reichenhofen c. 1400–Ulm 1467). Altarpieces, panels, church decorations.

Michael Pacher (Neufstift c. 1435–1498 Salzburg). Altarpieces, religious, panels.

Tillman Riemenschneider (Osterode c. 1460–Wurzburg 1531). Tombs, wood, stone (sandstone).

Veit Stoss (Nuremberg 1438/47–1533). Wood, painter, engraver, marble, limestone, alabaster.

SIXTEENTH-CENTURY GERMAN PAINTERS AND ───────────────── PRINTMAKERS ─────────────

Heinrich Aldegraver (c. 1502–1558). Painter, engraver.

Albrecht Altdorfer (Altdorf c. 1480–Ratisbonne 1538). Painter, draftsman, printmaker, architect. Portraits, religious prints, landscapes, battle scenes.

Jost Amman (Zurich 1539–Nuremberg 1591). Prolific engraver, woodcut designer.

Hans Baldung (called Grien) (Gmund 1484/85–Strasbourg 1545). Supernatural, religious, allegorical, portraits. Printmaker, stained glass designer.

Barthel Beham (Peham, Behem, Böhm) (Nuremberg 1502–Italy 1540). Religious, portraits. Engraver.

Hans Burgkmair the Elder (Augsburg 1473–1531/53/59). Graphic artist, biblical portraits, religious, miniaturist. Pioneer in woodcut portraits.

Lucas Cranach, the Elder (Kronach, Bavaria 1472–Weimar 1553). Printmaker, draftsman, religious, mythology, portraits, nudes.

Lucas Cranach, the Younger (Wittenberg 1515–Weimar 1586). Portraits, busts, nudes, some wood engravings.

Albrecht Dürer (Nuremberg 1471–1528). Religious, genre, portraits. Traveled Italy, Venice, Netherlands. Engraver, woodcut designer.

Urs Graf the Elder (Ursus Graff) (Soleure 1485–Bale 1527/28). Religious, genre. Stained glass, wood engravings.

Mathias Grünewald (Mathis Neithardt) (Wurzburg 1455/70/80–Halle 1528). Religious, allegorical, portraits, altarpieces.

Augustin Hirschvogel (Nuremberg 1503–1553). Engraver.

Hans Holbein the Elder (Augsburg 1460/65–Isenheim 1524). History, religious, portraits. Draftsman.

Hans Holbein the Younger (Augsburg c. 1497–London 1543). History portraits, religious. Traveled England. Draftsman, printmaker.

Wolf Huber (Feldkirch c. 1490–Passau 1553). Portraits, landscape, religious, mythological, genre, wood engravings. Pupil of Albrecht Altdorfer.

Hans von Kulmbach (Culmbach, Süss, Süsz von Kulmbach) (Kulmbach c. 1480–Nuremberg 1522). Religious, portraits, wood engraver.

Niklaus Manuel Deutsch (1484–1530). History, religious, portraits, altarpieces. Traveled Italy, Switzerland. Engraver.

George Pencz (Nuremberg c. 1500–1550). Painter, engraver.

Erhard Schoen (Schön) (died 1542). Active in Nuremberg. Religious, biblical illustrations, card designs. Draftsman, wood engraver.

SIXTEENTH-CENTURY GERMAN SCULPTORS

Peter Flötner (Flattner, Flodner) (Thurgau c. 1485–Nuremberg 1546). Genre statuettes. Wood carver.

Stephan Godl (Godel, Goldel, Jädel) (died Mühlau, near Innsbruck in 1543). Religious, mythological, figures for tomb of Maximilian I.

Wenzel Jamnitzer (Jamitzer, Gamiczer) (Vienna 1508–Nuremberg 1585). Statuettes and objects. Engraver, etcher.

Hans Leinberger, active at Landshut beginning of sixteenth century. Wood altarpieces and statues.

Leonhard Magt (died Innsbruck c. 1532). Bronze statues of saints.

Hermann Vischer (Fischer) (died 1488). Active in Nuremberg by 1457. Epitaphs and tombs.

Pieter Vischer the Elder (Nuremberg c. 1460–1529). Reliquaries, church ornaments, candelabras, statuettes. Religious, mythological. Son and student of Hermann Vischer.

Pieter Vischer the Younger (Nuremberg? 1487–1528). Tombs. Son and student of Pieter Vischer the Elder. Sculptor, engraver. Traveled Italy.

Matthaeus Wallbaum (Waldbaum, Wallpaum) (Kiel 1554–Augsburg 1632). Mythological, religious. Specialized in silver Diana groups.

SIXTEENTH CENTURY FRENCH PAINTERS

François Clouet (c. 1510–1572). Portraits.

Jean Clouet (1486?–1540). Portraits.

Jean Duvet (Langres 1485–c. 1562). First major French engraver.

Corneille de Lyon (c. 1500–c. 1574). Portraits.

RENAISSANCE ART, 1400–1600: MAJOR COLLECTIONS

—————— FIFTEENTH-CENTURY ITALIAN PAINTING ——————

Europe

Altenburg, Staatliches Lindenau-
Museum
Amsterdam, Rijksmuseum
Bergamo, Galleria dell'Accademia
Carrara
Berlin-Dahlem, Staatliche Museen
Bologna, Pinacoteca Nazionale
Budapest, Museum of Fine Arts
Cambridge, Fitzwilliam Museum
Dresden, Gemäldegalerie
Dublin, National Gallery of Ireland
Ferrara, Pinacoteca Nazionale
Florence
Fondazione Horne Museum
Galleria degli Uffizi
Frankfurt, Städelsches Kunstin-
stitut
London
National Gallery
Victoria and Albert Museum
Wallace Collection
Milan
Museo Civico, Castello Sforzesco
Museo Poldi Pezzoli
Pinacoteca Ambrosiana
Pinacoteca di Brera
Munich, Alte Pinakothek
Oxford, Ashmolean Museum of Art
and Archaeology
Paris
Musée National du Louvre
Musée Jacquemart-André
Perugia, Galleria Nazionale dell'
Umbria
Pisa, Museo Nazionale di S. Matteo
Rome, Pinacoteca Vaticana
Siena, Pinacoteca Nazionale

Turin, Galleria Sabauda
Urbino, Galleria Nazionale delle
Marche
Venice
Gallerie dell'Accademia
Fondazione Giorgio Cini
Verona, Museo di Castelvecchio
Vienna, Kunsthistorisches Museum

United States

Baltimore, Walters Art Gallery
Boston
Isabella Stewart Gardner Museum
Museum of Fine Arts
Cambridge, Fogg Art Museum, Har-
vard University
Cleveland, Cleveland Museum of
Art
Detroit, Detroit Institute of Arts
Kansas City (MO), William Rockhill
Nelson Gallery of Art and Mary
Atkins Museum of Fine Arts
Minneapolis, Minneapolis Institute
of Arts
New Haven, Yale University Art
Gallery
New York
Brooklyn Museum
Frick Collection
Metropolitan Museum of Art
Philadelphia, Philadelphia Museum
of Art
Princeton, Art Museum, Princeton
University
Washington, D.C., National Gallery
of Art
Worcester (MA), Worcester Art Mu-
seum

SIXTEENTH-CENTURY ITALIAN PAINTING

Europe

Berlin-Dahlem, Staatliche Museen
Bologna, Pinacoteca Nazionale
Cambridge, Fitzwilliam Museum
Cologne, Wallraf-Richartz-Museum
Dresden, Gallery
Florence
 Galleria degli Uffizi
 Galleria dell'Accademia
 Palazzo Pitti
London
 National Gallery
 Victoria and Albert Museum
Madrid, Museo Nacional del Prado
Milan
 Pinacoteca Ambrosiana
 Pinacoteca di Brera
Naples, Museo e Gallerie Nazionali
 di Capodimonte
Oxford, Ashmolean Museum of Art
 and Archaeology
Paris, Musée National du Louvre
Parma, Pinacoteca (Gallery)
Rome
 Galleria Borghese
 Musei Vaticani
Siena, Pinacoteca Nazionale
Venice
 Fondazione Giorgio Cini
 Gallerie dell'Accademia

Vienna, Kunsthistorisches Museum
Viterbo, Museo Civico

United States

Baltimore, Walters Art Gallery
Boston
 Isabella Stewart Gardner Museum
 Museum of Fine Arts
Cambridge, Fogg Art Museum, Harvard University
Cleveland, Cleveland Museum of Art
Detroit, Detroit Institute of Arts
New Haven, Yale University Art Gallery
New York
 Frick Collection
 Metropolitan Museum of Art
Philadelphia, Philadelphia Museum of Art
Princeton, Art Museum, Princeton University
Raleigh (NC), Museum of Art
Washington, D.C., National Gallery of Art
Williamstown, Sterling and Francine Clark Art Institute
Worcester (MA), Worcester Art Museum

FIFTEENTH-CENTURY ITALIAN DRAWING

Europe

Bayonne, Musée León Bonnat
Berlin, Staatliche Museen, Kupferstichkabinett
Budapest, Museum of Fine Arts
Cambridge
 Fitzwilliam Museum

Chantilly, Musée Condé
Dresden, Staatlichen Kunstsammlungen, Kupferstichkabinett
Düsseldorf, Staatlichen Kunstakademie
Florence, Galleria degli Uffizi

Haarlem
 Franz Koenigs Collection
 Teylers Museum
Hamburg, Hamburger Kunsthalle
Lille, Musée Wicar
London
 British Museum
 Victoria and Albert Museum
Milan, Pinacoteca Ambrosiana
Munich, Staatliche Graphische
 Sammlung
Naples, Pinacoteca
Oxford
 Ashmolean Museum of Art and
 Archaeology
 Picture Gallery, Christ Church
Paris
 École Nationale Supériore des
 Beaux-Arts
 Musée National du Louvre
Rennes, Musée des Beaux-Arts
Rome, Gabinetto Nazionale della
 Stampe

Rotterdam, Museum Boymans-van
 Beuningen
Siena, Biblioteca Communale
Stockholm, Nationalmuseum
Syracuse, Museo Bellomo
Turin, Biblioteca Reale
Venice
 Biblioteca Correr
 Gallerie dell'Accademia
Vienna, Graphische Sammlung Albertina

United States

Boston, Museum of Fine Arts
Brunswick (ME), Bowdoin College
 Museum of Art
Cambridge, Fogg Art Museum, Harvard University
Chicago, Art Institute of Chicago
Cleveland, Cleveland Museum of
 Art
New York, Metropolitan Museum of
 Art

———— FIFTEENTH-CENTURY ITALIAN PRINTMAKING ————

Europe

Amsterdam, Rijksmuseum
Berlin, Staatliche Museen, Kupferstichkabinett
Dresden, Staatlichen Kunstsammlungen, Kupferstichkabinett
Hamburg, Hamburger Kunsthalle
London, British Museum
Munich
 Bayerische Staatsbibliothek
 Staatliche Graphische Sammlung
Paris
 Bibliothèque Nationale
 Musée National du Louvre

Rome, Biblioteca Vaticana
Vienna, Graphische Sammlung Albertina

United States

Boston, Museum of Fine Arts
Brunswick (ME), Bowdoin College
 Museum of Art
Cambridge, Fogg Art Museum, Harvard University
Chicago, Art Institute of Chicago
Cincinnati, Cincinnati Art Museum
Cleveland, Cleveland Museum of
 Art

Minneapolis, Minneapolis Institute
of Arts

Washington, D.C., National Gallery
of Art

SIXTEENTH-CENTURY ITALIAN DRAWING AND PRINTMAKING

Europe

Amsterdam
 Museum Fodor
 Rijksmuseum Prentenkabinet
Aschaffenburg, National Museum
Bayonne, Musée Léon Bonnat
Berlin, Staatliche Museen, Kupfer-
 stichkabinett
Besançon, Museum
Bremen, Kunsthalle
Budapest
 Museum of Fine Arts
 National Gallery
Chantilly, Musée Condé
Cologne, Wallraf-Richartz-Museum
Copenhagen, The Royal Museum of
 Fine Arts
Darmstadt, Hessisches Landesmu-
 seum
Dresden, Staatliches Kunstsammlun-
 gen, Kupferstichkabinett
Dublin, National Gallery of Ireland
Düsseldorf, Kunstakademie
Edinburgh, National Gallery
Florence
 Biblioteca Marucelliana
 Biblioteca Medicea Laurenziana
 Biblioteca Riccardiana
 Casa Buonarroti
 Galleria degli Uffizi, Gabinetto dei
 Disegni
 Museo Nazionale del Bargello
 Palazzo Pitti
Frankfurt, Städelsches Kunstinstitut
Gijón, Instituto Jovellanos

Göttingen, Kunstsammlung der
 Universität
Haarlem, Teylers Museum
Hamburg, Hamburger Kunsthalle
Leiden, Prentenkabinet der Rijksuni-
 verstet
Leipzig, National Museum
Leningrad, Hermitage
Lille, Musée Wicar
Liverpool, Walker Art Gallery
London
 British Museum
 Royal Academy of Arts
 South Kensington Museum
 Victoria and Albert Museum
Marseilles, Musée de Longchamps
Melbourne (Australia), Museum
Milan
 Museo Civico
 Pinacoteca Ambrosiana
Moscow, Museum of Fine Arts
Munich, Staatliche Graphische
 Sammlung
Nancy
 Bibliothèque Municipale
 Musée Historique Lorrain
Naples, Museo e Gallerie Nazionali
 di Capodimonte
Oxford, Ashmolean Museum of Art
 and Archaeology
Paris
 Bibliothèque Nationale
 École Nationale Supérieure des
 Beaux-Arts
 Musée National du Louvre
Rennes, National Museum

Rome
 Gabinetto Nazionale delle Stampe
 Galleria Nazionale d'Arte Antica,
 Palazzo Corsini
 Galleria Nazionale, Palazzo Bar-
 berini
Rotterdam, Museum Boymans van-
 Beuningen
Stockholm, Nationalmuseum
Venice, Gallerie dell'Accademia
Vienna, Graphische Sammlung Al-
 bertina
Viterbo, Pinacoteca

United States

Boston
 Isabella Stewart Gardner Museum
 Museum of Fine Arts
Cambridge, Fogg Art Museum, Har-
 vard University

Chicago, The Art Institute of Chi-
 cago
Cleveland, Cleveland Museum of
 Art
Detroit, Detroit Institute of Arts
Los Angeles, Los Angeles County
 Museum of Art
New Haven, Yale University Art
 Gallery
New York
 Frick Collection
 Metropolitan Museum of Art
 Pierpont Morgan Library
Princeton, Art Museum, Princeton
 University
Providence, Museum of Art, Rhode
 Island School of Design
Washington, D.C., National Gallery
 of Art

_____ FIFTEENTH-CENTURY ITALIAN SCULPTURE _____

Europe

Ancona, Museo Archeologico Nazio-
 nale delle Marche
Aquileia, Museo Archeologico Na-
 zionale
Avignon, Musée Calvet
Berlin, Staatliche Museen
Bologna, Museo Civico Archeologico
Città di Castello, Pinacoteca Comu-
 nale
Empoli, Museo Diocesano, annesso
 alla Collegiata
Faenza, Pinacoteca e Museo Civico
Ferrara, Museo del Duomo
Florence
 Casa Buonarroti
 Fondazione Horne
 Museo Bardini e Galleria Corsi

 Museo Nazionale del Bargello
Leningrad, Hermitage
Lille, Musée des Beaux-Arts
London, Victoria and Albert Mu-
 seum
Lyons, Musée des Beaux-Arts
Milan
 Museo Civico
 Museo del Duomo
Naples, Museo Nazionale
Oxford, Ashmolean Museum of Art
 and Archaeology
Palermo, Museo Nazionale
Paris, Musée National du Louvre
Pavia, Museo Civico
Pesaro, Museo Oliveriano
Siena
 Museo dell'Opera Metropolitano
 Pinacoteca Nazionale

Turin, Museo Civico
Venice
 Museo Correr e Quadreria Correr
 Palazzo Ducale e Divisione Tech-
 nico Artistica
Verona
 Museo di Castelvecchio
 Museo Civico
Vienna, Kunsthistorisches Museum
Viterbo, Museo Civico

United States

Boston, Museum of Fine Arts
New York
 Frick Collection
 Metropolitan Museum of Art
Philadelphia, Philadelphia Museum
 of Art
Washington, D.C., National Gallery
 of Art

SIXTEENTH-CENTURY ITALIAN SCULPTURE

Europe

Amsterdam, Rijksmuseum
Berlin, Staatliche Museen
Bologna, Museo Civico Archaeolog-
 ico
Budapest, Szepmuvezzetimuseum
Florence
 Casa Buonarroti
 Galleria degli Uffizi
 Galleria dell'Accademia
 Loggia dei Lanzi
 Museo dell'Opera del Duomo
 Museo Nazionale del Bargello
 Palazzo Pitti
 Palazzo Vecchio
Fontainebleau, Musée National du
 Château de Fontainebleau
Genoa, Museo e Galleria dell' Acca-
 demia Ligustica di Belle Arti
London
 The British Museum
 Royal Academy of Arts
 Victoria and Albert Museum
Madrid, Museo Nacional del Prado
Milan, Castello Sforzesco
Naples, Museo Nazionale e Gallerie
 di Capodimonte
Paris, Musée National du Louvre

Rome
 Galleria Borghese
 Musei Vaticani
Venice
 Ca'd'Oro (Galleria Giorgio Fran-
 chetti)
 Museo Archeologico
 Palazzo Ducale
Verona, Musei Civici di Verona,
 Castelvecchio
Vienna, Kunsthistorisches Museum

United States

Allentown, Allentown Art Museum
Baltimore, Walters Art Gallery
Boston
 Isabella Stewart Gardner Museum
 Museum of Fine Arts
Brunswick (ME), Bowdoin College
 Museum of Art
Chicago
 Art Institute of Chicago
 David and Alfred Smart Gallery,
 University of Chicago
Cleveland, Cleveland Museum of
 Art
Columbia (SC), Columbia Museum
 of Art

Coral Gables (FL), Lowe Art Museum, University of Miami
Kansas City, (MO), William Rockhill Nelson Gallery of Art and Mary Atkins Museum of Fine Art
Lawrence (KS), Museum of Art, University of Kansas
Madison (WI), Elvehjem Art Center, University of Wisconsin
Memphis, Brooks Memorial Art Gallery
New York
 Frick Collection
 Metropolitan Museum of Art
Northampton (MA), Smith College Museum of Art

Notre Dame (IN), Snite Museum, University of Notre Dame
Oberlin, Allen Memorial Art Museum
Providence, Museum of Art, Rhode Island School of Design
Santa Barbara, University of California, Santa Barbara Art Museum
Seattle, Seattle Art Museum
Toledo, Toledo Museum of Art
Tucson, University of Arizona Museum of Art
Tulsa, Philbrook Art Center
Washington, D.C., National Gallery of Art

FIFTEENTH- AND SIXTEENTH-CENTURY DUTCH & FLEMISH PAINTING

Europe

Aix-en-Provence, Musée Granet
Amsterdam, Rijksmuseum
Antwerp
 Musée Royal Beaux-Arts
 Museum Mayer van den Bergh
Basel, Kunstmuseum
Beaune, Musée de l'Hôtel-Dieu
Berlin
 Kaiser-Friedrich Museum
 Staatliche Museen, Gemäldegalerie
Bruges, Groeninge Museum
Brussels
 Bibliothèque Royal Albert Uer
 Musées Royaux des Beaux-Arts de Belgique
Budapest, Museum of Fine Arts
Cambridge, Fitzwilliam Museum
Chantilly, Musée Condé
Cologne
 Kunstgewerbemuseum der Stadt

 Wallraf-Richartz-Museum
Copenhagen, Nationalmuseet
Danzig, Muzeum Pomorskie
Darmstadt, Hessisches Landesmuseum
Dijon, Musée des Beaux-Arts
Dresden, Staatliche Kunstsammlungen
Dublin, National Gallery of Ireland
Edinburgh, National Gallery
Florence, Galleria degli Uffizi
Frankfurt, Städelsches Kunstinstitut
Ghent, Museum voor Schone Kunsten
Haarlem, Teylers Museum
The Hague, Mauritshuis
Hamburg, Hamburger Kunsthalle
Leiden, Stedelijk Museum "De Lakenhal"
Leipzig, Museum der bildenden Künste
Leningrad, Hermitage
Lille, Musée des Beaux-Arts

Lisbon, Museu Nacional de Arte Antiga
Liverpool, Walker Art Gallery
London
 British Museum
 Courtauld Institute Galleries
 National Gallery
Lübeck, St. Annen-Museum
Lyons, Musée des Beaux-Arts
Madrid
 Museo Nacional del Prado
Melbourne (Australia), National Gallery of Victoria
Munich, Alte Pinakothek
Naples, Museo e Gallerie Nazionali di Capodimonte
Nuremberg, Germanisches Nationalmuseum
Oxford, Ashmolean Museum of Art and Archaeology
Paris
 Bibliothèque Nationale
 Musée de Cluny
 Musée du Petit Palais
 Musée National du Louvre
Prague, National Gallery
Rotterdam, Museum Boymans-van Beuningen
Rouen, Musée des Beaux-Arts et de Céramique
Stockholm, Nationalmuseum
Stuttgart, Staatsgalerie
Turin, Galleria Sabauda
Utrecht, Centraal Museum der Gemeente
Vienna
 Kunsthistorisches Museum
 Österreichische Nationalbibliothek

United States

Baltimore
 Baltimore Museum of Art
 Walters Art Gallery
Boston, Museum of Fine Arts
Chicago, Art Institute of Chicago
Cleveland, Cleveland Museum of Art
Detroit, Detroit Institute of Arts
Houston, Museum of Fine Arts
Merion Station (PA), Barnes Foundation Museum of Art
New Haven, Yale University Art Gallery
New York
 Cloisters
 Frick Collection
 Metropolitan Museum of Art, Lehman Collection
Pasadena, Norton Simon Museum
Philadelphia, Philadelphia Museum of Art, John G. Johnson Collection
Pittsburgh, Museum of Art, Carnegie Institute
Princeton, Art Museum, Princeton University
Richmond, Virginia Museum of Fine Arts
San Diego, Fine Arts Gallery of San Diego
Toledo, Toledo Museum of Art
Washington, D.C., National Gallery of Art
Worcester (MA), Worcester Art Museum

FIFTEENTH- AND SIXTEENTH-CENTURY
—————— DUTCH AND FLEMISH DRAWING ——————

Europe

Amsterdam, Rijksmuseum
Basel, Öffentliche Kunstsammlung, Kupferstichkabinett
Berlin, Staatliche Museen, Kupferstichkabinett
Bremen, Kunsthalle
Braunschweig, Herzog Anton Ulrich-Museum
Brussels, Cabinet des Estampes
Cracow, National Museum
Dresden, Staatliche Kunstsammlungen, Kupferstichkabinett
Frankfurt, Städelsches Kunstinstitut
Hamburg, Hamburger Kunsthalle
London, British Museum
Nuremberg, Germanisches Nationalmuseum
Oxford, Picture Gallery, Christ Church
Paris, Musée National du Louvre, Cabinet des Dessins
Rotterdam, Museum Boymans-van Beuningen

Vienna, Graphische Sammlung Albertina

United States and Canada

Brunswick (ME), Bowdoin College Museum of Art
New Haven, Yale University Art Gallery
New York
 Metropolitan Museum of Art
 Pierpont Morgan Library
Northampton (MA), Smith College Museum of Art
Oberlin, Allen Memorial Art Museum
Ottawa (Canada), National Gallery of Canada
Sacramento, E. B. Crocker Art Gallery
Washington, D.C., National Gallery of Art, Rosenwald Collection

FIFTEENTH- AND SIXTEENTH-CENTURY
—————— DUTCH & FLEMISH PRINTMAKING ——————

Europe

Amsterdam, Rijksmuseum, Prentenkabinet
Berlin, Staatliche Museen, Kupferstichkabinett
Frankfurt, Städelsches Kunstinstitut
Haarlem, Teylers Museum
London, British Museum
Munich
 Bayerische Staatsbibliothek
 Staatliche Graphische Sammlung

Naples, Biblioteca Nazionale "Vittorio Emanuele III"
Paris
 Bibliothèque Nationale
 Musée du Petit Palais
 Musée National du Louvre
Turin, Museo Civico
Venice
 Biblioteca Nazionale Marciana
Vienna, Graphische Sammlung Albertina

United States

Boston, Museum of Fine Arts
Chicago, Art Institute of Chicago
Cleveland, Cleveland Museum of
Art

Minneapolis, Minneapolis Institute
of Arts
New York, Metropolitan Museum of
Art
St. Louis, City Art Museum of St.
Louis

FIFTEENTH- AND SIXTEENTH-CENTURY GERMAN PAINTING

Europe

Augsburg, Staatliche Kuntsammlun-
gen, Gemäldegalerie
Basel
Kunstmuseum
Öffentliche Kunstsammlung
Berlin, Staatliche Museum
Budapest, Museum of Fine Arts
Cologne, Wallraf-Richartz-Museum
Colmar, Musée d'Unterlinden
Dresden, Dresden Gallery
Edinburgh, National Gallery of Scot-
land
Florence, Galleria degli Uffizi
Frankfurt, Städelsches Kunstinstitut
Glasgow, Glasgow Art Gallery and
Museum
Hamburg, Hamburger Kunsthalle
Karlsruhe, Staatliche Kunsthalle
Leningrad, Hermitage
Lisbon, Museu National de Arte An-
tiga
London
British Museum
Courtauld Institute of Art
National Gallery

Victoria and Albert Museum
Madrid, Museo Nacional del Prado
Munich
Alte Pinakothek, Bayerische
Staatsgemäldesammlungen
Bayerisches Nationalmuseum
Nuremberg, Germanisches National-
museum
Oxford, Ashmolean Museum of Art
and Archaeology
Paris, Musée National du Louvre
Prague, National Gallery
Stuttgart, Staatsgalerie
Vienna
Kunsthistorisches Museum
Österreichische Galerie

United States

Boston, Museum of Fine Arts
Chicago, Art Institute of Chicago
Cleveland, Cleveland Museum of
Art
New York, Metropolitan Museum of
Art
Washington, D.C., National Gallery
of Art

FIFTEENTH- AND SIXTEENTH-CENTURY GERMAN DRAWING

Europe

Bayonne, Musée Léon Bonnat

Berlin, Staatliche Museen, Kupfer-
stichkabinett

Bremen, Kunsthalle
Budapest, Szépmüvészeti Múzeum
Cambridge, Fitzwilliam Museum
Dresden, Sächsische Landesbibliothek
Frankfurt, Städelsches Kunstinstitut
Leningrad, Hermitage
Lille, Musée des Beaux-Arts
London, British Museum
Milan, Pinacoteca Ambrosiana
Munich, Staatsbibliothek
Nuremberg, Germanisches Nationalmuseum
Oxford, Ashmolean Museum of Art and Archaeology
Paris
　Bibliothèque Nationale
　Musée National du Louvre
Rotterdam, Museum Boymans-van-Beuningen
Vienna, Graphische Sammlung Albertina

United States

Boston, Museum of Fine Arts
Cambridge, Fogg Art Museum, Harvard University
Cleveland, Cleveland Museum of Art
Chicago, Art Institute of Chicago
Kansas City (MO), Rockhill Nelson Gallery of Art and Mary Atkins Museum of Fine Arts
New Haven, Yale University Art Gallery
New York, Metropolitan Museum of Art, Lehman Collection
　Pierpont Morgan Library
Sacramento, E. B. Crocker Gallery
Washington, D.C., National Gallery of Art, Rosenwald Collection

FIFTEENTH- AND SIXTEENTH-CENTURY GERMAN PRINTMAKING

Europe

Amsterdam, Rijksmuseum Prentenkabinet
Basel, Öffentliche Kunstsammlung
Berlin, Staatliche Museen, Kupferstichkabinett
Cambridge, Fitzwilliam Museum
Coburg, Kunstsammlungen der Veste
Dresden, Kupferstichkabinett
Frankfurt, Städelsches Kunstinstitut
Hamburg, Hamburger Kunsthalle
London, British Museum
Munich, Staatliche Graphische Sammlung
Nuremberg, Germanisches National Museum

Oxford, Ashmolean Museum of Art and Archaeology
Paris, Bibliothèque Nationale
Rotterdam, Museum Boymans-van Beuningen
Vienna, Graphische Sammlung Albertina

United States

Boston, Museum of Fine Arts
Cambridge, Fogg Art Museum, Harvard University
Chicago, Art Institute of Chicago
Cleveland, Cleveland Museum of Art
Fort Worth, Kimbell Art Foundation

New Haven, Yale University Art Gallery

New York, Metropolitan Museum of Art

Oberlin, Allen Memorial Art Museum

Princeton, Art Museum, Princeton University

Washington, D.C., National Gallery of Art, Rosenwald Collection

FIFTEENTH- AND SIXTEENTH-CENTURY GERMAN SCULPTURE

Europe

Berlin, Staatliche Museen
Colmar, Musée d'Unterlinden
Cologne, Kunstgewerbemuseum
Dijon
 Musée Archeologique
 Musée des Beaux-Arts
Düsseldorf, Kunstmuseum
Hamburg, Museum für Kunst und Gewerbe
Innsbruck, Hofkirche
London
 British Museum
 Victoria and Albert Museum
Munich, Bayerisches Nationalmuseum
Nuremberg, Germanisches Nationalmuseum
Paris
 Musée de Cluny
 Musée National du Louvre

Prague, National Gallery
Strasbourg, Musée de l'Oeuvre Notre-Dame
Vienna, Kunsthistorisches Museum
Warsaw, Museum Narodowe

United States

Boston, Museum of Fine Arts
Cambridge, Fogg Art Museum, Harvard University
Chicago, Art Institute of Chicago
New Haven, Yale University Art Gallery
New York
 Frick Collection
 Metropolitan Museum of Art
Providence, Museum of Art, Rhode Island School of Design
Washington, D.C., National Gallery of Art

SIXTEENTH-CENTURY FRENCH PAINTING

Europe

Berlin, Kaiser-Freidrich Museum
Chantilly, Musée Condé
Fontainebleau, Musée National du Château de Fontainebleau
Leningrad, Hermitage

London
 National Gallery
 Wallace Collection
Lyons, Musée des Beaux-Arts
Madrid, Museo Nacional del Prado
Oxford, Ashmolean Museum of Art and Archaeology

Paris
 Bibliothèque Nationale
 Ecole National Supérieure des
 Beaux-Arts
 Musée National du Louvre
Stockholm, Nationalmuseum
Turin, Turin Gallery
Versailles, Musée National de Ver-
 sailles et des Trianons
Vienna, Kunsthistorisches Museum

United States

Boston, Museum of Fine Arts
Chicago, Art Institute of Chicago
Cleveland, Cleveland Museum of
 Art
New York, Metropolitan Museum of
 Art

CHAPTER 8

Seventeenth-Century Art

Europe's religious, political, intellectual, and cultural life underwent significant transformations in the seventeenth century that deeply affected the arts. Protestantism swept away the certainties of Catholicism and challenged the authority of the pope as well as the cults of the Virgin and other protective saints. The ideological differences between the two religions plunged Europe into almost continual war during this century, which was one of the most destructive in Europe's history. It was an age of doubt about the meaning and purpose of life that brought with it a new responsibility for each individual to give order and direction to his existence. It produced new developments in philosophy, science, and religion to which our century is still heir.

In the face of doubt, Catholicism sought to affirm traditional beliefs. In every Catholic stronghold, saints and their relics were celebrated with renewed devotion. Older Christian images were accorded a new respect to which we owe the survival of much fourteenth-century painting. These earlier images were sometimes enshrined within new paintings or sculptures. Many Italian churches still preserve examples of a medieval painting surrounded by a seventeenth-century image that serves to focus on the early painting and give it new meaning. Seeking to revive the faith, the church commissioned countless paintings and sculptures about the lives of saints and martyrs. The pope's authority was reestablished, and Catholicism spread its message via the militant and active Society of Jesus, the Jesuits. The Catholics, then, met the Protestant challenge with their own Counter Reformation.

Throughout the seventeenth century, art was still at the service of nobles and kings in various countries and principalities. But in Holland, a new type of patron emerged—the Protestant merchant, whose tastes and interests were vastly different from those of his royal counterparts. Simple portraits, modest depictions of a quiet bourgeois life, pleasant landscapes and appealing still-lifes

233

suited the tastes of the merchant class, and a quietly revolutionary art was born that subtly but inexorably transformed the art of the next two centuries.

Religion and patronage were not the only forces to affect the arts. New observations in science challenged long-held beliefs and certainties about the nature of the world. As scientists shook the foundations of established beliefs, they forged new tools with which to study the elusive and complex nature of reality. Between 1606 and 1619 Johannes Kepler published his three laws of planetary motion, disproving the common belief that planets moved in perfect circles. As Galileo Galilei (1564–1642) sat in the military arsenal of Venice, he pondered the principle of inertia. Publishing his classic *Dialogue on the Two Great World Systems* in 1632, he reaffirmed Copernicus's theory that the earth was not the center of the universe and thereby incurred papal censure. In the tolerant atmosphere of Holland, the Frenchman René Descartes (1596–1650) set down the basis for scientific method and intellectual disclosure by affirming the principle of doubt and the acquisition of knowledge through observation with his famous statement, "I think therefore I am."

Every truth, then, was open to doubt except one: the knowledge of one's self. The individual became the prism through which life's uncertainties came into focus. The sense of self, which first emerged in the Renaissance and thereafter altered the direction of man's development, found its fulfillment in the seventeenth century. The study of the self was given its most poignant expression in the philosophic observations of Michel de Montaigne (1533–1592) and in the literature of Miguel de Cervantes (1547–1616) and William Shakespeare (1564–1616); and it emerged as a concern in the visual arts as well. Countless portraits record the liknesses of the many individuals who made up seventeenth-century society, from princes to beggars, while artists studied their own likenesses with greater frequency, leaving us numerous visual autobiographies. More than forty self-portraits trace Rembrandt's journey through life as he confronted his successes and personal tragedies. Numerous drawings take Bernini from youth to old age. It is no coincidence, then, that the descendant of earlier Medici patrons, Cardinal Leopoldo de Medici (1617–1675), began collecting artists' self-portraits. Today that collection in the Uffizi numbers nearly 500 works.

People were the subject and object of seventeenth-century art, and by these terms all of it can be called popular. Art reaffirmed religion and religious experiences for the general populace in Catholic countries, and in Protestant areas, especially Holland, a broad spectrum of the population supported art and was its main subject.

Though artists made sculptures, drawings, prints, and decorative arts, their most intense activity focused on painting. The most adaptable art form, it could capture a likeness or convey a religious message; it could decorate a home or embellish a church. It could be large or small, simple or complicated, cheap or expensive. Even the most expensive paintings, however, cost less than

an ambitious sculpture project. No matter who their patrons were or what they painted, the artists almost always used the same material: oil paint. Oil paint was flexible, fluid, and responsive. It adapted to each artist's hand and touch so that each could experiment to develop a new language of stroke and mark. Some painters preferred small brushes to make tightly controlled, meticulously rendered images; others used everything from palette knives to sponges, as well as brushes of all sizes, to create an inexhaustible range of marks, strokes, and colors.

Artists also experimented with a number of other materials, including copper, slate, glass, and wood. They would also frequently prepare small painted sketches called modelli for submission to a patron or for their own reference as studies for a painting. These vibrant expressions of a painter's spontaneous creativity were collected enthusiastically by patrons of the day, and many have entered collections of today's museums.

Artists explored the nature of reality in their work. Landscape, faces, and objects were examined and transmitted through the effective medium of oil paint. But the spectator was not always simply presented with a representation of reality. Sometimes artists deceived their viewers into seeing things that were not there—sculpture that looked like painting or painting that appeared to be sculpture. Distillations, distortions, and confusions of reality were the effects sought by artists, who were part of an age that had begun to fundamentally reexamine the nature of reality.

ITALIAN ART

PAINTING

The seventeenth century saw painting become the most popular medium for expressing and satisfying a wide range of needs, from the religious to the purely aesthetic. The distinctions that were established previously by function between types of painting became less important as painting came to emphasize aesthetic categories more than it served specific funtions. Although still a medium for private and public religious devotion, painting also came more and more to express an independent aesthetic merit that could be and was considered apart from its subject matter. Paintings fulfilled the aesthetic needs of growing numbers of private collectors at all social levels, for whom it became an expected part of one's cultivation to have paintings. Bought by a broader range of patrons, from princes, ecclesiastics, and merchants to the bourgeoisie, paintings could be obtained in an increasing variety of ways—by direct commissions to artists, from the growing numbers of artists' shops, or through dealers, who became an important intermediary between artists and their public. Art exhibitions became a regular feature of cultural life and coincided with feast and

other special days. Artists' works would be displayed in churchyards, where they were viewed and judged for their skill and artistry. Even travel or guide books of this period emphasized the artistic events or merits of the sites listed on their itineraries. Rome became a major center for artistic patronage, and Bologna, Naples, and Genoa produced important schools of artists. Seventeenth century Venetian and Florentine painters are less highly regarded.

Religious Painting

In the seventeenth century, painters were less concerned with painting as a medium for the timeless evocation of a universal religious concept. Rather, building on the increased psychological realism of their forebears, seventeenth-century Italian painters sought to heighten the mood of religious imagery. They attempted to convey a wide range of emotional states, from sadness, surprise, shock, fear, anguish, and despair to ecstasy, joy, and rapture. What may seem to us to be exaggerated and self-conscious painting was, for the seventeenth-century artist, necessary in order to emphasize and communicate the psychic states of his subjects.

Some traditional subjects, such as scenes of the Crucifixion, seem to have been in less demand and appear less frequently. Although images of the Madonna surrounded by saints remained popular, artists devoted more and more of their creative energy to portraying the lives and religious experiences of the various saints. Visions, conversions, meditation, contemplation, dreams, ecstasy, martyrdom, and miracles—all these events were endlessly recounted in paintings that spoke to the viewer on an ultimately spiritual level and reaffirmed the nature of religious experience as one that contradicts reason and logic. In order to bring the image and experience closer to the viewer, painters often used real models and depicted these with great clarity, rejecting the idealization that had been part of the medium's vocabulary for so long. An outstanding example of this approach is found in Orazio Gentileschi's *Judith and Maidservant with the Head of Holofernes* (Plate 4).

Altar paintings. Many of the large altarpieces painted during this period were part of a complex scheme of many decorative elements that often included sculpture, frescoed ceilings, elaborate frames, and exuberant architectural elements, all of which interacted to form a cohesive and dynamic unity. With decorative schemes that ranged from the highly ornate to the more subdued, the altar paintings we see in museum collections today are, for the most part, not displayed in their original contexts. However, it was not uncommon in the seventeenth century for overly rapacious collectors to confiscate altar paintings by certain painters or to purchase rejected works. Even in their day, these paintings were viewed somewhat more independently from context than paintings of previous periods had been, so that a museum visitor today might

experience these paintings much in the way that they were viewed at the time of their creation.

Private altars. These were still painted in large number for patrons by artists who specialized in such works. Among the most frequently depicted subjects were images of the Virgin, who was commonly depicted in half-length. Many examples of private altars are collected by museums today.

Secular Painting

With the rise in secular patronage, the range of subjects open to painters expanded rapidly. A whole new array of topics, some of which touched upon seventeenth-century tastes in classical literature, contemporary plays, and poetry or on intellectual themes of the day, were explored. It was probably rare that a painter would create or choose a subject that suited his own tastes, as his livelihood depended on the buyer's understanding of the painting and willingness to part with money to obtain it. Painters tended instead to flatter their patrons, appealing to their vanity, pride, acquisitiveness, sensuality, greed, or love of beauty. Rarely were Italian painters satirical or critical, for they aspired to be part of society and reflected its tastes and aspirations in their painting.

Portraits The heightened realism of seventeenth-century painting found its finest expression in portraiture, which captured both the personalities and features of its sitters with a greater sense of animation than had been characteristic of any portraiture of the past. Portraits of many types, both formal and informal, abounded. Generally intended to flatter the sitters, formal portraits were typically made of men of state, who are depicted in a state of heroic alertness and dynamism.

Allegories and Histories Allegories, concepts such as faith, the four elements, or reason were subjects that presented new challenges to the painter, who would often bestow upon human forms symbolic attributes and an allegorical title. Death became the theme of innumerable images, such as those of sleeping children, and overlapped with themes of love and lust. Physical and spiritual love were depicted in images of Venus and Amor, Judith, Cleopatra, and other heroines. The biblical, mythological, and historical imagery of the past was gradually categorized as "history" painting by theorists and artists who belonged to academies. Violent, macabre, and theatrical subjects became popular, as theater characters, such as Punchinello and other clowns, and stories of witches, magicians, fortune-tellers, and Gypsies found their way into artists' renderings. Suicides, brawls, and scenes of rape became the secular counterpart to the Christian themes of martyrdom and torture. Battle scenes, both historic and fictional, enjoyed popularity.

Passages of Time The favorite theme of picture cycles commonly commissioned by private patrons, the passage of time was expressed in scenes of the four seasons, the different times of day, and ages of man.

Landscape Landscape painting began to fulfill the city-dwelling patron's desire to experience nature, albeit vicariously, through the painted image. Becoming increasingly popular as an independent art form that did not merely serve as background for another subject, landscapes depicted a variety of scenes, ranging from idyllic passages that were composed according to strict formulas governing foreground, middle, and background, to violent and fanciful expressions of natural scenery. In addition to pure landscape, urban views featured both realistic and fanciful depictions of architecture. Classical ruins and contemporary buildings were added to the landscape painter's repertoire of images by the end of the century.

Still-Lifes These consisted of various types, and depicted such objects as musical instruments, vegetables, and fruits. They were often the product of specialists and found particular favor among Neapolitan and Venetian patrons, who developed a taste for them from Dutch and Flemish painters.

Nudes By the seventeenth century, the portrayal of nudes tended to be more academic and proper than it had been in the previous century. Often using a moralizing tone or story as the pretext for such a painting, these images lacked the sensuality of earlier nudes. By this time, many of the more erotic paintings featuring such themes as Danae (one of Zeus's most notorious mistresses) were commissioned by non-Italian patrons.

Genre Depicting scenes of people working, peasants, animals, festivals, dances, carnivals, and transitory moments from everyday life, genre painting was done by immigrant Dutch specialists in Italy who were named *Bambocci-anti*, after their deformed leader Pieter van Laer, known as Il Bamboccio, the puppet. The small scale of these paintings made them affordable to a wide range of middle-class buyers, and also tended to remove the viewer psychologically from the sometimes harsh reality they depicted.

Much of the genre painting of the time appealed to the viewer's senses, with scenes of drinking and toasting and food still-lifes evoking taste and thirst, and the sense of hearing was alluded to in images of concerts and musicians, which had been introduced as a subject of painting in the earlier century and became popular among seventeenth-century Italian painters.

DRAWING

If each century can be said to have had its own preoccupations and its own balance between the drawing and its subject, then one could say that seventeenth-century drawing—whether it depicts a head or a figure—was more sym-

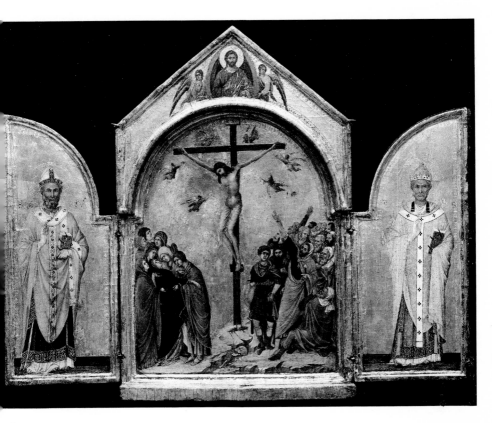

PLATE 1. *Triptych: Crucifixion* (center) *and Christ Blessing St. Nicholas* (left) *and St. Gregory* (right) by Duccio di Buoninsegna (Sienese School, 1255–1319). Tempera on panel, (right) 17¾ × 7½ in., (center) 24 × 15½ in., (left) 17¾ × 7½ in. Courtesy, Museum of Fine Arts, Boston. Purchased, Grant Walker and Charles Potter Kling Funds.

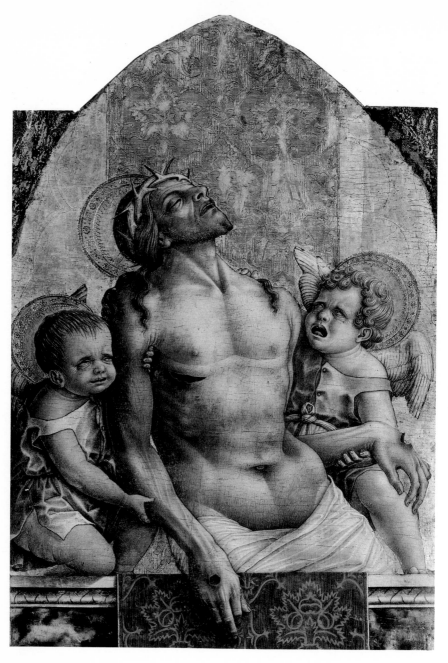

PLATE 2. *Pieta* by Carlo Crivelli (recorded 1457–1494). Oil on wood, 18½ in. wide × 28 in. high. Courtesy John G. Johnson Collection, Philadelphia Museum of Art (J.158).

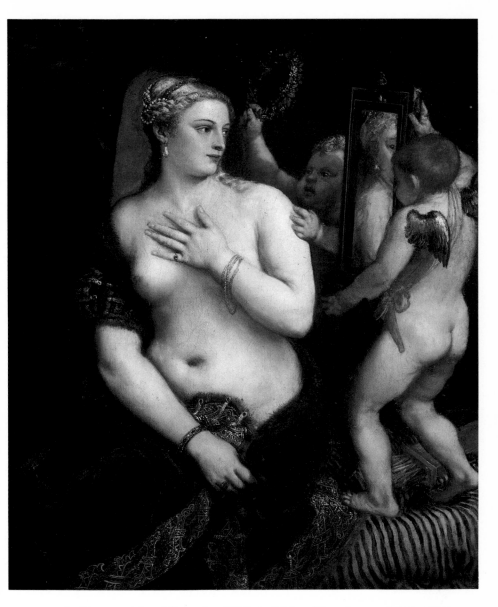

PLATE 3. *Venus with a Mirror* (c. 1555) by Titian (Venetian, c. 1477–1576). Oil on canvas, 49 × 41½ in. Courtesy of Andrew W. Mellon Collection, National Gallery of Art, Washington, DC.

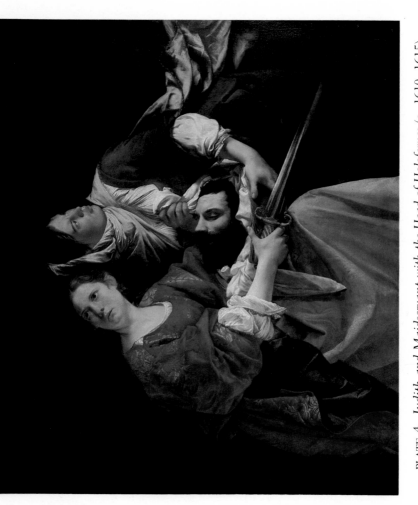

PLATE 4. *Judith and Maidservant with the Head of Holofernes* (c. 1610–1615) by Orazio Gentileschi (1563–1639). Oil on canvas, 52⁷⁄₁₆ × 61¼ in. Courtesy of the Wadsworth Atheneum (1949,52), Hartford, CT, the Ella Gallup Sumner and Mary Catlin Sumner Collection.

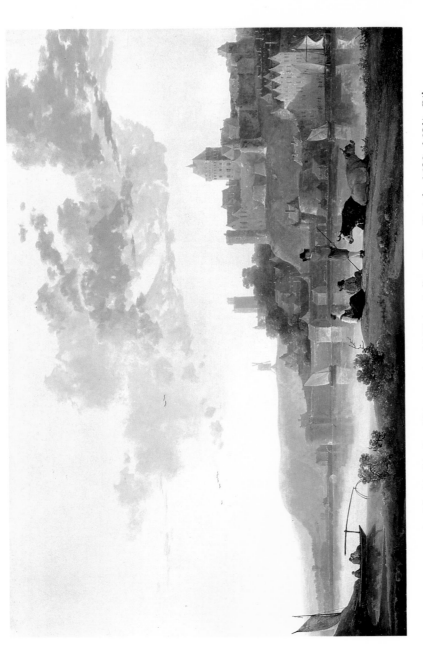

PLATE 5. *The Valkhof at Nijmegen* (c. 1665) by Aelbert Cuyp (Dutch, 1620–1691). Oil on panel, 19¼ × 29 in. Courtesy of the Indianapolis Museum of Art, 43.107. Gift in commemoration of the 60th anniversary of the Art Association of Indianapolis in memory of Daniel W. and Elizabeth C. Marmon.

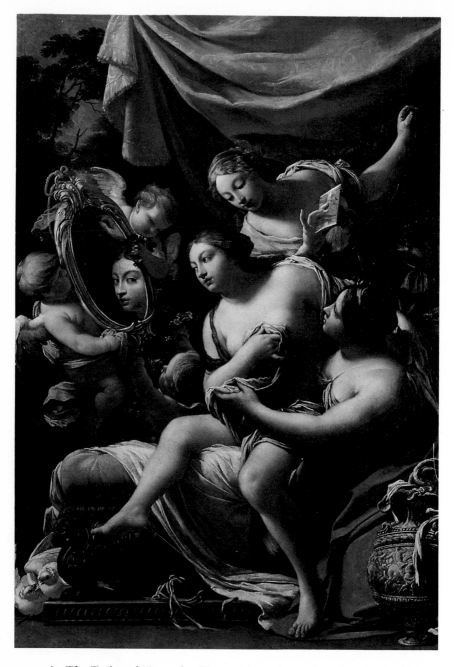

PLATE 6. *The Toilet of Venus* by Simon Vouet (French, 1590–1649). Oil on canvas, 65 × 45¼ in. Courtesy of the Museum of Art, Carnegie Institute, Pittsburgh; Gift of Mrs. Horace Binney Hare, 1952.

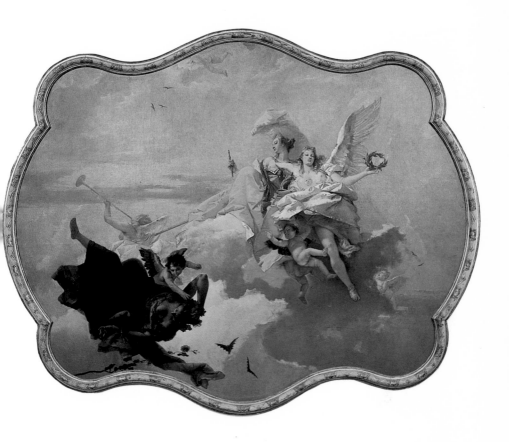

PLATE 7. *The Triumph of Virtue and Nobility over Ignorance* (c. 1740–1750) by Giovanni Battista Tiepolo (1696–1770). Oil on canvas, 126 in. high × 152½ in. wide. Courtesy of the Norton Simon Foundation, Pasadena, CA.

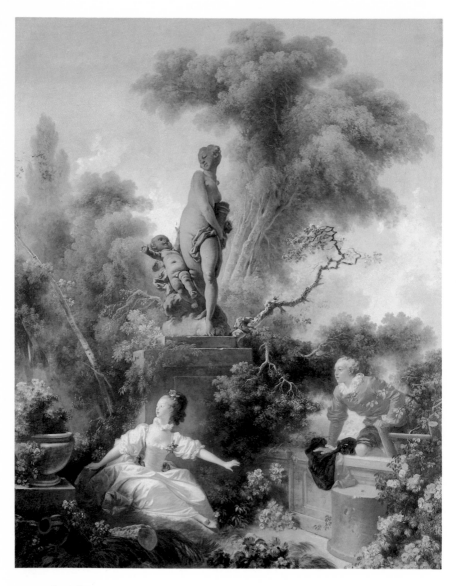

PLATE 8. *The Meeting* (1771–1773, in the series *The Pursuit of Love*) by Jean Honoré Fragonard (1732–1806). Oil on canvas, 125 × 96 in. Copyright the Frick Collection.

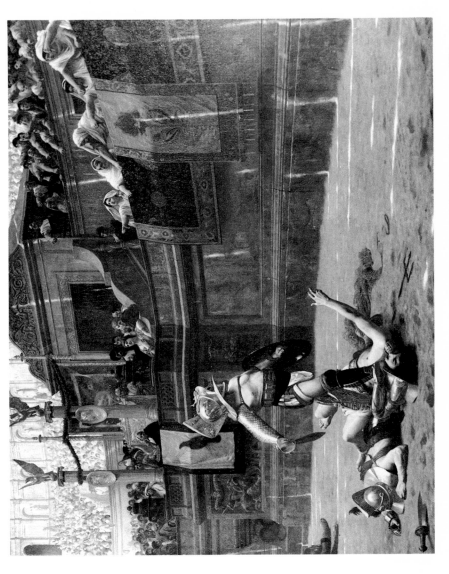

PLATE 9. *Pollice Verso* (1874) by Jean Léon Gérome (1824–1904). Oil on canvas, 39½ × 58⅝ in. Courtesy of the Phoenix Art Museum, 68/52.

PLATE 10. *Burning of the Houses of Parliament, 1834* (1835) by Joseph Mallord William Turner (1775–1851). Oil on canvas, 36½ × 48½ in. The Cleveland Museum of Art, CMA 42.647. Bequest of John L. Severance.

PLATE 11. *The Coming Storm* (1859) by Martin Johnson Heade (1819–1904). Oil on canvas, 28 in. high × 44 in. wide. Copyright © 1980, The Metropolitan Museum of Art. Gift of Erving Wolf Foundation and gift of Mr. and Mrs. Erving Wolf, 1975.

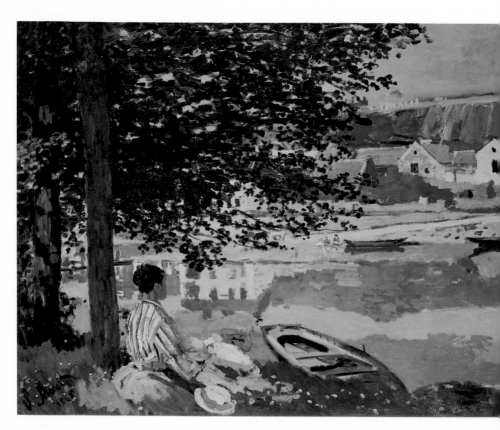

PLATE 12. *The River* (1868)·by Claude Monet (1840–1926). Oil on canvas, 31⅞ × 39½ in. Potter Palmer Collection, courtesy of the Art Institute of Chicago, 1922.427.

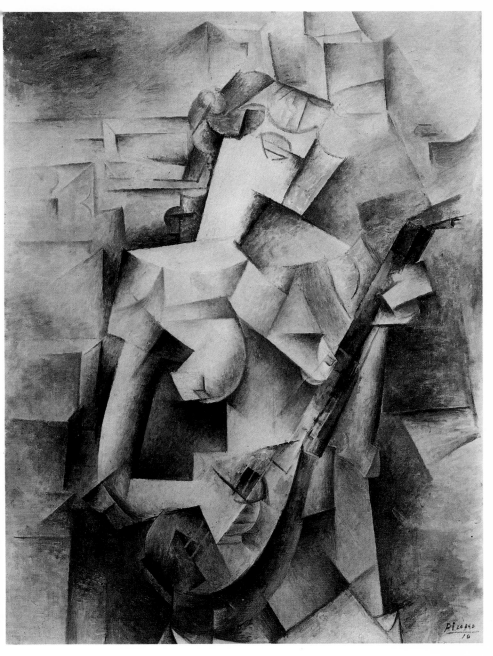

PLATE 13. *Girl with a Mandolin* (Fanny Tellier) (1910) by Pablo Picasso (1881–1973). Oil on canvas, 39½ × 29 in. Collection, courtesy of The Museum of Modern Art, New York, Nelson A. Rockefeller Bequest.

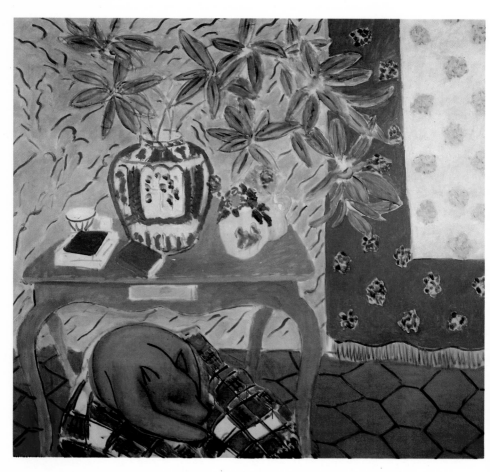

PLATE 14. *The Magnolia Branch* (1934) by Henri Matisse (1869–1954). Oil on canvas, 60¾ × 65¾ in. Courtesy the Baltimore Museum of Art: The Cone Collection, formed by Dr. Claribel Cone and Miss Etta Cone of Baltimore, MD, 1950.257.

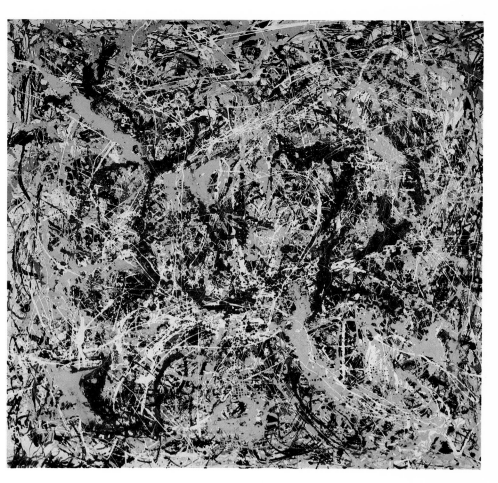

PLATE 15. *Number 11* (1949) by Jackson Pollock (1912–1956). Duco and aluminum paint on canvas, 115 × 121.4 cm. Courtesy of the Indiana University Art Museum, 75.87, Jane and Roger Wolcott Memorial.

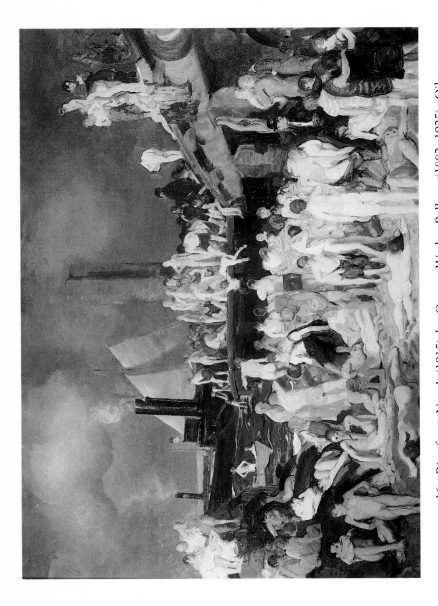

PLATE 16. *Riverfront No. 1* (1915) by George Wesley Bellows (1882–1925). Oil on canvas, 45 × 63 in. Courtesy of the Columbus Museum of Art, Ohio, Museum Purchase: Howald Fund (51.11).

biotically fused with the drawing mark. Throughout the sixteenth century, the calligraphic mark, which has its antecedents in the silverpoint and pen and ink technique of the fifteenth century, identified the form. By the seventeenth century, however, the form springs to life as if by magic, and the viewer is not as conscious of the individual marks that create it.

Drawing was a fully independent medium by the seventeenth century, and some artists did almost nothing but draw. As had been the case for centuries, artists learned to paint, make prints, or sculpt through drawing, but the approach became more systematic, especially in the academies of Bologna and Rome. The student learned first to copy drawings and prints, then paintings, antique sculpture, casts, and contemporary sculpture, before working from nature, be it models or landscapes. He learned to make an array of preparatory drawings for a project, ranging from studies of composition and perspective to figure and drapery studies.

With the advent of oil paint, fewer preparatory studies or drawings were made for portraits, although a number of drawings for portraits in print and sculpture survive. There is a rise in independent portrait drawing, however, and during this, the age of collecting, drawings were sought after enthusiastically. In Venice, Rome, Florence, and other large international cities, with their wealthy merchants, clergy, and nobility, patrons developed an eye for beauty and a competitive spirit, and large drawing collections were common. One famous collector, Padre Resta of Rome, amassed thousands of drawings, of which several hundred were by one artist alone. Sheets of drawings were gathered and often annotated by the collector's hand to identify (often wrongly) the author of the drawing and sometimes its subject. The drawings were then pasted into albums, which were large or small and sometimes dedicated to portraits or any number of other subjects. These albums, which are known through written commentaries about them, are only rarely found intact today. It was far more common for the collector or his descendants to resell the accumulated collections. In this way the assembled drawings were dispersed and joined other collections, eventually being passed down to today's museums. The routes traveled by these drawings through time are often partially recorded by collectors' marks and other inscriptions, which have been painstakingly recorded and identified by later scholars.

The three drawing techniques most frequently used in seventeenth-century Italy are described below.

Pen and Ink. More fluid and, in the hands of some draftsmen, more direct than charcoal or chalk, this technique involved dipping the pen directly into the ink for strokes of the pen and for washes. The spontaneity of pen and ink in drawing may have found its counterpart in painting in the oil sketches that grew in popularity around this time. Like pen and ink drawings, oil sketches were done on canvas without an intermediary or preparatory drawing.

Brush Drawings Already popular in Venice, these began to make great head-way in the rest of northern Italy. Brush drawing enabled artists to emphasize the dazzling contrasts between light and brushwork by exploiting the white of the page and color of the washes to achieve virtuoso effects. Because painting and color had always been the Venetian prerogative, it is no surprise that brush drawing remained more popuar in the north of Italy.

Chalk and Charcoal Often used in combination, these were extraordinarily popular as a medium for drawings. The availability of tinted paper (primarily blue, with some brown and gray) helped inspire the increased use of chalks. Combinations of colors—black and red; black, red, and white; and mixtures with yellows and tans—are found. The early experiments of drawing with colored chalks in the late sixteenth century found later adherents in the seven-teenth century. Approaches ranged from the spontaneous, almost impressionis-tic techniques of Venetian artists to the more rigorous, academic techniques of the artists of Bologna and Florence. Oiled chalks, which made a richer, grea-sier mark, were especially popular in Venice.

Artists were not limited to these materials. They often experimented, mixing chalk and pen and ink, and even added dashes of color from other sources such as oil paint. At times, the distinction between an oil sketch and a brush drawing made in oil is difficult to make.

PRINTMAKING

Among the many techniques used for printmaking in seventeenth-century Italy, engraving, etching, and monotype will be discussed. Woodcuts, which had enjoyed extensive use in printmaking in earlier centuries, declined as the interest in metal printing surged.

Engraving A traditional medium that retained many of its original functions as a means to reproduce paintings and as book illustrations, engravings contin-ued to be produced by many, including artists of the Carracci Academy in Bologna, which turned out notable copies of famous Italian masterpieces and other types of images. Engravings came to be regarded as records and source books for artists and provided a convenient reference source for many painters. Costume studies, figure studies, and the like were also found to be useful to these artists. At a time when genre, or everyday life, scenes became important in Italian art, it was not surprising that studies of characters such as beggars and peasants appeared in engravings of this period.

The notion of theme and variation, of making innumerable transmutations of a single idea, emerged during this time, giving way to expressions of artistic inventiveness and facility that become increasingly important for artists of the next century.

Etching The great medium for printmaking in the seventeenth century, etching appealed to artists because of the spontaneity and directness with which ideas could be translated into images on a metal plate. In a sense, artists drew directly onto the plate, often having prepared no preliminary studies, by gliding the etching needle through the waxed surface of the plate.

The number of artists who etched increased significantly in the seventeenth century, as evidenced by the list of artists at the end of this chapter. They created prints for a large and diverse audience, some of whom sought religious works in the form of small devotional images or scenes from the life of Christ or saints. The same religious need that spurred the production of so many paintings of conversions, visions, and martyrdom led to a proliferation of prints with religious subjects. However, just as the market for secular art in other media expanded, so was there a widening market for prints depicting a broad range of subjects, from scenes of archaeology and classical history to images of violence and social reality. Erotic themes and fantastic subjects drawn only from artists' imaginations created a host of new images that were acquired by an eager public.

Monotype As artists experimented with etching, one painter, Giovanni Benedetto Castiglione of Genoa, produced the earliest true monotype. This was achieved through a process whereby a plate (often made of glass) is coated with pigment. A stylus moves through the pigment, thereby removing it and creating a white line. A brush can then be used to apply pigment to produce a dark mark. Both marks combine to make the final image. The plate is then used to produce a single print (hence the name monotype). Obviously, monotypes are scarce, but the directness and fluidity with which the technique was applied resulted in some of the most vivid, energetic, and beautiful prints ever made.

SCULPTURE*

The two centuries between 1600 and 1800 witnessed a number of forces that significantly affected the sculpture of this period. The revitalization of the church under the Counter Reformation, the extraodinary expenditure of money for sculpture, and a shifting climate of tastes resulted in architecture and sculpture of a larger scale than had been witnessed before. During this period, sculpture was commissioned for large-scale religious and secular works, such as church decorations, tombs, and funerary monuments, as well as fountains and equestrian monuments. The written histories of this period concern themselves primarily with such commissions, which remain for the most part on their original sites—in the churches, town squares, and parks. Privately commissioned works of sculpture were destined for palaces and private resi-

*This section covers Italian sculpture for both the seventeenth and eighteenth centuries.

dences and therefore are not as well known, although these more commonly make their way into today's museums, along with the sketches and models for the large commissions that are not preserved in museums.

Traditionally associated with architecture, sculpture began to take on new relationships with its surroundings and acquired the capacity to be illusionistic. To make something sculptural appear painted, or vice-versa, to fuse architecture, sculpture, and painting in order to confuse and delight the viewer—these were the preoccupations of sculptors of this period. Not unlike the painting of the day, which had become illusionistic, somewhat theatrical, and concerned with the telling of stories, sculpture also began to express a concern with the narrative element. Sculptors began to recognize their powers, playing with levels of reality and delighting the viewer with endless games of deception and other trickery.

During this period, Rome was the most important center for Italian sculpture and Giovanni Lorenzo Bernini its chief artist. Bernini's vast connections and enormous shop had control over most commissions, and the style he developed spread throughout Italy and Europe. Roman sculptors did not only execute commissions for local patrons but shipped their works to many other Italian and European centers. In 1666 the French Royal Academy founded a branch in Rome, and numerous French sculptors visited the city, bringing new ideas and adopting the Roman style. The supremacy of Roman sculpture went unchallenged until later in the century, when Bologna, Genoa, and Venice developed their own schools of sculpture, and while Florence and Naples continued more or less their own traditions in sculpture, which had become established in the fifteenth century and were therefore less affected by Rome.

Only a visit to Rome, however, will enable the viewer to witness the two centuries of activity that transformed Roman architecture and sculpture on such a grand scale, for most of these works remain on their original sites. The visitor to an art museum will receive more limited exposure to Italian sculpture from this period and will generally find small-scale sculptures of the types or categories outlined in the following.

Statuettes

In the tradition of previous centuries, statuettes were made in a wide variety of materials, including bronze and ivory, and in great numbers by such sculptors as François Duquesnoy. These statuettes take on the flavor of a luxury object whose value lies partly in the material and partly in the technical virtuosity of the sculptor.

Small bronze statuettes began to play an important role as an element of interior decoration, and were often created in pairs for mantelpieces or as book ends. Less important as individual works of art, they were considered part of a

totality within the larger decorative scheme of a room. The perfection of a casting technique in the seventeenth century permitted the reproduction of infinite numbers of perfect bronze casts, which required no finishing except for the application of patinas, a chemically induced surface coating. The increasing number of small bronzes that were produced in Italy went to satisfy a demand that came from throughout Europe, especially from Holland, England, France, and Germany.

During this period, there were many sources of inspiration for sculptors of small bronzes. Chief among these sources were, of course, the large-scale sculptures that were being made at the time and examples of sculpture from the Renaissance as well as classical antiquity. Some artists clearly favored the rather timeless and stationary appearance of antique works and tried to express the same in sculptures of their own invention; others, inspired by the possibilities of creating movement and dynamic compositions, chose the style introduced to sculpture by the great Bernini.

An outstanding feature displayed by much of seventeenth- and eighteenth-century Italian sculpture—for works in both large and small scale—was its ability to express movement. Static and solid materials such as bronze, clay, or stone appear, in the hands of sculptors, to move, twist, and turn. Sculptures become animated, taking on an inner vitality and spirit that make the viewer believe these objects are infinitely capable of movement, even though they may be resting. Also characteristic of sculpture during this period was the emphasis on the narrative element and ability to recount a story. The stories on which sculpture came to rely were well known and included biblical lore or themes taken from classical and theatrical sources. The sculptor was expected to convey the essence of a story, using theatrical tools to exaggerate gestures and facial expressions, or stretch the movements of the figures. The sculptor also exploited his material, manipulating its surface to make light flicker and break. Here shining brightly, there casting a deep shadow—the light breaking over a surface animated the sculpture and kept the viewer's eyes roving over its constantly flickering form.

Bozzetto The distinction between the statuette and the initial sketch or study (called bozzetto) for a final work is often unclear, yet it is of critical importance for sculpture from this period. The existing scholarship on seventeenth-century Italian sculpture tells us that the role of the bozzetto began to change during this century. Not only was the bozzetto the initial stage in the creation of a final work but very often, due to the large scale and complexity of sculptural decoration, which demanded the assistance of many studio hands, it was the only stage at which the master was directly involved in the production of a work. Ranging from life-size to small-scale models and often produced in terra-cotta that was baked to ensure some permanence, bozzetti recorded the creative efforts of the principal master of a workshop and were highly prized in

an age that valued ideas and imagination above all. Thus, bozzetti were both useful to students as a reference and prized by collectors.

Models for many works, ranging from tombs to fountains, have made their way in great numbers into museum collections. Valued now for their energy and for the rapid but sure execution of a complex sculptural idea, bozzetti record not only the sculptor's imagination at work but also the skill of his hand as the material is gouged, shaped, cut, scraped, molded, and manipulated to conform to the artist's vision.

Portrait Busts

Like much of the art of this period, the portrait bust was imbued with a sense of liveliness, activity, and emotion. The boundary between the animate and inanimate became nearly indistinct for some of these busts, which, though made of stone, seemed to see, think, breathe, and move. The seventeenth-century love of illusionism in art led to a preoccupation in sculpture with differentiating textures, such as hair, fur, skin, beards, and clothing. The incising of pupils and irises gave faces greater specificity and focused their glances, thereby enhancing the illusion of animation.

Portrait busts had many uses. They were produced for family collections and formed parts of funerary monuments. They were made primarily from marble, although other materials, such as terra-cotta, bronze, colored marbles, and painted or unpainted wood, were also used.

Relatively small and portable, busts are easily removable from their original settings. Many of them have made their way into museums, where they may occupy a disproportionately large part of museum sculpture collections.

Reliefs

Reliefs in terra-cotta, ivory, and boxwood were produced as sketches for large-scale commissions and for their own sake. An ideal medium for the narration of stories, these reliefs drew on sacred and secular themes alike to express lively, animated images.

Medals

In Florence and Rome, the medal continued to be an important art form. Metal casting was revived in both centers, where collectors eagerly built collections of earlier medals. The struck medal continued to be produced simultaneously and in greater numbers, as its production was less laborious. Rome, Bologna, Naples, and Florence have produced numerous examples.

The Creche

For centuries before the 1600s it had been customary in Italy to celebrate Christmas with the display of a creche or presepio, that is, a re-creation of the Nativity. This most joyous event for Christians was reenacted in countless Christmas pageants in which ecclesiastics dressed as Magi and live animals played the roles of the biblical ox and ass. Sculpted and painted re-creations of the Nativity had been common as well, but the interest in the Nativity took on new dimensions during the early seventeenth-century.

With the encouragement of the Jesuits, churches began to display creches by grouping together sculpted representations of all the main characters in the Nativity. These sculptures were colored and very life-like, and provided a kind of tableau vivant of the Nativity. The popularity of creches was so widespread throughout Italy, Spain, and parts of northern Europe that many sculptors specialized in them.

During the seventeenth and eighteenth centuries, this sculpture took on epic proportions as creches began to include not only the central characters of the Nativity (Mary, Jesus, Joseph, the stable, the donkey and ox) but also the shepherds, angels, Magi, and, gradually, a supporting cast often numbering in the thousands. Figures from taverns, tavern keepers, butchers, grocers, shops, streets, the poor, beggars, and peasants were all included in the increasingly ambitious creche scenes. As the cast grew bigger, the figures grew smaller and the elaborate pageant unfolded in miniature.

The challenge of producing something small yet realistic appealed to sculptors and audiences alike. All sorts of materials were pressed into service—wood, terra-cotta, ivory, wax, hair, paint, bits of glass, and all kinds of fabrics—to re-create in miniature the characters, landscape, environment, and accoutrements of the epic Nativity. Many complex creches had hidden pullies and cranks that floated the angels through the skies, moved the star of Bethlehem across the heavens, and caused waterfalls to cascade. The addition of these mechanical devices brought greater life in an already spectacular image.

The results of these creches were so captivating that people traveled far and wide to witness them at Christmas. Naples was a special center for creche sculptures, and Neapolitan churches and museums still preserve a good number of charming examples. Other figures from creches have found their way into European and American museums, where they join other traditional decorations of Christmas time.

DUTCH ART

PAINTING

Probably no other period of painting translated the impression of life more directly into art than the painting of seventeenth-century Holland. Dutch

FIGURE 8-1. Map of Holland, c. 1600.

paintings depict people, places, and things with such conviction that we understand and relate directly to the events and objects we see. For a variety of reasons and circumstances still the subject of debate, seventeenth-century Holland produced a proliferation of great painting unequaled anywhere except Renaissance Italy. Dutch painters turned to their own existence to create images that exuded life, changing the ordinary into the sublime.

Patronage in Holland during this period accounts partially for both the selection and the variety of subjects depicted in painting. Holland did not have a large class of nobles, and few of its predominantly middle-class citizens were publicly Catholic. The Dutch citizens who supported the flowering of great painting during this century were probably, to a large extent, merchants and traders because the substantial wealth of Holland at the time was produced by trade. This resulted in a fairly high standard of living, with prosperity evenly distributed among a number of important cities: Amsterdam, Haarlem, Rotterdam, Utrecht, Leiden, Dordrecht, Delft, and Middelburg (see map of Holland, Figure 8-1). The people were quite modest in dress, wearing for the most part somber colors. They lived conservatively and frugally and placed great value on moderation, dignity, and tolerance. The teachings of John Calvin, which emphasized austerity, honest labor, and severe restrictions on religious imagery, took hold of the Dutch.

The Dutch were great explorers and mapmakers who, in 1650, completed the first map of the entire world. This love of maps, often the subject of Dutch painting, reflects their respect for utilitarian objects and their fascination with the world. The Dutch had a high regard for material objects and an interest in every aspect of life; so horticulture and branches of scientific study such as entymology and cartography were developed. Technical advances were made in navigation, fire fighting, and optics. High-quality craftsmanship was maintained and developed through an enthusiastic worldwide trade, which brought in such goods as glass from Venice and pottery from China.

Above all, however, the Dutch loved painting. Every building—from town and guild hall to estates and modest dwellings—had its requisite paintings. Everyone collected paintings, it seems, and travelers' accounts of the time remark on the fact that even poor cobblers owned paintings. Paintings could be bought at almost any fair, and markets had special booths given over to paintings. Some scholars theorize that paintings were a form of economic speculation that spawned an active trade in them as investments. Auctions were frequently held, and those whose fortunes declined were often forced to sell their paintings.

The seventeenth-century Dutch tended to collect paintings by type rather than by artist. In this respect they differed from their Italian counterparts, who sought works by certain esteemed masters. They preferred to decorate their homes with the various types of landscapes, still-lifes, and genre paintings that were produced with infinite variations by Holland's gifted painters. The aes-

thetic tastes of these Dutch patrons ran more to images that were directly related to their immediate experience than to primarily symbolic representations that transcended appearance.

As a result, the painters of seventeenth-century Holland worked with a freedom to depict nature and objects at face value, and, like artists anywhere, they were conscious of the effects they could conjure up. The artist was aware of the formal challenge presented by his subject matter and relied on direct observation, combined with formulas, to solve problems of structure and composition. Paintings were still made in the studio and were based only indirectly on nature by using drawings made on the spot. A final painting would often rely on composition supplied by other artists as guidelines.

Like their medieval counterparts, Dutch painters were tradesmen who knew the nature and limits of their jobs and performed them with skill and pride. Most of them did not work solely on commission. Instead, they painted images that they hoped to sell in markets and at fairs. They worked independently, risked failure, and counted on their knowledge of the marketplace to succeed. Trained according to the old guild system, artists would begin as apprentices and work in shops under a master, much as in medieval or Renaissance times. Although there were academies—such as the Haarlem Academy, established in 1583 by Karel van Mander, Cornelis van Haarlem, and Hendrik Goltzius—the academic system and theoretical approach did not affect most Dutch painters. Rather, they learned to paint practically, using primarily oil paints on canvas or panel and occasionally specializing in other media such as glass. They learned to draw and assembled sketchbooks as source material for studio pictures. Their paintings were often repetitive, but geared toward a steady market. Some painters specialized in a very narrow range of subjects, and practically no painter was active in every category of painting.

Working with few, if any, preconceived theories, the Dutch established a new direction for painting based on the love of exploring the substance of things. Objects, plants, flowers, foods, people and places are depicted with an immediacy that transforms the fleeting scenes of everyday life into images of permanence. There are many categories of these paintings, as we explain below.

Genre Painting

By the seventeenth century, the tradition of genre painting had already been well established, but the Dutch (particularly painters in Haarlem) had such an affinity for these subjects that Dutch genre paintings rank among the world's greatest. The subjects of these paintings are numerous. For the most part, they show us a satisfying middle-class life and focus most often on the material comforts of the home. Many a painting portrays the pleasant activities of the mistress of the house, who can be seen reading, playing instruments, or exa-

mining her jewelry. We also observe the domestic chores of maids or scenes of a mother with her child. The pleasures of eating or drinking, gambling, and dancing were depicted among members of the middle class and peasants are shown humorously, often raucously congregated in homes, inns, and gardens.

Ranging from quiet moments suffused with contemplation to scenes of bawdy riot, the subjects of genre painting form a kaleidoscope of seventeenth-century everyday life. We take pleasure in a painter's ability to convincingly render brocades and satins, pearls and porcelain. Some paintings contain an element of subtle drama or tension that engages our attention as we consider the meaning of a letter, gesture, or glance. By appealing to our senses of touch, hearing, and smell and by engaging our minds and emotions, Dutch genre paintings are unmatched in their ability to give effortless pleasure.

Portraits

Among the great achievements of Dutch painters were their portraits. These were commissioned at almost any opportunity—engagements, marriages, births, baptisms, circumcisions, university graduations, as well as deaths. Families traced their geneaology with portraits and, as families grew, copies were frequently made of images of important family members.

Portraits could be large and sometimes even life-size, but more often they were quite small. In fact, some painters specialized in delicate miniatures that were nonetheless accurate portraits. Painters who specialized in portraits were fairly well off, as most were commissioned with a prearranged price and delivery date.

Among the types of portraits were pairs of pictures depicting a husband and wife and the so-called "conversation pieces" that showed entire families together, eating, drinking, and playing music in the comfort and prosperity of their surroundings. Later examples of these painting often showed families in front of their estates. The Dutch had also been supporters of group portraits since the fifteenth century. Guild members, confraternities, militia groups, and veterans organizations regularly commissioned portraits that decorated their meeting halls. These group portraits were often integrated into the architectural embellishment of a room by being set into walls above fireplaces (so-called "chimney pieces").

Still-Lifes

The Dutch interest in all material objects resulted in a great variety of still-lifes. The earlier sixteenth-century manuscripts, with their lovingly executed borders depicting insects, fruits, and flowers, led the way to independent paintings of flower vases, fruits, and other edibles. Each type of still-life became a category of its own.

Flower pieces These developed about 1600, as rather strictly symmetrical, rigid depictions of flowers with an occasional insect or bird. Horticulture flourished in Holland, and between 1600 and 1637, the tulip, which had originally been imported from Turkey in 1554, became the object of a veritable mania. Naturally, tulips—in particular, variegated ones—were favorite subjects of flower pieces, but other flowers were also painted, including lily of the valley, iris, rose, narcissus, fritillaria, carnation, grape hyacinth, lily, columbine, pansy, anemone, and nigella. Flower paintings were usually pieced together from studies of various types of flowers kept in the studio.

The early, rather stiff arrangements of flowers gave way to more animated and natural paintings toward the mid- to late seventeenth century. Shells, imported from India or the West Indies, and insects would also be included in these paintings. Characterized by rich colors, infinite combinations, and painstakingly accurate renderings, flower pieces were most likely aided by the use of a magnifying glass, which permitted the detailed examination of flowers, insects, and shells.

Fruit and Food Still-Lifes Fruits (among these, grapes, cherries, apples, pears, lemons, oranges, and strawberries) and certain vegetables (such as asparagus) were among the subjects of Dutch still-lifes. Early examples of food still-lifes showed each food clearly and avoided any overlap.

Also popular in the first half of the seventeenth century were the so-called "breakfast pieces," which depict a light meal that could be eaten at any time: combinations of fruits, wines, cheeses, seafoods (fish, lobster, crab, oysters, and clams), smoked meats, pies, nuts, cakes, bread, and butter. Also shown in these paintings are the implements used for eating: glass or pewter beakers, plates, forks, knives, and tea canisters. Like the fruit still-lifes, early breakfast pieces avoided overlap, whereas later ones were more casually arranged, recording the momentary assembly of items for a meal. In these paintings, a damask cloth covering the table would be pulled to one side to reveal the dark wood of the table for color and textural contrast. By midcentury, subtle variations were introduced to an almost monochromatic palette of whites, greys, and browns that were combined to form the dull colors of glass, pewter, and oysters.

Toward the middle of the century, breakfast pieces declined in favor, giving way to the more luxurious "pronk still-life," which depicted a banquet rather than a modest meal. Magnificent and expensive objects, such as goldsmith's work, Venetian glass, and oriental ceramics, would join lavish displays of fruits, foods, and wines. In many respects, this change reflects the circumstances of new wealth found in such cities as Amsterdam by midcentury. The objects depicted in pronk still-lifes were not always owned by the painter or owner of the painting. Sources for images of these sumptuous objects included engravings and studies of objects for sale in a market. Occasionally these

objects were owned by the painter and then used repeatedly as models from one painting to another.

Vanitas Still-Lifes Some collectors preferred paintings of a more elevated nature, so painters created images that symbolically evoked the transitory nature of life and futility of human activity. Symbols of science (books and instruments), wealth (jewels and money), power (crowns), and frivolity (pipes, musical instruments, playing cards, and dice) were combined with symbols for time (skulls, watches, hourglasses, lamps, soap bubbles, and flowers) to inspire thought about the frailty and brevity of human existence. Leiden was an important city for such paintings and the Bible an important source for ideas. Some scholars point to the Calvinist stronghold at Leiden's university, but the morality conveyed by these still-lifes was an inevitable and obvious offshoot of an element that underlies many other examples of Dutch still-life paintings, namely, the sense of time and decay evoked by overripe fruits and foods.

Hunting Pieces These were never as popular in Holland as they were in Flanders. Images of dead game and fowl began to appear in Holland only after about 1640. Only a few painters specialized in them, and they were often commissioned by nobility.

Live Birds These were commissioned by rich burghers who had estates where they kept exotic and native fowl. These poultry breeders sometimes wanted "portraits" of their favorite specimens, and were supplied such portraits by various specialist painters.

Landscape Painting

Landscape painting was no less important than still-lifes or portraits. Holland's flat planes, dunes, forests, canals, and vast expanses of sea and sky were the subjects of innumerable paintings. Some painters specialized in particular types of landscapes, such as scenes of moonlit nights or beaches. Others explored a wide range of possibilities, limited only by their own vision of nature. Generally unhampered by the "theories" of landscape that guided so many painters in the rest of Europe, Dutch painters observed their environment directly and translated what they saw into original and convincing evocations of nature. A notable example of Dutch landscape painting is Aelbert Cuyp's *The Valkhof at Nijmegen* (Plate 5), perhaps one of the most serene views ever depicted. Of course, the painter's concern with composition and structure was still present. But although some landscape paintings from this period were more obviously staged than others, none was purely descriptive and none purely abstract.

In the 1620s the Dutch began to buy landscape paintings just as they had earlier acquired still-lifes, portraits, and genre paintings. Generally, landscape

paintings were standard in size and came in rectangular, oval, or round shapes. Paintings of modest proportions were most common and were set in simple black or gold frames after roughly 1650. Regardless of size, shape, or subject, the landscape painting almost always included figures of people. Scholars still speculate on the reasons for this, but the answer may lie, in fact, with the Dutch, for whom the inherent and simple pleasures of their existence were infinitely worthy of representation in painting. Included among these simple pleasures was the communion with nature, which was not viewed philosophically as a symbol for something greater, but rather pragmatically as the foundation of the Dutch existence in a benign, fathomable, and accommodating world.

Though explicit, few landscape paintings depict definable moments or seasons. Just as genre paintings were rarely specific, so landscape scenes rarely depicted a single moment, day, or season, preferring instead to suggest the subtle transition from one moment or season to another. The four seasons as a subject of landscape painting declined in popularity as other types of landscape painting emerged. The types of landscape scenes created by the Dutch painters are described in the following.

Dunes and Country Roads These depicted scenes of roads, dunes, farms, villages, and trees.

Panoramas Featuring scenes of vast plains stretching endlessly into the distance, these were perhaps the most "Dutch" contribution to painting and were derived from the inherent qualities of the Dutch terrain.

Rivers and Canals Depicting the networks of canals, rivers, and roads that formed the waterways and arteries of travel and trade within Holland, these posed special challenges to the artist, who had to be skilled in painting images of land, sky, and water.

Woods The representation of entire forests, rather than isolated trees, became an important element of landscape painting and was partly derived from Italian traditions. At times evoking the brooding, threatening, and magical atmosphere of the woods and at other times stressing the idyllic and verdant quality of forests, these paintings demonstrate that, even within a narrow type of landscape painting, the possibilities for interpretation were endless.

Winter There are no Italian or French, and few Flemish, counterparts to Dutch winter landscape scenes. Often devoted to portraying such pleasures of winter as ice skating or falling snow and sunlit snow, the winter landscape offered special opportunities for painters to demonstrate their ability to create an infinite variety of effects with limited colors.

Beaches This type of landscape became a popular image later in the seventeenth century. In the earliest examples, the beach served as a backdrop for other images, such as those of a beached whale or a landing boat.

The Sea A development of the 1650s, these landscape scenes depict buildings and streets, as well as distant views of towns from the sea.

Imaginary Views Drawing on the artist's fantasies or on imaginary combinations of Dutch, Scandinavian, Italian, and German landscapes, these views were painted to evoke moods ranging from melancholy to awe and to inspire the viewer's imagination to take flight. In general, these imaginary scenes affirm the certainty, regularity, and concreteness of nature rather than its more disturbing or violent aspects.

Views of Foreign Lands Images of landscapes found in Tyrol, Scandinavia, Italy, Germany, and Brazil were painted by traveling Dutch painters.

Nocturnal Views Scenes of landscapes by night were fairly common, providing a challenge to the painter to reproduce the wondrous effects of dark and light in the form of fire, moonlight, and reflections. Almost invariably demonstrating the continuity of existence, these night views are not threatening or ominous. Rather, they depict people going about their business at night—one fishes for crabs, another puts to shore; still others head for home to the comforts of rest.

Architectural Painting

Consisting mainly of street scenes and views of interiors, Dutch architectural paintings improvised on Flemish antecedents to develop paintings that treated buildings as independent subjects. Ironically, only this type of urban "landscape" painting could be depicted without people, presumably because the human forces behind the construction of edifices were implicit. Among the finest creations of Dutch architectural painters were scenes of church interiors, which were rendered as mystical and poetic visions of tonal gradations in compositions that were almost reverent in their attitude and execution.

History Painting

Though sometimes less highly regarded and even ignored by some scholars, history paintings were not infrequently produced by Dutch painters during this period. Most often associated with theoretical or academic art, these paintings were based on subjects from the Bible (often the Old Testament) or on scenes from ancient history and literature with moralizing overtones. Characterized by

a sense for originality and storytelling of the highest order, these paintings frequently gave the painter an opportunity to display his talents at painting figures. Perhaps the greatest painter in the history of Western art, Rembrandt was principally a history painter whose contribution to narrative painting remains unmatched to this day.

Because history paintings require a knowledge of literature and history, many such paintings that we see in museum collections today use subjects unfamiliar to the contemporary viewer. For those wishing to pursue an interest in history painting, the Bible provides extensive background on some of the literary traditions on which biblical history paintings drew, and other classical or historical subjects can be gleaned from studies of ancient history, mythology, and classical literature.

DRAWING

A treasured legacy that has been celebrated in numerous special exhibitions and studies, seventeenth-century Dutch drawings have survived in great number. Not all artists' drawings survive in equal numbers. Works on paper by Frans Hals, Jan Vermeer, and Jan Steen are extraordinarily scarce, while more than 1,000 drawings by Rembrandt are preserved. Not all types of drawings are equally represented either. Landscapes and figure studies are more commonly found today than still-life drawings.

Drawings served a variety of purposes. Some were initial sketches for an idea, others were created as independent works to be sold on their own merits, sometimes as cheaper substitutes for paintings. Like prints, some drawings depicted practical objects, such as the fire extinguisher (an invention of Jan van der Heyden in 1672), and sought to be informative in the way that Willem van de Velde the Elder's drawings showed the viewer a great deal of detail about ships and sailing.

Drawing techniques shifted during this century from the carefully observed delineations of the early seventeenth century to the open, rapid, and more spontaneous renderings that were characteristic of the later part of the century. Rembrandt, who stands apart in the history of painting as a genius, contributed directly to this development, for his swiftly executed drawings combined the mastery of keen observation and economy of execution that were to shape seventeenth-century Dutch draftsmanship. During this century, landscapes expanded into panoramas, and portraits tended to probe more deeply into the psychology of their subjects. Observation was keener and execution more succinct. Dutch drawings from this period reverberate with emotion, but never with sentimentality. They appeal to the viewer not only because of their technical mastery but also because they evoke many aspects of the human condition and respond to them with sympathy, understanding, and tolerance.

Those who drew had various tools at their disposal. Quill or reed pens and

ink, chalks, brushes and washes, watercolors, and combinations of these were frequently used on paper. The portability of drawing implements gave the medium an unsurpassed flexibility that allowed artists to record thoughts or impressions on the spot, resulting in drawings of all manner of subjects. Landscape drawings were made by artists on their walks. Scenes of fishermen, ice skaters, farmers, travelers, mothers and children, and peasants were observed and re-created with swift strokes of the pen or chalk. Every phenomena of nature—insects, plants, flowers, trees, and especially animals—were studied with fascination by artists. Many of these drawings were studies to be used for paintings; others were done purely out of interest and for their own sake. Artists also drew on their own imaginations to create images of the unseen, including biblical stories, legends, and the like. Again, many of these were done in preparation for history paintings, and others simply explored the visual possibilities of a particular subject.

PRINTMAKING

Dutch prints were collected for their beauty and virtuosity. From the time of their publication, there were buyers who valued the mastery of printmaking techniques and were concerned with the quality of an impression, or the "state" of a print. Prints were avidly collected by a broad spectrum of the population, for whom prints were thought to have an educational function, and could be purchased from booksellers, market vendors, auctions, print publishers, and artists' studios. Some prints were framed and hung like pictures, others were stretched between two rods (called rollen), and still others were placed into picture albums and preserved. These albums form the nucleus of many major print cabinets today. By the second half of the century, Dutch prints were collected as simple decorations or as components of vast libraries of encyclopedic knowledge, to which many educated people of the period aspired.

The many uses that prints found during this period determined to a large extent the subjects chosen for prints. Artists used these to familiarize themselves with the work of other artists, and many printmakers specialized in making reproductions of other artists' work. In this way, an artist's painting could become known throughout Europe, for prints were traded widely. Some artists kept collections of prints to teach their students drawing.

The Dutch thrived on hearing the news of the day, and their interest in current events spurred the development of some of the earliest gazettes, newspapers, and illustrated calendars. An assassination, a broken dike, a beached whale, celebrities, and military, political, or religious leaders of the day—all were recorded in prints that functioned much as photographs do today.

Prints were also an ideal medium for illustrating books of poems, fables, and songs. Such themes as the months of the year, the four seasons, the four elements, and the times of the day were no longer common to painting, but

found their way into prints, which were small and suited to the representation of information and ideas. The Dutch passion for ideas is evidenced by their emblem books, which combined pictures and words to create stories with a moral. Artists relied on emblem books to give an idea its proper and acknowledged form. Other types of books illustrated with prints included horticultural books, flower bulb catalogs, anatomical studies, and manuals on such topics as bookmaking and fire fighting.

Other subjects found in seventeenth-century Dutch prints had their origins in biblical stories, mythology, and scenes from everyday life. The ability to relate a story in pictorial form was a highly valued skill, and the narrative quality of Dutch prints is extraordinary. Series of prints recounting numerous episodes of a story were common at the beginning of the century but declined in popularity thereafter as stories condensed into a single frame became more frequent. In addition to narrating stories that conveyed a moral, many prints recorded the impressions and scenes of the long and frequent walks made by artists, who created these images for other walking enthusiasts. Excursions were made into the city, country, seashore, and foreign lands. Moonlight walks and journeys into forests, along the banks of rivers, and by castles, hedges, fences, and fields were celebrated in innumerable prints that were derived either directly from nature or composed from the artist's imagination. These prints depict a gentle and hospitable landscape that invites the traveler to wander and inspires a love of the land.

Among the most popular types of printmaking were woodcuts, engravings, and etchings. A common form of woodcut printing during this period employed several woodblocks inked with different colors to achieve often haunting effects of color called chiaroscuro. Woodcuts and engravings were most frequently used for book and newspaper illustrations.

Made by gliding a needle through the light, yielding wax coating on a metal plate, etchings were ideally suited for recording quick impressions of landscapes and for narrating stories. These plates could be easily reworked and altered as the artist's concept of the image changed, permitting a flexibility that made etching the most spontaneous and versatile medium of seventeenth-century Dutch printmaking. Some artists, among whom Rembrandt was the most notable and successful example, experimented with etchings further worked with a burin, a steel tool with an oblique point and a rounded handle. Called drypoint, this technique added another quality of line and tone to etched prints.

The enthusiasm for reproductions of paintings led to the development of the mezzotint, a technique that used a spiked wheel or rocker to mechanically produce dots on the printing plate. The dotted surface of the plate, after inking and printing, yielded infinitely varied tones of grays and blacks. Owing to their mechanical reproduction techniques and subject matter, mezzotints are regarded less highly as an art form than other techniques mentioned above.

SCULPTURE

In contrast to painting, of which there was a virtual outpouring, little sculpture was produced in seventeenth-century Holland. Although more sculpture was originally created than now survives, the activity in this medium was limited in comparison to other media such as painting. The principal types of sculpture created during this period were tombs, monuments, portrait busts, and other architectural or garden embellishments. More costly to produce than paintings, and therefore less frequently commissioned, the sculpture created at this time was not assembled in large private collections but rather was more integrated with its surroundings, thereby making the removal of such works from their original sites less feasible.

FLEMISH ART

Flanders and Holland shared a common artistic heritage that underwent distinct but not altogether dissimilar developments after the establishment of Flanders as a Catholic state and Holland as a Protestant one in 1588 (see map of Flanders, Figure 8-2). Although art historical scholarship distinguishes between these two regions, there were so many artistic crosscurrents and influences between Holland and Flanders that it is not until the seventeenth century that profound differences in style and content between Dutch and Flemish art can be pointed out.

A Catholic stronghold controlled by Philip II of Spain and his descendants, Flanders maintained a church and court that supported traditional religious imagery, whereas both of these forces had eroded in Protestant Holland. The great Flemish noble houses and churches required large-scale paintings that depicted historical, mythological, or religious subjects. The wealthy Flemings commissioned many of the same types of paintings found in Holland—notably genre, still-life, and landscape painting—but the Flemish renditions were more ostentatious and decorative than their Dutch counterparts. Scenes of valor or conquest, the fruits of the hunt, and battle scenes were far more popular as subjects of painting in Flanders than in Holland.

In addition to a penchant for certain subjects, Flemish art is also distinguished from Dutch art in style and manner of representation. By comparison with the calm reserve and contemplative nature of the relatively small-scale Dutch painting, Flemish painting is grandiose and energetic. If the Dutch valued the commonplace for its dignity and intrinsic value, the Flemish could be said to have exalted it, transforming it into something larger than life. Lusty, elegant, charming, and full of color and movement, Flemish painting exudes vitality. Rapidly executed with virtuouso brush marks and often expressing inner tensions in their compositions, Flemish paintings excite and confront the

FIGURE 8-2. Map of Flanders, c. 1600.

viewer, whereas Dutch paintings give pause for reflection. Compared to the order, stability, and often muted palette of Dutch painting, Flemish painting emphasizes diagonal and spiraling movements, dramatic gestures, and sparkling color. Heroic, fantastic, and imaginary, Flemish painting is in the grand tradition of large-scale decorative painting, which it produced with unparalleled virtuosity.

Like the Dutch, the Flemish took much inspiration from Italy and traveled there to study its masterpieces. But whereas the Dutch learned primarily from Italian landscapes and genre scenes, the Flemish concentrated on Italian religious and history painting and were inspired by the Venetian and Genoese traditions of loose and energetic painting.

If an interest in ostentation and display is characteristic of Flemish art, then it should not be surprising that sculpture, especially sculpted ornaments, played an important role in Flemish culture. In fact, native Flemish sculptors were summoned to Holland to supply sculptural decoration, due partly to the lack of

native talent in Holland. The church in Flanders was of course an important patron of sculpture, but many works were secular commissions originating from the many cities whose town halls, fountains, and prominent family estates required sculptural decorations.

Like Holland, Flanders was a land of artists who specialized not only in types of paintings but in other mediums as well. Printmakers, for example, were trained in a particular technique, be it wood engraving or etching. Perhaps due to the great demand for large-scale works and the tendency for patronage to favor certain important artists such as Peter Paul Rubens or Antoon Van Dyck, various specialists would often collaborate on a single work. A specialist in depicting animals might provide the fauna for an important history painting, while the great master created the figures. It was equally common that landscape specialists would rely on figure painters to populate their views of nature. Printmakers relied indirectly on other specialists by making their livelihood from reproductions of famous artists' compostions.

In addition to all of the types of art already mentioned, patrons valued art of quality and luxury in a variety of forms, including ivory carvings, precious objects such as painted cabinets, and fine works in metal.

RELIGIOUS PAINTING

Large-scale oil paintings depicting traditional religious themes, from the birth of Christ and the Last Judgment to episodes from the lives of various saints, decorated the altars and chapels of Flemish Catholic churches. Much of the figure placement, gesture, and overall composition were derived from Italian sources. The temperament of such paintings, characterized by an appeal to the emotions, also drew on seventeenth-century Italian traditions. However, Flemish paintings, though vital, lack on the whole the fervor and mysticism that are inherent in so much of Italian religious painting.

Individual patrons also selected religious themes for privately commissioned paintings. Just as in Italy, a popular subject for such works was the image of the Madonna holding her Child. The Flemish variant of this theme often framed the image with painted garlands of flowers, giving the whole painting a decorative quality that suited the tastes of Flemish patrons.

SECULAR PAINTING

History Painting

The depiction of biblical stories, which emphasized narrative and drama, prepared Flemish painters for other types of history painting that portrayed scenes from ancient history and mythology and contemporary events and literature. Just as the church commissioned these paintings as altar decorations, so the

Flemish archdukes, governors-general, and military leaders, as well as members of the courts of France, Spain, England, and Germany, sought out Flemish painters to supply large-scale history paintings for their palaces and castles.

Flemish history paintings are crowded and full of movement and drama. Stories appear not to unfold gradually, but rather to explode on the canvas. Ruben's fascination with movement and his unique approach to painting, which was based on an understanding that life is best expressed on canvas as a state of constant change, set the direction for generations of later painters.

The Nude

In an age that exuberated a particular vitality, seventeenth-century Flanders saw many mythological and historical subjects depicted as voluptuous nudes. Images of well endowed women being abducted or seduced or seducing men were popular among courtly patrons. Allegories of fecundity and earthly bounty were also produced, along with an occasional nude study. Interestingly, the provocative and fundamentally erotic nature of nudes found in late fifteenth- and sixteenth-century Italian painting was not recalled. Rather, the nudity depicted in Flemish painting of this period is more elemental, expressing a fundamental life force that is less erotic than it is vital.

Portraits

As important to the Flemish as they were to the Dutch, Flemish portraits tended to be more formal, reserved, and public. Many depicted members of nobility, who in general wished portraits to emphasize their position rather than their character. Even informal portraits retained a more courtly air about them by comparison with the unprepossessing ambience and accessibility of Dutch portraiture. Flemish portrait specialists were considered successful if they could endow their sitters with dignity and nobility, even when the sitters had no such qualities. Thus flattery rather than sincerity often underlay Flemish portraiture, but we are able to forgive such motivations in the face of Flemish masterpieces of portraiture that exude life and charm and succeed even on a grand scale. Flemish portraits may be different from their Dutch counterparts, but they are no less rewarding to behold.

Landscape Painting

Both Holland and Flanders owed the development of landscape painting to sixteenth-century Flemish painters (in particular Pieter Brueghel), but during the seventeenth century, Holland attracted a greater number of landscape specialists. Relatively few native landscape painters remained in Flanders, and those who did painted images comparable to those originating from Holland.

Views of forests, towns, the sea, vistas, and imaginary landscapes were common. Flemish landscapes tended to depend less on direct observation than on the artist's internal vision, and therefore they appear sometimes more artificial or fanciful.

The decorative purposes to which Flemish landscape views were oriented perhaps explain the greater popularity of thematic landscapes that depicted the months or seasons. Decorative landscape painters traditionally favored topographical views combined with woodland scenes, whereas other Flemish painters specialized in imaginary views of streets and town or city squares. The overall effect of giving pleasure to the eye, rather than the accuracy of the image, was prized most by painters and patrons alike.

Architectural Fantasies

An offshoot of the tendency toward imaginary imagery in Flemish landscape painting was an interest in architectural views that stressed the decorative elements of architecture and rarely depicted a structure for its own sake or appearance.

Genre

Scenes from the everyday life of peasants and burghers were also painted by the Flemish according to established Dutch traditions. In fact, the affinity for Dutch genre scenes expressed by the Flemish sets its genre painting apart stylistically from all of its other types of painting, which are generally more dynamic. If one could distinguish Flemish genre painting from its Dutch counterpart, the difference would lie in the Flemish tendency to idealize images and to stress the emotional aspect of a genre scene. By comparison, Dutch genre paintings may be said to be more true to life and of a somewhat more enigmatic nature.

Picture Galleries

A uniquely Flemish theme was scenes of picture galleries. Images of rooms festooned with paintings by old and contemporary masters were produced in considerable numbers. Among members of the Flemish nobility and wealthy families it had been a tradition to collect pictures on a grand scale, and it is this tradition that is reflected in paintings of picture galleries of this period. This type of painting was also perhaps a necessary, and in any event, fascinating development in a society that valued display to the point that it became itself a theme of painting.

Some examples of picture gallery paintings are important as historical documents because they reconstruct now lost or scattered collections and reveal to us which master artists, both native and foreign, were appreciated at the time.

Painted Cabinets

A painting type that was typically Flemish (generally produced in Antwerp) and a popular item for export, these ebony cabinets constituted a kind of miniature picture gallery. Usually quite small and used to contain jewelry or important papers, the cabinets were often adorned with tortoiseshell and divided into sections that were covered with miniature pictures. Door lids and drawers were painted with an interconnecting, sometimes biblical or mythological, theme.

Equestrian Paintings

The emphasis on the heroic and imaginary that underlay much of Flemish portraiture and still-life painting also led to the production of numerous paintings of horsemen. In combat or in conquest, astride the rearing charger or off on a hunt, these men on horseback epitomized virility, strength, and action.

Still-Lifes

As popular in Flanders as they were in Holland, still-life painting in Flanders included some types that were less common in Holland. For example, some still-life painters specialized in animal or hunting pieces, which displayed dead game or fish as the spoils of a hunt and sometimes showed these objects surrounded by garlands of fruits or flowers.

The breakfast pieces that were prevalent in Holland were gradually superseded in Flanders by hunting and other still-lifes that depicted sumptuous images of fruits, flowers, silks, and vases. The latter type formed a counterpart to the Dutch pronk still-life of the mid-seventeenth century. Vases of flowers were extremely popular as still-life subjects, and wreaths of flowers, sometimes surrounding images of religious subjects painted by other artists, were themes more specific to Flemish painting.

Oil Sketches

With the prevalence of large-scale commissions for paintings that often required studio assistance as well as the patron's prior approval of a work in the form of a detailed drawing or sketch, oil sketches became necessary and abundant during this period in Flanders. Lively and full of robust energy and spontaneous brush marks, these small-scale paintings were appreciated and collected in their own right. Many of these sketches for final works were executed rapidly and with less attention to detail, but they are nonetheless prized by museum collections today for their virtuoso handling of paint. Fluid, vibrant, and instinctive, these oil sketches often appeal to viewers more than their finished, somewhat more subdued and studied final versions.

DRAWING

Like their counterparts in Holland, artists in Flanders drew incessantly. Such great masters of the day as Rubens and Van Dyck probably produced thousands of drawings during their lifetime, yet what survives today numbers only in the hundreds. Compared to what has been passed down from previous centuries, however, a wealth of material has been preserved and is regarded as a precious legacy.

Most drawings were produced by artists as preliminary studies for prints or paintings, but many were also made as independent works for sale to collectors or presentation to patrons. Portrait drawings especially fell into this latter category. Patrons, family members, models, and places were the subjects artists drew, in addition to animals, landscapes, and sometimes special events. Due perhaps to loss, the wear of usage, or a fundamental difference in working methods, it is rare than one will find studies for still-lifes or flower paintings, whereas drawings of other subjects have been preserved and are themselves an optimistic and insightful celebration of life.

Flemish drawings can be characterized by their vivacity, love of color, and virtuosity. They exude vitality and record the rapid concentration of the artist's eye and hand at work. Sensual and perceptive, Flemish draftsmen chose those mediums that best suited their needs. Chalk, which is delicate and responsive to the lightest touch, was a particular favorite. Powdery or waxy chalks were commonly used in combinations of reds and blacks, or in more colorful mixtures, on papers often tinted buff or gray. Drawing with pen and ink, which permanently recorded each stroke, was also popular, as were washes of color such as bistre (a brown pigment derived from wood ash) applied with a brush.

PRINTMAKING

In Flanders as in Holland, prints flourished as a collector's item and in book illustration. By the seventeenth century, engraving had replaced woodcuts as a source for reproductive printmaking, although the woodcut continued to be used frequently for book illustrations. A number of painters, including such great masters as Van Dyck, experimented with etching, and draftsmen created etchings as individual prints and book illustrations that depicted the lives, activities, homes, and cities of their contemporaries.

By this time, there were also a number of professional printmakers (some of whom were also skilled in painting or draftsmanship) who sometimes created their own independent print designs and otherwise relied on the compositions of other painters. Firms that were established in previous centuries continued to produce prints, albums, and book illustrations. During this time, Rubens converted an engraver's school into a workshop, which was used to print reproductions of his paintings in order to market his work more widely. Among

those employed by Rubens was Christoffel Jegher, who used the somewhat older and difficult technique of woodcutting to produce exemplary images of a proficiency that matched or even excelled prints produced by others in copper.

The spontaneous, intuitive, and personal response of the artist to a landscape or genre scene—a hallmark of Dutch etching—was never quite matched by Flemish etchings of the time. Though an important center for the graphic arts in the seventeenth century, Flanders and particularly Antwerp experienced a decline after 1650, and the works produced after that point are not frequently collected or highly regarded today.

SCULPTURE

Supported by the traditional patronage of the church and nobility, Flemish sculptors produced a panoply of decorative sculpture—altars, tabernacles, rood screens, tombs, gates, and statuary. These sculpted forms were flamboyant and much of their inspiration was taken from Italy. As for any large-scale commission, sculptors would produce preliminary sketches, and many of these spontaneous studies in clay are preserved in museums today.

Sculptors of the day worked with a number of materials and sometimes specialized in a particular type of sculpture, such as relief plaques depicting biblical or mythological scenes. Woodcarvers busily turned out elaborately carved confessionals and choir stalls. Ivory—that ductile, smooth, and luxurious material that had been popular since before the Middle Ages—enjoyed a revival among seventeenth-century Flemish collectors. The greatest portion of carvings produced during this period imitated large-scale religious works on a small scale and were created for private collectors. Exquisitely carved crucifixes and madonnas were made and scenes from bacchanals, battles, Roman history, and mythology, as well as landscape views were also carved in relief.

In addition to the sculpted figures and reliefs, all sorts of practical items, including picture frames, plates, vases, furniture decorations, and candelabra were produced for Flemish and foreign patrons who had expensive tastes and large purses to match.

Toward the end of the seventeenth century, as commissions and economic opportunities in Flanders became scarce, Flemish sculptors began to migrate to England and to other parts of the Continent in order to support themselves. With the loss of these artists, who contributed to the artistic wealth of their later adopted countries, native Flemish sculpture became, for the time being, less abundant.

TAPESTRIES

Seventeenth-century Flemish tapestries featured subjects that were favored by their royal and monied patrons—scenes from hunts, mythology and ancient

history, the seasons, and religious themes. In such centers as Brussels, tapestry works employed such great painters as Rubens to supply cartoons from which tapestries could be woven. To some extent, it could be said that the history of tapestry came close to the history of painting.

After roughly 1650, Antwerp also became an important center for tapestry. Famed for its cartoons and tapestries, it, Brussels, and other centers exported tapestries throughout Europe, competing with other, notably French, tapestry makers. The competition heightened toward the end of the century, resulting in the introduction of new themes such as picture galleries, which had previously been found only in painting. Paintings could be copied in tapestries due to intricate stitching techniques that permitted the accurate rendering of detailed images. Paintings by certain masters known for their copies of other masters—David Teniers the Younger, for example—became especially fashionable as subjects for tapestry.

FRENCH ART

PAINTING

Between 1600 and 1700, French painting reached an extraordinarily high quality and became an influential artistic force whose impact was to last well into the twentieth century.

Many of the characteristics of seventeenth-century French painting were the result of its patronage. The royal court continued to exert the most profound influence on painting. The table on the next page shows the succession of French kings and republics during the sixteenth through twentieth centuries and the dates of their respective reigns. Henry IV, his widow Marie de Medici, and their heirs had very specific needs that were satisfied by certain kinds of painting. For instance, they demanded decorum and a certain pomp in their portraits and thereby dictated the style and format for portraiture that were to last throughout the century. Their royal palaces required large-scale decorations that painters furnished in the form of decorative allegories, using such themes as time and the seasons and classical tales that contained veiled or explicit references to their royal patrons. Those of nonroyal lineage who had the financial means emulated the court in dress, interior decoration, and the types of paintings they commissioned. Sometimes their large mansions, called hôtels, rivaled the palaces of the court in splendor. For this reason, the early part of the century is described as an age of painter-decorators who supplied royalty and high society with very large-scale images that had as their primary aim decoration. An example of the fanciful and charming aspects of decorative images is Simon Vouet's *The Toilet of Venus* (Plate 6), which combines elements of narrative, mythology and superb draftsmanship.

THE FRENCH MONARCHY AND REPUBLICS

Francis I	1515–1547
Henry II	1547–1559
Francis II	1559–1560
Charles IX	1560–1754
Henry III	1574–1589
Henry IV	1589–1610
(the first Bourbon)	
Louis XIII	1610–1643
Louis XIV (the Sun King)	1643–1715
Louis XV	1715–1774
Louis XVI	1774–1792
The First Republic	
The Terror	1793–1794
The Directory	1795–1799
The Consulate	
(Napoleon)	1799–1804
The First Empire	
(Napoleon I)	1804–1814
The Restoration	
Louis XVII	1814–1824
Charles X	1824–1830
The July Monarchy	
(Louis Philippe)	1830–1848
The Second Republic	1848–1852
The Second Empire	
(Napoleon III)	1852–1870
The Third Republic	1870–1940

French royalty affected painting on another very fundamental level. French artists, like those from other countries, had long been taught in a traditional workshop system beginning with apprenticeship and ending with independent master status. This workshop system was governed by the guild of St. Luke, which traced its origins back to medieval times. By midcentury the guild's power was declining, as some artists with royal support moved to establish an artists' academy, which was formally founded as the Royal Academy in 1648. The academy began to function actively in 1661, established a branch in Rome in 1666, and by 1667 began to hold annual exhibitions. Its growing strength was a manifestation of the belief in the intellectual or rational aspects of art shared by artists and royal patrons alike, who sought to remove art from the sphere of craftsmanship. Intellectual painting which emphasized balanced, har-

monious compositions and carefully delineated drawing as well as application of color, became increasingly pronounced with the official establishment of an academy.

By the academy's decree that art could only be taught under its aegis, the traditional guild system was gradually forced out of existence and the stature and influence of the academy were thus ensured. Establishing a system of intellectual and moral values that placed some types of painting above others, the academy placed history painting at the top of a hierarchy in which portraiture and still-life painting ranked much lower. Although portraitists and other types of painters were permitted membership in the academy, only history painters could hold high office.

Once the academy was functioning, it set new rules for the training of artists. According to a rigorous system of instruction, students studied and worked from antique models, using plaster casts and sometimes original sculptures. They were also thoroughly steeped in the traditions of Italian art, and engravings after Italian masterpieces were used as tools for teaching. Students also had access to the fabulous collection of Italian art at the Louvre, which was then the Royal Collections.

As the Royal Academy gained strength, the artists it produced had potentially lucrative careers open to them through the vast connections that bound the academy and the royal court. All important posts, including that of *premier peinture du roi* (chief painter to the king) and other adjunct positions, as well as the directorships of the Gobelins tapestry factory and the academy itself, were filled by appointments of the court. The court controlled patronage and, as a result, strongly influenced both the nature and subject matter of the official art produced by academy members.

The academy established clear categories by which painting was judged. Composition, drawing, color, and expression were all critical components in the production and evaluation of art. In its many lectures and discussions, the academy formulated a theoretical basis for art that set the stage for the development of academic art in the eighteenth and nineteenth centuries. In keeping with the predominantly theoretical approach of the academy, most of the art produced under its direction can be characterized by its order, rationality, and control. Furthermore, most artists, whether or not they adhered to the artistic principles of the academy, were far more conscious of the theoretical basis of their art than artists of the past had been. Thus their styles were at least influenced by the academy's belief in certain artistic principles, as well as by the intended function of an artwork and their own personalities.

Like artists from other countries during this period, French painters flocked to Rome to attend the branch of the Royal Academy there. Rome housed colonies of French, German, Dutch, and Flemish artists who all sought to study and derive inspiration from Italian traditions in art. There painters had all of the splendors of classical antiquity and the beauty of Rome and its country-

side at their disposal. Free from the restrictions imposed on them by their traditional patrons, French painters tended to work more independently and to produce whatever pleased them or whatever the market would bear—a wide spectrum of the possibilities in a city where the papal court, foreign ambassadors, local nobility, and tourists from all countries were eager to purchase works of art.

It will become evident to the reader in the pages that follow that religious painting declined in significance during this period of French painting, whereas certain types of secular painting become preeminent. The types of secular painting that were created in seventeenth-century French art are discussed in order of the significance they had during this period.

Religious Painting

Churches and private patrons continued to commission traditional religious subjects. These paintings served many of the same functions as earlier pictures, but in many cases there was less emphasis on the meditative qualities of the images and more on their decorative appeal. According to some scholars, the end of the century that witnessed the misfortunes of Louis XIV, economic strife, and wars created a change in patronage. History paintings began to lose favor to religious paintings as a conservative mood struck the country. Until roughly 1680, religious pictures were secondary to paintings commissioned to celebrate the king. After 1680, there were fewer reasons to celebrate royal victories and the king had become rather pious under the influence of the Marquise de Maintenon, whom he secretly married circa 1683. These factors contributed to a revival of religious paintings, and altarpieces and other church decorations were more actively commissioned.

History Painting

The ability to depict the essential elements of an important historic moment or a dramatic episode from literary, biblical, or mythological sources was considered in France the supreme test of the painter. Using few examples from recent history, artists derived inspiration and images from a repertoire of biblical, classical, or literary texts to re-create on canvas dramatic events from which the viewer could gain intellectual or moral stimulation. History or narrative painting had long existed before the Royal Academy emerged, but it gained a new importance in the minds of academy members. As the most intellectual form of painting, history painting became the highest, most valued form of expression, and history painters the most highly esteemed painters of their time.

Painters worked diligently to create a history painting. They studied history texts, literary sources, archaeology, and anatomy to obtain the most convincing, historically accurate, and dramatic depiction of a particular episode. The heroic

and grand purpose of history painting demanded that such art be of a rather large size. The painter carefully considered the gestures, poses, and expressions of the characters in his drama, as well as their relationship to one another and to the background. No element of a picture was disregarded and all were chosen to fulfill the lofty purposes of history painting, which was to depict the precise moment in a drama at which its meaning and impact were most clear. Chance inspiration, intuitive changes, and a spontaneous working method were not the means to achieve this goal. Many history painters modeled their compositions and images after classical or Italian examples. The painters of this self-consciously intellectual approach were also described as painters in the Grand Manner, creating images that evoked the loftiest ideals of art.

Portraits

Portraits were supremely important in a courtly environment. Painters who were fortunate enough to attract royal patronage spent much of their time recording the likenesses of various branches of the royal family and the members of its court. Portraits also played an important role in diplomatic exchanges, for the gifts reciprocated between royal houses often included portraits.

The primary purpose of such portraits was to preserve the likeness and express in every way possible the dignified position, power, and nobility of the sitter. Thus, a portrait painter who wanted to be successful flattered his sitter and underscored the latter's refined, aristocratic nature, even if this meant bending the truth a bit. Psychological insight was not as important to the patron as a pleasing likeness, which most often depicted the sitter in an aloof, self-controlled, and regal bearing. Visions of studied elegance, portraits were commonly bust-length or full-length. The subject was often shown with emblems defining his or her position, or sometimes appeared in the guise of some mythological character. Both sitter and painter were conscious of their common aim to adjust or embellish reality in order to achieve the proper official, public portrait.

Miniatures Besides large-scale portraits, the French popularized the miniature. Small, intimate likenesses were painted on vellum in tempera or sometimes in oil and occasionally on a form of baked enamel invented by the French. Circular and oval shapes were common for these miniatures, which often adorned snuffboxes, albums, and lockets.

Landscape Painting

As a type, landscape painting began to flourish in seventeenth-century France, and large-scale landscape images were particularly suitable to decorate the palaces of French royalty and upper classes. These landscape scenes tended to

emphasize a sense of order, harmony, perfection, and poetry because, like many other types of French painting during this century, they were the product of the mind rather than the eye.

Although painters often drew landscapes to record specific sites, such as the Italian countryside and the ruins around Rome and Tivoli, these drawings were used as notes for studio paintings that transformed and idealized the reality captured by those drawings. Various oil studies sometimes preceded the final large canvas, and they all aimed at evoking the structure and balance inherent in nature. Systems for establishing foreground, middle ground, and background yielded images that imposed order on the random growth of nature.

Occasionally, landscapes had subjects of a classical or literary derivation. But these historical landscapes tended to emphasize the natural setting for the story, allowing the scenery to become part of the drama that transported the viewer into a utopian vision full of dignity, integrity, and grace.

Painters active in Rome produced views of the city, its ruins, and the surrounding countryside. Elegiac views of harbors that often mingled myth and reality and evoked a bygone age of classical splendor and perfection must have been inspired by the grandeur that Rome still had for the French painters working there. It would not be hard to imagine that such paintings captured the imagination of many a tourist or ambassador who traveled to Rome.

Still-Life

According to some scholars, an economic crisis at the end of the seventeenth century prompted a rejection of monumental history painting and, in turn, allowed Dutch art to have a greater influence on French painting. Flower and other types of still-life paintings in the Dutch and Flemish style began to appear, but the number of painters practicing this type of painting in the early part of the century was very small (see list of artists at end of chapter).

Genre

Scenes of peasant and lower-class life were not extensively depicted in comparison with the number of history paintings and portraits produced by French artists of this period. Scholars are still sifting through the evidence to determine who the patrons of genre paintings might have been, but it appears that there was an emerging group of middle-class patrons who commissioned images of bourgeois life and who might have enjoyed the peasant scenes that were being produced by a small group of painters. These painters, most notably the Le Nain brothers and Abraham Bosse (see list of artists at end of chapter), were to a great extent inspired by Dutch genre painters.

DRAWING

One of the principal innovations of the French Royal Academy was the establishment of life drawing classes. Drawing was considered fundamental to the training of an artist. In fact, drawing instruction was the only academic program that remained relatively unaltered during the lifetime of the French academy. Consequently, museums have inherited a vast number of academic drawings, many of which were made during the life drawing classes held in the academy.

These drawings can often be identified by their technique and/or subject. A male model usually posed for about two hours a day as students gathered around him and drew his pose in red chalk (also called *sanguine* or *crayon rouge*) on white paper. Limited to the use of these materials, these artists in training were required to obtain all gradations of dark to light needed to render the musculature and to make the figure appear dimensional. They were required to draw without correcting mistakes, for which red chalk was ideal, as it is almost impossible to erase. This rigorous system trained students to work thoughtfully and deliberately, and taught them to make the most from a restricted material by exploiting its properties to the fullest.

Drawing from the live model was permitted only after the student had learned to draw from other sources. Learning first to draw from his teacher's drawings, he made studies after engravings and prepared individual studies of parts of the body—eyes, hands, face, and feet—to improve his understanding of proper anatomical rendering. Engravings and plaster casts after antique statues were the common sources for anatomy studies. Finally, the student studied plaster casts of complete statues, after which he graduated to the live model. After gaining sufficient proficiency in drawing the human figure, the draftsman could incorporate it into compositional and other studies that were necessary for the preparation of the history painting. In doing so, the artist could also use materials other than red chalk, including other colored chalk, lead pencil, pen and ink, or brush, and tinted papers.

Chalk is a very flexible material, and it remained a favorite medium of many artists even after their student days. Chalk could produce an infinite variety of lines and textures. Lines could be thick or thin depending on the hand's pressure. Those lines could be drawn in a crisscross pattern known as cross hatching to describe an object's volume. Chalk could be rubbed (or "stumped") or it could be dragged across the paper lightly to let the grain of the paper show through (called graining).

PRINTMAKING

French printmakers, like their counterparts in Italy and Holland, tended to use metal plates to make engravings and etchings. Woodcuts and monotypes, on the other hand, were not commonly used for prints.

ENGRAVING

Engraving was a method generally used by printmakers who made a living specializing in reproductions of the work of other artists. Some were attached to the French court and recorded its notable events, festivals, and ceremonies. These professionals are not well known by those outside the field of specialized scholarship.

ETCHING

Two seventeenth-century French artists who worked as printmakers, primarily as etchers, proved to be so gifted that their contributions to the history of the print are still valued today. Jacques Bellange (see list of artists at end of chapter) spent most of his career attached to the ducal court of Nancy in Lorraine, where he served Duke Charles III (reigned 1545–1608) and Duke Henry II (reigned 1608–1624). Bellange created etchings of the momentous funeral of Charles III and the grand entry of Henry II into Nancy. These prints were eagerly purchased by the general population, which was anxious to have a memento of such an historic occasion. Bellange also supplied decorations and entertainments for the court that were recorded as etchings. He is best known for his religious prints, which were highly personal and mystical interpretations of traditional subject matter, as well as inventive experiments with etching technique.

Jacques Callot (see list of artists at end of chapter) began and ended his career at the ducal court of Nancy, spending intervening years in Florence at the Medici court. Like Bellange, Callot spent a great deal of his time recording courtly festivals and various military engagements. The latter resulted in his famous series of etchings, the *Miseries of War* (1633). Callot's involvement in court and general entertainments led to the print series *Balli di Sfessania* (1622), which included the earliest known depictions of characters from the Italian Commedia dell'Arte that was then performing throughout Europe, and which helped popularize such characters as Pantaloon and Punchinello.

Callot exploited the small scale of the etching medium to create images of a grandiose and epic nature. His interest in daily life led to the production of a remarkable series of etchings of peasant and low-life types, and his religious prints included one of the most popular prints of the century, the *Temptation of St. Anthony* (c. 1635).

SCULPTURE*

Small-Scale Sculpture

Because seventeenth- and eighteenth-century French artists valued ideas, imagination, and inventiveness above all else, the viewer should not be concerned (as

*This section covers French sculpture for both the seventeenth and eighteenth centuries.

many tend to be today) about the repetition of these ideas in many mediums. The tendency many artists had to reproduce the same images in a variety of forms—paintings, drawings, and prints—has nowhere clouded the issue of intrinsic artistic merit more than in French sculpture. Although art history surveys acknowledge the achievements of large-scale French sculptors, they tend to ignore the abundant production of small works. These smaller sculptures are criticized because they often replicated large-scale commissions and because often many of the editions that were made did not receive the individual attention of their creator. Yet these small bronzes, terra-cottas, marbles, and porcelains were designed to fit the more modest proportions of French parlors and studies and were an important part of the overall decoration of French hotels. And they have been more successfully collected by art museums today, where they constitute a fascinating element in any museum collection.

Small sculptures were admired in their own time. More French bronzes were made and collected between roughly 1640 and 1789 than any other type of sculpture. According to the eminent contemporary scholar Sir Francis J. B. Watson, sculpture played a more important role in the interior decoration of French homes than Italian bronzes ever did in their decorative settings. In fact, the very popularity of French bronzes, which continued to be in demand through the nineteenth century, has contributed to their current status in art history scholarship.

How were sculptures made? According to some specialists only a fraction were copies made after existing models. Others were small-scale sculptures in their own right. They were issued in editions that were often quite large to satisfy a growing demand. For bronzes, the process of manufacture was as follows: Once the model was made, a mold was taken and the bronze then cast, to be chased and finished afterward. Only occasionally would all of these steps involve only one person; more commonly, the process entailed collaborative efforts among anonymous studio or factory members, who fulfilled designated tasks according to their special skills. There was a great deal of money to be made by selling casts, so factories sometimes owned the copyright to certain models. In many cases, we do not know any of the names of the artists involved; in other instances we do know the originator of a composition.

The appearance of a new, major, large-scale work, such as an equestrian monument of Louis XV, would naturally prompt a demand for copies by a larger audience with a general interest in the arts. The resulting bronze copies, though not unique, reproduced the large-scale model with an often astounding technical virtuosity and a sense for the adjustment needed for the smaller format that made these copies precious, delightful objects in their own right.

Due to the generally decorative function of all sculpture, the same statuettes were made in a variety of materials, including porcelain, marble, and terra-cotta. Porcelain, a hard, white ceramic first imported from China, had been used for all kinds of functional objects, but by the eighteenth century, its use

was extended to figurines. The most important French porcelain factory was established in Vincennes in 1738 and later moved to Sèvres. French porcelain makers searched for a formula to produce a clear, white Chinese porcelain that could compete with Meissen porcelain. This was achieved by 1769. Perhaps the pure white color of porcelain helped to popularize it. Colored figurines never gained the popularity in France that they had in Germany. With the love of bozzetti that was so fundamental to the age, it was perhaps the similarity between the rather matte white bisque porcelain perfected by Sèvres and terra-cotta, from which many bozzetti were cast, that enabled porcelain to convey the immediacy of a sketch while maintaining a light color so pleasing to the overall interior decoration.

Sculptors of substantial merit—including Falconet, Boizot, Clodion, Houdon, and Pigalle (see list of artists at end of chapter for details)—supplied models for the porcelain figure maker. Groups of children, *putti* (cherubs), mythological figures, and portrait busts of famous people ranging from Rousseau and Voltaire to members of the royal family, as well as actors and dancers, joined the cast of figures rendered in bronze, marble, porcelain, and terra-cotta sculpture.

Certainly the division between purely decorative art and art of a higher order was never less distinct than during this period of sculpture. Scholars suggest that, as porcelain rose in prominence, much bronze production was simply recast from terra-cotta or porcelain models. On the other hand, bronze casters not only produced exquisite small-scale works but also supplied furniture makers with models from which to make sculpted implements. These decorative works, such as clocks, candelabra, andirons, barometers, and wall lights, now often collected for their extraordinarily fine technique and sophisticated design, mixed the animate with the inanimate and disguised function in ornate form, making every aspect of the interior design so captivating that no single element actually stands out—all is alive with movement and fantasy.

Over the century, tastes varied as to the actual design and finish of many pieces of sculpture. Ormolu, or gilt bronze, decoration reached a high level of popularity in the late eighteenth century and remained in demand into the nineteenth.

Large-Scale Sculpture

Of the many types of large-scale sculpture—tombs, public monuments, garden statues, architectural embellishments, and the like—only one type commonly finds its way into the museum collection; the portrait bust. Portrait busts in marble and terra-cotta were very popular and are praised today for their vivacity and ability to capture a fleeting moment. A brief turn of the head, a glance, a parting of the lips produce a subtle expression that could change at any moment. The great portrait sculptors of the day—Lemoyne, Pigalle, Clodion, and

most notably Houdon—contributed marvelous portraits. They range from the traditional shoulder-length bust most common to the seventeenth century to the simple bust depicting only the head and neck that was revived from Roman antique traditions. Sculpted portraits also included full-length standing or seated figures, but these were more commonly associated with tomb sculpture.

SPANISH ART

By the seventeenth century, Spain could look back on a long history of political and economic dominance over Europe. Charles V, enriched by the gold that the Spanish drained from their conquered South American territories, ruled the Holy Roman Empire, which included the Netherlands, northern Italy, Spain, and Austria. By the time Charles retired to his monastery and handed the reins of power to his son, Philip II (reigned 1556–1598), Spain's preeminence was weakening: the Dutch had gained their freedom, Spain was at war with France, and the Spanish economy was declining. Philip IV (reigned 1621–1665) produced an heir, Charles VI (reigned 1666–1700), whose ancestry was the result of so much inbreeding that he had only 46 immediate ancestors compared to the normal 120 or so. Charles did not have the capacity to live, much less rule, normally and failed to produce an heir, thereby ending the Spanish Hapsburg line and leaving what was left of the Spanish Empire in 1700 to the French Bourbons.

The kingdom the Bourbons inherited was weakened by war, financial instability, famine, and plague. An entrenched bureaucracy and a powerful church, as well as the court, lived a life of conspicuous wealth side by side with the poor, whose marginal existence was in sharp contrast to the flagrant excesses of the rich. Unlike Holland, Spain did not develop a large merchant class.

In this period of economic and political decline, Spain produced a flowering of artistic genius supported by two principal patrons, the court and the church. The church, like its counterpart in other Catholic regions, desired art for use in devotion and church services. The court and bureaucracy required portraits and decorative works with which to embellish their residences and palaces.

The artists who supplied these images took much of their inspiration from Italian art, particularly that of Rome and Venice, and cast more than an occasional glance at the artistic output of Holland. Spain produced a number of artists whose stature and legacy are still subject to debate. Certain figures, such as Velázquez, have reached a position of undisputed greatness in the eyes of most, whereas other figures, such as Murillo, have fallen in and out of favor in successive eras.

Most of these painters have a common trait that renders them uniquely Spanish despite their sometimes foreign artistic origins. Theirs is an art of extremes, in which drama and the ordinary, dream and reality, emotions and

dispassion, pride and humility coexist with one another in an uneasy but effective truce. Like great artistic traditions elsewhere, Spanish art fruitfully employed the dynamics of paradox, fusing seemingly incompatible elements into a single image. Only lesser artists sounded a single note, exchanging drama for sentimentality or realism for a superficial and varnished interpretation of the truth. In the greatest Spanish works, passion is harnessed to a disciplined dignity and fatalism. A devotion to the harshness of reality and a fervent belief in the hope and comfort offered by faith are the two strains that run through the remarkable tradition of seventeenth-century Spanish art.

Of all the arts, only painting is widely known and collected outside Spain. Sculpture remained almost exclusively at the service of the church. Although painters were also draftsmen and occasional printmakers, their chief contribution was made in the art of painting, and it is on this medium that the discussion here will concentrate.

PAINTING

Portraiture

The Spanish court at Madrid actively patronized artists, whose major commissions were portraits. Intended to show the sitter in the most dignified and noble posture, portraits were most commonly full-length and bust-length, and group portraits were also done. Most portraits tended to be formal and detached from the viewer in order to keep the beholder at a respectful distance. Very little seventeenth-century Spanish portraiture went beyond the norm set by courtly images, although occasional informal portraits of family and friends show the more relaxed and approachable members of a different class.

In the hands of a genius such as Velázquez, the formality of courtly likenesses and behavior was given a startlingly informal and penetrating quality. In seemingly casual groupings, he recorded the arrogance of royalty and its self-imposed severity at the same time he captured the essence of their humanity that lay beneath the façade.

Religious Painting

An intensely Catholic country, Spain actively patronized religious paintings in the seventeenth century. Churches and monasteries commissioned large altarpieces depicting the religious ecstacies and martyrdoms endured by saints. Like other Catholics, the Spanish favored images of St. Peter, the first pope and patron of confession.

The laity also patronized religious art. Seville was an active center of lay patronage, and Murillo one of its most popular painters, whose images illuminated the human, sentimental features of Christian ideology. The dogma of the

Immaculate Conception was fervently upheld there, and countless images of it were commissioned. The Franciscan patrons of Seville and elsewhere commissioned images of Franciscan saints, usually engaged in acts of simple piety and charity, such as giving food to the poor or praying. The interest in bringing religion closer to human experience in artistic images prompted some artists (notably Murillo) to include children and beggars and other elements of genre painting into their religious works.

Nudes and Mythological Paintings

Inspired by Italian painters, the Spanish produced, on rare occasions, images of classical mythology. The Spanish court, familiar with the works of seventeenth-century Italians and Flemings, occasionally purchased works with mythological themes from native artists, but the threat of the Inquisition imposed severe limitations on nudity in Spanish art.

Genre Painting

It is somehow axiomatic that the usually well-to-do patrons of art sometimes would seek representations of conditions or people that are foreign to their own milieu. Thus, the nobility and wealthy classes of Italy and Spain developed a taste for images of beggars, the poorest members of society. An age that had as well-developed a sense for realism as the seventeenth century in Spain would only logically have found genre images especially fascinating. Spain, which had endured wars, famines, and plagues throughout the century, had a large population of impoverished, yet dignified people. They were the frequent subjects of Spanish painters, and their conditions in life were recorded at times unsparingly and at other times in an idealized fashion. Images of street urchins, beggar-children, and suffering men and women were effective in commanding the viewer's respect or exacting his sympathy.

Still-Life Painting

A less frequently patronized art form in Spain, still-lifes were painted, and some artists specialized in certain types of still-life. Paintings of flowers in baskets and vases often emulated Dutch and Flemish prototypes. Occasional vanitas still-lifes, depicting books and moralizing symbols of time or death, were also produced, but the beautiful and sparingly arranged still-lifes of fruits, vegetables, and assorted containers and jars are a characteristically Spanish interpretation of Dutch and Italian still-life traditions.

SEVENTEENTH-CENTURY ARTISTS
ITALIAN PAINTING,
—————— DRAWING, AND PRINTMAKING ——————

Bologna

Francesco Albani (Bologna 1578–1660). Church decorations, religious, palace murals, mythological history.

Guido Cagnacci (Santarcangelo di Romagna, near Rimini 1601–Vienna 1663). History, mythology, allegory. Engraver. Traveled Venice, Vienna.

Simone Cantarini (Opopezza, near Pesaro 1612–Bologna 1648). Religious, history. Student of Guido Reni. Engraver. Traveled Pesaro, Rome(?), Mantua.

Domenico Maria Canuti (Bologna 1620–1684). Religious. Traveled Rome.

Agostino Carracci (Bologna 1557–Parma 1602). Mythology, history, religious, palace decoration, few portraits. Brother of Annibale Carracci, cousin of Lodovico Carracci. Engraver, poet. Traveled Parma, Venice.

Annibale Carracci (Bologna 1560–Rome 1609). Religious, landscapes, mythology, some portraits. Worked with his brother and cousin. Engraver. Traveled Venice, Parma.

Lodovico Carracci (Bologna 1555–1619). Religious, mythology, some portraits. Engraver. Traveled Venice, Parma, Mantua, Rome.

Giacomo Cavedoni (Sassuolo 1577–Bologna 1660). Mythological, religious.

Carlo Cignani (Bologna 1628–Forlì 1719). Religious, history, mythology. Pupil of Francesco Albani.

Angelo Michele Colonna (Côme 1600–Bologna 1687). Church frescoes, religious, mythological. Traveled Florence, Parma, Modena, Genoa.

Pietro da Cortona (Cortona 1596–Rome 1669). Religious, history, mythology, frescoes, church decoration (Barberini Palace). Architect. Traveled Parma, Rome.

Girolamo Curti (Il Dentone) (Bologna 1570/77–1631/32). Architecture, specialist in perspective.

Domenichino (Domenico Zampieri) (Bologna 1581–Naples 1641). Religious, mythology, portraits. Traveled Modena, Reggio-Emilia, Naples, Parma, Rome.

Luca Ferrari (Reggio 1605–Padua 1654). Religious, mythological. Pupil of Guido Reni.

Francesco Giovanni Gessi (Bologna 1588–1649). Religious, mythology. Student of Guido Reni.

Guercino (Giovanni Francesco Barbieri) (Cento 1591–Bologna 1666). Religious, mythology. Traveled Ferrara, Venice, Rome, Piacenza.

Giovanni Lanfranco (Parma 1582–Rome 1647). Religious, history. Pupil of Annibale Carracci. Traveled Rome.

Mastelletta (Giovanni Andrea Donducci) (Bologna 1575–1655). Religious, landscape, genre.

Agostino Mitelli (Battedizo, near Bologna 1609–Madrid 1660). Architecture figures, history, religious. Engraver, etcher. Traveled Parma, Modena, Genoa.

Lorenzo Pasinelli (Bologna 1629–1700). Religious history, portraits. Decorator, etcher. Pupil of Boroni, Simone Cantarini. Traveled Turin, Mantua, Rome, Venice.

Andrea Regio (painted in Bologna c. 1640). Religious. Pupil of Guido Reni. Traveled Padua, Modena.

Guido Reni (Bologna 1575–1642). Religious, history, mythology. Etcher. Traveled Rome.

Giovanni Giacomo Sementi (Bologna 1580–Rome 1636). Religious history. Pupil of Guido Reni.

Elisabetta Sirani (Bologna 1638–1665). Religious. Engraver. Student of her father, Giovanni Andrea Sirani.

Giovanni Andrea Sirani (Bologna 1610–1670). Religious, portraits. Engraver. Pupil of Guido Reni.

Lionello Spada (Bologna 1576–Parma 1622). Religious history. Traveled Rome, Naples, Modena, Ferrara, Reggio.

Alessandro Tiarini (Bologna 1577–1668). Religious, history.

Florence

Alessandro Allori (Florence 1535–1607). Religious, history, portraits. Traveled Rome, Tuscany.

Giovanni Balduccio (Il Cosci) (Flourished in Florence 1550–1600, died Naples 1603). Religious, history, frescoes.

Stefano Della Bella (Florence 1610–1664). Religious, genre. Etcher, engraver, draftsman. Traveled Italy, Paris, Holland.

Lodovico Cardi (Il Cigoli) (Castelvecchio 1559–Rome 1613). History, religious. Sculptor, architect, poet, musician. Pupil of Alessandro Allori.

Jacopo Chimenti (Jacopo da Empoli) (Florence 1554–1640). Religious.

Sigismondo Coccapani (Florence 1583–1642). Religious. Architect.

Cesare Dandini (Florence c. 1595–1656/58). Religious.

Carlo Dolci (Florence 1616–1686). Religious, portraits. Student of Jacopo Vignali.

Ciro Ferri (Rome 1634–1689). Religious, frescoes. Sculptor. Pupil of Pietro da Cortona.

Felice Ficherelli (Il Riposo) (San Gimignano 1605–Florence 1660). Religious, history, mythology.

Orazio Fidani (Florence 1610–c. 1656). Religious, history, church paintings, some portraits.

Baldassare Franceschini (Il Volterrano) (Volterra 1611–Florence 1689). Religious, allegory, portraits (especially of the Medicis).

Francesco Furini (Florence 1604–1646). Specialist in faces of women and children, religious, history, portraits. Traveled Rome, Venice.

Giovanna Garzoni (Ascoli 1600–Rome 1670). Miniatures, portraits (especially of Medicis), and flowers.

Jacopo Ligozzi (Verona 1547–Florence c. 1627/32). History, portraits. Traveled Venice.

Lorenzo Lippi (Florence 1606–1665). Religious, court painter of Innsbruck. Poet. Pupil of Rosselli.

Giovanni Battista Lupicini (or Lopicino) (c. 1575/76–1648). Religious history. Pupil of Cigoli. Active in Florence c. 1625.

Giovanni Mannozzi (Giovanni da San Giovanni) (San Giovanni Valdarno 1592–Florence 1636). Student of Matteo Rosselli.

Giovanni Martinelli (c. 1610–1659 or 1668). Allegory, religious.

Sebastiano Mazzoni (Florence 1611–Venice 1678). Mythological, satirical portraits, religious. Poet. architect. Pupil of Cristoforo Allori.

Lieven Mehus (Oudenarde 1630–Florence 1691). Battles, landscapes. Pupil of Pietro da Cortona. Came to Milan 1640.

Francesco Montelaticci (Cecco Bravo) (Florence c. 1600–Innsbruck 1661). Genre, religious.

Simone Pignone (Florence 1614–1698). Mythological, religious. Pupil of Francesco Furini. Traveled Venice.

Bernardino Picetti (Bernardo Barbatelli or Bernardino Barbatelli) (Florence 1542/48–1612). Lives of saints, landscapes, fruits, flowers. Traveled Rome.

Matteo Rosselli (Roselli) (Florence 1578–1650). Religious, history, frescoes on the history of the Medicis. Traveled Rome.

Giovanni Battista Vanni (Pisa 1599–Florence 1660). Religious. Engravings of religious subjects. Architect, engraver. Pupil of Jacopo da Empoli, Matteo Rosselli, Cristoforo Allori.

Ottavio Vannini (Florence 1585–1643). Religious history.

Jacopo Vignali (also Jacopo da Prato Vecchio) (Prato Vecchio 1592–Florence 1664). History, religious. Pupil of Matteo Rosselli.

Genoa

Giovanni Andrea Ansaldo (Voltri, near Genoa 1584–Genoa 1638). Religious, biblical scenes.

Gioacchino Assereto (Genoa 1600–1649). Religious. Student of Luciano Borzone and Andrea Ansaldo.

Luciano Borzone (Genoa 1590–1645). Religious, history, some portraits. Engraver.

Giovanni Maria Bottalla (called Raffaelino) (Savona 1613–Milan 1644). Religious themes in the Raphaelesque style. Pupil of Pietro da Cortona.

Giovanni Bernardo Carboni (Albaro 1614–Genoa 1683). Religious, history.

Carlo Carlone (Scaria 1686–Côme 1775/76). Religious, allegory. Engraver. Traveled Venice, Rome, Germany.

Giovanni Andrea Carlone (Genoa 1590–Milan 1630). Religious. Worked in Genoa and Milan.

Giovanni Battista Carlone (Genoa 1592–Turin 1677). Religious.

Valerio Castello (Genoa 1624–1659). Church façade decoration, religious. Student of Domenico Fiasella and G. A. Ferrari.

Giovanni Benedetto Castiglione (Il Grechetto) (Genoa 1616–Mantua 1670). Religious, wild animal scenes, mythological. Student of Giovanni Andrea del Ferrari. Traveled throughout Italy.

Gregorio de Ferrari (Porto-Maurizio 1647–Genoa 1726). Religious, allegory. Pupil of Domenico Fiasella.

Giovanni Andrea de Ferrari (Genoa 1598–1669). Religious.

Domenico Fiasella (Il Sarzana) (Sarzana 1589–Genoa 1669). Religious history, portraits.

Bartolommeo Guidobono (Savonna 1654/57–Turin 1709). Religious, history, majolica decorations. Traveled Parma, Venice.

Domenico Piola (Genoa 1628–1703). Portraits (specialist in portraits of children), religious, mythology, genre. Etcher, engraver.

Sinibaldo Scorza (Voltaggio, near Genoa 1589–1631). Genre, landscape, animals, miniatures. Engraver.

Bernardo Strozzi (Genoa 1581–Venice 1644). History, portraits, religious.

Antonio Travi (Il Sestri or Il Sordo di Sestri) (Sestri Ponente 1608–1665). Religious, genre, landscapes.

Lombard School

Evaristo Baschenis (Bergamo 1607–1677). Still-lifes, especially fruits, animals, fish, musical instruments; battles, portraits, genre, home interiors.

Carlo Ceresa (San Giovanni Bianco 1609–Bergamo 1679). History, portraits, religious. Student of D. Crespi.

Milan

Giovanni Battista Crespi (Il Cerano) (Cerano 1575–Milan 1633). History, religious. Sculptor, architect. Traveled Rome, Venice.

Pier Francesco Mazzucchelli (Il Morazzone) (Morazzone 1571–1626). Religious, frescoes. Traveled Rome.

Giulio Cesare Procaccini (Bologna 1574–Milan 1625). History, religious. Sculptor, engraver.

Naples

Giovanni Bernardo Azzolini (Mazzolini or Massolini) (Naples c. 1560/72–1645). Religious. Active in Genoa 1610.

Giovanni Battista Caracciolo (Battistello) (Naples 1570–1637). Religious. Pupil of Girolamo Imparato.

Bernardo Cavallino (Naples 1616–1656/58; died in plague). History, religious, cabinet pictures. Pupil of Andrea Vaccaro.

Giovanni Andrea Coppola (Gallipoli 1597–c. 1659). Religious. Active middle of seventeenth century.

Belisario Corenzio (Achaia Province, Greece c. 1558–Naples c. 1640). History. Preferred frescoes more than oils.

Aniello Falcone (Naples 1607–1656; died in plague). Battles, religious, mythological. Engraver. Student of Giuseppe Ribera.

Luca Forte (c. 1640–1670). Still-lifes, fruits.

Cesare Fracanzano (Bisceglie c. 1605–c. 1653). Religious. Pupil of Jusepe de Ribera.

Francesco Fracanzano (Monopoli 1612–Naples 1656). Brother of Cesare Fracanzano. Religious. Pupil of Jusepe de Ribera.

Artemesia Gentileschi (Rome 1597–Naples c. 1651). Religious. Studied with her father, Orazio Gentileschi. Traveled Tuscany, London.

Luca Giordano (Luca fa presto) (Naples 1632–1705). Religious, mythology, allegory. Etcher. Pupil possibly with Falcone and Ribera. Etcher. Traveled Rome, Parma, Florence, Venice, Naples, Genoa, Spain.

Francesco Guarino (Guarino da Solofra) (Solofra 1611–Gravina 1654). History, peasants, farmers, beggars; some religious.

Girolamo Imparato (c. 1550–1621). History, religious. Lived in Naples. Traveled Rome, Venice, Lombardy.

Charles Mellin (Carlo Lorenese) (Nancy 1597–Naples 1649). French history.

Filippo Napolitano (Naples c. 1590–Rome 1629). Landscapes, history, genre.

Paolo Porpora (Naples 1617–Rome 1673). Still-lifes, battles, animals, flowers, fruits. Pupil of Aniello Falcone. Traveled Rome.

Mattia Preti (Cavalier Calabrese) (Taverna 1613–Malta 1699). Religious. Traveled Rome, Bologna, Cento, Parma, Modena, Venice, Emilia.

Giuseppe Recco (Naples 1634–Alicante 1695). Still-lifes, flower and fruit pieces, fruits of the sea, fish pieces, kitchen objects. Traveled Spain.

Jusepe de Ribera (Játiva, Spain 1591–Naples 1652). Religious, mythological, single-figure paintings. Traveled northern Italy.

Francesco de Rosa (Pacecco or Pacicco de Rosa) (Naples c. 1600–1654). History, genre, religious. Engraver. Pupil of Massino Stanzioni.

Giovanni Battista Ruoppolo (Naples 1629–1693). Flower and fruit pieces. Student of Paolo Porpora.

Fabrizio Santafede (c. 1560–1634). Religious. Traveled Rome, Bologna, Modena, Parma, Venice.

Massimo Stanzione (Cavaliere Massimo) (Naples 1585–1656). History. Student of Caracciolo, Santafede.

Andrea Vaccaro (Naples c. 1598–1670). History, mythology, religious. Pupil of Girolamo Imparato.

Rome

Cristofano Allori (Bronzino) (Florence 1577–1621). Religious history, some portraits.

Evaristo Baschenis. See entry under Lombard.

Giovanni Benedetto Castiglione (Genoa 1616–Mantua 1670). Religious, wild animals, beasts, mythological landscapes. Engraver. Traveled throughout Italy.

Michelangelo Merisi da Caravaggio (Caravaggio, near Milan 1573–Port'Ercole 1610). Early genre works, religious, mythological. Engraver. Traveled Naples, Malta, Syracuse, Messina, Palermo.

Michelangelo Cerquozzi (Rome 1602–1660). Genre, battles, history, still-lifes, fruits, flowers. Engraver.

Giovanni Domenico Cerrini (Perusa 1609–1681). Religious subjects, portraits, genre.

Baccio Ciarpi (Barga 1578–1644). Religious themes in Rome.

Giovanni Coli (Lucques 1643–1681). Religious. May have worked in Portugal. Pupil of Pietro da Cortona.

Gaspard Dughet (Gaspard Poussin or Le Guaspre) (Rome 1613–1675). Landscapes, statues, fish, chase scenes. Pupil of Nicolas Poussin. Traveled Perusa, Rome, Milan, Naples.

Domenico Fetti (Rome c. 1589–Venice 1624). Religious history, genre, portraits.

Orazio Gentileschi (Pisa c. 1565–London c. 1639). History, religious, still-lifes. Traveled Genoa, Paris, England.

Filipo Gherardi (Sancasciani) (Lucques 1643–1704). Religious. Worked with Giovanni Coli. Pupil of Pietro da Cortona.

Giacinto Gimignani (Pistoia 1611–Rome 1681). History, religious, frescoes. Engraver.

Paolo Gismondi (Perusa 1612–c. 1685). Religious. Pupil of Pietro da Cortona.

Domenico Guido (Guidi) (Torano 1625–Rome 1701). History, religious, mythological.

Francesco Maffei (Vicenza 1600/20–Padua 1660). Religious, mythological allegory.

Bartolommeo Manfredi (Ostiano, near Mantua 1580–Rome 1620). Religious history, genre, players, soldiers.

Carlo Maratti (Camerano 1625–Rome 1713). History, portraits, engravings, madonnas, religious history, frescoes.

Sebastiano Mazzoni (Florence 1611–Venice 1678). Mythological, satirical portraits, religious. Poet and architect. Student of Cristoforo Allori.

Pier Francesco Mola (Coldrerio 1612–Rome 1666). Religious, palace decorations. Engraver. Traveled Venice.

Padre Andreas Pozzo (Trent 1642–Vienna 1709). Religious, building decorations, frescoes. Writer on art and architecture.

Giovanni Francesco Romanelli (Viterbo 1610–1662). History, religious. Pupil of Pietro da Cortona. Traveled Paris.

Salvator Rosa (Aranella 1615–Rome 1673). History, battles, landscapes, seascapes, small historical compositions. Engraver, musician, poet. Traveled Rome, Naples, Viterbo.

Andrea Sacchi (Nettuno, near Rome 1599–Rome 1661). History, religious, portraits.

Carlo Saraceni (Venice c. 1580–1620). Mythological, religious. Engraver.

Sassoferrato (Giovanni Battista Salvi) (Sassoferrato 1609–Rome 1685). Religious history, portraits.

Giovanni Serodine (Ascona c. 1600–Rome 1631). Religious, history, some portraits.

Pietro Testa (Il Lucchesino) (Lucques 1611–Rome 1650). History, mythology, religious. Engraver. Pupil of Pietro da Cortona. Traveled Rome.

Alessandro Turchi (Verona 1578–Rome 1649). Historical, mythological, religious. Traveled Venice.

Siena

Rutilio di Lorenzo Manetti (Siena 1571–1639). Religious, allegory. Engraver, editor. Student of Francesco Vanni.

Ventura Salimbeni (Siena 1568–1613). History, religious. Engraver. Traveled Rome, Pisa, Florence.

Francesco Vanni (Siena 1563/65–1610). History, religious. Engraver. Traveled Bologna, Rome, Parma.

Venice

Antonio Bellucci (Pieve di Soligo, Treviso 1654–Pieve di Soligo 1726). Churches, religious. Etcher. Traveled Verona, Treviso, Castagnaro (near Venice), Germany.

Giulio Carpioni (Venice 1611–Verona 1674). Elegiac images, dreams, triumphs, bacchanals, some religious compositions. Engraver, etcher.

Federico Cervelli (Milan c. 1625–c. 1700). Active 1674–1700.

Girolamo Forabosco (or Ferrabasco) (Padua 1604–Venice after 1675). History, portraits.

Pietro Liberi (Libertino) (Padua 1614–Venice 1687). Church decorations, public monuments, history, allegory, mythological. Student of Alessandro Varotari. Traveled Rome, Parma.

Francesco Maffei (Vicenza 1600/20–Padua 1660). History, religious. Engraver.

Sebastiano Mazzoni (Florence c. 1611–Venice 1678). History, mythology, religious. Poet and architect.

Antonio Molinari (Venice 1665–after 1727). History, religious.

Pietro Muttoni (Della Vecchia) (Venice 1603–1678). Religious, mythology, allegory, portraits. Painting restorator. Student of Varotari.

Jacopo Negretti (Il Giovane) (Jacopo Palma, il Giovano) (Venice 1544–Venice 1628). Religious, mythological.

Domenico Robusti Tintoretto (Venice 1560–1635). Portraits, religious, mythological.

Alessandro Varotari (Il Padovanino) (Padua 1588–Venice 1648). History, religious, portraits.

––––––––––––––––––– ITALIAN SCULPTURE –––––––––––––––––––

Florence

Giovanni Bologna (Douai 1529–Florence 1608). Fountains, religious group and equestrian statues, mythological. Architect.

Francesco Fanelli (died Paris 1665). Religious, statuettes, busts. Traveled Genoa, England, Paris.

Ciro Ferri (Rome 1634–1689). Painter and sculptor: religious subjects, frescoes. Pupil of Pietro da Cortona.

Giovanni Battista Foggini (Florence 1652–1725). Busts, statues (mythological, historical).

Massimiliano Soldani (1656–1740). Religious, allegory. Medalist. Pupil of Ciro Ferri and Ercole Ferrata.

Giovanni Francesco Susini (died Florence 1646). Mythological subjects. Bronze.

Pietro Tacca (Carrara 1577–near Florence 1640). Historical statues (kings, dukes, etc.), religious, fountain studies. Architect.

Rome

Alessandro Algardi (Bologna 1595/1602–Rome 1654). Statues, mythological, religious. Ivory, bronze, silver. Architect. Traveled Venice, Mantua, Rome.

Francesco Baratta (Massa di Carrara 1590–Rome 1666). Fountains, religious, mythological. Pupil of Bernini.

Giovanni Lorenzo (Gianlorenzo) Bernini (Naples 1598–Rome 1680). Religious, mythological, busts, portraits. Bronze, marble. Architect. Leading sculptor of his age.

Andrea Bolgi (Il Carrarino) (Carrara 1605/06–Naples 1656). Statues of saints, busts, religious. Pupil of Bernini and Pietro Tacca.

Andrea Camassei (Bevagna, near Foligno 1601–Rome 1648). Mythological statues. Painter, engraver.

Francesco Duquesnoy. See François Duquesnoy, under French Sculpture.

Giacomo Antonio Fancelli (Rome 1619–1671). Statues, religious. Pupil of Bernini.

Ercole Ferrata (Pillio Inferiore, Côme 1610–Rome 1686). Tombs, statues, religious. Worked with Bernini.

Giuliano Finelli (Carrara 1601–Rome 1657). Statues, busts. Worked with Bernini. Traveled Naples, Rome.

Niccolo Menghini (Rome c. 1610–1655). Religious church decoration. Architect.

Francesco Mochi (Montevarchi, near Florence 1580–Rome 1654). Religious and equestrian statues, classical subjects. Medalist. Traveled Plaisance.

Ercole Antonio Raggi (Vico Morcote 1624–Rome 1686). Statues for churches in Rome, Milan, Paris, London. Student of Algardi and Bernini.

Ferdinando Tacca (Florence 1619–1686). Sculptor, caster, and architect. Traveled Madrid.

Italian Creche Sculpture

Giambattista Gaggini (Il Venetiano) (died 1659). Active in Genoa.

Giovanni Antonio Mafera (1653–1718). Active in Trapani and Palermo.

Lorenzo Mosca (died 1789). Active in Naples.

Giuseppe Sammartino (1720–1793). Active in Naples.

Domenico Vaccaro (c. 1680–1750). Active in Naples. Son of Lorenzo Vaccaro.

Lorenzo Vaccaro (1655–1706). Active in Naples.

—————— DUTCH PAINTING AND DRAWING ——————

Willem van Aelst (Delft 1627–Amsterdam after 1683). Still-lifes.

Jan Asselyn (Asselijn) (Dieppe, near Amsterdam 1610–Amsterdam 1652/60). Landscapes, views near Rome, animals and figures in genre scenes. Pupil of Esaias van de Velde.

Hendrick Avercamp (Amsterdam 1585–Kampen 1634). Landscapes. Draftsman.

Dirck van Baburen (Utrecht c. 1570–1624). Religious, genre.

Jacob Adriaensz Backer (Harlingen 1608–Amsterdam 1651). Portraits, historical scenes. Draftsman.

David Bailly (Leiden 1584–1657). Still-lifes. Draftsman.

Ludolf Bakhuysen (Emden 1631–Amsterdam 1708). Seascapes.

Jan Abrahamsz Beerstraeten (Amsterdam 1622–1666). Landscapes. Draftsman.

Cornelis Pietersz Bega (Haarlem 1620–1664). Genre. Draftsman, etcher.

Abraham Hendrickz Beijeren (Beyeren) (The Hague 1620/21–Oversehie 1690). Still-lifes, landscapes.

Claes (Nicolaes) Pietersz Berchem (Haarlem 1620–Amsterdam 1683). Landscapes, town views. Draftsman, etcher.

Gerrit Adriaensz Berckheyde (Haarlem 1638–1698). City views, landscape. Draftsman, architect.

Jan de Bisschop (Johannes Episcopius) (Amsterdam 1628–The Hague 1671). Landscapes, Italian subjects, including ruins. Draftsman, etcher, lawyer.

Abraham Bloemaert (Dordrecht 1564–Utrecht 1651). Landscapes, history, religious, portraits, genre. Draftsman.

Frederick Bloemaert (Utrecht after 1610–1669). Etcher. Son and student of Abraham Bloemaert.

Pieter Pietersz de Bloot (Rotterdam 1601/02–1658). Landscapes, genre. Draftsman.

Jan van Boeckhorst (Haarlem c. 1588–1631). Painted on glass. Draftsman, etcher.

Ferdinand Bol (Dordrecht 1616–Amsterdam 1680). Member of Rembrandt's studio. Painter, draftsman, etcher.

Paulus Bor (c. 1600–Amersfoort 1669). Allegories, religious, pastoral, Italianate, historical scenes.

Anthonie van Borrsom (Borssum) (Amsterdam 1629/30–1667). Landscapes. Draftsman. Pupil of Rembrandt.

Ambrosius Bosschaert the Elder (1573–The Hague 1621). Flowers, still-lifes.

Andries Dirksz Both (Utrecht 1612–Venice 1641). Genre, landscape scenes. Draftsman. Brother of Jan Dirksz Both.

Jan Dirksz Both (Utrecht c. 1618–1652). Landscapes, still-lifes, flowers. Draftsman.

Jan Salomonsz de Bray (Braij) (Haarlem 1627–1697). Landscapes, biblical history, mythological portraits, genre. Draftsman.

Salomon de Bray (Braij) (Amsterdam or Haarlem 1597–Amsterdam 1664). Biblical history, mythological. Draftsman, poet, architect.

Bartholomeus Breenberg (Deventer 1599/1600–Amsterdam before 1659). Landscapes. Draftsman, etcher.

Paul Bril (Antwerp 1554–Rome 1626). Landscapes, miniatures. Flemish. Draftsman, etcher.

Johannes van Bronckhorst (Leiden 1648–Hoorn 1726/27). Bird specialist, insects, flowers. Watercolorist, pastry chef.

Hendrick Ter Brugghen. See Hendrick Terbrugghen.

Willem Pietersz Buytewech (Buijtenwegh) (Rotterdam 1591/95–1624). Landscapes, genre, portraits. Draftsman, engraver, etcher.

Jan van de Cappelle (Capelle) (Amsterdam 1624–1679). Landscapes, seascapes, genre. Draftsman.

Pieter Jacobsz Codde (Amsterdam 1599–1678). Reunion portraits.

Cornelis Cornelisz (Haarlem 1562–1638). Portraits, biblical history.

Lieven Cruyl (Ghent c. 1640–1720). Italian vedute.

Aelbert Cuyp (Cuijp) (Dordrecht 1620–1691). Landscapes, animals, portraits, still-lifes. Draftsman.

Jacob Gerritsz Cuyp (Cuijp) (Dordrecht 1594–c. 1652). Portrait, genre, animals. Draftsman. Father of Aelbert Cuyp.

Cornelis Gerritsz Decker (active c. 1640–Haarlem 1678). Landscape.

Lambert Doomer (Amsterdam c. 1624–Alkmaar 1700). Landscapes. Draftsman.

Gerrit Dou (Leiden 1613–1675). Genre, portraits. Engraver.

Karel Dujardin (Amsterdam c. 1622–Venice 1678). Landscapes with shepherds and animals, portraits, genre scenes. Draftsman, etcher.

Cornelis Dusart (Haarlem 1660–1704). Genre. Draftsman, etcher.

Willem Cornelisz Duyster (Duijster) (probably Amsterdam 1599–1635). Genre, portraits, soldier scenes.

Gerbrandt van den Eckhout (Eeckhout) (Amsterdam 1621–1674). Biblical history, genre, landscapes, portraits. Draftsman. Pupil of Rembrandt.

Jacob Esselens (Amsterdam 1626–1687). Landscapes. Draftsman.

Allart van Everdingen (Alkmaar 1621–Amsterdam 1675). Landscapes. Draftsman, engraver.

Cesar Boetius van Everdingen (Alkmaar c. 1617–1678). History, portraits, military scenes.

Barent Fabritius (Middelburg 1624–Amsterdam 1673). Genre scenes. Draftsman. Brother of Carel Fabritius. Active in Leiden 1650–1672.

Carel Fabritius (Middelburg 1622–Delft 1654). History, biblical, portraits, genre. Pupil of Rembrandt.

Govert Flinck (Cleves 1615/16–Amsterdam 1660). Biblical, portraits, history. Draftsman.

Abraham Furnerius (Amsterdam 1620/28–Rotterdam c. 1654). Landscapes. Draftsman. Pupil of Rembrandt.

Jacob de Gheyn II (Antwerp 1565–The Hague 1629). Flowers, miniatures. Draftsman, etcher. Pupil of H. Goltzius.

Jacob de Gheyn III (Haarlem c. 1596–Utrecht 1641). Portraits, historical subjects. Draftsman, engraver. Son of Jacob de Gheyn II.

Jan Goedaert (Middelburg 1620–c. 1668). Artist/scientist, best known as entymologist.

Hendrick Goltzius (Mulbraecht [Limbourg] 1558–Haarlem 1617). Portraits, religious subjects. Draftsman, engraver.

Jan van Goyen (Goijen) (Leiden 1596–The Hague 1656). Landscapes. Draftsman.

Josua de Grave (Graaf) (Amsterdam 1643–The Hague 1712). City views, landscapes. Draftsman.

Pieter de Grebber (Haarlem c. 1600–1652/53). Religious, history, portraits. Some Flemish training.

Joris Abrahamsz van der Haagen (Arnhem c. 1615–The Hague 1669). Landscapes, genre. Draftsman.

Jan Hackaert (Amsterdam c. 1629–1699). Landscapes. Draftsman, etcher.

Dirck Hals (Haarlem 1591–1656). Genre, portraits, conversation pieces, interiors. Draftsman. Brother of Franz Hals.

Franz Hals (Antwerp 1580/85–Haarlem 1666). Portraits.

Cornelis de Heem (Leiden 1631–Antwerp 1695). Still-lifes, fruits, insects. Pupil of father, Jan Davidsz de Heem.

Jan Davidsz de Heem (Utrecht 1606–Antwerp 1684). Still-lifes, flowers.

Bartholomeus van der Helst (Haarlem 1613–Amsterdam 1670). Portraits.

Jan van der Heyden (Heijden) (Gorinchem 1637–Amsterdam 1712). City views, genre. Draftsman, inventor of fire extinguisher, 1672.

Meindert Hobbema (Amsterdam 1638–1709). Landscapes.

Abraham Hondius (Rotterdam c. 1625/35–London 1695). Hunting and animal scenes. Lived in Amsterdam.

Gerrit van Honthorst (Utrecht 1590–1656). Genre, portraits.

Willem van Honthorst (Utrecht 1594–1666). Genre. Brother of Gerrit van Honthorst.

Pieter de Hooch (Hoogh) (Rotterdam 1629–Haarlem 1681). Genre.

Samuel van Hoogstraten (Dordrecht 1627–1678). Biblical history, portraits, genre, still-lifes, architectural fantasies. Draftsman, writer, theorist. Pupil of Rembrandt.

Arnold Houbraken (Dordrecht 1660–Amsterdam 1719). Classical scenes, history. Etcher, writer on art.

Gerard Houckgeest (The Hague c. 1600–Berg op Zoom 1661). Architecture, painter church interiors. Engraver.

Constantijn Huygens the Younger (The Hague 1628–1697). Landscapes. Draftsman. Son of Constantijn Huygens the Elder.

Willem Kalf (Rotterdam 1622–Amsterdam 1693). Genre. still-lifes.

Bernhardt (Bernardo) Keil (Elsinore 1624–Rome 1687). Peasant scenes, genre painter. Pupil of Rembrandt.

Jan van Kessel III (Amsterdam 1641–1680). Landscapes, town views. Draftsman.

Cornelis Ketel (Gouda 1548–Amsterdam 1616). Portraits, pioneer in the full-length portrait, single portraits. Worked in England.

Hendrik Cornelis de Keyser (Utrecht 1565–Amsterdam 1621). Genre. Draftsman, sculptor, architect.

Thomas de Keyser (Amsterdam c. 1596–1667). Portraits. Architect.

Valentijn Klotz (Clotz) (c. 1650–The Hague after 1718). Topographical draftsman, engineer.

Wouter Knyff (Knijff) (Wesel 1607–Haarlem 1693). Landscapes.

Jacob Koninck (Amsterdam c. 1616–Denmark 1708). Interiors, views, landscapes, court portraits.

Philips Koninck (Amsterdam 1619–1688). Landscapes, history, portraits. Brother of Jacob Koninck.

Pieter van Laer (Il Bamboccio) (Haarlem 1592/95–1642). Genre, landscape. Draftsman. In Italy, 1626.

Gérard de Lairesse (Liège 1641–Amsterdam 1711). Author of drawing treatise, engraver, draftsman.

Pieter Lastman (Amsterdam c. 1583–1633). History, religious. Teacher of Rembrandt.

Pieter Lely (Saest 1618–London 1680). Portraits. Draftsman. To England, 1641.

Paulus Lesire (Dordrecht 1611–1656). Portraits.

Johannes Leupennius (Amsterdam 1647–1693). Etcher, cartographer, painter, geographer. Pupil of Rembrandt.

Judith Leyster (Leijster) (Haarlem 1609–Heemstede 1660). Portraits, still-lifes, animals, genre. Wife of Jan Molenaer.

Jan Lievens (Leiden 1607–Amsterdam 1674). Landscapes, portraits, history, religious. Draftsman.

Johannes Lingelbach (Frankfurt 1622–Amsterdam 1674). Landscapes, peasant scenes, genre.

Dirck van der Lisse (Breda, active 1639–The Hague 1669). Mythological, religious, landscapes.

Jan Looten (Amsterdam 1616–London c. 1681). Landscapes.

Isaak Luttichuys (Luttichuijs) (London 1616–Amsterdam 1673). Portraits.

Nicolaes Maes (Dordrecht 1634–Amsterdam 1693). Genre, portraits, history. Pupil of Rembrandt.

Karel van Mander I (Meulebeke 1548–Amsterdam 1604). Landscapes, genre. Draftsman, poet, art historian.

Karel van Mander II (Courtrai c. 1579–Delft 1623). Portraits, history, tapestry drawings.

Karel van Mander III (Delft c. 1610–Copenhagen 1672). Historical scenes, portraits. Grandson of Karel van Mander I.

Jan Martszens (Martsen) the Younger (Haarlem 1609–after 1647). Battle scenes, horses.

Jan Meerhout (died Amsterdam 1677). Landscapes.

Gabriel Metsu (Leiden 1629–Amsterdam 1667). Genre scenes.

Michiel van Miereveld (Mierevelt) (Delft 1567–1641). Portraits.

Frans van Mieris the Elder (Leiden 1635–1681). Genre, draftsman.

Willem van Mieris (Leiden 1662–1747). Classical subjects, genre, portraits, landscapes. Sculptor, draftsman.

Nicholas Cornelisz Moejaert (Claes Moeyaert) (Amsterdam c. 1590/91–1655). History, mythological.

Jan Molenaer (Haarlem c. 1610–1668). Genre painter. Husband of Judith Leyster.

Klaes (Claes) Molenaer (Haarlem c. 1630–1676). Genre, landscapes.

Pieter Molijn (Molyn) (London 1595–Haarlem 1661). Genre, landscapes. Draftsman, etcher.

Paulus Moreelse (Utrecht 1571–1638). Portraits, mythological, religious, genre, history. Architect.

Frederik de Moucheron (Emden 1633–Amsterdam 1686). Landscapes. Draftsman.

Jan Muller (Amsterdam 1571–1628). Genre, classical subjects. Draftsman.

Daniel Mytens (Mijtens) the Elder (Delft c. 1590–The Hague 1648). Court portraits.

Johannes Natus (active 1660, Middelburg). Genre, peasant scenes, Italianate landscapes.

Aert van der Neer (Amsterdam 1603/04–1677). Landscapes. Draftsman.

Caspar Netscher (Heidelberg 1639–The Hague 1684). Portraits, genre.

Adriaen van Ostade (Haarlem 1610–1685). Genre scenes. Draftsman, engraver.

Isaak van Ostade (Haarlem 1621–1649). Landscapes, genre. Draftsman. Brother of Adriaen van Ostade.

Antonie Palamedes Stevers (Delft 1601–Amsterdam 1673). Genre, portraits.

Palamedes Palamedes Stevers (London 1607–Delft 1638). Battle scenes. Brother of Antonie Palamedes.

N. L. Peschier (active 1660). Vanitas still-lifes, genre.

Gerrit Pietersz (Sweelinck) (Amsterdam 1566–after 1608). Mythological scenes. Draftsman, engraver.

Cornelis van Poelenburgh (Utrecht 1586–1667). Classical subjects, history, landscapes.

Willem de Poorter (1608–Haarlem after 1648). History, religious. Pupil of Rembrandt.

Frans Post (Haarlem c. 1612–Haarlem 1680). Landscapes, exotic views of Brazil. Draftsman, etcher.

Paulus Potter (Enkhuizen 1625–Amsterdam 1654). Landscapes, animals. Draftsman, etcher.

Adam Pynacker (Pijnacker) (Delft 1622–Amsterdam 1673). Landscapes, hunting scenes. Draftsman, etcher.

Jan Symonsz Pynas (Pijnas) (Haarlem c. 1583/84–Amsterdam 1631). Biblical and historical subjects. Draftsman, etcher.

Jan Anthonisz van Ravesteyn (The Hague c. 1570–1657). Portraits. Draftsman.

Rembrandt Harmensz van Rijn (Leiden 1606–Amsterdam 1669). Portraits, religious scenes, landscapes, history. Draftsman, etcher.

Pieter Gerritsz van Roestraten (Haarlem 1630–London 1700). Still-lifes, genre, portraits.

Roelant Roghman (Amsterdam 1597–1686). Landscapes. Draftsman, etcher.

Gillis Rombouts (Haarlem 1630–1678). Master in Haarlem in 1652. Landscapes influenced by Ruisdael.

Jacob Isaacskzoon van Ruisdael (Haarlem 1628/29–1682). Landscapes. Draftsman, etcher.

Abraham Rutgers the Elder (Amsterdam 1632–1699). Landscapes, topographical views. Draftsman.

Rachel Ruysch (Ruijsch) (Amsterdam 1664–1750/54). Still-life, flowers.

Pieter Jansz Saenredam (Assendelft 1597–Haarlem 1665). Architecture, church interiors, topographical views. Draftsman.

Cornelis Saftleven (Gorinchem 1607–Rotterdam 1681). Peasant scenes, landscapes, religious scenes, genre. Draftsman. Brother of Herman Saftleven.

Herman Saftleven (Rotterdam 1609–Utrecht 1685). Landscapes. Draftsman, etcher.

Roelant Savery (Courtrai 1576–Utrecht 1639). Landscapes, animals, flower still-lifes. Draftsman. Fleming who worked in Holland.

Godfried Schalken (Made 1643–The Hague 1706). Portraits, genre.

Willem Schellinks (Amsterdam 1627–1678). Landscapes. Draftsman, etcher.

Jan Steen (Leiden 1626–1679). Genre, mythology, biblical history, history portraits. Draftsman.

Matthiaes Stomer (Amersfoort 1600–Sicily? after 1651). Biblical scenes, history.

Herman van Swanevelt (Woerden c. 1600–Paris 1655). Italianate landscape with biblical and mythological figures.

Michael Sweerts (Brussels 1624–Goa 1664). Portraits, genre.

Gerard Ter Borch the Elder (Zwolle 1584–1662). Painter, engraver, draftsman.

Gerard Ter Borch the Younger (Zwolle 1617–Deventer 1681). Portraits, genre. Draftsman.

Moses Ter Borch (Zwolle 1645–sea of Harwich 1667). Portraits, model studies. Draftsman. Brother of Gerard Ter Borch the Younger.

Hendrick Terbrugghen (Deventer 1588–Utrecht 1629). Religious, mythological, history, genre.

Jacob van der Ulft (Gorinchem 1627–Noordwijk 1689). Italianate landscapes. Glass painter(?), Draftsman, etcher.

Adriaen van de Velde (Amsterdam 1636–1672). Landscapes, animals. Etcher.

Esaias van de Velde (Amsterdam c. 1590–The Hague 1630). Battle scenes. Etcher.

Jan Jansz van de Velde III (Haarlem, 1620–Amsterdam 1663). Still-lifes.

Jan van de Velde II (Delft c. 1593–Enkhuizen 1641). Landscapes, portraits. Draftsman, engraver.

Willem van de Velde the Elder (Leiden 1611–Greenwich, England 1693). Marine scenes.

Willem van de Velde the Younger (Leiden 1633–Greenwich, England 1707). Marine scenes. Son of Willem van de Velde the Elder.

Adriaen Pietersz van de Venne (Delft 1589–The Hague 1662). Portraits, historical scenes, book illustrations. Draftsman, poet.

Simon Peeterz Verelst (The Hague 1644–London 1721). Portraits, still-lifes, flowers.

Constantin Verhout (1638–1667). Portraits, still-lifes, genre. Worked in Gouda.

Jan Vermeer (Delft 1632–1675). History, architectural, genre, landscapes.

Paulus Willemsz van Vianen (Utrecht 1565/70–Prague 1613). Landscapes. Goldsmith, medalist, draftsman.

Jan Victors (Amsterdam 1619/20–Dutch East India 1676). History, religious, portraits, genre, landscapes. Pupil of Rembrandt.

David Vinckeboons (Mechlin 1576–Amsterdam 1629). Landscapes. Draftsman.

Claes Jansz Visscher (Amsterdam 1587–1652). Landscapes. Draftsman, engraver.

Cornelis Visscher (Haarlem 1619–Amsterdam 1662). Portraits. Draftsman, engraver.

Simon Jacobsz de Vlieger (Rotterdam c. 1600–Weesp 1653). Marine scenes, landscapes, animals. Draftsman, engraver. Pupil of Willem van de Velde.

Jan Vonck (Amsterdam 1630–after 1660). Still-lifes, birds, hunting scenes.

Cornelis Hendriksz Vroom (Haarlem 1591/92–Haarlem 1661). Landscapes, marine scenes. Draftsman.

Jakob van Walscapelle (Dordrecht 1644–Amsterdam 1727). Still-lifes, flowers, fruits.

Antonie Waterloo (Lille c. 1610–Utrecht 1690). Landscapes. Art dealer, draftsman.

Jan Weenix (Amsterdam 1640–1719). Still-lifes, flowers, portraits.

Jan Baptist Weenix (Amsterdam 1621–near Utrecht c. 1660). Landscape painter. Draftsman.

Henricus van Weerts (active second half of seventeenth century). Still-lifes.

Cornelis Claesz van Wieringen (Haarlem c. 1580–1633/43). Marine scenes, landscapes.

Emanuel de Witte (Alkmaar 1617–Amsterdam 1692). Architecture painter, views.

Kaspar van Wittel (Gasparo Vanvitelli) (Utrecht 1653–near Rome 1736). Architecture, views, landscapes.

Philips Wouwermans (Haarlem 1619–1668). Landscapes, animals, battle scenes.

—————— FLEMISH PAINTINGS AND DRAWING ——————

Lucas Achtschellinck (Brussels 1626–1699). Wooded landscapes (figures sometimes added by other artists). Tapestry designer.

Alexander Adriaenssen (Antwerp 1587–1661). Still-lifes with birds, fruit, cheese, and flowers, fish, cats.

Denis van Alsloot (Brussels c. 1570–c. 1627). Landscapes with religious and mythological subjects (figures sometimes added by other artists).

Jacques d' Arthois (Artois) (Brussels 1613–1686). Wooded landscapes with figures (horseman, etc., sometimes added by others).

Gillis Backereel (Antwerp c. 1592–before 1662). Religious, history. Studied in Rome.

Willem Backereel (Antwerp 1570–Rome 1615). Landscapes. Brother of Gillis Backereel.

Frans (Francesco) Badens (Antwerp 1571–Amsterdam c. 1618). Genre, mythology, portraits, religious scenes.

Cornelis de Baellieur (Antwerp 1607–1671). Religious subjects, picture galleries.

Hendrik van Balen the Elder (Antwerp 1575–1632). Religious and mythological subjects. Glass and tapestry design.

Jan Anthonie van der Baren (Brussels 1615?–Vienna 1686). Flowers and gar-
lands (central images supplied by others).

Nicasius Bernaerts (Antwerp 1620–Paris 1678). Animals, still-lifes, game
pieces. Pupil of Franz Snyders in Rome.

Jans Frans van Bloemen (Orizonte or Horizonte) (Antwerp 1662–Rome 1748).
Italianate landscapes (figures supplied by others). Engraver.

Pieter van Bloemen (Standart) (Antwerp 1657–1720). Military pieces, Italianate
landscapes, genre figures, animals.

Johann Boeckhorst (Lange Jan) (Münster 1605–Antewerp 1668). Religious,
mythology, portraits. Tapestry designer. Pupil of Jacob Jordaens.

Pieter Boel (Antwerp 1622–Paris 1674). Decorative still-lifes, game pieces.
Engraver.

Theodore Boeyermans (Antwerp 1620–1678). Religious, history, allegory, con-
versation pieces, portraits.

André Bosman (Antwerp 1621–Rome c. 1681). Flowers and garlands.

Ambrosius Bosschaert the Elder (Antwerp 1673–The Hague 1621). Flowers.

Pieter Bout (Brussels 1658–1719). Landscapes, coasts, markets and fairs, skat-
ing scenes. Draftsman.

Ambrosius Breughel (Antwerp 1617–1675). Landscapes with figures. Son of
Jan "Velvet" Brueghel.

Jan Breughel (Breughel the Elder; Velvet) (Brussels 1568–Antwerp 1625).
Landscape with figures, animals, flower garlands, flower pieces, flower gard-
ens. Son of Pieter Brueghel the Elder.

Jan Breughel the Younger (Jan Breughel II) (Antwerp 1601–1678). Landscapes,
flowers, animals, religious, allegories, battle pieces. Son of Jan "Velvet"
Brueghel, copied father's paintings. Art dealer.

Paul Bril (Antwerp or Brede 1554/56–Rome 1626). Landscapes with small
figures. Etcher.

Adriaen Brouwer (Adrien Brauwer) (Audenarde) 1605/06–Antwerp 1638). Peas-
ant genre, landscape with small figures, religious. Engraver.

Pieter Brueghel the Younger (Hell Brueghel) (Brussels 1564–Antwerp 1638).
Religious (Hell pieces), landscape. Son of Pieter Brueghel the Elder, copied
father's paintings.

Pieter Brueghel III (Antwerp 1589–after 1634). Worked in the tradition of his
father, Pieter Brueghel the Younger (Hell Brueghel).

Denis Calvaert (Dionisio Fiammingo) (Antwerp c. 1540–Bologna 1619). Land-
scapes, religious, history.

Jean Guillaume Carlier (Jan Willem) (Liège 1638–1675). Religious.

Charles de Cauwer (Cauver or Couwer) (Antwerp? before 1590–1658). Land-
scapes, religious, still-lifes.

Jean Baptiste Champaigne (Brussels 1631–Paris 1681). Religious, history, por-
traits.

Phillip de Champaigne (Brussels 1602–Paris 1674). Religious, decorative,
portraits.

Pieter Claeissins (Claessens or Claes) the Younger (Bruges c. 1550–1623). Religious, portraits, decorative works. Cartographer.

Hendrick de Clerck (Brussels c. 1570–c. 1629). Religious, mythological, figures for landscapes of Denis van Alsloot.

David de Coninck (Koninck) (Antwerp 1636–Brussels 1699). Hunting scenes, animals, birds, game pieces.

Alexander Coosemans (Antwerp 1627–1689). Still-lifes, fruits, flowers, vegetables.

Augustin Coppens (Brussels c. 1668–after 1695). Landscapes, topographic drawings, tapestry designs.

Gonzales Coques (Antwerp c. 1614–1684). Portraits, conversation pieces, genre, picture galleries.

Jan Cossiers (Antwerp 1600–1671). Religious, history, portraits, genre(?).

Louis Cousin (Luigi Primo or Gentile) (Brussels 1606–Rome c. 1667). Religious, portraits, decorative. Tapestry designer.

Joos van Craesbeeck (Brussels c. 1606–1654). Peasant and bourgeois genre, studio interiors, landscapes, portraits.

Gaspard de Crayer (Craeyer) (Antwerp 1582–Ghent 1669). Religious, history, portraits.

Jacob Denys (de Nys) (Antwerp 1644–1708?). Religious, history, allegory, portraits.

Michele Desubleo (De Subleo) (Michele Flammingo) (Maubeuge? c. 1601–Parma? after 1676). Religious, portraits, allegories.

Simon Dubois (Antwerp 1632–London 1708). Portraits, landscapes, military pieces.

Antoon Van Dyck (Sir Anthony) (Antwerp 1599–London 1641). Portraits, religious, mythological. Engraver.

Justus van Egmont (Leiden 1601–Antwerp 1674). Portraits, religious, history. Tapestry designer.

Wilhelm Schubert von Ehrenberg (Aerdenberg) (Antwerp 1630–c. 1676). Architectural interiors and views.

Andries van Ertvelt (Eertveld) (Antwerp 1590–1652). Marine scenes, many with warships.

Jacob Foppens van Es (Essen) (Antwerp 1596–1666). Still-lifes, fish, fruit.

Nicolaas van Eyck (Antwerp 1617–1679). Ceremonial, warfare, military scenes.

Jacques Fouquieres (Fockeel, Foucquier, Fouquier, Foquier) (Antwerp c. 1585–Paris 1659). Landscapes.

Pieter Franchoys (François) (Mechlin 1601–1654). Portrait, genre, religious landscape.

Constantyn Francken (Antwerp 1661–1717). Warfare, outdoor subjects, portraits. Son of Hieronymous Francken III.

Frans Francken (Franck) II (The Younger) (Antwerp 1581–1642). Religious, history, social scenes, interiors.

Frans Francken (Franck) III (Antwerp 1607–1667). Religious, church interiors, picture galleries.

Jan Fyt (Antwerp 1611–1661). Animals, birds, still-lifes. Engraver.

Goltzius Geldorp (Louvain 1553–Cologne c. 1616). Portraits, biblical subjects, nudes.

Jacob de Gheyn II (the Younger) (Antwerp 1565–The Hague 1629). Religious, history, flower pieces, horses. Engraver.

Antoon Goubau (Goebouw, Goubay) (Antwerp 1616–1698). Military scenes, landscape, religious, genre. Draftsman, tapestry cartoons.

Abraham Govaerts (Goyvaerts, Godvaerts) (Antwerp 1589–1626). Wooded landscapes with religious, mythological, or genre figures added by other painters.

Hendrick Govaerts (Goovaerts) (Mechlin 1669–Antwerp 1720). Portraits, contemporary genre, history.

Gualetrus (Wouter) Gysaerts (Antwerp 1659–after 1674). Flowers, garlands around panels by other painters.

Cornelis Norbertus Gysbrechts (Antwerp before 1643–after 1675). Trompe l'oeil still-lifes.

Pieter Gysels (Gheysels, Gyzens) (Antwerp 1621–1690). Still-lifes, landscapes, genre.

Willem van Haecht II (Antwerp 1593–1637). Interiors of picture galleries.

Jan van den Hecke (Ecke or Eycke) (Quaremonde 1620–Antwerp 1684). Landscape, still-lifes, garlands.

Abraham van den Hecken (Heck) (Antwerp 1618–London? after 1655). Interiors, religious subjects, genre, still-lifes, flower, portraits.

Cornelis de Heem (Leiden 1631–Antwerp 1695). Still-lifes, fruits. Son of Jan Davidsz de Heem.

Jan Davidsz de Heem (Utrecht 1606–Antwerp 1683). Still-lifes, flowers, fruit, shellfish, silver, glass.

Daniel van Heil (1604?–Brussels after 1662). Landscapes, winter scenes, fire.

Leonard van Heil (Brussels 1605–after 1661). Flowers, insects, small animals. Brother of Daniel van Heil.

Jan van den Hoecke (Antwerp 1611–Brussels 1651). Religious, allegories, history, portraits. Tapestry designer.

Robert van den Hoecke (Antwerp 1622–1668). Battles, camp pieces.

Gillis Claesz D'Hondecouter (Hondecoutre) (Antwerp c. 1580–Amsterdam 1638). Landscapes, some with animals. Often considered Dutch.

Jan Lambertz Houwaert (Giovanni di Lamberto) (Antwerp?–Genoa 1668). Portraits, religious subjects.

Jacob Huysmans (Houseman) (Antwerp c. 1633–London 1696). Portraits, religious, history.

Abraham Janssens (Antwerp 1575–1632). Religious (often with torchlight), history, portraits, allegories.

Hieronymus (Jeroom) Janssens (The Dancer) (Antwerp 1624–1693). Conversation pieces, social scenes.

Hans Jordaens I (Antwerp before 1556–Delft 1630). Genre, coast scenes with fires, night scenes.

Hans (Jean) Jordaens III (Lange Jan or den Langen Jordaens) (Antwerp c. 1595–1643). Religious (Old Testament), allegories, picture galleries. Son of Hans Jordaens II.

Jacob Jordaens (Antwerp 1593–Putte, 1678). Religious, mythological, genre, portraits. Tapestry designer, wall hangings.

Alexander Keirinckx (Keerincx, Kerrincx, Carings) (Antwerp 1600–Amsterdam 1652). Wooded landscapes, views.

Jan van Kessel I (The Elder) (Antwerp 1626–1679). Still-lifes, animals, birds, insects.

Jan van Kessel II (The Younger) (Antwerp 1654–Madrid 1708). Portraits, mythological, landscapes, animals, still-lifes.

Cornelis Ketel (Gouda 1548–Amsterdam 1616). Allegories, religious, portraits, group portraits.

Kerstiaen de Kueninck (Koninck, Coninck) the Elder (Courtrai c. 1560–Antwerp c. 1635). Landscapes.

Gerard de Lairesse (Liège 1641–Amsterdam 1711). History, allegories, mythology, religious, portraits. Engraver.

Pieter van Lint (Antwerp 1609–1690). Religious, history, portraits.

Adam Frans van der Meulen (Brussels 1632–Paris 1690). Military pieces, warfare, ceremonies, genre. Tapestry designer.

Pieter Meulener (Meulenaer, Molenaer) (Antwerp 1602–1654). Contemporary warfare, military scenes, social scenes.

Jan Miel (Miele) (The Little One, Petit Jean) (Beveren 1599–Turin 1663). Italian genre, religious. Engraver.

Jean François Millet (Francisque) (Antwerp 1642–Paris 1679). Picturesque landscapes, religious scenes.

Hendrik van Minderhout (Rotterdam 1632–Antwerp 1696). Marine and port scenes.

Antoine Mirou (Antwerp 1570–after 1653). Landscapes with figures.

Josse (Jodocus) Momper (Antwerp 1564–1635). Landscapes.

Peter Neeffs (Neefs, Nefs) I (The Elder) (Antwerp c. 1578–1656/61). Church interiors.

Adriaen van Nieulandt (Nieuweland) (Antwerp 1587–Amsterdam 1668). Landscapes with religious, mythological, genre figures; portraits; still-lifes.

Willem (Guillaume) van Nieulandt (Nieuweland) (Guglielmo Terranova) (Antwerp 1584–Amsterdam c. 1635). Italianate landscapes, views in Rome.

Willem (Guillaume) Panneels (Antwerp 1600–after 1640). Mythology. Engraver after Rubens.

Bonaventura Peeters the Elder (Antwerp 1614–Hoboken 1652). Marine and port scenes. Engraver, poet.

Bonaventura Peeters the Younger (Antwerp 1645/48–1702). Wooded landscapes, marine and port scenes. Son of Bonvaventura Peeters.

Catharina Peeters (Antwerp 1615–1676). Marine scenes. Sister of Bonaventura Peeters the Elder.

Clara Peeters (Pieters) (Antwerp c. 1594–1657?) Still-lifes, food and fish, fruit, flowers.

Gillis Peeters (Antwerp 1612–1653). Landscapes, port scenes, warfare. Brother of Bonaventura Peeters the Elder.

Jan Peeters (Antwerp 1624–c. 1677). Marine scenes, naval battles, landscapes, town views. Engraver, draftsman. Brother of Bonaventura Peeters the Elder and Gillis Peeters.

Jan Peeters the Younger (Dr. Peeters) (Antwerp c. 1667–London 1727). History, clothing for portrait specialists.

Marten Pepyn (Antwerp 1575–1643). Religious subjects, portraits.

Henri Perez (Peris, Peres) (Antwerp c. 1635–1671). Portraits, landscapes with figures.

Jean Michel Picart (Brabant c. 1600–Paris 1682). Flowers and fruit, landscapes. Art dealer.

Aert Pietersz (Amsterdam 1550–1612). Portraits, group portraits, religious.

Pieter Pietersz (Antwerp 1641–Amsterdam 1603). Portraits, history, Brother of Aert Pietersz.

Pieter van der Plas (Brussels? c. 1600–c. 1647). Portraits, civic, groups. Not related to Dutch painter David van der Plas.

Jan Porcellis (Parcelles, Perseles) (Ghent c. 1585–Soeterwoude 1632). Marine scenes. Engraver.

Frans Pourbus the Younger (Antwerp 1569–Paris 1622). Portraits, group portraits, miniatures, religious.

Erasmus Quellinus (Quellin) (Antwerp 1607–1678). Religious, history, mythology, allegories. Book illustrator.

Jan Erasmus Quellinus (Quellin) (Sederboom) (Antwerp 1634–Mechlin 1715). Religious, history, still-lifes, portraits, Son of Erasmus Quellinus.

Nicolas Regnier (Ranieri, Reinieri) (Maubeuge c. 1590–Venice 1667). Religious, portraits.

Gaspar Rem (Rems) (Antwerp 1542–Venice? after 1614). Portraits, religious.

Jan van Reyn (Dunkirk 1610–1678). Portraits, religious, history.

Theodoor Rombouts (Roelands or Roelants) (Antwerp 1597–1637). Religious, history, genre. Traveled in Italy.

Peter Paul Rubens (Siegen 1577–Antwerp 1640). Religious, history, mythology, allegories, portraits, landscapes with animals, rural and social genre. Engraver, pageant, and tapestry designer, book illustrator.

David Ryckaert III (Antwerp 1612–1661). Indoor and outdoor peasant genre, social scenes, fantasy images.

Antoon Sallaert (Sallaerts) (Brussels c. 1590–c. 1658). Religious, portraits, civic group portraits, ceremonies and processions. Woodcut and tapestry designer.

Roelant Jacobsz Savery (Xavery) (Courtrai c. 1576–Utrecht 1639). Landscapes with figures, animals, birds, flowers. Became insane.

Carel van Savoyen (Savoy) (Antwerp before 1625–Amsterdam 1655). Mythology, often with nudes, history.

Marten Schoevaerdts (Schoverdts) (Brussels c. 1665–c. 1694). Landscapes, peasant scenes. Engraver.

Cornelis Schut (Antwerp 1597–1655). Religious, history, allegory. Engraver, tapestry designer.

Daniel Seghers (Segers or Zeghers) (Antwerp 1590–1661). Still-lifes, flower pieces, garlands.

Gerardo Seghers (Geeraard Zegers) (Antwerp 1591–1651). Religious, history, allegory, portraits, genre.

Jan Siberechts (Sybrecht) (Antwerp 1627–London 1703). Wooded landscapes, peasants, animals, interiors, views of mansions.

Pieter Snayers (Antwerp 1592–Brussels c. 1666). Contemporary wars, ceremonies, hunting scenes, landscapes, portraits, religious.

Jan Snellinck (Snellincx) (Melchlin 1544/49–Antwerp 1638). Religious, history. Tapestry designer.

Frans Snyders (Snyers; Sneyders; Sneis) (Antwerp 1579–1657). Still-lifes, flowers and garlands, animal and hunting scenes.

Joris van Son (Zoon) (Antwerp 1623–1667). Still-lifes, fruit, flowers, shellfish, tortoises, vessels, garlands.

Jan Sons (Soens) (Bois-le-Duc 1548/33–Parma 1611 or Cremona 1614). Landscapes, genre, religious.

Jan Frans Soolmaker (Solemaker) (Antwerp 1635–Italy? after 1665). Italianate landscapes, usually with animals or figures.

Huybrecht (Hubertus) Sporkmans (Sporckmans) (Antwerp 1619–1690). Religious, allegories, portrait groups.

Bartholomeus Spranger (van den Schilde) (Antwerp 1546–Prague 1611). Landscapes, mythologies with nudes.

Hendrik Staben (Antwerp 1578–Paris 1658). Social scenes, interiors, picture galleries.

Adriaen van Stalbemt (Stalbempt, Stalband) (Antwerp 1580–1662). Landscapes, religious, mythologies, genre. Engraver.

Hendrik van Steenwiyck II (The Younger) (Antwerp c. 1580–London c. 1649). Architectural scenes, church interiors, architectural backgrounds for other painters.

Justus Sutterman (Sutterman or Zetterman) (Antwerp 1597–Florence 1681). Portraits, allegories, religious.

Peeter Symons (Symen or Simons) (Flourished in Antwerp before 1615–1637). Mythologies, still-lifes.

David Teniers the Elder (Antwerp 1582–1649). Religious, mythologies, peasant genre.

David Teniers the Younger (Antwerp 1610–Brussels 1690). Indoor and outdoor genre, military pieces, gallery interiors, religious, portraits. Copyist and art dealer. Son of David Teniers the Elder.

Jan Philips van Thielen (Mechlin 1618–Boisschot 1667). Garlands.

Jan Thomas (Ypres 1617–Vienna 1678). History, religious, genre, portraits. Engraver, one of the first to use mezzotint.

Theodoor van Thulden (Tulden) (Hertogenbosch 1606–1669). Religious, history, peasant genre. Engraver.

Pieter Thys (Thijs, Tyssens) (Antwerp 1624–1677). Religious, history, portraits.

Gillis (Egidius) van Tilborgh (Tilborch) (Brussels c. 1625–c. 1678). Portraits, conversation groups, interiors, peasant genre, religious, allegories.

Pieter Tillemans (Antwerp c. 1684–Suffolk 1734). Military scenes, landscapes, views of mansions, portraits, animals.

Lucas van Uden (Antwerp 1595–c.1672). Landscapes with figures by other painters. Engraver.

Adriaen van Utrecht (Antwerp 1599–1652/53). Poultry scenes, still-lifes with game birds, shellfish, fruit.

Joachim Anthonisz Uytewael (Wtewael) (Utrecht 1566–1638). Religious, mythology, kitchen interiors, portraits. Designer of glass windows.

Lodewijk de Vadder (Brussels 1605–1655). Wooded landscapes with figures by other painters. Engraver, tapestry designer.

Bernard Vaillant (Lille 1632–1698). Portraits in oil and pastel. Mezzotint engraver. Brother and pupil of Waillerant Vaillant.

Jacques Vaillant (Lille c. 1625–Berlin 1691). Portraits, history, religious. Mezzotint engraver. Brother and pupil of Bernard Vaillant.

Jean Vaillant (Lille 1627–c. 1668). Landscapes, portraits. Engraver. Brother and pupil of Waillerant Vaillant.

Waillerant Vaillant (Lille 1623–Amsterdam 1677). Portraits in oil and pastel, genre, still-lifes. Mezzotint engraver.

Frederick Van Valkenborch (Falckenburg) (Antwerp c. 1570–Nuremberg 1623). Landscape with figures, religious. Son of Martin van Valkenborch.

Gillis Van Valkenborch (Falckenburg) (Antwerp c. 1570–Frankfort 1622). Landscapes with figures, religious. Son of Martin Van Valkenborch.

Martin Van Valkenborch (Falckenburg) (Frankfort 1535–1612). Landscapes with figures, religious.

Otto van Veen (Leiden 1556–Brussels 1629). Religious, history, portraits. Tapestry designer, engraver.

Pieter van de Velde (Antwerp 1634–after 1687). Marine scenes, naval warfare.

Caspar Pieter Verbruggen the Elder (Antwerp 1635–1681). Garlands, vases with allegorical figures.

Caspar Pieter Verbruggen the Younger (Antwerp 1664–1730). Flowers and fruits, many as decorations for ceilings and over doors.

David Vinckeboons (Mechlin 1576–Amsterdam c. 1630). Landscapes, peasant genre, religious, night views. Engraver.

Cornelis de Vos (Hulst 1585–Antwerp 1651). Religious, history, portraits.

Cornelis de Wael (Waal) (Antwerp 1592–Rome 1667). Military scenes, marine scenes, Italian genre, religious. Engraver, art dealer.

Jan Wildens (Antwerp 1584/86–1653). Landscapes with figures supplied by others.

Adam Willaerts (Antwerp 1577–Utrecht 1664). Marine, battle, and coast scenes.

Thomas Willeboirts (Bosschaert) (Bergen-op-Zoom 1613–Antwerp 1654). History, religious, portraits. Tapestry designer who copied Rubens and Van Dyck.

Gaspard (Jaspar) de Witte (Antwerp 1624–1681). Italianate landscapes, religious and other figures. Tapestry designer.

Frans Wouters (Lierre 1612–1659). Landscapes, mythologies, religious, genre. Engraver, art dealer.

FLEMISH PRINTMAKING

Boëtius Adams Bolswert (Bolsward) (Bolsward, Friesland c. 1580–Antwerp 1633). History prints. One of the Rubens school.

Schelte Adams Bolswert (Bolsward, Friesland c. 1581–Antwerp 1659). Religious prints. Painter. Brother of Boëtius Adams Bolswert.

Christoffel Jegher (Antwerp 1596–1652). Woodcut master, also worked in metal. Reproductions of Rubens' works for publishing. One of the Rubens school.

Paul Pontius (Antwerp 1603–1648). Reproductions of Rubens' works. One of the Rubens school; student of Lucas Emil Vorsterman.

Lucas Emil Vorsterman I (Bommel 1595–Antwerp 1675). Religious prints. Painter, drawer (ink portraits). Traveled England.

FRENCH PAINTING, DRAWING, AND PRINTMAKING

Charles Beaubrun (Amboise 1604–Paris 1692). Portraits. Cousin of Henri de Beaubrun.

Henri Beaubrun (Amboise 1603–Paris 1677). Portraits.

Jacques Bellange (c. 1575–Nancy 1616). Portraits, allegorical, religious. Draftsman, engraver.

Jacques Blanchard (Paris 1600–1638). Religious, mythological, some portraits. Engraver.

Abraham Bosse (Tours 1602–Paris 1676). Historical, allegorical, religious. Engraver of French bourgeoise life done humorously, draftsman, etcher, architect, writer.

Sébastien Bourdon (Montpellier 1616–Paris 1671). Historical, battle scenes, landscapes, portraits, religious. Engraver. Traveled Venice, Rome.

Jacques Callot (Nancy 1592–1635). City views, everyday life, war, religious themes, figure studies. Drawer, engraver, etcher.

Philippe de Champaigne (Brussels 1602–Paris 1674). Portraits, religious history. Draftsman.

Jean Baptiste Corneille (Paris 1649–1695). Religious, mythological, portraits, genre. Engraver.

Michel Corneille the Younger (Paris 1642–1708). Religious, mythological. Engraver. Pupil of Charles Le Brun.

Jacques Courtois (Saint-Hippolyte 1621–Rome 1676). Military scenes, religious themes, landscapes.

Jean Charles Delafosse (Paris 1636–1716). Historical, religious themes, still-lifes, views. Draftsman, architect.

Michel Dorigny (Saint-Quentin 1617–Paris 1685). History, portraits, mythological, allegorical. Engraver.

Gaspard Dughet (Rome 1615–1675). Landscapes. Close friend and student of Nicolas Poussin.

Charles Errard (Bressuire 1570–1635). History, portraits, hotel decorator. Engraver, architect.

Georges Focus (Faucas) (Châteaudun 1641–Paris 1708). Landscapes.

Jean Baptiste Jouvenet (Jean III) (Rouen 1644–Paris 1717). History, religious, portraits.

Nicolas Lagneau (dates unknown). Painting; portraits. Draftsman. Worked in Paris sixteenth and seventeenth centuries.

Laurent de La Hire (Paris 1606–1656). Landscapes, religious, tapestry cartoons for Gobelins. Worked for Richelieu and did paintings on lapis and stone.

Nicolas de Largillière (Paris 1656–1746). Portraits, still-lifes, history.

Georges de La Tour (Vic-sur-Seille 1583–Lunéville 1652). Religious, genre themes often by candlelight.

Charles Le Brun (Paris 1619–1690). History, religious, mythological, portraits. Engraver.

Claude Lefebvre (Fontainebleau 1632–Paris 1675). Portraits. Pupil of Eustache Le Sueur and Charles Le Brun.

Antoine Le Nain (Laon c. 1588–Paris 1648). Genre, portraits, history. Brother of Louis and Mathieu Le Nain.

Louis Le Nain (Laon c. 1593–Paris 1648). Peasant scenes, genre, religious, portraits.

Mathieu Le Nain (Laon c. 1607–Paris 1677). Genre, portraits, religious.

Jean Le Pautre (Paris 1618–1682). Architectural decorations, portraits, religious, historic, still-lifes. Engraver.

Eustache Le Sueur (Paris 1617–1655). History, genre, religious, mythological.

Nicolas Pierre Loir (Paris 1624–1679). Royal palaces, hunting scenes for Gobelins, made copies of paintings by Poussin, historical themes, portraits.

Claude Lorraine (Claude Gellée) (Chamagne 1600–Rome 1682). Landscapes with mythological, historical, or religious themes, seaports, views of Rome. Highly influential painter.

Claude Mellan (Abbeville 1598–Paris 1688), Portraits. Draftsman, etcher.

Charles Mellin (Carlo Lorenese) (Nancy 1597–Naples 1647). Religious, mural decorations. Engraver.

Pierre Mignard I (Le Romain), (Troyes 1612–Paris 1695). Portraits, history, religious, miniaturist. *Premier peinture du roi* after Charles Le Brun.

Robert Nanteuil (Reims 1623–Paris 1678). Portraits. Pastellist and draftsman.

François Perrier (Le Bourguignon) (Salins 1584/90–Paris 1650). Historical and mythological themes. Decorator for Hôtel Lambert, Hôtel de la Vrillière.

Nicolas Poussin (Villers 1594–Rome 1665). Landscapes with religious, historical, or mythological themes.

Pierre Puget (Château-Follet, near Marseille 1620–Fougette 1694). Portraits, religious. Sculptor, architect, engineer.

Hyacinthe Rigaud (Perpignan 1659–Paris 1743). Portraits, religious, history. Pastellist.

Jacques Sarrazin (Noyon 1588/92–Paris 1660). Religious. Bas-relief sculpture with religious themes.

Israël Silvestre (Nancy 1621–Paris 1691). Religious, views, landscapes, topographical. Draftsman, engraver.

Jacques Stella (Lyon 1596–Paris 1657). History, religious, mythological. Engraver.

Henri Testelin (Paris 1616–The Hague 1695). Portraits. One of the founders of the Royal Academy. Writer on art, engraver. Pupil of Simon Vouet.

Louis Testelin (Paris 1615–1665). Roman emperors, religious themes. Engraver. Pupil of Simon Vouet. Brother of Henri Testelin.

Simon Vouet (Paris 1590–1649). Religious history, portraits, mythological. Lived in Italy 1612–1627.

FRENCH SCULPTURE*

Lambert Sigisbert Adam (Adam the Elder) (Nancy 1700–Paris 1759). Public monuments, church and hotel decoration, mythological and religious subjects.

Michel Anguier (Eu 1612/14–Paris 1686). Religious statues, church decoration, bronzes, reliefs, busts.

Simon Louis Boizot (Paris 1743–1809). Marble busts of famous personalities, small bronzes. Prix de Rome 1762.

*Includes seventeenth- and eighteenth-century French sculptors.

Jacques Buirette (Paris 1631–1699). Vases, decorative sculpture. Pupil of Desjardins (Martin van den Bogaert).

Clodion (Claude Michel) (Paris 1738–Paris 1814). Small subjects in terracotta, mythological subjects in bas-relief, vases, statues, group statues, bronzes. Prix de Rome 1759.

Guillaume Coustou the Elder (Lyon 1677–Paris 1746). Statues in marble, hotel ornamentation, public monuments. Nephew of Antoine Coysevox.

Nicolas Coustou (Lyon 1658–Paris 1733). Statues in marble of mythological and religious subjects, busts, bas-reliefs, church decoration. Nephew of Antoine Coysevox.

Antoine Coysevox (Lyon 1640–Paris 1720). Busts of famous people, statues, public works, equestrian statues. Bronze, marble, stucco.

Paul Louis Cyffle (Bruges 1724–Ixelles-les-Bruxelles 1806). Public monuments, statuettes. Sculptor for the king of Poland. Ceramicist.

Martin Desjardins (van den Bogaert) (Brede, Holland 1640–Paris 1694). Decorations for parks, churches, hotels; bas-reliefs; statues, equestrian statues; public monuments. Mythological subjects. Marble, bronze.

Edme Dumont (Paris 1722–1775). Statues in marble, terra-cotta.

François Duquesnoy (Il Fiammingo; François Flamand) (Brussels 1594–Livorno, Italy 1643). Figurines in wood and ivory, bronze and marble mythological figures.

Étienne Maurice Falconet (Paris 1716–1791). Classical sculpture, allegorical, busts, statuettes, statues in marble and terra-cotta. Pupil of Jean Baptiste Lemoyne II.

François Girardon (Troyes 1628–Paris 1715). Classical subjects, religious. Bas-reliefs, church decorations, busts, tombs.

Pierre Granier (Les-Matelles 1635–Paris 1715). Marble busts, garden and park sculpture, bas-reliefs.

Guillielmus de Groff (Antwerp 1680–Munich 1742). Statuettes, busts. Stucco worker, cabinetmaker.

Jean Antoine Houdon (Versailles 1741–Paris 1828). Church sculpture, hotel decoration, statues, busts of celebrities. Religious and mythological themes. Caster in bronze. Prix de Rome 1761.

Louis Félix de La Rue (Paris 1720/31–1765). Bas-reliefs. Draftsman, watercolorist. Pupil of Adam.

Felix Lecomte (Paris 1737–1817). Busts, statues in marble, mausoleum. Pupil of Falconet. Prix de Rome, 1758.

Robert Le Lorrain (Paris 1666–1743). Tombs, bronze statues, public monuments. Mythological, religious and genre subjects. Pupil of Girardon. Prix de Rome 1689.

Jean Baptiste Lemoyne (Paris 1679–1731). Mythological subjects, tombs and statues. Uncle of Jean-Baptiste Lemoyne II.

Jean Baptiste Lemoyne II (Paris 1704–1778). Tombs, statues, portrait busts of famous people.

Jean Louis Lemoyne (Paris 1665–1755). Marble and terra-cotta portrait busts. Pupil of Coysevox.

Pierre Lepautre (Paris 1660–1744). Public statues, mythological group statues, bas-reliefs. Bronze and marble. Engraver.

Gaspard Marsy II (Cambrai 1624–Paris 1681). Hotel decorations, Louvre ornamentation, bas-reliefs. Garden statues at Versailles. Mythological subjects.

Jean Baptiste Nini (Urbino 1717–Chaumont-sur-Loire 1786). Medallions of terra-cotta. Crystal engraver, ceramicist.

Jean Baptiste Pigalle (Paris 1714–Paris 1785). Garden pieces, tombs, monuments. Pupil of Jean Baptiste Lemoyne.

Pierre Puget (Château-Follet, near Marseille 1620–Fougette, near Marseille 1694). Bas-reliefs, busts, statues. Painter, architect, engineer.

Sébastien Slodtz (Antwerp 1655–Paris 1726). Bas-reliefs, statues for public parks. Pupil of Girardon.

Jean Thierry II (Lyon 1669–1739). Chapel interiors of Versailles, statues. Pupil of Coysevox.

Pierre Philippe Thomire (Paris 1751–1843). Bronze specialist. Ornamental figures, bronze decorations. Worked at Sèvres Manufacturers as a bronze sculptor. Pupil of Houdon.

SPANISH PAINTING

Juan de Arellano (Santorcaz 1614–Madrid 1676). Flower paintings.

Francisco Camilo (Madrid c. 1635–1671). Religious, history.

Alonso Cano (Granada 1601–1667). Religious sculptor.

Juan Carreno de Miranda (Avilés 1614–Madrid 1685). Religious portraits.

Eugenio Caxes (Cajes) (Madrid c. 1577–1634). Religious.

Juan Francisco Carrion (no dates). Still-lifes.

Mateo Cerezo (Burgos 1635–Madrid 1666). Religious.

Claudio Coello (Madrid 1642–1693). Religious, portraits.

Francisco Collantes (1599?–1656). Religious.

Juan Antonio Escalante (Córdova 1633–Madrid 1670). Religious, mythology.

Jeronimo Jacinto Espinosa (Concentaina 1600–Valencia 1680). Religious.

El Greco (Domenikos Theotokopoulos) (Canadia, Crete 1541–Toledo 1614). Religious, portraits.

Francisco Herrera the Elder (Seville 1575–Madrid 1657). Religious. Architect.

Francisco Herrera the Younger (Seville 1622–Madrid 1685). Religious, portraits.

José Jiménez Donoso (Consuegra 1628–Madrid 1690). Religious.

Juan Bautista Maino (Postrano, near Toledo c. 1578–Madrid 1649). History, battle scenes.

Estaban March (d. 1660). Religious, genre.

Juan Bautista Martínez del Mazi (Cuenca Province c. 1610/15–Madrid 1667). Portraits.

Francisco Meneses Osorio (Seville c. 1630–c. 1705). Religious. Figure painter.

José Moreno (Burgos 1642–1674). Religious.

Bartolomé Estéban Murillo (Seville 1617–1682). Religious, portraits, genre.

Pedro Orrente (Montealegre c. 1570–Valencia 1645).

Francisco Pacheco (Sanlúcar de Barrameda 1564–Seville 1654). Religious, portraits.

Antonio Palomino (Bujalance) (Córdoba 1655–Madrid 1726). Religious, mythology.

Juan de Pareja (Seville c. 1604/07–Madrid 1670). Religious, portraits(?).

Antonio Pereda y Salgato (Valladolid c. 1611–Madrid 1678). Religious, still-lifes.

Bartolomé Pérez (Madrid 1634–1693). Flower painter, still-lifes.

Jusepe de Ribera (Lo Spagnoletto) See entry under Italy, Naples.

Juan de Roelas (Valladolid 1558/60–Olivares 1625). Religious.

Pedro Ruiz Gonzales (Arandilla [Cuenca] 1640–Madrid 1706). Religious.

Louis Tristan de Escamilla (near Toledo 1586–Toledo 1624). Religious.

Juan Valdes Leal (Seville 1622–1690) Religious, allegories, portraits.

Diego Rodríguez de Silva y Velázquez (Seville 1599–Madrid 1660) Religious, portraits, genre. Considered the greatest genius of the Spanish school.

Francisco de Zurbarán (Fuento di Cantos, Extremadora 1598–Madrid 1664). Religious, still-lifes.

SEVENTEENTH-CENTURY ART: MAJOR COLLECTIONS
ITALIAN PAINTING

Europe

Berlin-Dahlem, Staatliche Museen
Bologna, Pinacoteca Nazionale
Cento, Pinacoteca
Dresden, Gemäldegalerie
Ferrara, Pinacoteca Nazionale de Ferrara
Florence
 Galleria degli Uffizi
 Palazzo Pitti
Genoa, Museo e Galleria dell'Accademia Ligustica di Belle Arti
London, National Gallery

Lugano, Museo Civico
Messina, Museo Nazionale
Milan, Pinacoteca di Brera
Naples, Museo Nazionale de San Martino
Rome
 Galleria Borghese
 Galleria dell'Accademia Nazionale di San Lucca
 Galleria Doria Pamphilj
 Galleria Spada
 Musei Capitolini
 Palazzo della Farnesina
 Pinacoteca Vaticana

Turin, Pinacoteca
Vienna, Kunsthistorisches Museum

United States and Canada

Chicago, Art Institute of Chicago
Cleveland, Cleveland Museum of
Art
Dayton, Dayton Art Institute
Detroit, Detroit Institute of Arts
Greenville, Bob Jones University
Gallery of Sacred Art and Bible
Lands Museum
Hartford, Wadsworth Atheneum
Kansas City (MO), William Rockhill
Nelson Gallery of Art and Mary
Atkins Museum of Fine Arts

New York, Metropolitan Museum of
Art
Oberlin, Allen Memorial Art Museum
Ottawa, National Gallery of Canada
Raleigh, North Carolina Museum of
Art
St. Louis, City Art Museum of St.
Louis
San Francisco, M. H. de Young
Memorial Museum
Sarasota, John and Mable Ringling
Museum of Art
Toledo, Toledo Museum of Art
Washington, D.C., National Gallery
of Art

--------------- ITALIAN DRAWINGS AND PRINTS ---------------

Europe

Berlin, Graphische Sammlung
Düsseldorf, Kunstmuseum
Edinburgh, National Gallery
Florence
Galleria degli Uffizi
Gabinetto Disegni e Stampe degli
Uffizi
Hamburg, Hamburger Kunsthalle
London
British Museum
Victoria and Albert Museum
Milan
Castello Sforzesco
Pinacoteca Ambrosiana
Pinacoteca di Brera
Naples, Museo Nazionale di San
Martino
Oxford, Ashmolean Museum of Art
and Archaeology
Paris, Musée National du Louvre

Rome, Gabinetto, Nazionale delle
Stampe
Stuttgart, Staatsgalerie
Venice, Gallerie dell'Accademia
Vienna, Graphische Sammlung
Albertina
Windsor, Royal Art Collection

United States and Canada

Boston, Museum of Fine Arts
Buffalo, Albright-Knox Art Gallery
Cambridge, Fogg Art Museum, Harvard University
Chicago, Art Institute of Chicago
Cleveland, Cleveland Museum of
Art
Detroit, Detroit Institute of Arts
Hartford, Wadsworth Atheneum
Los Angeles, Los Angeles County
Museum of Art
New Haven, Yale University Art
Gallery

New York
 Metropolitan Museum of Art
 Pierpont Morgan Library
Ottawa, National Gallery of Canada
Philadelphia, Philadelphia Museum
 of Art
Princeton, Art Museum, Princeton
 University

Sacramento, E. B. Crocker Art
 Gallery
Sarasota, John and Mable Ringling
 Museum of Art
Stanford, Stanford University Art
 Gallery and Museum
Washington, DC, National Gallery
 of Art

--------------- ITALIAN SCULPTURE ---------------

Europe

Bassano del Grappa, Museo Civico
Berlin-Dahlem, Staatliche Museen
Bologna, Museo Civico Archeologico
Dresden, Staatliche Kunstsamm-
 lungen, Skulpturensammlung
Florence
 Galleria degli Uffizi
 Museo degli Argenti
 Museo Nazionale del Bargello
Forlì, Pinacoteca Communale
Leningrad, Hermitage
London, Victoria and Albert Mu-
 seum
Lyon, Musée des Beaux-Arts
Madrid, Museo Nacional del Prado
Munich, Bayerisches National-
 museum
Naples
 Museo e Gallerie Nazionali di
 Capodimonte
 Museo Nazionale di San Martino
Paris, Musée National du Louvre
Parma, Galleria Nazionale
Rome
 Galleria Borghese
 Galleria, Nazionale d'Arte Antica
 Galleria Nazionale, Palazzo Bar-
 berini

Musei Vaticani
Udine, Museo Civico e Gallerie
 d'Arte Antica e Moderna
Venice
 Museo del Settecento Veneziano,
 Palazzo
 Rezzonico
 Museo Correr e Quadreria Correr
Vicenza, Museo Civico d'Arte e
 Storia
Vienna, Kunsthistorisches Museum

United States

Baltimore, Walters Art Gallery
Cambridge, Fogg Art Museum, Har-
 vard University
Cleveland, Cleveland Museum of
 Art
Detroit, Detroit Institute of Arts
Lawrence, Museum of Art, Univer-
 sity of Kansas
New York, Metropolitan Museum of
 Art
Providence, Museum of Art, Rhode
 Island School of Design
Seattle, Seattle Art Museum
Washington, D.C., National Gallery
 of Art

DUTCH PAINTING

Europe

Aix-en-Provence, Musée Granet
Amsterdam
 Amsterdams Historisch Museum
 Rijksmuseum
Berlin-Dahlem, Staatliche Museen
Braunschweig, Herzog Anton Ulrich-
 Museum
Copenhagen, Museum of Fine Art
Dresden, Gemäldegalerie
Florence, Galleria degli Uffizi
Frankfurt, Städelsches Kunstinstitut
Haarlem, Frans Halsmuseum
The Hague, Mauritshuis
Kassel, Staatliche Kunstsammlungen
Leningrad, Hermitage
London
 National Gallery
 Wallace Collection
Munich, Alte Pinakothek, Bayerische
 Staatsgemäldesammlungen
Paris, Musée National du Louvre
Rotterdam, Museum Boymans-van
 Beuningen
Schwerin, Staatliches Museum
Stockholm, Nationalmuseum
Utrecht, Centraal Museum der
 Gemeente Utrecht
Vienna, Kunsthistorisches Museum

United States

Boston, Museum of Fine Arts
Chicago, Art Institute of Chicago
Cincinnati, Cincinnati Art Museum
Cleveland, Cleveland Museum of
 Art
Detroit, Detroit Institute of Arts
Hartford, Wadsworth Atheneum
New York
 Frick Collection
 Metropolitan Museum of Art
Oberlin, Allen Memorial Art
 Museum
Philadelphia, Philadelphia Museum
 of Art
Raleigh, North Carolina Museum of
 Art
St. Louis, St. Louis City Art
 Museum
San Francisco, M. H. de Young
 Memorial Museum
Toledo, Toledo Museum of Art
Washington, D.C., National Gallery
 of Art

DUTCH AND FLEMISH
DRAWINGS AND PRINTS

Europe

Amsterdam
 Gemeentemusea
 Rijksmuseum Prentenkabinet
 Six Collectie
Bayonne, Musée Léon Bonnat
Berlin, Staatliche Museen, Kupfer-
 stichkabinett

Brussels, Bibliothèque Royale Albert
 Ier
Cambridge, Fitzwilliam Museum
Copenhagen, Statens Museum fur
 Kunst, Kobberstiksameling
Dresden, Staatlichen Kunstsammlun-
 gen, Kupferstichkabinett
Edinburgh, National Gallery

Frankfurt Städelsches Kunstinstut
Haarlem
 Gemeente Archief
 Teylers Museum
The Hague, Rijksmuseum Meer-
 manno Westreenianum
Hamburg, Hamburger Kunsthalle
Leiden, Prentenkabinet der Rijksuni-
 versitet
Leningrad, Hermitage
Lille
 Musée des Beaux-Arts
London
 British Museum
 Victoria and Albert Museum
Madrid, Biblioteca Nacional
Munich, Staatliche Graphische
 Sammlung
Oxford
 Ashmolean Museum of Art and
 Archaeology
 Christ Church
Paris
 Bibliothèque Nationale
 École Nationale Superiore des
 Beaux-Arts
 Fondation Custodia F. Lugt Col-
 lection, Institute Neerlandais
 Musée National du Louvre

 Musée du Petit Palais
Rotterdam, Museum Boymans-van
 Beuningen
Turin, Biblioteca Reale
Vienna, Graphische Sammlung
 Albertina

United States and Canada

Boston, Museum of Fine Arts
Cambridge, Fogg Art Museum, Har-
 vard University
Chicago, Art Institute of Chicago
Cincinnati, Cincinnati Art Museum
Cleveland, Cleveland Museum of
 Art
New Haven, Yale University Art
 Gallery
New York
 Metropolitan Museum of Art
 New York Public Library
 Pierpont Morgan Library
Oberlin, Allen Memorial Art
 Museum
Ottawa, National Gallery of Canada
St. Louis, City Art Museum of St.
 Louis
Worcester, Worcester Art Museum

FLEMISH PAINTING

Europe

Antwerp, Musée Royal des Beaux-
 Arts
Berlin-Dahlem, Staatliche Museen
Bruges, Musée Municipal des Beaux-
 Arts
Brussels
 Musées Royaux d'Art et d'Histoire
 Musée Royaux des Beaux-Arts de
 Belgique

Budapest, Museum of Fine Arts
Cambridge, Fitzwilliam Museum
Dresden, Gemäldegalerie
Florence, Galleria delgi Uffizi
The Hague, Mauritshuis
Leiningrad, Hermitage
London
 Dulwich College Picture Gallery
 National Gallery
Louvain, Abbaye du Parc
Madrid, Museo Nacional del Prado

Munich, Bayerische
 Staatsgemäldesammlungen
Paris, Musée National du Louvre
Rome, Musei Vaticani
Stockholm, Nationalmuseum
Valenciennes, Musée des Beaux-Arts
Vienna, Kunsthistorisches Museum
Warsaw, Museum Narodowe

United States

Boston, Museum of Fine Arts
New York
 Frick Collection
 Metropolitan Museum of Art

FLEMISH TAPESTRIES

Europe

Brussels, Musée Royaux d'Art et
 d'Histoire
Milan, Castello Sforzesco
Tarragona, Museo Diocesano
Vienna, Kunsthistorisches Museum

United States

Boston, Museum of Fine Arts
Philadelphia, Philadelphia Museum
 of Art

FRENCH PAINTING

Europe

Berlin-Dahlem, Staatliche Museen
Chatsworth, Museum
Copenhagen, Statens Museum for
 Kunst
Dresden, Gemäldegalerie
Leningrad, Hermitage
London
 National Gallery
 Wallace Collection
Madrid, Museo Nacional del Prado
Moscow, Pushkin Museum
Paris, Musée National du Louvre

Rouen, Musée des Beaux-Arts et de
 Céramique
Vienna, Kunsthistorisches Museum

United States

Cambridge, Fogg Art Museum, Har-
 vard University
Hartford, Wadsworth Atheneum
New York, Metropolitan Museum of
 Art
Philadelphia, Philadelphia Museum
 of Art

FRENCH DRAWINGS AND PRINTS

Europe

Amsterdam, Rijksmuseum Prenten-
 kabinet
Berlin, Kupferstichkabinett
Besançon, Musée des Beaux-Arts et
 d'Archéologie

Chantilly, Musée Condé
Dijon
 Bibliothèque Municipale
 Musée des Beaux-Arts
Florence
 Galleria degli Uffizi

Gabinetto Desegni e Stampe degli Uffizi
Frankfurt, Staatliche Museen, Städelsches Kunstinstitut
London, British Museum
Montpellier, Musée Atget
Nancy
 Musée des Beaux-Arts
 Musée Historique Lorrain
Oxford, Ashmolean Museum of Art and Archaelogy
Paris
 Bibliothèque Nationale
 Musée Carnavalet
 Musée des Arts et Traditions Populaires
 Musée National du Louvre
 Musée du Petit Palais
Rennes, Musée des Beaux-Arts
Rotterdam, Museum Boymans-van Beuningen
Stockholm, Nationalmuseum
Toulouse, Musée Paul Dupuy
Vienna, Graphische Sammlung Albertina

Cambridge, Fogg Art Museum, Harvard University
Chicago, Art Institute of Chicago
New York
 Brooklyn Museum
 Cooper Hewitt Museum of Design
 Metropolitan Museum of Art
 Pierpont Morgan Library
Oberlin, Allen Memorial Art Museum
Ottawa, National Gallery of Canada
Pasadena, Norton Simon Museum
Philadelphia, Philadelphia Museum of Art
Princeton, Art Museum, Princeton University
Sacramento, E. B. Crocker Art Gallery
San Francisco, Fine Arts Museums of San Francisco
Washington, D.C., National Gallery of Art
Williamstown, Sterling and Francine Clark Art Institute

United States and Canada

Baltimore, Baltimore Museum of Art
Boston, Museum of Fine Arts

―――――――――――― FRENCH SCULPTURE ――――――――――――

Europe

Berlin-Dahlem, Staatliche Museen
Braunschweig, Herzog Anton Ulrich Museum
Brussels, Musée Royaux des Beaux-Arts de Belgique
Copenhagen, Ny Carlsberg Glyptotek
Dijon, Musée des Beaux-Arts
Dresden, Staatliche Kunstsammlungen, Skulpturensammlung

Edinburgh, Royal Scottish Museum
Gotha, Schlossmuseum
Hamburg
 Hamburger Kunsthalle
 Museum für Kunst und Gewerbe
Leningrad, Hermitage
Lisbon, Museu Nacional de Arte Antiga
London
 Victoria and Albert Museum
 Wallace Collection

Lyon, Musée des Beaux-Arts
Montpellier, Musée des Beaux-Arts
Nancy, Musée des Beaux-Arts
Orléans, Musée des Beaux-Arts
 d'Orléans
Oxford, Ashmolean Museum of Art
 and Archaeology
Paris
 Bibliothèque des Arts, Cabinet des
 Medailles
 Musée des Arts Décoratifs
 Musée Jacquemart-André
 Musée National du Louvre
Strasbourg, Musée des Beaux-Arts
Versailles, Musée National de Ver-
 sailles et des Trianons

United States

Baltimore, Walters Art Gallery
Boston, Museum of Fine Arts

Cambridge, Fogg Art Museum, Har-
 vard University
Chicago, Art Institute of Chicago
Detroit, Detroit Institute of Arts
Lawrence, Museum of Art, Univer-
 sity of Kansas
New York
 Frick Collection
 Metropolitan Museum of Art
Notre Dame, Snite Museum of Art
Philadelphia, Philadelphia Museum
 of Art
Phoenix, Phoenix Art Museum
Providence, Museum of Art, Rhode
 Island School of Design
San Francisco, Fine Arts Museums
 of San Francisco
Washington
 Corcoran Gallery of Art
 National Gallery of Art

——————————— SPANISH PAINTING ———————————

Europe

Amsterdam, Rijksmuseum
Barcelona, Museo de Bellas Artes de
 Cataluña
Barnard Castle, Bowes Museum
Budapest, Museum of Fine Art
Cádiz, Museo Provincial Bellas Artes
Dresden, Staatliche Kunstsammlun-
 gen
Edinburgh, National Gallery
Grenoble, Musée de Peinture et de
 Sculpture
Huesca, Museo Arqueológico Provin-
 cial
Leningrad, Hermitage
Lisbon, Museu Nacional de Arte An-
 tiga

London
 Dulwich College Picture Gallery
 National Gallery
 Wallace Collection
 Wellington Museum
Madrid
 Academia de San Fernando
 Biblioteca Nacional
 Museo Cerralbo
 Museo Nacional del Prado
Munich, Alte Pinakothek, Bayerische
 Staatsgemäldesammlungen
Paris, Musée National ,du Louvre
Rome, Galleria Doria Pamphilj
Sevilla, Museo de Bellas Artes
Stockholm, Nationalmuseum
Toledo, Casa y Museo del Greco

Valencia, Museo Provincial
Vienna, Kunsthistorisches Museum

United States and Canada

Birmingham, Barber Institute of Fine
 Arts, University of Birmingham
Boston, Museum of Fine Arts
Chicago, Art Institute of Chicago
Cleveland, Cleveland Museum of
 Art
Detroit, Detroit Institute of Arts
Hartford, Wadsworth Atheneum
Los Angeles, Los Angeles County
 Museum of Art

New York
 Brooklyn Museum
 Frick Collection
 Metropolitan Museum of Art
Ottawa, National Gallery of Canada
Sarasota, John and Mable Ringling
 Museum of Art
St. Louis, City Art Museum of St.
 Louis
Toledo, Toledo Museum of Art
Washington, D.C.
 Dumbarton Oaks Research and
 Collection
 National Gallery of Art

CHAPTER 9

Eighteenth-Century Art

The eighteenth century has been called by various names: the Age of Reason, the Age of Enlightenment, the Age of Revolution, and, somewhat derisively, the Age of Frivolity and Pleasurable Pursuits. It was, in fact, all of these. The eighteenth century witnessed many transformations in thought and attitudes, and was preoccupied with the workings of the human mind and the means through which it experiences reality. Expanding the body of information and knowledge was a goal that absorbed the Encyclopedists completely, while scientists applied newly established critical methods to decipher the laws that govern the universe. As scientific inquiry progressed and confidence increased in man's ability to discern through reason the physical laws of the universe, the old certainties of faith were replaced by a new religion embodied by rationalism. If faith still governed human action and thought in the seventeenth century, then reason was to become the guiding principle of the eighteenth. Science and technology preoccupied a few innovative thinkers in the previous century, but during this, the Age of Enlightenment, they fascinated many. Since the time of Copernicus and Galileo, science had known that man and earth were no longer the center of the universe, and it was now reasoned that God could not be encountered through faith but only deduced through logical argument. And it was purely through rational thought, coupled perhaps with the spirit of optimism and faith in human capabilities that so infected this age, that the philosopher Gottfried Leibnitz (1646–1716) was to propose that this was the best of all possible worlds.

Certainly economic improvements helped support Leibnitz's contention. More wealth was distributed over a larger portion of the population than ever before. Industry, manufacturing, trading, and transportation produced money, leisure time, and mobility for a wide spectrum of society. A society that had leisure time and affluence inevitably sought idle pastimes, and found these in

abundance. Such sports as hunting and racing, a form of bowling, card play-ing, and other games were enjoyed. Theaters and concerts were attended. Pleasure gardens, circuses, and other amusements offered relaxation and diver-sion. As traveling became popular, tourists flocked to local points of interest, and, as transportation became more convenient and less expensive, they also toured abroad. The Continental tour was considered a prerequisite of every English lady's or gentleman's cultivation, and tourists from France, Germany, Holland, and Flanders flocked to Italy via the Swiss Alps.

There were innumerable intellectual pastimes as well. As the literacy rate increased, so the demand for reading material of all types increased. More newspapers and magazines were published. Specialized publications provided information of all kinds, ranging from archaeology to gardening. The novel became a popular form of literature and claimed the talents of many notable writers, particularly in England, which produced the likes of Henry Fielding (1707–1754) and Tobias Smollett (1721–1771).

The eighteenth century was also a musical age in which every court had its resident musician. The great composers of the day—Antonio Vivaldi (1675?–1741), Johann Sebastion Bach (1685–1750), Friedrich Händel (1685–1759), Joseph Haydn (1732–1809), and Wolfgang Amadeus Mozart (1756–1791)—served the various courts by providing compositions for every conceivable occa-sion. Concerts were also given for the general public. The ability to perform music was considered a part of one's cultivation, and no self-respecting eigh-teenth-century home was without a clavichord, piano, or other instrument. Cultivated ladies and gentlemen usually knew how to sing, play music, and dance.

It was to some extent an age of the amateur. Science, archaeology, music, writing, drawing, and painting increasingly became the preoccupations of dedi-cated dilettantes, as well as specialists. Anyone with the proper training and skill could further his or intellectual capacities through these interests. Intelli-gent discourse on a wide variety of topics was expected of those who attended social clubs or gatherings, which proliferated throughout Europe and were called salons in France.

The visual arts played a major role in eighteenth-century life. Art enriched the home by providing decoration and intellectual stimulation. It gave visual form to the varied interests and passions of the day and was used to illustrate books, record archaeological sites, and depict scientific experiments.

Artists had a diversified range of patrons in the eighteenth century. Although artists still served the Church and aristocracy, they also increasingly supplied art for the wealthy upper classes and other strata of society. Producing elaborate room decorations for the noble and rich, simpler images for the ladies and gentlemen of the bourgeoisie, and prints and drawings for those who could afford to buy them at booksellers and fairs, artists reached a diversified audience with a broad range of subject matter. Decorative images, portraits, scenes of

daily life, illustrations, history painting, religious images, and landscapes were all produced in abundance by eighteenth-century artists.

The intellectualism of the age affected the artist, too. His facility at invention, interpretation, composition, and decoration was constantly tested as he honed his analytical skills and constructed images with an eye to conveying an intellectual judgment to the viewer. The artist created images in such a way that the viewer could evaluate and judge them as well. Thus, the artist and his audience met through the artistic image, and, through that medium, exchanged an idea or opinion. Even decorative images that were meant simply to delight the eye, in fulfilling their aim of inciting the viewer to fanciful daydreaming, compelled the viewer to recognize the very nature of such relaxation as frivolity. With this realization, the viewer experienced, along with the pleasure of contemplating the image, the sadness such frivolity induced. In still other cases, an artist's interpretation of subject matter emerged in the form of pure judgment, which was often critical or satirical. William Hogarth and Francisco Goya, for example, interpreted human events in terms of their shortcomings; thus, the frailties of human nature—false pride, stupidity, ignorance, violence, self-indulgence, and the greed that motivated so much human activity—were humorously or savagely depicted in their works. In Hogarth's case, one may assume that the intended audience shared his attitudes, whereas in Goya's case, the condemnation was so profound and personal that few might have been expected to adopt his view.

If the seventeenth century left nothing certain but the knowledge of one's self, the eighteenth century both exploited the confidence such knowledge brought and anticipated its limitations. The Age of Reason investigated the nature of understanding and man's capacity to perceive reality, often with conflicting results. One of the greatest philosophers of the age, David Hume (1711–1776), concluded in his three-volume *Treatise on Human Nature* that knowledge was merely the accumulation of sense perceptions. Thus, the very period that celebrated rationality and civilized man was also to espouse a countervailing notion of heightened sensibility and the noble savage.

The ambiguity that characterized the philosophical thought of the day also manifested itself in art. By roughly 1750, a fascination with emotion and the underside of rationality had become an obsession with artists and writers alike. The spiritual suffering induced by emotions capable of overruling reason—love, hate, jealousy, remorse, despair, fear, and uncontrolled passions—was to cast doubt on the supremacy of reason. The destructive, dark counterpart to rationalism appeared in the guise of devils who emerged from within man's soul, threatening the fragile order man had constructed from the principles of reason. The eighteenth century was an age that uncovered the dual nature of man as both a supremely rational and a deeply emotional being. This dualism in thought was to find its equivalent expression in the artistic currents of this century. Grounded in the belief in rationality, Neoclassicism sought to use art

as a powerful tool to deflect man's susceptibility to all-consuming emotion and direct him to rational thought and moral behavior. The Romantics, on the other hand, were to create an art that, by its very nature, affirmed the deep emotionalism and spirituality of man. These two conflicting tendencies were carried over into the following century. Often overlapping in their concerns, the Romantics and Neoclassicists alike responded to the revolutionary politics of the age and expressed its ideals in their art.

The eighteenth century was the last great age of the artist as decorator and the first great age of the artist as commentator. Sharing the fascination with the human mind that so captivated the eighteenth century, artists transported their viewers to the realms of unspeakable delight or unimaginable horror, exposing the dual nature of man's soul and anticipating the nineteenth-century distinction between the conscious and subconscious elements of the mind. In their many observations of human activity, artists of this period acutely recognized the dignity as well as the folly of the fascinating and complex era in which they lived.

ITALIAN ART

PAINTING

Eighteenth-century painters still served many of the same functions their predecessors did. They decorated churches with frescoed ceilings and wall decorations and produced numerous large-scale history paintings for their patrons. By the late seventeenth and early eighteenth centuries, economic conditions fostered some changes in patronage. Foreigners flocked in great numbers to Italy, creating a new market for "souvenir" pictures that depicted scenes of cities and famous monuments. An enthusiasm for archaeology spread among foreigners and Italians alike, which nurtured a new branch of view painters who specialized in antiquarian subjects—in the main, scenes of ruins both real and imaginary.

The literacy rate and theater attendance were increasing, as evidenced by the growing numbers of libraries and the broadening range of painted images. Painters began to derive their inspiration more and more from literature and theater, whose characters were added to the standard repertoire of religious and classical themes in painting. The market for small-scale paintings thrived, and the love of genre painting that developed in the seventeenth century intensified during the eighteenth century. Middle-class patrons who could afford these small paintings purchased them in great numbers and often requested small-scale studies or copies of famous large-scale pictures.

The artist emerged by midcentury with a new persona. The cult of genius,

short-lived in the sixteenth and only occasionally vented in the seventeenth century, flourished during this period. The celebrated genius of both art and literature was not the eccentric and withdrawn character who suffered the vicissitudes of inspiration or lack thereof. Rather, the eighteenth century ideal of genius was embodied by the sophisticated and rational creator who worked effortlessly and by dint of sheer virtuosity, skill, and inventiveness. In painting, artists could vary established themes or formulas endlessly to the satisfaction of patron and artist alike, and it was common practice to create paintings on one theme in infinite variation.

Of necessity, what is available in art museums of the painterly output of this period represents only a partial picture. The ceiling, wall, and large-scale altar paintings created at the time were so fused with their architectural surroundings through elaborately curved and undulating frames and often so large and cumbersome as to be impossible to remove. As a result, our exposure to altar paintings and mural decorations in museums is largely fragmentary, as most of these creations remain in their original contexts or sites. By comparison, however, more portraits, genre, landscape, and history paintings have made their way into museums, due largely to the fact that they were privately owned and produced in greater numbers. What these paintings reveal in general is a change in outlook and approach to many traditional subjects. If the previous century often used dark, deep shadows to create a psychologically gripping effect, the eighteenth-century palette was lighter, more fanciful, and more decorative. The flights of fantasy that characterize much of the painting of the eighteenth century yielded more imaginative images that were to presage the Romantic tendencies in painting of the next century. The often disturbing emotions evoked by seventeenth-century paintings were supplanted by moments of humor and charm that invite reflection but permit a psychological distance between the viewer and the object viewed, which was at best refined and at worst vacuous. The violent, stormy events depicted in painting of the earlier century are often transformed into scenes of great propriety and politeness that reveal a self-conscious moral overtone and a reserve not found in seventeenth-century painting.

In such a brief introduction, it would be impossible to describe the various styles artists espoused. Suffice it to say that the range was great, extending from a monumental simplicity derived from painting of the seventeenth century to the complexity of vivid and crowded images full of dizzying movement and infinite space.

In this, the last great age of Italian painting, its achievements were supreme and its influence far-reaching, with Italy's greatest painters taking their careers as far as St. Petersburg, Lisbon, and London. New schools of painting became important in this century. Venice was ranked most supreme, Naples superseded Rome in importance, while Bologna declined in favor and Florence was all but forgotten.

RELIGIOUS PAINTING

Altarpieces

Commissions for altar paintings continued unabated in the eighteenth century, but, in the new Age of Rationalism, scientific thought, and religious skepticism, these paintings seem to be characterized by a less profound religious intensity. With the tastes running to images of pageantry and elegance, these paintings depicted traditional subjects, such as the Adoration of the Magi and the Madonna Enthroned, which are replete with splendid costumes and pomp and majesty. Due to their large scale and integration into a complex architectural setting, few altar paintings are to be found in museum collections. Those that are collected have usually lost their fanciful and elaborately carved frames that wove these paintings into the decorative scheme of their original settings.

Private Altar Paintings These remained an important part of personal devotions. Sometimes commissioned in sequence with images dedicated to specific themes, such as Christ's death and man's salvation, they tended to be less spiritually profound. A new taste developed during this period for intimate scenes from Christ's childhood, for example, images of Joseph with the Infant Christ. The traditional image of the Madonna holding the Child also survived in altar paintings of this century.

SECULAR PAINTING

History Painting

The ever widening range of subjects explored by seventeenth-century painters was, in this century, grouped under the theoretical rubric of history painting in order to distinguish it from the lower genre painting. Battle scenes, subjects from the Old and New Testaments, and themes from mythology and classical antiquity were most popular and continued past traditions in history painting. Alexander the Great, Hannibal, Caesar, and Scipio were often the central figures for classical history paintings, especially those with moralizing themes. Commissioned by wealthy, often artistocratic, patrons whose palaces had ample room to accommodate them, these and other large-scale history paintings emphasized the heroic and the ideal. These paintings assumed a great deal of knowledge and literacy on the part of the viewer and often flattered or challenged the viewer by presenting the familiar in a new way. Full of direct and implied meaning, history paintings contained actual and symbolic narrative and must have been a rich and rewarding visual experience for those knowledgeable about the subject matter.

In addition to the aforementioned themes, allegories of time, the seasons, the four corners of the world, the four elements, the arts, and music were

popular sources for painterly images. Giovanni Battista Tiepolo's *Triumph of Virtue over Ignorance* (Plate 7) demonstrates another commonly found allegorical theme, namely, the victory of one (usually moral) force over another, evil element. Stories taken from literature, for example, the romance of the sixteenth-century Italian poet Torquato Tasso (1544–1595) supplied characters and themes for numerous paintings.

Genre Painting

Having first developed a taste for this type of painting in the previous century, Italy in the eighteenth century saw a flowering of genre painting as numerous cities—including Turin, Florence, Bologna, Rome, Naples, and Venice—produced their own native genre painters. Ranging in approach from the direct realism of Lombard school paintings of peasants, hunters, cripples, beggars, idiots, vagabonds, and washerwomen to the uncritical and intimate depictions of contemporary life by Venetian artists, genre scenes were characterized by their generally small scale and modesty. They were painted for people whose rooms and wealth were similarly modest and whose taste for decorative pictures created a constant demand. By the eighteenth century, genre paintings were also occasionally bought by the most distinguished aristocratic patrons, indicating that distinctions of merit based on subject matter were becoming less important among collectors of painting.

Landscape Painting

A combination of economic, social, and cultural conditions produced an abundance of landscape painting in Italy during this period. By the early eighteenth century, painters began to rely increasingly on foreign travelers, especially the English and Germans, who toured Italy regularly, for their patronage. These patrons sought records, whether realistic or fanciful, of the sites they had seen and visited. Italy offered numerous attractions, of which the most picturesque was the city of Venice, its canals festooned with gaily colored palazzi and alive with pageants of boats. The ancient ruins of Rome and Naples also provided subjects for painting. Always in great demand, topographical and imaginary views of landscapes, harbors, ruins, and festivals were often painted in pairs as souvenirs for export by painters who specialized in them. In fact, these paintings were most often found outside Italy, and are today among the most common and enchanting images found in museum collections.

Still-Life Painting

Flower, animal, bird, and fish still-lifes continued to be popular in Naples, Bologna, Rome, and Florence. Still-life paintings, though less well known

than history paintings, may often appeal more to us today, yet they are not as frequently displayed in museums or discussed in the literature. These paintings were frequently parts of sets sold as pairs or as a series and were intended to be part of domestic interior decoration.

The Nude

Eighteenth-century Italy, especially Venice, revived the sixteenth-century tradition of eroticism and sensuality in depictions of the nude figure. Such themes as Susannah and the Elders, Cleopatra, and Venus which had been so common in the sixteenth century, regained popularity among some eighteenth-century collectors.

Although bacchic scenes were common in interior decorations, they retained a restrained, almost playful mood, and displayed none of the primal sensuality of images painted in the sixteenth century.

Portraits

All of the major centers, and no doubt other cities as well, had their share of portrait painters. It had become fashionable during this century for foreign travelers in Italy to have their portraits painted. Most of these are formal, revealing little about the lives and moods of the sitters. However, some regions, particularly Venice and northern Italy, continued the seventeenth-century tradition of painting penetrating and insightful portraiture that was less formal and remote from the viewer.

Oil Sketches

The oil sketch remained an important type. As a preliminary study for, or small-scale version after, a large-scale painting, the oil sketch was enthusiastically collected during the eighteenth century.

DRAWING

In style and technique, eighteenth-century Italian drawing developed in the tradition of the seventeenth century. Chalk, pen, and ink—the favored materials—were handled with supreme virtuosity. Venice was the home of some of the greatest draftsmen of the century, although Rome still attracted innumerable artists, as did Naples, Florence, Bologna, and other cities.

Why and what artists drew changed not so much in character as in emphasis. Drawing was no longer considered merely an adjunct to other artistic endeavors, but often an end in itself. Some artists specialized in drawing, and their oeuvre is regarded as highly, if not more so than, as their paintings or other

work. Because drawings had been collected enthusiastically for two centuries, artists drew merely for the sake of expressing their skill at it. Theme and variation—taking a concept and exploring the potential for personal inventiveness within the limits imposed by a particular subject and format—produced some of the most delightful and masterful drawings, among which a single theme might appear fifty or one hundred times.

The great decorators of palaces and churches, the great scene painters, portraitists, and architectural and history painters explored their concepts for paintings in drawings. By the end of the century, a considerable body of drawings began to record experiences of everyday life, a subject that had long been explored in painting but that was new to Italian drawing. A much larger body of finished drawings served as cheaper substitutes for paintings or as preparations for prints.

During this period, there was also a heightened interest in caricature, reflecting the satirical bent found in much of the artistic activity throughout Europe. In Rome, certain artists, for example, Giuseppe Ghezzi (see list of artists at end of chapter), specialized in caricaturing the society there, and patrons could even be found to support these amusing interpretations of their own personas.

PRINTMAKING

By the eighteenth century, the woodcut had fallen to near complete disuse in printmaking. Two other modes of printmaking, however, continued to flourish.

Engraving

Used to reproduce paintings by the masters of the period, all of the categories of eighteenth-century Italian painting were recreated to some extent through engravings. The most popular subjects included views of towns and scenes of ruins reproduced from paintings. Original images were also made by a number of artist-engravers, most of whom were Venetian. Professional engravers abounded in Venice and, to some extent, in Rome.

Etching

Etching, like engraving, was centered in Venice, where the tourist trade helped support a lively industry. Many etchings were produced in standard sizes and with related themes in varying compositions, so that a buyer would be encouraged to purchase a set of prints. Furthermore, artists tended to think in terms of theme and variation, so that one subject, such as a view of Venice, was treated in many different ways by a single artist. Other images were based on personal imagination and were entitled *capricei* or inventions. The best known and most highly regarded etchers were Bernardo Belloto, Antonio Canal (Canaletto), and

Giandomenico and Giambattista Tiepolo (see list of artists at end of chapter). Rome was also a flourishing printmaking center, and its prints have as their principal subject the city's archaeological sites and ruins. Its principal artist was Giovanni Battista Piranesi (see list of artists).

FRENCH ART

During the eighteenth century, the French state had been firmly established (see Figure 9-1) and the French court, comprising the king and his entourage, still wielded a powerful control over the arts through patronage and the Royal Academy. This situation was not to change until the Revolution of 1789. From the paintings, drawings, sculptures, prints, and decorative objects that constitute today's museum collections of eighteenth-century art, the viewer will note that these and other conditions shaped French art of this period in unique ways.

The court continued to set styles, and society continued to emulate them. Style, expressed as a certain taste in everything from hairstyle and dress to furniture and painting, pervaded French society. The wealthy desired material comforts but were also conscious of aesthetic beauty. They had a thirst for objects to delight the eye that is virtually without parallel in the history of art. They lived in hôtels as their forebears had done, but their rooms were smaller, scaled more to human proportions, and lavishly decorated with creature comforts: furniture, carpeting, tapestries, mirrors, lamps, pictures, sculpture, clocks, and fireplaces. These were all created to be pleasing to the eye as well as functional.

Many social activities point to a general enthusiasm for art. Salons sponsored by the Academy were eagerly attended, and artists were summoned and paid to illustrate the margins of salon catalogs with the works on display. Publishers profited from the sale of guides to private collections. Collecting abounded, and in particular drawing collections were numerous and often large. The famous banker and collector Pierre Crozat had more than 5,000 drawings alone. Dealing in books, pictures, drawings, and prints brought large profits. The demand for sculpture, prints, porcelain, tapestries, and furniture resulted in the establishment of factories that produced "editions" in great numbers to satisfy their customers. This vast production is now scattered in museum and private collections.

Scholars tell us that the eighteenth century in France began with an invocation to the artist to study nature—its variety, its naiveté, and its soul. What was the "nature" that artists studied and on which so many objects were based? To a certain extent, what was meant by nature were the inherent properties of natural forms, which were recalled in the swelling or curving shapes of furniture and all manner of decorative objects. In a broader sense, there was also an

FIGURE 9-1. Map of France, c. 1789.

interest in the elements of nature—the land, weather, trees, and lakes—that constitute the setting for human existence. But a closer look at how "nature" is rendered in French art of this period reveals that it was not nature as landscape that captured the viewer's imagination, but rather human nature.

Eighteenth-century French society was fascinated by the nature of man, which became a topic of discussion among writers and philosophers from Voltaire to Jean Jacques Rousseau. And every aspect of human activity and nature was studied by artists in their work, which ranged from the rather neutral recording of everyday life to the penetrating studies of character found in portraits and genre scenes. The human mind became the actual subject of

many great portraits that reveal with profound insight the psychology and personality of the sitter.

Other paintings explored their subjects' dreams and fantasies, ideals and limitations. The emergence of the so-called *fêtes champêtres* and *fêtes galantes*—those enchanting reveries in parks where the eternally youthful enjoyed freedom and contentment in a perfect and harmonious setting—was a profound expression of the deepest yearnings of this age. Furthermore, by evoking longing in the representation of dreamlike or ideal images of society, artists permitted society to question itself and the nature of its desires. In related areas, French society had its share of great philosophers, idealists, and critics whose belief in rationality, espousal of a return to nature or the simple life, or advocacy of moral virtue and family values all expressed ideals that were themselves part of human nature and ever changing.

Today, we react to universal qualities in the art of this period. We instinctively recognize its sensuality, and still respond to images that express longing or unrequited love. Paintings of idealized amusements tend to raise questions in our minds as well—how long such pastimes could be enjoyable, who would be privy to such pleasures, and so on. The captivating richness of French art embraces many types of artistic expression, from the profoundly insightful exploration of subtle or elusive nuances of mood and feeling to the merely delightful or sensual. Whether it entertains, instructs, or amuses us, eighteenth-century French art tells a rich and complex tale effortlessly in the guise of mere decoration.

PAINTINGS

Churches and religious institutions were still active patrons of painting in eighteenth-century France. This fact is often overshadowed by characterizations of France in this century as rational, skeptical, and anticlerical. Although few altar paintings or religious works have entered museum collections, those that have demonstrate a general attitude of propriety and restraint. Noble sentiment, elevated thoughts, and dignified actions were considered appropriate to religious themes.

Because the vast majority of museum collections of eighteenth-century French painting is not religious in inspiration or subject matter, however, our discussion will be devoted to secular painting, on which the influence of the Royal Academy continued to be profound.

The Royal Academy

Although many different types of painting were to flourish in France during this century, the Grand Manner of history painting was the only one espoused

and taught by the academy. History painters were still the most highly regarded, held the most important positions, and were professors. By the standards of the academy, genre, still-life, and portrait painting ranked much lower.

Among the most significant activities of the academy were the annual competitions held among students and artists, who were given a theme from classical mythology, the Bible, or Roman history and created paintings of that theme. The works were then shown and judged in competition for which the first prize was a Prix de Rome, entitling its recipient to travel to Rome to study in the branch of the academy there. Early prizes sometimes had to be privately financed but after 1748 scholarships were established.

By 1737, the academy began to hold annual salons; after 1751, salons were held every two years until the French Revolution. These public exhibitions produced the first professional art critics, who interpreted and assessed works in an exhibit for the interested reader and salon visitor. Journals, periodicals, and pamphlets were published to aid those who attended the salons.

History Painting

A form of painting that aspired to moral overtone, history painting continued to challenge the painter's intellect, his abilities as narrator, his knowledge of history and literature, and his skill as a composer in the Grand Manner. Likewise, an interest in both Roman and Greek antiquity inspired French history painters in this century as it had in the previous, for not only were the stories and forms of antiquity conducive to the purposes of French history painting but the culture itself never lost its interest in the past. Between 1738 and 1748, Herculaneum and Pompeii were excavated, thus enhancing an interest in ancient art. As the love of antiquity swept France, so did an interest in archaeological exactness in history painting, which began to take on some of the noble simplicity and calm grandeur for which the theorist, Johann Winckelmann, praised ancient art. The revival of classicism in history painting was to become further strengthened in the next century.

Inasmuch as history painting was the most theoretical and intellectual of all the types of painting, it was not surprising that the philosophical and political ideas arising out of the ferment of prerevolutionary France should have gained expression in history painting of the later decades of the century. Painting became engaged in the serious issues of the day, articulating the belief in duty, sacrifice, and virtue, first in the guise of antique subjects, such as the Oath of Horatii, and later in direct images of heroes of the Revolution. Through its now subdued coloring, severe order, and earnest subject matter, painting exhorted and embodied the ideals that helped to spawn the Revolution.

Genre Painting

Perhaps no other type of French painting developed in as many new directions as the now familiar category of genre painting. Inspired by Dutch and Flemish traditions, the French embraced genre paintings, which became an ideal vehicle for expressing the many interests and tastes of eighteenth-century French society. As the century progressed and tastes changed, nowhere are these changes more dramatically reflected than in their influence on genre painting.

Fête Galante and Fête Champêtre At the beginning of the century, new subjects emerged that are now usually known by their French names, the *fête galante* and the *fête champêtre*. In translation, these mean the pursuit of love and the pursuit of outdoor feasts or amusements. The actual subject of many of these paintings is often vague, thus allowing the viewer's imagination to supply meaning for the placement and action of its various characters.

Scenes of flirtation, unrequited love, human passions, and the pursuit of pleasure all demonstrate the French preoccupation during this century with the world of the imagination. After all, these images do not depict an actual reality, but an idealized one that exists only in the mind. Both criticized for their frivolity and artificiality and praised for their wit and charm, these pictures at their best illustrate elusive yet undeniably true sentiments. They elicit subtle responses of longing, humor, melancholy, or listlessness from the viewer. They do not inspire action but contemplation—and so they should, for their original function was to decorate private rooms. These paintings graced the walls of sitting rooms or drawing rooms—places that invited idle relaxation and daydreaming. It was for such pastimes that painters created dreamlike images of people playing music, dancing, flirting, talking—in short, whiling away eternity in pleasant amusements. Jean Honoré Fragonard's *Pursuit of Love* (Plate 8) originally constituted a series of paintings on the theme of love that decorated a French drawing room.

The inspiration for these images came from Dutch painting and the theater, especially Italian comedy and its repertoire of characters, such as Harlequin, Scapin, Pierrot, Messetin, Scaramouche, Colombine, and the Doctor. And, of course, each artist drew inspiration from his own imagination. Interpretations of painterly subjects ranged from the purely poetic to the merely insipid; some artists, like Jean Antoine Watteau, were capable of evoking profound and often disturbing emotions, whereas others were content with rendering simple images of merriment. In either case, the infinite variety of subjects and interpretations was rooted in a common understanding of the function of painting, which was to appeal to the mind and imagination through the senses. The great practitioners of fantasy images included Watteau, Fragonard, François Boucher, Nicolas Lancret, and Jean Baptiste Joseph Pater (see list of artists at end of chapter).

Scenes of Everyday Life Other painters, notably Jean Baptiste Siméon Chardin, dealt with an aspect of genre painting that is best known from seventeenth-century Dutch traditions. Children preoccupied with simple amusements, ladies engaged in reading or rest, the performance of household duties, the care of children—these images derive their inspiration from the careful observation of daily life. In the hands of a master like Chardin, these scenes became immediately popular among a wide range of patrons that included the aristocracy. Like their more fanciful counterparts, such pictures provide visual comfort and make no reference to anything outside the realm in which the images exist. In innumerable depictions of domestic felicity, no intrusions from the outside world distract the viewer from peaceful contemplation. No windows or exterior views remind the viewer of the reality beyond the image within the frame.

In the hands of other painters, the daily life of eighteenth-century French society was recorded faithfully, almost at face value. Paintings of people in fashionable dress sometimes closely resembled popular engravings of the time that depicted contemporary fashion, although the paintings would often have subtle overtones and risqué double meanings.

Both types of genre painting were popular through the middle of the century. The nonjudgmental attitude that permitted the painterly depiction of idle pastimes and pleasures started to change toward the end of the century. A revived interest in paintings with moral messages, ones that stressed familial virtues, such as discipline, piety, chastity, and loyalty, manifested itself. Much of this change can be associated with the influence of the French encyclopedist Denis Diderot, whose criticism of painting challenged the artist to ". . . move me, astonish me, break my heart, let me weep, tremble, stare, be enraged; you will delight my eyes afterward if you can."* Out of this challenge emerged a new hero, Jean Baptiste Greuze, whose genre paintings emphasized such moral virtues. In spite of the moralizing climate that was to develop, an erotic element remained rooted in some paintings. The chaste heads and figures of young girls would often continue to suggest sensuality, and some painters, such as Fragonard, depicted scenes of sometimes overly violent passions.

The Nude

Rigid distinctions between history, genre, and nude painting are not made in eighteenth-century French art. The taste for eroticism that helped create the *fête galante* also saw the nude, especially the female nude, become a subject of painting in various guises. Mythological themes—scenes of gods and goddesses cavorting in the woods, bathing or sleeping, or pairs of lovers caught in com-

*Hugh Honour, *Neo-Classicism* (Harmondsworth, England: Penguin Books, 1968), p. 144.

promising situations—all permitted the representation of gloriously sensuous nudes. Images of young girls, lying uninhibitedly in their boudoirs in various states of dress or activity, were also increasingly popular among patrons during the first three-quarters of the century.

But such pretexts were hardly necessary. Unabashedly sensual, these nudes acknowledge the viewer's appetite for the erotic and exploit one's fascination with voyeurism. These paintings may be said to fall in the category of fantasy images, and they appeal to a very fundamental aspect of human nature.

Portraits

Portraiture continued to be in great demand and had its own specialists, including Jean Marc Nattier, Maurice Quentin de Latour, François Boucher, Marie Louise Elisabeth Vigée-Le Brun, and Adélaide Labille-Guiard (for details, see list of artists at end of chapter).

Commissioned by patrons on every social level, portraits recorded likenesses of family members and illustrious celebrities, and they were used to decorate rooms and albums or were worn as jewelry. Court portraits, were of course, the most grandiose, often depicting members of royalty as various Olympian deities. This style of portraiture enjoyed a great vogue and became popular among other classes as well.

The subjects of portrait painting, irrespective of social rank, invariably wanted to be seen as gracious, aristocratic, refined, and at leisure. Yet, despite such self-conscious posturing, many French portraits delve deeper than mere surface appearance and actually allow insights into the personality of the sitter. Such portraits often engage the viewer because they regard him directly and with confidence, humor, and intelligence. Some appear so enlivened that the viewer could believe that their subjects would break their silence at any moment to exchange some pleasantry. Mildly flirtatious women smile out at us, sometimes enigmatically, but always engagingly.

Traditional large-scale oil portraits were later to be joined by smaller portraits done in other mediums, including pastel. Large or small, portraits tended to be casually informal. The best of them are spirited characterizations that reflect through their subjects the charm and sensibility of the age.

Pastel Portraits These were introduced to France by Rosalba Carriera, who came from Venice in 1719–20 and resided with the collector Pierre Crozat. Although other artists had used pastels in the earlier century, Carriera's style gave pastel portraits a new impetus and popularity.

Offering infinite possibilities for gradations and colors that create a sense of vapor, pastels caught the fancy of patron and artist alike. Pastels had an advantage over other mediums in that they provided a color image of the sitter and could be rendered rapidly and directly in front of the subject. Nattier, Latour,

and Jean Baptiste Perroneau were among the chief pastelists, whose portraits were avidly sought by collectors in eighteenth-century Paris.

Still-Life Painting

Displayed in the salon of the academy, still-lifes were admired for a realism that fooled the eye (*trompe l'oeil*). Many were painted by such artists as Chardin for the same reasons Dutch painters so loved to paint them: to explore the formal problems and challenges they presented, including composition, texture, light, the juxtaposition of shapes, and the infinite possibilities of placing objects in relation to one another.

In seventeenth-century Holland, still-life painting was supported largely by middle-class patrons, but in eighteenth-century France, the aristocracy as well as the middle class enjoyed and collected still-lifes. The best known painter of still-lifes was Chardin, who chose simple, unpretentious objects and endowed them with great dignity. A genius of composition, Chardin made deceptively simple pictures that are, in fact, some of the most complex compositions ever painted.

Still-lifes continued to be a popular type among many painters, and the categories included: the buffet, in which flowers and fruit are combined with ornate tableware; trophies of the hunt, involving dead game; allegories, such as the four seasons or occupations such as the arts, sciences, or music, which were represented by symbols; preparations for meals involving arrangements of fish, game, or fowl; and domestic interiors with food-laden tables.

Animal and Hunt Scenes

Animal and hunt scenes were subjects for painting often commissioned by royal patrons. The king not only liked to have his prize hunting dogs immortalized in paint but liked scenes of them in action with their prey. It was also customary to have a painter depict the unusual antler formations taken in hunts, most of which were preserved for posterity in the palace at Fontainebleau. Like a good deal of other French painting, hunting and animal scenes trace their origins back to seventeenth-century Flemish painting. The painter most associated with this subject is Jean Baptiste Oudry, whose catalog of works now exceeds 600 paintings and 1,000 drawings. Like the Flemish painters from whom he took so much inspiration, Oudry was a virtuoso painter who specialized in a brilliant technique and created paintings of breathtaking realism and illusionism.

Landscape Painting

By the second half of the century, a few painters specialized in landscapes that were independent images and not incidental backgrounds for other paintings.

French artists traveling to Italy painted scenes along the way of the mountains and coast. Classical ruins, Roman temples, and amphitheaters—all captured the eye of French landscape painters, some of whom specialized in views of Roman ruins almost to the exclusion of other subjects. (A parallel trend can be found in Italian landscape painting of this period.) Other landscape painters, such as Joseph Vernet, concentrated on picturesque views of French regions, especially Paris.

Like genre painters, landscape painters were called on principally to create decorative works for rooms appointed in a specific style. The style known as Louis XVI, which was rather formal, less curvilinear than Louis XIV, and inspired by Roman antiquity, found an ideal decoration for its rooms in the landscape paintings of views of ruins, both real and imaginary.

The native interest in landscape painting declined in eighteenth-century France, so many French landscapes were commissioned by English or Italian patrons.

Oil Sketches

In the eighteenth century, it was not common for painters to render final paintings out of doors, but many (notably Alexandre François Desportes) did make sketches in the open air. Other small oil sketches were commonly prepared (though not necessarily out of doors) by painters prior to their work on large-scale commissions. Rapidly executed with a minimum of detail, these oil sketches are highly prized today as examples of spontaneity, accuracy of observation, and mastery of composition.

DRAWING

Except for Italy and Holland, perhaps no other country valued drawing as highly and for so many reasons as did France in the eighteenth century. Collectors abounded, and drawings were made in the thousands. The demand was so high that reproductive prints were often made. Those who collected drawings desired them not only to keep in albums but also to frame and hang in their houses. Independent drawings, finished versions of the hasty sketch, were as highly coveted and abundant here as they had been in Holland in the previous century.

Drawing techniques varied, but colored chalks and pastels became favored mediums, and the pen was less often used. The addition of color to drawing explains, in part, the popularity of pastels, which were used in combinations such as black, white, and red. Brush drawings, which exploited the ability of the brush to convey nuance, range of shading, and coloristic subtlety, also continued to be made.

With energy, economy, and masterful strokes of unequaled delicacy, French

draftsmen of this century wielded chalk, brush, pen, or crayon to capture the elements of life around them. Many of the subjects depicted in painting—courtly revels, portraits, still-lifes, genre scenes, erotic images, the nude—all were treated in drawing, which at the time was not sharply distinguished from painting. Drawings were, of course, still executed as preliminary sketches for paintings. Studies from live models or of composition were tested on sheet after sheet.

Drawings were also a very useful medium for traveling artists. With the discovery of Pompeii and Herculaneum and the continued interest in classical antiquity, artists would pack up paper and drawing tools—the most portable materials—and set out for Rome and other scenic Italian regions to record the views. At this point, a tour of Italy was still considered essential to the artist's development.

Apart from scenic views rendered by traveling artists, landscape drawings were not overly plentiful during this period. French draftsmen seemed more interested in subjects that allowed them to explore their inner visions. Even studies that had their origins in reality were touched with dreamlike quality, with the fleeting and elusive nature of a reverie. Landscape images also never quite served the purposes or interests of a culture that was, first and foremost, fascinated by human nature.

This century saw the emergence of the professional illustrator, the "commercial" artist, who, like Gabriel de Saint-Aubin, recorded the life of Parisian society. These drawings were true-to-life and pleasant and mirrored society in flattering and charming visions. They were used as cheap substitutes for paintings and sometimes illustrated costume books.

The stylistic range of eighteenth-century French draftsmanship was wide. From the delicate yet assured touch of Watteau, unequaled for grace and refinement, to the more robust strokes of Boucher and the unparalleled vigor of Greuze, French draftsmen occupy a special place in the history of drawing, and their works are the prizes of museums that own and display them today.

PRINTMAKING

Because museum collections and published surveys tend to divide materials by medium, prints will be dealt with here as a separate category, even though no such clear distinctions between mediums existed at the time these prints were made. Prints served many of the same purposes that paintings and drawings did in the eighteenth century.

French society had a tremendous appetite for images that could be satisfied only by a large production of prints. Increasing numbers of professional engravers, coming from all parts of the Continent to congregate in France, reproduced paintings, drawings, and pastels by professional artists for a wide audience. The demand was so great that much energy and technical ingenuity

was expended to develop new techniques for rendering the effects of color, crayon, and chalk or pastel more successfully. The professional engraver Gilles Demarteau of Liège (1722–1776) perfected a technique that imitated the grainy effect of crayon on paper by using a very fine roulette wheel, achieving what was called the "crayon manner." Later, Louis Marin Bonnet perfected the "pastel manner" and Jacob Christoph Le Blon (1667–1741) returned from England to publish the first color reproductions of paintings, using a variant of the mezzotint. The effects of wash drawings were simulated by aquatint, an etching technique that flooded areas of a plate with tones and thereby produced infinite gradations of dark and light.

Some printmakers specialized in making drawings in the margins of salon catalogs of paintings that were on display; then they made prints from the drawings so people could have illustrated mementos of the exhibit. Other printmakers were commissioned by the royal court not only to design but also to record special events with prints, such as weddings and their requisite balls, firework displays, banquets, masked balls, funerals, and all sorts of public rituals, including the inspection of residences, the reception of dignitaries, and so on. Also, artist-engravers painted, drew, and occasionally turned out an etching or oversaw the reproduction of their own works. After all, an edition of prints could bring twenty to thirty times more than the sale of a painting, so it was quite worthwhile for the artist to pursue the sale of prints.

Because French society was so deeply involved in the arts, not surprisingly there were also a number of amateur printmakers. Among those who are known, Madame de Pompadour (1721–1764, fourth mistress of Louis XV) made 52 etchings after the works of the artist Boucher, and Vivant Denon, a diplomat by profession, was a gifted engraver.

Parisian society in all its stylish detail became as much a subject of prints as it became dependent on prints to keep up with the trends of the times. Fashion illustrators provided prints of the season's styles, thus originating the now familiar fashion plate. Scenes of daily social life in action were in great demand, so many printmakers made a good living depicting vignettes of social life. In these prints one could see ladies and gentlemen fashionably dressed and engaged in all manner of activities, from the mildly or explicitly licentious (some prints were entitled *The Indiscretion* or *The Seductive Proposal*) to more mundane pastimes such as a day at the races, the opera, dinners, social visits, and special events such as births.

Competing in a marketplace, artists produced images that suited the tastes of the times. Those tastes were diversified, but shared a basic fascination with human activity. Whether these scenes were idealized, erotic, imaginary, or humorous or whether they were viewed for idle contemplation, sensual pleasure, entertainment, or moral edification, their subjects spoke directly to the viewer, who could identify on a fundamental level with the scenes that passed before his eyes.

One could almost describe this period as one more fascinated by pictures than by words. Book illustration is a case in point. By the eighteenth century, the leisure and literacy rate helped increase the trade in books. The small pocket book, to be carried and read at will, was quite popular in France as it had been in seventeenth-century Holland. Small illustrations for these and other books were sought. Painters sometimes supplied drawings to be used for illustration, and other artists were specialists in illustration, such as Charles Nicolas Cochin. The most elaborate illustration was the frontispiece, but other images could be scattered throughout the book and decorative designs were also printed.

The first French bibliophile societies were formed in the eighteenth century, and their activities included, among other things, the commissioning of illustrated books. The demand for illustration was so strong that sometimes the books were simply pretexts for illustrations (and criticized for this) to the point where profusely illustrated books with minimal text began to appear by the end of the century.

Prints related to eighteenth-century French politics as well. In one respect, art in any medium had always had some political element because the royal court was so influential in the areas of patronage, artistic training, and the setting of styles. Images were also recognized for their influence, and, as political tensions mounted toward the end of the century, image making played an increasingly important role. Inspired by English caricaturists, the French began to satirize various elements of society, especially the nobility. Of course, there was censorship, but nonetheless various tracts and manifestos were produced and illustrated with prints. Eventually swept up in the political ferment of the times, much as painting had been, printmaking played a key role in propagating the ideas that culminated in the Revolution of 1789.

TAPESTRY

France set the trend for tapestry production throughout Europe in the eighteenth century. The Gobelins factory, reopened in 1699, was the principal tapestry-producing shop in France, followed by Beauvais and Aubusson. Tapestry manufacture was to a great extent related to picture making, a point demonstrated by the fact that painters were frequently directors of tapestry factories and supplied many of the designs used by the weavers.

The formerly monumental scale of tapestries was reduced to allow them to embellish apartments or homes of more modest proportions. Generally made in series, tapestries depicted various themes. Many scenes of hunt were designed by Jean Baptiste Oudry, and Boucher supplied designs for mythological scenes. The opera, tragedy, comedy, history, so-called Chinese themes, pastoral amusements, and subjects derived from literature (notably Don Quixote and La Fontaine) were among the sources for images woven into tapestries. In each

case, a painter-director supplied designs, often directed the choice of colors, and supervised the production to ensure its fidelity to the original image.

ENGLISH ART

Although England produced centuries of notable artists, its eighteenth-century artists deserve special mention for their exceptional talents, which enabled them to develop new materials and subjects that were to be advanced in the next century.

England, like the rest of Europe, had a nobility that patronized the arts. In the eighteenth century, its ranks were joined by wealthy middle-class members and the gentry, whose lifestyle, pastimes, and country estates were to influence the types of art that were commissioned. These patrons sought images that reflected their interest in people, cities, country life, and animals and sports, so artists supplied a whole new range of portrait, landscape, and genre images to accommodate these tastes.

England also developed a Royal Academy in 1768 to encourage the teaching and patronage of the arts and to elevate the status of artists. The academy also promoted history painting, as academies had done in other countries. But the broad spectrum of patronage in England gave rise to a wide range of subject matter in addition to history painting, and it is this wealth and variety to which museums today are the fortunate heirs.

English art in the eighteenth century was diverse both in subject matter and in the materials it used. Oil painting was widely practiced and artists created works in oil in large and small sizes, depending on the needs of their patrons. The multitude of subjects explored by artists in oil was also represented in watercolor, a medium that gained particular popularity in England during this century. Professional and amateur artists alike were drawn to watercolor for its many advantages: A broader spectrum of pigments was available, and because water was the primary component, colors dried quickly. Watercolors also required less paraphernalia than oil painting; paper (generally white), pigments, water, and brushes were the basic implements needed by the watercolorist. By their nature, watercolors were portable, so they were quickly put to use by artists to record sights as they walked about. Watercolors were also used to add color to a hastily sketched drawing.

As a cheaper substitute for painting, watercolor joined engraving and drawing as art forms that could be bought by the less well-to-do. As a result, artists created diverse images of English life in a number of mediums, each of which was patronized by members of various levels of society, depending on their interests and financial resources. For this reason, too, the discussion that follows does not adhere to strict distinctions between mediums, as was done in the treatment of Italian and French art in this chapter. Rather, the following

section will progress thematically according to the various subjects treated—be these formal history paintings, portraits, landscapes, scenes of daily life—for all were rendered in oil and watercolor painting, drawing, and printmaking of the time.

ANIMALS AND SPORTING SCENES

In England, as in Holland a century earlier, certain patrons sought to preserve images of their prized animals, and commissioned pictures of their valuable dogs or fine cattle. More than any other creature, however, the English prized horses. By the eighteenth century, the English had produced a variety of breeds, from heavy coach and draft horses to sleek hunters and racing horses. Valued for their power, beauty, grace, and speed, the fine horses that were bred with such care were also "immortalized" in innumerable images.

During this century, all kinds of sports became popular, both as sports and as subjects of art. Between 1680 and 1730, horse racing became less of an amateur sport and more of the professional enterprise in the sense that we still recognize today. Drawing record crowds to race courses, champion horses became minor celebrities in their time and were depicted in portraits.

Painters also recorded the pursuits of the English on hunts, focusing mostly on the participants and occasionally on the spoils of the hunt. Fox hunting, a chore that had hitherto been left to farmers, became the rage among the English gentry during this century. Astride horses and aided by hunting dogs, they rode through fields and leapt over fences in relentless pursuit of the fox. Fortunes were spent breeding better hunters and hounds. Deer hunting, hawking, and bird and rabbit hunts were also popular pastimes.

Among the other interests reflected in images of this period were sailing, archery, boxing, and cricket—all sports that developed a following in the eighteenth century.

LANDSCAPE

The interest in landscape imagery developed as a result of a number of confluent trends and conditions in England during the eighteenth century. As the means of transportation improved and people traveled more, they gained exposure to a wider variety of landscapes and, hence, an appreciation for landscape scenery itself. For the upper classes, a trip to the Continent (a Grand Tour) was obligatory. Most toured Italy via the Alps, commonly stopping in Venice, Rome, and Naples. These Italian sites also became important subjects for landscape. Also, walking became a national pastime, and was enjoyed as much for the scenery as for the activity.

Landscape images from this period can be categorized by type. The most

frequently treated themes were mountain scenes, coastal views, and views of ruins, the countryside, and cities. In the early part of the century, foreign views and scenes of various important sites in Italian cities were most common. Later in the century, however, a taste for native English landscapes evolved as the fashion of walking took hold.

Views of mountains and coasts were exploited for their capacity to induce both fear and delight. Mountains, with their dizzying heights, were rendered by artists both as manifestations of the wildest, most untamed natural elements and as awesome spectacles. Similarly, this combination of reactions inspired many scenes of rugged coastlines, whose jagged rocks are both beautiful and dangerous. The theme of shipwreck also began to appear in the art of this period. The emotional power of such imagery expressed a Romantic tendency that was to gain momentum during the nineteenth century.

By the late eighteenth century, the English landscape was dotted with hundreds of abandoned churches and castles. Arousing fascination in Britain just as the archaeological finds in Italy had stimulated interest in France during this period, ruins and archaeological sites were popular themes of art toward the end of the eighteenth and well into the nineteenth century. Made by man and ravaged by time, these ruins were transformed in art into moral lessons that reminded viewers of their mortality and the transience of worldly existence.

As a subject of landscape imagery, views of foreign cities were common during this century and were later joined by scenes of British cities. In the latter, artists recorded famous streets and well-known landmarks and, on occasion, showed large panoramas of cities as if seen from a high balcony or from afar in the countryside.

SCENES FROM SOCIAL LIFE

The eighteenth-century English lived a more public life than we do today. The family circle extended beyond the nuclear unit and included a vast network of relatives who often lived within the same district and with whom contact was maintained. Acquaintances were not limited to one's family circle but to one's social group. People established contact with other members of their social rank by joining clubs, giving entertainments, and attending resorts and theaters together. These groups were closely knit and tended to be exclusive.

A good deal of this public activity focused on drawing attention to one's social position and membership in a certain group. Those of a group regularly promenaded at resorts or sporting events or in gardens and theaters so that they could be seen by others and thereby have their associations and status publicly announced.

Life was very pleasant for the affluent. Food was plentiful and cheap, and people routinely overindulged. For those who had the means, there were

countless ways to indulge oneself. Fine clothes, furniture, coaches, wine, food, and entertainment were abundant. It is not surprising that such an environment produced excesses.

The rich fabric of upper-class urban life provided a fertile ground for artists. In drawings, watercolors, and paintings, they portrayed the promenades, fashions, parties, and entertainments of the affluent, sometimes poking fun at the frailities they revealed, such as gluttony, pomposity, avarice, and vanity. Among the artists active in this type of image making was William Hogarth, who is notable for having invented the serial narrative image, which contains stories with a strong moral overtone that reads like painted novels. Both painted and printed, these images recounted, for example *A Harlot's Progress* (engraved 1732), in which a country girl comes to the city and falls on evil ways; and *A Rake's Progress* (engraved 1735), which depicts the downfall of Rakewell, a young man who marries an old woman for her fortunes and then loses them while gambling.

THE FANCY PICTURE AND ILLUSTRATION

The English landed gentry's aesthetic tastes did not run to gradiose history painting, but rather favored portraits and an art form called the fancy picture, which was inspired by French themes of amusement but adopted certain literary overtones in England.

The English also adopted the French habit of illustrating books, and so history painters found new and quite profitable preoccupation in this area. Between 1709 and 1716, the enterprising publisher Jacob Thonnson the Elder produced illustrated editions of Shakespeare and other Elizabethan dramatists, as well as the collected works of Beaumont, Fletcher, and Ben Jonson. These early publications were first illustrated by French artists, but the work was soon turned over to Englishmen, who applied their talents to many other types of illustration as well. In addition to literary works, publications dealing with travel, local points of interest, and fashion were also frequently illustrated. Beautifully engraved scenery illustrated Jean François Albanis Beaumont's *Travels through the Maritime Alps*, which was published in 1795 in London. The English interest in gardening and country estates was reflected in J. Seeley's account of *Stowe, A Description of House and Gardens*, published in 1797 in Buckingham. The fashion plate became popular, and many publications, notably Heideloff's *Gallery of Fashion* (1797), depicted in plate after plate fashionable people in their trend-setting pleasure resorts. Contemporary magazines such as *London* were also richly illustrated.

Whereas fancy pictures were generally executed in oil, illustrations were generally done in pencil or ink with wash or watercolor. These were then turned over to a professional engraver, who prepared the images for the printed medium.

PORTRAITS

To the English aristocracy and gentry, portraits were understandably important. They commemorated ancestors, conveyed the status and dignity of the sitter, and thereby provided visible proof of the position and history of a given family. Quite often costing a considerable sum, large individual portraits were common among the aristocracy and adorned the walls of family palaces and estates.

English portraiture of the early eighteenth century was modeled after French, Italian, and Dutch portrait painting. The creation of a portrait was something of a collective industry. It was not uncommon for one artist to paint faces and hands and another to supply the drapery. Although the likeness of the face was primary in portraiture, a skilled hand was needed to render a well-painted fabric that indicated the wealth and position of the sitter.

Group Portraits, or Conversation Pieces

Long popular in Holland, group portraits became common in England during this century. Among the most charming products of English art during this period, they epitomize the cultural, economic, and family life of the wealthy. Some historians interpret these images to signify a greater affluence among a larger proportion of the population. This affluence produced more leisure time and more pleasurable pursuits and may have contributed to the more harmonious and closely knit family life.

Conversation pieces were hung in drawing and dining rooms, where they contributed to the warmth and resplendence of mansion interiors. Typical scenes show the family as a group or its individual members engaged in pleasant pastimes in an environment of material comfort. Children play under the watchful and affectionate eyes of their parents; others make music, read, dance, study, collect, sing, or play a game. Showing families gathered together in pleasant company on the family estate, these portraits have an informality that is characteristic of genre painting.

EIGHTEENTH-CENTURY ARTISTS
───── ITALIAN PAINTING, DRAWING, PRINTMAKING ─────

Bologna

Vittorio Maria Bigari (Bologna 1692–1776). History, altarpieces. Student of Giuseppe Crespi.

Carlo Cignani (Bologna 1628–Forlì 1719). Religious, mythology, history.

Giuseppe Maria Crespi (Lo Spagnuolo/Spagnoletto) (Bologna 1665–1747). Genre, portraits, New and Old Testaments. Etcher, engraver.

Luigi Crespi (Bologna 1710–1779). Painter, art historian, son of Giuseppe Crespi.

Donato Creti (Cremona 1671–Bologna 1749). History, genre (bucolic and idyllic scenes), people, landscapes. Draftsman.

Gaetano Gandolfi (San Matteo della Decima 1734–Bologna 1802). History. Engraver.

Ubaldo Gandolfi (San Matteo della Decima 1728–Ravenna 1781). History. Sculptor, engraver, anatomical drawings.

Antonio Gionima (Venice 1697–Bologna 1732). Religious.

Gian Gioseffo dal Sole (Bologna 1654–1719). Religious subjects with strong landscape and architectural motifs, genre. Religious and allegorical etchings.

Ercole Graziani (Bologna 1688–1765). Religious. Student of Donato Creti.

Anton Maria Haffner (Bologna 1654–Genoa 1732). Church decoration. Brother of Enrico Haffner.

Enrico Haffner (Bologna 1640–1702). Church decoration.

Aureliano Milani (Bologna 1675–1749). Church decoration, religious. Etcher, engraver of religious subjects.

Francesco Monti (il Bolognese) (Bologna 1685–Bergamo 1768). Religious.

Domenico Pedrini (1728–1800). Religious. Student of Vittorio Bigari.

Bologna: Quadraturisti

Giovan Antonio Burrini (Bologna 1656–1737). History. Engraver.

Marcantonio Chiarini (Bologna 1652–1710). Architecture. Engraver.

Marcantonio Franceschini (Bologna 1648–1729). Genre, history, religious.

Bologna: the Bibiena Family

Antonio Galli da Bibiena (Parma 1700–Milan or Mantua 1774). Church and palace frescoes in Bologna and Parma, Livorno, Mantua. Third son of Ferdinando.

Ferdinando Galli da Bibiena (Bologna 1657–1743). Interiors, architecture, church paintings, architectural drawings. Traveled Parma.

Francesco Galli da Bibiena (Bologna 1659–1739). History, mythology. Architect, responsible for most theaters. Brother of Ferdinando. Worked in Rome, Genoa, Naples, Vienna.

Giuseppe Galli da Bibiena (Parma 1696–Berlin 1757). Decorations for Dresden Opera House. Architect. Son of Ferdinando. Traveled Barcelona, Munich, Prague, Cinz, Stuttgart, Venice.

Naples

Carlo Bonavia (Bonaria), active 1740–1756. Landscapes, seascapes.

Giuseppa Bonito (Castellamare, near Naples 1705–Castellamare 1789). Painter, engraver. Genre, popular and anecdotal scenes, portraits.

Pietro Cappelli (d. 1724), active in Rome and Naples. Landscape perspectives.

Lorenzo di Caro, doc. 1740–1762.

Francesco Celebrano (Naples 1729–1814). Painter, sculptor.

Jacopo Cestaro (1718–1778). Religious.

Leonardo Coccorante (1700–1750). Landscapes, architectural settings.

Giaquinto Diano (Pozzuoli 1730–Naples 1803). Religious.

Antonio di Dominici (Palermo c. 1730–Naples c. 1795). History.

Pietro Fabri, doc. 1763–1776. History, architecture, genre. Traveled London.

Filippo Falciatore, doc. 1728–1768. Religious, small history and genre. Student of Paolo Matteis.

Fidele Fischetti (Naples 1734–1789). Religious, mythology.

Saverio Xavier della Gatta, doc. second half of eighteenth century. Religious. Student of Jacopo Cestaro.

Corrado Giaquinto (Molfetta c. 1690–Naples 1765). History. Worked for Ferdinand VI, King of Spain. Student of Francesco Solimena.

Luca Giordano (Naples 1632–1705). History, religious, etchings. Traveled Rome, Milan, Venice.

Gennaro Greco (Mascacotta) (Naples 1663–1714). Landscapes, painter of architecture.

Antonio Joli (Modena 1700–1777). Theater decorations, architectural scenes, views, cities. Traveled England, Germany, Spain.

Ludovico Mazzanti (Orvieto c. 1679–Viterbo 1775). Portraits, religious.

Domenico Mondo (1723–1806). Religious paintings. Student of Francesco Solimena.

Leonardo Oliveri (Martina, France 1692–Naples after 1745).

Paolo de Matteis (Cilento, near Naples 1662–Naples 1728). Religious. Engraver. Student of Luca Giordano. Traveled France, Rome.

Francesco de Mura (Naples 1696–1782). History, portraits, Palais Royal decorations. Student of Francesco Solimena. Traveled Naples, Turin.

Francesco Parisi (Il Calabrese), doc. 1709–d. 1743. Religious, landscapes, seascapes. Student of Paolo de Matteis.

Giovanni Battista Rossi, doc. 1749–1782. Religious.

Nicola Maria Rossi (Russo) (Naples c. 1647/99–1702/55). Genre, history, animals, decorations. Student of Luca Giordano.

Francesco Solimena (Canale di Serino 1657–Barra 1747). History, architecture, frescoes, some portraits.

Gaspare Traversi (originated from Naples), doc. 1749–1769. Genre, portraits, religious.

Northern Italian Painters Outside Venice

Giuseppe Bazzani (Mantua c. 1690–1769). Mythology, religious, allegory.

Claudio Francesco Beaumont (Turin 1694–1766). Religious. Traveled Rome.

Giambattista Crosato (Giovanni Battista) (c. 1697–1756). Allegory, religious, mythology.

Bartolommeo Guidobono (Savona 1657–Turin 1709). Painted on majolica, religious. Settled in Genoa. Traveled Parma, Venice.

Alessandro Magnasco (Genoa 1667–1749). History, landscapes, genre, portraits, religious. Traveled Milan, Florence.

Giuseppe Nogari (Venice 1699–1763). History, portraits. Traveled Turin.

Rome

Pompeo Batoni (Pompeo-Girolamo) (Lucca 1708–Rome 1787). History, altarpieces, mythology, portraits.

Marco Benefial (Rome 1684–1764). Religious.

Niccolo Berrettoni (Macerata di Montefeltro, near Pesaro 1637–Rome 1682). Frescoes, altarpieces, religious.

Jan Frans von Bloeman (called Orizonte) (Antwerp 1662–Rome 1749). Landscape painter, history. Flemish.

Sebastiano Conca (Gaete 1676–Naples 1764). Portraits, history, religious.

Luigi Garzi (Pistoia 1638–Rome 1721). History, portraits, landscapes.

Pier Leone Ghezzi (Rome 1674–1755). History, caricatures. Son of Giuseppe Ghezzi.

Giovanni Ghisolfi (Grisolfi) (Milan 1623/32–1683). History, architecture, frescoes. Student of Salvador Rosa.

Corrado Giaquinto (Molfetta c. 1690–Naples 1765). History. Student of Sebastiano Conca.

Lodovico Gimignani (Rome 1643–Zagarole 1697). Religious, some portraits.

Andrea Locatelli (Rome 1693–1741). History, mythology, architecture, genre, landscapes and seascapes.

Benedetto Luti (Florence 1666–Rome 1724). History, religious, etcher.

Agostino Masucci (Rome 1691–1758). History, religious, portraits.

Lodovico Mazzanti (Orvieto c. 1679–Viterbo 1775). Religious, altarpieces, frescoes.

Giovanni Odazzi (Rome 1663–1731). Religious. Engraver, etcher.

Giovanni-Paolo Pannini (Piacenza 1691/21–Rome 1765). Roman and Greek ruins, landscapes with figures, history.

Giuseppe Passeri (1654–1714). Portraits, religious.

Giovanni Battista Piranesi (near Mestre 1720–Rome 1778). Noted draftsman, etcher of views, primarily Roman antiquity.

Stefano Pozzi (Rome 1707–1768). History, decorations on public monuments, altarpieces. Student of Carlo Maratti and Agostino Masucci.

Michele Rocca (Parmigianino, Parmigiano le Jeune, Michele da Parma) (Parma 1670/75–Venice 1751). Religious, history.

Francesco Trevisani (Capo d'Istria 1656–Rome 1746). History, religious.

Florence

Bartolomeo del Bimbi (near Florence 1648–c. 1725). Still-lifes, fruit, flowers.

Matteo Bonechi (Florence 1672–1726). Allegory, altarpieces.

Margherita Caffi (Cremona, second half of seventeenth century). Flowers and fruits.

Giovanni Domenico Ferretti (Florence 1692–1766/69). History.

Antonio Domenico Gabbiani (Florence 1652–1726). History, portraits, altarpieces. Engraver.

Sebastiano Galeotti (Florence 1676–Vico 1746). History, religious. Student of Alessandro Gherardini.

Alessandro Gherardini (Florence 1655–Livorno 1723). History.

Giovanni Camillo Sagrestani (Florence 1660–1731). Portraits, religious, tapestry designer.

Venice

Jacopo Amigoni (Venice 1675 or Naples 1682–Madrid 1752). History, mythology, altarpieces, portraits. Engraver. Traveled Rome, Munich, London, Madrid.

Antonio Balestra (Verona 1666–1740). Portraits. Engraver.

Bernardo Belloto (Venice 1720/24–Varsovie 1780). Views, landscapes, architectural settings. Engraver, etcher. Traveled England, Munich, Vienna, Dresden, Poland, Italy.

Pietro Bellotto (Volzano 1627–Gargnano 1700). Portraits, history.

Federico Bencovich (Il Damatino) (Venice c. 1677–Gorizia 1753). Altarpieces. Etcher.

Sebastiano Bombelli (Udine 1635–Venice c. 1719). History, court portraits. Traveled Innsbruck.

Mattia Bortoloni (San Bellino 1696–Bergamo 1750). Church frescoes, altarpieces.

Antonio Canal (Canaletto) (Venice 1697–1769). Views, landscapes, picturesque scenes, festivals, genre, scenes of Venice. Spent ten years (1745–1755) in England.

Luca Carlevaris (Casanobrio or Luca da Ca Zenobio) (Udine 1663/65–Venice 1730/31). Views, landscapes.

Rosalba Carriera (Venice 1675–1757). Miniaturist, snuffboxes, portraits, allegory. Pastellist. Traveled Paris, Strasbourg, Vienna.

Giacomo Ceruti (Il Pitocchetto) (Milan or Brescia, active 1728–1760). Religious, genre, portraits. Traveled Venice, Padua.

Giambettino Cignaroli (Giovanni Battista Bettini) (Salo, near Verona 1706–Salo 1770/72). Religious, mythological, history.

Gasparo Diziani (Belluno 1689–Venice 1767). Italian caricaturist, religious, mythology. Traveled Rome, Germany.

Francesco Fontebasso (Venice 1709–1769). Engravings of religious subjects, mythology. Student of Sebastiano Ricci. Traveled Rome.

Giuseppe Ghislandi (Fra Vittore del Galgario) (San Leonardo 1655–Venice 1743). Portraits. Bergamo school.

Francesco Guardi (Venice 1712–1793). Views, landscapes, architecture, interiors, canals, churches.

Gianantonio Guardi (Giovanni Antonio) (Venice 1698–1760). History, portraits, older brother of Francesco Guardi.

Giulia Lama (Lisalba), active second half of eighteenth century. History, religious.

Alessandro Longhi (Venice 1733–1813). State portraits, history, genre. Son of Pietro Longhi. Student of Nogari. Etcher.

Pietro Longhi (Venice 1702–1785). Genre, bourgeois life, festivities, townspeople, portraits. Etcher.

Michele Marieschi (Venice 1696–1743). Landscape views of Venice, architecture, perspectives. Etcher.

Francesco Migliori (Meliori) (c. 1684–1734). Biblical, mythological.

Giuseppe Moretti (Val Camonica early 18th cent.–Venice 1772) Architecture, views, perspectives. Student of Canaletto.

Giuseppe Nogari (Venice 1699–1763). Portraits, history. Student of Antonio Balestra.

Giovanni Antonio Pellegrini (Venice 1675–1741). History, allegory, religious. Student of Sebastiano Ricci. Traveled Antwerp, England, Germany, Flanders, Austria, Italy.

Giovanni Battista Piazzetta (Giambattista) (Pietrarossa, near Venice 1682–Venice 1754). History, portraits, genre. Engraver.

Giovanni Battista Pittoni (Venice 1687–1767). Religious, history. Student of his uncle, Francesco Pittoni, and of Antonio Balestra. Traveled Bologna.

Francesco Polazzo (Venice 1683–1753). History, portraits. Restorator. Student of Giovanni Piazzetta.

Marco Ricci (Belluno 1676–Venice 1729). Landscapes, perspectives. Etcher. Nephew and student of Sebastiano Ricci. Traveled Turin, Rome, Florence, Milan, London, Venice.

Sebastiano Ricci (Cividal di Belluno, Venice 1659–Venice 1734). History, religious. Engraver, etcher. Traveled Bologna, Parma, Rome, Florence.

Pietro Rotari (Verona 1707–St. Petersburg 1762). History, portraits of women in England. Etcher, pastelist. Student of Antonio Balestra. Traveled Naples, Rome, Dresden, Padua, Vienna, Russia.

Giambattista Tiepolo (Giovanni Battista) (Venice 1696–Madrid 1770). History, genre, portraits, religious. Etcher, draftsman. Leading fresco painter of his century.

Giandomenico Tiepolo (Giovanni Domenico) (Venice 1727–1804). History, genre, religious. Draftsman, caricaturist. Son of Giambattista Tiepolo. Traveled Würzburg, Spain, Dresden, Genoa.

Angelo Trevisani (Barbieri Trevisani) (Treviso or Venice 1669–1753). History, portraits. Etcher.

Giuseppe Zais (Forno di Canale 1709–Treviso 1784). Landscapes with figures, and animals, views, history.

Gaetano Zompini (Nervesa 1700–Venice 1778). Altar paintings, religious/biblical scenes. Drawer, etcher. Illustrated Dante and Petrarch and engraved a series of representations of life in Venice in the eighteenth century.

Francesco Zuccarelli (Pitigliano 1702–Florence 1788). History, genre, landscapes. Etcher, watercolorist. Studied in Florence. Traveled London, Germany, Paris, Holland, Tuscany.

───── FRENCH PAINTING, DRAWING, PRINTMAKING ─────

Claude Félix Théodore Caruelle d'Aligny (Chaumes 1798–Lyon 1871). Landscapes.

Etienne Allegrain (Paris 1644–1736). Landscapes.

Jacques André Aved (probably Douai 1702–Paris 1766). Portraits.

Jean Jacques Bachelier (Paris 1724–1806). Still-lifes, flowers, history, hunting scenes. Draftsman of ornaments.

Pierre Antoine Baudouin (Paris 1723–1769). Portraits, miniatures, genre, landscapes, mythological, love themes. Draftsman. Pupil of François Boucher.

Jacques Antoine Beaufort (Paris 1721–Rueil, Seine-et-Oise 1784). Classical history.

Jean Victor Bertin (Paris 1775–1842). Landscapes.

Jean Joseph Xavier Bidauld (Carpentras 1758–Montmenrency 1846). Landscapes.

Louis Léopold Boilly (Bassée 1761–Paris 1845). Genre, portraits, love themes. Engraver.

Pierre Jean Boquet (Paris 1751–1817). Landscapes (mountains), wild animals. Engraver, designer for Sèvres porcelain.

François Boucher (Paris 1703–1770). History, genre, mythological, portraits, landscapes, decorative panels for rooms. Engraver. Premier painter for the king, director of Royal Academy and Beauvais tapestry factory.

André Charles Boulle (Paris 1642–1732). Cabinetmaker for Louis XIV.

Bon de Boullogne (Paris 1649–1717). Mythological, church decorations, biblical history. Etcher, engraver. Brother of Louis de Boullogne.

Louis de Boullogne le Jeune (Paris 1654–1733). History, religious, mythological. Academician, engraver.

Joseph Boze (Martiques, Bouches-du-Rhône 1744/45–Paris 1826). Portraits.

Nicolas Guy Brenet (Paris 1728–1792). History, religious, mythological. Engraver. Pupil of François Boucher.

Louis Carrogis (Carmontelle) (Paris 1717–1806). Portraits, especially profiles. Pastelist, watercolorist, engraver.

Jean Baptiste Siméon Chardin (Paris 1699–1779). Genre, still-lifes, portraits. Leading painter of his age.

Pierre Philippe Choffard (Paris 1730–1809). Engraver of portraits, announcements, invitations. Draftsman.

Jacques François Courtin (Sens 1672–Paris 1752). Genre, biblical history. Academician. Pupil of Louis de Boullogne.

Antoine Coypel (Paris 1661–1722). History, mythological, portraits. Academician, dramatist, art critic.

Nicolas Coypel (Paris 1690–1734). Mythological. Academician. Half brother of Antoine Coypel.

Michel François Dandré Bardon (Aix-en-Provence 1700–Paris 1778). History, religious, allegorical.

Henri Pierre Danloux (Paris 1753–1809). Portraits. Engraver.

Jacques Louis David (Paris 1748–Brussels 1825). Portraits, history, biblical history, mythological.

Philibert Louis Debucourt (Paris 1755–Belleville 1832). Genre, hunting scenes. Color printer, draftsman, engraver. Pupil of Joseph Marie Vien.

Nicolas Delaunay (Paris 1739–1792). Historical scenes after Rubens. Academician, engraver. Pupil of Lempereur.

Robert Delaunay (Paris 1749–1814). Portraits, vignettes, copies of famous works. Engraver. Brother and pupil of Nicolas Delaunay.

François Nicolas Bathélemy Dequevauviller (Abbeville 1745–Paris 1807). Landscapes. Engravings after Allori, Rosa, Lavreince.

Charles Melchior Descourtis (Paris 1753–1820). Views. Color printer, engraver. Pupil of Jean François Janinet.

Jean Baptiste Henri Deshayes (le Romain) (Colleville, near Rouen 1729–Paris 1765). Biblical, mythological, portraits. Gobelins and Beauvais tapestry designs. Pupil of François Boucher and Carle van Loo.

Alexandre François Desportes (Champigneulle, Champagne 1661–Paris 1743). Animals, portraits, hunting scenes, mythological, still-lifes.

Pierre Salomon Domenchin de Chavanne (Paris 1672–1744). Landscapes.

Gabriel François Doyen (Paris 1726–St. Petersburg 1806). History, religious, mythological, portraits.

François Hubert Drouais (Paris 1727–1775). Portraits, court painter.

Baron Joseph Ducreux (Nancy 1735–Paris 1802). Portraits. Engraver.

Jacques Dumont (Paris 1701–1781). History, religious history, mythological, portraits. Academician, engraver.

Françoise Duparc (Marseilles 1705–1778). Portraits, genre, history.

Joseph Siffrèd Duplessis (Carpentras 1725–Versailles 1802). Portraits.

Louis Jean Jacques Durameau (Paris 1733–Versailles 1796). History, some genre and portraits.

Henri Antoine de Favanne (London 1668–Paris 1752). History, mythological, decorative painter.

Jean Honoré Fragonard (Grasse 1732–Paris 1806). Genre, allegorical, erotic themes, landscapes, history. First to defy the Royal Academy after 1767. Draftsman, etcher.

Louis Galloche (Paris 1670–1761). History, landscapes, mythological. Musician.

Claude Gillot (Langres 1673–Paris 1722). Genre, mythological. Engraver, draftsman, illustrator. Teacher of Jean Antoine Watteau.

Hubert François le Bourguignon Gravelot (Paris 1699–1772). Leading French book illustrator. Draftsman and engraver.

Jean Baptiste Greuze (Tournus 1725–Paris 1805). Genre pictures with a moral tale; heads and figures of young girls emphasizing beauty, sentiment, morality, portraits; history. Rejected the Royal Academy because he was voted in as a genre painter.

Alexis Grimou (Argenteuil 1678–Paris 1733/40). Genre, portraits.

Jean Pierre Louis Laurent Houel (Rouen 1735–Paris 1813). Landscapes.

Jean François Janinet (Paris 1752–1814). Religious, history, genre, literary, allegorical. Color printer, engraver, aquatinter, chemist.

Adélaide Labille-Guiard (Paris 1749–1803). Portraits, oils and pastels.

Nicolas Lancret (Paris 1690–1743) *Fêtes galantes*, genre, nudes, Italian comedy.

Maurice Quentin de Latour (Saint-Quentin 1704–1788). Portraits. Pastelist.

Nicholas Lavreince (Niklas Lafrensen) (Stockholm 1737–1807). Miniaturist, genre, allegorical. Watercolorist, gouache.

Achille Etna Michallon (Paris 1796–1822). Landscapes. Teacher of Jean Baptiste Camille Corot.

Louis Gabriel Moreau (L'Aîné) (Paris 1740–1806). Landscapes. Engraver, etcher, gouache. Brother of Moreau le Jeune.

Moreau le Jeune (Jean Michel) (Paris 1741–1814). Draftsman, gouache and watercolors, designs for printers. Illustrator of Molière, Voltaire, Rousseau.

Jean Marc Nattier the Younger (Paris 1685–1766). History. Portraits, battle scenes. Engraver, pastelist.

Jean Pierre Norblin de la Gourdaine (Misy-Fault-Yonne, Seine-et-Marne 1745–Paris 1830) Genre, *fêtes*, history, portraits, pastiches, gouaches. Engraver, draftsman. Engravings after Rembrandt.

Jean Baptiste Oudry (Paris 1686–Beauvais 1753). Hunting scenes, genre, landscapes, animals, still-lifes. Engraver, director of Gobelins factories.

Jean Baptiste Joseph Pater (Valenciennes 1695–Paris 1736). *Fêtes galantes*, picturesque military camp scenes, genre, history. Engraver.

Jean Baptiste Perroneau (Paris 1715–Amsterdam 1783). Portraits, genre. Pastelist, engraver.

Antoine Pesne (Paris 1683–Berlin 1757). Court painter for the king of Prussia, portraits, genre, history, some mythological.

Jean Baptiste Pillement (Lyons 1728–1808). Landscapes, seascapes, genre, flowers. Engraver, designer, chinoiserie, silk designs, watercolorist, draftsman.

Jacques André Portail (Brest 1695–Versailles 1759). Flowers, fruits, landscapes, portraits. Engraver, draftsman, highly realist.

Pierre Paul Prud'hon (Cluny 1758–Paris 1823). History, portraits, mythological, allegories.

Pierre Antoine Quillard (Paris 1701–Lisbon 1733). Genre, altarpieces, *fêtes galantes*. Pupil of Jean Antoine Watteau.

Jean Raoux (Montpellier 1677–Paris 1734). Genre, history, allegorical portraits, portraits, decorative *fêtes galantes*. Pupil of Bon de Boullogne.

Hyacinthe Rigaud (Perpignon 1659–Paris, 1743). Portraits. Ennobled by Louis XIV.

Hubert Robert (Paris 1733–1808). Landscapes, decorative Roman ruins, genre. Draftsman, curator of the Louvre, watercolorist.

Augustin de Saint-Aubin (Paris 1736–1807). Portraits. Engraver, illustrator.

Gabriel de Saint-Aubin (Paris 1724–1780). Everyday life, genre, allegorical, mythological. Draftsman, engraver. Brother of Augustin de Saint-Aubin.

Jean Baptiste Blaise Simonet (Paris 1742–after 1813). Still-lifes. Engraver of Greuze paintings, also after Moreau le Jeune and Baudoin.

Pierre Hubert Subleyras (Saint-Gilles-du-Gard 1699–Rome 1749). Religious, history, still-lifes, genre, some portraits. Engraver.

Louis Tocque (Paris 1696–1772). Portraits of celebrities, court painter.

Jean François de Troy (Paris 1679–Rome 1752). Religious history, genre, portraits, mythological, occasional erotic subjects. Etcher.

Pierre Henri de Valenciennes (Toulouse 1750–Paris 1819). Landscapes, outdoor sketches.

Carle (Charles André) van Loo (Nice 1705–Paris 1765). Academic history, genre, modern subjects, portraits, frescoes, oils, religious, mythological. Sculptor. Uncle of Louis Michel van Loo.

Charles Amédée Philippe van Loo (Turin 1719–Paris 1795). Academic history, painter, genre, portraits.

Louis Michel van Loo (Toulon, Var 1707–Paris 1771). Academic history, portraits, mythological, some landscapes.

Claude Joseph Vernet (Avignon 1714–Paris 1789). Landscapes, seascapes. Etcher.

Antoine Vestier (Avallon 1740–Paris 1824). Portraits, miniaturist.

Joseph Marie Vien (Montpellier 1716–Paris 1809). History, religious, genre. Engraver.

Louis Vigée (Paris 1715–1767). Portraits, oils and pastels. Father of Elisabeth Vigée-Le Brun.

Marie Louise Elisabeth Vigée-Le Brun (Paris 1755–1842). Portraits.

Jean Antoine Watteau (Valenciennes 1684–Nogent-sur-Marne 1721). Genre, *fêtes galantes*, mythological, Italian comedy and landscape. Draftsman.

—— ENGLISH PAINTING, DRAWING, PRINTMAKING ——

Jacques Laurent Agasse (Geneva 1767–London 1849). Genre, animals. Engraver.

James Barry (Cork, Ireland 1741–London 1806). History, mythological, biblical. Draftsman, etcher.

Thomas Bewick (Cherryburn, near Newcastle 1753–Gateshead 1828). Animals, birds. Etcher, engraver, illustrator, watercolorist.

William Blake (London 1757–1827). History, literary, allegorical, fantastical. Draftsman, poet, etcher.

John Brown (Edinburgh 1752–Leith 1787). Portraits. Draftsman of historical scenes, portraits and literary themes. Poet.

Antonio Canal. See entry under Italian Painters, Venice.

John Constable (East Bergholt, Suffolk 1776–London 1837). Landscapes, topographical views. Engraver, watercolorist.

John Singleton Copley (Boston 1738–London 1815). Portraits, history.

Richard Cosway (Devonshire 1742–London 1821). Portraits. Miniaturist, draftsman.

Alexander Cozens (Russia 1717–London 1786). Landscapes, history. Draftsman, watercolorist.

John Robert Cozens (London 1752–England 1797). Landscapes. Son and pupil of Alexander Cozens. Watercolorist.

Edward Dayes (1763–London 1804). Watercolor: architectural, topographical.

Joseph Farington (Leigh, Lancashire, 1747–near Manchester 1821). Watercolor: views, landscapes.

Robert Freebairn (1765–London 1808). Landscapes, architectural views. Watercolorist.

John Henry Fuseli (Zurich 1741–Putney-Hill 1825). History, allegorical. Illustrator, writer, draftsman, watercolorist.

Thomas Gainsborough (Sudbury, Suffolk 1727–London 1788). Portraits, landscapes. Draftsman, watercolorist.

Thomas Girtin (Southwark 1775–London 1802). Landscapes. Watercolorist.

John Glover (Houghton-on-the-Water, Leicester 1767–Launceston, Tasmania 1849). Landscape watercolors.

Gavin Hamilton (Lanarkshire 1723–Rome 1798). Portraits, literary scenes (Homeric subjects), classical. Engraver.

William Hamilton (Chelsea 1751–London 1801). History, portraits. Engraver, illustrator.

Thomas Hearne (Brinkworth, Wiltshire 1744–London 1817). Watercolor: landscapes, views.

Robert Hills (Islington 1769–London 1844). Watercolor: animals, landscapes, views.

William Hodges (London 1744–Brixham 1797). Landscapes, views. Illustrator.

William Hogarth (London 1697–1764). Genre, history, portraits. Engraver.

Thomas Jones (Radnorshire, Wales 1743–1803). Watercolor: landscapes, historical.

Angelica Catharina Maria Anna Kauffmann (Chur, Switzerland 1741–Rome 1807). Portraits, history, genre, mythological.

Sir Thomas Lawrence (Bristol 1769–London 1830). Portraits. Pastellist, draftsman.

Philippe Jacques Loutherbourg (Strasbourg 1740–London 1812). History, battle scenes, seascapes, landscapes, portraits.

Thomas Malton, Jr. (London 1748–1804). Watercolor: architectural views.

George Morland (London 1763–1804). Genre, contemporary life scenes, allegorical, seascapes, landscapes.

John Hamilton Mortimer (Eastbourne 1740–London 1779). History, allegorical, exotic subjects, ancient literature subjects. Draftsman.

Paul Sandby Munn (Greenwich 1773–Margate 1845). Landscape watercolors.

Francis Nicholson (Pickering, Yorkshire 1753–London 1844). Watercolor: portraits, topographical views.

William Pars (London 1742–Rome 1782). Watercolor: views, landscapes.

Sir Henry Raeburn (Stockbridge, near Edinburgh 1756–Edinburgh 1823). Portraits.

Sir Joshua Reynolds (Plympton, Devonshire 1723–London 1792). Portraits, history. Draftsman, watercolorist.

George Romney (Lancashire 1734–Kendal 1802). Mythological drama, biblical history, genre, portraits. Draftsman, watercolorist.

Michael Angelo Rooker (London 1743/46–1801). Watercolor: topographical, landscapes.

Thomas Rowlandson (London 1756–1827). Watercolor: architectural, genre, portraits, allegorical.

Alexander Runciman (Edinburgh 1736–1785). Landscapes, history. Draftsman, engraver.

Paul Sandby (Nottingham 1725–London 1809). Topography, landscapes, views, portraits. Draftsman, engraver, watercolorist.

Thomas Sandby (Nottingham 1723–Windsor 1798). Watercolor: landscapes, views. Brother of Paul Sandby.

John "Warwick" Smith (Irthington 1749–London 1831). Landscape watercolors.

George Stubbs (Liverpool 1724–London 1806). Watercolor: sporting events, portraits, genre, animals (horses and dogs), conversation pieces.

Francis Towne (Exeter 1739/40–London 1816). Genre, landscapes. Watercolorist.

Benjamin West (Springfield, Pa. 1738–London 1820). History, biblical, contemporary military subjects. Draftsman, watercolorist.

Richard Westall (Hertford 1765–London 1836). Watercolor: genre, mythological.

Francis Wheatley (London 1747–1801). Landscapes, portraits, modern literary subjects, genre. Engraver, watercolorist.

Richard Wilson (Montgomeryshire, Wales 1713–Colommendy, Wales 1782). Portraits, landscapes. Draftsman.

Joseph Wright (Wright of Derby) (Derby 1734–1797). Portraits, allegorical, genre, landscapes. Musician.

Johann Zoffany (Frankfurt 1734/35–Strand-on-the-Green 1810). Portraits, theatrical sources, history, genre.

EIGHTEENTH-CENTURY ART: MAJOR COLLECTIONS

—————————— ITALIAN PAINTING ——————————

Europe

Asolo, Museo Civico
Bassano del Grappa, Museo Civico
Bergamo, Galleria dell'Accademia
 Carrara
Berlin-Dahlem, Staatliche Museen
Bologna, Pinacoteca Nazionale
Brussels, Musée Royaux des Beaux-
 Arts de Belgique
Dresden, Staatliche Kunstsammlun-
 gen, Gemäldegalerie Alte Meister
Edinburgh, National Gallery
Florence, Galleria degli Uffizi
Hamburg, Hamburger Kunsthalle
Kassell, Gemäldegallerie
Leipzig, Museum der bildenden
 Künste
Leningrad, Hermitage
Liverpool, Walker Art Gallery
London, National Gallery
Milan, Museo Poldi Pezzoli
Munich, Alte Pinakothek, Bayerische
 Staatsgemäldesammlungen
Naples, Museo e Galleria Nazionale
 di Capodimonte
Oxford, Ashmolean Museum of Art
 and Archaeology
Paris, Musée National du Louvre
Rome
 Accademia di S. Lucca
 Galleria Nazionale d'Arte Antica
Stockholm, Nationalmuseum

Treviso, Museo Civico Luigi Bailo
Venice
 Galleria dell'Accademia
 Galleria Querini-Stampalia
 Museo Correre Quadreria Correr
 (Ca Rezzonico)
Vienna, Kunsthistorisches Museum

United States and Canada

Baltimore, Walters Art Gallery
Boston, Museum of Fine Arts
Chicago, Art Institute of Chicago
Cleveland, Cleveland Museum of
 Art
Hartford, The Wadsworth Atheneum
Kansas City (MO), William Rockhill
 Nelson Gallery of Art and Mary
 Atkins Museum of Fine Arts
Minneapolis, Minneapolis Institute
 of Arts
Montreal, Montreal Museum of Fine
 Arts
Pasadena, Norton Simon Museum
Philadelphia, Philadelphia Museum
 of Art
Raleigh, North Carolina Museum of
 Art
Richmond, Virginia Museum of
 Fine Arts
St. Louis, City Art Museum of St.
 Louis

Seattle, Seattle Art Museum
Springfield (MA), Springfield Museum of Art
Toledo, Toledo Museum of Art

Washington, D.C., National Gallery of Art
Worcester (MA), Worcester Art Museum

—————— ITALIAN DRAWINGS & PRINTS ——————

Europe

Berlin, Staatliche Museen, Kupferstichkabinett
Darmstadt, Hessisches/Landesmuseum
Hamburg, Hamburger Kunsthalle
London
 British Museum
 Victoria and Albert Museum
Oxford
 Ashmolean Museum of Art and Archaeology
 Picture Gallery, Christ Church
Paris, Musée National du Louvre
Stuttgart, Staatsgalerie
Trieste, Civico Museo
Turin, Biblioteca Reale
Venice, Museo Correr e Quadreria Correr
Vienna, Graphische Sammlung Albertina

United States

Boston, Museum of Fine Arts
Cambridge, Fogg Art Museum, Harvard University
Chicago, Art Institute of Chicago
Cleveland, Cleveland Museum of Art
Houston, Museum of Fine Arts
Los Angeles, Los Angeles County Museum of Art
New Haven, Yale University Art Gallery
New York
 Cooper-Hewitt Museum
 Metropolitan Museum of Art
 Pierpont Morgan Library
Philadelphia, Philadelphia Museum of Art
Princeton, Art Museum, Princeton University
Providence, Museum of Art, Rhode Island School of Design
San Francisco, Achenbach Foundation for Graphic Arts, California Palace of the Legion of Honor
Washington, D.C., National Gallery of Art

—————— FRENCH PAINTING ——————

Europe

Amiens, Musée de Picardie
Angers, Musée
Autun, Musée Rolin
Auxerre, Musée d'Art et d'Histoire

Avignon, Musée Calvet
Berlin
 Gemäldegalerie
 Staatliche Museen
 Staaliche Schlösser und Gärten, Charlottenburg

Birmingham, Birmingham Museum and Art Gallery

Bordeaux, Musée des Beaux-Arts

Caen, Musée des Beaux-Arts

Carcassonne, Musée des Beaux-Arts

Chantilly, Musée Condé

Chartres, Musée de Chartres

Douai, Musée de Douai

Dijon, Musée des Beaux-Arts

Dresden, Staatliche Kunstsammlungen, Gemäldegalerie

Edinburgh, National Gallery of Scotland

Fontainebleau, Musée National du Château de Fontainebleau

Glasgow, Hunterian Museum and University Art Collections

Karlsruhe, Staatliche Kunsthalle

Le Havre, Nouveau Musée des Beaux-Arts

Leningrad, Hermitage

Lille, Musée des Beaux-Arts

London
 National Gallery
 Sir John Soane's Museum
 Wallace Collection

Madrid, Museo Nacional del Prado

Moscow, Pushkin Museum

Munich
 Alte Pinakothek, Bayerische Staatsgemäldesammlungen

Oxford, Ashmolean Museum of Art and Archaeology

Paris
 Musée Carnavalet
 Musée de la Chasse et de la Nature
 Musée Cognacq-Jay
 Musée Jacquemart-André
 Musée National du Louvre

Rennes, Musée des Rennes (Beaux-Arts)

Rome
 Galleria Corsini
 Galleria Nazionale d'Arte Antica
 Museo di Roma, Palazzo Braschi

Stockholm, Nationalmuseum

United States and Canada

Baltimore
 Baltimore Museum of Art
 Walters Art Gallery

Boston, Museum of Fine Arts

Chicago
 Art Institute of Chicago
 University of Chicago

Cleveland, Cleveland Museum of Art

Detroit, Detroit Institute of Arts

Hartford, Wadsworth Atheneum

Houston, Museum of Fine Arts

Indianapolis, Indianapolis Museum of Art

Kansas City (MO), William Rockhill Nelson Gallery of Art and Mary Atkins Museum of Fine Arts

Minneapolis, Minneapolis Institute of Arts

New Orleans, New Orleans Museum of Art

New York
 Frick Collection
 Metropolitan Museum of Art

Northampton (MA), Smith College Museum of Art

Ottawa (Canada), National Gallery of Canada

Pasadena, Norton Simon Museum

Pittsburgh, Museum of Art, Carnegie Institute

Princeton, Art Museum, Princeton University

Richmond, Virginia Museum of Fine Arts

St. Louis, City Art Museum of St. Louis
San Francisco, Fine Arts Museums of San Francisco
Springfield (MA), Museum of Fine Arts
Toledo, Toledo Museum of Art

Toronto (Canada) Art Gallery of Ontario
Washington, D.C.
 National Gallery of Art
 Phillips Collection
Worcester, Worcester Art Museum

────────────── DRAWINGS AND PRINTS ──────────────

Europe

Amsterdam, Rijksmuseum
Bayonne, Musée Léon Bonnat
Cambridge, Fitzwilliam Museum
Chantilly, Musée Condé
Cologne, Wallraf-Richartz-Museum
Frankfurt, Städelsches Kunstinstitut
London, British Museum
Oxford, Ashmolean Museum of Art and Archaeology
Paris
 Musée des Arts Décoratifs
 Musée Cognacq-Jay
 Musée National du Louvre
Rotterdam, Museum Boymans-van Beuningen
Stockholm, Nationalmuseum
Vienna, Graphische Sammlung Albertina

United States and Canada

Buffalo, Albright-Knox Art Gallery
Cambridge, Fogg Art Museum, Harvard University

Chicago, Art Institute of Chicago
Cleveland, Cleveland Museum of Art
Detroit, Detroit Institute of Arts
New Haven, Yale University Art Gallery
New York
 Cooper-Hewitt Museum
 Metropolitan Museum of Art
 Pierpont Morgan Library
Ottawa, National Gallery of Canada
Providence, Museum of Art, Rhode Island School of Design
St. Louis, City Art Museum of St. Louis
San Francisco, Achenbach Foundation for Graphic Arts, California Palace of the Legion of Honor
Washington, D.C., National Gallery of Art
Williamstown, Sterling and Francine Clark Art Institute

────────────── TAPESTRY ──────────────

Europe

Naples, Palazzo Reale
Paris
 Mobilier National

Musée des Arts Décoratifs
Musée Jacquemart-André
Musée National du Louvre

Rome
 Galleria Doria Pamphilj
 Musei Vaticani

United States

New York, Metropolitan Museum of
 Art

———————————— ENGLISH PAINTING ————————————

Europe

Birmingham
 Barber Institute of Fine Arts, Uni-
 versity of Birmingham
 Birmingham Museum and Art
 Gallery
Brighton, Art Gallery and Museum
Cambridge, Fitzwilliam Museum
Cardiff, National Museum of Wales
Derby, Museum and Art Gallery
Dublin, National Gallery of Ireland
Edinburgh,
 National Gallery
 Scottish National Portrait Gallery
Ipswich, Ipswich Museums and Art
 Galleries
Leeds, Leeds City Art Gallery, Gas-
 coigne Collection
Leningrad, Hermitage
Liverpool, Walker Art Gallery
London
 British Museum
 Dulwich College Picture Gallery
 National Gallery
 National Maritime Museum
 (Greenwich)
 National Portrait Gallery
 Royal Academy of Arts
 Sir John Soane's Museum
 South London Art Gallery
 Tate Gallery
 Victoria and Albert Museum
 Wallace Collection
Manchester
 City of Manchester Art Galleries
 Whitworth Art Gallery

Norwich, Castle Museum
Nottingham, City Art Gallery and
 Museum
Oxford, Ashmolean Museum of Art
 and Archaeology
Paris, Musée National du Louvre
Southampton, Southampton Art
 Gallery
Vienna, Kunsthistorisches Museum

United States and Canada

Boston, Museum of Fine Arts
Cambridge, Fogg Art Museum, Har-
 vard University
Chicago, Art Institute of Chicago
Cincinnati, Cincinnati Art Museum
Detroit, Detroit Art Institute
Fort Worth, Kimbell Art Foundation
Hartford, Wadsworth Atheneum
Kansas City (MO), William Rockhill
 Nelson Gallery of Art and Mary
 Atkins Museum of Fine Arts
Los Angeles, Los Angeles County
 Museum
Minneapolis, Minneapolis Institute
 of Arts
New Haven
 Yale Center for British Art
 Yale University Art Gallery
New York
 Frick Collection
 Metropolitan Museum of Art
Northampton (MA), Smith College
 Museum of Art
Ottawa, National Gallery of Canada

Philadelphia, Philadelphia Museum of Art

Pittsburgh, Museum of Art, Carnegie Institute

Raleigh, North Carolina Museum of Art

Richmond, Virginia Museum of Fine Arts

St. Louis, City Art Museum of St. Louis

San Francisco, M. H. de Young Memorial Museum

San Marino, Henry E. Huntington Library and Art Collection

Washington, D.C.
 Corcoran Gallery
 National Gallery of Art

——————— ENGLISH DRAWINGS AND PRINTS ———————

Europe

Amsterdam, Rijksmuseum

Berlin-Dahlem, Staatliche Museum

Birmingham, Birmingham Museum and Art Gallery

Cambridge, Fitzwilliam Museum

Cardiff, National Museum of Wales

Dublin, National Gallery of Ireland

Edinburgh, National Gallery

Glasgow, Hunterian Museum and University Art Collections

Ipswich, Ipswich Museums and Art Galleries

London
 British Museum
 Courtauld Institute of Art Library
 National Gallery
 Tate Gallery
 Victoria and Albert Museum

Manchester, Whitworth Art Gallery

Rotterdam, Museum Boysmans-van Beuningen

Vienna, Graphische Sammlung Albertina

United States

Cambridge, Fogg Art Museum, Harvard University

Chicago, The Art Institute of Chicago

Cleveland, Cleveland Museum of Art

Detroit, Detroit Art Institute

Middletown (CT), Davison Art Center

Minneapolis, Minneapolis Institute of Arts

New Haven
 Yale Center for British Art
 Yale University Library

New York
 Metropolitan Museum of Art
 Pierpont Morgan Library

Philadelphia, Philadelphia Museum of Art

Providence Museum of Art, Rhode Island School of Design

San Marino, Henry E. Huntington Library and Art Gallery

Toledo, Toledo Museum of Art

Washington, D.C., National Gallery of Art

CHAPTER 10

Nineteenth-Century Art

In the eighteenth century, the modern age had dawned upon Europe. It witnessed the phenomenal development of man's intellectual capacities, as well as the discovery of his limitations. It was an age of idealism and confidence, cynicism and pessimism, rationalism and deep emotionalism. The cultural and intellectual climate of the age of Enlightenment induced violent changes in politics and the arts by setting ideas into motion that were ultimately to transform the geography, political structure, and culture of Europe.

The mounting discontent in America and France with existing systems of government during the eighteenth century led to America's war of independence from Great Britain between 1775 and 1778, establishing a democratic form of government that had been articulated as the ideal of Rousseau's *Social Contract*. A kindred spirit of democracy pitted the middle classes and workers of France against the monarchy in 1789, which was brought down, if only temporarily, with the execution of Louis XVI in 1793. In the name of liberty, equality, and fraternity, the eighteenth century saw the partial realization of the avowed ideals of the age—life, liberty, and the pursuit of happiness.

The nineteenth century bore the inevitable consequences of the idealism and rationalism that characterized the preceding century. Largely through the scientific method born of the Renaissance and furthered by the Enlightenment, this era began to uncover the natural phenomena that underlay the workings of the world. Between 1800 and 1900, ideas emerged that fundamentally altered man's view of the world and his relationship to it. Charles Darwin's *Origin of the Species* appeared in 1859 and radically transformed the face of human history, which became one step further removed from God and was placed on equal footing with the animal world out of which it evolved. In 1858, Sir Richard Burton, in tracing the origin of the Nile, found Lake Tanganyika, and, in 1862 Louis Pasteur's experiments with bacteria led to the discovery of the

causes of many infectious diseases. As the scientific method forged ahead—through analysis, research, and questioning—exploring natural phenomena, man's affinity to God became ever weaker.

Technological advances, the stepchildren of the scientific method, transformed human life and its environment. The Industrial Revolution was to dawn on England by 1770, making it the world's most industrialized nation by 1815. Its factories produced goods uniformly and efficiently, and those were then transported by the new rail systems and steamship lines. By 1870, the European continent had also been industrialized, and the northeastern United States had its share of manufacturing centers.

The advent of the industrial age produced many benefits, including an improved standard of living for greater numbers and linkage between formerly isolated towns, cities, and even countries, which were now connected by tunnels, bridges, and railway systems that were feats of engineering in themselves. However, industrialization also drastically transformed the appearance of towns and villages, which by then had developed into cities and urban centers, with all manner of pollution produced by smoke-belching factories. The natural environment was not merely drastically altered—it had been subjugated to the needs and aspirations of the new age.

The responses of the nineteenth century to the dramatic developments that were unfolding around it are nowhere better reflected than in the art of this period. No other century except perhaps the twentieth witnessed as many different approaches to image making as did the nineteenth century. From the traditional academic painters to the Symbolists, artists created in an atmosphere of relative freedom, sometimes adapting ideas from the past or charting entirely new directions that were to presage the art of the next century. The differences among nineteenth-century artists' technique, imagery, color, and brushwork in painting and surface treatment in sculpture are astounding. During this century and for the first time in the history of art, artists who shared similar attitudes or beliefs would band together, sometimes giving formal names to their causes or movements. (Not all nineteenth-century art movements were organized as such; many have been so classified by later art historians.) In this chapter the reader will find descriptions of each of these movements that are intended to serve as brief synopses and not exhaustive accounts. In fact, given the similarities and cross-influences between some nineteenth-century movements, it would be virtually impossible to identify concerns that were strictly unique to one group or another.

The conditions under which artists created had changed by the nineteenth century. The aristocracy figured less frequently as a powerful force in art patronage, and the church was even less active. The upper and middle classes, by contrast, supported art with a great enthusiasm that was shared by government institutions that were also to patronize art during this period. Academies continued to train artists and sponsor numerous exhibitions, including the

well-attended annual salons in Paris and other, more ambitious displays, such as the Crystal Palace exhibition of 1851 and the International Exhibition in Paris of 1852. A growing concern for public institutions, coupled with an increasing awareness of history, helped establish numerous important museums during this century. Museums of all sorts, ranging from natural history to history to art museums, were founded. At the time of their creation these institutions were quite often indistinct from one another, although the century gradually witnessed the specialization of museums into the various categories we know today.

The public, the French Academy, and artists shared an interest in an art that served no specific purpose other than to represent certain styles and subject matter that were considered important in and of themselves. The notion that art is created for its own sake originated in the nineteenth century and continues to influence our contemporary conceptions about art.

Throughout Western civilization, important needs were met by artworks. Religious beliefs were given concrete form in holy images that were thought capable of performing miracles. Portraits commemorated or celebrated the individual; pictures recounted stories, described nature, or imposed order on an assemblage of objects. These pictures served to delight and instruct. By the nineteenth century, philosophic and aesthetic issues took precedence over utilitarian considerations and art came to be seen much as it is viewed today—as a personal, inspired idea given aesthetic form by a gifted and creative individual who is distinguished by his inventive talents.

Affiliated with the institutions of government, the academies tended to support art that was traditional and, to some minds, conservative. History painting was still the most highly regarded form of art, and its various elements—narrative, composition, skilled draftsmanship, historical authenticity, and a high degree of finish—remained beyond question. The "official" art espoused by the French Academy found its ideal expression in Neoclassicism and academic art of this century.

However, the position of the academy toward art was to be criticized and in some instances ultimately rejected by nineteenth-century artists, who questioned and reconsidered the very premise of art. With the firm conviction that their creativity had intrinsic value and their insights or forms of expression an unassailable validity, artists began to emancipate themselves from the aesthetic standards of the academy. A daring, though not altogether surprising initiative, it shocked and outraged critics, audiences, and academy members alike. It was a significant development, however, for it signified an unprecedented independence of mind among artists and spawned a new cult of artistic genius that found its truest expression in the Romantics. The celebrated artist of this cult was one who relied on inborn talent and personal inspiration, rather than on rational standards or academic training, to create art.

It follows from this that a state of isolation or alienation was not only

inevitable but almost even necessary for the artist to realize his innermost visions. Unlike the eighteenth-century artist, who functioned in many ways like a small entrepreneur and adapted his art to his client's wishes and needs, the nineteenth-century artist was a lonely visionary subject to the vicissitudes of the Muses and disdainful of the demands of the marketplace. This century saw a parting of the ways of artists and patrons. Although some artists still anticipated the needs of the market and tailored their work to meet them, others chose to heed only the voices of their innermost souls. The artist, not the client, determined the subject matter, material, scale, color, and techniques in accordance with what was required to represent his personal vision. As artists determined for themselves what was artistically relevant, they developed new subjects and new interpretations of traditional themes.

If one could identify one subject among all others that preoccupied nineteenth-century artists, it would be the landscape. In an age that had witnessed the transformation of nature by technology and its machinery, the image of nature assumed a significance that was unmatched by any other period of art. Landscape scenery evoked notions of an unspoiled environment in the midst of an urban milieu; it suggested the passage of time and hence a sense of history; it posed considerable challenges to artists who sought to record the nuances and effects of light and atmosphere. But, most importantly, it became a vehicle for expressing a profound need for spiritualism that went unfulfilled in an age that had forsaken religion for scientific rationalism and skepticism. Few other periods used landscape imagery so effectively as a means to affirm man's inexorable bond with, and separation from, the infinite and universal presence of nature. Nor was there another subject that permitted the artist so easily to impose himself on it and lose himself in it at the same time.

The history of art is full of ironies and, as other chapters in this book point out, the making of art is fraught with paradoxes as well. The relationship of the nineteenth century to landscape imagery is a fascinating example of the paradox, for it both affirmed the Renaissance ideal of the celebrated individual artist who was unique in his creative spirit and prized above all others the one subject in art in which the artist's identity could best be submerged. When we view a nineteenth-century landscape, we admire nature's work as much as we do the artist's, and the genius of this century is that we do not know, nor is it really important, where one leaves off and the other begins.

PAINTING

NEOCLASSICISM

The nineteenth century was a period of change and continuation. Much of the subject matter and ephemeral style of the previous century, characterized by its delicate, sometimes erotic, and playful imagery, gradually lost ground, in part

due to the growing current of classicism mentioned in the previous chapter under French history painting. In France, the revival of classicism survived the Revolution, and its expression was associated with official art, the French Academy, and history painting.

Nearly fifty years earlier, the theorist La Font de Saint-Yenne had stated that history painting should represent "the virtuous and heroic actions of great men, exemplars of humanity, generosity, grandeur, courage, disdain for danger and even . . . life itself, . . . passionate zeal for the honor and safety of the country."* Between 1800 and 1850, La Font's principles still affected the content and manner of painting.

The neoclassical view was based on the firm belief that paintings were effective conveyors of ideas and could influence their audience. The art it produced appealed not only to the emotions but also to reason, whose purpose it was to harness emotion. The neoclassical credo flourished outside France as well. Because neoclassicism was considered a rejection of traditional French styles and influences, its attitudes were embraced wholeheartedly by countries that had experienced a rebirth of nationalism and patriotism in the wake of Napoleon's siege of Europe. Germany, Switzerland, Italy, and England spawned their own versions of the movement that is now commonly called neoclassicism. In England, it was linked with the development of scientific societies. For example, the Lunar Society, which performed scientific experiments, was established, and Joseph Wright of Derby, one of the famed English painters of the neoclassical manner, belonged to this society and depicted some of its experiments in his painting. In Germany, the theoretician Johann Georg Sulzer proclaimed that good history painting should evoke a salutory response in the viewer by awakening in him a sense of morality.

Regardless of their national origins, neoclassicists shared common goals and strove to create an art that epitomized clarity, dignity, and grandeur. They sought to express an immutable truth that could not be compromised. To some, this search for truth is attributable to the disdain and repulsion with which neoclassicists regarded the cynical, flippant, shallow, and amoral art of the past. Rejecting the studied casualness and frivolity of eighteenth-century art, they strove to endow art with a deliberate, rigid, and determined purpose and structure. Relying on their intellect and reason, they examined nature and history in an attempt to discern eternal principles and timeless truths. Their interests lay with universal concepts, and their attitude was one of uncompromising idealism.

For these artists, ancient literature and art served as worthy sources for the subject matter of neoclassical painting. Roman history, not its empire but its Republican age, was heralded as a golden age of virtue. Themes of self-sacrifice

*Hugh Honour, *Neo-Classicism* (Harmondsworth, England: Penguin Books, 1968), p. 44.

and death were common—Andromache mourning Hector, Socrates imbibing hemlock, the sisters of Horatii mourning their dead loves, and General Wolfe, Lord Chatham, and Marat expiring. The notion that death was final but not horrible, that it was the logical conclusion to a morally correct, if turbulent, life gained currency in neoclassical painting. Also, the concept of immortality one gains by inhabiting the memories of the living, rather than through some form of eternal afterlife, took root, manifesting itself in a number of paintings in which funeral scenes concentrate on the mourners, those left behind to grieve over and cherish the memory of the deceased.

The neoclassicists adopted as their artistic models the masters of the Renaissance, notably Raphael and his circle. The neoclassical style can be characterized by its simplification of line, color, and space and purification of content and form. Solidity, clarity, dignity, and permanence (the universal qualities) replaced the ephemeral, subtle, and often ambiguous art of the eighteenth century, which spoke to the viewer indirectly through nuance and implication. Neoclassical art, instead of appealing to the whim of the imagination or the subconscious, sought to stir the viewer's conscience, rouse his sense of duty, and inspire in him morality, dignity, and virtue.

Although history, especially Roman history, remained the principal subject matter of neoclassical art, a number of these artists painted portraits and landscapes as well. The inclusion of portrait, landscape, and even an occasional genre subject into the neoclassical repertoire did not, however, challenge the supremacy of historical themes, which still remained the most highly prized and priced. Rather, landscape subjects were oriented to the same goals as history painting, even if they served only as backgrounds to a scene with a moralizing theme. Painters in the neoclassical style were encouraged to depict only the most beautiful elements of nature, for these alone could transport the viewer to the peaceful and perfect realm of ideas or evoke the awe-inspiring sense of the power and greatness of creation. Especially in the hands of the German neoclassical painters, the landscape assumed a heroic, often epic quality. Many painters modeled their work after seventeenth-century landscape painting, which was used as a handy formula for weaker artists and as a standard for better artists.

ACADEMIC ART

The distinction between what we now call academic and neoclassical art is somewhat artificial. Both were usually associated with official patronage in their respective countries, and both followed the general precepts of the academy, producing art according to its standards. France, which was the center for so much of the artistic development of the nineteenth century, maintained a powerful academy that was active throughout the century.

Each year, the French Academy sponsored a competition and then awarded

prizes, including the coveted Grand Prix de Rome, which usually guaranteed its recipient fame and fortune, as well as a trip to Rome to study the great masters. The salons exhibited works submitted by the competitors and attracted great crowds that included wealthy members of the bourgeoisie, who were eventually to comprise a steady clientele for many salon painters.

Salon painting was not easy. Artists devoted much effort and time to create their images, researching diligently through history books and literature to lend the proper, historically authentic setting and detail to their images. Their technique was painstaking, requiring many slow, deliberate applications of paint to achieve the proper finish expected of a good salon painting.

Carefully crafted and deliberately executed, these products of rigorous academic training are testimony to the success and failure of the academic system. What the academy regarded as standard practice, we now sometimes view as rigid and oppressive, perhaps even unimaginative. What the salon visitor regarded as elevated, we now regard as popular, for the art of the salon catered to the tastes and interests of a broad spectrum of nineteenth-century society.

What kinds of subjects appealed to this society? Of course, history painting, the primary subject of neoclassical art, was preeminent in academic art as well. Jean Léon Gérome's *Pollice Verso* (Plate 9) is a fine example of the interest in Roman history, depicted with archaeological accuracy, attention to detail, and fascination with a dramatic moment. Other popular subjects included events from national history, military exploits, and scientific discoveries. In 1817, the French salon established the new category of historical landscape, which fused landscape in the heroic tradition with history painting, resulting in a hybrid form that reaffirmed both the supremacy of history painting and the conservative nature of the academy. Historical landscape became a legitimate category of painting that qualified for competition for the Grand Prix de Rome.

Fully aware of the nature and interests of their clientele, painters produced portraits in great numbers, as well as paintings of many other subjects, which were also treated by the Romantics (see the following section for a detailed discussion). These included themes of power, corruption, wealth, venality, sexuality, and love, all of which captured the imagination of salon-goers. When erotic images became too explicit—something that happened easily because artists had the skill and training to render every detail convincingly—the academy would reject a painting for being overly sensual. Academic nudes, in their various guises, deal with sensuality in a manner that often seems coy and hypocritical compared to the more lighthearted and honest treatment of erotic themes of the previous century. On this and other points, nineteenth-century academic art is criticized by scholars for its shallowness and jaded attitudes.

Yet within the academic tradition, new and original subjects were developed that permit a fascinating glimpse into the nineteenth-century world. The creators of these new subjects were called Orientalists, a name derived from the expanding frontiers of politics and art during this period. By the 1880s, French

activity in the Middle East began to lure painters. Some artists traveled in an official capacity and recorded the ongoing military battles in the area; others struck out independently out of an attraction to the exotic world of Egypt, Morocco, Turkey, Algeria, Spain, Greece, and Ethiopia. Many artists collected the paraphernalia, costumes, carpets, swords, and metalwork produced in these regions, whose fascinating and colorful life were recorded in many paintings. Scenes of Oriental bazaars, slave markets, curiously dressed inhabitants, and tropical vistas appealed to the prevailing tastes for sensual exotica and adventure and found ready acceptance among many French artists' clientele. Thus, although some paintings produced by the academic system are superficial, others are beautifully painted and remarkable historical documents.

Because academic painters tended to accept the academy's hierarchy of values, scenes from everyday life were not generally considered worthy of artists' efforts. However, art that dealt with life and death in its grandest, most dramatic terms was created, as images surrounding the rites of death abounded. In countless scenes of burial and mourning, the nineteenth-century fascination with death and the mystery it represented was explored. Regarded as another form of exotica, as another journey into the unknown, death as a subject of art was treated in many maudlin, overly dramatic, and sentimental paintings of nineteenth-century academic artists.

ROMANTICISM

The academy and official art were powerful forces in shaping the art of the nineteenth century. Rationality and a belief in the intrinsic order of the universe and perfectability of humanity underlay much of the art created under the aegis of the academy. The aesthetic standards espoused by the academy were perceived as limits, however, by a movement that we now call Romanticism. Seeking to transcend the limitations of official art, the Romantics turned to their own imagination, feelings, and innermost souls to create an art form unique for its extreme subjectivity. The emotions expressed by Romantic artists were intense and complicated. The German writer E. T. A. Hoffmann described Beethoven as a pure Romantic, for his music set in motion the lever of fear, awe, horror, and suffering, awakening that infinite longing that is the essence of Romanticism.

The American Romantic artist Washington Allston said: "Trust your own genius, listen to the voice within you, and sooner or later she will make herself understood not only to you, but she will enable you to translate her language to the world, and this it is which forms the only real merit of any work of art."[*] From this passage it becomes evident that, under the influence of Romanticism, the very concept of the artist had changed. In fact, it is the Romantic

*Hugh Honour, *Romanticism* (New York: Harper & Row, 1976), p. 16.

notion of the artist as a temperamental, often rebellious, and ultimately alie-nated individual to which we today are still heir.

Placing highest value on individuality, spontaneity, and the inviolability of the inner voice of artistic genius, the Romantics resisted any regulation, sys-tem, or program such as those imposed by the academy as being antithetical to the very purpose and creation of art. The Romantic artist did not enter the profession in order to acquire or practice skills as a tradesman, but rather to fulfill a private, spiritual need. In rejecting the academy and official patronage, the Romantics displayed their contempt for the popular appeal and commercial successes of academic art, which in fact did cater to the tastes of its middle-class patrons. Recoiling from an art thus debased, the Romantic artist withdrew from worldly success and endured financial hardship in order to avoid compromising his artistic integrity. Gradually the concept was born of the lonely and impover-ished artist who, having often rebelled against a conservative family and tho-roughly rejected regulation by official institutions of art, fell victim to aliena-tion and suffering as a result of his superior sensibilities and the demonic forces of creativity within him.

The artist's alienation from society led to a rift between art and the public. The art produced by the Romantics was intended for the select few who could understand and appreciate it, and so the appeal and accessibility of art began to be limited to an elite. This turn of events is ironic, for, at the same time elitism in the arts was developing, the nineteenth century saw the establishment of innumerable museums that attempted to make art available to the general public. Also, because artists were now principally concerned with issues of style and purpose and heeded only their inner voices (to the virtual neglect of their audience), a different concept about the fundamental nature of art gained widespread currency. The notion that art existed for its own sake was one that originated in the nineteenth century, largely at the instigation of the Roman-tics, and still forms the basis for our contemporary understanding of art.

As the idea took root that individual creativity and genius were the essential forces in the creation of art, a new cult of genius contributed to a sudden popularity and proliferation of artists' biographies in Germany, Italy, and France. The early masters—Titian, Michelangelo, Raphael, and Guercino—became the stuff of biography and legend that emphasized their talent, inspira-tion, and romantic attachments. Gradually, then, the eighteenth-century ideal of the artist—that urbane, witty, poised, and cultivated member of society—gave way to a new model. Rough, uncultivated, isolated, misunderstood, and tortured by greatness, the nineteenth-century artist was a creature of genius and superior sensibilities who fulfilled his destiny best by dying young. The seven-teenth-century Italian poet Torquato Tasso and Don Quixote, hero of Cer-vantes' legendary novel, became quintessential models of the Romantic artist, and their stories were endlessly recounted in many Romantic images.

Because the Romantic artist relied primarily on inspiration and the internal

voice of genius, failure was accepted as a natural outcome of any genuine artistic endeavor. In fact, without an occasional disaster, no artist was considered authentic in the sense that he relied solely on inspiration. In this respect, the nineteenth-century Romantic attitude echoed one that prevailed in sixteenth-century Italy, when the failed experiments of some artists ended many a career in midstream, resulting in desperation and, sometimes, suicide.

At the core of Romanticism was an art that spoke from the depth of emotion. The Romantics felt that art consisted of one spirit speaking to another, and that the form such communication took was not as essential as the spirit itself. In this sense, Romantic art appealed to universal qualities and also gave rise to the concept of a single work embodying all forms of art—music, poetry, painting, and drama. Given the German label *Gesamtkunstwerk*, this notion gained credence throughout Europe and found its most satisfactory expression in opera, which used music, drama, stage and costume design, and poetry in one magnificent, often irrational, whole.

Romantic artists treated many of the themes that had been the subject matter of other artists, including history and landscape. They explored battle scenes as a part of history painting in their own unique style, depicting not the forces of good against evil, as traditional history painting would have had it, but rather emphasizing the exotic by incorporating such unusual characters as bandits or outlaws into these scenes. Other topics more specifically attuned to the inclinations of Romantics were explored, notably the phenomenon of madness, which was perceived to be intimately related to genius. Among nineteenth-century Romantics there was a near obsession with madness and the insane, as images of mental wards, their patients, and artists tormented by demons proliferated. In literature, the theme of madness also occurred, for example, in the stories of E. T. A. Hoffmann.

Death, a subject that had long preoccupied neoclassical and academic art, was a matter of curious obsession for the nineteenth century as a whole. To some, death was envisioned as the gentle brother of sleep; to others it represented a terrifying passage into the unknown. Many Romantic artists saw in death desolation, isolation, grief, and despair and depicted it with ambiguity, foreshadowing only the abyss that awaited the living. Death and love were frequently commingled as themes of Romantic art, in which images of death brought on by love were common. In a sense, all Romantic images of love were tinged with the suggestion of death, however subtle or explicit.

Notwithstanding the importance of these various themes in Romantic art, it was the landscape that gave Romanticism its most eloquent and profound vehicle for expressing the subjectivity and emotion that were at the core of this movement. Romantic artists understood instinctively the power of nature to inspire awe, terror, and emotional intensity almost beyond description. This awe and fear are graphically demonstrated in J. M. W. Turner's *Burning of the Houses of Parliament*, 1834 (Plate 10), in which the forces of nature destroy

manmade constructs. The grandeur, power, and overwhelming presence of nature were exploited for their associative powers: A violent storm induced feelings of awe, a sunset or rainbow aroused a sense of reverence, and an infinite horizon awakened profound longing. Through landscape images, the Romantics expressed man's condition as one that was finite in time and space, yet capable of contemplating the infinite. Landscape images effectively conveyed this dualism by depicting isolated figures dwarfed by their surroundings and lost in contemplation of the landscape. German and English landscape paintings of this period epitomize the ability of Romantic art to evoke the sense of isolation, melancholy, wonder, innocence, and purity of spirit to which Romanticism aspired.

Through nature, the Romantics were able to express a spirituality that in earlier centuries was expressed in religious images of conversion or ecstasy. The need the Romantics felt to express spirituality can best be understood in the context of general, historical trends. The current of rationalism, born of the Renaissance and propelled further by the Enlightenment, produced skepticism toward religion that reduced the role of the Almighty "to the part of a constitutional monarch who is kept in existence for reasons of decorum, but without real necessity and without influence on the course of affairs."*

This same rationalistic current, however, spawned a spiritual fervor and yearning for the blessed condition that only faith could provide. The massive revival of churches in the nineteenth century is one indication of the spiritual starvation of this period; similarly, the significance of nature and landscape, at least in the art of this century, points to the same phenomenon. Nature became the reaffirmation of man's place in the scheme of things, in a world that had order and profound meaning and was touched by the hand of God. In the words of Philip Otto Runge, "Everything harmonizes in one great chord: then my soul rejoices and soars in the immeasurable space around me. There is no high, no low, no time, no beginning, no end. I hear and feel the living breath of God who holds and supports the world, in whom everything lives and acts."†

For American artists, the divinity of nature was most profoundly expressed in scenes of the wilderness, virgin forests, and waters of the American West. Their European counterparts depicted landscape scenery that often featured Gothic structures or ruins. To the Romantics, Gothic architecture was a manifestation of Divine power and grace, and its structures were considered ideal for inclusion in landscape views because of their ability to inspire other, largely spiritual associations. Ruins were integrated into landscape scenes as emblems of both the transience and permanence of human existence.

The revival of interest in religion and spirituality accounts in part for the Romantics' obsession with the past. In the brief discussion that follows, two

*Arthur Koestler, *The Sleepwalkers* (New York, 1959), p. 509.
†Hugh Honour, *Romanticism*, p. 73.

movements, both religious in inspiration, shed considerable light on the extent to which Romanticism owed its origins to religion and revivalism. In a sense, all of the nineteenth century may be said to be a series of revivals of various ages. The Gothic and Rococco revivals lasted between roughly 1835 and 1840, classicism was embraced anew in the 1860s, and a new taste for the Baroque revived seventeenth-century styles between 1880 and 1890.

More than any other movement, Romanticism fundamentally changed the artist's conception of himself, his role in society, and the purpose and appearance of his art. Without the radical changes wrought by artists we now call the Romantics, many other developments that were to take place in the nineteenth century would not have evolved, nor could we today lay claim to many of our notions about art and artists that are the legacy of Romanticism.

The Nazarenes

One of the earliest manifestations of landscape art as an expression of religious fervor, as a metaphor for Divine order, was the work of the Nazarenes. A group of German and Austrian artists active in Rome banded together in 1809 to form the Brotherhood of St. Luke, after the medieval Academy of St. Luke. Founded by Franz Pforr and Johann Friedrich Overbeck, the group was later joined by Peter Cornelius and Julius Schnorr von Carolsfeld (see list of artists at end of chapter). They lived in a deserted monastery in Rome and tried to emulate the life and work of purity and serenity that they felt characterized medieval artist-monks.

The Pre-Raphaelites

In 1848, the Pre-Raphaelite brotherhood was founded in London by the painters William Holman Hunt, Dante Gabriel Rossetti, John Everett Millais, William Michael Rossetti, F. G. Stephens, James Collinson, and the sculptor Thomas Woolner. These artists were united in their admiration for Italian painters from before the time of Raphael, especially Perugino, whose work epitomized the innocence, purity, and spirituality to which the Pre-Raphaelites aspired in their art.

Such purity expressed itself in a style that delineated each form with care and deliberation. The technique of late medieval artists was to articulate everything as though seen through a magnifying glass, because to these artists, each element, however minor, was touched by the hand of God and therefore equally important. In technique and inspiration, the Pre-Raphaelites emulated their late medieval predecessors: Every element in an image was seen to have potential symbolism and meanings, and Pre-Raphaelite paintings are often layered with meanings and associations with stories that form the context for images.

The paintings of the Pre-Raphaelites told many kinds of stories, including

ones that were religious in content, such as the life of the Virgin, the childhood of Christ, and other themes in keeping with the spiritual aims of the movement. The purity and helplessness of children and the innocence of early adolescence were often portrayed.

Medieval romances and tales of knights and heroes also provided sources for Pre-Raphaelite paintings. These appealed particularly to the nineteenth-century nobility, who were pleased by images that associated them with the past glories of chivalry and pageantry and commissioned such paintings enthusiastically. Stories of love, often based on medieval romances, were depicted and stressed the sentiment of love, rather than the physical passion. To Pre-Raphaelites, love was an eternal idea that was transcendent and approximated the Divine in its finest form. In fact, unrequited love was regarded as the ideal, for it remained untainted by the satisfaction of more base human passions.

Other themes taken up by Pre-Raphaelite paintings included the fallen woman, lost honor, and the outcasts of society. In part celebrating strict social values and in part criticizing them, the Pre-Raphaelites depicted both faces of a society that imposed its values successfully, that is to say, also severely, thus stifling natural behavior and restricting the acceptable outlets for human emotions. Paintings of the fallen, be these women or the pariahs of society, were characterized by an intense outpouring of emotion that might perhaps not have found expression elsewhere than in painting.

The Pre-Raphaelites emerged in an environment that witnessed countless revivals of the past. The phenomenon of their emergence as a group also demonstrates a dualism that characterizes so much of nineteenth-century art. By holding fast to a rigid ideal, artists articulated the discrepancy between their own reality and the ideal. In holding up an ideal of woman, for example, as chaste, passive, and pliable, they also mirrored opposite, more base sentiments that were suggested in some paintings, which were, in fact, often remarkably sensual.

The actual brotherhood of the Pre-Raphaelites remained rather small, but its influence made itself felt on a wide range of painters, if only for short periods of time. By 1863, the movement was, for all intents and purposes, defunct. The brotherhood had dissolved in 1853, and the artists who were momentarily inspired by its existence developed in various other artistic directions.

REALISM AND NATURALISM

If the nineteenth century can be characterized as a period in which artists explored numerous directions in art, then it was inevitable that some would attempt to translate nature as straightforwardly as they saw it into their paintings and drawings. Scholars have given these artists many different names and grouped them according to their associations, but no matter how they are now classified, they all shared a fundamental concern with the phenomenon of reality and its representation untainted by theoretical or emotional bias.

Nineteenth-century artists had, for the first time, several standards against which to measure their reality. Many looked to seventeeth-century Dutch painting, whose genre scenes, landscapes, and town views were, to nineteenth-century minds, dispassionately, albeit sympathetically, recorded. But another standard was soon provided by the recently invented camera. Between 1830 and 1840, the first photographs began to offer artists an unprejudiced record of nature that was produced by a mechanical eye and that objectively translated everything in its view onto film. The photograph was instantly regarded by all to be important—as a tool, guide, challenge, or new material—but its effect was greatest on those artists who were principally preoccupied with questions of reality and its painterly representation. Two schools of painting reflect the concerns of naturalism.

The Barbizon School

The Barbizon school was formed about 1830 by a group of painters working in and around the forest of Fontainebleau near Barbizon, France. In an unusual departure from traditional painting method, according to which only drawings or quick sketches were made out of doors, these artists brought their easels and supplies right into the landscape they were to paint. They were interested primarily in the effects of light and the atmosphere. Some, notably Camille Jean Baptiste Corot, saw in nature tranquility and stability, an approximation of Arcadian perfection. But no matter what their individual slant (and most were inevitably subjective to a degree), they did attempt to record images of nature in their essential yet specific characteristics.

Realism

Later in the century, the tendency expressed by Barbizon school painters in France was to manifest itself after 1848 in a group of painters called the Realists, who were most closely associated with Gustave Courbet. This new school of Realism attempted to look at nature and society at all levels dispassionately, or often with a critical eye. A number of social critics emerged from this group.

The Biedermeier School

In Germany and Scandinavia, the counterpart to the French Realist movement was the so-called Biedermeier school, whose goal was the straightforward depiction of nature and whose belief lay in the "greatness of small things." These artists saw nature as a gentle, serene, and harmonious presence. At best, Biedermeier school paintings are pleasing and, at worst, quite dull. Genre painting, the depiction of everyday life, was ideal subject matter for this school,

which produced numerous pictures, often with a moralizing tone, of middle-class life.

The Hudson River School

The Hudson River school developed in America roughly between 1825 and 1875. It consisted principally of landscape painters who created images with the firm conviction that America's landscape was its greatest single asset, its strength and the source of its future. They saw nature as a display of God's creation in its fullest, most universal and elemental terms. Like their Romantic counterparts in Germany and England, painters of this school often used landscape to inspire a religious or moral feeling. Some paintings featured biblical subjects and titles, such as *Expulsion from the Garden of Eden*. Others merely used such devices as a deep vista, a dead tree stump, or images of powerful natural phenomena such as waterfalls or mountains to imply the cycles of time, the powers of creation, the splendor of nature, and the Divine. Much of the work of these painters was done along the Hudson River in New York State, as well as in New England. Some artists traveled west, attracted by the grandiose panoramas the West offered.

Luminism

After about 1850, a group of American painters explored the effects of light in landscape in such a way that scholars have now come to call their approach Luminism. Though not a formally organized group, the Luminists shared a tendency to infuse their rather broad vistas with a glowing light. The fusion of light with atmosphere gave these images a calm, restful, and almost crystalline purity. Painted at various times of the day, the Luminist view of nature was expansive, with horizon lines sometimes clearly defined by the juncture of water and air and stretching endlessly into the distance. Martin Johnson Heade's *The Coming Storm* (Plate 11) beautifully balances the natural configurations and compositional structure in such a way that both complement and enhance one another. These artists imposed their views on nature in a sympathetic, circumspect, and quietly poetic manner that recalls in some ways seventeenth-century Dutch landscape painting, which was similar for its lack of theoretical premeditation. Like the Dutch, the Luminists struck a subtle balance between art and nature, never imposing themselves too strongly onto the image.

American Naturalism and Illustration

The American continent, with its diverse landscapes and population, its varied flora and fauna, soon attracted a large number of artists who supported them-

selves by making illustrations of the natural surroundings and matters of public interest. These artists painted, drew, engraved, or made lithographs of American life and, along with the painters of American landscape, produced the most thoroughly American art of the nineteenth century. The work of these illustrators often consisted of hastily painted sketches or rapidly executed watercolors and drawings, some of which were later translated through painstaking graphic processes into illustrations for such magazines as *Harper's Weekly*.

American Genre Painting

Just as the Realists in Europe, in particular France, turned to daily life as a subject for painting in the firm belief that it was the noblest subject matter of art, so in America, between 1830 and 1840, certain painters rendered scenes of the mundane activities of farm and frontier life. Scenes of horse trading, fur traders, fishing, politicking, music, dancing, and the life and exploits of pioneers and explorers were recorded with dignity and simplicity. These images supply us with firsthand knowledge of nineteenth-century American history.

The American Barbizon School

Active from roughly 1847 to the 1890s, the American Barbizon painters were influenced by their French counterparts and also demonstrated an interest in the rich imagery of quiescent, bucolic landscapes and the tranquil agrarian life of rural America. They worked with generalized rather than specific forms and conveyed a certain mood and poetry in their paintings. Some artists worked in this mode through the 1920s.

PAINTERS OF CONTEMPORARY SOCIETY (THE SCHOOL OF INCIDENT)

Throughout the nineteenth and into the twentieth century, art patrons in Europe and particularly England actively supported painting that depicted contemporary life, more specifically middle-class or the more fashionable upper-class society. The taste for such paintings had its origins in the previous century and continued to develop through this period, in which art that reflected the affluence, comforts, and leisurely pastimes of the wealthy found a loyal following among the well-to-do. A number of gifted painters from Europe and America made their livelihood satisfying the demand for this type of art among upper-class patrons, who, for the most part, did not inhibit artists' freedom of expression or hamper their personal development. Although these so-called painters of contemporary society have received less attention by scholars and critics than other, less conventional artists of the nineteenth century, the recent past has seen a revival of interest in the achievements of this group, which have

been reevaluated and now are considered to be, in some instances, major.

Of all the types of painting created by the artists of contemporary society, portraits were the most often commissioned. Whether noble of birth or entrepreneurial, the patrons of this art sought portraits of themselves that flattered, dignified, and enhanced their best features while underplaying those considered less appealing to their tastes. A difficult lot to please, these rather demanding sitters were often exasperating, as evidenced by the now famous comment by John Singer Sargent, one of the most notable portrait painters of the day: Sargent defined the portrait as a painting in which something was always wrong with the mouth.

Notwithstanding the travails these painters must have undergone in order to please their sitters, the then fashionable large or life-size portraits were produced in great numbers, for their majestic proportions made them ideal accents for the sumptuous settings of the equally majestic mansions they inhabited. Working directly before their subjects, these portrait painters were observant and skilled as well as enormously talented in rendering skin textures, brocades, satins, and the trappings of a life of leisure.

Although portraits were the mainstay of society painters, other scenes of contemporary life were rendered: images of people strolling along boulevards, amusing themselves at the beach or theater, or relaxing in their finely appointed homes. What distinguished society painters to some extent was their superb ability to paint in the tradition of seventeenth- and eighteenth-century Dutch and French painting. Exacting, highly polished, and often idealized, the paintings of society artists were facile, sometimes sentimental, and highly accurate in the rendering of detail. Because they tended to cater to their patrons' aspirations to fashionability, gentility, and propriety, society painters are criticized for going to great lengths to please their patrons, somewhat at the expense of their own artistic independence. However, as past prejudices against "conventional" painting lessen, contemporary viewers will admire these painters for their brilliant and vivacious handling of paint and ability to capture the spirit of their time.

IMPRESSIONISM

Truth to nature, the preoccupation of the Barbizon school, was also the motivating force behind the most famous of all nineteenth-century art movements, Impressionism. The naturalistic representation of reality—without idealization, manipulation, or subjective bias—was then regarded as revolutionary in art, and certainly it was by the standards of academic art and history painting.

The avowed purpose of the Impressionists was to study the effects of light on surfaces. As a result, these artists depicted subjects that lent themselves to the dispassionate observation of light: the occasional still-life, many portraits, family scenes, and, above all, landscape. The Impressionist concern with the

rendering of light necessitated a departure from the normal practice of studio painting and led to painting out of doors, directly in front of the subject at hand. Seated on river banks or knolls, in gardens or cities, the Impressionists developed through keen observation a profound sensitivity to light, atmosphere, and its effects on color and the appearance of things. The scintillating patterns of light on water, the dappled effects of light filtering through trees, the tinted vapors of early morning or evening—all of these natural phenomena were to absorb the Impressionists completely. Claude Monet's *The River* (Plate 12) is an early example of the Impressionists' preoccupation with natural effects.

Because what they observed was in a constant state of flux, these painters worked fairly rapidly, often on a series of paintings, but considered and executed each brush stroke carefully in order to approximate that which was seen most faithfully on the painted surface. Detail, finish, and the imposition of an overarching rational order were often neglected, for the eye focused during the painting process only on that which was seen.

The working methods of the Impressionists were not revolutionary, for artists had made oil sketches since the late sixteenth century. As far as we know, drawings were made out of doors as early as the late seventeenth century, and by the eighteenth century, artists made watercolors and gouaches in the open air. Oil sketches made on site were even common during the nineteenth century, but they differed from the work of the Impressionists in one vital respect: Most artists' sketches remained only notes and references to be used for a final work that was finished in the studio, and, as such most of these oil sketches were never exhibited. Thus, in the very goals they set for painting, the Impressionists differed fundamentally in that they sought simply, by dint of astute observation and skilled strokes of the brush, to capture the properties of light and objects at a specific time in a given surrounding. By recording the subtle changes of light that take place in a landscape over a period of hours, the Impressionists allowed the viewer to become aware of natural phenomena, such as naturally evolving gradations of light and color, that would otherwise escape one's notice in daily life.

Developing a new language of painting through the direct study of nature, the Impressionists made remarkable achievements in the use of color. The academic color system, which used finite gradations of dark to light, was not adequate to the needs of the Impressionists, who observed that color did not work in such systematic ways in nature. Abandoning all system and responding only to what they saw, the Impressionists would paint a shadow cast by a green tree blue, or a brightly lit spot yellow or red. Thus, the colors rendered in Impressionist paintings are compelling because they are based on visual experience, rather than conceptual learning. Other conventions then prevailing in painting, such as the attempt to create objects in a fictional three-dimensional space, were discarded in favor of authenticity of representation.

The art of the Impressionists was initially met with criticism by a public

that had, by and large, accepted the academic rules of proper painting. These same audiences would acknowledge the beauty of Impressionist painting, being among other things aficionados of the sketch, but could not accept the sketch in place of the "finished work." Nonetheless, the relationship between the Impressionists and the academy was not one of complete alienation. Beginning in 1874 and for several years thereafter, the Impressionists held their own exhibitions in the studio of Gaspard Félix Tournachon Nadar, the photographer, in Paris. In 1863, several Impressionists participated in the Salon des Refusés and, in later years, the salon even accepted some Impressionist artists. Only one academic painter, Jean León Gérôme, was an implacable enemy of the Impressionists; others either supported or at least tolerated them.

After 1886, the year of the last Impressionist exhibition, the movement changed and its artists developed in several different directions. Many of the original Impressionists began increasingly to follow their own private inclinations in painting and explored uncharted territories, sometimes resulting in work that bordered on pure painting that had no subject at all except color. Others, following a latent tendency to intellectualize, codify, and create rules, established their own theories of color and form.

However dispassionately the Impressionists sought to represent reality, their images of sunlit gardens, rainy boulevards, cultivated fields, and rivers and ponds are in fact a celebration of natural beauty such as had never before existed in art. These paintings are an affirmation of life, an optimistic representation of nature and the comforts of domesticity. In this sense, they share with the seventeenth-century Dutch a buoyant spirit that is transcendent and still capable of moving art lovers today.

Neo-Impressionism

The Neo- or Post-Impressionists were theoretical and quasi-scientific in their approach to painting. Responding far more with their minds than with their eyes or creative instincts, these later Impressionists transformed the impulsive, daring methods of their predecessors into systems for paint application, and pointillism, divisionism, and other intellectual painting resulted. Although some of the Neo-Impressionist art rivals other masterpieces in the grand tradition of rational painting, it does not exude the life, air, and human sympathy that characterize the great achievements of Impressionist painting.

SYMBOLISM

If one could imagine a mingling of the intellectual character of Neoclassicism, the emotional emphasis of Romanticism, and the sympathetic yet objective approach of Impressionism to the representation of reality, then one would

have a basis for understanding Symbolism. The Symbolist movement developed in the 1880s as a reaction against the avowedly neutral, nonsubjective approach of the Impressionists to art. In fact, some of the first Symbolists were artists who had once been associated with Impressionism, but who distanced themselves from their origins in search of an art form that permitted the infusion of greater subjectivity and emotion into artistic representations.

The Symbolists, like many other nineteenth-century movements, were a paradoxical group. Their ideals and aims were sometimes mutually exclusive or even contradictory. In 1886, the poet Jean Moréas stated that the purpose of Symbolism was to clothe ideas in a form perceptible to the senses. Although in this respect the Symbolists may be regarded as intellectuals, because their art originated from concepts, the ideas they chose to give form were often not rational but emotional in inspiration. The emotions to which the Symbolists gave expression purported to be universal, yet paradoxically they were grounded only in the individual artist's experience or subconscious.

The Symbolists examined the universal human condition by looking into their own souls, by articulating their own experience as one that could somehow be regarded as universal. Finding within themselves a microcosm of the human condition, these soul-searching artists often confronted despair and pain, weakness instead of strength, and a debased and corrupted state. Generally pessimistic in their outlook, the Symbolists found nothing to support the optimism to which European society as a whole had been heir as a result of scientific rationalism and the Renaissance. In many ways, the gesture of self-examination to which these artists subjected themselves reflected the concerns of society as a whole, which had become by the end of the century tainted by a kind of fatalism.

It should only be logical that the Symbolists used art as a vehicle for self-examination. Their art depicted a state of mind troubled by melancholy, loneliness, and despair. They envisioned the artist not as a hero, but rather as a dreamer who was ineffectual rather than vital and who could be overpowered or even destroyed by his own creative urge. Relationships between human beings were also examined, but served only to reinforce the Symbolists' pessimism. To them, human relationships were characterized by betrayal, mistrust, pain, and suffering.

As one can well imagine, death was a frequent subject of Symbolist painting and was often associated with love and eroticism. Figures from classical antiquity that represented death, the demons, or degenerate eroticism—notably Orpheus, Salome, and the Sphinx—sometimes appeared in Symbolist art. Above all other symbols, however, women occupied a significant place in Symbolist representations. Perhaps inspired by a society that idealized and repressed women at the same time, the Symbolists portrayed women in psychologically disturbing ways. In some paintings, the female embodies lust, temptation, corruption, deception, betrayal—all that was carnal and debased. The

Sphinx, Eve, Salome, Delilah, and the Vampire were prototypes of the woman who captured and destroyed men. In other Symbolist paintings, women embody sensuality, fecundity, and the endless cycle of birth and death. No matter how the female character was interpreted, however, the feature that epitomized women most consistently in Symbolist imagery was their lush, flowing, sweeping masses of hair.

Isolation, the frailty or even futility of human relationships, and illness and misery were other themes that flowed through Symbolist painting. Individuals are shown plagued by uncontrollable circumstances that impair their very existence. In almost all Symbolist imagery, human beings are passive, dominated by forces beyond their control. The only vital force to appear in this art is embodied by woman, who often uses her powers destructively.

Demons, creative muses, and the interrelationship between visual and other art forms—music, poetry, and literature—were also themes of Symbolist art. Religion played a role in this movement as well, which admired the art of the Pre-Raphaelites. In 1892, the Symbolists established the Salon de la Rose et Crois (Salon of the Rose and Cross), which was dedicated to beauty and the ideals of past artistic traditions. In existence for six years, the salon showed numerous exhibitions that attracted thousands of visitors.

In giving expression to their ideas, the Symbolists did not use detailed, illusionistic, or descriptive natural forms. Instead, they reduced shapes and eliminated detail and space, giving their images a quality of flatness. Because their art was subjective and did not adhere to the order implicit in the objective world, the Symbolists depicted their subjects in states of fragmentation or isolation. Thus, one will find disembodied heads, free-floating eyes, plants, or other shapes hovering in empty skies. These images may seem vague and disjointed, but they suggest forms that are somehow familiar, if distantly, to the viewer. By their very nature, these images involve the viewer more actively in the process of giving meaning to art, for they themselves merely suggest elements that the viewer then recognizes and must associate with his or her own experience. In a sense, the Symbolist acts upon the viewer much like the Vampire or Salome: Ensnaring his viewers first by suggestion, he then launches them on an inexorable journey through the psyche, where they may very well be plagued by demons of their own making.

ART NOUVEAU (JUGENDSTIL OR STIL LIBERTY)

The term Art Nouveau pertains primarily to the applied arts, such as jewelry, ceramics, glass making, textiles, wallpaper design, and poster art. Art Nouveau affected painting and sculpture less deeply.

The style traces its origins back to the English revival of arts and crafts in the 1870s and 1880s. Deriving its inspiration from organic forms, such as are embodied by insect, floral, and plant life, Art Nouveau distills asymmetrical,

gracefully curving, and attenuated configurations that emphasize the pattern and linearity of a particular form. A tensile, vital, and curved line is the singlemost distinguishing feature of the Art Nouveau style.

Although styles varied (the British, for example, gave Art Nouveau a more geometric character), many forms were chosen because they implied deeper meanings. Water lillies, peacock feathers, flower buds, trees, swans, and the dragonfly and butterfly were symbols of beauty, energy, the exotic, and the sublime. Women were often symbols of sensuality and eroticism, themes that also underlay other emblems used by Art Nouveau.

The style was promoted and exported by the East India House, later known as Liberty and Company in London, whence the designation of Stil Liberty derives.

DRAWING

Drawing in the nineteenth century covered an incredible range that included many of the traditional subjects. The training of artists in the academies, following the procedure established in the last century, still stressed the skills of draftsmanship; thus, the student artist would execute drawings of other drawings, paintings, casts, and, finally, live models of the human figure. This last category of studies became more numerous during this century, perhaps because more artists took to hiring their own models.

Artists commonly made drawings as composition exercises and preparatory sketches for paintings, sculpture, and prints. Included in these types of drawings were the many portrait, notably head, studies and drawings. Portrait drawings themselves were in great demand and plentiful because they were inexpensive, quickly produced, and portable. From rapidly executed sketches to finished, detailed full-figure portraits, these drawings flourished, reviving such earlier traditions as profile portraiture, and supported numerous artists who specialized in this type of drawing.

Continuing eighteenth-century traditions, drawings depicted the activities of daily life in all its profusion. Markets still existed for drawings of fashionable society at leisure, a subject that some artists still approached with the style and tone of reverence that had been established during the previous century, and others worked in a somewhat less serious mode, injecting humor, satire, and wit into these representations. The Realists and Impressionists broadened the spectrum of subject matter included in this category of drawing to encompass images of society's more lowly citizens—farmers, laborers, and burlesque and carnival dwellers. Daily life was recorded by these artists spontaneously and without regard to traditional formulas, endowing these drawings with a direct-

ness and immediacy lacking in other, more traditional techniques that adhered to habit and system.

The subject that developed the widest appeal and found its most diverse expression in drawings was the landscape. Landscape drawings were made on numerous occasions, frequently related to walking and traveling, which had become internationally popular pastimes by the nineteenth century. The English traveled routinely to the Continent, making the obligatory stops in the Alps, Italy, and other scenic sites. Europeans traveled to Italy, throughout the Middle East, and, if they could, to America; in turn, Americans began to make their pilgrimages to Europe. All of this movement generated an abundance of drawings on paper.

In addition to depicting picturesque or interesting sites, artists drew landscapes as studies for paintings or to record atmospheric conditions in a state of flux. Many such drawings capture a fleeting moment of light or time, evoking a certain universal experience shared by all who have witnessed the transformation of nature by extraordinary forces. Artists drew everything—mountains, streams, lakes, vast panoramas, skies and clouds, architectural views and cityscapes—with ocean and marine themes in general especially popular. Trees held a particular fascination for landscape artists, who made sketches or detailed renderings of all sorts of trees. Some were meant to be specific "portraits" of trees; others were idealized and attempted to express the natural process of growth so clearly and heroically embodied by the tree.

In addition to landscape proper, many artists drew nature studies to record the natural flora and fauna they found on sometimes quite arduous expeditions. Assisting naturalists or becoming naturalists themselves, these artists frequently prepared systematic studies of exotic animals, birds, and plants. These natural forms often found their way into flower or vegetable still-life drawings that were to become cheaper substitutes for paintings.

Other subject matter treated in drawings included wars, historic events, and the exotic life of American Indians or the peoples of the Middle East. Illustrators would record scenes of these subjects in sometimes hastily rendered sketches or finished drawings. In addition to drawings that relied principally on external events or phenomena for inspiration, many artists created fantasy drawings based purely on imagination. The Pre-Raphaelites and Symbolists in particular drew fanciful and deeply personal images that were often disturbing and psychologically penetrating visions.

APPROACHES

Artists traditionally adopted various approaches to drawing and, in the nineteenth century, these often came to be associated with a philosophical orientation. The academic style, for example, emphasized line and the importance of delineating form and was generally associated with neoclassical and academic

art. The Impressionists and Romantics, by contrast, favored the use of a more personal or intuitive approach, using marks to achieve a broader range of stroke and coloristic effect. But artists of all types and affiliations used both approaches to drawing and generally evolved from the linear approach to one that was more personal and colorful. For some artists, drawing was a way to explore initial ideas and was preliminary to works of painting or sculpture. To others, notably Honoré Daumier, Constantin Guys, and Henri de Toulouse-Lautrec, drawing was the primary form of expression.

TECHNIQUES

Most of the techniques used by nineteenth century artists for drawing were traditional. Chalks and pen and ink were common tools, although sepia ink gradually superseded bistre in ink drawings, and silverpoint, an early technique of drawing with a silver stylus, was used on occasion as a substitute for the pen. Charcoal continued to be admired for its deep, grainy richness and ability to render atmospheric effects.

A closely related material, graphite, also became popular because it was like charcoal in that it could be rubbed, yet it was harder and could produce, if needed, a thin, rather brisk, line. Graphite was refined in 1795 by several experimenters (notably Nicolas Conté, and Johann Faber) into the tool we now call a "lead" pencil. In fact, the "lead" was hardened graphite enclosed in wood, and was the prototype of today's most basic writing and drawing tool, the common pencil. Pencil became one of the most popular mediums in the nineteenth century and was used for a wide range of subjects in drawing, including portraits, nudes, compositions and landscapes, and nature studies. A flexible material, pencil could produce a clean contour, fine crosshatching, short or long marks, dark or light ones. It combined some of the best qualities of graphite in a more flexible form. Pencil was especially conducive to the detailed renderings so many nineteenth-century artists loved and allowed the artist to note every blade of grass in a landscape, describe every twig of a tree, or trace every curl and eyelash of a woman's hair and face. Portraitists, illustrators, topographers, travelers, and naturalists used pencil almost exclusively outside the studio. It was clean, lightweight, and easily portable, and the drawings lasted a long time, were correctable, and therefore very practical.

Other mediums in which drawings were rendered are discussed in the following sections.

Pastels

Pastels continued to be an important material for artists, both for drawings that were quick sketches or substitutes for paintings. Pastel drawings were made on a variety of materials, notably linen.

Pastels were an ideal material for the Impressionists because they allowed artists to make pure marks of color that aptly defined the effects of light and atmosphere on people and landscapes. In the hands of the Impressionists, the mundane activities of daily life came alive in drawings that translated images into pure pastel colors, laid one on top of or next to another. With pastels, the artist could achieve both detail and broad sweeps of color simultaneously. Some Impressionists produced their most reductive images, which consisted of pure color, with pastels.

American artists also used pastel and established the Society of American Painters in Pastel in 1882. Although the work of these artists is now scarce, an occasional example of their pastel drawings may be found in museum collections.

Watercolor

Watercolor gained widespread use in the nineteenth century, attracting artists, amateurs, and specialists alike to the medium. Special exhibitions were devoted exclusively to works in watercolor, and special societies were formed. Leading the trend was England, where watercolors had been popular since the eighteenth century and where the first Watercolor Society was established in 1804. America's New York Watercolor Society followed in 1850, to be joined by the French Société d'Aquarellistes Français in 1879.

Watercolor was a challenging medium. Mixing pure colors from a cake or tube with water, and using small brushes on absorbent paper, artists had to be skilled, for once the color soaked into paper, it was permanent. Colors mixed with water could be diluted to near transparency or saturated with pigment to achieve intensity. Using pigments and water often left colors transparent, thus allowing the white of the paper or a color previously laid down to show through. Opacity was achieved by using certain additional pigments, the most common of these being Chinese white.

Watercolors could imitate works in oil in color, size, and subject matter. They could be detailed, finished, and relatively large, or they could be sketch-like, immediate, and spontaneous. In general, the history of watercolor reveals how artists learned to exploit its special properties, thereby distinguishing it from other mediums and making it more and more a thoughtful and spontaneous union of white paper and puddles of color.

The subjects represented in watercolor spanned a whole spectrum of images, from genre scenes and miniatures to fashion and still-life images. Portraits, illustrations, every conceivable subject was executed in watercolor, but the happiest union between this medium and its subject occurred with landscape. Nineteenth-century art witnessed the transformation of the objective, idealized landscape image into one that was suffused with greater subjectivity and that

evoked a direct emotional response from the viewer to nature. Light, reflections in water, mists, and shadows found a beautiful, often exquisite equivalent in watercolor, which allowed for a fruitful union of subject, artist, and material. A medium as personal and immediate as watercolor was therefore ideal for landscape imagery and the effects it sought. It was also a practical medium, for artists could easily wander through a landscape, select a site, set up their materials, and begin the complex and fascinating process of looking at and responding to the scenery. Or, by contrast, artists in their studios could rapidly set down their private, often fanciful visions of landscape using this delicate and personal medium.

Artists recorded scenes from their travels to exotic places and through forests and wilderness in watercolor. London, Paris, Venice, the Italian countryside, the Middle East, the Alps, and medieval ruins were all subjects rendered in this medium. Because they were made rapidly and often on a small scale, watercolors were turned out in the hundreds, resulting in an abundant legacy of these engaging works on paper.

PRINTMAKING

Between 1800 and 1900, printers had access to more and better paper and a whole new range of printing techniques. At the same time, printers found a market that seems to have had an insatiable appetite for printed images. The result was that, during the nineteenth century, more images were printed than had been produced in all the previous centuries combined. Currier and Ives, for example, sold more than 73,000 prints between c. 1838 and 1907.

Graphic illustrations accompanied most newspaper stories. A whole generation of illustrated magazines, supported by eager subscribers, was born in this century: England's *Penny Magazine* was established in 1832, *Punch* in 1841, and the *Illustrated London News* in 1842; elsewhere *L'Illustration* and *Illustrierte Zeitung* appeared on the scene in 1843. America followed Europe's lead with *Harper's Weekly* in 1857.

Illustrated books also abounded, and those dealing with foreign countries were especially popular throughout Europe, sometimes running to many volumes as did Baron Taylor's twenty-volume *Picturesque Views of Ancient France*, which was published between 1820 and 1878 in Paris. Literary classics were commonly accompanied by illustrations, and some artists made very successful careers simply by providing illustrations.

The large numbers of illustrations then available were the result of technical advances that permitted much larger editions to be pulled from a single plate. The relative yields to be expected from various techniques differed greatly, and are cited here to give the reader a sense of the volume of activity that sur-

rounded printmaking during this period. The fragile drypoint yields no more than 150 impressions, whereas the more sturdy woodcut can yield 8,000 to 10,000 impressions, depending on how deeply the grain is cut on the block. Naturally, woodcuts were widely used in the nineteenth century, and the related wood engraving, which employs the end grain of the wood and is therefore commensurately stronger, was also revived.

The introduction of steel facing to copper plates made them much tougher and produced higher yields. Lithography, invented about 1796 by the Bavarian Aloys Senefelder, was a further boon to printmaking. Based on the principle of the antipathy between oil and water, lithography involved the use of greasy ink or crayon drawn on a stone, which was then wetted. Only the greased areas repelled water and picked up the subsequent application of printer's ink. It was a remarkably durable method that allowed one to obtain between 8,000 and 10,000 impressions from one stone.

Photography and related photographic engravings soon put some professional illustrators out of business, because photographs supplied the specific detail and truth to nature that the nineteenth century so admired. Nevertheless, both professional illustrators and artist-printmakers continued to experiment with new techniques and perfect the older methods of printmaking, leaving behind a legacy of rich and diverse prints out of which contemporary museum collections are built.

During this century, printmaking, like drawing, became an increasingly independent medium that exploited the various properties inherent in each technique. The following sections discuss some of the most important printmaking techniques.

Lithography

Although lithography was practiced throughout Europe and the United States, it found its most devoted following in France. Most academic artists there disdained it as a medium inadequate to historical subjects, but other groups such as the Romantics experimented with lithography with fascinating results. The immediacy of the lithograph appealed to the Impressionists, who produced landscapes, interiors, and other images using lithographic methods.

Many of the uses that prints had in the eighteenth century were carried over into this century, which saw a proliferation of subjects in lithograph prints. The fashionable scenes of social life and all kinds of illustrations, ranging from the literary, archaeological, historic, journalistic, and scenic to the picturesque, were produced in this medium. Among the most popular forms of lithography were the caricature and related forms of social commentary that were anything from comical to caustic. The activities of various members of society, depicted in all their frailty and pomposity, were observed with wit and devastating accuracy. Politics, religion, morality, the theater, and social life in general

were scrutinized by artists who then translated their observations into carica-tures or cartoons for such publications as *La Caricature* (which went through 251 issues before being closed by the censors in 1835), *Le Charivari*, *Fliegende Blätter* (established 1843), and *Journal pour Rire.*

In addition to serving as illustrations of various subjects, the lithograph helped spawn and popularize the poster as an art form. Once described as pictures meant to be seen by people who did not mean to see them, posters emerged as book advertisements in the 1830s. Once placed out of doors, where they had to compete with traffic and confusion, as well as the size of the surrounding environment, posters called attention to themselves by being simple, brightly colored, and boldly designed. Between 1860 and 1900 every-thing from music halls and theaters, to champagne, soft drinks, and cigarettes were advertised in posters. Posters were later recognized for their artistic prop-erties, and the first poster exhibit was held in New York in 1890, followed by another in London in 1894. They were so eagerly collected that by 1896 the United States boasted some 6,000 collectors of these gaudy and pleasing adver-tisements. Today, nineteenth-century posters rank among the most valued as-sets of any print collection.

Lithography permitted all sorts of effects and experiments. In producing plates, some artists used a scraper and greasy crayon; others used dabbers and ink, and still others spattered liquid ink onto stone using a brush or a broken-toothed comb. The smooth, supple gesture made possible by using a lithograph crayon and the painterly effects that could be achieved with lithograph ink made this medium an important one for artists interested in working directly and spontaneously on the printing surface.

Color Lithographs By the late 1870s, artists explored the possibilities of creat-ing colored lithograph images by using a number of stones inked with different colors. Posters, which gave primacy to simple forms, flat color, and large shapes, benefited from these experiments. Some Impressionists and Post-Im-pressionists investigated the different textures and patterns that could be achieved through color printing, resulting in intimate, delicately colored litho-graphs that rank among the most beautiful printed images extant.

Etching

Because a print could not be pulled in the thousands from its plates, etching was not extensively used by artist-illustrators. However, because they could work directly on the prepared plate much as they could draw directly on paper, certain artists throughout the nineteenth century continued to use etching. Some experimented with only a few etchings in their lifetimes, others devoted themselves almost exclusively to the medium, and still others produced enough etchings so that these constitute an important part of their oeuvre.

Early in the century, artists of the Barbizon school, notably Corot, Millet, and Theodore Rousseau, experimented with landscape etchings. Corot also tested the method of cliché-verre, a form of etching that uses a glass rather than a metal plate and that prints on photosensitive paper. Some of the Impressionists also attempted etchings, many of which were made in the open air, and others were derived purely from the imagination.

Etching presented special challenges to the artist, who had to be certain of each stroke and work spontaneously, sometimes foregoing the preparatory drawing. The etchings these artists produced exploited the wide-ranging capabilities of this medium, allowing equally for specific as well as ephemeral images. Using a few touches of line on paper, the etching would seem flooded with light or steeped in shadow, depending on the effects sought by the artist.

Color Etchings Inspired by Japanese woodcuts that had found their way to Europe, some artists began to experiment with ways to introduce color to the etching process. By mixing resin or asphaltum powder into the coating of a plate, artists could change the texture, tone, or color of a plate. This process is called aquatint.

Woodcuts

Woodcuts and wood engravings were primarily used for book and magazine illustrations, because they yielded large printings. In addition, however, the Symbolists, found in the woodcut an ideal medium for expressing their own aesthetic, which strove for simplified forms against simple backgrounds. Both black and white and color woodcuts, derived by using more than one printing block, were made.

Monotypes

The monotype had fallen into disuse by the end of the eighteenth century and was not employed again until certain artists developed a new concern for light, tone, and suggestive forms (see list of artists at end of chapter). For painter-printmakers who sought painterly, spontaneous effects rather than detailed representation, the monotype was an ideal medium of expression.

SCULPTURE

Ironically, sculpture is more abundant in the nineteenth century than in any previous period, yet it is not often selected for permanent display by museums. Why? Its very abundance is part of the answer. The rest of the answer lies in the reservations some museums have about the "originality" and artistic merit

of such sculpture. These aesthetic judgments are based on reactions to certain technical advances that were made in the nineteenth century that enabled sculptors to respond to a steadily growing demand for their works.

The nineteenth century was the great age of monuments. Every major city in Europe and the United States felt compelled to commission monuments to honor important persons or occasions. Every native son, writer, would-be hero, civic leader, and the like was commemorated with a monument. All important public buildings, such as town halls, post offices, and opera halls, required sculptural ornaments. Parks too were decorated with fountains and other sculpture, and bridges were festooned with lamps and figures. This urge to commemorate, honor, decorate, and embellish public sites kept a large body of sculptors very busy. Furthermore, churches and cemetaries still made demands on the sculptor. The tombs created in the nineteenth century were often more splendid, and certainly more grandiose, than many made before then.

The public was an equally eager patron of sculpture for use in the home, and the demand for small-scale sculpture was great. Improving on technical innovations made during the eighteenth century, the nineteenth century further refined casting techniques that made it possible for professional foundries to issue reduced casts of known large-scale works in relatively large numbers. This process was inspired by the need to meet an intense demand and also ensured a regular income to sculptors who would otherwise have had to survive from commission to commission.

To some contemporary minds, such mechanical processes tend to diminish the artistic merit of a sculpture. The issue is debated, and often decisions regarding aesthetic merit are made on an individual basis: Some sculptors oversaw the process, others designed sculpture on a small-scale and did not simply reduce large monuments, thereby giving the final product a higher quality. Although recent scholarship has begun to reexamine nineteenth-century sculpture and several important exhibitions have been devoted to it, collections tend to be diverse and, in a single museum, far less comprehensive than collections of paintings, drawings, or prints from the same period. Notwithstanding some of the prevailing prejudices, some museums represent nineteenth-century art with fascinating examples of sculpture that are well worth looking at.

The established institutions of art, the academies and their annual exhibitions, which were an integral part of the cultural life of large European cities, helped launch the careers of many sculptors. Like painters, sculptors submitted their works to the salons and treated great historical or narrative themes. Sometimes sculpted figures were made to personify a concept, such as the "genius of electricity," or "nature," and at other times historic or literary themes were rendered in a sculptural group. Like history painting, many of these sculptures had a narrative quality and recounted stories well known to the public.

Sculptors also supplemented their income from large commissions with portraits, which were made in many forms. Busts and large plaques in relief and

usually in profile were the most common forms of portraiture, although occasional full-length sculptures were also made. A rather humorous development in nineteenth-century sculpture was the caricature. Some nineteenth-century sculptors specialized in caricatures of well-known personalities that exaggerated their subjects' most characteristic features, rendering them both recognizable and funny. These caricatures were sometimes issued in large quantitites and became quite popular among collectors of personality sculptures.

Other types of images gained immense popularity during this century and can be found most commonly in today's museums. The cult of personality and the prevailing interest in history and current events resulted in the popularity of small, usually bronze, figurines of notable historic and contemporary personalities, including artists, actors, composers, writers, and leaders. Queen Victoria, Napoleon, Napoleon III, Joan of Arc, Charles VII, Sarah Bernhardt, Victor Hugo, and Beethoven were among the characters often portrayed in these statuettes.

Parallel to the great interest in landscape among nineteenth-century painters was the popularity of the animal figure in sculpture. Occasional renderings of a horse, bull, or other animal can be found in Renaissance art, but no period saw such an equivalent outpouring of sculpted animals. Lions, panthers, wild birds, stags, alligators, and bears were depicted in violent action, either the victims or perpetrators of an attack. Dogs, cats, owls, and snakes were studied and sculpted with anatomical accuracy and shown in poses most characteristic for the species. These small decorative animal figures, which had long been produced in miniature by goldsmiths, were viewed as fascinating symbols of a violent, untamed nature. Tables set for banquets would be decorated with elaborate combinations of animal sculptures, and small bronzes were found in libraries and studies as interior decorations for the nineteenth-century home.

In addition to these special categories of subjects, many of the same themes that were found in painting abounded in sculpture. Cupid and Psyche, Daphnis and Chloe, Paolo and Francesca, and Roger and Angelica were depicted in countless sculpture groups. The themes of motherhood and the rapacious femme fatale were also popular. The interest in history that produced revivals of so many earlier styles also prompted artists, especially sculptors, to render scenes from primitive history. Such themes as "The First Cradle," "The First Funeral," "The First Family," and "Adam and Eve" recounted the lives of early man in the biblical sense and were immensely popular.

Many materials were used in nineteenth-century sculpture. Bronze was the single-most popular medium and prompted artists to experiment with technique in order to produce new textures and surfaces. Depending on their training and outlook, artists would strive for literal accuracy, anatomical realism, and polished surfaces; or, by contrast, they transformed the more immediate, tactile, and unfinished appearance of their sketches into bronzes that retained a rough, broken, and spontaneous surface. Many artists mixed materi-

als, combining ivories, bronzes, precious metals, and stones. Marble continued to be an important material, as the use of wood gradually declined or fell to the work of artisans.

In general, sculpture of the nineteenth century exudes life, capturing the spirit and essense of human and animal forms in a way that still speaks to the viewer today. Often excessively emotional, delightfully sensual or sentimental, but always technically proficient, nineteenth-century sculpture is the last phase in which the natural form would dominate artistic production. The close of the nineteenth century saw sculpture, even more than painting, turn to many diverse and fascinating directions.

PHOTOGRAPHY

In 1826, the French physicist Joseph Nicéphore Niepce produced the first photograph by exposing a pewter plate to the view from his window. By 1837, Louis Daguerre refined the process by using mercury vapor to develop the image and common salt to fix it. Photography was to find use in this early stage in portraiture.

Like other technical processes, photography challenged many and saw numerous refinements. An Englishman, W. H. F. Talbot, managed to eliminate the bulky metal plates used for daguerreotype and produced the first paper negatives, calling his new process calotype. Much larger images were thus possible, making landscape and other views logical subjects for the calotype. David Octavius Hill and Robert Adamson were famous calotype photographers.

By 1851, F. Scott Archer reduced the exposure time necessary for photography, and in perfecting the so-called collodion process, created a negative capable of capturing more detail. He also developed a new wetplate developing technique that made it possible to print numerous photographs from a single negative. This innovation made it possible to use photography as a substitute for other forms of illustration in newspapers and magazines. By midcentury, photographers joined or replaced the illustrator who recorded historic events, such as wars. Roger Fenton documented the Crimean War in 1855 with photographs, and Mathew Brady recorded images of the American Civil War. By 1888, George Eastman had put the first hand-held camera on the market, and photography became increasingly accessible to a broad spectrum of society.

As soon as photography became available for an increasing number of applications, its uses and potential as an art form and as a recording device were exploited as much as they were disputed. Some immediately declared photography the supreme art form, because its perfect representation of reality caused it to supersede any other form. To others, it was merely a mechanical device that could never replace the more traditional methods of artistic expression.

In any event, photography was instantly recognized as a tool for artists work-

ing in other mediums. It was an aid to artists in understanding and interpreting the appearances of objective reality. From the beginning, however, there were photographers who sought to create artistic images unique to this new process who sometimes relied on the traditional subject matter and composition used in painting. Many of these images are regarded today as equal in artistic expressiveness to other traditional mediums.

NINETEENTH CENTURY ARTISTS
PAINTING

French Neo-Classicists

Julien Leopold Boilly (or Jules) (Paris 1796–1874). History, genre.

Nicolas Toussaint Charlet (Paris 1792–1845). Genre.

Léon Mathieu Cochereau (Montigny-le-Gaimelon 1793–Bizerte 1817). Genre.

Jacques Louis David (Paris 1748–Brussels 1825). Allegorical, history, mythological.

Philibert Louis Debucourt (Paris 1755–Belleville 1832). Colored engraving specialist, genre.

Paul (Hippolyte) Delaroche (Paris 1797–1856). History, portraits, sculpture.

Jean Louis Demarne (Brussels 1744/54–Paris 1829). Genre, animals.

Martin Drolling (Oberbergheim, near Colmar 1752–Paris 1817). Genre, interiors.

Andre Dutetre (Paris 1753–1842). Portraits, battles.

Etienne Barthelemy Garnier (Paris 1759–1849). History, mythological, portraits.

Baron François Pascal Simon Gerard (Rome 1770–Paris 1837). History. Pupil of David.

François Marius Granet (Aix-en-Provence 1775–1849). Church interiors, oil landscape sketches, genre.

Baron Antoine Jean Gros (Paris 1771–Sèvres 1835). History, portraits, mythological. Pupil of David.

Pierre Narcisse Guerin (Paris 1774–Rome 1833). History, mythological. Pupil of David.

Jean Auguste Dominique Ingres (Montauban 1780–Paris 1867). Mythological, history, portraits. Pupil of David.

Jean Baptiste Isabey (Nancy 1767–Paris 1855). Portraits. Pupil of David.

Louis Gabriel Eugène Isabey (Paris 1803–1886). Genre, landscapes, seascapes.

Jean Louis Launeville (1748–Paris 1826). Portraits. Pupil of David.

Guillaume Lethiere (Letiers) (Sainte-Anne de la Guadeloupe 1760–Paris 1832). History, genre.

Jean Michel Moreau (Le Jeune) (Paris 1741–1814). Genre, illustrations, graphic arts.

Pierre Paul Prud'hon (Cluny 1758–Paris 1823). History, mythological, classics, portraits.

Denis Auguste-Marie Raffet (Paris 1804–Genoa 1860). History, genre.

Jean Baptiste Regnault (Paris 1754–1829). History, mythological.

Antoine Charles-Horace (Charlot or Carle) Vernet (Bordeaux 1758–Paris 1836). Historical, battles, animals.

Emile Jean Horace (Horace) Vernet (Paris 1789–1863). History, military.

Marie Louise Elisabeth Vigee-Le Brun (Paris 1755–1842). Portraits.

German Neo-Classicists

Asmus Jakob Carstens (Saint-Jürgen near Schleswig 1754–Rome 1798). Portraits, mythological.

Daniel Nicolas Chodowiecki (Danzig 1726–Berlin 1801). History, portraits.

Peter von Cornelius (Düsseldorf 1783–Berlin 1867). History.

Josef Georg von Edlinger (Gratz 1741–Munich 1819). Portraits.

Anselm Feuerbach (Speyer 1829–Venice 1880). History, landscapes, portraits.

Friedrich Heinrich Fuger (Heilbronn 1751–Vienna 1818). Portraits, mythological, historical.

Buonaventura Genelli (Berlin 1798–Weimar 1868). History, draftsman.

Anton Graff (Winterthur 1736–Dresden 1813). Portraits, miniatures. Etcher.

Angelica Kauffmann (Chur, Switzerland 1740–Rome 1807). Genre, portraits.

Joseph Anton Koch (Obergibeln, Elbigenalp 1768–Stuttgart 1839). History, genre, landscapes.

Johann Peter Krafft (Hanau 1780–Vienna 1856). Portraits, genre, landscapes, history.

Johann Baptist Lampi, the Elder (Romeno 1751–Vienna 1830). Portraits, history.

Johann Baptist Lampi, the Younger (Trent 1775–Vienna 1837). Portraits, genre.

Anton von Maron (Vienna 1733–Rome 1808). Portraits, history. Pupil of Mengs.

Anton Raphael Mengs (Aussig, Bohemia 1728–Rome 1779). History, religious, portraits.

Johann Friedrich August Tischbein (Maestricht 1750–Heidelberg 1812). Portraits.

Johann Heinrich Wilhelm Tischbein (Haina 1751–Eutin 1829). Portraits.

Georg Friedrich Eberhard Wachter (Eberbard) (Balingen 1762–Stuttgart 1852). History, mythological. Pupil of Regnault and Koch.

Later Neo-Classicists, Idealists, "Intellectuals"

Arnold Bocklin (Basel 1827–Fiesole 1901). Sculptor and painter. Genre, landscape, portraits.

Léon Bonnat (Bayonne 1833–Monchy-Saint-Eloi 1922). Portraits, landscapes, historical.

Adolphe William Bouguereau (La Rochelle 1825–1905). Portraits, history, mythological, genre.

Alexandre Cabanel (Montpellier 1823–Paris 1889). Historical, mythological.

Eugène Carrière (Gournay 1849–Paris 1906). Genre, portraits.

Charles Auguste Emile Duran (Lille 1837–Paris 1917). Portraits, history. Sculptor.

Ignace Henri Jean Théodore Fantin-Latour (Grenoble 1836–Buré 1904). Portraits, history, still-lifes, genre.

Anselm Feuerbach (Speyer 1829–Venice 1880). History, landscapes, portraits.

Hans von Marees (Elberfeld 1837–Rome 1887). Portraits, history.

Gustave Moreau (Paris 1826–1898). History, mythological. Watercolorist.

Pierre Puvis de Chavannes (Lyons 1824–Paris 1898). Genre.

Odilon Redon (Bordeaux 1840–Paris 1916). History, portraits, genre.

American Neo-Classicists

John Singleton Copley (Boston 1738–London 1815). Portraits, history.

Charles Willson Peale (Queen Annes County, Md. 1741–Philadelphia 1827). Portraits, allegorical, trompe l'oeil.

Gilbert Stuart (North Kingston, R.I. 1755–Boston 1828). Portraits.

Thomas Sully (Lincolnshire, England 1783–Philadelphia 1872). Portraits, history, romantic mood.

John Trumbull (Lebanon, Ct. 1756–New York 1843). History, battles, portraits.

John Vanderlyn (Kingston, N.Y. 1775–1852). Modern history painter, classical subjects. Pupil of Gilbert Stuart.

Benjamin West (Springfield, Pa. 1738–London 1820). History paintings, portraits. Romantic, sublime.

French Academic Artists

Eugène-Emmanuel Amaury-Duval (Paris 1808–1885). Portraits, mythological. Pupil of Ingres.

Jules Robert Auguste (Paris c. 1789–1850). Oriental tradition, allegorical, literary, historical. Sculptor. Prix de Rome, 1810.

Félix Joseph Barrias (Paris 1822-Paris 1907). Historical, mythological, portraits, landscape. Prix de Rome, 1844.

Paul Baudry (La Roche-sur-Yon, Vendes 1828–Paris 1886). Mythological, religious history. Prix de Rome, 1850.

Joseph Louis Hippolyte Bellangé (Paris 1800–1866). Battles, military subjects. Lithographer.

Léon Adolphe Auguste Belly (Saint-Omer 1827–Paris 1877). Orientalist, views of the East, portraits.

Jean Achille Benouville (Paris 1815–1891). Landscapes. Brother of Léon.

Léon Benouville (Paris 1821–1859). Historical, mythological, scenes, religious.

Narcisse Berchère (Etampes 1819–Asnières 1891). Historical landscapes of the Orient. Engraver, lithographer.

Léon Bonnat (Bayonne 1833–Monchy-Saint-Eloi 1922). Portraits, landscape, historical, biblical. Salon of 1857.

Adolphe William Bouguereau (La Rochelle 1825–1905). Portraits, history, mythological, genre. Prix de Rome, 1850.

Gustave Clarence Rodolphe Boulanger (Paris 1824–1888). Biblical history, mythological, history. Prix de Rome, 1849. Pupil of Paul Delaroche.

Alexandre Cabanel (Montpellier 1823–Paris 1889). Biblical history, allegorical, mythological. Prix de Rome, 1845.

Théodore Chasseriau (Samaná, Hispaniola 1819–Paris 1856). Orientalist, biblical history, Middle Eastern history, portraits, mythological. Engraver. Worked with Ingres.

Léon Cogniet (Paris 1794–1880). History, battle scenes, Orientalist, portraits. Prix de Rome, 1817. Pupil of Guerin.

Jean Joseph Benjamin Constant (Paris 1845–1902). Orientalist, historical scenes. Pupil of Cabanel.

Fernand Anne Piestre Cormon (Paris 1854–1924). Orientalist, history, portraits. Pupil of Cabanel and Fromentin.

Thomas Couture (Senlis, Oise 1815–Villiers-le-Bel 1879). History, portraits, genre. Prix de Rome, 1832. Teacher.

Pascal Adolphe Jean Dagnan-Bouveret (Paris 1852–Quincey 1929). Modern life, mythological, literary, portraits. Pupil of Gerome and Corot.

Adrien Dauzats (Bourdeaux 1804–Paris 1868). Landscapes, genre, architecture.

Edouard Bernard Debat-Ponsan (Toulouse 1847–Paris 1913). Portraits, landscapes, history, genre. Pupil of Cabanel.

Alexandre Gabriel Decamps (Paris 1803–Fontainebleau 1860). Orientalist, landscapes, genre, military history. Engraver, lithographer.

Edme Alexis Alfred Dehodencq (Paris 1822–1882). Orientalist, travel paintings, genre, portraits.

Paul (Hippolyte) Delaroche (Paris 1797–1856). History, religious, military, portraits. Sculptor.

Jules Elie Delaunay (Nantes 1828–Paris 1891). History, biblical, mythological, some portraits.

Edouard Detaille (Paris 1848–1912). Military history. Pupil of Meissonier.

Ludwig Deutsch (Vienna 1855–1935). Orientalist, draftsman of genre and landscapes. Pupil of Laurens.

Hippolyte Flandrin (Lyons 1809–Rome 1864). Military history, religious, mythological, portraits. Prix de Rome, 1822.

Emile Friant (Dieuze 1863–Paris 1932). History, genre, portraits. Sculptor.

Eugène Fromentin (La Rochelle 1820–St. Maurice 1876). Oriental, military, landscapes, Arabic scenes. Writer.

Louis Gallait (Tournay 1810–Brussels 1887). Portraits, genre.

Jean Léon Gérome (Vesoul 1824–Paris 1904). Orientalist, biblical history, genre. Engraver, sculptor. Pupil of Paul Delaroche.

Henri Gervex (Paris 1852–1929). History, mythological, social realism. Pupil of Cabanel and Fromentin.

Victor Julien Giraud (Paris 1840–1871). Orientalist, caricaturist.

Eugène Alexis Girardet (Paris 1853–1907). Orientalist, landscapes, genre. Pupil of Gerome. Engraver.

Karl Girardet (Locle 1813–Paris 1871). History, genre, contemporary life, Orientalist. Pupil of Cogniet.

Auguste Barthélémy Glaize (Montpellier 1806–Paris 1893). Allegorical history, genre, portraits, biblical history. Prix de Rome, 1866.

Marc Gabriel Charles Gleyre (Chevilly 1808–Paris 1874). History, genre, portraits. Ran famous atelier, teacher.

Gustave Achille Guillaumet (Puteaux 1840–Paris 1887). Genre, landscapes, Orientalist. Writer and etcher. Pupil of Barrias and Picot.

Jean Louis Hamon (Côtes-du-Nord 1821–St. Raphael 1874). Genre, history.

Antoine-Auguste-Ernest Herbert (Grenoble 1817–1908). History. Prix de Rome, 1839.

Jean Jacques Henner (Bernweiler, Alsace 1829–Paris 1905). History, biblical, portraits, some landscapes. Prix de Rome, 1855.

Charles Gustave Housez (Condé 1822–Valenciennes 1880). Genre, historical.

Anne Francois Louis Janmot (Lyons 1814–1892). Biblical history with romantic overtones.

Charles Zacharie Landelle (Laval 1821–Chennevieres-sur-Marne 1908). Religious, history, genre, Oriental subjects, portraits. Pupil of Delaroche and Scheffer.

Jean Paul Laurens (Fourquevoux 1838–Paris 1921). History, some biblical. Pupil of Cogniet.

Jean Jules Antoine Lecomte du Noüy (Paris 1842–1923). History, portraits, genre. Took over Gleyre's studio. Sculptor.

Alphonse Legros (Dijon, France 1837–Watford, England 1911). Religious, genre, portraits. Sculptor and engraver.

Karl Ernest Rodolphe Heinrich Salem Lehmann (Kiel 1814–Paris 1882). Biblical history, portraits.

Jules Eugène Lenepveu (Angers 1819–Paris 1898). Historical, genre, portraits, murals. Prix de Rome, 1847. Pupil of Picot.

Emile Lévy (Paris 1826–Passy 1890). Historical, genre, portraits. Prix de Rome, 1854. Pastelist. Pupil of Pujol and Picot.

Henri Leopold Lévy (Nancy 1840–Paris 1904). History, some landscapes. Pupil of Picot, Fromentin, and Cabanel.

Evariste Vital Luminais (Nantes 1822–Paris 1896). History, animals, genre.

Prosper Georges Antoine Marilhat (Vertaizon 1811–Thiers 1847). Landscapes, Oriental ruins.

Jean Louis Ernest Meissonier (Lyons 1815–Paris 1891). Portraits, history, genre, contemporary scenes; best known for small sketches. Sculptor, engraver.

Charles Louis Lucien Muller (Paris 1815–1892). History, genre, portraits. Pupil of Gros and Cogniet.

Alphonse Marie de Neuville (St. Omer 1835–Paris 1885). Military scenes, figures, battles. Illustrator.

Dominique Louis Papety (Marseilles 1815–1849). Genre, biblical, views. Prix de Rome, 1836. Pupil of Cogniet.

Octave Penguilly L'Haridon (Paris 1811–1870). Military, genre, history, landscapes. Illustrator, engraver.

Isidore Alexandre Augustin Pils (Paris 1813–Douarnenez 1875). Genre, military, history. Etcher.

Alexandre Protais (Paris 1826–1890). History, military.

Alexandre Georges Henri Regnault (Paris 1843–Buzenval 1871). History, genre, Orientalist, mythological, portraits, views. Prix de Rome, 1866.

Joseph Nicolas Robert-Fleury (Cologne 1797–Paris 1890). History, lithographer.

Tony Robert-Fleury (Paris 1837–1912). History, genre. Son of Joseph Nicolas; pupil of Delaroche.

Ary Scheffer (Dordrecht, Netherlands 1795–Argenteuil 1858). History, genre, military, portraits. Engraver, sculptor, lithographer.

Jean Victor Schnetz (Versailles 1787–Paris 1879). Biblical history, genre, portraits, popular Italian picturesque scenes. Lithographer. Pupil of David, Regnault, Gros.

Adolf Schreyer (Frankfurt 1828–Cronberg 1899). Orientalist, genre, animals, military scenes, landscapes.

Charles Emile Vacher de Tournemine (Toulon 1812/14–1872/73). Orientalist. Landscapes, seascapes. Pupil of Isabey.

Emile Jean Horace Vernet (Paris 1789–1863). History, military subjects, Orientalist, some biblical history, portraits. Lithographer.

French Romantics

Rosa Bonheur (Bordeaux 1822–Milun 1899). Painter, sculptor of animals, landscapes.

Nicholas Louis Cabat (Paris 1812–1893). Landscapes, river scenes.

Théodore Chasseriau (Samaná, Hispaniola 1819–Paris 1856). Orientalist, biblical history, Middle Eastern history, portraits, mythological. Engraver. Worked with Ingres.

Eugene Ciceri (Paris 1813–1890). Landscapes. Lithographer.

Thomas Couture (Senlis 1815–Villiers-le-Bel 1879). History, genre, few portraits and biblical subjects.

Eugène Delacroix (Charenton 1798–Paris 1863). History, religious history, classical, mythological, literary, some still-lifes.

Narcisse Diaz le Peña (Bordeaux 1807–Menton 1876). Genre, landscape, still-lifes. Barbizon School, 1840.

Newton Fielding (Huntington, Yorkshire 1799–Paris 1856). Landscapes, animals. Engraver, lithographer, watercolorist.

Hippolyte Flandrin (Lyons 1809–Rome 1864). Religious paintings.

Eugene Fromentin (La Rochelle 1820–St. Maurice 1876). Genre, landscapes, chase scenes, Oriental scenes. Writer.

Théodore Gericault (Rouen 1791–Paris 1824). History, animals, some portraits. Sculptor, draftsman.

Francois Marius Granet (Aix-en-Provence 1775–1849). Religious history, landscapes, interiors. Watercolorist.

Paul Huet (Paris 1803–1869). Landscapes, animals. Watercolorist.

Philippe Jacques Loutherbourg (Strasbourg 1740–London 1812). Landscapes, historical and battle scenes, animals.

Prosper Marilhat (Vertaizon, Puy-de-Dôme 1811–Thiers 1847). Desert landscapes, Far East and Oriental scenes.

Charles Meryon (Paris 1821–Saint-Maurice, Seine 1868). Landscapes, Parisian scenes and places. Etcher, draftsman.

Georges Michel (Paris 1763–1843). Landscapes, fantasies. Watercolorist.

Adolphe Monticelli (Marseilles 1824–1886). Painter of figures, portraits, landscapes, still-lifes.

Victor Louis Mottez (Lille 1809–Bièvres 1897). Religious history, portraits.

Léon Sabatier (died Paris 1887). Draftsman and lithographer of landscapes and architecture.

Ary Scheffer (Dordrecht 1795–Argenteuil 1858). Religious history, genre, military, portraits. Etcher, engraver, sculptor, lithographer.

Baron Isidore Taylor (Brussels 1789–Paris 1879). Landscapes. Draftsman, engraver.

Eugène Emanuel Viollet-le-Duc (Paris 1814–Lausanne 1879). Landscapes. Architect and watercolorist.

Félix Ziem (Côte-d'Or 1821–Paris 1911). Venetian views, seascapes, landscapes.

English Romantics

Thomas Barker (Barker of Bath) (Pontypool, Monmouthshire 1769–Bath 1847). Literary, landscapes, genre, portraits, religious. Lithographer.

Richard Parkes Bonington (Nottingham 1802–London 1828). Genre, animals, landscapes, seascapes, portraits. Watercolorist.

John Brett (Surrey 1831–London 1902). Landscapes, seascapes, genre, portraits.

Ford Madox Brown (Calais 1821–London 1893). Historical and biblical themes, modern life, genre.

George Chinnery (London 1774–Macao, China 1852). Ivory miniatures, portraits. Draftsman.

David Cox (Birmingham 1783–Harborne, near Birmingham 1859). Watercolor specialist. Landscapes, architectural settings. Draftsman.

Richard Dadd (Chatham 1817–London 1887). Fantastical scenes, literary themes. Later went mad. Draftsman.

Francis Danby (County Wexford, Ireland 1793–Exmouth 1861). Landscapes, biblical history, genre.

William Davis (Dublin 1812–London 1873). Landscapes, portraits, still-lifes.

William Dyce (Aberdeen, Scotland 1806–London 1864). Mythological themes, religious, landscapes, frescoes.

Augustus Leopold Egg (London 1816–Algiers 1863). Historical, allegorical, modern life, genre, literary.

William Etty (York 1787–London 1849). Mythological, human figures, nudes, literary themes, frescoes.

William Powell Frith (Studley, Yorkshire 1819–London 1909). Literary illustrations, scenes of modern life.

Sir Francis Grant (Kilgraston 1808–Melton Mowbray 1878). Sporting pictures, portraits, court painter.

Benjamin Robert Haydon (Plymouth, Devonshire 1786–London 1846). Religious, mythological. Writer on art theory.

James Holland (Burslem, Staffordshire 1800–London 1870). Flowers in watercolors, topographical landscape views.

Theodor von Holst (London 1810–1844). Illustrations, erotic drawings, genre.

Arthur Hughes (London 1832–Kew Green 1915). Genre, allegorical, love themes, history. Illustrator.

William Henry Hunt (Covent Garden, London 1790–1864). Landscapes, topographical views, drawings of interiors, genre, still-lifes. Watercolorist, draftsman.

William Holman Hunt (London 1827–Kensington 1910). Religious, literary, history.

John William Inchbold (Leeds 1830–1888). Landscapes. Engraver.

Sir Edwin Landseer (London 1802–1873). Animals, genre.

Edward Lear (London 1812–San Remo, Italy 1888). Birds, landscapes illustrations. Draftsman.

Lord Frederic Leighton (Scarborough 1830–Kensington 1896). Religious history, historical genre. Draftsman, sculptor. Traveled Florence, Rome, Brussels, Spain, Egypt.

Charles Robert Leslie (London 1794–1859). Scenes from literary sources, landscapes.

John Frederick Lewis (London 1805–Walton-on-Thames 1876). Animals, sports, Spanish scenes. Draftsman.

John Linnell (Bloomsbury 1792–Redhill 1882). Landscapes, portraits, biblical. Miniaturist, printmaker.

Daniel Maclise (Cork, Ireland 1811–London 1870). Literary subjects, figures, historical.

John Martin (Haydon, Northumberland 1789–Douglas, Isle of Man 1854). Biblical history. Engraver, glass painter, illustrator.

Sir John Everett Millais (Southampton 1829–London 1896). Religious, genre, landscape, portraits, history. Draftsman.

William Mulready (Ennis, Ireland 1786–Bayswater 1863). Landscapes, genre, sporting events.

Samuel Palmer (London 1805–Redhill 1881). Landscapes. Illustrator, watercolorist, draftsman.

Samuel Prout (Plymouth 1783–Camberwell 1852). Architectural views, landscapes, ruins.

Dante Gabriel Rossetti. See entry under The Pre-Raphaelites.

John Ruskin. See entry under Later Pre-Raphaelites.

David Scott (Edinburgh 1806–1849). Classical history, portraits. Engraver, illustrator.

Joseph Mallord William Turner (London 1775–Chelsea 1851). Landscapes, views, architectural settings. Watercolorist, draftsman.

James Ward (London 1769–Cheshunt 1859). Outstanding mezzotint engraver, animal painter, landscapes, historical subjects, female nudes.

George Frederic Watts (London 1817–Limmerlease 1904). Allegorical, portraits.

Sir David Wilkie (Cults, near Edinburgh 1785–died at sea, near Malta 1841). Peasants, genre, portraits, contemporary life, literary, history, landscapes, portraits. Draftsman, engraver.

William Lindsay Windus (Liverpool 1822–London 1907). Literary, history, genre.

The Pre-Raphaelites

Henry Alexander Bowler (Kensington 1824–London 1903). Landscapes, literary.

Ford Madox Brown (Calais 1821–London 1893). History, literary.

James Collinson (Mansfield, Nottinghamshire 1825–1881). History, genre.

Walter Howell Deverell (Charlottesville, Va. 1827–Chelsea, England 1854). Literary, genre.

William Dyce (Aberdeen, Scotland 1806–London 1864). History, portraits, fresco revivals.

Augustus Leopold Egg (London 1816–Algiers 1863). Literary, history, genre, allegorical, modern life.

William Holman Hunt (London 1827–Kensington 1910). Religious, literary, history.

Robert Braithwaite Martineau (London 1826–1869). Genre, history. Pupil of William Holman Hunt.

Sir John Everett Millais (Southampton 1829–London 1896). Portraits, landscapes, history, genre, literary, religious. Draftsman.

Dante Gabriel Rossetti (London 1828–Birchington 1882). History, portrait drawings, literary, religious, genre. Draftsman, poet. Pupil of Ford Madox Brown.

William Bell Scott (Edinburgh 1811–Penskill Castle 1890). Literary. Writer, history painter. Engraver.

Thomas Seddon (London 1821–Cairo 1856). Landscape painter of Oriental and Mideast subjects.

Elizabeth Eleanor Siddal (London 1834–1862). Drawings, watercolors. Biblical sketches, illustrations of Shakespearean dramas. Wife of Dante Gabriel Rossetti.

James Smetham (Yorkshire 1821–Stoke Newington 1889). Landscapes, genre. Etcher, writer.

William Lindsay Windus (Liverpool 1822–London 1907). Genre, history, literary.

Later Pre-Raphaelites

John Brett (Surrey 1830–London 1902). Landscapes, seascapes, genre, portraits.

Sir Edward Coley Burne-Jones (Birmingham 1833–London 1898). Tapestry and stained glass designs, history. Traveled Milan and Venice.

Thomas Charles Farrer (London 1839–1890). Landscapes. Lived in U.S. 1860–1872.

John William Hill (England 1812–Nyack Turnpike, N.Y. 1879). Landscapes and topographical painter. Engraver.

Arthur Hughes (London 1832–Kew Green 1915). Genre, themes of love, historical. Illustrator

Lord Frederic Leighton (Scarborough 1830–Kensington 1896). Historical genre, religious history. Draftsman. Sculptor. Traveled Florence, Rome, Brussels, Spain, Egypt.

William Morris (Walthamstow, Essex 1834–Kelmscott Manor, Oxfordshire 1896). Genre, literary, history. Designs for Morris & Co. firm: wallpapers, furniture, tapestry, stained glass. Draftsman, decorator, poet, architect.

Thomas Buchanan Read (Chester County, Pa. 1822–New York 1872). Religious allegory, ideal subjects, portraits. Sculptor, architect, writer.

William Trost Richards (Philadelphia 1833–Newport, R.I. 1905). Landscapes, seascapes. Traveled Florence, Rome, Paris.

John Ruskin (London 1819–Coniston 1900). Landscapes, painter of architecture. Art critic, writer, professor, patron painter, watercolorist.

Simeon Solomon (London 1840–1905). History, literary, mythological.
Frederick George Stephens (London 1828–Hamme. Smith 1907). Gave up painting c. 1850. Writer on art.
Henry Wallis (London 1830–Sutton 1916). History, landscapes. Art critic.

German Romantics

Albrecht Adam (Nordling, Bavaria 1786–Munich 1862). Military subjects, battles, landscapes, portraits. Engraver, lithographer.
Karl Blechen (Cottbus 1798–Berlin 1840). Landscapes, painter of theater decorations. Later went mad. Lithographer, engraver. Traveled Rome.
Heinrich Bürkel (Pirmasens 1802–Munich 1869). Landscapes, genre. Traveled Italy.
Caspar David Friedrich (Griefswald 1774–Dresden 1840). Landscapes.
Johann Peter Hasenclever (Remscheid 1810–Düsseldorf 1853). Genre, portraits. Pupil of Wilhelm Schadow.
Peter von Hess (Düsseldorf 1792–Munich 1871). Historical, battles. Engraver.
Theodor Hosemann (Brandenburg 1807–Berlin 1875). Genre, landscapes. Illustrator, lithographer.
Christian Morgenstern (Hamburg 1805–Munich 1867). Landscapes. Traveled Russia, Norway, France, Italy.
Karl Steffek (Berlin 1818–Königsberg 1890). Historical, portraits, animals. Lithographer and engraver of historical and genre scenes. Traveled Berlin, Paris, Rome, Vienna.
Friedrich Wasmann (Hamburg 1805–Meran 1886). Portraits.

Biedermeir Romanticism

Josef Kehren (Hülchrath 1817–Düsseldorf 1880). Religious history. Pupil of Schadow.
Alfred Rethel (Diepenbend bei Aachen 1816–Düsseldorf 1859). Landscapes, watercolors, a few history paintings. Isolated, tragic figures. Draftsman, engraver in wood.
Adrian Ludwig Richter (Dresden 1803–1884). Landscapes, animals. Illustrator. Traveled Strasbourg, France, Rome, Naples.
Moritz von Schwind (Vienna 1804–Munich 1871). History, religious history, some portraits. Engraver.
Karl Spitzweg (Munich 1808–1885). Genre, landscapes. Illustrator.

The Nazarenes

Peter Cornelius (Düsseldorf 1783–Berlin 1867). History, biblical history. Illustrator. Traveled Munich, Vienna, Rome.
Joseph von Führich (Kratzau in Bohemia 1800–Vienna 1876). Religious scenes, frescoes. Engraver, illustrator. Traveled Prague, Rome.

Heinrich Maria von Hess (Düsseldorf 1798–Munich 1863). History, religious, mythological, genre, portraits. Traveled Rome.

Franz Horny (Weimar 1798–Olevano 1824). Landscapes. Traveled Munich, Rome.

Johann Konrad Hottinger (Vienna 1788–Lenzburg 1828). Religious. Traveled Rome, Vienna, Munich. Pupil of Overbeck.

Ferdinand von Olivier (Dessau 1785–Munich 1841). History, religious history, landscapes. Leading Nazarene. Lithographer. Brother of Heinrich. Traveled Dresden, Paris, Vienna.

Heinrich von Olivier (Dessau 1783–Berlin 1848). History, portraits. Traveled Dresden, Paris.

Johann Friedrich Overbeck (Lübeck 1789–Rome 1869). Religious subjects, history, portraits. Creator of Nazarene movement. Engraver. Traveled Vienna.

Franz Pforr (Frankfurt 1788–Albano 1812). History, portraits. Traveled Vienna, Rome, Naples.

Franz Riepenhausen (Göttingen 1786–Rome 1831). Religious history, copies of Italian frescoes of the 15th and 16th centuries. Brother of Johann.

Johann Riepenhausen (Göttingen 1788/89–Rome 1860). History, mythological, portraits.

Wilhelm von Schadow (Berlin 1788–Düsseldorf 1862). Religious history, portraits. Writer. Traveled Rome, France.

Johann Evangelist Scheffer von Leonhartshoff (Vienna 1795/96–1822). Religious, portraits. Engraver. Traveled Italy.

Julius Schnorr von Carolsfeld (Leipzig 1794–Dresden 1872). Religious history. Illustrator, professor.

Franz Stecher (Nauders 1814–Innsbruck 1853). Religious, altarpieces.

Philipp Veit (Berlin 1793–Mainz 1877). Painter of religious history and architecture. Traveled Dresden, Munich, Rome.

Georg Ludwig Vogel (Zurich 1788–1879). History, landscapes. Engraver of genre subjects. Traveled Rome, Vienna, Florence.

Joseph Wintergerst (Wallerstein 1783–Düsseldorf 1867). Biblical subjects. Traveled Munich, Vienna, Rome.

American Romantics

Washington Allston (Georgetown, S.C. 1779–Cambridge, Mass. 1843). History, some portraits, classical subjects, religious, and landscapes.

Albert Bierstadt (Solingen near Düsseldorf 1830–New York 1902). Landscapes, Rocky Mountains.

Thomas Birch (London 1779–Philadelphia 1851). Specialist in marine painting, landscapes, portraits.

Thomas Doughty (Philadelphia 1793–New York 1856). Landscapes, both direct and sentimental.

Alvin Fisher (Needham, Ma. 1792–1863). Landscapes, portraits; earlier paintings were of animals and rural genre scenes.

Edward Hicks (Bucks County, Pa. 1780–1849). Landscapes, historical religious. Over 100 versions of the Peaceable Kingdom.

William Morris Hunt (Brattleboro, Vt. 1824–Appledore, Me. 1879). History, genre, landscapes. Illustrator.

Rembrandt Peale (Bucks County, Pa. 1778–Philadelphia 1860). Portraits, historical. Writer.

William Rimmer (Liverpool, England 1816–South Milford, Mass. 1879). Portraits, history. Sculptor, physician.

Robert Salmon (Scotland 1775–c. 1848/51). Moved to Boston 1828. Marine scenes and landscapes.

Thomas Sully (Lincolnshire, England 1783–Philadelphia 1872). History. Created the romantic portrait, leading portraitist in Philadelphia.

Benjamin West (Springfield, Pa. 1738–London 1820). Historical, battles, portraits, romantic and sublime.

Later American Romantics

John La Farge (New York 1835–Providence, R.I. 1910). Stained glass, genre. Watercolorist.

Albert Pinkham Ryder (New Bedford, Mass. 1847–Elmhurst, N.Y. 1917). Landscapes, seascapes, figures, literary. Writer.

Elihu Vedder (New York 1836–Rome 1923). Historical, landscapes, decorations, portraits, fantasy, murals.

Spanish Romantics

Francisco José Goya y Lucientes (Fuente de Todos, Aragon, Spain 1746–Bordeaux, France 1828). Portraits, history, and imaginary themes. One of the great figures of his age.

French Realists

John Constable (East Bergholt, Suffolk 1776–London 1837). Landscapes, religious, history, portraits.

Gustave Courbet (Ornans 1819–La Tour-de-Peilz, Switzerland 1877). Genre, landscapes, portraits.

Honoré Daumier (Marseilles 1808–Valmondois 1879). Paintings, lithographs, and sculptures depicting the tragic side of life. Genre, literary, portraits, religious.

Ignace Henri Jean Théodore Fantin-Latour (Grenoble 1836–Buré 1904). History, genre, portraits, still-lifes. Engraver. Worked with Courbet.

Henri Joseph Harpignies (Valenciennes 1819–St. Privé 1916). Landscapes. Watercolorist.

Edouard Manet (Paris 1832–1883). Realism, genre, mythological, allegorical, portraits. Engraver.

Anton Mauve (Zaandam 1838–Arnhem 1888). Landscapes, animals.

Adolf von Menzel (Breslau 1815–Berlin 1905). Genre, history. Engraver.

Jean François Millet (Gruchy near Greville 1814–Barbizon 1875). Genre, peasant scenes, landscapes, religious, portraits. Draftsman, engraver.

Henri Rousseau (Laval 1844–Paris 1910). Genre, landscapes, imaginary scenes, portraits, jungle scenes, still-lifes.

James Abbott McNeill Whistler (Lowell, Mass. 1834–London 1903). Genre, portraits, landscapes. Engraver, lithographer, writer.

Barbizon School

Rosa Bonheur (Bordeaux 1822–Melun 1899). Landscapes, animals. Sculptor.

Nicolas Louis Cabat (Paris 1812–1893). Landscapes, genre. Engraver.

Antoine Chintreuil (Pont-de-Vaux, Ain 1816–Seine-et-Oise 1873). Landscapes. Pupil of Corot.

Jean Baptiste Camille Corot (Paris 1796–Ville-d'Avray 1875). Landscapes. Some biblical history, literary themes, genre, animals. Engraver.

Charles François Daubigny (Paris 1817–1878). Landscapes. Engraver.

Narcisse Virgile Diaz de Peña (Bordeaux 1808–Menton 1876). Landscapes, genre, mythological portraits. Joined Barbizon in 1840.

Jules Dupré (Nantes 1811–l'Isle Adam 1889). Landscapes. Engraver.

Henre Joseph Harpignies (Valenciennes 1819–St. Privé 1916). Landscapes. Watercolorist. Pupil of Corot.

Charles Emile Jacque (Paris 1813–1894). Landscapes, animals.

Felix Hippolyte Lanoüe (Versailles 1812–1872). Landscapes.

Stanislas Victor Edouard Lépine (Caen 1835–Paris 1892). Landscapes. Specialized in scenes along the Seine. Pupil of Corot.

Jean François Millet (Gruchy near Gréville 1814–Barbizon 1875). Landscapes, genre, some religious and literary themes, portraits. Draftsman, engraver.

Pierre Etienne Théodore Rousseau (Paris 1812–Barbizon 1867). Landscapes, genre. Etcher.

Constant Troyon (Sèvres 1810–Paris 1865). Landscapes, animals, genre.

German, Swiss, and Austrian Realists

Johann Ludwig Aberli (Winterthur 1723–Berne 1786). Picturesque sites. Engraver.

Johann Jakob Biedermann (Winterthur 1763–Aussersihl 1830). Landscapes, portraits, animals. Engraver.

Peter Birmann (Biermann) (Basel 1758–1844). Landscapes, portraits.

Christian Hülfgott Brand (Frankfort-sur-Oder 1695–Vienna 1756). Landscapes, portraits. Father and teacher of Johann.

Johann Christian Brand (Vienna 1722–1795). Landscapes. Engraver.

Johann Jokob Dorner, the Younger (Munich 1775–1852). Landscapes. Engraver.

Erasmus Ritter von Engert (Vienna 1796–1871). History, portraits, landscapes, interiors. Biedermeier school.

Anton Faistenberger (Salzburg 1663–Vienna 1708). Landscapes. Etcher.

Friedrich Gauermann (Miesenbach 1807–Vienna 1862). Landscapes, animals, genre. Biedermeier school.

Johann Conrad Gessner (Zurich 1764–1826). Genre, horses. Son of Swiss poet Salomon Gessner. Engraver, lithographer.

Johann Wolfgang von Goethe (Frankfurt 1749–Weimar 1832). Some landscape paintings. Dilettante painter. Student of Oeser and others. Writer, poet, playwright, philosopher.

Karl Wilhelm Gropius (Brunswick 1793–Berlin 1870). Theater decorations, landscapes.

Ludwig Hess (Zurich 1760–1800). Views of Alps and Italian sites. Engraver of animals and landscapes. Pupil of Salomon Gessner.

Johann Erdmann Hummel (Cassel 1769–Berlin 1852). Landscapes, genre. Engraver.

Johann Christian Klengel (Kesseldorf near Dresden 1751–Dresden 1824). Landscapes with figures, genre, mythological. Engraver.

Ferdinand Kobell (Mannheim 1740–Munich 1799). Landscapes. Engraver of landscapes and genre subjects. Etcher.

Franz Kobell (Franz Innocenz Josef Kobell) (Mannheim 1749–Munich 1822). Landscape and architecture, Roman ruins. Draftsman. Brother of Ferdinand.

Wilhelm von Kobell (Wilhelm Alexander Wolfgang von Kobell) (Mannheim 1766–Munich 1855). Landscapes, battles. Engraver, watercolorist. Son and student of Ferdinand.

Franz Krüger (Köthen 1797–Berlin 1857). Portraits, horses, battles. Engravings of horses, dogs.

Karl Markó, the Elder (Leutzschau 1791–near Florence 1860). Portraits, landscapes.

Karl Markó, the Younger (Budapest 1822–Moscow 1891). Lived in Italy. Landscapes, portraits.

Maximilien de Meuron (Corcelles near Concise 1785–Newchâtel 1868). Landscapes, mountains, the Alps, portraits.

Christoph Nathe (Nieder-Bielau 1753–Schadewalde 1808). Landscapes, portraits, sepia drawings. Watercolorist, etcher.

Adam Friedrich Oeser (Pressburg 1717–Leipzig 1799). Portraits, miniatures, church decorations, frescoes. Sculptor, etcher, professor.

Friedrich Preller, the Elder (Eisenbach 1804–Weimar 1878). Landscapes, marine subjects. Engraver.

Joseph Rebell (Vienna 1787–Dresden 1828). Landscapes. Engraver.

Johann Christian Reinhart (Hof 1761–Rome 1847). Landscapes, portraits. Engraver, pastelist, animal studies. Pupil of Oeser.

Karl Rottman (Handschuhsheim near Heidelberg 1798–Munich 1850). Romantic landscapes, scenes of Bavarian life, Greek landscapes.

Karl Friedrich von Schinkel (Neuruppin 1781–Vienna 1841). Landscapes, theater decorations, architecture, architectural drawings.

Johann Wilhelm Schirmer (Julich 1807–Karlsruhe 1863). Biblical landscapes, Engraver, lithographer.

Christian Georg Schütz, the Elder (Schüz) (Flörsheim 1718–Frankfurt 1791). Landscapes with figures and animals.

Christian Georg Schütz, the Younger. (Flörsheim 1758–Frankfurt 1823). Landscapes, ruins. Nephew and student of Schütz, the Elder.

Johann Conrad Seekatz (Grünstadt 1711–Darmstadt 1768). Genre, history, military, landscapes.

Karl Steffeck (Berlin 1818–1890). History, portraits, animals. Lithographer, engraver.

Franz Steinfeld the Younger (Vienna 1787–Pisck, Bohemia 1868). Landscapes. Lithographer, sculptor, engraver. Biedermeier school.

Wilhelm Steinfeld (Vienna 1816–Ischl 1854). Biedermeier school. Student and son of Franz Steinfeld.

Mattias Rudolf Toma (Vienna 1792–1869). Landscapes. Biedermeier school. Etcher, lithographer.

Max Josef Wagenbauer (Grafing 1774–Munich 1829). Animals, landscapes. Lithographer.

George Augustus Wallis (Merton 1770–Florence 1847). Heroic landscapes with classical figures.

Caspar Wolf (Muri 1735–Mannheim 1798). Alps, landscapes.

Johann Heinrich Wüest (Zurich 1741–1821). Romantic Alps landscapes, genre. Etcher.

Michael Wutky (Krems 1739–Vienna 1823). Austrian-Italiante landscapes.

German Naturalists

Johann Philipp Eduard Gärnter (1801–1877). Landscapes, architecture. Student of Karl Gropius.

Karl Wilhelm Gropius (Brunswick 1793–Berlin 1870). Theater decorations, landscapes.

Johann Erdmann Hummel (Cassel 1769–Berlin 1852). Landscapes, genre. Engraver.

Franz Krüger (Köthen 1797–Berlin 1857). Portraits, horses, battles. Engravings of horses, dogs.

Karl Steffeck (Berlin 1818–1890). History, portraits, animals. Lithographer, engraver.

German Biedermeier Naturalists

Erasmus Ritter von Engert (Vienna 1796–1871). History, portraits, landscapes, interiors.

Friedrich Gauermann (Miesenbach 1807–Vienna 1862). Landscapes, animals, genre.

Franz Steinfeld the Younger (Vienna 1787–Pisck, Bohemia 1868). Landscapes. Lithographer, sculptor, engraver.

Wilhelm Steinfeld (Vienna 1816–Ischl 1854). Student and son of Franz.

Mattias Rudolf Toma (Vienna 1792–1869). Landscapes. Etcher, lithographer.

Danish Naturalists

Dankvart Dreyer (Assens 1816–Barlose near Assens 1852). Landscapes.

Carl Christian Constantin Hansen (Rome 1804–Copenhagen 1880). Religious, history, genre.

Christian Albrecht Jensen (Bredsted 1792–Copenhagen 1870). Portraitist. Engraver.

Christen Schjellerup Kobke (Copenhagen 1810–1848). Landscapes, architecture, portraits, genre, marine life.

Jörgen Roed (Ringsted 1808–1888). Portraits, figures, genre, architecture.

Christian Skovgaard (Peter Kristian Thomsen Skoogaard) (Hammershus near Ringsted 1817–Copenhagen 1875). Landscapes, genre.

Frederick Sodring (Aalborg 1809–Lille Mariendal near Hellerup 1862). Landscapes.

American Realists

Thomas Eakins (Philadelphia 1844–1916). Portraits, genre, realism, some nudes. Sculptor.

William Michael Harnett (Clonakilty, Ireland 1848–New York 1892). Exacting still-lifes, minutely detailed still-lifes, cluttered tabletops, desks, and single objects.

Winslow Homer (Boston 1836–Prout's Neck, Me. 1910). War genre, later landscapes and seascapes. Lithographer, draftsman, watercolorist, illustrator.

John Frederick Peto (Philadelphia 1854–Island Heights, N.J. 1907). Trompe-l'oeil still lifes. Influenced by William Harnett.

Hudson River School

Thomas Cole (Bolton-le-Moors, England 1801–Catskill, N.Y. 1848). Landscapes, views, allegorical, religious. Founder of Hudson River School. Engraver.

Frederick Edwin Church (Hartford, Ct. 1826–New York 1900). Landscapes. Luminist. Pupil of Cole.

Jasper Francis Cropsey (Staten Island, N.Y. 1823–Hastings-on-Hudson, N.Y. 1900). Landscapes. Architect. Influenced by Cole.

Thomas Doughty (Philadelphia 1793–New York 1856). Landscapes. Lithographer.

Asher Brown Durand. See entry under American Naturalists/Illustrators.

Sanford Robinson Gifford (Greenfield, N.Y. 1823–New York 1880). Landscapes, portraits. Luminist.

John Frederick Kensett (Cheshire Ct. 1816–New York 1872). Landscapes. Luminist. Engraver.

Luminists

Frederick Edwin Church (Hartford, Ct. 1826–New York 1900). Landscapes. Pupil of Cole.

Sanford Robinson Gifford (Greenfield, N.Y. 1823–New York 1880). Landscapes, portraits.

Martin Johnson Heade (Lumberville, Pa. 1819–1904). Landscapes, flowers, birds, genre, storms, seascapes, marshes.

George Inness (Newburgh, N.Y. 1825–Scotland 1894). Real and imaginary landscapes. Engraver.

John Frederick Kensett (Cheshire, Ct. 1816–New York 1872). Landscapes.

Fitz Hugh Lane (Gloucester, Mass. 1804–1865). Seascapes, landscapes, harbor views. Lithographer.

Worthington Whittredge (Springfield, Ohio 1820–Summit, N.J. 1910). Landscapes, portraits, genre. Daguerreotypist.

American Naturalists/Illustrators

Edwin Austin Abbey (Philadelphia 1852–London 1911). History, English themes, Shakespearean subjects. Muralist.

John James Audubon (Les Cayes, Haiti 1785–New York 1851). Portraits, birds, plants, flowers, animals. Illustrator.

George Caleb Bingham (Augusta County, Va. 1811–Kansas City, Mo. 1879). Genre, river, and political scenes, some portraits. Traveled Düsseldorf.

Robert Frederick Blum (Cincinnati 1857–New York 1903). Illustrator for *Scribner's Magazine*, mostly Japanese scenes. Painter of frescoes. Engraver.

Alfred Laurens Brennan (Louisville, Ky. 1853–Brooklyn, N.Y. 1921). Illustrator, engraver.

Dennis Miller Bunker (Garden City, N.Y. 1861–1890). Figures, portraits.

Andrew Fisher Bunner (New York 1841–1897). Landscape paintings, pen-and-ink drawings.

George Catlin (Wilkes-Barre, Pa. 1796–Jersey City, N.J. 1872). Portraits of American Indians and scenes of their lives, landscapes of American West.

John Gadsby Chapman (Alexandria, Va. 1808–Brooklyn, N.Y. 1889). Portraits, history, Roman landscapes. Illustrator, writer. Traveled Italy.

Walter Appleton Clark (Worcester, Mass. 1876–New York 1906). Sculptor.

Thomas Cole (Bolton-le-Moors, England 1801–Catskill, N.Y. 1848). Landscapes. Founder of Hudson River School.

Joseph Clement Coll (Philadelphia 1881–1921).

Nathaniel Currier (Roxbury, Mass. 1813–New York 1888). Lithographic illustrator: topical landscapes, genre, sports.

Felix Octavius Carr Darley (Philadelphia 1822–Claymore, Del. 1888). Illustrator of works by Cooper, Dickens, and Hawthorne. Later painter of genre, portraits, and historical scenes.

Asher Brown Durand (Jefferson Village, N.Y. 1796–1886). Landscapes. Hudson River School. Engraver.

Henry Farny (Ribeauvillé, France 1847–1916). Painter and illustrator of North American Indians.

Harry Fenn (Richmond, England 1845–Montclair, N.J. 1911). Illustrator, genre scenes. Watercolorist.

Arthur Burdet Frost (Philadelphia 1851–1929). Humorous illustrations and drawings.

George Hawley Hallowell (Boston 1872–1926). Decorative sketches for altarpieces. Painter and architect.

George Peter Alexander Healy (Boston 1813–Chicago 1894). Portraits, history, landscapes. Traveled Paris.

Edward Hicks (Bucks County, Pa. 1780–1849). Landscapes, historical and religious. Earlier, coach, sign, and ornament painter.

Winslow Homer (Boston 1836–Prout's Neck, Me. 1910). Worked for *Harper's Weekly* and *Ballou's Pictorial*. Painter of genre, landscapes, and seascapes. Watercolorist, draftsman, lithographer. Illustrator of military scenes and cartoons.

William Morris Hunt (Brattleboro, Vt. 1824–Appledore, N.H. 1879) History, allegorical, genre, landscapes.

Henry Inman (Utica, N.Y. 1801–New York 1846). Portraits, landscapes, genre, miniatures. Traveled Europe. Illustrator.

William Robinson Leigh (Berkeley, Ct. 1866–1955). Scenes of American life, genre.

William James Linton (London 1812–New Haven, Ct. 1898). Wood engraver.

William Sidney Mount (Setauket, Long Island, N.Y. 1807–New York 1868). Genre, rural life in Long Island, portraits, religious history. Pupil of Henry Inman.

Thomas Nast (Landau, Germany 1840–Guayaquil, Ecuador 1902). Draftsman for American magazines and newspapers. Caricaturist.

William Page (Albany, N.Y. 1811–Tottenville, Staten Island, N.Y. 1885). Portraits, genre, classical and religious history, landscapes. Illustrator.

Maxfield Frederick Parrish (Philadelphia 1870–1966). Covers for magazines and publicity posters.

Joseph Pennel (Philadelphia 1857–Brooklyn, N.Y. 1926). Landscapes. Engraver.

Howard Pyle (Wilmington, Del. 1853–Florence, Italy 1911). Landscapes, portraits. Draftsman, illustrator, painter, writer.

John Quidor (Tappan, N.Y. 1801–Jersey City, N.J. 1881). Literary, genre. Illustrator.

Charles Stanley Reinhart (Pittsburgh, Pa. 1844–New York 1896). Genre. Illustrator.

Frederic Remington (Canton, N.Y. 1861–Ridgefield, Ct. 1909). Illustrator for *Harper's Weekly, Century, Outing*—Western scenes. Painter, sculptor, writer.

William Rimmer (Liverpool, England 1816–South Milford, Mass. 1879). History, battle, fantasy pictures, portraits. Sculptor, physician.

William Allen Rogers (Springfield, Ohio 1854–Washington, D.C. 1913). Caricatures.

Charles Marion Russell (Oak Hill, Mo. 1864–Great Falls, Mt. 1926). Western scenes in *Harper's Weekly*. Painter of the West. Sculptor.

Gerald Henderson Thayer (Cornwall-on-Hudson 1883–1935). Illustrator, painter, writer.

Thure (Brouthur) Thulstrup (Stockholm 1848–New York 1930). Illustrator of Civil War for military newspapers.

Elihu Vedder (New York 1836–Rome 1923). Allegorical, symbolic scenes, some landscapes. Muralist, symbolist.

A. R. Waud (1828–1891). Principle military artist for *Harper's Weekly*.

Alexander Wilson (Paisley, Scotland 1766–Philadelphia 1813). Ornithology. Engraver, draftsman, illustrator.

Newell Convers Wyeth (Needham, Mass. 1882–?). Generally worked in oil. Genre scenes. Pupil of Howard Pyle.

American Genre Painters

Daniel Huntington (New York 1816–1906). Portrait specialist, history, genre.

Eastman Johnson (Lovell, Me. 1824–New York 1906). Portraits, genre, rural life, landscapes.

Emanuel Leutze (Gmünd, Germany 1816–Washington, D.C. 1868). History, genre. Düsseldorf School.

Richard Caton Woodville (Baltimore, Md. 1825–London 1855). History, battle scenes.

American Barbizon Painters

William P. Babcock (Boston 1826–Bois d'Arcy, France 1899). Figures, classical, biblical, still-lifes.

Winkworth Alban Gay (Hingham, Mass. 1821–1910). Landscapes. Pupil of Constant Troyon.

William Morris Hunt (Brattleboro, Vt. 1824–Appledore, Me. 1879). Landscapes with animals and children.

George Inness (Newburgh, N.Y. 1825–Scotland 1894). Leading American Barbizon painter, landscapes.

Daniel Ridgway Knight (Philadelphia 1839–Paris 1924). Landscapes, genre.

Dwight William Tryon (Hartford, Ct. 1849–South Dartmouth 1925). Landscapes, seascapes.

Alexander Helwig Wyant (Evans Creek, Ohio 1836–New York 1892). Landscapes.

Painters of Contemporary Society

Albert Besnard (Paris 1849–1934). Portraits, views, street scenes.

Richard Parkes Bonington (Arnold, near Nottingham, England 1802–London 1828). Views, landscapes, seascapes, portraits.

Lady Elizabeth Thompson Butler (Lausanne 1844/51–1933). Lived in England. Military scenes, soldiers. Watercolorist.

William Merritt Chase (Williamsburg, Ind. 1849–New York 1916). Portraits, beach and field scenes, genre, interiors.

William Dyce (Aberdeen, Scotland, 1806–London 1864). Figures, portraits, landscapes, frescoes.

William Powell Frith (Studley, Yorkshire, England 1819–London 1909). Recorded festivals, portraits, genre. Watercolorist.

Paul César Helleu (Vannes, France 1859–Paris 1927). Genre, daily life, portraits.

Daniel Maclise (Cork, Ireland 1811–London 1870). History, genre, portraits.

William Mulready (Ennis, Ireland 1786–Bayswater 1863). Battles, parks, landscapes.

William McGregor Paxton (Baltimore, Md. 1869–1941). Genre, portraits, murals, celebrities of Philadelphia and Boston.

Richard Redgrave (Pimlico, England 1804–London 1888). Outdoors, portraits. Engraver, watercolorist.

John Singer Sargent (Florence, Italy 1856–London 1925). Portraits, interiors, landscapes.

Walter Richard Sickert (Munich 1860–Bath, England 1942). Portraits, landscapes, seascapes.

Alfred Stevens (Blandford 1823–London 1875). Portraits, genre.

Marcus C. Stone (London 1840–1921). Historical, genre. Illustrator.

William Strutt (London 1826–1915). Genre, portraits. Watercolorist.

James Joseph Jacques Tissot (Nantes 1836–Buillon 1902). Historical, fashionable genre, landscapes, portraits. Draftsman, etcher.

Edward Matthew Ward (Pimlico, England 1816–Windsor 1879). Military scenes, royalty portraits.

Sir David Wilkie (Cults near Edinburgh, 1785–died at sea near Malta 1841). Historical, genre, portraits. Etcher.

William Frederick Yeames (Taganrog, U.S.S.R. 1835–Teignmouth, England 1918). Historical, genre.

French Impressionists

Frédéric Bazille (Montpellier 1841–Beaune-la-Rolande 1870). Genre, landscapes, still-lifes, portraits. Killed in combat.

Eugène Louis Boudin (Honfleur 1824–Paris 1898). Seascapes, landscapes, portraits, still-lifes. Exhibition of 1847.

Félix Bracquemond (Paris 1833–1914). Birds, seascapes, landscapes, portraits. Exhibition of 1847. Engraver.

Gustave Caillebotte (Paris 1848–Argenteuil 1894). Contemporary scenes, genre, landscapes, portraits.

Paul Cézanne (Aix-en-Provence 1839–1906). Still-lifes, landscapes, genre, portraits. Exhibition of 1847.

Hilaire Germain Edgar Degas (Paris 1834–1917). Dancers, ballet scenes, genre, portraits. Pastelist, engraver, lithographer, sculptor.

Ignace Henri Jean Théodore Fantin-Latour (Grenoble 1836–Buré 1904). Historical, genre, mythological, portraits, still-lifes. Engraver.

Eva Gonzales (Paris 1850–1883). Figures, portraits, still-lifes. Pastelist.

Jean Baptiste Armand Guillaumin (Moulins 1841–Paris 1927). Landscapes, genre, portraits. Pastels.

Johann Barthold Jongkind (Latrop near Rotterdam 1819–Côte-Saint-André, Isère 1891). Landscapes, seascapes, portraits. Watercolorist, engraver.

Stanislas Victor Edouard Lepine (Caen 1835–Paris 1892). Landscapes. Exhibition of 1847. Pupil of Corot.

Edouard Manet (Paris 1832–1883). Genre, portraits, still-lifes. Engraver.

Alfred Meyer (Paris 1832–1904). Exhibition of 1847. Enameler.

Claude Oscar Monet (Paris 1840–Giverny 1926). Landscapes, seascapes, figures, views, portraits. Exhibition of 1847.

Berthe Morisot (Bourges 1841–Paris 1895). Landscapes, figures, portraits, genre. Exhibition of 1847. Engraver, lithographer.

Camille Pissarro (Saint Thomas, West Indies 1830–Paris 1903). Contemporary life, genre, views of figures, landscapes, seascapes. Exhibition of 1847. Draftsman, engraver.

Pierre Auguste Renoir (Limoges 1841–Cagnes 1919). Contemporary life,

genre, figures, portraits, still-lifes, landscapes. Exhibition of 1847. Pastelist, engraver, sculptor.

Georges Seurat (Paris 1859–1891). Pointillist. Landscapes, genre, "Grande Jatte" scenes, portraits, military. Draftsman.

Alfred Sisley (Paris 1839–Moret-sur-Loing 1899). Landscapes, views. Exhibition of 1847. Etcher, lithographer.

Vincent Willem van Gogh (Groot-Zundert, Netherlands, 1853–Auvers, France 1890). Landscapes, genre, interiors, portraits, still-lifes.

Neo-Impressionists

Charles Angrand (Criquetot-sur-Ouville 1854–Rouen 1926). Pointillist. Genre, landscapes. Pastelist, draftsman, charcoal.

Henri Edmond Cross (Henry Delacroix) (Douai 1856–Saint-Clair 1910). Landscapes, gardens, flowers, genre, figures in landscapes.

Maximilien Luce (Paris 1858–1941). Pointillist, landscapes, views, genre. Draftsman, lithographer.

Albert Dubois-Pillet (Paris 1845–LePuy 1890). One of the founders of Salon des Indépendants in 1884. Landscapes, views, flowers, portraits.

Georges Pierre Seurat (Paris 1859–1891). Pointillist. Landscapes, genre, "Grande Jatte" scenes, portraits, military. Draftsman.

Paul Signac (Paris 1863–1935). Seascapes, landscapes, still-lifes. Lithographer.

American Impressionists

Frank Weston Benson (Salem, Mass. 1862–1951). Ladies in gardens, mural decorations for Library of Congress, still-lifes, sporting scenes, etchings of hunting fowl.

Dennis Miller Bunker (New York 1861–1890). Portraits, landscapes. Pupil of William Merritt Chase.

Theodore Earl Butler (1876–1937). Portraits, landscapes, gardens. Pupil of Claude Monet.

Joseph de Camp (Cincinnati 1858–BocaGrande, Fla. 1923). Genre, portraits.

Mary Cassatt (Allegheny, Pa. 1845–Oise Mesnil-Théribus near Beauvais 1926). Mother-and-child themes, genre, contemporary life, landscapes, portraits. Engraver, pastelist.

William Merritt Chase (Williamsburg, Ind. 1849–New York 1916). Portraits, still-lifes, landscapes, interiors.

Charles Harold Davis (Amesbury, Mass. 1856–1933). Landscapes.

Thomas Wilmer Dewing (Boston 1851–1938). Figures, women.

Frank Duveneck (Covington, Ky. 1848–Cincinnati 1919). Figures, portraits, landscapes.

William James Glackens (Philadelphia 1870–Westport, Ct. 1938). Newspaper

illustrator; park and cafe scenes, landscapes, figure compositions, still-lifes. Illustrator, graphic artist.

Arthur Clifton Goodwin (Portsmouth, N.H. 1866–c. 1915). Views and scenes of Boston and New York City, genre. Illustrator.

Childe Hassam (Dorchester, Mass. 1859–East Hampton, N.Y. 1935). Landscapes, town views, genre, street scenes, interiors. Wood engravings, watercolors.

George Inness (Newburgh, N.Y. 1825–Scotland 1894). Landscapes.

Ernest Lawson (San Francisco 1873–New York 1939). Landscapes, street scenes.

Homer Dodge Martin (Albany, N.Y. 1836–St. Paul, Mn. 1897). Landscapes.

Willard Leroy Metcalf (Lowell, Mass. 1853–New York 1925). Landscapes. Illustrations of figures and flowers.

Lila Cabot Perry (Boston 1848–1933). Portraits, figures, landscapes. Writer.

Edward Willis Redfield (Bridgeville, Pa. 1869–1965). Landscapes, winter scenes.

Robert Reid (Stockbridge, Mass. 1862/63–Clifton Springs, N.Y. 1929). Genre, figures, landscapes. Primarily a muralist.

Theodore Robinson (Irasburg, Vt. 1852–New York 1896). Rustic subjects, landscapes, figures.

John Singer Sargent (Florence 1856–London 1925). Portraits, landscapes, interiors, genre. Drawings, watercolors.

Emerson Edward Simmons (Cambridge, Mass. 1852–Baltimore, Md. 1931). Mural decorations.

Edmund Charles Tarbell (West Groton, Mass. 1862–New Castle, N.H. 1938). Genre, figures, portraits, still-lifes, interiors.

John Henry Twachtman (Cincinatti, Ohio 1853–Gloucester, Mass. 1902). Landscapes. Etcher, pastelist.

Julian Alden Weir (West Point, N.Y. 1852–New York 1919). Figures, landscapes. Etcher, pastelist.

James Abbott McNeill Whistler (Lowell, Mass. 1834–London 1903). Portraits, figures, genre, landscapes. Printmaker, engraver, lithographer, writer.

Alexander Helwig Wyant (Evans Creek, Ohio 1836–New York 1892). Landscapes.

Symbolists

Edmond Francois Aman-Jean (Chevry-Cossigny, Sein-et-Marne 1860–Paris 1935). Portraits, genre, still-lifes. Engraver, lithographer, pastelist.

Emile Antoine Bourdelle (Montauban 1861–Vésinet near Paris 1929). Painter of mythological scenes, genre, portraits. Sculptor of busts, bronzes. Draftsman.

Sir Edward Coley Burne-Jones (Birmingham 1833–London 1898). Religious, allegorical, mythological, genre. Engraver.

Aubrey Vincent Beardsley (Brighton 1872–Menton 1898). Illustrations for *Madame Bovary, Manon Lescaut,* and Oscar Wilde's *Salome.* Draftsman.

Eugène Carrière (Gournay 1849–Paris 1906). Mother-and-child themes, genre, children, portraits, women.

Jean Delville (Louvain 1867–Brussels 1953). Grand Prix de Rome 1895. Biblical subjects.

Maurice Denis (Granville 1870–Paris 1843). Genre, religious, portraits. Writer on art, engraver.

James Ensor (Ostend 1860–1949). Portraits, landscapes, genre, still-lifes. Engraver, writer.

Charles Filiger (Thann 1863–Brest 1928). Landscapes, religious, mystical. Engraver, musician.

Paul Gauguin (Paris 1848–Hiva-Hoa, Marquesas Islands 1903). Genre, portraits, still-lifes, landscapes, Tahitian life. Ceramicist, engraver, wood sculptor.

Ferdinand Hodler (Bern 1853–Geneva 1918). Historical, genre, portraits, landscapes.

Augustus Edwin John (Tenby, Wales 1878–Fordingbridge, Hampshire, 1961). Figures, portraits, landscapes, still-lifes, murals.

Fernand Khnopff (Grembergen 1858–Brussels 1921). Religious, mythological, landscapes, genre. Pastelist, sculptor, lithographer.

Gustav Klimt (Baumergarten near Vienna 1862–Vienna 1918). Religious, portraits, landscapes.

Max Klinger (Leipzig 1857–Grossjena near Nuremberg 1920). Religious, historical, genre, mythological, landscapes.

Georges Lacombe (Versailles 1868–Alençon 1916). Portraits. Sculptor of busts, wood reliefs.

Georges Minne (Ghent 1866–Laethem-Saint-Martin 1941). Portraits, mother-and-child themes, genre. Sculptor and draftsman.

Gustave Moreau (Paris 1826–1898). Historical, biblical, classical.

Edvard Munch (Loïten, Norway 1863–Ekely, Norway 1944). Genre, landscapes, portraits. Engraver, lithographer.

Alphonse Osbert (Paris 1857–1939). Portraits, landscapes, genre. Showed in all six Salons de la Rose and Croix exhibitions.

Pablo Picasso (Málaga, Spain 1881–Mougins, Alpes-Maritimes 1973). Portraits, still-lifes, animals, landscapes, genre, interiors. Sculptor, engraver, ceramicist.

Armand Point (Algiers 1860/61–Marlotte, France 1932). Figures, portraits, mythological.

Pierre Puvis de Chavannes (Lyons 1824–Paris 1898). Religious, allegorical, mythological, genre, portraits.

Paul Ranson (Limoges 1864–Paris 1909). Tapestry cartoons, genre, biblical.

Odilon Redon (Bordeaux 1840–Paris 1916). Still-lifes, mythological, genre, religious. Lithographer, pastelist, watercolorist, draftsman in charcoal.

Auguste Rodin (Paris 1840–Meudon 1917). Sculptor. Statues, statuettes, busts. Literary, mythological, religious, portraits.

Félicien Rops (Namur, Belgium 1833–Oise, France 1898). Religious, genre, portraits, landscapes. Frontpieces, posters, caricatures. Draftsman, engraver, lithographer, etcher, writer.

Georges Seurat (Paris 1859–1891). Pointillist. Landscapes, genre, "La Grande Jatte" scenes, portraits, military. Draftsman.

Johann (Jan) Theodorus Toorop (Poerworedjo, Java 1858–The Hague 1928). Genre, landscapes, mythological. Engraver.

Vincent Willem van Gogh (Groot-Zundert, Netherlands 1853–Auvers, France 1890). Landscapes, interiors, portraits, still-lifes, genre.

Edouard Vuillard (Cuiseaux 1868–La Baule 1940). Interiors, genre, landscapes, still-lifes.

The Nabis
(Symbolists active in Paris, 1889–1900)

Pierre Bonnard (Fontenay-aux Roses, near Paris 1867–Cannet 1947). Modern life, genre, landscapes, still-lifes. Lithographer.

Maurice Denis (Granville 1870–Paris 1943). Religious, poetic, still-lifes, landscapes, genre. Engraver, writer on art.

Henri Gabriel Ibels (Paris 1867–1936). Journal illustrations, posters, genre, landscapes. Pastelist, lithographer, caricaturist, writer.

Aristide Maillol (Banyuls-sur-Mer 1861–Banysuls-sur-Mer 1944). Nudes, figures, genre, classical. Sculptor.

René Piot (Paris 1869–1934). Painter and decorator of theaters. Murals, genre, landscapes, still-lifes.

Paul Ranson (Limoges 1864–Paris 1909). Painter, tapestry cartoons, genre, biblical themes.

Josef Rippl-Ronaïi (Kaposvar, Hungary 1861–Budapest 1930). Genre, contemporary life, portraits. Engraver, art critic, pastelist.

Ker Xavier Roussel (Lorry-les-Metz 1867–L'Etang-la-Ville 1944). Still-lifes, landscapes, mythological, scenes, genre. Engraver, pastelist.

Paul Sérusier (Paris 1863–Morlaix 1927). Genre, landscapes, still-lifes.

Félix Edmond Vallotton (Lausanne 1865–Paris 1925). Genre, figures, landscapes, still-lifes, portraits. Engraver, sculptor.

Jan Verkade (Zaandam, Holland 1868–Beuron Monastery, Germany 1946). Murals for a Benedictine monastery in 1893, religious themes, genre.

_____ DRAWING _____

French Illustrators, Genre Artists, Caricaturists

Gustave Paul Doré (Strasbourg 1832–Paris 1883). Genre, caricatures, cartoons. Draftsman, engraver, painter, sculptor.

Gavarni (Guillaume Sulpice, Chevalier) (Paris 1804–1866). Lithographic illustrations, wood engravings, fashion plates, French life from high society to old age.

Sean Grandville (Ignace-Isidore Gérard) (Nancy 1803–Vanves 1847). Illustrated fantasy, animals in human dress, social satire, visionary, dreams. Watercolorist.

(Ernest Adolphe Hyacinthe) Constantin Guys (Flushing, Holland 1802–Paris 1892). Specialized in drawing military imagery. Dark side of life, prostitutes, genre.

English Watercolorists

William Blake (London 1757–1827). Literary.

Richard Parkes Bonington (Arnold near Nottingham 1802–London 1828). Genre, views, architectural topography, figures.

Thomas Shotter Boys (Pentonville, 1803–near London 1874). Landscapes.

Edward Francis Burney (Worcester 1760–London 1848). Satires of musical events, genre.

William Callow (Greenwich 1812–Great Missenden, Buckinghamshire 1908) Views of architecture, landscapes.

Edward Calvert (Appledore, Devon 1799–Hackney 1883). Landscapes with literary themes.

John Constable (East Bergholt, Suffolk 1776–London 1837). Landscapes, views.

John Sell Cotman (Norwich 1782–London 1842). Genre, architecture, landscapes.

David Cox (Birmingham 1783–Harborne near Birmingham 1859). Views, landscapes.

Joshua Cristall (Camborne, Cornwall 1768–London 1847). Landscapes.

Francis Danby (County Wexford, Ireland 1793–Exmouth 1861). Landscapes, views.

Peter De Wint (Stone, Staffordshire 1784–London 1849). Landscapes, views, still-lifes, genre.

Joseph Farington (Leigh, Lancashire 1747–near Manchester 1821). Views, landscapes.

Anthony Vandyke Copley Fielding (East Sowerby, Yorkshire 1787–Worthing near Brighton 1855). Views, landscapes, literary.

Myles Birket Foster (North Shields, Northumberland 1825–Weybridge, Surrey 1899). Landscapes, rustic scenes.

Henry Fuseli (Johann Heinrich Fussli) (Zurich 1741–Putney Hill, England 1825). Literary, genre.

Thomas Girtin (Southwark, London 1775–London 1802). Architectural views, landscapes.

John Glover (Houghton-on-the-Water, Leicester 1767–Launceston, Tasmania 1849). Landscapes.

William Havell (Reading 1782–Kensington 1857). Landscapes, views.

Thomas Hearne (Brinkworth, Wiltshire 1744–London 1817). Landscapes, views.

Robert Hills (Islington 1769–London 1844). Animals, landscapes, views.

William Henry Hunt (London 1790–1864). Architectural topography, portraits, still-lifes, genre.

Samuel Jackson (Bristol 1794–Clifton 1869). Landscapes.

Edward Lear (London 1812–San Remo, Italy 1888). Landscapes, birds.

John Frederick Lewis (London 1805–Walton-on-Thames 1876). Oriental subjects, genre, animals, architecture.

John Linnell (London 1792–Redhill 1882). Landscapes.

Paul Sandby Munn (Greenwhich 1773–Margate 1848). Landscapes.

Francis Nicholson (Pickering, Knaresborough, Whitby 1753–London 1844). Portraits, topographic views.

Samuel Palmer (London 1805–Redhill 1881). Landscapes, literary.

Samuel Prout (Plymouth 1783–Camberwell 1852). Picturesque architecture.

James Baker Pyne (Bristol 1800–London 1870). Landscapes.

George Fennel Robson (Durham 1788–London 1833). Landscapes.

Thomas Rowlandson (London 1756–1827). Architecture, genre, portraits, allegorical.

Paul Sandby (Nottingham 1725–London 1809). Figures, genre, topographical.

John "Warwick" Smith (Irthington 1749–London 1831). Landscapes.

George Stubbs (Liverpool 1724–London 1806). Sporting events, portraits, genre, animals (horses and dogs), conversation pieces.

Francis Towne (Exeter 1739/40–London 1816). Landscapes.

Joseph Mallord William Turner (London 1775–Chelsea 1851). Landscapes, views, architecture, genre.

William Turner of Oxford (Oxfordshire 1789–Woodstack 1862). Landscapes.

John Varley (London 1778–1842). Landscapes, views, topographical.

Richard Westall (Hertford 1765–London 1836). Genre, mythological.

Francis Wheatley (London 1747–1801). Genre, fair scenes.

American Artist-Illustrators

Edwin Austin Abbey (Philadelphia 1852–London 1911). History, English themes; Shakespearean subjects. Also muralist.

Robert Frederick Blum (Cincinnati 1857–New York 1903). Illustrator for *Scribner's Magazine*, mostly Japanese scenes. Painter of frescoes, engraver.
Alfred Laurens Brennan (Louisville, Ky. 1853–Brooklyn, N.Y. 1921). Illustrator, engraver.
Dennis Miller Bunker (Garden City, N.Y. 1861–1890). Figures, portraits.
Andrew Fisher Bunner (New York 1841–1897). Landscape paintings, pen-and-ink drawings.
Walter Appleton Clark (Worcester Mass. 1876–New York 1906). Sculptor.
Joseph Clement Coll (Philadelphia 1881–1921).
Felix Octavius Carr Darley (Philadelphia 1822–Claymore, Del. 1888). Illustrator of works by Cooper, Dickens, Hawthorne. Painter of portraits, history, genre.
Henry Farny (Ribeauville 1847–1916). Painter and illustrator of North American Indians.
Harry Fenn (Richmond, England 1845–Montclair, N.J. 1911). Illustrator, genre, watercolors.
Arthur Burdett Frost (Philadelphia 1851–1929). Humorous illustrations and drawings.
George Hawley Hallowell (Boston 1872–1926). Decorative sketches for an altarpiece. Painter and architect.
Winslow Homer (Boston 1836–Prout's Neck, Me. 1910). Worked for *Harper's Weekly* and *Ballou's Pictorial*. Painter, watercolorist, draftsman, lithographer.
William Morris Hunt (Brattleboro, Vt. 1824–Appledore, Me. 1879). Historical, allegorical, genre, landscape.
William Robinson Leigh (Berkeley, Ct. 1866–1955). American life.
William James Linton (London 1812–New Haven, Ct. 1897). Wood engraver.
Thomas Nast (Landau, Germany 1840–Guayaquil, Ecuador 1902). Draftsman for American magazines and newspapers. Caricaturist.
Maxfield Frederick Parrish (Philadelphia 1870–1966). Covers for magazines and publicity posters.
Joseph Pennel (Philadelphia 1857–Brooklyn, N.Y. 1926). Landscapes. Painter, engraver.
Howard Pyle (Wilmington, Del. 1853–Florence, Italy 1911). Landscapes, portraits. Draftsman, illustrator, painter, writer.
Charles Stanley Reinhart (Pittsburgh 1844–New York 1896). Genre, illustrations.
William Rimmer (Liverpool, England 1816–South Milford, Mass. 1879). History, battles, fantasy pictures, portraits. Sculptor, physician.
Frederic Remington (Canton, N.Y. 1861–Ridgefield, Ct. 1909). Illustrator for *Harper's Weekly, Century, Outing*—Western scenes. Painter, sculptor, writer.
William Allen Rogers (Springfield, Ohio 1854–Washington, D.C. 1913). Caricatures.

Charles Marion Russell (Oak Hill, Mo. 1864–Great Falls, Mt. 1926). Western scenes in *Harper's Weekly*. Painter of the West. Sculptor.

Gerald Henderson Thayer (Cornwall-on-Hudson 1883–1935). Illustrator, painter, writer.

Thure (Brouthur) Thulstrup (Stockholm 1848–New York 1930). Illustrator of Civil War scenes for military newspapers.

Elihu Vedder (New York 1836–Rome 1923). Allegorical, symbolic scenes, landscapes. Muralist, symbolist.

A. R. Waud (1828–1891). Principle war artist for *Harper's Weekly*.

Newell Convers Wyeth (Needham, Mass. 1882–?). Generally worked in oil. Genre scenes. Pupil of Howard Pyle.

PRINTMAKING

Lithographers

Victor Jean Adam (Paris 1801–Virofly 1866).

Antoine Louis Barye (Paris 1796–1875).

Aubrey Vincent Beardsley (Brighton 1872–Menton 1898).

Pierre Bonnard (Fontenay-aux-Roses, near Paris 1867–Le Cannet 1947).

Rodolphe Bresdin (Montrelais near Ingrande, Inférieure 1822–Sèrvres 1885).

Cham (Amédée de Noe) (Paris 1819–1879).

Nicolas Toussaint Charlet (Paris 1792–1845).

Jules Chéret (Paris 1836–Nice 1931).

Jean Baptiste Camille Corot (Paris 1796–Ville-d'Avray 1875).

Honoré Daumier (Marseilles 1808–Valmondois 1879).

Jules David (Paris 1808–1892).

Alexandre Gabriel Decamps (Paris 1803–Fontainebleau 1860).

Hilaire Germain Edgar Degas (Paris 1834–1917).

Eugène Delacroix (Charenton 1798–Paris 1863).

Jean Louis Demarne (Brussels 1744–Paris 1829).

Eugène François Maris Joseph Devéria (Paris 1808–Pau 1865).

Gustave Paul Doré (Strasbourg 1832–Paris 1883).

Ignace Henri Jean Théodore Fantin-Latour (Grenoble 1836–Buré 1904).

Gustav Heinrich Gottlob Feckert (Cottbus 1820–Berlin 1899).

Newton Fielding (Huntington, Yorkshire, England 1799–Paris 1856).

Gavarni (Guillaume Sulpice Chevalier) (Paris 1804–1866).

Théodore Géricault (Rouen 1791–Paris 1824).

Anne Louis Girodet de Roucy Trioson (Montargis 1767–Paris 1824).

Francisco José Goya y Lucientes (Fuente de Todos, Aragon, Spain 1746–Bordeaux, France 1828).

Sean Grandville (Ignace-Isidore Gérard) (Nancy 1803–Vanves 1847).

Baron Antoine Jean Gros (Paris 1771–Sèvres 1835).

Jules Alexandre Grün (Paris 1868–1934).

Charles François Prosper Guérin (Sens 1875–Paris 1939).
James Duffield Harding (Deptford, England 1798–Barnes 1863).
Louis Pierre Henriquel-Dupont (Paris 1797–1892).
Louis Adolphe Hervier (Paris 1818–1879).
Paul Huet (Paris 1803–1869).
Jean Baptiste Isabey (Nancy 1767–Paris 1855).
Friedrich Jentzen (Berlin 1804–Weimar 1875).
Fritz Kriehuber (Vienna 1836–1871).
Eugen Krüger (Altona 1832–Dûsternbrook 1876).
Eugène Louis Lami (Paris 1800–1890).
Louis Lepoittevin (Neuville-Champ-d'Oisel 1847–1909).
Friedrich Johann Gottlieb Lieder called Franz (Potsdam 1780–Pest 1859).
Edouard Manet (Paris 1832–1883).
Jean Henri Marlet (Autun 1771–1847).
Adolf von Menzel (Breslau 1815–Berlin 1905).
Achille Etna Michallon (Paris 1796–1822).
Henry Monnier (Paris 1805–1877).
Alphonse Mucha (Ivancice, Moravia 1860–Prague 1939).
Edvard Munch (Loïten, Norway 1863–Ekely, Norway 1944).
Eugen Napoleon Neureuther (Munich 1806–1882).
Sir William Nicholson (Newark-on-Trent 1872–Blewbury 1949).
Joseph Denis Odevaere (Dionysius) (Bruges 1778–Brussels 1830).
Edme Jean Pigal (Paris 1798–Sens 1872).
Camille Pissarro (Saint Thomas, West Indies 1830–Paris 1903).
John Skinner Prout (Plymouth 1806–London 1876).
James Ferrier Pryde (Edinburgh 1866/69–London 1941).
Denis Auguste Marie Raffet (Paris 1804–Genoa 1860).
Odilon Redon (Bordeaux 1840–Paris 1916).
Pierre Auguste Renoir (Limoges 1841–Cagnes 1919).
François Rude (Dijon 1784–Paris 1855).
Moritz von Schwind (Vienna 1804–Munich 1871).
Georges Seurat (Paris 1859–1891).
Théophile Alexandre Steinlen (Lausanne 1859–Paris 1923).
Rodolphe Töpffer (Geneva 1799–1846).
Henri de Toulouse-Lautrec (Albi 1864–Malromé 1901).
Joseph Travies de Villers (Winterthur 1804–Paris 1859).
Antoine Charles Horace (Carle) Vernet (Bordeaux 1759–Paris 1836).
Emile Jean Horace Vernet (Paris 1789–1863).
Edouard Vuillard (Cuiseaux 1868–La Baule 1940).
Edouard Wattier (Lille 1793–Paris 1871).
Emile Wattier (Paris 1800–1868).
Benjamin West (Springfield, Pa. 1738–London 1820).
James Abbott McNeill Whistler (Lowell, Mass. 1834–London 1903).

ETCHERS

Jacques Beltrand (Paris 1874–?).
Albert Besnard (Paris 1849–1934).
William Blake (London 1757–1827).
Eugène Louis Boudin (Honfleur, France 1824–Paris 1898).
Henri Boutet (Sainte-Hermine 1851–?).
Félix Bracquemond (Paris 1833–1914).
Henri de Braekeleer (Antwerp 1840–1888).
Rodolphe Bresdin (Montrelais near Ingrande, Loire-Inférieure 1822–Sèvres 1885).
Félix Hilaire Buhot (Valognes, Manche 1847–Paris 1898).
Eugène Carrière (Gournay 1849–Paris 1906).
Mary Cassatt (Allegheny City, Pa. 1844–Mesnil-Théribus, near Beauvais 1926).
Théodore Chasseriau (Samaná, Hispaniola 1819–Paris 1856).
Gustave Courbet (Ornans, France 1819–La Tour-de-Peilz, Switzerland 1877).
Honoré Daumier (Marseilles 1808–Valmondois 1879).
Alexandre Gabriel Decamps (Paris 1803–Fontainebleau 1860).
Hilaire Germain Edgar Degas (Paris 1834–1917).
James Ensor (Ostend 1860–1949).
Ignace Henri Jean Théodore Fantin-Latour (Grenoble 1836–Buré 1904).
Jean Louis Forain (Reims 1852–Paris 1931).
Paul César Helleu (Vannes 1859–Paris 1927).
Paul Huet (Paris 1803–1869).
Pierre Georges Jeanniot (Geneva 1848–1934).
Johann Barthold Jongkind (Latrop near Rotterdam 1819–Grenoble 1891).
Louis Auguste Mathieu Legrand (Dijon 1863–Livry-Gargan 1951).
Alphonse Legros (Dijon 1837–Watford near London 1911).
Wilhelm Leibl (Cologne 1844–Würzburg 1900).
Auguste Louis Lepère (Paris 1849–Domme 1918).
Edouard Manet (Paris 1832–1883).
Ernest Meissonier (Lyons 1815–Paris 1891).
Adolf von Menzel (Breslau 1815–Berlin 1905).
Camille Pissarro (Saint Thomas, West Indies 1830–Paris 1903).
Pierre Puvis de Chavannes (Lyons 1824–Paris 1898).
Théodule Ribot (St. Nicolas d'Attez (Eure) 1823–Colombes 1891).
Auguste Rodin (Paris 1840–Meudon 1917).
Francis Seymour Haden (London 1818–Alresford 1910). Over 200 etchings.
François Clément Sommier (Henri Somm) (Rouen 1844–Paris 1907).
Joseph Mallord William Turner (London 1775–Chelsea 1851).
Suzanne Valadon (Bessines, France 1865–Paris 1938).
James Abbott McNeill Whistler (Lowell, Mass. 1834–London 1903).

Woodcut Makers

Thomas Bewick (Cherryburn near Newcastle, England 1753–Gateshead 1828).
Wilhelm Busch (Wiedensah, Germany 1832–Mechtshausen 1908).
Maurice Denis (Granville, France 1870–Paris 1943).
Caspar David Friedrich (Greifswald, Germany 1774–Dresden 1840).
Winslow Homer (Boston 1836–Prout's Neck, Me. 1910).
Edvard Munch (Loïten, Norway 1863–Ekely, Norway 1944).
Sir John Tenniel (London 1820–1914).

Monotype

William Merritt Chase (Williamsburg, Ind. 1849–New York 1916).
Hilaire Germain Edgar Degas (Paris 1834–1917).
Frank Duveneck (Covington, Ky. 1848–Cincinnati 1919).
Jean Louis Forain (Reims 1852–Paris 1931).
Paul Gauguin (Paris 1848–Hiva-Hoa, Marquesas Islands 1903).
Camille Pissarro (Saint Thomas, West Indies 1830–Paris 1903).
Maurice Brazil Prendergast (St. John's, Newfoundland 1859–New York 1924).
Théophile Alexandre Steinlen (Lausanne 1859–Paris 1923).
Charles Alvah Walker (London, N.H. 1848–Brookline, Mass. 1920).

SCULPTURE

French Sculptors

Louise Abbéma (Etampes 1858–Paris 1927). Portraits, medals, still-lifes, landscapes. Pastelist, watercolorist, oils.
Zacharie Astruc (Angers 1835–Paris 1907). Portrait busts, medallions.
Jean Auguste Barre (Paris 1811–1896). Mythological and allegorical figures, religious sculptures, portrait medallions, busts, statuettes, statues.
Louis Ernest Barrias (Paris 1841–1905). Large- and small-scale decorative figures. The first funeral, Joan of Arc.
Frédéric Auguste Bartholdi (Colmar 1834–Paris 1904). Public sculptures. Statue of Liberty, New York.
Antoine Louis Barye (Paris 1796–1875). Public monuments, animal and figure groups.
Sarah Bernhardt (Rosine Bernard) (Paris 1844–1923). Actress. Small animal and decorative bronzes. Portrait painter.
Jean Baptiste Carpeaux (Valenciennes 1827–Courbevoie 1875). Public monuments, portraits, small bronzes geared to reproduction.
Albert Ernest Carrier-Belleuse (Anizy-le-Château 1824–Sèvres 1887). Small figure busts of notable historical and fictitious personalities. Terra-cotta, marble, bronze.
Henri Michel Antoine Chapu (Mée 1833–Paris 1891). Public monuments and

funerary monuments, including small versions for large markets; portrait busts and medallions.

Jean Baptiste Clésinger (Besançon 1814–Paris 1883). Small, often erotic statuettes, busts, and animals.

Charles Henri Joseph Cordier (Cambrai 1827–Algiers 1905). Portrait busts, studies of Africans.

Jean Pierre Cortot (Paris 1787–1843). Portrait busts, allegorical, religious, mythological statuettes.

Charles Cumberworth (U.S.A. 1811–Paris 1852). Small models for Susse Feres, large and small statuettes. Prix de Rome, 1842. Disqualified for being non-French.

Charles Courtney Curran (Hartford, Ky. 1861–1942). Painter of portraits and interiors.

Aimé Jules Dalou (Paris 1838–1902). Public monuments, maternal images, mothers and children, portrait busts, clay images of workers and nudes.

Jean Pierre Dantan (Paris 1800–Baden Baden 1869). Over 400 portraits and 500 caricatures, issued en masse by Susse Feres.

Honoré Daumier (Marseilles 1808–Valmondois 1879). Thirty-four portrait busts still survive, cast posthumously; clay figurines also later cast in bronze.

Pierre Jean David d'Angers (Angers 1788–Paris 1856). Portraits, medallions, public monuments, statuettes of famous personalities.

Auguste Hyacinthe Debay (Nantes 1804–Paris 1865). Public monuments, some small sketches.

Hilaire Germain Edgar Degas (Paris 1834–1917). Over 150 wax models of figures and horses. Destroyed many plaster heads; 74 were cast after World War I.

Sébastien Delarue (Romorantin 1822–Paris 1868). Portraits, famous people.

Louis Desprez (Paris 1799–1870). Portraits, public and religious monuments, portrait statuettes.

Jacques Augustin Dieudonné (Paris 1795–1873). Portrait busts, medallions, religious, historical.

Gustave Paul Doré (Strasbourg 1832–Paris 1883). Large- and small-scale groups with religious, mythological, and allegorical meaning.

Paul Dubois (Nogent-sur-Seine 1829–Paris 1905). Statuettes of various subjects, religious, literary, genre, famous personalities.

Francisque Joseph Duret (Paris 1804–1865). Mythological, genre, allegorical, portrait statues.

Jean Bernard Duseigneur (Jehan) (Paris 1808–1866). Portrait busts, over 80 portrait medallions, religious. Archaeologist, art historian.

Antoine Etex (Paris 1808–Chaville 1888). Public monuments, statues, portrait busts, reductions of large-scale works.

Jean Alexandre Joseph Falguière (Toulouse 1831–Paris 1900). Over 50 portrait busts, monuments of famous men, nudes, reductions of large-scale works.

Jean Joseph Hippolyte Romain Ferrat (Aix-en-Provence 1822–1882). Public monuments for Aix-en-Provence, some reductions and small-scale works.

Jean Jacques Feuchère (Paris 1808–1852). Decorative and utilitarian objects, small reliefs, portrait busts, statuettes, occasional public monuments, famous artists' portraits.

Louis Julien Franceschi (Jules) (Bar-sur-Aube 1825–Paris 1893). Public monuments, architectural sculptures, nude figures.

Christophe Fratin (Metz c.1800–Raincy 1864). Animal specialist, often terracotta.

Emmanuel Frémiet (Paris 1824–1910). Animals, including reproductions and many large-scale works.

Jacques Louis Gautier (Paris 1831–?). Portrait busts, statuettes.

Jean François Théodore Gechter (Paris 1796–1844). Public monuments, animal sculptures.

Théodore Géricault (Rouen 1791–Paris 1824). Seven small works. Painter.

Jean Léon Gérome (Vesoul 1824–Paris 1904). Modeled plasters, given to professors, foundaries, or marble carvers; statuettes often reduced from them. Mythological and historical figures, occasional portraits.

Philippe Grass (Wolxheim 1801–Strasbourg 1876). Portraits, public monuments, small-scale statues of mythological and historical subjects.

Pierre Eugène Emile Herbert (Paris 1828–1893). Portrait busts, public and architectural sculptures.

Frédéric Etienne Leroux (Ecouché 1836–Paris 1906). Portrait busts, public monuments.

Etienne Hippolyte Maindron (Champtoceaux 1801–Paris 1884). Portraits, monuments.

Marcello (Adèle d'Affry, Duchess of Castiglione-Colonna) (Friburg, Switzerland 1836–Castellamare 1879). Portraits, mythological statues, especially of femmes fatales derived from history or mythology.

Ernest Meissonier (Lyons 1815–Paris 1891). Nineteen wax maquettes of battle themes, some cast in editions later.

Pierre Jules Mène (Paris 1810–1879). Animal sculptures.

Marius Jean Antonin Mercié (Toulouse 1845–Paris 1916). Tombs, public monuments, portrait busts, historical and mythological statues, bronze reductions.

Jules Moigniez (Senlis 1835–Saint Martin du Terre 1894). Animals.

Hippolyte Alexandre Julien Moulin (Paris 1832–Charenton 1884). Historical, mythological sculptures, reductions often made in bronze. Portrait busts.

Charles François Nanteuil-Leboeuf (Nanteuil) (Paris 1792–1865). Portrait busts, historical and mythological figures, bronze reductions.

Princess Maris Christine d'Orléans (Duchess of Wurtemberg) (Palermo 1813–Pisa 1839). Historical, biblical, literary themes in relief or as sculptural groups. Reduced-scale bronzes.

Jean Jacques Pradier (James) (Geneva 1790/92–Rueil-Malmaison, Seine-et-Oise 1852). Portraits, public monuments, statuettes, small-scale figure groups.

Antoine Augustin Preault (Paris 1809–1879). Portrait medallions, public monuments, numerous clay sketches, bronze versions of them.

Auguste Rodin (Paris 1840–Meudon 1917). Public monuments, portrait busts, mythological and allegorical figures executed in plaster, repeated in bronze or marble.

François Rude (Dijon 1784–Paris 1855). Public monuments, tombs, mythological, historical. Some bronze reductions issued. Prix de Rome, 1812.

Jean François Soitoux (Soitout) (Besançon 1816–Paris 1891). Public monuments.

Baron Henri Joseph François de Triqueti (Conflans 1804–Paris 1874). Public monuments, busts of historical figures.

François Willeme (Sedan 1830–Roubaix 1905). Portrait medallions, busts, statuettes, developed photo-sculptures.

English Sculptors

Lawrence Alma-Tadema (Dronrijp, Holland 1836–Wiesbaden, Germany 1912). Statuettes. Painter.

Harry Bates (Stevenage 1850–London 1899). Reliefs, bronze busts.

Alfred Drury (London 1856–Wimbledon 1944). Historical subjects, statues.

Edward Onslow Ford (London 1852–1901). Statuettes, bronzes.

John R. A. Gibson (Gyffin 1791–Rome 1866). Mythological marble statues, busts.

Sir Alfred Gilbert (London 1854–1934). Portrait busts, public monuments, tombs; mythological, allegorical, religious statues; statuettes. Painter and watercolorist.

Lord Frederic Leighton (Scarborough 1830–London 1896). Genre subjects, statues, statuettes. History painter.

Albert Joseph Moore (York 1841–1892) Figure painter, illustrator. Architectural decoration.

Frederick William Pomeroy (died in Clintonville, 1924). Active in London by 1857. Marble statues and statuettes.

Hiram Powers (Woodstock Vt. 1805–Florence, Italy 1873). Classical statues in marble, mythological, portrait busts.

George Frederic Watts (London 1817–Limmerlease 1904). Portraits, mythological, literary, busts. History and portrait painter.

PHOTOGRAPHY

Robert Adamson (Scotland 1821–1848). Calotype portraits. Collaborated with David Octavius Hill.

Matthew Brady (1823–1896). American Civil War photographs.
Julia Margaret Cameron (1815–1879). First major woman photographer.
Louis Jacques Mandé Daguerre (Paris 1787–1851). Inventor of the Daguerreotype, 1839.
Roger Fenton (1819–1869). First Crimea War photographs, 1855.
Francis Frith (1822–1899). Middle East, Holy Land photographs.
David Octavius Hill (Scotland 1802–1870). Landscapes, portraits. Collaborated with Robert Adamson. Painter.
Gaspard Félix Tournachon Nadar (1820–1910). Photographs of celebrities.
Timothy O'Sullivan (1840–1882). Photographs of Civil War and American West.

NINETEENTH-CENTURY ART: MAJOR COLLECTIONS
———————— PAINTING ————————

Europe

Amsterdam, Rijkmuseum
Amsterdam, Stedelijk Museum
Berlin-Dahlem, Staatliche Museen, Neue Nationalgalerie
Brussels, Musées Royaux des Beaux-Arts de Belgique
Copenhagen
 Ny Carlsberg Glyptotek
 Statens Museum for Kunst
Düsseldorf, Kunstmuseum
Glasgow, Glasgow Art Gallery and Museum
Hamburg, Hamburger Kunsthalle
Leningrad, Hermitage
Lille, Musée des Beaux-Arts
London
 Courtauld Institute Galleries
 National Gallery
 Tate Gallery
Madrid, Museo Nacional del Prado
Moscow, Museum of Modern Western Art
Munich, Bayerische Staatsgemäldesammlungen

Paris
 Bibliothèque Nationale
 Musée du Jeu de Paume
 Musée National du Louvre
 Musée National d'Art Moderne
Prague, Modern Gallery
Reims, Musée des Beaux-Arts
Rome, Galleria Nazionale d'Arte Moderna
Rouen, Musée des Beaux-Arts et de Cénamique
Stockholm, Nationalmuseum
Stuttgart, Staatsgalerie
Vienna
 Graphische Sammlung Albertina
 Kunsthistorisches Museum
 Osterreichische Galerie
Zurich, Kunsthaus Zürich

United States and Canada

Baltimore, Baltimore Museum of Art
Boston, Museum of Fine Arts
Cambridge, Fogg Art Museum, Harvard University
Chicago, Art Institute of Chicago

Columbus, Columbus Gallery of
Fine Arts
Dallas, Dallas Museum of Fine Arts
Dayton, Dayton Art Institute
Denver, Denver Art Museum
Detroit, Detroit Institute of Arts
Hartford, Wadsworth Atheneum
Jacksonville, Cummer Gallery of Art
Kansas City (MO), William Rockhill
Nelson Gallery of Art and Mary
Atkins Museum of Fine Arts
Minneapolis, Minneapolis Institute
of Arts
New Haven, Yale University Art
Gallery
New York
Brooklyn Museum
Metropolitan Museum of Art
Museum of Modern Art
Norfolk, Chrysler Museum
Northampton, Mass., Smith College
Museum of Art

Oberlin (OH), Allen Memorial Art
Museum
Omaha, Joslyn Art Museum
Ottawa (Canada), National Gallery of
Canada
Philadelphia, Philadelphia Museum
of Art
Providence, Museum of Art, Rhode
Island School of Design
St. Louis, City Art Museum of St.
Louis
San Francisco, Fine Art Museums of
San Francisco
Toledo (OH), Toledo Museum of
Art
Washington, D.C.
Corcoran Gallery of Art
Phillips Collection
Williamstown (MA), Sterling and
Francine Clark Art Institute

AMERICAN ART

United States

Albany, Albany Institute of History
and Art
Andover (MA), Addison Gallery of
American Art, Phillips Academy
Baltimore
Baltimore Museum of Art
Peale Museum
Walters Art Gallery
Boston
Isabella Stewart Gardner Museum
Museum of Fine Arts
Society for the Preservation of New
England Antiquities
Brunswick (ME), Bowdoin College
Museum of Art
Buffalo, Albright-Knox Art Gallery

Cambridge, Fogg Art Museum, Har-
vard University
Chicago, Art Institute of Chicago
Cincinnati, Cincinnati Art Museum
Cleveland, Cleveland Museum of Art
Cooperstown (NY), New York State
Historical Association
Denver, Denver Art Museum
Detroit, Detroit Institute of Arts
Fort Worth, Fort Worth Art Center
Museum
Gloucester (MA), Cape Ann Histori-
cal Association
Hartford, Wadsworth Atheneum
Huntington (NY), The Heckscher
Museum
Indianapolis, Indianapolis Museum
of Art

Kansas City (MO), William Rockhill Nelson Gallery of Art and Mary Atkins Museum of Fine Arts

Milwaukee, Milwaukee Art Center and Layton Art Gallery

Minneapolis, Minneapolis Institute of Arts

New Bedford (MA), Whaling Museum and Old Dartmouth Historical Society

New Haven, Yale University Art Gallery

New York
Brooklyn Museum
Metropolitan Museum of Art
Museum of the City of New York
National Academy of Design
New-York Historical Society Museum
New York Public Library
Whitney Museum of American Art

Newark (NJ), Newark Museum

Newport News (VA), Mariners Museum

Northampton (MA), Smith College Museum of Art

Oakland (CA), Oakland Museum

Oberlin, Ohio, Allen Memorial Art Museum

Philadelphia
Jefferson Medical College
Pennsylvania Academy of the Fine Arts
Philadelphia Museum of Art

Reading (PA), Reading Public Museum and Art Gallery

Rochester (NY), Memorial Art Gallery of the University of Rochester

St. Johnsbury (VT), St. Johnsbury Athenaeum

St. Louis, City Art Museum of St. Louis

San Diego,
Fine Arts Gallery of San Diego
Timken Art Gallery

San Francisco, Fine Arts Museums of San Francisco

Shelburne (VT), Shelburne Museum, Inc.

Springfield (MA), Museum of Fine Arts

Stony Brook, Long Island (NY), Suffolk Museum and Carriage House

Toledo (OH), Toledo Museum of Art

Tulsa, Thomas Gilcrease Institute of American History and Art

Utica (NY), Munson-Williams-Proctor Institute

Washington, D.C.
Corcoran Gallery of Art
Freer Gallery of Art
National Museum of American Art
National Portrait Gallery
U.S. Capitol Art Collection

Waterville (ME), Colby College Museum of Art

Wichita (KS), Wichita Art Museum

Winterthur (DE), Henry Francis du Pont Winterthur Museum

Worcester (MA), Worcester Art Museum

DRAWING

Europe

Albi
Albi Museum
Musée Toulouse-Lautrec

Amsterdam
Stedelijk Museum
Rijksmuseum Vincent Van Gogh

Avignon, Musée Calvet
Basel
 Kupferstichkabinett
 Kunstmuseum
 Rudolph Staechelin Familien Stiftung
Belgrade, National Museum
Besançon, Musée des Beaux-Arts et d'Archéologie
Bremen, Kunsthalle
Budapest, Museum of Fine Arts
Copenhagen, Nationalmuseet Charlottenlund
Dijon, Musée de Dijon
Glasgow, Glasgow Art Gallery and Museum
Grenoble, Musée Grenoble
Hamburg, Hamburger Kunsthalle
Lille, Musée des Beaux-Arts
London
 British Museum
 Courtauld Institute Galleries
London, Tate Gallery
Milan, Galleria d'Arte Moderna
Montpellier, Musée Fabre
Munich, Staatliche Graphische Sammlung
Otterlo, Rÿksmuseum Kröller Müller
Paris
 Ecole National Supérieure des Beaux-Arts
 Musée National du Louvre
 Musée National Gustave Moreau
 Musée Marmottan
 Musée du Petit Palais
Rome, Galleria Nazionale d'Arte Moderna

Stuttgart, Staatsgalerie, Graphische Sammlung
Vienna, Graphische Sammlung Albertina

United States

Albany, Albany Institute of History and Art
Andover (MA), Addison Gallery of American Art
Boston, Museum of Fine Arts
Cambridge, Fogg Art Museum, Harvard University
Chicago, Art Institute of Chicago
Cleveland, Cleveland Museum of Art
Detroit, Detroit Institute of Arts
Hartford, Wadsworth Atheneum
New Haven,
 Yale Center for British Art
 Yale University Art Gallery
New York
 Cooper-Hewitt Museum of Design
 Metropolitan Museum of Art
 New-York Historical Society
 Pierpont Morgan Library
Princeton, Art Museum, Princeton University
Providence, Museum of Arts, Rhode Island School of Design
San Francisco, Achenbach Foundation for Graphic Arts
Utica (NY), Munson-Williams-Proctor Institute, Museum of Art
Washington, D.C.
 Smithsonian Institute
 Dumbarton Oaks Research Library and Collection

PRINTMAKING

Europe

Bremen, Kunsthalle

Dresden, Staatliche Kunstsammlungen, Kupferstichkabinett
London, British Museum

Oslo, Munch Museet
Paris
 Bibliothèque de l'Institut d'Art et
 d'Archeologie
 Bibliothèque Nationale
 Musée Rodin
Stockholm, Nationalmuseum

United States

Baltimore, Baltimore Museum of Art
Bloomington, Indiana University Art
 Museum
Boston, Museum of Fine Arts
Cambridge
 Fogg Art Museum, Harvard Uni-
 versity
 Houghton Library, Harvard Uni-
 versity
Chicago, Art Institute of Chicago
Cincinnati, Cincinnati Art Museum
Cleveland, Cleveland Museum of
 Art
Indianapolis, Indianapolis Museum
 of Art

Los Angeles
 Grunwald Center for Graphic Arts,
 UCLA
 Los Angeles County Museum of
 Art
Montclair (NJ), Montclair Art
 Museum
New Haven, Yale University Art
 Gallery
New York
 Avery Architectural Library, Co-
 lumbia University
 Metropolitan Museum of Art
 New York Public Library, Prints
 Division
 Whitney Museum of American Art
Providence, Museum of Art, Rhode
 Island School of Design
San Francisco
 Achenbach Foundation for
 Graphic Arts
 Fine Arts Museum of San Fran-
 cisco
Washington, D.C., National Gallery
 of Art, Rosenwald Collection

—————————— SCULPTURE ——————————

Europe

Angers, Musée des Beaux-Arts
Besançon, Musée des Beaux-Arts et
 d'Archéologie
Copenhagen
 Ny Carlsberg Glyptotek
 Thorvaldsen Museum
Dijon, Musée de Dijon
Geneva, Musée d'Art et d'Histoire
Lyon, Musée des Beaux-Arts
London
 Heim Gallery
 National Gallery
Marseilles, Musée des Beaux-Arts
Nancy, Musée des Beaux-Arts

Paris
 Ecole National Supérieure des
 Beaux-Arts
 Musée Carnavalet
 Musée National du Louvre
 Musée du Petit Palais
 Musée Rodin
Rome, Museo e Galleria Borghese
Valenciennes, Musée Classé des
 Beaux-Arts

United States and Canada

Amherst (MA), Mead Art Building,
 Amherst College
Baltimore
 Baltimore Museum of Art
 Walters Art Gallery

Boston, Museum of Fine Arts
Buffalo, Albright-Knox Art Gallery
Cambridge, Fogg Art Museum, Harvard University
Chicago
 Art Institute of Chicago
 David and Alfred Smart Gallery, University of Chicago
Cleveland, Cleveland Museum of Art
Detroit, Detroit Institute of Arts
Hartford, Wadsworth Atheneum
Lawrence (KS), Helen Foresman Spencer Museum of Art, University of Kansas
Los Angeles, Los Angeles County Museum of Art
Louisville (KY), J. B. Speed Art Museum
Minneapolis
 Minneapolis Museum of Arts
 Walker Art Center
New Haven, Yale University Art Gallery
New York
 Brooklyn Museum
 Joseph H. Hirshhorn Collection
 Metropolitan Museum of Art
 New-York Historical Society
Oberlin (OH), Allen Memorial Art Museum
Ottawa (Canada), National Gallery of Canada
Philadelphia, Philadelphia Museum of Art
Portland (OR), Portland Museum of Art
San Francisco, Fine Arts Museums of San Francisco
Shelburne (VT), Shelburne Museum
Toledo, Toledo Museum of Art
Washington, D.C.
 Corcoran Gallery of Art
 Hirshhorn Museum and Sculpture Garden
 National Gallery of Art
 National Museum of American Art
 Smithsonian Institute
Worcester (MA), Worcester Art Museum

—————————— PHOTOGRAPHY ——————————

United States

Chicago, Art Institute of Chicago
New York
 Metropolitan Museum of Art
 Museum of the City of New York
 Museum of Modern Art
Rochester (NY), International Museum of Photography, George Eastman House
Washington, D.C.
 Museum of American History, Smithsonian Institution
 The National Archives of the United States

CHAPTER 11

Twentieth-Century Art

The nineteenth century was a period of transition. It continued past traditions in art, producing images for an audience that was relatively attuned to the religious, literary, and philosophical ideas reflected in painting and sculpture. It was also an age that introduced the notion of pure art produced merely for its own sake by artists who had emancipated themselves from the strictures of a prevailing aesthetic and the constraints of the traditional artist-patron relationship. Art became, in the hands of its modern creators, a self-fulfilling purpose, a vehicle through which the individual artist expressed a sometimes purely private aesthetic or vision in a uniquely personal language.

In the twentieth century, the idea of art for art's sake is no longer revolutionary but commonplace and even dominant as the principle by which art is produced by its makers and received by its audience. The twentieth-century viewer of art has little or no conception of another kind of art that might, as it did in earlier centuries, serve specific functions or purposes. That viewer may be as baffled by the art of his own century as he is uninitiated to the concrete historical or aesthetic contexts in which art of the past was created and appreciated. Twentieth-century art, completely liberated from the obligation to serve other than its own self-defined ends, ceased to speak or be comprehensible to the viewer with no prior knowledge of its concerns.

The viewer of twentieth-century art can only appreciate its many and varied representations if he understands the positions taken by certain groups of artists on aesthetic and cultural issues of the day. The various attitudes of twentieth-century artists allow us to define them into groups or movements, much as the art of the nineteenth century can be discussed by collective trends. Modern art history tends to be written in terms of movements or "isms," and museums tend to exhibit examples of one movement after another in historic progression. Thus, in this chapter, the reader will find the discussion organized according to

movements that are generally acknowledged to have been seminal in twentieth-century art. Although some of these movements and artists were often over-looked or rejected in their own day, they are now considered important, original, and forward-looking.

Beginning with the nineteenth century, the tendency for artists to be out of step with or ahead of their times spawned the phrase "avant-garde." This term describes the separation that developed between society at large and an art that was no longer traditional, perhaps peripheral, and no doubt easily misunderstood. The advantage of hindsight, which allows us to view these once rejected movements as historically significant, has not only permitted us to accept unflinchingly avant-gardism but has also created the expectation that all art be radically new. Our modern concept of originality almost dictates that art bear no ostensible relationship to its past, and artists are expected to create entirely unique images at a continual rate. With this complete reversal of earlier standards governing art, our age considers the artist who works in more traditional modes as backward and unimportant. At best, such an artist is *retardetaire* and at worst old-fashioned. And while current artistic movements succeed one another at an increasingly rapid pace and artists struggle to be new and constantly different, the audience for modern art is perhaps the first to require verbal explanations in order to understand the concepts encountered in modern art.

Two fundamental trends emerged in the art of the twentieth century. The most celebrated of these is the development of abstraction in the first decade of the 1900s. Signaling the complete departure of art from any attempt to represent objective reality in the form and context we visualize and experience it, abstraction was heralded by many artists as a new and vibrant form of self-expression. While abstract art was embraced by some artists, others continued the traditions of representational art that made some reference to visual reality. These representational movements are sometimes less highly regarded because they are traditional, but museums display examples of both approaches, leaving the ultimate choice to the viewer.

What the museum visitor encounters in museum collections of twentieth-century art challenges him in many different ways. The viewer's sense of reality, his conception of his place in time and space, his identity and understanding of society and its values all are called into question by certain, mostly nonrepresentational images. Through any number of visual manipulations and use of symbols, these abstract works exist purely in the realm of ideas, making few, if any, references to an objective or identifiable experience. In one sense, modern art can be said to have reverted to the tradition of symbolic, conceptual art that persisted in world cultures longer and in more instances than representational art. One need only consider, for example, Early Christian, Byzantine, and Medieval art, which, though sometimes representational, often expressed a complex symbolic content. Thus, the twentieth century may be said to have

revived conceptual imagery, albeit in a completely new context and toward entirely different ends.

Included in the treatment of twentieth-century art that follows are movements that are most commonly considered vital to understanding the development of art between 1900 and 1960. These movements embodied, to a large extent, positions adopted by artists that were then peripheral or unconventional, but that have now come to be regarded as part of the mainstream of modern art. From their position of relative freedom, artists of the avant-garde produced an infinite variety of art forms in the broadest imaginable spectrum of images, materials, and ideas. Ranging from the amusing to the shocking, the cynical to the absurd, and the frightening to the enchanting, modern art is among the most diversified forms of expression imaginable.

The role of museums in the development of modern art is a vital one. Museums have been and still are active patrons of twentieth-century art, with the result that many artists have produced works of a scale and power that could only be adequately appreciated in an art museum. And where an artist's career was formerly dependent on the patronage of noble or wealthy families, today an artist's importance is often gauged by the number of museums that display and/or own his or her works. Thus, art museums are often the original context for a good deal of contemporary art and have grown so large and their importance so vital that a number of museums have been established whose sole function is to exhibit and preserve modern art.

Although the description of modern art movements in this chapter is extensive, it is neither exhaustive nor complete. Not mentioned in the discussion are the various movements that sought to produce art forms that were never intended to last or to be collected and that therefore cannot be contained in museum collections. Examples of such movements include performance art, earthworks, happenings, and mural art. Also, the various traditional mediums—painting, sculpture, drawing, and printmaking—are categories that still exist in modern art but are not as decisive as they were in earlier periods of art. In fact, even the distinction between art and craft is not pronounced in modern art, and many exhibitions are defined today only by the materials used, such as fiber exhibitions, clay exhibitions, exhibitions of works on paper, and so on. Also omitted from the discussion in this chapter are art forms that are not regarded as "art," including commerical illustration, advertisements, industrial engineering and design, billboards, package design, road and bridge design, and the like.

In twentieth-century art, the viewer will find a fascinating, highly diverse expression of contemporary culture. Never before has simple representation coexisted with its direct antithesis nor, as far as we know, have people argued as much about the relative merits of one or the other. This period of art has also afforded the opportunity for so many not to choose or debate but purely to enjoy modern art in its many forms and celebrate the experiences that can be gained from its rich diversity.

CUBISM

Cubism is considered by historians to be the single-most important movement in twentieth-century Western art. It was also one of the briefest and smallest and had few practitioners. Its initiators, Pablo Picasso and Georges Braque, first experimented with images we now call Cubist in roughly 1906; by 1914 the movement had already been dramatically transformed, and by the mid-1920s, according to some critics, Cubism was over. In some eight years, from 1906 to 1914, and sometimes in a matter of days, Picasso and Braque altered the direction of their own work and thereby changed forever the direction of Western art. Initially deriving their inspiration from the late Impressionists, particularly Paul Cézanne, the Cubists introduced completely nonrepresentational, or "abstract," art to the modern world. As such, their influence was worldwide, and contemporary painting would not look as it does now had it not been for the Cubists.

What were the Cubists' concerns and why were their contributions so significant? During those fateful years in Paris, Picasso and Braque experimented with new ways to deal with problems of space, form, subject matter, color, reality, beauty, and function in art. Cubism first began with the medium of painting; and its practitioners, like most other painters, recognized that the two-dimensionality of the working surface imposed inherent limitations on artistic representation. If the artist created illusions of dimensionality on the canvas, the image would still remain an imitation of reality. Experimenting first with traditional subjects, such as portraits, nudes, still-lifes, and landscapes, the Cubists explored the possibility of creating new "forms" out of these subjects in an attempt to make them both dimensional and flat at the same time. This challenge recalls the trials many other representational painters have faced, but the Cubists resolved the problem anew.

One way to explain what the Cubists achieved would be to say that they fragmented their subjects; that is, they took the bottles in a still-life or the head of a portrait and broke these down into their visual components. By reducing the image that creates the illusion of reality into its simple elements, the artist reminded the viewer that the eyes actively participate in the illusion, and that the illusions of spatial recession or projection are merely the result of manipulation as evident as the illusion itself. Picasso's *Girl with a Mandolin* (Plate 13) is one of the masterful examples of the early Cubist experiments.

In Cubism, the manner of representation was as important as the subject matter itself. The artists gave an image structure by aligning and interconnecting its components. The novelty of Cubist representation was that it uncovered previously unknown visual relationships that, though unconventional and perhaps even contrary to reality as one experienced and visualized it, were nonetheless meaningful and even pleasing. Thus, in the hands of the Cubists, an image became a delicate duet between the object and the illusion: It fluctuated

constantly between the allusion to a third dimension and the assertion of the two-dimensional picture plane. At once it created the illusion and denied it. These artists sought to do the impossible—to create and dissolve an object simultaneously, to record an image that at once disintegrates and reintegrates itself continuously before the viewer.

After an early phase of experimentation—now called analytical Cubism—new attempts were made to respond to the problem of introducing reality into an image. By 1912, fragments of actual objects had entered into Picasso's still-lifes, giving birth to the collage that fused the "real" and the fictitious in a new and imaginative way. Soon all sorts of actual objects—wallpaper, newspaper, and photographs—were combined with painted forms, resulting in many layers of reality that were melded into a single image. With this step, modern art came to embrace subject matter that led it in many new directions, including purely conceptual art. The Cubists used their art to affirm the importance of ideas in art and communicated concepts and purely visual schemes without making the slightest attempt to imitate nature. Color, composition, drawing, texture, scale, and relationships between shapes were in and of themselves subjects worthy of examination and often were the sole reason behind some of the images created by the Cubists. These artists were the first to reject the notion that the relationship between the image and the object was one of pure imitation, and sought to articulate the reality of the image itself as being distinct from an objective reality to which an image might, however obliquely, refer.

The Cubists stressed the process of image making as much as they recognized the significance of the final result and attempted to convey a sense of the process in their images. The product never sought to be finished and complete in the traditional sense of the word, for then it would lose its energy and spontaneity.

Inspired by the vitality of tribal arts and motivated by their belief in an art that must relate to its times, the Cubists initiated an experiment that still has permutations today. Their work established a fundamental distinction between art and life, between optics and vision, between past and present. The once unified path that artists followed was now split forever between realistic and traditional representation, on the one hand, and abstract, nonobjective, and modern image making, on the other.

SYNCHROMISM

Developing a style now called Synchromism, a few painters created an art of pure color to define shapes that were largely Cubist in inspiration. Originating in Paris about 1912, Synchromist painting used colors on opposite ends of the color spectrum in dynamic shapes and visual rhythms, in part inspired by music. First introduced to America through the Armory Show of 1913, Syn-

chromism deeply influenced some of the earliest examples of American abstract art.

ORPHISM

Orphism was a term created by the French poet and novelist Guillaume Apollinaire between 1912 and 1913 to describe the work of two Cubists, Robert and Sonia Delaunay. Characteristic of Orphism was its unique treatment of color, light, the sensation of movement, and forms that were derived purely from the artist's imagination. Other artists who created works in this vein were Francis Picabia, Marcel Duchamp, Frantisek Kupka, and Ferdnand Léger.

RAYONISM

Rayonism began in Russia in early 1911 as an experiment with pure abstraction. Also inspired by Cubism, Rayonism employed linear "rays" of light that produced facets of color and light on the canvas. The principal Rayonists were Mikhail Larionov and Natalia Gontcherova. The Rayonist Experiment lasted only a few years, and, by 1914, both artists had gone in other directions.

FAUVISM

Fauvism—from *les fauves,* "the wild beasts"—was a term coined by a French critic to describe the works of several artists exhibiting at the Salon d'Automne in Paris in 1904. Led by Henri Matisse, the Fauves created some of the most vivid, energetic, and colorful images of the twentieth century. A movement that lasted only from 1905 to 1910, Fauvism made a significant contribution to modern art and is considered the forerunner of Expressionism.

Emphasizing the purely formal aspects of image making, the Fauves treated traditional subjects—including still-lifes, portraits, landscapes, interiors—and certain images of society's outcasts. In a novel, formal treatment of these subjects, the Fauves used color as the organizing principle in an image: Color controlled composition and defined drawing. Pure color was often taken directly from the paint tube and used in conjunction with other colors that jointly occupied whole areas of the painting surface. Because these Fauve compositions featured primarily color, the resulting images tended to be flat and to deny illusions of space and depth. Often a subject matter was chosen primarily as a pretext for finding or exploring relationships between visual forms on the painting surface. To critics of the time, who were still accustomed to the finished, detailed, and generally illusionistic works of academic art, these Fauve images must have seemed raw and unrefined. To contemporary viewers, they seem to exude an energy that affirms the creative spirit and celebrates painting and life as few other painterly images have done.

EXPRESSIONISM

The 1880s and the period from roughly 1905 to 1920 witnessed numerous artistic experiments that are described as Expressionist. Expressionists worked throughout Europe, but in the main, Expressionism found its most devoted adherents among artists in Germany and Austria.

To artists who considered themselves Expressionists, form and content were inseparable from one another. Form—composition, color, shape, drawing, brushwork, and the like—evolved from the subject matter or content of an image. This notion regarding the integral relationship between form and content was not original and had many antecedents, including the theories endorsed by neoclassicism. Nor was there any novelty in the idea that certain content, especially emotional states, could be effectively conveyed to the viewer by using certain forms and colors. The neoclassicists used stable, harmonious composition to convey an eternal moral principle, and the dynamic compositions and moving forms of Romantic imagery aptly conveyed its artists' restless emotional states.

Although the Expressionists inherited certain precepts from earlier movements, they applied these to a vocabulary of color, composition, and subject matter that was derived from distinctly modern movements, such as Fauvism, Cubism, and the Nabis. The Expressionists were also inspired by tribal art and art of the fourteenth and fifteenth centuries. In these less refined productions the Expressionists found a greater emotional purity and strength.

Using subjects that ranged from traditional street scenes, nudes, and portraits to biblical themes, nature, death, and human relationships and isolation, the Expressionists explored the human condition in their diverse imagery. Expressionist art is characterized by its imagery of despair, trouble, tension, and anxiety. It reflects a universal condition in which man is tormented by suffering and threatened by his own psyche, the uncontrolled dynamics of society, and the tragedies of disease, hunger, violence, and war that cut even shorter the brief thread of life. Other, more neutral subjects, such as still-lifes, were less appealing to these artists, who were concerned with emotionally charged issues.

Expressionist works used characteristically clashing and unmodulated colors in raw, often jagged and distorted shapes arranged in dense, claustrophobic, and flattened compositions. Paintings used frenzied, direct brushwork. The Expressionists worked with many types of materials. Painting and sculpture were joined by daring and inventive experiments in printmaking. Prints exploited the immediate properties of the materials; thus, bold and vibrant lithographs were produced, along with equally powerful woodcuts carved with a chisel. The synthesis of material (form) and message (content) for which the Expressionists strove was especially successful in these mediums.

Although they shared a common belief in the fundamental purpose of art, the Expressionists were highly individual. Each artist's oeuvre was shaped by

his or her own inner vision and explored themes of particular concern to that artist. Like other experiments in twentieth-century art, the Expressionists carried the dual nature of art, embodied in form and meaning, to its limits. In their search for shapes, colors, and lines to convey meaning most effectively, the Expressionists reduced these to their most essential characteristics, bringing their art to the edge of pure abstraction and, ultimately, beyond the realm of traditional, representational meaning.

Two groups are commonly identified with Expressionism. Die Brücke, or The Bridge, was established in Dresden in 1905 and originally consisted of Ernst Ludwig Kirchner, Fritz Bleyl, Erich Heckel, and Karl Schmidt-Rottluff. The second was Der Blaue Reiter, or The Blue Rider, a group based on an exhibition held in 1911 in Munich that displayed the works of August Macke, Heinrich Campendonk, David and Vladimir Burliuk, Arnold Schoenberg, Wassily Kandinsky, Franz Marc, and Gabriele Münter. The Blaue Reiter held a second exhibition and its leaders, Macke and Kandinsky, published a journal by the same name.

FUTURISM

The name for this Italian group, active from 1906 to 1916 in Milan and Paris, was coined by the poet-editor Filippo Marinetti in 1908. The term was chosen for its aptness in describing the group's optmistic belief in the future. Both utopian and rebellious, the Futurists used their art to confront a society they felt to be complacent, sentimental, conventional, nostalgic, and apathetic. The Futurists scorned nostalgia in any form, and looked forward to the future with confidence and enthusiasm. They believed in man's inherent strength and the promise of improved social conditions offered by technology. To these artists, the products of modern technology, its machines, were more beautiful than Greek sculpture. The Futurists raged against the feelings of impotence, timidity, and submission that characterized man's existence in the modern age. In their art, they reaffirmed man's strength, daring, will, and capacity for action.

The Futurists exhibited internationally, issued manifestos, and staged events using tactics that were in some ways similar to those of the anarchists, with whom the Futurists sympathized. Futurist ideas were expressed in poetry, criticism, music, and architecture, as well as painting and sculpture.

Unlike Cubism, to which it owed a great debt, Futurism stressed content over form. Human experience as it is translated into mental processes was the subject of Futurist art. Space, interval, mental associations, memory, and the senses of touch, smell, and sound were all part of the Futurist language of expression. Like the Impressionists, the Futurists used certain visual means to express the reciprocal relationship between the environment and objects in that environment. Both capable of motion, objects and the space around them are shown in relationships of dynamic interaction. This interaction was articulated

in "force lines" that irradiate many Futurist drawings and paintings, giving them an intense, vibrant energy.

The dynamics of movement tc' ally captivated the imagination of the Futurists, and the expression of motion in visual terms was their principal concern. Like the Expressionists, the Futurists believed that form and content were completely interdependent. They developed new and original visual equivalents for motion: The repetition of forms across a painting propelled the image across the surface and the eye of the viewer along with it. The sensation of speed and quickly moving objects was conveyed by using acutely placed diagonal lines and repeating force lines, resulting in dizzying and disorienting vortices.

Motion and the associative powers of the human mind are evoked through the use of simultaneous imagery. By filling a canvas with objects and images that were distinct and yet interconnected by their association with a specific event or moment, the Futurists invented compelling equivalents for the sensation of time, motion, memory, and the actual processes of thought. The components of these images mingle and separate in a kaleidoscopic and almost haphazard manner.

The youthful idealism and enthusiasm that spawned Futurism could not be maintained. Its flowering was brief, halted abruptly by the outbreak of World War I. Today, Futurist imagery seems almost orgiastic or violent and stands as a celebration of life and the triumph of science and technology.

VORTICISM

A movement that lasted from 1913 to 1920, this short-lived phase in English art shared the concerns of Cubism and Futurism. Like the Cubists and Futurists in orientation, the Vorticists were forward-looking and disregarded the painterly conventions of the past in their attempt to find visual equivalents for the energy and potential of the machine and the future.

The group was centered around Wyndham Lewis, who claimed to have invented Vorticism, and included such artists as C. R. W. Nevison, William Robert, Henri Gaudier-Brzeska, Sir Jacob Epstein, and David Bomberg.

SUPREMATISM

Suprematism carried the elements of Cubism and Futurism to their ultimate, most extreme conclusion. The Suprematists reduced color to pure black and white and form to basic geometric shapes. In its reductive simplicity, Suprematism was an early expression of the purest abstraction in art.

Kasimir Malevich, who initiated the movement, sought to express the primacy of feeling in the creation of Suprematist art. Other artists who grew out of this movement were El Lissitsky, László Moholy-Nagy, and Vladimir Tatlin.

DADA

In 1914, World War I began and with it a movement that aspired to bring to art the contradictions and paradoxes that were epitomized by war, a state that witnesses both the immense destructive forces and the heroic or principled gestures of humanity. Revolted by war, artists reacted with despair and cynicism, or with a determined idealism that sought beauty and order in a world of madness and chaos. Both cynical and idealistic, moral and amoral, positive and nihilistic, Dada was a movement that both affirmed and negated the purpose, value, and meaning of art.

The movement took shape in many places, although Zurich is generally considered its place of origin. In 1916, a group of writers and artists there gathered in the small Cabaret Voltaire to hear poetry readings, listen to music, and admire pictures made by friends. It was in this somewhat chaotic atmosphere that Dada was born. Inspired in part by the Futurists in Paris, the Dadaists in Zurich created a radically different art in a number of nonvisual forms—noise music and poetry readings accompanied by the cacophony of bells, drums, banging on tabletops, screams, sobs, and whistles. The visual imagery of Dada was equally unorthodox, taking shape in the form of collages, wood-reliefs, and daring experiments with new materials. Dada as a movement soon appeared in New York City, Berlin, Hanover, Paris, and Cologne.

The word "Dada" is as paradoxical as the movement itself. In Russian, it means "yes, yes"; in French, "rocking horse"; and in German, "idiotic babble." Historians alternately assert or deny any or all meanings of the term and still debate its origins. Even its artists defined Dada variously: One manifesto declared it to mean nothing, and another asserted, "Dada stands for art without sense. This does not mean nonsense. Dada is without a meaning as Nature is."*

Dada was a movement born of artists' awareness of their particular place in time. Revolted by the war and the society that spawned it, Dadaists sought to shock society out of its self-destructive complacency in order that it might develop a new self-awareness and freedom from convention. No Dadaist would likely have admitted to such aims; in fact, to such a direct question, he would most likely have responded with some nonsensical answer.

In order to elicit the desired reaction—shock—the Dadaists reduced art to chaos. Dadaist performances were held throughout Europe and consisted of poetry readings and dances set to music that were designed to jolt and provoke their audiences. That they did, and, in fact, their readings of nonsense poetry were often as not drowned out by the hoots and jeers of outraged audiences.

To create visual images, Dadaists did the opposite of what was commonly expected. Instead of making an object by hand, these artists used manufactured

*Hans Arp in *Dada, Art, and Antiart,* by Hans Richter (New York, McGraw-Hill, 1965), p. 37.

objects and called them art. Instead of basing their art on a carefully premeditated plan to create an image—for example, beginning with a drawing and ending, after many steps, with a painting, sculpture, or other result—Dadaists relied purely on chance and accident to achieve their results. The chance fluttering of papers on a floor might have been the basis for a collage. Knowledge and reason were thus totally undermined and replaced by happenstance and the unknown as the creative origins of art. The artist relied on his ability to recognize beauty in the haphazard and allowed accident, rather than design, to dictate the final form of an object.

The materials Dadaists used in their art were unorthodox. Randomly found objects, trash, discarded flotsam and useless materials, manufactured objects, cameraless photography, typography, illustrations, and all manner of mundane objects made their way into Dadaist art, where they were placed in new, sometimes disturbing, sometimes shocking, and sometimes beautiful contexts. These works could evoke anger, challenge, threaten, or enlighten the viewer, but they always played on the viewer's ability to recognize objects from a more conventional context in their radically altered, new arrangements. Collage, the assembly of diverse materials, was a favored form of the Dadaists.

The human figure was only a peripheral concern of the Dadaists and was gradually eliminated from their art. For some, the rejection of the human form as a subject matter in art was tantamount to the rejection of humanity as a whole. For others, it was a gesture of reaction against the restraints of figurative art and an affirmation of artistic freedom. Some Dadaists sought to express the primordial power that images of earlier, preindustrial cultures held. In so doing, they strove to restore magical and religious forces to the making of art that had been entirely eliminated by science and technical precision.

Dada was a short-lived experiment. By 1919 it was on the decline and, according to some scholars, expired as a movement by 1924. It is difficult today to appreciate fully the original power of Dadaist art. Now enshrined by the very institutions it sought to undermine and destroy, Dadaist art can be said to have lost its ability to shock.

SURREALISM

The most vital period of Surrealist art fell between the two world wars. The first Surrealist manifesto was issued in 1924 by the writer André Breton (1896–1966), and the first Surrealist exhibition was held in 1925. Following on the heels of Dada, Surrealism has been described as a movement inspired by a concept of a new, regenerated humanity that was to replace the state of hypocrisy and complacency that was so vehemently attacked by Dada as the human condition. Surrealism shared with other early twentieth-century movements a fundamental utopian attitude that held that man could change his condition by first understanding the limits imposed by society and then freeing himself from

these useless and outdated constraints. Like other utopian artists, the Surrealists did not pander to the aspirations of conventional society but rather prescribed what they thought it should attain. Surrealism therefore placed the artist not only outside society but in some ways above it, implying that the artist's role was not only to make art but also to use that vehicle to criticize and thereby correct society's shortcomings.

The tools Surrealists used were in part inherited from Dada. Although Surrealism was a movement in which poetry figured prominently, it also produced much painting and sculpture. It relied heavily on the technique established by Dada of taking a recognizable object out of its usual context and giving it new meaning and new associations. Surrealism thus depended on making objects recognizable, and its painters were often masters of convincing illusionism. Photography and film were mediums that lent themselves easily to use by these artists for creating illusion and distortion, as images could be mixed infinitely with the camera.

Surrealism grew out of the same cultural soil that produced Freud and psychoanalysis—an art form based on the investigation of the human mind. Surrealism explored the subconscious, the dream world, and irrational elements of the psyche in the firm belief that the discoveries to be made from such exploration would be of greater fundamental importance to the human condition than any other form of social analysis.

In their efforts to approach the subconscious realm in art, Surrealists created a form of writing and drawing that was "automatic" and that emanated from the psyche directly and without premeditation. In this way, the subconscious dictated the subject matter and form of a particular visual expression. The *cadavre exquise*, or "exquisite corpse," was a particular form of automatic writing and drawing in which an artist would draw part of an image on a folded sheet of paper without knowing what others before and after him would draw. Once the sheet was filled and the isolated components assembled, the result would be completely spontaneous imagery that created a new and previously unknown reality.

Surrealists were also fascinated by the ephemeral state of mind between sleep and consciousness, dream and reality, sanity and insanity, as one in which the mind functioned purely, unfettered by the constraints of logic and social behavior. By abandoning all established order, convention, and regulation, the artists sought to transcend the standards and values of a given society and reach the far deeper well of emotion and drive contained in the nether regions of the psyche. Each artist was capable only of exploring his own psyche, and the nature of each artistic expression depended on the depth of each one's self-examination. The artist's journey into the private, sometimes disturbing, and certainly frightening realm of the self—namely, the subconscious—was a lonely one. Each artist tended to develop a unique language of symbols and forms that had specific meaning only to him or her.

By descending into the inner depths of his own soul, the Surrealist ultimately hoped to be united with the macrocosm that is human existence and consciousness. The goal of Surrealism was to merge the individual psyche with the universal, which encompassed all. In a sense, Surrealim was a mystical movement that strove to resolve some of life's mysteries.

CONSTRUCTIVISM

Inspired by the collages of the Cubists, Constructivist art was notable for its creation of sculpture that was "constructed" as opposed to chiseled or modeled. These sculpted constructions were most actively produced from about 1914 to 1930 in Russia, where a group of idealistic artists created a new art in order to represent most effectively their new-found utopian society. To the Constructivists, machinery, mass production, and assembly lines were the means to achieve equal distribution of wealth and goods throughout society. Thus their sculpture looks machine-like and was often manufactured mechanically. These forms express the modernity and sense of the eternal present that so held the Constructivists in sway.

The sculpted forms of Constructivism were assembled using modern materials, such as plastics and glass, as well as more traditional materials, such as wood and bronze. Space, the voids around and between solid forms, was used in a positive and distinctive way by the Constructivists. The hollows in a sculpture were used to create a new relationship between space and the object and thus became a vital part of the final image.

The Constructivists applied their ideas to a broad range of subjects, from monuments and heads to abstract assemblies based on geometric shapes, such as spheres or cubes. In addition to sculpture, the Constructivists experimented with a wide range of products, from drawings, watercolors, graphic arts, and paintings to stage designs.

Due to the conservative nature of the Russian government after the Revolution and until the 1930s, when the government suppressed all modern or leftist deviations from proletariat realism, most of the Constructivists immigrated to Berlin.

THE BAUHAUS

The Bauhaus was an academy established in 1919 in Germany by Walter Gropius. It was dedicated to teaching the fundamentals of design and craftsmanship for everything from building exteriors to the furniture, utensils, textiles, and works of art housed within these structures.

The theory behind the Bauhaus was based on a great admiration for the superb craftsmanship of the Middle Ages, and it also stressed the value of collective enterprise. Bauhaus teachers saw no fundamental difference between

the basic elements of architectural design and those of painting and emphasized the principles common to both. Like de Stijl, with which it sympathized, the Bauhaus movement rejected the notion of architecture and art as ornament. All art forms—sculpture and painting, textile and glass design—were based on this concept.

Weight and support, equilibrium, stress, mass, space, balance, modular repetition, and contrasts between solids and voids, dark and light, light and heavy, smooth and rough, large and small—these were the concerns of the Bauhaus, and they applied equally to all types of works. There was no unified stylistic program at the Bauhaus, but, because most artists worked within the framework of Bauhaus theory, their art shared certain affinities despite a great variety of expression.

The Bauhaus moved several times, first from Weimar to Dessau and, finally, to Berlin, where it was dissolved in 1933 due to political pressure. Many members of the Bauhaus emigrated to the United States, where its teachers made a significant contribution to the development of American design and architecture.

DE STIJL

This Dutch movement was contemporary with Constructivism and had links with the Bauhaus. Like the Futurists and other utopian artists, the originators of de Stijl felt that a new style needed to be developed that was commensurate with contemporary life, and they created such a style for everything from buildings to teacups.

In the view of artists of de Stijl, life was meant to be neat, clean, and harmonious. Rooms were to be spacious and filled with well-designed, useful objects. Buildings were to be likewise functional, not stylized or ornamental. It was thought that people living in such an environment would be inspired to lead more orderly, harmonious, and productive lives.

The painters and sculptors of de Stijl did not, for the most part, derive their subjects directly from nature, but rather adapted forms occurring in nature to arrive at their most fundamental, basic aspect. In this process of reduction, these artists sought to express a collective, universal beauty. To the members of de Stijl, the basic elements of form (horizontal and vertical axes) and primary colors (red, yellow, blue, black, and white) were the only essential components of art. Art was distilled to its purest, most fundamental aspect. Subject matter, emotion, sentimentality, and subjectivity were expurgated and art thus purified. By reducing art to its most elemental and rational components, the de Stijl artist could communicate pure thought untainted by individual, incidental considerations.

Theo van Doesburg, de Stijl's foremost theoretician, espoused the belief that art should show a technical perfection equal to its conception. It was to show

no element of human weakness, no lack of precision, and no trace of incompletion. By eliminating all that was extraneous or distracting, de Stijl artists sought to express timeless, universal concepts and thereby set the spirit free. To express this spirit more fully, art had to depart from strictly natural forms, using these as a mere basis for an entirely intellectual art. By making pure, geometric paintings and sculptures in primary colors, the artists of de Stijl gave expression to pure thought made for the sake of thought alone. The forms these artists created fall somewhere between mathematical communication, the most abstract of all forms of thought, and visual concepts. Characterized by their balance, harmony, proportion, and serene contemplation, the masterpieces of de Stijl art deeply affected future generations of artists.

PURISM

Expounded in the review *L'Esprit Nouveau* (1920–1925), the theory of Purism was proposed by Amédée Ozenfant and Le Corbusier. They advocated disciplined, simplified forms in art and architecture, rejecting tendencies toward decorativeness that they perceived in Cubism. The influence of Purism on modern art is still a subject of debate.

SCHOOL OF PARIS

Between 1905 and roughly 1940, Paris was recognized as the international center for art, and a large number of great artists either settled there permanently or visited Paris in order to absorb its visual, social, and intellectual vitality. The name "School of Paris" has come to be associated with a style of art that involved figurative or abstract forms and that used various approaches, ranging from relatively traditional to largely Expressionist styles. Henri Matisse's *The Magnolia Branch* (Plate 14) beautifully demonstrates the artist's unique ability to transform mundane objects of reality into a highly refined composition full of color and life.

Paris had long attracted artists from around the world, however, the outbreak of World War II interrupted this tradition and forced many artists to take refuge elsewhere, notably in New York, which henceforth became the international art center of the world.

PHOTO SECESSION GALLERY "291"

Founded in 1905 and run by the photographer Alfred Stieglitz, the Photo Secession Gallery was located at 291 Fifth Avenue in New York and was therefore generally called "291." The gallery was active at 291 until 1917, and continued in other locations until 1946.

Stieglitz published *Camerawork* between 1903 and 1917, an organ that was

dedicated to contemporary art much as the gallery was, which exhibited and supported modern art, including that of American abstract artists. It regarded photography as an art form equal to painting and sculpture and regularly exhibited all forms of contemporary abstract art.

The Precisionists

Out of the milieu of the Photo Secession Gallery emerged a small group of painters during the 1920s that was never formally united, but whose members shared an interest in clean-cut contours, simplified forms, and large flat areas of color, as well as smooth surfaces and a sense of precision and clean order. Its artists included Charles Demuth, Georgia O'Keeffe, Charles Sheeler, and Niles Spencer.

ABSTRACT EXPRESSIONISM

This movement was born in the late 1940s, when a group of painters—William Baziotes, Robert Motherwell, Mark Rothko, Clyfford Still, and Barnett Newman—organized the Subject of the Artist school. It is apparent from the name of this group that these artists were as concerned with content in art as with form. Dissatisfied with the utopian orientation of much European abstract art, which seemed irrelevant in the face of World War II, the Abstract Expressionists searched for new ways to affirm value and meaning in human existence. Their search for values led them to Surrealism. The Surrealists had emigrated from Europe to America for the duration of the war, and the American Expressionists found an affinity for the Surrealist notion of a universal, collective unconscious that united all humanity. The Abstract Expressionists were also fascinated by the Surrealists' use of automism, through which the collective unconscious could be expressed and attained. Other painters in this school were attracted to the primordial human drive expressed through sexual subject matter in many Surrealist images.

Thus, inspired by Surrealism and motivated by a need to find new ways to convey human values on a universal level, the Abstract Expressionists created an art form that was rich in its variety of solutions and compelling for its daring attempts to resolve the many contradictions implicit in its very goals.

As a means to achieve universal communication, many Abstract Expressionists eliminated specific, identifiable form from their imagery. Instead, they produced images that emphasized both the nature of painting, which was defined primarily by pure color, and the process of its creation. Painters who were concerned primarily with the process of image making underscored this concern by creating images that somehow conveyed the act of painting. The artist's involvement with process is nowhere more clearly expressed than in the work of Jackson Pollock, in whose painting *Number 11* (Plate 15) one can

visualize the artist's dance around the canvas as he dribbled, threw, and splashed paint across the canvas. By emphasizing the process itself, the artist was able to express and thereby celebrate the very activity of painting. And only by letting the act of painting be automatic, spontaneous, and unpremeditated could the artist approach the universal unconsciousness that resides in all humanity.

In doing all of this, however, the artist was confronted with paradoxes. The spontaneity of his gestures compelled him to forsake control. The desire to give himself over to the language of paint alone meant that subject matter or content became secondary to form and the act of expression. In the attempt to create a universal image, the individual identity of the artist was lost. Only by leaving marks or traces of his specific gestures and by formally guiding those gestures in the active process of creation could the artist affirm his individual presence as part of the collective.

Confronting these Abstract Expressionist images, which were generally painted on a large scale, the viewer both loses and finds himself. The abstract language of the imagery removes the viewer from a sense of his place in time; it displaces his own immediate concerns. At the same time, the vibrant surface of the canvas affirms the viewer's sensory perceptions. The universal imagery of Abstract Expressionism affirms the viewer's individuality by conveying a sense of loneliness. By its very universality, the image conveys to the viewer a sense of his own specificity. By being immense, the image awakens the viewer's awareness of his own size.

Abstract Expressionism has been called a herioc art; and, in a sense, it is— both for its daring attempt to express at once chaos and order, destruction and creativity, and for its affirmation of a vital, humane spirit in the face of annihilation and loss of meaning.

Abstract Expressionism is an art about movement. It evokes movement by depicting in paint energetic gestures that involve the whole body in a primordial, ritual dance that is the creative process. It also evokes movement by negation: Images so perfectly still that they hover, endlessly suspended before a viewer, compel that viewer to cease movement and contemplate the image.

Abstract Expressionism is also an art about transition. It transforms the static, inert element of paint into motion. It transforms a meaningless flow of paint into an expression of the complex human condition. It sometimes transforms recognizable images into visions of purely painterly abstraction. It transforms uniquely American characteristics—the taste for power, bravura, grandeur, and drama—into a universal art of an epic scale.

In Europe, painters living in Paris and elsewhere were attracted to the possibilities inherent in Abstract Expressionism. They favored its painterly approach, physicality, and automatic qualities, as well as its speed and energy. The European Abstract Expressionists also responded to the search for universal symbols, which they sometimes expressed through a fusion of animal and

human form. One of the most vital manifestations of post–World War II European Expressionism came in the COBRA movement, which derived its name from the first letters of Copenhagen, Brussels, and Amsterdam. The COBRA artists searched for the common basis of man and animal and found it in the universal desire of all things to live and thrive. They expressed this desire through the raw forms of abstraction and folk art.

The origins and development of Abstract Expressionism were as paradoxical as its purposes. It began as the search for nonintellectual, spiritual meaning by artists who ultimately fulfilled their aims only through intellectual insight and realization. It was an art of nonverbal communication by artists who made many eloquent statements concerning their purposes. It was an art of revolutionaries that became the norm. The standards it established are those against which later artists were to measure themselves.

AMERICAN REALISM

The Eight and the Ashcan School

The American Academy, established in the nineteenth century, was like its earlier European counterparts in that it exerted influence and power in the art world and often helped determine the success or failure of an artist. Like Europe's academies, the American Academy was conservative, traditional, and inflexible. It established artistic traditions and standards that influenced art into the twentieth century, until a group of vibrant young painters, led by Robert Henri (1865–1929), rejected its stodgy politics and attitudes as aesthetically stifling. Consistently rebuffed in exhibitions juried by the academy, a group now known as The Eight—consisting of William Glackens, George Luks, John Sloan, Everett Shinn, Arthur B. Davies, Maurice Prendergast, Ernest Lawson, and Henri—exhibited in 1908 to demonstrate its independence from the academy.

The Eight attempted to inject new life and spirit into painting by finding a subject matter close to the hearts and experiences of painters. Life and art were thought to be the same thing, and The Eight and other associated painters observed and painted everything they saw: city slums, theater, commerce, and the whole fabric of urban life with its urchins, derelicts, and milling crowds on streets and bridges. The urban milieu in all its vast diversity and with its full cast of characters fascinated these painters.

Trained often as journalistic reporters, these artists had a gift for observation and representation of the most essential detail. They also had extraordinary powers of recall and could rely on sketches and mental images to create wholly convincing depictions of city life in its rawest form.

Because their art was based on direct observation of the unembellished truth of city life, these painters developed a truly American subject matter and,

because of their sometimes commonplace imagery, inherited the name of Ashcan school. Most of the members of this group were students of Henri, the most prolific and influential teacher of this group.

The Ashcan School took its inspiration from French Impressionism, especially Edouard Manet, and from seventeenth-century Dutch realism, notably Frans Hals. Encouraged by Henri, the Ashcan school learned to paint energetically and with assurance and bravura. Their unsparing yet optimistic visions captured the vitality of the modern city and endowed people of all walks of life with dignity in the face of any circumstances. George Bellows' *Riverfront No. 1* (Plate 16) records his interest in and affection for resourceful young city dwellers, who have taken to the river to escape the city's heat. To some artists, the poor were colorful, picturesque characters full of determination. To others, the condition of the poor evoked the artists' pathos and inspired empathetic images of their oppression and degradation. Some scholars have pointed to the satirical content in Ashcan School painting, but, in general, the function of art as a vehicle for social reform was subordinate to artistic issues with which these painters were primarily concerned.

Regionalism

Realist painting from the 1920s and 1930s is often called American Scene painting. During this period, America was relatively isolated, both politically and artistically, from the rest of the world, and many artists were preoccupied with purely American subjects, in whose relevance and vitality they believed firmly. American life, its cities, and more often its small towns and rural districts were the subjects of American Scene painting. The "provinces" were frequently depicted as lonely, isolated places suffused with a haunting quiet. In their search for quintessentially "American" subjects, the Regionalists often ended their journey in the bleak, cold, and intellectually narrow world of the small rural town. Other artists turned these same subjects into images full of nightmarish, dreamlike, or fanciful qualities.

The financial deprivation of many artists in the 1930s was to some extent alleviated by the WPA, or the federal Works Project Administration, which was established in 1935 to support artists by commissioning murals for public buildings throughout the United States. By the start of World War II, these projects had been phased out, and art schools and universities took the place of government in giving institutional financial support to artists.

During and after World War II, Realism continued to be an important force in American art. The Eight, the Ashcan school, the Regionalists, and the later Realists form a long continuum in the Realist tradition of painting that is now carried on by new generations of artists.

POP ART

By the 1950s, in England and shortly thereafter in the United States, artists sought a means to reintroduce into art subjects that were grounded in present-day reality. Among the themes they found relevant to the realities of modern life were mass production and mass consumption. With these subjects in mind, these artists also used mediums that most effectively spoke to and influenced the consumer—billboards, pictorial advertisements, television, film, and comic strips. The heroes of popular culture in film and television, as well as media personalities, became the subjects of this art, Pop Artists.

The culture these artists depicted was one that appeared to be fascinated with violence and high speeds and obsessed with sex, sex symbols, and the consumption of food and various goods. Using the most visually pervasive elements of this culture, Pop Art celebrated the vulgar and the banal, the most common and most powerful forces in American society. The images produced by Pop Artists have all of the intensity, power, humor, and energy of the culture from which they are derived. Sometimes satirical and sometimes neutral, Pop Art examined a culture that contemporary viewers recognize from experience and to which they may respond with fascination, revulsion, horror, humor, or even admiration.

The tools Pop Artists used were to some extent inherited from early art movements, notably Cubism, Surrealism, and Abstract Expressionism. Fragmented and associative images, repetitions of forms, and mundane objects taken out of one context and put in another are all devices used by its antecedents.

Preoccupied with the passing trends of a popular culture, Pop Artists became, in a sense, the historians of that culture in that they preserved relics from a culture that is, in essence, ever changing and fascinated by novelty. Historians have variously called Pop Art overrated, superficial, banal, or the most influential movement in contemporary art. Because of the directness with which it speaks to the viewer's experiences, Pop Art evokes some form of response from all, and in particular from the media that inspired this movement in the first place.

MINIMAL ART

Reacting to what it regarded as the capricious and often highly personal art of the Abstract Expressionists, a group of artists began, during the 1960s, to create an art based on elemental forms. Having no meaning outside themselves and yet exuding an undeniable presence, these forms were reduced both in complexity and color to their barest essentials. The work of the so-called Minimalists is generally large, simple, serene, and passive.

Minimalism gave rise to new relationships between the viewer and the object. By its very presence, this art increases the viewer's awareness of the nature,

scale, and shape of the space that the object, and therefore the viewer, occupy. In this respect, Minimal Art is more dependent on context than is other contemporary art, because it interacts with its environment more than other types of art. At the same time, the reductive simplicity of Minimalism has an almost uniform effect on the viewer: It reduces the subjectivity of the viewer's responses and decreases his sense of individuality by imposing uniformity on him that echoes the object's lack of individuality.

Many of the characteristic distinctions between painting and sculpture gave way in Minimal Art. Walls could be adorned with canvases that were shaped; the traditional stretched canvas could be replaced by a limp one; sculptural forms of all kinds existed on the wall or floor. No matter its material, Minimal Art tended to aspire to "objecthood," thus making any pictorial message irrelevant and substituting in its place the simple meaning inherent in the presence of the object.

In Minimal Art, an object is often created through the repetition of a single shape or form. Modular permutations or variations on a theme have given Minimalism the distinction of being called a "one-image" art. Because the logical repetition of form can be carried out by anyone following specific instructions, Minimal Art is often the product of studio assistants or machine production; it even appears to be somehow anonymous or at least not attributable to the efforts of a specific creator.

OP ART

In 1965, a group of artists came to widespread public attention for its experiments with optics in art. Espousing no particular philosophy, these artists sought no other objective in their art than to remind the viewer that what he perceives is determined by the manner in which the eye receives and transmits visual information. Op Art pointed out that the processes of visual perception are not objective, and that the human eye sometimes participates in an illusion by perceiving things that are not actual.

In Op Art, graphlike images, repetitive and mechanical forms, and afterimages and patterns were produced by artists with a sophisticated understanding of the effects of colors on the eye. Much of Op Art is devoid of "style," in the common sense of the word, and lacks that specific quality that an artist bestows on his work and that distinguishes it from the work of other artists. Op Art appears anonymous and mechanical and is commercially reproducible.

TWENTIETH-CENTURY ARTISTS
———————————— CUBISTS ————————————

Georges Braque (Argenteuil-sur-Seine, France, 1882–Paris 1963).
Marcel Duchamp (Blainville, Normandy, France 1887–Neuilly 1968).

Albert Gleizes (Paris 1881–Avignon 1953).
Juan Gris (Madrid 1887–Paris 1927).
Henri Hayden (Warsaw 1883–Paris 1970).
Jean Helion (Couterne, France 1904–).
Auguste Herbin (Quievy, France 1882–Paris 1960).
Frank (Frantisek) Kupka (Opocno, Bohemia 1871–Puteaux, near Paris 1957).
Roger de La Fresnaye (Le Mans 1885–Grasse 1925).
Henri Le Fauconnier (Hesdin 1881–Paris 1946).
Fernand Léger (Argentan, France 1881–Grif-sur-Yvette, France 1955).
André Lhote (Bordeaux 1885–Paris 1962).
Jean Lurçat (Bruyères-en-Vosges, France 1892–Saint Paul 1966).
Louis Marcoussis (Markous) (Warsaw 1878–Cusset, France 1941).
Jean Metzinger (Nantes, France 1883–Paris 1956).
Francis Picabia (Paris 1879–1953).
Pablo Picasso (Malaga, Andalusia, Spain 1881–Antibes, France 1973).
Jacques Villon (Damville, France 1875–1963)

Cubist Sculptors

Alexander Archipenko (Kiev, USSR 1887–New York 1964).
Raymond Duchamp-Villon (Damville, France 1876–Cannes, France 1918).
Henri Laurens (Paris 1885–1954).
Jacques Lipchitz (Druskieniki, Lithuania 1891–Capri, Italy 1973).

Later Cubists

Alexander Archipenko (Kiev, USSR 1887–New York 1964).
Robert Delaunay (Paris 1885–Montpellier 1941).
Raymond Duchamp-Villon (Damville, France 1876–Cannes, France 1918).
Henri Laurens (Paris 1885–1954).
Jacques Lipchitz (Druskieniki, Lithuania 1891–Capri, Italy 1973).
Amédée J. Ozenfant (Saint Quentin, France 1886–Cannes, France 1966).
Ossip Zadkine (Smolensk, USSR 1890–Paris 1967).

—————————————— SYNCHROMISTS ——————————————

Patrick Henry Bruce (Long Island, Va. 1880–New York 1937).
Arthur Burdett Frost, Jr. (Philadelphia 1887–1917).
Stanton MacDonald-Wright (Charlottesville, Va. 1890–Pacific Palisades, Calif. 1973).
Morgan Russell (New York 1886–1953).

ORPHISTS

Robert Delaunay (Paris 1885–Montpellier 1941).
Sonia Delaunay (Ukraine 1885–1979).
Marcel Duchamp (Blainville, Normandy, France 1887–Neuilly, France 1968).
Frank (Frantisek) Kupka (Opocno, Bohemia 1871–Puteaux, near Paris 1957).
Fernand Léger (Argentan, France 1881–Grif-sur-Yvette, France 1955).
Francis Picabia (Paris 1879–1953).

FAUVES

Jean Biette (Le Havre), active in the 19th and 20th centuries in Paris.
Georges Braque (Argenteuil-sur-Seine 1882–Paris 1963).
Charles Camoin (Marseilles 1879–Paris 1965).
Auguste-Elisée Chabaud (Nîmes 1882–Mas de Martin, near Graveson, Bouches-du-Rhône 1955).
André Derain (Chatou 1880–Garches 1954).
Kees Van Dongen (Delfshaven, near Rotterdam, the Netherlands 1877–Monaco 1968).
Raoul Dufy (Le Havre 1877–Forcalquier, Basses-Alpes 1953).
Jules Léon Flandrin (Corens, near Grenoble 1871–Paris 1947).
Achille Emile Othon Friesz (Le Havre 1879–Paris 1949).
Henri-Charles Manguin (Paris 1874–Saint-Tropez 1949).
Albert Marquet (Bordeaux 1875–Paris 1947).
Henri Emile Matisse (Le Cateau-Cambresis, France 1869–Nice 1954).
René Piot (Paris 1869–1934).
Jean Puy (Roanne, Loire 1876–1960).
Georges Rouault (Paris 1871–1958).
Louis Valtat (Dieppe 1869–Paris 1952).
Maurice Vlaminck (Paris 1876–Rueil-la-Gadelière 1958).

EXPRESSIONISTS

Early Expressionists

James Ensor (Ostend, Belgium 1860–1949).
Edvard Munch (Loïten, Norway 1863–Ekely, Norway 1944).
Georges Rouault (Paris 1871–1958).

German Expressionists

Ernst Barlach (Wedel, Germany 1870–Rostock, USSR 1938).
Max Beckmann (Leipzig 1884–New York 1950).

Lovis Corinth (Tapiau, East Prussia 1858–Zandvoort, Netherlands 1925).
Ferdinand Hodler (Bern, Switzerland 1853–Geneva 1918).
Otto Dix (Untermhaus, 1891–Hemmenhofen 1969).
George Grosz (Berlin 1893–1959).
Alexey von Jawlensky (Kuslovo, USSR 1864–Wiesbaden 1941).
Wassily Kandinsky (Moscow 1866–Neuilly-sur-Seine 1944).
Paul Klee (Münchenbuchsee 1879–Muralto-Locarno, Switzerland, 1940).
Gustav Klimt (Baumgarten, near Vienna 1962–Vienna 1918).
Oskar Kokoschka (Pöchlarn, Austria 1886–1980).
Kaethe Schmidt Kollwitz (Königsberg, E. Prussia 1867–Moritzburg, E. Germany 1945).
Wilhelm Lehmbruck (Duisbourg-Meiderich 1881–Berlin 1919).
Max Liebermann (Berlin 1847–1935).
Franz Marc (Munich 1880–Verdun 1916).
Ludwig Meidner (Bernstadt, Silesia 1884–Darmstadt 1966).
Paula Modersohn-Becker (Dresden 1876–Worpswede 1907).
Gabriele Münter (Berlin 1877–Murnau 1962).
Emil Nolde (Nolde on Danish/German border 1867–Seebüll, Germany 1956).
Christian Rohlfs (Niendorf, Germany 1849–Hagen, Germany 1938).
Egon Schiele (Tulln 1890–Vienna 1918).
Chaim Soutine (Smilowitchi, near Minsk, USSR 1893–Paris 1943).

Die Brücke

Fritz Bleyl (1881–?)
Erich Heckel (Döbeln, Germany 1883–Hemmenhofen 1970).
Ernst Ludwig Kirchner (Aschaffenburg, Germany 1880–Frauenkirch, Switzerland, 1938).
Otto Mueller (Liebau 1874–Breslau 1930).
Max Hermann Pechstein (Zwickau, Germany 1881–Berlin 1955).
Karl Schmidt-Rottluff (Rottluff, Saxony 1884–W. Berlin 1976).

Der Blaue Reiter

David Burliuk (Burljuk) (Kharkov, USSR 1882–1967).
Vladimir Burliuk (Burljuk) (no dates).
Heinrich Campendonk (Krefeld 1889–Amsterdam 1957).
Wassily Kandinsky (Moscow 1866–Neuilly-sur-Seine 1944).
August Macke (Meschede 1887–Perthes-les-Hurles (Champagne) 1914).
Franz Marc (Munich 1880–Verdun 1916).
Gabriele Münter (Berlin 1877–Murnau 1962).
Arnold Schoenberg (Vienna 1874–USA 1951).

FUTURISTS

Giacomo Balla (Turin, Italy 1871–Rome 1958).
Umberto Boccioni (Reggio di Calabria 1882–Verona 1916).
Giovanni Boldini (Ferrara 1845–Paris 1931).
Carlo Carra (Quargnento 1881–Milan 1966).
Antonio Mancini (Rome 1852–1930).
Emilio Filippo Tommaso Marinetti (Alexandria, Egypt 1876–Milan 1944).
Luigi Russolo (Venice 1885–Cerro di Laveno 1947).
Gino Severini (Cortona, Italy 1883–Paris 1966).

VORTICISTS

David Bomberg (Birmingham, England 1890–London 1957).
Sir Jacob Epstein (New York 1880–London 1959).
Henri Gaudier (Gaudier-Brzeska) (Saint-Jean-de-Braye, France 1891–Neuville-Saint-Vaast, France 1915). Sculptor.
Wyndham Lewis (Nova Scotia, Canada 1882–London 1957).
Christopher Richard Wynne Nevinson (Hampstead, England 1889–London 1946).
William Patrick Roberts (London 1895–).

RAYONISTS

Natalia Gontcharova (Ladyzhino, USSR 1881–Paris 1962).
Mikhail Larionov (Ternopol, Ukraine, USSR 1881–Paris 1964).

SUPREMATISTS

Lazar (El) Lissitzky (Smolensk, USSR 1890–Moscow 1941).
Kasimir Malevich (Kiev 1878–Leningrad 1935). Inventor of Suprematism movement.
Laszlo Moholy-Nagy (Bacsbarsod, Hungary 1895–Chicago 1946).
Vladimir Evgrafovitch Tatlin (Moscow 1885–Novo-Devitch, near Moscow 1956).

DADAISTS AND SURREALISTS

Jean (Hans) Arp (Strasbourg, France 1886–Basel, Switzerland 1966). Showed in first Surrealist exhibition in Paris, 1925.
Johannes Theodor Baargeld (Alfred Grünewald) (Cologne-Tyrol 1927). Poet and painter.
Balthus (Klossowski de Rola) (Paris 1908–).
Hans Bellmer (Katowice, Silesia, German/Polish border 1902–Paris 1975).
Georges Braque (Argenteuil-sur-Seine 1882–Paris 1963).

Victor Brauner (Piatra Neamtz, Rumania 1903–Paris 1966). Showed in first Surrealist exhibition in Paris, 1925.

Edward Burra (London 1905–Rye, England 1976).

Giorgio de Chirico (Volos, Greece 1888–1978).

Salvador Dali (Figueras, Gerona, Spain 1904–). Showed in first Surrealist exhibition in Paris, 1925.

Paul Delvaux (Antheit-les Huys, Belgium 1897–). Showed in first Surrealist exhibition in Paris, 1925.

André Derain (Chatou 1880–Garches 1954).

Oskar Dominguez (Tenerife, Canary Islands 1906–1958).

Katherine S. Dreier (New York 1877–Milford, Conn. 1952).

Marcel Duchamp (Blainville, France 1887–Neuilly, France 1968).

Max Ernst (Brühl, Germany 1891–Paris 1976).

Alberto Giacometti (Stampa, Switzerland 1901–Chur, Switzerland 1966). Surrealist sculptor until 1934.

George Grosz (Berlin 1893–1959).

John Heartfield (Helmut Herzfelde) (Munich 1891–Berlin 1968).

Barbara Hepworth (Wakefield, Yorkshire 1903–1955). Sculptor of minimal abstract forms derived from Surrealism.

Hannah Hoech (Thuringen, Germany 1889–). Collages.

Marcel Janco (Bucharest, Rumania 1895–).

Paul Klee (Münchenbuchsee, near Bern, 1879–Muralto-Locarno, Switzerland 1940).

F. E. McWilliam (Banbridge, Ireland 1909–).

René Magritte (Lessines, Belgium 1898–Brussels 1967). Showed in first Surrealist exhibition in Paris, 1925.

André Masson (Balagny, France 1896–). Showed in first Surrealist exhibition in Paris, 1925.

Henri Emile Matisse (Le Cateau-Cambresis, France 1869–Nice 1954).

Joan Miro (Barcelona, Spain 1893–). Showed in first Surrealist exhibition in Paris, 1925.

Henry Moore (Castleford, Yorkshire 1898–). Sculptor of primordial forms drawn from Surrealist traditions.

Luc-Albert Moreau (Paris 1882–1948).

Paul Nash (London 1889–Boscombe, England 1946).

Meret Oppenheim (Berein, Germany 1913–). Objects.

Wolfgang Paalen (Vienna 1907–).

Roland Penrose (London 1900–).

Francis Picabia (Paris 1879–1953).

Pablo Picasso (Malaga, Andalusia, Spain 1881–Antibes, France 1973).

Man Ray (Philadelphia 1890–Paris 1976).

Otto van Rees (Fribourg-en-Brisgau, Germany 1884–Utrecht 1957).

Ceri Richards (Dunvant, near Swansea, Wales 1903–1971).

Hans Richter (Berlin 1888–Locarno, Switzerland 1976).

Pierre Roy (Nantes, France 1880–Milan, Italy 1950). Showed in first Surrealist exhibition in Paris, 1925.

Kurt Schwitters (Hermann Edward Karl Julius) (Hannover, Germany 1887–Ambleside, England 1948). Collages.

Kurt Seligmann (Basel, Switzerland 1900–New York 1962).

Georges Seurat (Paris 1859–1891).

Yves Tanguy (Paris 1900–Woodbury, Ct. 1955). Showed in first Surrealist exhibition in Paris, 1925.

CONSTRUCTIVISTS

Alexandra Exter (Bielostock, near Kiev 1882–Fontenay-aux-Roses, near Paris 1949).

Naum Gabo (Briansk, USSR 1890–1977).

Lazar (El) Lissitzky (Smolensk, USSR 1890–Moscow 1941).

Alexandr Mikhailovitch (St. Petersburg 1891–Moscow 1956).

Paul Nash (London 1889–Boscombe, England 1946).

Antoine Pevsner (Orel, USSR 1886–Paris 1962).

Liubov Popova (near Moscow 1889–Moscow 1924).

Olga Rosanova (1886–1918).

Varvara Stepanova (Kovno, USSR 1894–Moscow 1958).

Vladimir Evgrafovitch Tatlin (Moscow 1885–Novo-Devitch, near Moscow 1956).

Christopher Wood (Knowsley, England 1901–Salisbury, England 1930).

Georges Yakoulov (or Jakouloff) (Tiflis, USSR 1884–Baku, USSR 1928).

THE BAUHAUS

Teachers

Anni Albers (Berlin c. 1900–New Haven, Ct. 1933).

Josef Albers (Bottrop, Germany 1888–New Haven, Ct. 1976). Taught at Bauhaus c. 1920–1933.

Willi Baumeister (Stuttgart 1889–1955).

Herbert Bayer (Haag, Austria 1900–). Typographical design.

Max Bill (Winterthur, Switzerland 1908–).

Lyonel Feininger (New York 1871–1956). Taught at Bauhaus c. 1919–1924.

Walter Gropius (Berlin 1883–1969). Architect.

Johannes Itten (Süderen-Linden, Germany 1888–Zurich 1967).

Wassily Kandinsky (Moscow 1866–Neuilly-sur-Seine 1944). Taught at the Bauhaus 1922–1933.

Paul Klee (Münchenbuchsee near Bern 1879–Muralto-Locarno, Switzerland 1940). Taught at Bauhaus 1921–1930.

Gerhard Marks (1889–). Taught at Bauhaus 1919–1925.

Adolf Meyer (1881–Baltrum, Germany 1929).

Laszlo Moholy-Nagy (Bacsbarsod, Hungary 1895–Chicago 1946). Taught at Bauhaus, 1922–1928.

Georg Muche (Querfurt, Germany 1895–). Taught at Bauhaus, 1919–1927.

Oskar Schlemmer (Stuttgart 1888–Baden-Baden 1943). Painter, theater designer. Taught at Dessau, Weimar; taught at Bauhaus, 1920–1929.

Lothar Schreyer (Blasewitz, near Dresden 1886–Hamburg 1966).

Students

Mordecai Ardon (Tuchow, Poland 1896–). Painter.

Herbert Bayer (Haag, Austria 1900–).

Max Bill (Winterthur, Switzerland 1908–). Painter.

Paul Citroen (Berlin 1896–). Painter.

Werner Gilles (Rheydt 1894–Essen 1961). Painter.

Ludwig Hirschfeld-Mack (Frankfurt 1893–Sidney, Australia 1965).

Hans Hofmann (Weissenberg, Bavaria 1880–New York 1966).

Ida Kerkovius (Riga, Latvia 1879–1970). Painter, weaver.

Friedrich (Fritz) Kuhr (Liège 1899–1975). Painter.

Richard Oelze (Magdeburg, East Germany 1900–1980). Painter.

Lou Scheper-Berkenkamp (Wesel, Germany 1901–). Painter.

Alexander Schwawinsky (Xanti) (Basel, Switzerland, 1904–). Painter, graphic designer.

Hans Thiemann (Langendreer 1910–). Painter.

Fritz Winter (Altenbögge 1905–). Painter.

——————————— DE STIJL ———————————

Jean (Hans) Arp (Strasbourg, France 1886–Basel, Switzerland 1966).

Constantin Brancusi (Pestisani Gorj, Rumania 1876–Paris 1957).

Theo van Doesburg (E. M. Kupper) (Utrecht 1883–Davos, Switzerland 1931). Painter, stained glass designer.

Cesar Domela (Domela-Nieuwenhuis) (Amsterdam 1900–). Painter.

Werner Graeff (Wuppertal, Germany 1901–Essen, Germany 1962). Film maker, muralist.

Vilmos Huszar (Budapest 1884–1960). Stained glass designer, interior decorator.

Bart van der Leck (Utrecht 1876–Blaricum, the Netherlands 1958). Painter, stained glass, textile designer, book illustrator.

Lazar (El) Lissitzky (Smolensk, USSR 1891–Moscow 1941). Constructivist, painter, graphic designer.

Piet Mondrian (Amersfoort, the Netherlands 1872–New York 1944). Painter.
Hans Richter (Berlin 1888–Locarno, Switzerland 1976). Painter, film maker.
Gerrit Thomas Rietveld (Utrecht, 1888–1964). Architect, furniture designer.
Gino Severini (Cortona, Italy 1883–Paris 1966).
Georges Vantongerloo (Antwerp 1886–Paris 1965).
Friedel Vordemberge-Gildewart (Osnabrück, Germany 1899–Ulm, Germany 1963). Painter, typographic designer, poet.

―――――――――――――― PURISTS ――――――――――――――

Willi Baumeister (Stuttgart 1889–1955).
Le Corbusier (Charles-Edouard Jeanneret-Gris) (La Chaux-de-Fonds, Switzerland 1887–Cap Martin, France 1965).
Amédée Ozenfant (Saint Quentin, Aisne 1886–1966 Paris).

―――――――――――――― SCHOOL OF PARIS ――――――――――――――

Alexander Archipenko (Kiev 1887–New York 1964).
Jean-Louis Boussingault (Paris 1883–1943).
Constantin Brancusi (Pestisani, Gorj, Rumania 1876–Paris 1957).
Georges Braque (Argenteuil-sur-Seine 1882–Paris 1963).
Alexander Calder (Philadelphia 1898–New York 1976).
Marc Chagall (Vitebsk, USSR 1887–).
Salvador Dali (Figueras, Gerona, Spain 1904–).
Stuart Davis (Philadelphia 1894–New York 1964).
Robert Delaunay (Paris 1885–Montpellier 1941).
Sonia Delaunay (Ukraine 1885–1979).
Charles Demuth (Lancaster, Pa. 1883–1935).
André Derain (Chatou 1880–Garches 1954).
Arthur Garfield Dove (Canandaigua, N.Y. 1880–Centerport, N.Y. 1946).
Marcel Duchamp (Blainville, Normandy, France 1887–Neuilly, France 1968).
Raoul Dufy (Le Havre 1877–Forcalquier, Basses-Alpes 1953).
Max Ernst (Brühl 1891–Paris 1976).
Tsougoharu Foujita (Tsuguji Fujita) (Tokyo 1886–Zurich 1968).
Otto Freundlich (Pomerania, Germany 1878–Maidanek Concentration Camp, Lublin, Poland 1943).
Achille -Emile -Othon Friesz (LeHavre 1879–Paris 1949).
Naum Gabo (Briansk, USSR 1890–1977).
William James Glackens (Philadelphia 1870–Westport, Ct. 1938).
Albert Gleizes (Paris 1881–Avignon, France 1953).
Julio Gonzalez (Barcelona 1876–Arceuil, near Paris 1942).
Juan Gris (Madrid 1887–Paris 1927).

Marcel Gromaire (Noyelles-sur-Sambre 1892–Paris 1971).
Marsden Hartley (Lewiston, Me. 1877–Ellsworth, Me. 1943).
Hans Hartung (Leipzig 1904–).
Edward Hopper (Nyack, N.Y. 1882–New York 1967).
Wassily Kandinsky (Moscow 1866–Neuilly-sur-Seine, France 1944).
Frank (František) Kupka (Opocno, Bohemia 1871–Puteaux, near Paris 1957).
Roger de La Fresnaye (LeMans 1885–Grasse 1925).
Amédée de La Patellière (Vallet, near Nantes 1890–Paris 1932).
Marie Laurencin (Paris 1883–1956).
Fernand Léger (Argentan 1881–Grif-sur-Yvette 1955).
Jacques Lipchitz (Druskieniki, Lithuania 1891–Capri, Italy 1973).
Stanton Macdonald-Wright (Charlottesville, 1890–Pacific Palisades, Calif. 1973).
Louis Marcoussis (Markous) (Warsaw 1878–Cusset 1941).
John Marin (Rutherford, N.J. 1870–Cape Split, Me. 1953).
Albert Marquet (Bordeaux 1875–Paris 1947).
Henri Emile Matisse (Le Cateau-Cambresis, France 1869–Nice 1954).
Alfred Henry Maurer (New York 1868–1932).
Jean Metzinger (Nantes, France 1883–Paris 1956).
Joan Miro (Barcelona 1893–).
Amedeo Modigliani (Livorno, Italy 1884–Paris 1920).
Julius Pascin (Vidin, Bulgaria 1885–Paris 1930).
Antoine Pevsner (Orel, USSR 1886–Paris 1962).
Francis Picabia (Paris 1879–1953).
Pablo Picasso (Malaga, Andalusia, Spain 1881–Antibes, France 1973).
Maurice Brazil Prendergast (St. John's, Newfoundland 1859–New York 1924).
Diego Rivera (Guanajuato, Mexico 1886–Mexico City 1957).
Georges Rouault (Paris 1871–1958).
Morgan Russell (New York 1886–Broomall, Pa. 1953).
André Dunoyer de Segonzac (Boussy-Sainte-Antoine, Seine-et-Oise 1884–Paris 1974).
Pierre Soulages (Rodez, Aveyron, France 1919–).
Chaim Soutine (Smilowitchi, near Minsk, 1893–Paris 1943).
Nicolas de Stael (St. Petersburg, USSR 1914–Antibes, France 1955).
Maurice Utrillo (Paris 1883–Dax 1955).
Suzanne Valadon (Bessines, Haute-Vienna 1865–Paris 1938).
Jacques Villon (Damville, France 1875–1963).
Maurice Vlaminck (Paris 1876–Rueil-la-Gadelière 1958).
Ossip Zadkine (Smolensk, USSR 1890–Paris 1967).

PHOTO SECESSION GALLERY "291"

Oscar Bluemner (Hannover, Germany 1867–1938), active from 1905–1917.
Charles Demuth (Lancaster, Pa. 1883–1935), active 1905–1920.

Arthur Garfield Dove (Canandaigua, N.Y. 1880–Centerport, N.Y. 1946), active from 1905.

Samuel Halpert (Bialystok, Poland 1884–Detroit 1930), active from 1905.

Marsden Hartley (Lewiston, Me. 1877–Ellsworth, Me. 1943), active from 1905.

John Marin (Rutherford, N.J.1870–Cape Split, Me. 1953).

Alfred Henry Maurer (New York 1868–1932).

Georgia O'Keeffe (Sun Prairie, Wis. 1887–), active from 1905.

Charles R. Sheeler (Philadelphia 1883–Dobbs Ferry, N.Y. 1965), active from 1905.

Niles Spencer (Pawtucket, R.I. 1893–Sag Harbor, N.Y. 1952).

Edward Steichen (Luxembourg 1879–West Redding, Conn. 1973).

Alfred Stieglitz (Hoboken, N.J.1864–New York 1946).

Abraham Walkowitz (Tumen, Siberia 1878–Brooklyn, N.Y. 1965), active from 1905.

Max Weber (Bialystok, Poland 1881–Great Neck, N.Y. 1961).

ABSTRACT EXPRESSIONISTS

William Baziotes (Pittsburgh 1912–New York 1963).

Norman Bluhm (Chicago 1920–).

James Brooks (St. Louis 1906–).

Willem de Kooning (Rotterdam, Netherlands 1904–).

Sam Francis (San Mateo, Calif. 1923–).

Helen Frankenthaler (New York 1928–).

Karl Otto Götz (Aix-la-Chapelle 1914–).

Arshile Gorky (Vosdanig Manoog) (Tiflis, USSR 1904–Sherman, Ct. 1948).

Adolph Gottlieb (New York 1903–Easthampton, Long Island, N.Y. 1974).

Philip Guston (Montreal, Quebec 1913–1981).

David Hare (New York 1917–).

Hans Hofmann (Weissenberg, Germany 1880–New York 1966).

Paul Ripley Jenkins (Cody, Wyo. 1940–Seattle, Wash. 1974).

Lester Johnson (Minneapolis 1919–).

Franz Kline (Wilkes–Barre, Pa. 1910–New York 1962).

George McNeil (New York 1908–).

Joan Mitchell (Chicago 1926–).

Robert Motherwell (Aberdeen, Wash. 1915–).

Barnett Newman (New York 1905–1970).

Jules Olitski (Gomel, USSR 1922–).

Jackson Pollock (Cody, Wyo. 1912–Easthampton, Long Island, N.Y. 1956).

Ad Reinhardt (Buffalo, N.Y. 1913–New York 1967).

Milton Resnick (Bratslav, USSR 1917–).

Jean-Paul Riopelle (Montreal 1923–).
Mark Rothko (Daugavpils, Latvia USSR 1903–New York 1970).
Karl Horst Sonderborg (Denmark 1923–).
Theodoros Stamos (New York 1922–).
Clyfford Still (Grandin, N.D. 1904–).
Bradley Walker Tomlin (Syracuse, N.Y. 1899–New York 1953).
Jack Tworkov (Biala, Poland 1900–New York 1982).
Emilio Vedova (Venice, Italy 1919–).

European Abstract Expressionists

Afro (Afro Basaldella) (Udine 1912–1976).
Pierre Alechinsky (Brussels 1927–).
Karel Appel (Amsterdam 1921–).
Corneille (Cornelis van Beverloo) (Liège, Belgium 1922–).
Jean Dubuffet (Le Havre 1901–).
Hans Hartung (Leipzig 1904–).
Asger Jorn (Denmark 1914–1973).
Georges Mathieu (Boulogne-sur-Mer 1921–).
Pierre Soulages (Rodez, France 1919–).
Nicholas de Staël (St. Petersburg, USSR 1914–Antibes, France 1955).

—————————— AMERICAN REALISM ——————————

The Eight

Arthur Bowen Davies (Utica, N.Y. 1862–Florence, Italy 1928).
William James Glackens (Philadelphia 1870–Westport, Ct. 1938).
Robert Henri (Cincinnati 1865–New York 1929).
Ernest Lawson (San Francisco 1873–New York 1939).
George Benjamin Luks (Williamsport, Pa. 1867–1933).
Maurice Brazil Prendergast (St. John's, Newfoundland 1859–New York 1924).
Everett Shinn (Woodstown, N.J.1876–New York 1953).
John Sloan (Lock Haven, Pa. 1871–Hanover, N.H. 1951).

Ashcan School

Gifford Reynolds Beal (New York 1879–1956).
George Wesley Bellows (Columbus, Ohio 1882–New York 1925).
Glenn O. Coleman (Springfield, Ohio 1887–Long Beach, N.Y. 1932).
Guy Pene Du Bois (Brooklyn, N.Y. 1884–Boston 1958).
Eugene Higgins (Kansas City, Mo. 1874–New York 1958).
Rockwell Kent (Tarrytown, N.Y. 1882–1971).

Leon Kroll (New York 1884–1974).
Walt Kuhn (Brooklyn, N.Y. 1880–1949).
Alfred Henry Maurer (New York 1868–1932).
Jerome Myers (Petersburg, Va. 1867–New York 1940).
Everett Shinn (Woodstown, N.J.1876–New York 1953).

Regionalists

Aaron Bohrod (Chicago 1907–).
John Cox (New York 1900–).
Edward Hopper (Nyack, N.Y. 1882–New York 1967).
Peter Hurd (Roswell, N.M. 1904–).
Karl Knaths (Eau Claire, Wis. 1891–).
Moses Soyer (Tambov, USSR 1899–1974).
Raphael Soyer (Tambov, USSR 1899–). Twin brother of Moses.
Max Weber (Bialystok, Poland 1881–Great Neck, N.Y. 1961).

Later American Realists

Ivan Le Lorraine Albright (Chicago 1897–).
Milton Avery (Altmar, N.Y. 1893–New York 1965).
Jack Beal (Richmond, Va. 1931–).
Larry Bell (Chicago 1939–).
Thomas Hart Benton (Neosho, Mo. 1889–1975).
Isabel Bishop (Cincinnati 1902–).
Peter Blume (Smorgonie, USSR 1906–).
Aaron Bohrod (Chicago 1907–).
Louis Bouche (New York 1896–).
Charles Burchfield (Ashtabula, Ohio 1893–1967).
Chuck Close (Monroe, Wash. 1940–).
John Steuart Curry (Dunavant, Kans. 1897–Madison, Wis. 1946).
Arthur Bowen Davies (Utica, N.Y. 1862–Florence, Italy 1928).
Edwin Dickinson (Seneca Falls, N.Y. 1890–New York 1978).
Richard Clifford Diebenkorn, Jr. (Portland, Ore. 1922–)
Richard Estes (Evanston, Ill. 1936–).
Philip Evergood (New York 1901–Southbury, Ct. 1975).
John B. Flannagan (Fargo, N.D. 1895–New York 1942).
William Gropper (New York 1897–1977). Major cartoonist.
Alex Katz (New York 1927–).
Gaston Lachaise (Paris 1882–New York 1935).
Gabriel Laderman (Brooklyn, N.Y. 1929–).
Alfred Leslie (New York 1927–).
Jack Levine (Boston 1915–).

Reginald Marsh (Paris 1898–New York 1954).
Loren MacIver (New York 1909–).
Walter Tandy Murch (Toronto, Canada 1907–1967).
Philip Pearlstein (Pittsburgh, 1924–).
Abraham Rattner (Poughkeepsie, N.Y. 1895–).
Anton Refregier (Moscow 1905–).
Ben Shahn (Kaunas, Lithuania 1898–New York 1969).
Mitchell Siporin (New York 1910–).
Wayne Thiebaud (Mesa, Ariz. 1920–).
Mark Tobey (Centerville, Wis. 1890–Basel, Switzerland 1976).
George Tooker (Brooklyn, N.Y. 1920–).
Andy Warhol (McKeesport, Pa. 1928–).
Franklin Chenault Watkins (New York 1894–).
Grant Wood (Anamosa, Iowa 1892–Iowa City 1942).
Andrew Newell Wyeth (Chadds Ford, Pa. 1917–).

POP ARTISTS

Valerio Adami (Bologna, Italy 1935–).
Billy Al Bengston (Dodge City, Kans. 1934–).
Peter Thomas Blake (Dartford, Kent, England 1932–).
Jim Dine (Cincinnati, Ohio 1935–).
Winfred Gaul (Düsseldorf, Germany 1928–).
Red Grooms (Nashville, Tenn. 1937–).
Richard Hamilton (London 1922–).
Duane Hanson (Alexandria, Minn. 1925–).
David Hockney (Bradford, England 1937–).
Robert Indiana (New Castle, Ind. 1928–).
Jasper Johns (Allendale, S.C. 1930–).
Allen Jones (Southampton, England 1937–).
Edward Kienholz (Fairfield, Wash. 1927–).
Ron B. Kitaj (Chagrin Falls, Ohio 1932–).
Peter Klasen (Lubeck, Germany 1935–).
Roy Lichtenstein (New York 1923–).
Richard Lindner (Hamburg, Germany 1901–).
Claes Oldenburg (Stockholm, Sweden 1929–).
Eduardo Paolozzi (Edinburgh, Scotland 1924–).
Peter Phillips (Birmingham, England 1939–).
Mel Ramos (Sacramento, Calif. 1935–).
Bernard Rancillac (Paris 1931–).
Robert Rauschenberg (Port Arthur, Texas 1925–).
Martial Raysse (Golfe-Juan, France 1936–).
Larry Rivers (Bronx, N.Y. 1923–).

James Rosenquist (Grand Forks, N.D. 1933–).
Edward Joseph Ruscha (Omaha, Neb. 1937–).
Lucas Samaras (Kastoria, Greece 1936–).
George Segal (New York 1924–).
Wayne Thiebaud (Mesa, Ariz. 1920–).
Andy Warhol (McKeesport, Pa. 1928–).
Tom Wesselmann (Cincinnati, Ohio 1931–).

MINIMALISTS

Auguste-Paul-Charles Anastasi (Paris 1820–1889).
Carl André (Quincy, Mass. 1935–).
Walter Darby Bannard (New Haven, Ct. 1934–).
Mel Bochner (Pittsburgh, Pa. 1940–).
Dan Flavin (New York 1933–).
Al Held (Brooklyn, N.Y. 1928–).
Charles B. Hinman (Syracuse, N.Y. 1932–).
Robert Huot (Staten Island, N.Y. 1935–).
Donald Judd (Excelsior Springs, Mo. 1928–).
Ellsworth Kelly (Newburgh, N.Y. 1923–).
Morris Louis (Baltimore, Md. 1912–Washington, D. C. 1962).
Robert Morris (Kansas City, Mo. 1931–).
Kenneth Noland (Asheville, N.C. 1924–).
Claes Oldenburg (Stockholm, Sweden 1925–).
Jules Olitski (Gomel, USSR 1922–).
Larry Poons (Tokyo, Japan 1937–).
Robert Smithson (Passaic, N.J.1938–Amarillo, Tex. 1973).
Frank Stella (Malden, Mass. 1936–).
Jack Youngerman (Louisville, Ky. 1926–).
Larry Zox (Des Moines, Iowa 1937–).

OP ARTISTS

Yaacov Agam (Rishon-le-Zion, Israel 1928–).
Josef Albers (Bottrop, Germany 1888–New Haven, Conn. 1976).
Richard Anuskiewicz (Erie, Pa. 1930–).
Karl Gerstner (Streng Klarer) (Basel, Switzerland 1930–).
Heinz Mack (Lollar, Germany 1931–).
Larry Poons (Tokyo, Japan 1937–).
Bridget Louise Riley (London 1931–).
Tadasky (Kuwayama Tadasuke) (Nagoya, Japan 1935–).
Victor de Vasarely (Pécs, Hungary 1908–).

TWENTIETH-CENTURY ART: MAJOR COLLECTIONS

——————————————— CUBISM ———————————————

Europe

Basel, Kunstmuseum
Basel, Öffentliche Kunstsammlung
Bern, Kunstmuseum
Düsseldorf, Kunstsammlung Nord-
 rhein-Westfalen
Eindhoven, Stedelijk Van Abbemu-
 seum
Glasgow, Glasgow Art Gallery and
 Museum
The Hague, Haags Gemeentemu-
 seum
Le Havre, Nouveau Musée des
 Beaux-Arts
Leningrad, Hermitage
London, Tate Gallery
Milan, Galleria d'Arte Moderna
Moscow, Pushkin Museum
Otterlo, Rijksmuseum Kröller-Müller
Paris
 Bibliothèque Historique de la Ville
 de Paris
 Musée National d'Art Moderne
 Musée National du Louvre
Prague, National Gallery
Saarbrücken, Saarlandmuseum
Stockholm, Moderna Museet
Stuttgart
 Württembergische Landesmuseum
 Staatsgalerie
Venice, Peggy Guggenheim Founda-
 tion

United States and Canada

Buffalo, Albright-Knox Art Gallery
Chicago, Art Institute of Chicago
Cincinnati, Cincinnati Art Museum
Los Angeles
 Los Angeles County Museum of
 Art
 Norton Simon Museum
New York
 Solomon R. Guggenheim Mu-
 seum
 Museum of Modern Art
Ottawa (Canada), National Gallery of
 Canada
Palm Beach (FL), Norton Gallery
 and School of Art
Philadelphia, Philadelphia Museum
 of Art
Pittsburgh, Museum of Art, Carnegie
 Institute
St. Louis, City Art Museum of St.
 Louis
Utica (NY), Munson-Williams-
 Procter Institute
Washington, D.C.
 Joseph H. Hirshhorn Museum and
 Sculpture Garden, Smithsonian
 Institute
 Phillips Collection

——————————————— FAUVISM ———————————————

Europe

Avignon, Musée Calvet
Bagnols-sur-Cèze, Musée

Basel, Kunstmuseum
Bordeaux, Musée de Peinture et de
 Sculpture

Copenhagen, Statens Museum for
Kunst
Düsseldorf, Kunstsammlung Nord-
rhein-Westfalen
Grenoble, Musée des Beaux-Arts
Le Havre, Nouveau Musée des
Beaux-Arts
Leningrad, Hermitage
London, Tate Gallery
Lyon, Musée des Beaux-Arts
Menton, Musée
Oslo, Nasjonalgalleriet
Nice
Musée Masséna
Musée Matisse
Paris
Bibliothèque Historique de la Ville
de Paris
Musée du Petit Palais
Musée National d'Art Moderne
Saint-Tropez, Musée de l'Annonciade
Strasbourg, Musée d'Art Moderne
Stuttgart, Staatsgalerie
Vienna, Museum des 20. Jahrhun-
derts
Zurich, Kunsthaus

United States and Canada

Baltimore, Baltimore Museum of Art
Boston, Museum of Fine Arts

Chicago, Art Institute of Chicago
Detroit, Detroit Institute of Arts
Fort Worth, Kimbell Art Foundation
Houston, Museum of Fine Arts
Merion Station (PA), Barnes Foun-
dation Museum of Art
Milwaukee, Milwaukee Art Center
and Layton Art Gallery
Minneapolis, Minneapolis Institute
of Arts
New York
Brooklyn Museum
Solomon R. Guggenheim
Museum
Museum of Modern Art
Whitney Museum of American Art
Ottawa (Canada), National Gallery of
Canada
Philadelphia, Philadelphia Museum
of Art
Saint Louis, City Art Museum of St.
Louis
San Francisco, San Francisco Mu-
seum of Modern Art
Toronto (Canada), Art Gallery of
Ontario
Washington, D.C.
Dumbarton Oaks Research Library
and Collection
National Gallery of Art

GERMAN EXPRESSIONISM

Europe

Amsterdam, Stedelijk Museum
Antwerp, Koninklijk Museum voor
Schone Kunsten
Basel
Kunstmuseum
Berlin
Brücke-Museum

Georg-Kolbe-Museum
Staatliche Museen
Bern, Kunstmuseum
Bordeaux, Musées des Beaux-Arts
Bremen, Kunsthalle
Brussels, Musées Royaux des Beaux-
Arts de Belgique
Cologne, Wallraf-Richartz-Museum
Copenhagen, Museum für Moderne
Kunst

Darmstadt, Hessisches Landesmuseum
Dortmund, Museum am Ostwall
Dresden, Staatliche Kunstsammlungen
Duisburg
 Städtisches Kunstmuseum
 Wilhelm-Lehmbruck-Museum
Düsseldorf
 Kunstmuseum
 Kunstsammlung Nordrhein-Westfalen
Essen, Museum Folkwang
Frankfurt
 Frankfurter Kunstverein
 Städelsches Kunstinstitut
Grenoble, Musée de Peinture et de Sculpture
Hagen, Städtisches Karl-Ernst-Osthaus Museum
Hamburg, Hamburger Kunsthalle
Hannover
 Kestner-Gesellschaft
 Niedersächsische Landesgalerie
Heidelberg, Kurpfälzisches Museum
Karlsruhe, Staatliche Kunsthalle
Kiel, Kunsthalle
Krefeld, Kaiser-Wilhelm-Museum
Liège, Musée des Beaux-Arts
Lübeck, Museen für Kunst und Kulturgeschichte der Hansestadt
Lucerne, Kunstmuseum
Mannheim, Städtische Kunsthalle
Mönchengladbach, Städtisches Museum
Munich
 Bayerische Staatsgemäldesammlungen
 Staatliche Graphische Sammlung
Münster, Landesmuseum für Kunst und Kulturgeschichte
Neuss, Clemens-Selz-Museum
Oldenburg, Landesmuseum für Kunst und Kulturgeschichte

Oslo
 Munch Museet, Oslos Kommunes Kunstsamlinger
 Nasjonalgalleriet
Oostende, Musées des Beaux-Arts
Otterlo, Rijksmuseum Kröller-Müller
Paris
 Musée d'Art Moderne de la Ville de Paris
 Musée National d'Art Moderne de la Ville de Paris
 Musée du Petit Palais
Rotterdam, Museum Boymans-van Beuningen
Saarbrüchen, Saarlandmuseum
Seebüll, Nolde-Museum
Stuttgart, Staatsgalerie
Ulm, Ulmer Museum
Vienna, Graphische Sammlung
 Kunsthistoriches Museum
Wiesbaden, Städtisches Museum-Gemäldegalerie
Wuppertal, Von der Heydt Museum
Zurich, Kunsthaus

United States

Boston, Museum of Fine Arts
Bloomington, Indiana University Art Museum
Cambridge, Busch-Reisinger Museum of Germanic Culture, Harvard University
Chicago, Art Institute of Chicago
Detroit, Detroit Institute of Arts
Grand Rapids (MI), Grand Rapids Art Gallery
Kansas City (MO), William Rockhill Nelson Gallery of Art and Mary Atkins Museum of Fine Arts
Los Angeles, Los Angeles County Museum of Art
Minneapolis, Minneapolis Institute of Arts

New York
 Solomon R. Guggenheim
 Museum
 Museum of Modern Art

St. Louis
 City Art Museum of St. Louis
 Washington University Gallery of
 Art

FUTURISM

Europe

Amsterdam, Stedelijh Museum
Basel, Kunstmuseum
Como, Museo Civico
Grenoble, Musée de Peinture et du
 Sculpture Beaux-Arts
The Hague, Haags Gemeente-
 museum
Hannover Niedersächsisches Landes-
 museum
Milan
 Castello Sforzesco, Gabinetto dei
 Disegni
 Galleria d'Arte Moderna
 Pinacoteca di Brera
Paris, Musée National d'Art Moderne

Rome
 Accademia di San Luca
 Galleria Nazionale d'Arte Moderna

United States

New Haven, Yale Univesity Art
 Gallery
New York
 Metropolitan Museum of Art
 Museum of Modern Art
Pittsburgh, Museum of Art, Carnegie
 Institute
Washington, Joseph H. Hirshhorn
 Museum and Sculpture Garden,
 Smithsonian Institute

SYNCHROMISM, ORPHISM, VORTICISM, RAYONISM, SUPREMATISM

Europe

Amsterdam, Stedelijk Museum
Basel, Kunstmuseum
Bielefeld, Kunsthalle
Biot, Musée Fernand Léger
Cardiff, National Museum of Wales
Dijon, Musée des Beaux-Arts
Düsseldorf, Kunstsammlung Nord-
 rhein-Westfalen
Eindhoven, Stedelijk van Abbe-
 museum
Essen, Museum Folkwang
Geneva, Petit Palais

Grenoble, Musée de Peinture et de
 Sculpture
Hannover, Niedersächsische Landes-
 galerie
Leeds, Leeds City Art Gallery
Leningrad, Hermitage
Liverpool, Walker Art Gallery
London
 Courtauld Institute Galleries
 Tate Gallery
 Victoria and Albert Museum
Manchester, Whitworth Art Gallery,
 University of Manchester
Moscow, Staatliche Tretjakoff Galerie

Nottingham, Castle Museum and Art Gallery
Otterlo, Rijksmuseum Kröller-Müller
Oxford, Ashmolean Museum of Art and Archaeology
Paris
Musée d'Art Moderne de la Ville de Paris
Musée National d'Art Moderne
Preston, Harris Museum and Art Gallery
Southampton, Southampton Art Gallery
Stockholm, Moderna Museet
Venice, Peggy Guggenheim Foundation
Winterthur, Kunstmuseum mit Sammlung des Kunstvereins

United States and Canada

Austin, The University of Texas, The Michner Collection
Baltimore, Baltimore Museum of Art
Buffalo, Albright-Knox Art Gallery
Chicago, Art Institute of Chicago
Columbus, Columbus Gallery of Fine Arts
Dallas, Dallas Museum of Fine Arts
Des Moines, Des Moines Art Center
Greensboro (NC), Weatherspoon Art Gallery, University of North Carolina
Hartford, Wadsworth Atheneum
Lincoln, Sheldon Memorial Art Gallery, University of Nebraska

Los Angeles, Los Angeles County Museum of Art
Milwaukee, Milwaukee Art Center and Layton Art Gallery
Minneapolis
Minneapolis Institute of Arts
Walker Art Center
New Haven, Yale University Art Gallery
New York
Solomon R. Guggenheim Museum
Metropolitan Museum of Art
Museum of Modern Art
Whitney Museum of American Art
Ottawa (Canada), National Gallery of Canada
Philadelphia
Pennsylvania Academy of the Fine Arts
Philadelphia Museum of Art
Pittsburgh, Museum of Art, Carnegie Institute
Rochester (NY), International Museum of Photography at George Eastman House
San Diego, Fine Arts Gallery
Utica, Munson-Williams-Procter Institute
Washington, D.C.
Joseph H. Hirshhorn Museum and Sculpture Garden, Smithsonian Institute
National Collection of Fine Arts, Smithsonian Institute

SURREALISM & DADA

Europe

Amsterdam, Stedelijk Museum
Basel, Kunstmuseum

Berlin, Staatliche Museen, Nationalgalerie
Bern, Kunstmuseum
Brussels, Musée d'Art Moderne

Düsseldorf, Kunstsammlung Nordrhein-Westfalen
Glasgow, Glasgow Art Gallery and Museum
Hamburg, Hamburger Kunsthalle
Hannover, Niedersächsisches Landesmuseum
Leiden, Prentenkabinet der Rijksuniversitet
Leningrad, Hermitage
London
 Acoris, The Surrealist Art Centre
 Tate Gallery
Milan, The Gianni Mattiolo Foundation
Newcastle-upon-Tyne, Hatton Gallery, The University
Paris, Musée National d'Art Moderne
Rotterdam, Museum Boysmans-van Beuningen
Stockholm
 Moderna Museet
 Nationalmuseum
Venice, Peggy Guggenheim Collection
Zurich, Kunsthaus

United States

Baltimore, Baltimore Museum of Art
Buffalo, Albright-Knox Art Gallery
Cambridge, Fogg Art Museum, Harvard University
Chicago, Art Institute of Chicago

Cleveland
 Cleveland Museum of Art
 Salvador Dali Museum, A. Reynolds Morse Foundation
Detroit, Detroit Institute of Arts
Hartford, Wadsworth Atheneum
Los Angeles, Los Angeles County Museum of Art
New Haven, Yale University Art Gallery
New York
 Solomon R. Guggenheim Museum
 Metropolitan Museum of Art
 Museum of Modern Art
 Whitney Museum of American Art
Philadelphia, Philadelphia Museum of Art
Pittsburgh, Museum of Art, Carnegie Institute
St. Louis
 City Art Museum of St. Louis
 Washington University Art Collection
San Francisco, San Francisco Museum of Art
Trenton, New Jersey State Museum
Waltham (MA), Rose Art Gallery, Brandeis University
Washington, D.C., Joseph H. Hirshhorn Museum and Sculpture Garden, Smithsonian Institute
West Palm Beach (FL), Norton Gallery

CONSTRUCTIVISM, THE BAUHAUS, DE STIJL, PURISM

Europe

Amsterdam
 Stichting Architecturmuseum
 Stedelijk Museum
Basel, Kunstmuseum

Berlin
 Galerie des 20. Jahrhunderts
 Staatliche Museen, Nationalgalerie
Bonn, Städtisches Kunstmuseum
Darmstadt
 Bauhaus-Archiv
 Hessisches Staatsarchiv
Drachten, "t Bleekerhûs"
Eindhoven, Stedelijk Van Abbe-
 museum
Essen, Museum Folkwang
The Hague, Haags
 Gemeentemuseum
Hamburg, Hamburger Kunsthalle
Krefeld, Kaiser-Wilhelm-Museum
Leningrad
 Russian Museum
 Theatrical Museum
Lódž, Muzeum Sztuki
London
 Tate Gallery
 Victoria and Albert Museum
Moscow, Staatliche Tretjakoff Gal-
 erie
Otterlo, Rijksmuseum Kröller-Möller
Paris
 Institut Neerlandais, Foundation
 Custodia
 Musée National d'Art Moderne
Rotterdam, Museum Boymans-van
 Beuningen
Strasbourg, Musée d'Art Moderne
Stuttgart
 Staatsgalerie
 Staatsgalerie, Graphische Samm-
 lung
 Württembergisches Landesmuseum
Utrecht, Centraal Museum der Ge-
 meente
Zurich, Kunsthaus

United States

Baltimore, Baltimore Museum of Art
Cambridge, Busch-Reisinger Mu-
 seum of Germanic Culture,
 Harvard University
Chicago, Art Institute of Chicago
Cincinnati, Cincinnati Art Museum
Cleveland, Cleveland Museum of
 Art
Houston, Museum of Fine Arts
Ithaca, Herbert F. Johnson Museum
 of Art, Cornell University
Minneapolis, Minneapolis Institute
 of Arts
New Haven, Yale University Art
 Gallery
New York
 Solomon R. Guggenheim Mu-
 seum
 Museum of Modern Art
Philadelphia, Philadelphia Museum
 of Art
Pittsburgh, Museum of Art, Carnegie
 Institute
Portland (OR), Portland Museum of
 Art
Providence, Museum of Art, Rhode
 Island of Design
Toledo, Toledo Museum of Art
Utica (NY), Munson-Williams-Proc-
 tor Institute
Washington, D.C.
 Joseph H. Hirshhorn Museum and
 Sculpture Garden, Smithsonian
 Institute
 National Gallery of Art
 Phillips Collection
Wellesley, Jewett Art Museum, Wel-
 lesley College

SCHOOL OF PARIS

Europe

Amsterdam, Stedelijk Museum
Antibes, Musée Picasso
Barcelona, Museo Pablo Picasso
Basel
 Beyeler Galerie
 Kunstmuseum
Copenhagen, Statens Museum for
 Kunst
Düsseldorf, Kunstsammlung Nord-
 rhein-Westfalen
Grenoble, Musée de Peinture et de
 Sculpture
Leningrad, Hermitage
London, Tate Gallery
Moscow
 Museum of Modern Western Art
 Pushkin Museum
Nice, Musées Municipaux
Paris
 Musée Matisse
 Musée National d'Art Moderne
Stockholm, Moderna Museet
Venice, Peggy Guggenheim Founda-
 tion
Wuppertal, Von der Heydt-Museum

United States

Baltimore, Baltimore Museum of Art
Boston, Museum of Fine Arts
Chicago, Art Institute of Chicago
Detroit, Detroit Institute of Arts
Hartford, Wadsworth Atheneum
Houston, Museum of Fine Arts
Merion Station (PA), Barnes Foun-
 dation Museum of Art
New Haven, Yale University Art
 Gallery
New York
 Solomon R. Guggenheim
 Museum
 Museum of Modern Art
Philadelphia, Philadelphia Museum
 of Art
Providence, Museum of Art, Rhode
 Island School of Design
Provincetown (MA), Chrysler Art
 Museum
San Francisco, San Francisco Mu-
 seum of Modern Art
Washington D.C., Phillips Collec-
 tion

– PHOTO SECESSION GALLERY "291" AND PRECISIONISTS –

United States

Andover (MA), Addison Gallery of
 American Art, Phillips Academy
Ann Arbor, Museum of Art, Univer-
 sity of Michigan
Athens (GA), Georgia Museum of
 Art, University of Georgia
Baltimore, Baltimore Museum of Art
Boston, Museum of Fine Arts
Buffalo, Albright-Knox Art Gallery

Cambridge, Fogg Art Museum, Har-
 vard University
Chicago, Art Institute of Chicago
Cleveland, Cleveland Museum of
 Art
Columbus, Columbus Gallery of
 Fine Art
Detroit, Detroit Institute of Arts
Hanover (NH), Hopkins Center Art
 Gallery, Dartmouth College
Hartford, Wadsworth Atheneum

Lincoln, Sheldon Memorial Art
 Gallery, University of Nebraska
Los Angeles, Los Angeles County
 Museum of Art
Milwaukee, Milwaukee Art Center
 and Layton Art Gallery
New Britain (CT), New Britain Mu-
 seum of American Art
New York
 Brooklyn Museum
 Solomon R. Guggenheim Mu-
 seum
 Metropolitan Museum of Art
 Museum of Modern Art
 Whitney Museum of American Art
Philadelphia
 Pennsylvania Academy of the Fine
 Arts
 Philadelphia Museum of Art
Providence, Museum of Art, Rhode
 Island School of Design
Rochester (NY), Memorial Art

Gallery of the University of
 Rochester
San Antonio, Marion Koogler
 McNay Art Institute
Santa Barbara, Santa Barbara Mu-
 seum of Art
Springfield (MA), Museum of Fine
 Art
St. Louis, City Art Museum of St.
 Louis
Tempe, University Art Gallery, Ari-
 zona State University
Utica, Munson-Williams-Proctor In-
 stitute
Washington, D.C.
 Corcoran Gallery of Art
 Joseph H. Hirshhorn Museum and
 Sculpture Garden, Smithsonian
 Institute
 National Museum of American Art
 Phillips Collection

ABSTRACT EXPRESSIONISM

Europe

Amsterdam, Stedelijk Museum
Basel, Öffentliche Kunstsammlung
Düsseldorf, Kunstsammlung Nord-
 rhein-Westfalen
London, Tate Gallery
Munich, Städtische Galerie im Len-
 bachhaus
Stockholm, Nationalmuseum
Stuttgart, Staatsgalerie

United States and Canada

Andover (MA), Addison Gallery of
 American Art, Phillips Academy
Atlanta, High Museum of Art

Austin, University Art Museum,
 University of Texas
Baltimore, Baltimore Museum of Art
Berkeley, University Art Museum,
 University of California
Buffalo, Albright-Knox Art Gallery
Champaign, Krannert Art Museum,
 University of Illinois
Chicago, Art Institute of Chicago
Cleveland, Cleveland Museum of
 Art
College Park, University of Maryland
 Art Gallery
Dallas, Dallas Museum of Fine Arts
Dayton, Dayton Art Institute
Des Moines, Des Moines Art Center
Detroit, Detroit Institute of Arts
Flint, Flint Institute of Arts

Hartford, Wadsworth Atheneum
Iowa City, Museum of Art, University of Iowa
Ithaca, Herbert F. Johnson Museum of Art, Cornell University
Los Angeles, Los Angeles County Museum of Art
Milwaukee, Milwaukee Art Center and Layton Art Gallery
Minneapolis
 University Gallery, University of Minnesota
 Walker Art Center
New Haven, Yale University Art Gallery
New York
 Brooklyn Museum
 Columbia University Art Collection
 Metropolitan Museum of Art
 Museum of Modern Art
 New York University Art Collection
 Whitney Museum of American Art
Oberlin (OH), Allen Memorial Art Museum
Philadelphia, Philadelphia Museum of Art

Pittsburgh, Museum of Art, Carnegie Institute
Provincetown (MA), Chrysler Art Museum
Raleigh, North Carolina Museum of Art
Regina (Canada), Norman MacKenzie Art Gallery, University of Saskatchewan
Richmond, Virginia Museum of Fine Arts
St. Louis, City Art Museum of St. Louis
San Francisco
 San Francisco Museum of Art
 School of Art
Syracuse, Everson Museum of Art
Utica (NY), Munson-Williams-Proctor Institute
Waltham (MA), Rose Art Museum, Brandeis Univesity
Washington, D.C.
 Joseph H. Hirshhorn Museum and Sculpture Garden, Smithsonian Institute
 Phillips Collection
West Palm Beach (FL), Norton Gallery

─────── EUROPEAN ABSTRACT EXPRESSIONISM ───────

Europe

Aachen, Suermondt-Museum
Basel, Kunstmuseum
Berlin, Staatliche Museen
Bielefeld, Städtische Sammlungen
Cologne, Wallraf-Richartz Museum
Düsseldorf, Kunstsammlung Nordrhein-Westfalen
Essen, Museum Folkwang
Grenoble, Musée de Peinture et du Sculpture

Hamburg, Museum für Kunst und Gewerbe
Hannover, Kunstverein
London, Tate Gallery
Mannheim, Städtische Kunsthalle
Nantes, Musée des Beaux Arts
Paris
 Musée d'Art Moderne de la Ville de Paris
 Musée National d'Art Moderne, Centre National d'Art Contemporaine

Rotterdam, Museum Boymans-van-
Beuningen
Rouen, Musée des Beaux-Arts et de
Ceramique
Turin, Galeria de Arte Moderna,
Museo Civico
Vienna, Museum des 20. Jarhhun-
derts

Winterthur, Kunstmuseum
Zürich, Kunsthaus

Canada

Montreal, Museum of Fine Art
Ottawa, National Gallery of Canada
Quebec, Museum of the Province

—————— AMERICAN REALISM: REGIONALISM ——————

United States

Andover (MA), Addison Gallery of
American Art, Phillips Academy
Athens (GA), Georgia Museum of
Art, University of Georgia
Austin, University Art Museum,
University of Texas
Bloomfield Hills (MI), Cranbrook
Academy of Art Museum
Bloomington, Indiana University Art
Museum
Boston, Museum of Fine Arts
Buffalo, Albright-Knox Art Gallery
Cedar Rapids
Cedar Rapids Art Center
Coe College, Marvin Cone Col-
lection
Chicago, Art Institute of Chicago
Cincinnati, Cincinnati Art Museum
Cleveland, Cleveland Museum of
Art
Columbus, Columbus Gallery of
Fine Arts
Dallas, Dallas Museum of Fine Arts
Detroit, Detroit Institute of Arts
Hartford, Wadsworth Atheneum
Indianapolis, Indianapolis Museum
of Art
Lincoln (NE), Sheldon Memorial
Art Gallery, University of Ne-
braska

Memphis, Brooks Memorial Art
Gallery
Milwaukee, Milwaukee Art Center
and Layton Art Gallery
Newark (NJ), Newark Museum
New Britain (CT), New Britain Mu-
seum of American Art
New York
Brooklyn Museum
Metropolitan Museum of Art
Whitney Museum of American Art
Norman, Museum of Art, University
of Oklahoma
Omaha, Joslyn Art Museum
Philadelphia
Pennsylvania Academy of the Fine
Arts
Philadelphia Museum of Art
Pittsburgh, Museum of Art, Carnegie
Institute
Raleigh, North Carolina Museum of
Art
Roswell (NM), Roswell Museum and
Art Center
St. Louis, City Art Museum of St.
Louis
Syracuse, Syracuse University Art
Collection
Terra Haute, Sheldon Swope Art
Gallery
Toledo, Toledo Museum of Art
Tucson, University of Arizona,

C. Leonard Pfeiffer Collection
of American Art
Utica (NY), Munson-Williams-Proc-
tor Institute
Washington, D.C.
Corcoran Gallery of Art
Joseph H. Hirshhorn Museum and
Sculpture Garden, Smithsonian
Institute

National Gallery of Art
Phillips Collection
Wichita, Wichita Art Museum
Williamstown (MA), Williams Col-
lege Museum of Art
Worcester (MA), Worcester Art
Museum
Youngstown (OH), Butler Institute of
American Art

POP ART

Europe

Aachen
Neue Galerie
Amsterdam, Stedelijk Museum
Berlin, Nationalgalerie
Cologne
Museum Ludwig
Wallraf-Richartz Museum
Darmstadt, Hessisches Landes-
museum
Eindhoven, Museum Kempenland
Hamburg, Hamburger Kunsthalle
Humlebaek, Louisiana Museum
Krefeld, Kaiser-Wilhelm-Museum
Liverpool, Walker Art Gallery
London
Institute of Contemporary Art
Tate Gallery
Victoria and Albert Museum
Oldham, Oldham Musèum and Art
Gallery
Paris, Musée National d'Art
Moderne
Stockholm, Moderna Museet
Tübingen, Kunsthalle

United States and Canada

Austin, University Art Museum,
University of Texas
Buffalo, Albright-Knox Art Gallery

Champaign (IL), Krannert Art
Gallery, University of Illinois
Chicago, Art Institute of Chicago
Cincinnati, Cincinnati Art Museum
Dallas, Dallas Museum of Fine Arts
Des Moines, Des Moines Art Center
Fort Worth, Fort Worth Art Center
Museum
Houston
Museum of Fine Arts
Rice University, Rice Museum,
Institute for the Arts
Kansas City (MO), William Rockhill
Nelson Gallery of Art and Mary
Atkins Museum of Fine Arts
Lawrence, Museum of Art, Univer-
sity of Kansas
Lincoln (NE), Sheldon Memorial
Art Gallery, University of Ne-
braska
Los Angeles, Los Angeles County
Museum of Art
Milwaukee, Milwaukee Art Center
and Layton Art Gallery
Minneapolis
Minneapolis Insitute of Arts
Walker Art Center
New York
Jewish Museum
Museum of Modern Art
Whitney Museum of American Art

Northampton (MA), Smith College Museum of Art
Ottawa (Canada), National Gallery of Canada
Pasadena, Pasadena Art Museum
Princeton, Art Museum, Princeton University
St. Louis, Washington University, Gallery of Art
Toronto (Canada), Art Gallery of Ontario

Vancouver (Canada), Vancouver Art Gallery
Waltham (MA), Rose Art Museum, Brandeis University
Washington, D.C., Joseph H. Hirshhorn Museum and Sculpture Garden, Smithsonian Institute
Worcester (MA), Worcester Art Museum

MINIMALISM

Europe

Berlin, Staatliche Museen
Eindhoven, Stedelijk van Abbe-museum
London, Tate Gallery
Otterlo, Rijksmuseum Kröller-Müller
Paris, Musée National d'Art Moderne
Zurich, Kunsthaus

United States and Canada

Baltimore, Baltimore Museum of Art
Boston, Museum of Fine Arts
Buffalo, Albright-Knox Art Gallery
Cleveland, Cleveland Museum of Art
Dallas, Dallas Museum of Fine Arts
Detroit, Detroit Institute of Arts
Edmonton (Canada), Edmonton Art Gallery
Greensboro (NC), Weatherspoon Art Gallery, University of North Carolina
Los Angeles
 Franklin D. Murphy Sculpture Garden, University of California
 Los Angeles County Museum of Art

Milwaukee, Milwaukee Art Center and Layton Art Gallery
Minneapolis, Walker Art Center
New York
 Finch College Museum of Art, Contemporary Wing
 Solomon R. Guggenheim Museum
 Jewish Museum
 Museum of Modern Art
 New York University Art Collection
 Whitney Museum of American Art
Northampton (MA), Smith College Museum of Art
Oberlin (OH), Allen Memorial Art Museum
Philadelphia, Philadelphia Museum of Art
Purchase (NY), Neuberger Museum
St. Louis, City Art Museum of St. Louis
San Francisco, San Francisco Museum of Modern Art
Vancouver (Canada), Vancouver Art Gallery
Washington, D.C.
 Corcoran Gallery of Art
 Joseph H. Hirshhorn Museum and

Sculpture Garden, Smithsonian
Institute
National Gallery of Art

Waltham (MA), Rose Art Gallery,
Brandeis Univesity

————————————— OP ART —————————————

Europe

Cambridge, Fitzwilliam Museum
Essen, Museum Folkwang
Gourdes, Vasarely Museum
London, Tate Gallery
Manchester, Whitworth Art Gallery

United States and Canada

Baltimore, Baltimore Museum of Art
Buffalo, Albright-Knox Art Gallery
Chicago, Art Institute of Chicago
New York, Museum of Modern Art
Victoria (Canada), National Gallery
Washington, D.C., Joseph H. Hirsh-
horn Museum and Sculpture
Garden, Smithsonian Institute

CHAPTER 12

Asian Art

INDIAN ART

Most collections of Indian art outside India include two basic mediums, painting and sculpture. The viewer who experiences these works in museums often does so without the benefit of understanding the context in which this material was originally inspired and created. In order to allow the museum visitor some insight into the origins and functions of Indian art, especially sculpture, this section will include brief descriptions of the three basic Indian religions, Hinduism, Buddhism, and Jainism. Each a complex system of thought, these religions and their iconography are integral to understanding much of the art of India.

Hinduism, Buddhism, and Jainism have at their core a basic belief in the cyclical scheme of the universe. Following a cycle of continual birth, destruction, and rebirth, all life forms are thought to undergo a process of perpetual dying and returning to life in various incarnations. Depending on one's religion, a human being may view his place in this endless cycle in any number of different ways. Each life span is believed to be punishment or reward for one's action in a past life, and each individual is alone responsible for his fate.

To many Westerners, such a view of life is fatalistic and completely alien to their own beliefs. It has been said more than once that a visit to India is enthralling because Indian culture is so foreign to Western traditions. Individuality, materialism, a thirst for power, a sense of history, egotism, vanity, and many other motivations that have shaped the development of Western culture and art do not play a role in Indian art.

Many have pointed to India's geography and topography as an explanation of the differences between its culture and the West. India has a tropical

481

climate that undergoes dramatic seasonal changes, ranging from severe droughts to monsoons and floods. Its climate can be life-sustaining as well as furiously destructive, and nature dominates human life in fundamental ways. Western societies, by virtue of their technological developments, have evolved means to temper the effects of natural forces. This ability to control the extent of nature's impact on the environment and human life bolsters the Western sense of autonomy, control, and self-reliance. In India, the immense, indomitable forces of nature, which are thought to be associated with divinities, are considered beyond human control or understanding. In this sense, India's art can be seen as an expression of these overwhelming forces.

India's history is measured, for the most part, according to the various ruling dynasties that have controlled parts of the country's massive land area. These general areas are indicated in the accompanying map (see Figure 12-1) and are referred to in the time line at the end of this section.

HINDUISM

Hinduism is a faith that has no single founder, creed, or god. It combines a variety of beliefs and practices that, together, ensure one's peaceful existence on earth and the eventual passage of one's soul to a higher realm. Hinduism is founded on a caste system that strictly stratifies society. At the top of the social hierarchy are the Brahmans, or priests, followed by Kshatriyas, or warriors and rulers, Vaisyas, or merchants and farmers, and Shudras, which include peasants, laborers, and the Untouchables, who are so named because their work places them in contact with unclean things.

Hinduism also asserts that there are certain fixed stages in the human life cycle, beginning with childhood and progressing to marriage and the raising of a family and finally to a slow retirement from worldly concerns. Its ethos is based on honesty, courage, faith, self-control, purity, and nonviolence.

The two great Hindu deities are Vishnu and Shiva. Both of these divinities are often activated by a female counterpart or consort. Shiva and Vishnu have numerous incarnations and relationships with other deities. The principal Hindu deities are listed in the table at the end of this chapter. Six of these— Ganesha, Krishna, Nandi, Nataraja, Parvati, and Shiva (see table for an explanation of their basic traits or roles)—are illustrated in their most common or typical representational forms in Figure 12-2.

Hindus typically had their family god installed in a small shrine in the home and worshiped a greater god at a nearby temple. The images in temples were worshiped through the offices of a priest or directly by the temple visitor. Temple deities were depicted in powerful but also repetitive imagery that followed certain formulas for their representation.

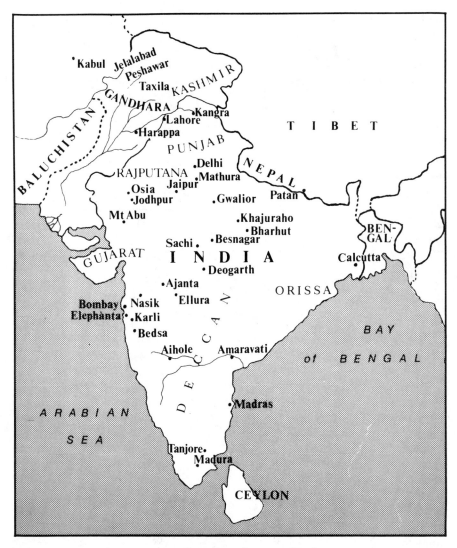

FIGURE 12-1 The important districts and cities of India.

BUDDHISM

The Buddha, variously called the Enlightened One, Gautama, or Siddhartha, was born about 563 B.C. and died about 483 B.C. A prince, great teacher, and thinker, he conceived of a means to escape the endless cycle of existence. Called the rightfold path or middle way, it required that one have the right views, aspirations, speech, conduct, occupation, frame of mind, and thought.

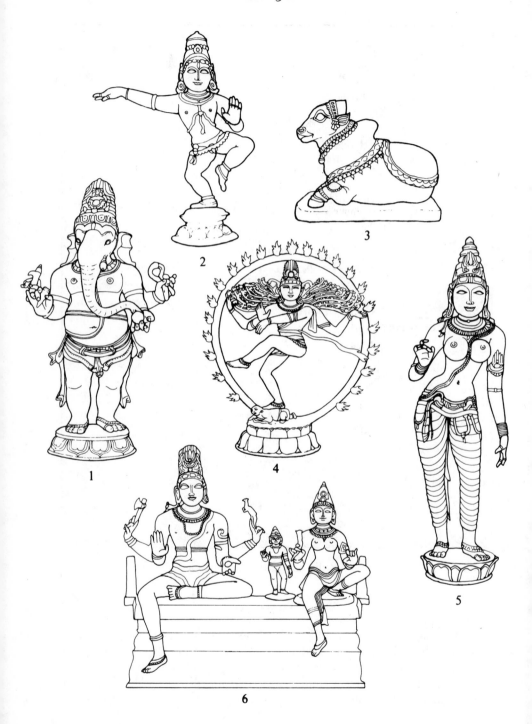

2

3

1

4

5

6

Upon the Buddha's death, his followers, both men and women, evangelized others and established monasteries throughout the East, including China and Japan. Their worship was based on the veneration of the Buddha's relics, which were housed in domed structures called stupas. These were decorated with images of the divine Buddha and episodes from his life. Aniconic, or symbolic, representations of the Buddha were followed by iconic, or figural, representations by roughly the third century A.D..

The episodes from the Buddha's life are numerous, but follow this basic chronology. His mother, Queen Māyā, miraculously conceives the Buddha and bears him effortlessly from her right side. Dreaming that her son is destined to become an emperor or a Buddha, Māyā mother dies of joy, and the Buddha, or Siddhartha, is raised by his aunt, Mahaprajapati. To prevent his conversion to asceticism, his father raises him in splendor, and Siddhartha marries Yasodhara. After he encounters a beggar, then a sick man, a funeral, and finally an ascetic who has found peace of mind, Siddhartha abandons his princely life and retires to the forest. Having cut off his long hair and exchanged his princely garments for rags, the wandering Buddha practices austerities until he almost starves to death. Then, under the sacred fig tree, he meditates and is tempted by the three daughters of Mara, Mara's demons, and then Mara himself. The following dawn, Siddhartha receives perfect enlightenment. He then confronts the choice between nirvana (extinction, or release from earthly desires and pain) and return to earth to spread the word. He chooses to preach. He preaches a middle road of salvation through right actions. For forty-four years he travels and performs miracles, including the calming of a drunken elephant sent to destroy him. In his miraculous meditations, he is transformed into flames and water and fills the sky with lotuses and other Buddhas. He converts his family, including Nanda, his half-brother. He is given an offering by a child (later reborn as the emperor Ashoka) and by a monkey (later reborn as the son of a Brahman).

At the age of eighty, the Buddha prepares to die. After saying farewell to his disciples, he meditates and passes into nirvana. His body is burned on a pyre that is miraculously extinguished by rain, and his relics are thought to be preserved in stupas throughout India.

The Buddha is often represented in human form as a monk and carries the signs of power and wealth: the tuft on his brow (urna) and the topknot (ushnisha), which indicates knowledge beyond mortal capacity. He is often shown meditating, standing, or descending from the celestial sphere to teach the right path to mortals.

FIGURE 12-2 Six of the principal Hindu deities (see table at end of chapter for explanation of each). (1) Ganesha, the Hindu God of Wisdom; (2) The young Krishna dancing; (3) Nandi, Shiva's Sacred Bull; (4) Nataraja, Shiva as Lord of the Dance; (5) Parvati, Shiva's consort; (6) Shiva, shown with Parvati.

Around the time of Christ, Mahayana (Greater Vehicle) Buddhism came about. Mahayana is the belief that others could follow the rightfold path and achieve salvation. Various enlightened bodies or beings, called Bodhisattvas, were thought to return from the peace of nirvana to preach. The term Bodhisattva also applies to a Buddha just before he attains enlightenment. The various Buddhist deities are described in the table at the end of this chapter.

Buddhistic Hinduism

Buddhism and Hinduism were fused in certain regions, producing other deities. Included among these are Yamantaka, who wears a necklace of skulls, has many terrifying faces and arms, and is worshiped in Tibet; Trailokyavijaya, who has four heads, four arms, and tramples on Shiva's head; Jambhala, the fat god of wealth, who holds a lemon and a mangosteen; Shaktis, female deities, including Tara, who was born of the Buddha's tears.

Buddhism lost its vigor in India between 500 and 800 A.D., but it remained a powerful force in China and other parts of Asia.

JAINISM

Jainism involves the worship of Mahavira (c. 548–c. 476 B.C.), who, like the Buddha, resisted nirvana in order to preach salvation to mankind. Like Buddhism, Jainism was a monastic order, and it used images in much the same way as Buddhism did. Jain imagery did not proliferate to the extent that Buddhist imagery did. Today Jain art is generally limited to western India. The Jain sect sometimes practiced nudity, a practice that is sometimes reflected in its sculpture.

SCULPTURE

Indian sculpture had many functions and origins that were similar in nature to those that inspired Western art between 1100 and 1500. Religious in purpose, the sculpture of India was intended to help its viewers grasp concepts that would enable them to abandon their material existence and enter an elevated spiritual state. Bridging the two states, Indian sculpture reflects both the material and spiritual worlds. It is based on a deep understanding of the material world, but does not imitate it. Rather, sculpture idealizes the physical and thereby helps transport the worshiper to a plane of higher thought.

Each element of an Indian sculpture is part of a complex network of meanings that may be well known or esoteric. Deities are commonly depicted as introspective, noncommunicative beings. Their trancelike expressions often reflect a state of meditation, when bodily experience is suspended and the mind ascends to higher realms.

Other sculptures may represent a particular phase in the universal, cyclical

chain of events. An aspect of the human condition may be shown to evoke or give expression to a higher state. The one element of the human condition that is most commonly evoked to express a higher spiritual realm is sensuality. In Hinduism, sensuality and even explicit sexuality are regarded as symbols for the human urge to be united with the divine.

Dance, the rhythmic movements of the body to chant or music, was another common theme in Indian sculpture. Gods are shown in a celestial dance, or worshipers are depicted in an ecstatic dance of adoration. Perhaps no other culture wove the language of dance so beautifully into its sculptural expression as did India.

Historically, the materials most frequently used in Indian sculpture were wood, stone, bronze, and terra-cotta. Of these, wood sculptures have suffered particular losses. Stone sculptures were carved out of live rock or formed parts of freestanding temples. The fragments of stone sculpture that are now known or preserved in museums have been taken from temple complexes. Very often information about these fragments is limited to the general region of origin, although on rare occasions, museum labels will indicate the names of temples from which these carved stone fragments were taken.

Terra-cotta works are known primarily through excavations of certain sites. Bronzes were cast during various dynastic periods and were used to make both large- and small-scale works. Frequently, bronze sculptures have bases that can accommodate handles, and it is likely that these were carried in processions.

Large sculptures were used for altars or temple decorations, and smaller ones were used in private worship in the home. Religious worship in India did not generally involve congregations led by a priest; rather, devotions were carried out by groups of individuals before images of their deities. In religious worship, women were usually segregated from men and attended their own temples.

Museum labels will often identify the subject of a particular piece of sculp-ture, its geographical origins, and its approximate date, usually by dynasty. Artists' names were never cited because Indian artisans, like their early Western counterparts, worked collectively as craftsmen in workshops, and their identities were considered unimportant in artistic production. Indian craftsmen followed rigidly codified rules, which were sometimes set down in writing, governing the proper representation of a particular deity. It is thought that Indian workshops made art of different religious persuasions interchangeably, and that the same workshop could be hired one day to create a Buddhist work and the next day to make a Jain or Hindu sculpture. Thus, artisans were hired for their skills, and their particular religious beliefs were of no consequence to their work.

PAINTING

India has a long and distinguished history of fresco painting. Between 100 and A.D. 600 the now famous caves at Ajanta were decorated with murals depicting

the Buddha's incarnations. Only fragments of fresco paintings have survived, and few examples are found in today's museums.

However, a form of painting in miniature was also practiced in India. The earliest known examples are found on Buddhist manuscripts, which were written on palm leaf strips. After the Muslims began to control various parts of northern India from the eighth century onward (see time line), the patronage of manuscripts shifted from Buddhists to members of the Jain sect. As an act of piety, Jain merchants commissioned illustrated manuscripts for libraries.

The Muslim sultans of India also built great libraries filled with illustrated manuscripts. Outside the Muslim areas of India, the growth of vernacular Hindu literature spurred the development of manuscript illumination in the Hindu courts of Rajasthan (see map, Figure 12-1). The painting of this region is called Rajput.

In the sixteenth century, a new Muslim dynasty, the Mughal, was formed, and it submerged Rajput painting. This dynasty was tolerant of Hinduism and brought Persian and Hindu artists into closer contact with each other. Paintings in miniature from this period evidence a tendency to strive for realism of representation. Portraiture and history subjects are introduced to the traditional images that embellished poetic and religious tracts. Ragas, which represent music, and birds were common subjects of miniature paintings.

In the hills of Punjab, a school of painters remained relatively independent of Muslim influence. The region is designed Pahari ("of the hills") and it had many centers, including Bundi, Mewar, Jodhpur, and Jaipur (see map). By the early eighteenth century, Mughal painters traveled to Pahari and influenced the art of that region.

INDIAN ART TIME LINE

——————— PRE-BUDDHIST INDIA ———————

c. 3000–1500 B.C.	Indus Valley civilization
c. 1500–800 B.C.	Aryan culture (Aryan invasions) or Vedic Period
642–320 B.C.	Shaishunaga-Nanda Period

——————— BUDDHIST PERIOD ———————

322–185 B.C.	Maurya (Asoka) Period
185–72 B.C.	Sunga Period

c. 70 B.C.–
c. A.D. 236 Andhra Period, which includes the Satavahana Dynasty, 220 B.C.–A.D. 236; the Kushan (including Gandhara or Indo-Parthian) Dynasty, c. A.D. 50–320.

320–647 A.D. Gupta Period

_____ HINDU DYNASTIES PERIOD _____

600–750	Pallava Dynasty (Eastern India)
c. 907–1053	Chola Dynasty
765–1197	Solanki Dynasty of Gujarat
750–1200	Pala and Sena Dynasties of Bengal
1076–1586	Ganga Kingdom of Orissa
c. 800–1315	Chandella Dynasty of Bundelkhand
550–642	Chalukya Dynasty of the Deccan
757–973	Rastrakuta Dynasty of the Deccan
900–1190	Kingdoms of Rajputana and Deccan
1111–1318	Hoysala and Yadava Dynasties of Mysore
1200–c. 1300	Sultanate of Delhi (Northern India)
1336–1646	Vijayanagar Dynasty (Southern India)
1646–1900	Madura Period (Southern India)
1526–1756	Mughal Dynasty (North Central India)
c. 1500– c. 1900	Rajput Dynasty (Northern India)

CHINESE ART

Among the most captivating displays in today's art museums are the artifacts of China's great 3,000-year cultural history. By roughly 1500 B.C., if not earlier, China had developed pottery, metallurgy, stone sculpture, and painting. Pottery and painting evolved into purely aesthetic art forms at a very early time relative to Western culture. By 900 A.D., and perhaps even before then, paintings and ceramics were created and appreciated for their own aesthetic merits. By then, China had already had a more than 1,000-year history of art that served no other function than to transmit and interpret images and ideals elegantly. Paintings were collected, aesthetic criticism was a well-rooted discipline, and artists were part of a cultivated society that pursued the practice of music, poetry, and painting and the study of philosophy. Although painting

was considered an intellectual exercise, it shared with pottery the demand for consummate skill.

Chinese culture as it is reflected in its art cannot be understood outside the context of imperial rule. The first Chinese Empire was unified between 221 and 226 B.C., and the imperial bureaucracy it established was to be the greatest source of artistic patronage throughout China's history. In the formation of this imperial bureaucracy, the role of Confucianism was vital. The philosophy of Confucius (c. 551–479 B.C.), whose search for a way to peace, harmony, and general welfare led to a series of works known as the Confucian Classics, formed the basis of Chinese social order and thought. Confucian thought assumed the essential goodness of man and stressed the principal obligations of all members of society to the well-being of the family, the community, and the state. Chief among the virtues were loyalty, duty, justice, knowledge, sincerity, propriety, politeness, ceremony, and deference, especially to one's elders, family, rulers, guests, and friends.

By the time of the Han Dynasty (see Chinese Art Time Line). Confucianism had become the state philosophy. State examinations, which were required for entry into official life in China, were based on the Confucian Classics. Confucian scholars graded these examinations and thereby controlled entry into the administrative system. The examination process thus created a unique social stratum of scholar-bureaucrats who were at once cultured and practical. The bureaucrat administered public affairs, on the one hand, and patronized painting, calligraphy, music, and poetry, on the other.

Through the Confucian system, manners for social interaction were developed. Breeding and restraint were greatly valued, as was the respect for one's elders and tradition. This system of decorum deeply influenced the art of painting, which refrained from the excesses of emotion and turned reverently to the past for inspiration and models. The Confucian system endowed Chinese culture with a certain conformity, love of beauty, spirituality, and balance that is reflected in the mixture of practical and aesthetic considerations and mundane and spiritual aims in Chinese art.

Confucian philosophy inspired scholars and painters for centuries and was often complemented by Taoist thought, through which the ascetic, reclusive, meditative, and individualistic tendencies of Chinese thought flowed. By the third century A.D., Buddhism also found its way into China and affected the patronage of sculpture and painting to varying degrees throughout the succeeding centuries.

A time line of the Chinese dynasties is included in this section so that the museum visitor will understand how Chinese art is dated. Also, a map of China (Figure 12-3) shows major cities and archaeological sites. The discussion of art forms in this section is organized by medium—sculpture, painting, and ceramics. Although the distinction between sculpture and pottery is somewhat arbitrary and the two categories often overlap, the division is maintained be-

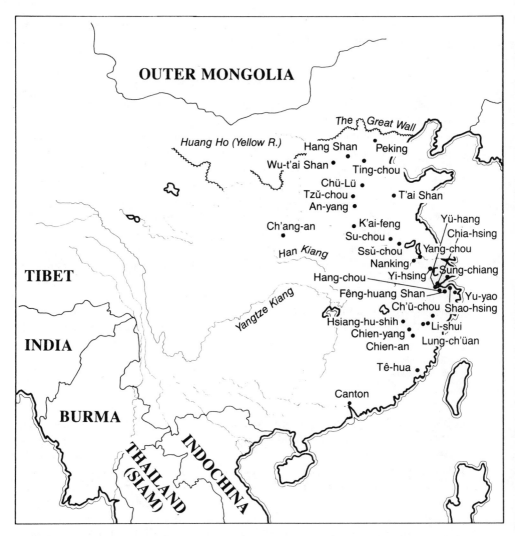

FIGURE 12-3 Map of China indicating major cities, archaeological sites, the Great Wall, the Buddhist caves.

cause most museums and texts tend to separate Chinese art objects along these lines. With regard to the romanization of Chinese words, the Wade-Giles system has been used here, as it is the system most commonly used by Western museums to transcribe Chinese characters.

Although viewers may not understand the language or comprehend specific images, China's art, from its early bronzes to later paintings and ceramics, can

be appreciated by all for the technical skill, respect for materials, and innate understanding of natural forms that they display.

SCULPTURE

Chinese sculpture underwent many changes during the 3,500 years in which it was produced. The development of sculpture in China is outlined in the following section by dynasty. Not included in the discussion are large-scale public and temple sculptures, which are normally not found in Western museums. Our knowledge of monumental sculpture is incomplete due to the destruction of a large proportion of what was produced.

Most sculpture now housed in museums has been found in temples or excavated from tombs. Tomb excavation is still ongoing and promises to yield many exciting discoveries. The museum visitor will notice that, in collections of Chinese sculpture, labels identify the subject, material, and approximate date of a piece, but not the artist. This is so because most Chinese sculptors worked anonymously in large cooperative workshops that were commissioned to produce images of burial, commemoration, or worship. The purpose and meaning of the sculptures themselves were considered more important than the identities of the artisans. Unlike painting, which was extensively collected and whose creators were often celebrated, sculpture was considered a craft of a more utilitarian than aesthetic function.

Shang Dynasty

Grave sites have yielded innumerable bronze vessels and jade objects, such as axes and knives. The vessels take many shapes, some of which may have been derived originally from now lost wood or pottery vessels. The purpose of Shang vessels is still not well understood. They are believed to have been ritual vessels associated with important cults because their production represented considerable monetary investment and technical skill. It is thought that some of these vessels were used to hold or heat sacrificial wine, and others may have contained food. Because all known Shang vessels were excavated from graves, they are assumed to have been prized possessions.

The decorations on Shang vessels follow rather consistent conventions. Relying on symmetry, balance, and rigidly defined formulas to depict various animal faces—including dragon profiles, cicada masks, and snake and spiral motifs—these decorations were applied in relief to the surface.

Chou Dynasty

During the Chou Dynasty, decorations began to cover more of the surface of bronze vessels. Some bear inscriptions of dedication for a specific occasion;

other inscriptions have been interpreted to mean that the vessels were dedicated to a particular ancestor. What these decorations meant to the owners is still not known. It appears that some owners may have ordered a whole set of vessels uniform in design and others may have possessed a group of vessels that spanned a broad spectrum of styles.

Because these vessels were buried, chemical reactions with minerals in the earth have produced a surface (patina) that is not part of the original appearance of the bronze.

Ch'in Dynasty

Little large-scale sculpture from the Ch'in Dynasty was known until the 1974 excavation of about 7,000 life-sized clay soldiers, horses, chariots, and army officers at the tomb of Emperor Ch'in, who unified China and laid the basis for imperial order for the subsequent 2,000 years. These figures, among the great treasures of the People's Republic of China, indicate that much remains to be discovered about Chinese sculpture and early Chinese burial practices.

Han Dynasty

Thousands of stone, clay, and jade objects have been found in various tombs dating from this dynasty. These small sculptures take both human and animal forms, resembling, in the latter category, bears, dogs, pigs, chickens, horses, and lions. There were also monster figures, such as chimeras, that probably acted as tomb guardians. Although their intended function is not always known, these were often made of gray clay and were sometimes glazed.

It was apparently a common practice to line the walls of offering chambers in front of the tomb with stone slabs. These slabs were decorated with relief designs showing battle, hunting, and history scenes, as well as portrayals of legends, mythology, and folklore.

Metal casting of the Han Dynasty is considered qualitatively inferior to Shang and Chou bronzes, with the notable exception of mirrors, which were well cast and extraordinarily well designed during this period.

Northern and Southern Dynasties

With the collapse of the Han Dynasty, the Chinese Empire was fragmented into various regions. This complex period is generally designated as the Northern and Southern Dynasties period. During this time, Buddhism was introduced to China from India. Although Buddhist sculpture was produced during this period, few examples from before the fifth century have survived due to iconoclastic outbursts that destroyed some Buddhist art.

Wei and Ch'i Dynasties

Buddhist sculpture from this period survives in greater numbers. Chinese artists often took Indian models as their prototypes to portray the Buddha, the Buddha of the future (Maitreya), and the Bodhisattvas. These divinities were shown as human beings whose real existence lay far above the material realm of most human existence. They are expressions of an ideal, transcendent state. The Buddha was considered an elevated being whose perfection was expressed through a generalized human form. The facial expressions of Buddhas are remote, meditative, mystical, yet warm and sincere, sympathetic, and optimistic.

During the Wei Dynasty it became common for families to bring honor to themselves by commissioning stele (stone slabs) with images of the Buddha and/or his life. These were set up in temples or courtyards. Small bronze shrines depicting images of Buddhas were also made for private use. Given their small size, these shrines could be carried by their owners from one place to another to perform their devotions.

Scholars tell us that, sometime after A.D. 550, freestanding sculptures of divinities became increasingly common. No longer only a component of a stele or surrounded by halos of flames (mandorlas), many were larger than life-sized and placed in temples. Local stone, including marble, was used to carve out impressive statues of Buddhas, Bodhisattvas (Avalokiteshvaras, or Kuan Yin, in particular), and monks. During these dynasties various forms of Buddhism developed, including Hinayana (Lesser Vehicle) Buddhism, which was represented by Ananda and Mahakyasyapa, monks who attained and came to symbolize personal salvation attained through one's individual efforts, and Mahayana (Greater Vehicle) Buddhism, which was represented by Bodhisattvas who symbolized universal salvation, which could be achieved for many through the aid of those who had already attained salvation. One such enlightened one, Amitabha, the Buddha of the pure land or early paradise, gained a wide following and was frequently depicted in sculpture.

T'ang Dyansty

Buddhism reached the peak of its influence on Chinese cultural life about A.D. 700. Scholars estimate that such perishable materials as wood, bronze, clay, and lacquer were used more often than stone to create Buddhist sculptures. The use of these less durable materials explains why fewer Buddhist sculptures from this period, compared to earlier periods, have survived.

Buddhist stele and freestanding sculptures of divinities in stone and other materials are characterized by a greater fluidity of movement, more animation, and a more natural appearance. Toward the end of the T'ang Dynasty, as sculptures became more complex, surfaces were worked with restlessly moving drapery and ornament, and divinities were endowed with a languor and sensuality that was previously unknown.

Large-scale stone sculptures of horses and monsters guarded the tombs of emperors and officials, and clay burial figures (see the discussion of pottery later in this chapter) were produced in abundance.

Five Dynasties through Sung Dynasty

Buddhism declined as a power in Chinese society during these centuries. However, a certain amount of freestanding Buddhist sculpture survives from this period. Among the most prevalent materials used by sculptors was wood. With wood and pliable materials such as clay, sculptors were able to bestow human grace, plumpness, sensuality, and tranquility upon their images of divinities, which became more life-like in appearance even though they remained idealized types.

Among the Bodhisattvas frequently represented is Avalokiteshvara, also known as Kuan Yin, the Bodhisattva who aided the suffering. He is shown in hermaphroditic form, with both male and female attributes. Through his relaxed posture alone, he imbues the viewer with a sense of comfort. As the Great Protector, he assumes a position of royal ease and is shown seated on the cloud of heaven, with his legs casually bent or one leg dangling and with one extended arm placidly draped over one knee, as he grants a blessing to the viewer.

Another commonly found sculptural figure is the Lohan, the half-saintly recluse and ascetic follower of the Buddha who maintains his state of enlightenment through acts of self-deprivation and meditation. Portrait-like images of Lohans in wood, lacquer, and pottery show them meditating, expressing both dignity and humility, spirituality, and a strong physical presence. Among the most remarkable sculptures of this period, examples of these Lohans may be found in museums though rarely in lacquer.

Buddhist sculpture continued into the Ming Dynasty. Portrait statues as well as images of divinities were produced through the Ch'ing Dynasty.

PAINTING

The history of Chinese painting is long and venerable. Painters began applying brush and color or ink to walls and other surfaces 1,000 years before Christ, if not earlier, and painting continued to be a major form of expression through the nineteenth century. The 3,000-year tradition of Chinese painting is one of the longest and greatest in the history of human civilization.

Our knowledge of this distinguished history is incomplete due to the fragmentary nature of what has survived. The survival rate for painting from before the Ch'ing Dynasty is very low and diminishes with each preceding dynasty.

Of the many kinds of painting produced in China, Western museums tend to preserve a limited number of types. Wall paintings found in tombs or

temples are rarely removed and transferred into museum collections. Museums are more likely to preserve the portable types of paintings that decorated homes and formed parts of the vast private collections that were built from the fifth century A.D. through the nineteenth century. Portable paintings most commonly took the form of hanging scrolls, screens, hand scrolls, albums, and fans.

Rooms were divided by screens that were covered with silk and painted with various scenes, and walls were adorned with vertical sheets of silk hung by a silk cord at one end. Of the screens that must have adorned many Chinese homes, very few survive. Considered the province of professional artisan-craftsmen who were motivated by commercial interests, screens were rarely executed by scholar-painters.

Scrolls were often hung in pairs or as a set of three. Hand scrolls, which were very long sheets of silk or paper rolled up, also were painted. Held between two hands, scrolls were opened from right to left, and the viewer never saw more than about two feet of the scroll at a single glance. As the right hand rolled, the left hand unrolled. Hand scrolls are unique because they allow the viewer to see images in progression, as one sequence leads to another, and over a period of time. Museum visitors today view a stationary scroll segment behind glass, and therefore lose the sense of sequential progression as well as the intimate involvement with the painting that comes from carefully handling the scroll and unrolling and rolling it. Museums will often change the part of a scroll that is displayed, in order to give visitors a chance to see more.

Albums were another form of painting that was personally owned and portable. Collectors made a habit of assembling sheets of paintings by various artists in a single album and, gradually, artists themselves explored the possibilities of theme and variation by filling an album with interrelated images of their own invention.

Fans, which early on took the shape of a leaf and later became the segmented, curved shape we know today, were another commonly found surface upon which painters plied their skill.

The materials most commonly used in Chinese painting were silk, paper, and ink and brush, as well as colors. Brush and ink, the most common materials, were applied in the allied fields of calligraphy (Chinese writing, which was considered an art in itself) and drawing. Much Chinese painting is a unique blend of painting and drawing as lines vary from thick to very thin. Responding to the viscosity of ink, that is, the drag of ink on paper or silk, and his own personal touch or writing style, the artist must understand the nature of the materials in order to bring an internal vision to life.

The subjects that Chinese painters explored were diverse and depended to some extent on patronage and the milieu in which an artist created. Painters working in courtly circles provided commemorative images, including portraits, records of important past and present events, scenes of daily life, and decorative

images of flowers and animals. Monk painters, who worked in temples, and painters who had patrons who sought religious images produced a variety of Buddhist or Taoist images. The dividing line between religious and secular imagery in Chinese painting is often hard to define, for what may seem to us to be simple images are often laden with meaning. Not only images of Buddhas and Bodhisattvas, but certain landscapes, too, evoke elements of Buddhist thought. Such mundane animals as water buffalo were thought to embody the Taoist values of natural, nonurban existence. To Taoists, images of the dragon were expressions of the supreme power and great mystery with which these thinkers were preoccupied.

By the Sung Dynasty, another important group of painters, the scholar-officials, became increasingly active. During this period, the various categories of subjects deemed fit for painting were established. Many of these subjects had been handed down from earlier generations. In fact, the impact of tradition in Chinese painting cannot be overestimated. Artists learned their styles and, to some extent, their subjects by copying older masters. Thus, the history of Chinese painting is a long continuum of slowly changing styles and subjects as past intertwines with present in an unending kaleidoscope of variation. The Western concept of originality was alien to Chinese artists, who revered the past and emulated it. We owe much of our understanding of earlier Chinese painting to the many artists of later periods who copied now lost older images.

From what is known of Chinese painting, the pull of tradition was met by an equally powerful proclivity for individuality and originality. Over the centuries, Chinese painting changed; certain subjects gained, as others lost, importance. In the work of scholar-painters, images of flowers, especially prunus, or plum, and cherry, evoked ideas of purity. Bamboo was thought to reflect the ideal man, who was as resilient and pliant as the bamboo yet never lost his integrity, just as bamboo bends to the winds yet remains unbattered. Each image could call forth concepts that related to literature, poetry, and philosophy, as well as to painting.

Of all the subjects of Chinese painting, perhaps the most profoundly important was landscape. Centuries of artists interpreted the mountains, valleys, streams, and lakes of China through a combination of observation of nature, regard for past traditions, and personal response.

In general, Chinese painters did not attempt simply to represent nature as they saw it, but rather to convey its essence or spirit. The essential qualities that distinguish a hill, a tree, a flower, or an animal were distilled and brilliantly interpreted with brush and ink and sometimes in color. In landscape painting, the artist most often endeavored to express the universal, timeless aspects of a world of nature in which human beings played a minor role. Generally, some sort of diffuse light would pervade a landscape, whose vantage point might command a sweeping view of nature that encompasses not only mountains but

also valleys, streams, woods, and fields. Allusions to three-dimensional space that would orient the viewer to a particular view were unnecessary, for the painter wanted the viewer to be free to wander ceaselessly through a landscape of essential truths.

Very often scholar-painters also wrote poetry; in fact, painting was often viewed as a form of poetry that employed visual patterns, rhythms, and pacing, much as does poetry with words, sounds, and silences. Paintings were often used to illustrate a poem or a line from a poem that would serve as the inscription for the image and thus become part of the image itself. At other times, artists would write poems in response to a painting or compose paintings of poems.

Chinese painters signed their works and, over the centuries, collectors added their seals to paintings. These seals reflect the long and honored history of ownership, or provenance, of a painting as it passed from one collection to another.

Like great forms of art from other cultures, Chinese painting continually maintained a delicate balance between reality and illusion, between the specific and the general, between its subject and its material. A Chinese landscape painting, for example, may be admired first for the wonderful web of calligraphic strokes that create subtle patterns and marvelous textures across the surface of silk or paper. Then, taking a step back, the viewer will encounter a moving, life-like representation of trees, rivers, animals, plants, flowers, mountains, air, and sky that are the composite images of these myriad brush strokes.

The Chinese painter, like many other artists, makes his performance seem effortless, but his accomplishment is the product of years of training, practice, and discipline, as well as individual creativity. Only when an artist has practiced enough can he yield to intuition, abandon his inhibitions, and let chance guide his brush.

Chou Dynasty

The earliest known paintings appeared on walls of tombs or on lacquer boxes, and already there was a strong connection between brush writing (calligraphy) and painting.

Han Dynasty

Confucianism and Taoism became the bases of thought in China. Confucian scholars controlled the state examinations, on which entry into official administrative life in China depended. This established the tradition of the scholar-administrator, the bureaucrat who appreciated literature, calligraphy, poetry, and painting.

Three Kingdoms, Six Dynasties

Painting flourished at the courts of the various dynasties. Having reached the status of a fine art, painting was collected and analyzed and criticized according to rules established during this period. Individual painters were celebrated, and famous artists are known from written histories. Few paintings from this period survive, however.

Subjects commonly depicted included courtly ladies and gentlemen in their various pursuits; the daily rituals and scholarly activities of men and women; festivals, including the Festival of the River, held annually in the spring to help commemorate ancestors; and popular manners and customs. Paintings of the human figure were highly accomplished during the T'ang Dynasty.

T'ang Dynasty

Painting took a more worldly, realistic, and pragmatic orientation. Courtly painting included primarily portraits of scholars, officials, rulers, and court beauties. Religious paintings were for Buddhist caves and temples and consisted of wall paintings and processional banners painted with images of the Buddha and paradise, among other themes. Buddhist hanging scrolls and hand scrolls were commissioned by wealthy patrons and were either donated to temples or added to personal collections.

Landscape, an important theme in painting during this dynasty, is still often viewed as a setting for human activity, but also becomes an independent subject worthy of representation in its own right. Pure landscapes allowed the artist to express poetic and contemplative moods.

Very little original T'ang Dynasty painting survives, and most of it is known through later copies.

Sung Dynasty

The great persecution of Buddhists in A.D. 845 diminished the role of Buddhist temples as patrons of painting. Courtly power and patronage diminished somewhat, but the class of scholar-painters grew, and the court continued to play an influential role in the training and recruitment of artists through the establishment of the Sung Academy.

During the Sung Dynasty, various categories of painting were established: the Buddha and Bodhisattvas; Taoist portraits of emperors and kings; deities, demons, holy priests; dragons and tigers; historical figures; landscape; flowers, bamboo, and birds; wild donkeys and other animals; human activities; all forms of lower existence including insects; scenes of agriculture; and decorative paintings in blue and green.

Of these categories, painters traditionally favored figures, flower (with bam-

boo and plum the most important subcategories) and bird, and, of course, landscape. Scholar-painters sought to combine calligraphy, poetry, and painting in a single beautiful image.

Yüan and Ming Dynasties

Courts continued to support resident artists who provided both personal and official paintings. The political upheavals of the Mongol invasion during the Yüan Dynasty lessened official power and patronage.

Buddhist temples continued to be patrons of art, and private patrons still commissioned paintings of Buddhist subjects to donate to a Buddhist order. By the time of the Ming Dynasty, the number of monk-painters who worked in temples decreased. There were active professional artists who provided decorative works for the homes of wealthy city dwellers.

The uncertain political climate drove scholar-painters into retreat. They became wen-jen or literati artists, removed themselves from the commercial and political spheres, and produced paintings for their own pleasure and for the sake of art. An unusual system of patronage developed among wen-jen artists, whereby artists traded and exchanged works among themselves. On birthdays, auspicious events, and various occasions, and sometimes as favors, gifts were given or exchanged and usually took the form of a painted scroll or piece of calligraphy.

When the Mongols were defeated during the Ming Dynasty, painters continued to hold official posts, but wen-jen artists persisted in renouncing official positions and chose to paint for pure amusement, which they did in relative economic security. Although the names of more than 1,000 Ming Dynasty artists of merit are known, scholars estimate that 90 percent of the original production has been lost.

Painting from this period included official portraits and decorative paintings that celebrated anniversaries and festivals or commemorated special events. Portraits and figure paintings increased in number, but these were regarded as mere craft by scholar-painters.

During the late Yüan and Ming Dynasties, landscape became the subject most commonly depicted by scholar-painters. Animal and bird painting diminished in importance, as images of bamboo, plum, and pine flourished. Flowers, bamboo, and pine represented the major wen-jen ideals of purity, strength, and longevity. Painters often specialized in a single category, such as flowers or bamboo.

Among the wen-jen, paper replaced silk as the most favored material. The fan no longer resembled the leaf form, but was now constructed from paper and bamboo slivers to form the curved shape we know today. Collectors' albums no longer contained various works by different artists, but usually comprised a succession of images by a single artist. Different interpretations of

the same image (variations on a theme) and sequential subjects, such as the seasons, became common.

Ch'ing Dynasty

More paintings survive from this period than from any previous era. Painting was practiced by a broad spectrum of society. There were professional court or official painters who produced portraits, historical images, depictions of literary gatherings, and other imperial scenes. The wen-jen artists, who disdained portrait and figure painting in favor of landscape, flower, or bamboo painting, were still active. There was also a rising body of educated amateurs, for whom poetry, calligraphy, music, and painting were essential elements of their culture. Many new manuals aided these amateurs in their pursuit of painting, which came to be regarded as an intuitive skill that did not require rigorous training in a studio or academy.

The paintings of past dynasties were used as models that artists could copy or from which they could distill their own variants. Tradition was a powerful force, although there were original artists who worked outside the mainstream of traditional painting.

Vast painting collections were amassed during the Ch'ing Dynasty and catalogs of holdings were produced.

CHINESE POTTERY

Throughout their civilization, the Chinese devoted themselves to the making of pottery, and the tradition for potting evolved from the first, rather crude early pots, which were unglazed and porous, to the superb celadon pots of the Sung Dynasty.

Over the centuries, many experiments were made with clays and glazes. Among the earliest survivors of China's long history of pottery making are vessels that were made from clay and baked to ensure their hardness and permanence. The art of applying a nonporous glaze to a pot is thought to have been discovered in the Chou Dynasty. Han Dynasty tombs have yielded the first great quantity of Chinese ceramics. This dynasty also witnessed the first experiments with "proto-porcelain," or hard stonewares that gradually were refined to produce true porcelain. The word "porcelain" evolved from the Portuguese term *porcellana*, which describes a type of cowrie shell that resembled porcelain in its white color. The sixteenth-century Portuguese thought that the Chinese used ground-up shell to make their porcelain. In fact, Chinese porcelain was made from kaolin and "petuntse" clay. The origins of actual porcelain are unknown, but the character "tz'û," meaning "porcelain," has been dated from the third century A.D.

Kaolin clay is derived from feldspar granite and pegmatite, and remains

white after firing. It was discovered near the hills of Ching-tê-chên, an area that became a ceramic-producing center. Petuntse clay, which derives its name from the Chinese words *pai-tun-tzû* is related to kaolin clay, but uses feldspar in a different state. The two types of clay were carefully mixed together and left to sit for several years before being made into pots. Legends state that some batches of clay waited for a hundred years to be used, although scholars discount this assertion.

It is known that porcelain clay had to be dried, sometimes for several months, and then glazed with a material that was often made from petuntse. The potted forms were then set on sand or stilts inside the kiln, and traces of sand or stilt marks can often be found on the bottoms of pots. It took anywhere from thirty-six hours to twenty days to fire porcelain completely, and temperatures were carefully monitored.

The making of pottery and porcelains underwent many transformations and refinements over the centuries. These are discussed briefly in the following section. All of Chinese pottery demonstrates an excellence of craftsmanship and artistry that is characteristic of Chinese art in general. Natural materials, artistic tradition, and individual skills were fused to create objects that exude life, energy, and animation despite their anonymous origins. To encounter a well-made piece of Chinese porcelain is to see how an artist's spirit can be captured and preserved in an exquisite and rare form.

Han Dynasty

Although the Chou Dynasty produced examples of pottery that used a nonporous glaze, the Han Dynasty is the first era from which a good number of pottery vessels have survived. Many vessels served as tomb accessories that the deceased would use in their afterlife, and that included a wide assortment of images of people, animals, and models of buildings. Pottery replicas replaced the human and animal sacrifices that were formerly placed in tombs. Among the commonly found vessels are "hill jars," cylindrical vessels with a "magic mountain," or axis of the universe, atop the lid. Lead-glazed earthenware, a cheaply produced ceramic, became a popular material for funerary vessels and tomb figurines during this dynasty.

Tomb figures included both human and animal "guardians" that were placed as a pair on each side of the entrance to the burial chamber. Warrior figures were often put in tombs belonging to such high-ranking officials as generals or prefects. A wealthy official might be accompanied in his grave by ceramic musicians in groups, dancers, beautiful women of mysterious identity and function, equestrian figures, horses with riders or grooms, chariot horses, drivers, merchants (including foreigners), and all sorts of animals, including camels, boars, and cattle.

Wei Dynasty

Tomb figurines from this period included a vast array of human and animal forms. Made of hard gray pottery, these ceramic figures were originally painted, but only traces of paint are visible today.

T'ang Dynasty

The tomb figurines produced during this period were more vivid and animated than earlier examples. Tomb embellishments became very ambitious, and figurines were sometimes rather large, up to three feet high. Tomb decoration assumed such splendor that an imperial decree was later issued to restrict the number and size of grave figures.

Producing both glazed and unglazed pottery, T'ang Dynasty potters most commonly used green, brown, yellow, and sometimes blue glazes. They also experimented with various types of stoneware. Yueh ware, a material very close to porcelain, was produced. Yueh celadon ware was exported. Hsing ware, the first pure, white porcelain, was produced in the late T'ang Dynasty.

Sung Dynasty

During this period, the art of porcelain reached its apex. The finest pottery ever made is considered to come from the Sung Dynasty, which witnessed the perfect union of form, technique, glaze, function, and decoration. Pottery was enthusiastically collected as an art form, and a true collector was said to be one who ended his life owning only a single piece of white Sung ware, undecorated and of perfect proportions.

As burial customs changed, fewer funerary figurines were produced. However, numerous other types of pottery emerged and were named according to the regions in which they were made or the special technique by which they were produced.

Tz'u-chou ware, produced in Chihli Province through the Ch'ing Dynasty, was a stoneware that took several forms. The process of manufacture involved these basic steps: a piece would be covered with a slip, a clay solution of creamy consistency used to coat pottery; on the white slip ground, brown or black glazes would be freely painted or a creamy glaze applied; decorations would then be incised on the glaze-covered surface. After the first firing, which produced contrasting colors, additional enamel colors of red, green, or yellow were applied over the glaze, and the piece was then refired.

Chien ware came from Fukien, in southern China. Most of the Chien ware that was produced took the form of conical bowls used for drinking tea. These bowls were commonly exported to Japan.

Chun ware, a nonwhite northern ware, was made in both imperial and

nonimperial kilns in Honan. Characteristically, Chun ware is a gray to gray-tan porcelain with blue, purple, and red free-flowing glazes.

Honan ware developed a dark oil-spot glaze that appears to have been splashed with silver.

Ju ware was imperial porcelain made for a very brief time from around 1107 to 1127. Characterized by a soft bluish gray to pale lavender glaze, examples of Ju ware are rarely found in the United States.

Kuan ware was produced in official kilns for official or imperial use in the northern capital. Its colors ranged from white to gray, blue, and green. Its celadon (green) ware, which rivaled jade in color, was developed to yield a deliberately cracked surface.

Lung-chu'üan ware, along with Kuan ware, attempted to produce a porcelain that could compete with the feel, color, texture, and shape of jade. Gradually an aesthetic for crackled surfaces grew.

Ting ware is considered the earliest true white porcelain. It is translucent and often covered with either a colorless glaze or brown and black glazes. Sometimes incised or lacquered for decoration, Ting ware was produced in Chihli Province and derived its name from the sound it produces when tapped.

Tung ware was an imperial ware made for a brief time.

Ying ching ware is characteristically a shadowy blue color and is often decorated with incised designs.

Yüan Dynasty

During the Yüan Dynasty the introduction of a porcelain decorated with blue (cobalt) or red (copper) underglazes established the beginning of the great blue and white porcelain tradition. The decline in official patronage during this dynasty is thought by some to have produced a decline in the quality of pottery.

Ming Dynasty

Ming Dynasty white porcelains are considered among the greatest ever made. This period witnessed the first major exports of porcelain to Europe, notably Portugal and the Netherlands. Porcelain figurines of the Buddha, Kuan Yin, Lohans, emperors, and others become relatively common.

Using both under- and overglazing to produce pure, strong colors—including white, red (from copper), the later ox-blood red (called Lang ware), blue, and yellow—Ming Dynasty pottery used various shapes and colors to create stunning effects. Celadon and brown were other colors commonly used. Yellow was the imperial color, and its use was generally reserved for the emperor. Various blues, including Somali blue, were obtained to produce the finest blue and white ware ever made.

In the late Ming period, brightly colored mixtures of three or five colors of enamel were commonly applied over the glaze.

Fa Hua ware describes a technique that imitates cloissóne enamel. Fa Hua ware of three or five colors was often exported to Japan.

Ch'ing Dynasty

Technically, pottery from this period is among the finest ever made, yet it is not always as highly regarded because of its mechanical perfection.

Beginning with this dynasty, the distinction between domestic and export ware is an important one. Because there was a steady European demand for decorative, multicolored ceramics, the Chinese produced porcelain using a range of colors for the French and English as well as the Dutch. *Famille Verte*, which used two colors of green, iron-red, yellow, and aubergine, applied to various types of wares, including figurines, animals, birds (especially parrots), stags, horses, figures of Buddhas, and models of pagodas and grottoes. They were often sold in pairs for interior decoration. Later Ming production came to include the *Famille Rose*, the French designation for a white porcelain that used rose, yellow, and green enamels to add delicate touches of color.

Great services of blue and white ware, or colored ware, were produced on order for export, and Chinese potters often incorporated European subjects and porcelain shapes for their European customers. The domestic demand for porcelain favored single-colored wares in ox-blood or bean red, as well as in shades of gray and gray-green. Blue and white ware continued to be made for domestic consumption. Its production became somewhat more mechanical, but therefore all the more perfect than before.

CHINESE ART TIME LINE

c. 1766–1027 B.C.	Shang Dynasty
c. 1027–256 B.C.	Chou Dynasty
c. 1027–770 B.C.	Western Chou
770–256 B.C.	Eastern Chou
722–481 B.C.	Spring and Autumn
403–221 B.C.	Warring States
221–206 B.C.	Ch'in Dynasty
206–A.D. 220	Han Dynasty

206 B.C.–A.D. 8	Western Han
A.D. 8–23	Hsin
A.D. 25–A.D. 220	Eastern Han
220–265	Three Kingdoms
220–280	Wu
221–263	Shu
220–265	Wei
220–589	Six Dynasties
386–581	Northern Dynasties
386–534	Northern Wei
534–549	Eastern Wei
535–556	Western Wei
550–577	Northern Ch'i
557–581	Northern Chou
420–589	Southern Dynasties
317–420	Eastern Chin
420–479	Liu Sung
479–502	Southern Ch'i
502–557	Liang
557–589	Ch'en
581–618	Sui Dynasty
618–907	T'ang Dynasty
907–960	Five Dynasties
907–923	Later Liang
923–937	Later T'ang
937–946	Later Chin
947–950	Later Han
951–960	Later Chou
960–1279	Sung Dynasty
960–1127	Northern Sung
1127–1279	Southern Sung

1279–1368	Yüan Dynasty
1368–1644	Ming Dynasty
1403–1424	Yung Lo
1426–1435	Hsuan Te
1465–1487	Ch'eng Hua
1506–1521	Cheng Te
1522–1566	Chia Ching
1573–1619	Wan Li
1644–1912	Ch'ing Dynasty
1662–1722	K'ang Hsi
1723–1795	Yung Cheng
1736–1795	Ch'ien Lung
1796–1820	Chia Ch'ing

JAPANESE ART

A brief introduction to Japanese art is nearly impossible. Like China, Japan has a long and rich cultural history, and its arts rank among the finest and most diversified ever produced. Non-Japanese collections of Japanese art are, as one should expect, uneven and provide only a small sampling of what has survived.

As the time line makes clear (see later in chapter), Japan underwent numerous changes in government that altered the location of the capital or introduced a different ruling clan. Those changes divide Japan's history into the various phases by which its art is dated. A map indicating the islands and major cities of Japan is provided (Figure 12-4).

The history of Japanese art is the history of a long association with, and admiration for, the arts of China. It is also the history of an indigenous culture that adapted and transformed these influences into something original and wholly Japanese.

For centuries, Japan admired not only Chinese art but Chinese government, which at various times it attempted to emulate. The two cultures, however, were fundamentally different. China was ruled by an imperial family and a vast network of scholar-administrators whose entry into civil service was gained by examination. By contrast, Japan's ruling families vied with one another for power and usurped all but titular power from the emperor. Positions of office were gained by inheritance, rather than through open examination, and so the administrative ranks were closed to the continual influx of new blood and new talent.

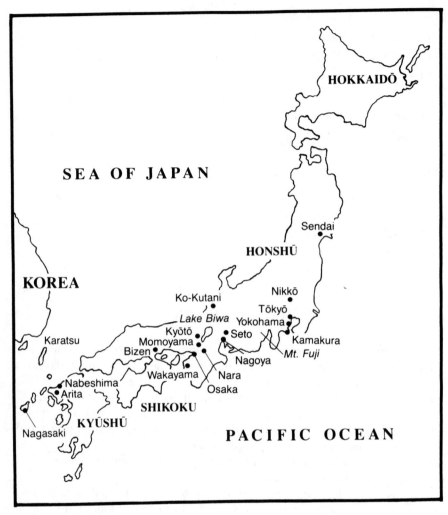

FIGURE 12-4 The islands and major cities of Japan.

Artistically, there was, early on in Japanese history, a tendency to treat life as well as art as something with its own aesthetic. Human activities became ritualized, and the objects associated with them beautiful. The principal impetus for this aesthetic attitude came from the court, which was removed from politics by the ruling families and therefore devoted all its energies to the realm of the arts.

Out of this court system grew an art of sophisticated refinement. Sumptuous, elegant paintings and sculptures, as well as luxurious utilitarian objects—lacquerware, pottery, metalwork, and textiles—were produced. A taste for luxury

is characteristic of any court, given its financial resources and refined sensibilities, but the Japanese court supported a unique approach to the arts. Because the court required both superb craftsmanship in all the arts and functional as well as decorative objects, it supported a breed of artist-craftsmen for whom pottery and textiles were as important as painting and sculpture. Perhaps this situation helps explain a distinctive characteristic of all Japanese arts, namely an overwhelmingly sensitive and sophisticated understanding of design.

Certainly, there were no true Japanese counterparts to the Chinese scholar-painters, whose pursuits were intellectual and for whom painting had both metaphysical and aesthetic meaning. And although some of the styles associated with Chinese painter-scholars were adopted, Japanese artists performed different functions in society and adapted these borrowed styles to suit their own needs.

No matter the medium—sculpture, lacquerware, pottery, painting, metalwork, or textiles—the Japanese artist-craftsman had a superb sense of material, subject, form, and function, and united all of these elements into a harmonious whole. The artist's understanding of design enabled him to fuse form and function, blend natural and abstract elements, combine color and line, and employ pattern and symmetry, as well as randomness and asymmetry, with consummate skill. With graceful ease, natural forms—flowers, plants, animals, and people—could be combined with purely abstract elements in a composition that wedded the natural and the abstract in designs that would embellish a box, a vase, or a screen.

The Japanese were as masterful at creating and resolving visual paradoxes as they were at letting the viewer appreciate the process. Poppies seem carelessly blown across the surface of a vase as if by some unseen wind, cranes in flight become a breathtaking design on a screen—these images inspire the viewer's admiration for the deftness with which natural and artificial worlds are bridged. Nature seems to lose nothing in its translation into the artificial, and the artifice is no less noticeable for taking natural forms as its subjects. Thus, Japanese culture is one that reaches artistic greatness by resolving seemingly irreconcilable differences, and its achievement is one to be appreciated by all.

PAINTING

Similar to Chinese painting in its forms, materials, and functions, Japanese painting became unique to its own culture by gradually transforming the Chinese models on which it was based.

Early Japanese painting was supported by two types of patrons, the Buddhist sects and the courts. Buddhist painting took many of the traditional forms it had in China and elsewhere: portraits of priests, icons or images of the Buddha or Bodhisattvas, mandalas (images of perfect wholeness), and scrolls, which were dedicated to various temples. These schematic representations were sym-

like Van Gogh
use of symbolism

bolic, expository forms of painting that guided the believer through the intrica-
cies of the Buddhist faith.

Various sects of Buddhism patronized other types of painting. Because nature
was considered by some sects to be the key to understanding the mysteries of
the universe, landscape paintings were made to reflect Buddhist thought. In the
Heian period (see time line, later in the chapter), images of the Buddhist
paradise and hell were painted for the Jodo, or "pure land," sect of Buddhism.
In the Kamakura period, Zen Buddhism gained a large following, and Zen
Buddhist painting, which was based on contemplation, reflection, and momen-
tary flashes of insight, became an important form of expression. The execution
of Zen Buddhist painting involved strokes of the ink brush that were as rapid as
the moments of enlightenment to which this religion aspired.

Among secular patrons, the royal court had a profound influence on art. The
Japanese royal court had the wealth, leisure, and interest to develop a ritualized,
sophisticated, and lavish court life unsurpassed in world history. It supported
literature, poetry, music, and painting, as well as the decorative arts of ceramics,
textiles, and metalworking. In fact, the decorative nature of all Japanese art
tended to make the distinction between painting and crafts less meaningful than
it was in other cultures and regions. The Japanese developed superbly designed
objects, be they lacquerware, textiles, metalwork, or painting.

Paintings in the form of scrolls, screens, albums, and fans were most com-
mon. Screens and hanging scrolls were often used in pairs or in groups of
three. Very often painters took Chinese examples as their models. The eclectic
nature of Japanese painters endowed them with the capacity to work in several
styles at once. Thus, the styles they used could vary, depending on whether
they were painting a screen, scroll, or album.

The subjects of Japanese painting included portraits, landscapes, animals,
and illustrations of poems and novels. By the late twelfth century the Japanese
had developed their own unique interpretation of these subjects. The Japanese
favored landscapes that depicted the four seasons, views of famous beautiful
sites, and illustrations of seasonal labors. All of these themes embodied the
notion of continuity within change, a concept fundamental to decorative paint-
ing. Daily life, in its great variety and complexity, was a favorite subject for
scroll paintings. Other subjects, such as battle scenes, histories, biographies,
and fantasies, were also used for paintings.

By the Edo period, patrons of painting came to include wealthy merchants,
who often acquired the courtly taste for splendor in their homes and displayed
the wealth of their possessions. As the market for painting expanded, so, too, did
the range of its subject matter. Color prints emerged as a popular art form and
enabled the artist to broaden his repertoire of themes and images. Everything
from erotica to scenes of theater and street life was depicted in these vivid images.

Various schools of painters applied different styles and approaches to subjects
of paintings. By the Edo period, literary painting, which was greatly inspired

and often accompanied by poetry, became increasingly important. The short, evocative haiku poem supplied both inspiration and an essential ingredient for many a beautifully executed brush painting.

As in China, amateurs in Japan were encouraged to take up the brush, and, during the eighteenth and nineteenth centuries, paintings reflect the spirit, power of observation, and humor of gifted but unknown artists who found in painting a perfect form of self-expression.

SCULPTURE

The earliest known forms of Japanese sculpture, which had a long history, are objects associated with fertility and burial rites, dating from the Jōmon and Haniwa periods. A significant period in sculpture began with the introduction of Buddhism in the sixth century A.D. as the official religion of Japan. Thereafter sculptors provided the many images of Buddha, Bodhisattvas, and related figures that adorned Buddhist shrines and temples. Wood was the material most commonly used for these sculptures, although clay was also important in this period, and lacquerware became prevalent by the Nara period.

It was common practice for Buddhist monks to commission portrait statues of their leaders, usually upon the leader's death, as well as portraits of historical figures who were important to their faith. These portraits were placed within a portrait hall that formed part of a monastic complex or in the main hall, along with other Buddhist images. Sometimes objects of a commemorative or devotional nature, such as texts, relics, or images, were placed inside these statues, or often vessels containing the ashes of a deceased person were housed in the portraits.

Buddhist sculpture and portraits constitute a remarkable and significant tradition in Japanese art. One of the many legendary and historical figures recorded in portraits was the popular Prince Shokotu Taishi, who made Buddhism the state religion of Japan. Shown praying as a child, as a young adult, or as regent, images of Prince Shokotu were venerated throughout the country during the Kamakura period.

By the Kamakura era, secular sculpture in the form of portraits of various leaders became common. The tradition of portrait sculpture ceased during the Edo period.

Most of the great large-scale sculpture has not left Japan. Preserved in the many surviving temples and treasuries, sculptures are part of the precious national treasure. Rare examples may be found in Western museum collections, but, divested of their original context, these sculptures and their original function cannot be appreciated fully. Nonetheless, individual sculptures demonstrate the elegance, supreme craftsmanship, and innate understanding of material that characterize all of Japanese art.

Japanese lacquerware, metalwork, and small sculptures are more frequently found in Western museums. Lacquer utensils, ranging from cosmetic boxes to writing desks, are often inlaid with mother-of-pearl and colored with gold dust that has been sprinkled into the lacquer. These lacquer artifacts are unparalleled for their beauty of design and quality of workmanship. Other utilitarian objects, such as sword guards, hilts, and sash buttons (*netsuke*), became art forms in their own right. Owned by a broader spectrum of the population, these delicate, ingenious, humorous, and finely rendered objects were more readily available and are therefore more frequently found in museums in the West.

POTTERY

Early Japanese pottery was influenced by Chinese models. The earliest phase from which pottery vessels survive is the Yayoi phase. During the Nara period, the three glazes of green, yellow, and blue, which had been prevalent in T'ang Dynasty China, were common in Japan.

By the fifteenth century, a great deal of pottery was manufactured for the then newly established tea ceremony, which involved the gathering of a small group (usually five) in a teahouse in a quiet garden. Once the group was assembled and seated, the host began an elaborate ritual to serve and prepare the tea. Even the drinking of the tea was ritualized. Early examples of the implements used in this ceremony—a lacquer caddy, bamboo whisk, tea bowl, iron water kettle, stoneware water vessel, and napkins—are today highly prized objects in museum collections. This refined ceremony involved a lively, ruggedly simple stoneware that is characterized by its spontaneously asymmetrical designs. The kiln sites in Seto produced an important group of tea ceremony stoneware. During the Momoyama and Tokugawa periods, Shino and Oribe stoneware were produced for use in tea ceremonies.

During the Edo period, Japanese porcelain flourished with a new variety of techniques and designs. Porcelain was locally produced, and four important types were introduced. Kakiemon ware, named after the family said to have developed it, used enamel colors. Overglazes of red, green, and blue enamels were delicately applied to a white ground. Nabeshima ware, bolder, harder, and more precise in design and pattern, applied red and green overglazes to a blue underglaze to produce intricate patterns. Imari ware often shows Western images and employs a dark blue underglaze and red enamel. Kutani ware is rather rough and uses energetic designs in bold red, green, blue, and yellow overglazes.

Individual potters' names were known more frequently after the seventeenth century, and artists' names are often associated with a particular vase found in a museum collection.

JAPANESE ART TIME LINE

JŌMON PHASE

c. 9000–300
B.C. The most commonly preserved objects were made of clay and took the form of large vessels and small figures. The period derived its name from the cord-like pattern that decorated vessels and figurines. Indented and raised patterns were worked into the clay before it was fired.

YAYOI PHASE

c. 200 B.C.–
200 A.D. Named after an area of Tokyo where the pottery was found, the Yayoi phase demonstrated great sophistication and knowledge of technique. Bronze casting was probably learned from invading Koreans, who brought Chinese bronzes with them. Typical of the Yayoi phase are its elaborately decorated bells called *dotaku*.

HANIWA (KOFUN OR TUMULUS PERIOD)

200–552 During this period, the imperial clan Yamato gain power. A number of important burial mounds (tumuli) were made for them. Associated with these tombs are numerous clay sculptures of warriors, horses, musicians, women, animals, birds, and houses. These sculptures probably evolved from earlier cylinders of baked clay (haniwa) that were placed around a grave mound to keep the dirt from washing away, and that were eventually decorated with sprightly figures or animals.

ASUKA (SUIKO) PERIOD

558–645 Buddhism became the state religion due to the enthusiasm of the scholarly Crown Prince Shotoku (552–621). Gigaku masks, used in temple rituals, became prevalent. Painter-craftsmen were increasingly active in this period, but little of their work has survived.

────────────────────── NARA PERIOD ──────────────────────

Early Nara The capital moved to Nara. A great deal of Buddhist sculpture
(Hakuho) was produced and survives. Portraiture from this period was
645–710 particularly highly regarded. Clay is introduced as a material
Late Nara for sculpture. Two lacquer techniques are also introduced:
(Tempyo) hollow, dry lacquer (*dakkatsu-kanshitsu*) and wood-core dry
710–794 lacquer (*mokushin-kanshitsu*). Gigaku masks are highly prized.
 Ceramics, lacquerware, and textiles reach a high level of
 achievement. Painting in this period is influenced considera-
 bly by Chinese models.

────────────────────── HEIAN PERIOD ──────────────────────

794–897 The new capital of Heian-kyo (now Kyoto) is established.
(Early Heian Various sects of Buddhism render its iconography more com-
or Jogun) plex. The demand for sculpture is so great that single-block
897–1185 wood carving cannot keep pace, and a new technique is devel-
(Late Heian oped for assembling pieces of carved wood in a workshop
or Fujiwara) system. Wood parts are carved roughly, assembled by assis-
 tants, and then finished by pupils. The final image is then
 painted or decorated with gold leaf. The royal court becomes
 ineffectual as a governing force and devotes itself to the arts.
 The novel *Genji Monogatari* (*Tale of Genji*), written by the
 Lady Murasaki Shikibu in the early eleventh century, de-
 scribes the romances and intrigues of the court, which become
 a popular subject of painting. Painting develops its own na-
 tional styles and subjects. Lacquerware reaches new heights of
 decorative beauty. Pottery is considered to be in a state of
 decline. Metalwork is further refined and produces various
 decorations and objects, such as mirrors.

────────────────────── KAMAKURA PERIOD ──────────────────────

1185–1333 The capital is moved to Kamakura. Nara sculptural style is
 revived, and the Kamakura is considered the last great classi-
 cal phase of Japanese sculpture. The names of more sculptors
 are known, and secular sculpture, including portraits of im-
 portant men (clan rulers, etc.), are introduced. The decora-
 tive arts, including arms and armor, gain prominence. The
 sword becomes an especially valued form of metalware. In
 Buddhist painting, new sects introduce the theme of Buddha
 meeting the believer in paradise and scenes of punishment

and hell. Zen Buddhism, which does not value religious icons, gains ground during this period. New forms of Zen painting are introduced. Popular literature includes the *Heike Monogatari* (Tales of the Heike, or Taira, Clan), and other histories, battle stories, biographies, and fantasies become subjects for painting. Animal subjects become more common in scroll painting.

NAMBOKU-CHO PERIOD
(MUROMACHI OR ASHIKAGA)

1334–1573 The Ashikaga family gains ascendancy over the Kamakura clan. New rulers build a palace in the Muromachi district north of Tokyo. Gradually, a strong middle class of merchants emerges, and women become economically subordinate to men. Samurai emerge as mercenaries and become popular themes of literature and art. Increased wealth and more luxurious dwellings expand the market for decorative paintings (screens, paintings on sliding doors, hanging scrolls). Painting becomes the preeminent art form. Zen Buddhism, perhaps the most dominant cultural force, deeply affects painting; brush paintings are prevalent. Landscapes and the famous Zen priests Kanzan and Jittoku become important subjects in painting. Various schools of painting are formed, including the Kano and Tosa schools. The tea ceremony is taken up by the court and becomes a highly ritualized form of relaxation. Nō theater was formed during this period, and Nō masks used in performances are preserved. Lacquerware, metalware, and pottery used in the tea ceremony are highly regarded; Seto ware and Temmoku ware become very popular.

MOMOYAMA PERIOD

1573–1615 Momoyama takes its name from the Momoyama (Peach Hill) castle built by the ruler Hideyoshi in 1593. Portugal begins trading with Japan about 1541/43. Tea ceremony utensils and decorative art forms are most prevalent. Paintings (paired screens or series of hanging scrolls) decorate many homes. The Kano school of painting gains in importance, as the Tosa school seems to decline. Most ceramic production supplies utensils for tea ceremony. Seto kilns are still active, and introduce Shino ware, a white glaze with brown decoration, and Oribe ware, a brightly colored pottery that is characteristically green. The Ky-

oto kilns are a source of simple, rustic ware patterned with dark, salmon, or white glazes called raku.

_____ EDO PERIOD (TOKUGAWA) _____

Early Edo
(1615–1716)
Late Edo
(1716–1868)

Capital moved to Edo, then a village that became the site of Tokyo. The Tokugawa shoguns gain control and close Japan off from outside influence by barring foreigners' entry into Japan. The merchant class grows in number and wealth. Confucian thought deeply affects Japanese thinking and social order. Rimpa, a new style of art associated with the merchant class, develops, which fuses elements of painting and other art forms. The Kano school is considered academic and monotonous. A literary school of painting flourishes, called Nanga. Haiku—short poems composed on themes of nature or travel—inspire painting and become part of the painted image. Zen painting continues, while brush paintings by amateurs or anonymous painters record images of daily life and become common in the eighteenth and nineteenth centuries. The center of this painting is the village of Otsu-e, from which this form takes its name. After 1740, color wood-block printing becomes prevalent. Scenes from daily life prevail as subjects of Ukiyo-e school printmakers. Prints are issued in large editions and can be afforded by many. A special form of color prints, called the Surimono, is created to celebrate special events, such as birthdays and the New Year. Lacquerware and textiles undergo new changes and refinement, while pottery and porcelain become increasingly important. New wares, such as Nabeshima, Kakiemon, Kutani, and Imari, are among those introduced. Individual potters' names are known more frequently as pottery is accepted as an art form. Netsuke, or small, carved objects, are extensively produced and avidly collected in the West.

_____ MEIJI PERIOD _____

1868–1912 Named after Emperor Meiji who gained power in 1867 and opened Japan to the West. The Japanese art which yielded to Western influences was less sought after.

_____ TAISHO PERIOD _____
1912–1926

_____ SHOWA PERIOD _____
1926–present

ASIAN ART: MAJOR COLLECTIONS

—————————————— INDIAN ART ——————————————

India

Allahabad, Municipal Museum
Banaras, Bharat Kala Bhavan Museum of Indian Arts and Archaeology
Bikaner, Archaeological Museum
Bombay, Prince of Wales Museum of Western India
Calcutta, Indian Museum
Chamba, Bhuri Singh Museum of Archaeology and Art
Chandigarh, Punjab Museum
Gwalior, Central Archaeological Museum
Jammu, Dogra Art Gallery
Khajuraho, Archaeological Museum
Lucknow, State Museum
Madras, Government Museum and National Art Gallery
Muttra, Curzon Museum of Archaeology
Nagarjunikonda, Nagarjunikonda Archaeological Museum
Nalanda, Archaeological Museum
New Delhi
 Central Asian Antiquities Museum
 National Museum of India
Patna, Archaeological Museum
Sarnath, Archaeological Museum
Taxila, Archaeological Museum

Asia

Kabul (Afghanistan)
 Kabul Museum
 Dar-ul-Aman Museum
Colombo (Ceylon), Art Gallery (Ceylon Society of Art)
Dedigama (Ceylon), Museum
Lahore (Pakistan), Central Museum
Peshawar (Pakistan), Archaeological Museum

Europe

Berlin-Dahlem, Staatliche Museem
Berlin, Museum für Indische Kunst
Cambridge, Fitzwilliam Museum
Dublin, Chester Beatty Library and Gallery of Oriental Art
Edinburgh, Royal Scottish Museum
London
 British Library
 British Museum
 The India Office Library and Records
 School of Oriental and African Studies, University of London
 Victoria and Albert Museum
Oxford
 Ashmolean Museum of Art and Archaeology
 Bodleian Library
Paris, Musée Guimet
Vienna, Österreichisches Museum für angewandte Kunst

United States

Baltimore, Walters Art Gallery
Boston, Museum of Fine Arts
Cambridge, Fogg Art Museum, Harvard University
Chicago, Art Institute of Chicago
Cincinnati, Cincinnati Art Museum
Cleveland, Cleveland Museum of Art

Denver, Denver Art Museum
Detroit, Detroit Institute of Arts
Kansas City (MO), William Rockhill
 Nelson Gallery of Art and Mary
 Atkins Museum of Fine Arts
Los Angeles, Los Angeles County
 Museum of Art
New York
 Metropolitan Museum of Art
 Pierpont Morgan Library
Philadelphia
 Free Library of Philadelphia
 Museum of Art

Portland (OR), Portland Art Museum
St. Louis, City Art Museum of St.
 Louis
Seattle, Seattle Art Museum
Springfield (MA), Museum of Fine
 Arts
Washington, D.C., Freer Gallery of
 Art, Smithsonian Institute
Williamstown (MA), Williams Col-
 lege Art Museum

CHINESE ART

Asia and Europe

Berlin, Staatliche Museen
Hong Kong, Museum and Art
 Gallery
Kyoto (Japan)
 Fuji'i Yurinkan
 Kyoto National Museum of Art
Liaoning (China), Liaoning Provin-
 cial Museum
London, British Museum
Nara-shi (Japan), Yamato Bunkakan
 Museum
Osaka (Japan)
 Fujita Art Museum
 Osaka Municipal Museum of Fine
 Arts
Paris
 Musée Cernuschi
 Musée Guimet
Peking, Imperial Museum, Imperial
 Palace
Shanghai, Shanghai Museum
Stockholm
 Museum of Far Eastern Anti-
 quities
 Nationalmuseum

Taipei (Taiwan), National Palace
 Museum
Tokyo
 Gotoh Art Museum
 Hatakeyama Museum
 Tokyo National Museum

United States and Canada

Boston, Museum of Fine Arts
Cambridge, Fogg Art Museum, Har-
 vard University
Chicago, Art Institute of Chicago
Cincinnati, Cincinnati Art Museum
Cleveland, Cleveland Museum of
 Art
Honolulu, Honolulu Academy of
 Arts
Kansas City (MO), William Rockhill
 Nelson Gallery of Art and Mary
 Atkins Museum of Fine Arts
Los Angeles, Los Angeles County
 Museum of Art
New Haven, Yale University Art
 Gallery
Minneapolis, Minneapolis Institute
 of Arts, Pillsbury Collection

New York, Metropolitan Museum of
Art
Philadelphia, University Museum,
University of Pennsylvania
Princeton, Art Museum, Princeton
University
St. Louis, City Art Museum of St.
Louis

San Francisco, Asian Art Museum of
San Francisco
Seattle, Seattle Art Museum
Toronto (Canada), Royal Ontario
Museum of Archaeology
Washington, D.C., Freer Gallery of
Art

——————————— JAPANESE ART ———————————

Asia and Europe

London, British Museum
Nara-shi (Japan)
Nara National Museum
Yamato Bunkakan
Osaka (Japan)
Fujita Art Museum
Osaka Municipal Museum of Fine
Arts
Paris, Musée Guimet
Stockholm, Museum of Far Eastern
Antiquities
Tokyo
Gotoh Art Museum
Hatekayama Museum
Nezu Institute of Fine Arts
Tokyo National Museum

United States

Boston, Museum of Fine Arts
Chicago, Art Institute of Chicago
Cleveland, Cleveland Museum of
Art
Los Angeles, Los Angeles County
Museum of Art
New York, Metropolitan Museum of
Art
San Francisco, Asian Art Museum of
San Francisco
Seattle, Seattle Art Museum
Washington, D.C., Freer Gallery of
Art

PRINCIPAL HINDU DIVINITIES

Aditi	Goddess of the Infinite, Mother Goddess, Sky-Goddess.
Adityas	Aditi's children: Indra, Mitra, Rudra, Tvashtar, Varuna, Vishnu.
Agni	The Vedic God of Fire.
Ananta (also called Shesha)	Endless time depicted as coiled serpent.
Brahma	Supreme God of Hindu trinity, which also includes Shiva and Vishnu. The Creator.
Durga	Wife of Shiva; worshiped extensively in Bengal. A frightening goddess.
Ganesha	Son of Shiva and Parvati, elephant-headed; worshiped by scribes and merchants; called Lord of Obstacles (see Figure 12-2).
Ganga	The River Ganges; wife of Shiva, daughter of Himalaya.
Garuda	Sunbird; symbol and mount of Vishnu.
Gopis	Milkmaids; young Vishnu's loves.
Hari-Hara	A combination of Vishnu and Shiva.
Himalaya	The Mountain, Home of Snow. Father of Parvati, Ganga.
Kali	The Black Goddess, wife of Shiva: the horrifying, bloodthirsty aspect of Shiva's wife. She is sometimes shown dancing on Shiva's body, bringing death back to life.
Krishna	An incarnation of Vishnu; called the Dark One. Once a cowherd and a prince (see Figure 12-2).
Lakshmi	Goddess of Fortune and beauty; wife of Vishnu.
Manu	Man's ancestor. Saved by Vishnu as fish.
Nagas	Snakes, often seen as cobras; symbol of water; ancestors of princes.
Nandi	Bull, symbol of Shiva's creative principle (see Figure 12-2).
Nataraja	A form of Shiva as Lord of the Dance. During his cosmic dance, Shiva creates, destroys, and re-creates the universe, crushing evil (see Figure 12-2).

PRINCIPAL HINDU DIVINITIES (Cont.)

Parashurama	Vishnu as Man; shown with Shiva's Ax.
Parvati	Wife of Shiva; daughter of Himalaya (see Figure 12-2).
Prajapati	Vedic universal creator; later becomes Brahma.
Purusha	The origin of the cosmos and society, which were created out of his dismembered body.
Radha	Krishna's principal mistress.
Rudra	Vedic jungle god; god of death, disease, beasts. Later became Shiva.
Shakti	Wife of Shiva; his feminine side.
Shiva	Worshiped as Phallus or Linga. Common emblems are the ax and the deer, which he is shown holding. Sometimes shown as Vindhara, the god of Music, holding the flute. His wives include Parvati, the ideal feminine beauty and goddess of Love; Sati, who consumed herself on the sacrificial pyre, establishing the custom of suttee; and Ganga, the river Ganges, which runs through Shiva's hair. Shiva was seen as creator and destroyer, sexual and ascetic. See also Nataraja (see Figure 12-2).
Skanda	Six-headed son of Shiva.
Vishnu	With Shiva, one of the main Hindu gods. Vishnu appears as ten avatars or incarnations: 1. Matsya, the fish, who saved Manu, man's ancestor, from the flood. 2. Kurma, the tortoise, who had the churning pole on his back when the gods and demons churned the ocean to obtain Soma, the fluid of life. 3. Varaha, the boar, who saved the earth from the deluge. 4. Narasimha, the lion. 5. Vamana, the dwarf. 6. Parashurama, who destroyed the warrior class. 7. Rama, a prince, symbol of duty, filial piety, and marital tenderness.

8. Krishna, the most popular incarnation. He was a cowherd as a child and was so powerful he killed a big watersnake. As a young man he charmed the young shepherdesses, who all believed he loved them. He died from a wound in his feet.
9. The Buddha.
10. Kalki, a rider on a white horse.

Vishnu is often shown holding a wheel or conch shell.

BUDDHIST DEITIES (BUDDHAS OF MEDITATION OR DHYANI BUDDHAS OR BODHISATTVAS)

Vairochana, the Manifester	Shown white, with a disk, astride a dragon.
Ratnasambhava, the Gem-Born-One	Shown yellow, with a jewel, astride a lion; protector of the south.
Amitabha (Boundless Light), the Illuminator	Shown red, holding a lotus, accompanied by a peacock; protector of the west.
Amoghasiddhi, the Omnipotent Conqueror	Shown green, holding a double thunderbolt and borne by an eagle; protector of the west.
Akshobhya, the Unagitated or Immovable	Shown blue, with a thunderbolt, astride an elephant; protector of the east.
Samantabhadra (Limitless Blessing), He Who Is Without Beginning or End	Shown green, astride an elephant; symbol of happiness and good fortune.
Vajrapani	Wielder of the thunderbolt.
Ratnapani	Bearer of the jewel.
Avalokiteshvara (in China, Kuan Yin; in Japan, Kwannon, both females)	Lord Beholding with Compassion, the enlightened one who looks down with mercy and aids the suffering.
Visvapani	Upholder of the universe, the all-embracing understanding.
Manjushri, Patron of Wisdom and Science	Shown yellow with a red mouth, astride a blue lion; symbolized by a book or sword of knowledge.
Kshitigarbha	The matrix of the earth who controls the paths of souls after judgment.

CHAPTER 13

Pre-Columbian Art

❧

The term pre-Columbian applies to the art produced by various civilizations that existed in the Americas before the Spanish conquest in the sixteenth century. The Spanish colonists subdued the native inhabitants of the region extending from Mexico to Peru (see maps, Figures 13-1 and 13-2), and often destroyed their arts and culture in the process. What is known today of these cultures is limited to materials that have been excavated from archaeological sites, which most commonly yielded pottery, metal and stone work, as well as textiles.

Pre-Columbian art is mysterious, fascinating, and sometimes frightening. Although pre-Columbian art forms contain elements that the viewer recognizes, such as animal and human figures, their original meaning and purpose are often unclear to the viewer who experiences this art in the context of a museum.

The masks, vessels, fabrics, and other artifacts that survived the destruction of pre-Columbian civilizations depict animal and human forms with a sense of conviction and deep understanding. The snake, condor, and jaguar are so well interpreted that their presence as decorative embellishment on an object endow it with special, almost magical powers. The steady rhythm of repeated motifs on an artifact echoes the chant of some ancient ritual and creates a bold, severe, and timeless design that carries the message of the chant into the future.

In their pottery forms, the various pre-Columbian cultures proved to be innovative, sophisticated, and imaginative. As far as we know, none of these cultures had pottery wheels, and it is assumed that they used molds and free forms to create beautiful potted wares that humorously reflected images of their daily life. "Portrait" faces of fish and human and animal figures adorn Mochica and Chimu ware, while Nazca ware is notable for its stunning colors and bold ornamentation, and Maya vases are awesome for their complex imagery.

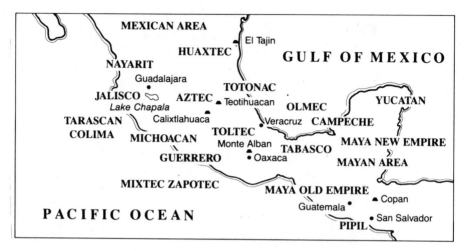

FIGURE 13-1 The major cultural sites and regions of Central America (from Mexico to Guatemala) from the period before Columbus.

Because most museums preserve at least a few examples of pre-Columbian art, the following sections provide a brief description of the best known cultures of pre-Columbian civilization. Fundamentally, there were two art-producing regions under pre-Columbian civilization, namely, Central and South America.

In Central America, the civilizations of Mexico, Guatemala, and Honduras are the best known and have been most extensively excavated. The materials of these cultures are dated according to a chronology of three basic periods. The Pre-Classic Period (2000 B.C.–300 A.D.) was characterized by village settlements that had stone, pottery, and textile industries and that were generally farming communities. The best known Pre-Classic cultures are the Tlatlico and the Olmec. The Classic Period (300–900) witnessed the evolution of urban centers inhabited by the principal Classic Period cultures, the Teotihuacán, Veracruz, Zapotec, Mixtec, and finally, the Maya. During the Post-Classic Period (900–1519, the latter date marking the arrival of Cortez and Spanish conquest of the region), there was considerable upheaval in Central America as various groups, including the Huastec and the Toltec, struggled for power. Post-Classic culture came to be dominated by the Aztecs, who were, in turn, destroyed by Cortez.

In South America, Peru is an especially important region whose sites have yielded the artifacts of various cultures. The earliest known cultures were the Chavín and Paracas, while later groups included the Mochica, Nazca, Tiahuanaco, Chimu, Chancay, and Inca.

Since most museum collections are organized by culture and time period,

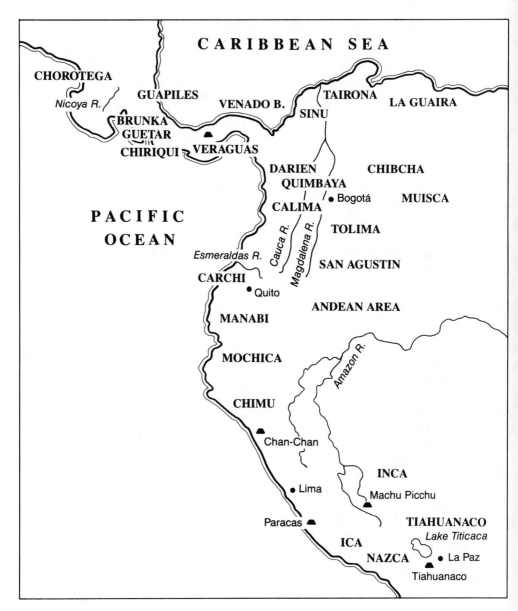

FIGURE 13-2. The major cultural sites and regions of South America from the period before Columbus.

the discussion that follows treats, in chronological order, both the Central and South American cultures of pre-Columbian civilization.

CENTRAL AMERICA

MEXICO

Tlatlico

The name of both a Pre-Classic period site in the valley of Mexico and a culture that flourished from roughly 2000 B.C. to 300 A.D., the Tlatlico occupied a site that is today part of Mexico City. Over 300 Tlatlico burial sites have been found and have yielded a variety of figurines and vessels. Female figurines are most common, although male and two-headed figures, and small sculptures of dancers, dwarfs, and acrobats have also been excavated. These figurines conform to other types found in sites throughout Central America.

Olmec

The Olmec, or "rubber people," inhabited southern Veracruz and western Tabasco between around 1500 and 400 B.C. Olmec sites have yielded large sculptures that included colossal heads, altars, and stelae. Jade and serpentine were used for small-scale sculpture, which expresses the same monumental simplicity displayed by large-scale works. Olmec decoration is characterized by an anthropomorphic design whose large lips and embryonic features have earned it the name "baby face." These faces fuse human eyes and facial structure with a feline snarl.

Teotihuacán

Called the earliest true urban site of Central America, Teotihuacán is situated thirty miles north of Mexico City. Its people were active from roughly 100 B.C. to 600 A.D. In addition to wall painting and large-scale architecture, the Teotihuacán culture is noted for its carved stone masks and pottery with stucco ornament.

Veracruz

Situated along the Gulf of Mexico, this culture flourished between 300 and 900 A.D. Their principal site was Tajín, although numerous other sites have been located. Veracruz sites have typically yielded stone yokes, axe forms, and pottery figurines, all of which were used for various rituals.

Zapotec

The Zapotec or "cloud people" culture existed between approximately 300 and 900 A.D. in Monte Albán in Oaxaca, Mexico. Much of the known artistic production of the Zapotec consists of tombs and funerary urns. Made of gray-ware pottery, these urns show various figures, such as priests with elaborate headdresses and ornaments, gods and goddesses, musicians, jugglers, ball players, and others.

Mixtec

These people appear to have superceded the Zapotec culture from about 900 to 1519. Mixtec craftsmen were skilled metalworkers, mosaicists, manuscript painters, and potters. Their polychrome ceramics are especially valued, as are their stone and bone carvings. Their civilization is thought to have influenced the later Aztecs.

Maya

The Mayan civilization extended over southern Mexico, Guatemala, Honduras, and the Yucatán peninsula between 300 and 900 A.D.. Theirs was one of the most celebrated cultures, whose architecture, art, and hieroglyphic writing were highly developed. The writing system has been preserved in the form of codices or texts transcribed by hand onto papyrus rolls and reveal an advanced knowledge of astronomy and mathematics.

Huastec

The Huastec civilization traces its ancestry back to the Maya culture, from which it split in approximately 1400 B.C. Huastec culture is best known for its Post-Classic period (900–1519), during which time a distinctive pottery type was developed that used black paint over a cream slip, a mixture of fine clay and water used in ceramic casting for decoration.

Toltec

The Toltec people were probably warriors who invaded Mexico around 900 A.D. Their culture spread from the legendary capitol of Tollán (Tula) on the Tabasco-Campeche Gulf Coast, along the Yucatán, and into Central America.

The Toltecs adopted many of the art forms of cultures they conquered. Their pottery, called "Plumbate ware," was manufactured by applying slips that were high in iron content to pottery, then firing it at high temperature to produce a hard, lustrous finish. Up until around 1200, the Toltecs produced elaborately decorated effigy vessels using this technique.

Aztec

The Aztec legend states that seven tribes migrated into the valley of Mexico and that, by 1428, the Mexican tribe gained supremacy over all others. At the time of their defeat by Cortez in 1519, the Aztec realm extended to both coasts of Mexico. A great deal of Aztec art takes its inspiration from the Mixtec culture, whose products the Aztecs seem to have imported from Puebla. The Aztecs greatly admired the Toltecs, from whom they claimed (falsely) to have descended.

PANAMA

Veraguas

The site of the Veraguas culture of Panama has yielded grinding stones decorated with stylized images of birds or animals. "Tumbaga," an alloy of gold and copper, was used to cast figures of birds, animals, frogs, crocodiles, and stylized human forms that are the most notable Veraguas artifacts. Typically, these figures exhibit a protruding eye. Large stone pendants were also made, and bells were incorporated into their decoration.

The dates of this culture are still debated. Recent scholarship suggests that the Veraguas, Coclé, and Azuero sites of Panama reflect a single culture that lasted from 2000 B.C. to 900 A.D.

Coclé

This culture flourished between 300 B.C. and 1550 A.D. Known for its metalwork, which was related to the Quimbaya metalwork of Colombia, Coclé metal artifacts are among the earliest in Central America. The Coclé are also noted for their elegant ceramics that were decorated with images of dragons, crabs, and dancing animal and human forms.

Chiriquí

The Chiriquí people inhabited southwest Panama from 1200 to 1500 A.D. and are noted for their cast gold, which was commonly used to create frog-shaped pectoral decorations. The Chiriquí also produced fine ceramic ware, which was often decorated with alligator designs in red and black. This culture produced "metates," or grinding stones for grain, in the form of small jaguars.

SOUTH AMERICA

PERU

Chavín

Between 900 and 200 B.C. this culture in northern Peru developed an art style that was characterized by its frequent use of bird or feline and human motifs. The style was widespread and was used for stone carvings, goldwork, textiles, and a gray pottery. The finest pottery is said to come from the site of Cupisnique in the Chicama valley. Other sites of this culture include Chavín de Huántar.

Paracas

The site of a famous excavation, Paracas has yielded textiles and pottery produced from around 700 B.C. to 100 A.D. This culture also produced burial garments that were made of wool and cotton and richly embroidered with fanciful animal designs, or that were made of brocades or tapestry and were painted.

Paracas pottery generally has two spouts and is decorated with incised patterns that commonly featured feline motifs. Its pottery was often painted after firing.

Mochica

Named after the site of Moche in the Chicama valley, the Mochica culture thrived between around 200 and 700 A.D. Mochica textiles, and its wood, stone, and bone carvings are widely admired, along with its gold and silver work inlaid with shell or turquoise. Mochica ceramics are also much celebrated and include mold-made vessels in the form of animals, plants, and figures. These vessels depict scenes of daily life as well as heads that are so convincing and realistic that they are designated portrait heads. Much of the ceramic was painted, commonly in red.

Nazca

A civilization of southern Peru that flourished from around 100 to 700 A.D., Nazca is best known for its polychrome painted pottery, which was produced in the form of bowls, beakers, or twin-spouted vessels with bridge handles. These were vividly painted with animal and bird as well as feline and human motifs. Nazca colors include reds, black, white, oranges, grays, and violets.

Tiahuanaco

Originating around 100 B.C. at Lake Titicaca in Bolivia, Tiahuanaco super-ceded the Mochica and Nazca cultures of Peru from around 700 to 1000 A.D. Its textiles and pottery are distinctively decorated with stylized cat and condor motifs.

Chimu

A culture that flourished from around 1000 to 1500 A.D., the Chimu capitol was Chan-Chan in the Moche valley of Peru. Its art forms included figures and staffs carved from wood; vessels made of hammered gold or silver; masks and other ornaments inlaid with shell and turquoise; textiles; and mold-made black pottery, which often had stirrup-spouts. These artifacts were frequently deco-rated with reliefs or shaped into figurative, animal, or fruit forms.

Chancay

Chancay culture, which lasted from 1000 until 1400 A.D., is best known for its pottery jars and figures, known as Cuismancu, which were covered with a white slip and painted with a black line decoration.

Inca

This civilization dominated the central Andes, including Peru, Ecuador, Bo-livia, and Chile, between 1476 and 1534. Although the Incas absorbed the art of cultures they conquered, certain forms are considered distinctively Incan: textiles; dishes of carved stone; heads for maces, or hammer-like instruments; figures; painted pottery vessels; figurines of men, women, and llamas in gold or silver; and "keros," or special goblets made of painted wood.

NON-PERUVIAN SITES

Manteno

Ecuador is the site of the Manteno culture (500–1550 A.D.), which inhabited the Manabi region. Manteno stone carvings are considered important, in particular its stone slabs incised with bird, animal or human designs, its human and animal figures, and its carved chairs, which were supported at the base by stone animals and figures. Silver- and goldsmithing were also known to this culture, which produced a monochrome pottery that was incised with decorations.

Arawak

The Arawak culture of the West Indies (700–1550 A.D.) produced figures carved in wood or stone that embodied a spirit called "Zemi." It also manufactured wooden stools that were decorated with carved animal heads and were sometimes inlaid with gold and shell.

Quimbaya

Known for their fine gold jewelry and other metalwork, the Quimbaya inhabited Colombia from about 100 to 1550 A.D. Using an alloy of gold and copper called tumbaga, they produced small figurines and vessels. They also manufactured pottery in various forms, including bowls and hollow figurines.

Chibcha

The Chibcha civilization flourished in Colombia from 1000 to 1550 A.D. Its most notable production came in the form of "tunjos," or plaques made of cast gold and tumbaga that took the form of flat figures. These figures were further embellished with inlaid designs of fine wire. Chibcha pottery included bowls, jars, and effigy vessels that bore stamped or incised decorations.

Valencia

The tomb sites of the Valencia culture (c. 1000–1550 A.D.) of central Venezuela have yielded small pottery figurines with flat, rectangular heads.

Tuncahuan

The Tuncahuan (500 B.C.–500 A.D.) of highland Ecuador are noted for their pottery, which consisted principally of bowls and pedestal vessels that were decorated with black, red, and cream-colored designs of animal and geometric forms.

Aguada

The Aguada culture (c. 600–1000 A.D.) of Argentina is known for its pottery and clay figurines of animals and human beings. Plaques of copper, cast in human and feline forms, have also been found.

Diaguita

Two cultures are designated by the name Diaguita. One was based in Chile and the other in Argentina, and both were active from about 1000 to 1450 A.D.

The Argentinian Diaguita culture produced several pottery styles, including Santa Maria and Belen, primarily for funerary urns. These urns were painted in black and red and featured stylized faces.

The Chilean Diaguita culture is known for its bowls and jars that display modeled heads and are painted with red, white, and black patterns of geometric forms and stylized faces.

Marajoara

The Marajoara culture of Brazil (c. 600–1300 A.D.) inhabited the Marajó Island off the Amazon River. Their pottery included funerary urns and "tangas," or triangular pottery forms that are thought to have been used for covering the pubic area.

Santarém

The site of Santarém culture on the Tapajós River in Brazil has yielded the remains of a culture that flourished from around 1000 to 1500 A.D. Monochrome Santarém pottery was made for ceremonial use and is notable for its use of human, animal, and bird forms as decoration.

PRE-COLUMBIAN ART: MAJOR COLLECTIONS

Europe and Central and South America

Basel, Museum für Völkerkunde
Bogota (Colombia), Museo del Oro
Cambridge, Cambridge University Museum of Archaeology and Ethnology
Cologne, Rautenstrauch-Joest-Museum
Dresden, Saachsische Landesbibliotek
Florence, Opificio delle Pietre Dure
Guatemala City (Guatemala), Museo Nacional de Historia y Bellas Artes
Hamburg, Museum für Völkerkunde und Vorgeschichte
Jalapa, Veracruz (Mexico)
Museo de Antropologia, Universidad Veracruzana
Museo Regional
Leipzig, Museum für Völkerkunde
Liverpool, Free Public Museum
London, British Museum
Madrid
Museo Arqueológico Nacional
Museo de América
Mexico City
Anahuacalli Museum
Carlos Pellicer Collection
Frederick Field Collection
Museo Nacional de Antropologia
Mitla, Oaxaca (Mexico)
Dario Quero Collection
Museo Frissell
Munich, Staatliches Museum für Völkerkunde

Paris
 Bibliothèque Nationale
 Musée de l'Homme
Rome
 Museo Preistorico Etnografico Lu-
 igi Pigorini
 Vatican Library
Rotterdam, Museum voor Land- en
 Volkenkunde
San Jose (Costa Rica), Museo Na-
 cional de Costa Rica
Toluca (Mexico), Museo
Vienna
 Hofbibliotek
 Museum für Völkerkunde
Villahermosa, Tabasco (Mexico),
 Museo "La Venta Parque"
Zurich, Museum Rietberg

United States and Canada

Atlanta, Paul A. Clifford Collection
Baltimore, Baltimore Museum of Art
Bloomington, Indiana University Art
 Museum
Cambridge, Peabody Museum of Ar-
 chaeology and Ethnology
Chicago
 Art Institute of Chicago
 Field Museum of Natural History
Cleveland, Cleveland Museum of
 Art
Dayton, Dayton Art Institute
Detroit, Detroit Institute of Arts
Gainesville (FL), University Gallery,
 University of Florida
Hartford, Wadsworth Atheneum
Hollywood, Stendahl Art Galleries
Honolulu, Honolulu Academy of
 Arts
Kansas City (MO), William Rockhill
 Nelson Gallery of Art and Mary
 Atkins Museum of Fine Arts

Los Angeles
 Los Angeles County Museum of
 Natural History
 Museum of Cultural History, Uni-
 versity of California
New Haven, Yale University Art
 Gallery
New Orleans
 Museum of Art
 Middle American Research Insti-
 tute
New York
 American Museum of Natural His-
 tory
 Brooklyn Museum
 Museum of Primitive Art
 Museum of the American Indian
Philadelphia
 Philadelphia Museum of Art
 University Museum, University of
 Pennsylvania
Princeton, Art Museum, Princeton
 University
Providence, Museum of Art, Rhode
 Island School of Design
St. Louis, City Art Museum of St.
 Louis
San Francisco, M.H. de Young Me-
 morial Museum
Toronto (Canada), Royal Ontario
 Museum, University of Toronto
Tulsa (OK), Thomas Gilcrease Insti-
 tute of American History and
 Art
Washington, (D.C.)
 Dumbarton Oaks Research Library
 and Collection
 National Gallery of Art
 United States National Museum,
 Smithsonian Institute
Worcester (MA), Worcester Art Mu-
 seum

CHAPTER 14

Tribal Arts

୧୷ଡ଼ଡ଼ଡ଼

THE ARTS OF AFRICA AND OCEANIA

To enter a gallery containing the arts of Africa and Oceania (including New Zealand and Australia) is to come upon a primordial world in which ephemeral spirits and life forces are given material substance. While collections of "tribal art" may depict animals, people, plants, and other recognizable objects, or even entirely imaginary creatures, these objects remain, on the whole, mysterious. Because they are presented in the absence of the context that gave them spiritual and functional value, tribal artifacts found isolated in a museum collection have been transformed into purely aesthetic objects. However, these objects are the product of more than purely aesthetic considerations. They express a profound and fundamental human need to organize, protect, and give meaning to life, and to link the physical with the spiritual.

Most of the art from these regions (see maps, Figures 14-1 and 14-2) was used in various religious or ritual practices that developed to ensure the well-being and security of an individual, group, family, or village. Group survival was usually considered to take precedence over the survival of any single individual, and much of the tribal art one encounters in museum collections can be linked to a specific tribal group or society. Because survival depended on a number of factors—adequate sources of food, through agriculture or hunting and gathering, or both; health; the upbringing of future generations; and stable leadership, usually by a king or chief—important rites came to be associated with group survival. Ritual acts were devoted to the consecration of the ground for planting, ancestor worship, fertility, the accession of new rulers, and preservation of spiritual and physical well-being. All stages of human life, from birth and childhood to coming of age, marriage, and death, as well as the seasons of the year and times of the day, were marked by ritual. Tribal religion was based

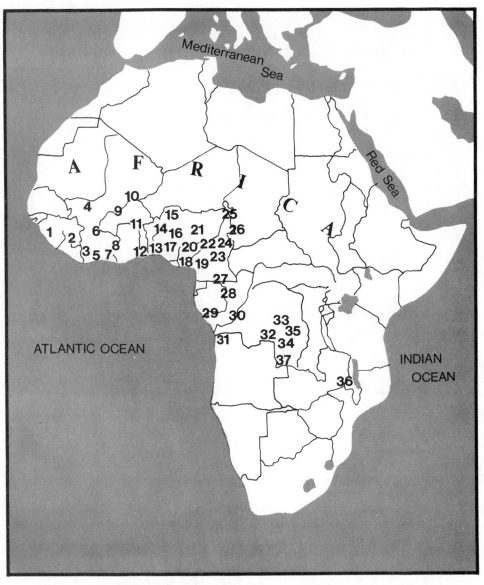

FIGURE 14-1. The geographic distribution of various important tribal groups within contemporary boundaries in Africa. The tribes are: (1) Baga; (2) Kissi; (3) Dan; (4) Bambara; (5) Ngere; (6) Senufo; (7) Guro; (8) Baule; (9) Bobo; (10) Dogon; (11) Mossi; (12) Ashanti; (13) Fon; (14) Yoruba; (15) Hausa; (16) Ife; (17) Edo; (18) Ijo; (19) Ibo; (20) Ibibio; (21) Nok; (22) Ekoi; (23) Bamum; (24) Bamileke; (25) Sao; (26) Massa; (27) Fang; (28) Bakota; (29) Mpongwe; (30) Bateke; (31) Bakongo; (32) Bapende; (33) Bakuba; (34) Bajokwe; (35) Bena Lulua; (36) Baluba; and (37) Balunda.

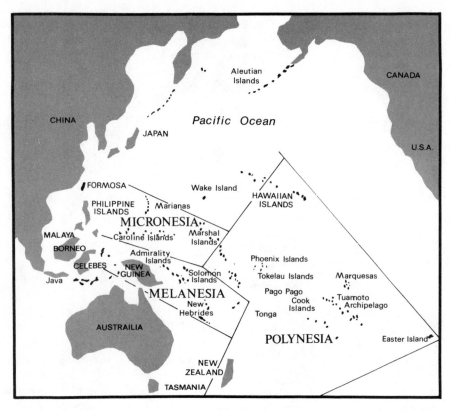

FIGURE 14-2. Oceania and the Pacific Basin, indicating the regions of Micro-
nesia, Melanesia, and Polynesia.

on a belief in the existence of many kinds of spirits that inhabited animals,
plants, and other natural forms. Good or evil, these spirits had to be ac-
knowledged and appeased.

Most tribal art from tropical regions is made from wood, an abundant but
perishable material. Thus, with several important exceptions, most museum
collections of African and other tribal art contain artifacts of relatively recent
manufacture. Objects dating from the nineteenth century are considered ven-
erable, and most museums have works of far more recent origin.

Carved from wood, many tribal art objects derive their shape from the
naturally tubular form of tree trunks, while carved hollow shells, disks, masks,
and planks were produced by hollowing out or flattening wood. The tools most
commonly used in woodworking included iron knives, adzes (heavy curved
tools with broad, chisellike ends), scrapers, and chisels. Wood could be painted
or adorned with beads, shells, and combinations of other materials, such as
various grasses and fibers. Other materials used in tribal arts included clay,

which was baked or fired and sometimes painted, and bronze, iron, gold, and silver. Though less common than wood, metals were preferred by certain tribal groups who specialized in making metal implements or objects. Other naturally abundant or even rare materials could be and were used.

The training of artists varied according to region. In Africa, the artist was taught by a master, who was sometimes also a priest, diviner, or magician. In some cultures, the position of artist-craftsman was inherited, while in others it was achieved through demonstration of talent and inclination. Irrespective of method of training, however, artists were prominent figures in all tribal cultures because they enabled a group to express its religious beliefs, perform its rituals and, therefore, survive.

Musem labels usually identify an artifact by the group that produced it and the geographic region in which the group resides. Labels often specify an object by type (mask, doll, or the like) and occasionally identify the ritual with which an object is associated. Tribal rituals are rarely explained fully, and sometimes the details of a particular rite are not known.

Since most tribal sculpture is rarely more than fifty years old, museums tend to display materials of relatively recent date. Museums and collectors attempt to obtain authentic pieces, of course, and signs of use or wear, the formation of patinas, and the accumulation of layers of other materials applied to some forms of sculpture during special ceremonies, are all considered indications of authenticity. Although contemporary tribal arts are supported by an active tourist trade and continue to be produced, these pieces are considered copies of traditional sculpture. Their authenticity is questionable because they are not commissioned or used by the same tribal groups for whom original pieces were made.

In the following section, a brief overview is given of the types of tribal art objects the viewer will find in museum collections.

MASKS AND HEADDRESSES

Among the most captivating and fascinating tribal art objects to have been made, masks assume various animal, human, and imaginary forms, and are associated with numerous types of rituals, from rites of initiation, puberty, and burial to those performed by secret societies and others dedicated to driving out evil spirits. Men were more often permitted to wear masks and participate in activities involving their use, while few women were allowed to even touch the mask, for fear these might thus be robbed of their power.

Often made in pairs, masks were worn horizontally across the top of the head, or vertically over the face. Generally, masks were but one component in a large ensemble of dress that included costumes, ornaments, and other masks. The spirit of the mask was thought to possess the body of its wearer, who then performed rites associated with that particular mask. Music and dance were very often an essential part of ceremonies involving masks.

Although the function of certain masks is not fully understood, it is known that they were often used to conjure up magical forces. Also, some tribal cultures are known to have had secret societies whose purpose it was to maintain a certain balance of power within their tribal group by instilling fear in its members. Some of these societies were official, and maintained public order, administered justice, and executed or punished criminals. The masks of these societies were thus deliberately humorless and monstrous in appearance for they were intended to inspire fear and strike terror in the souls of their beholders.

FIGURES

Figures were carved for various purposes and to express different meanings. The frequently depicted image of the mother and child, for example, symbolized fertility, continuity, stability, and nurturing, if the mother was shown nursing her child.

Some figures formed parts of a larger complex, such as a house, and would serve as houseposts. Others were placed in shrines, where they were used in ancestral worship or related rites. Ancestor worship was frequently directed toward a group's royal forebears. Images of earlier tribal leaders or chiefs were placed in shrines and venerated by their followers.

Reliquary Figures

The remains of one's ancestors were typically kept in a basket or bark-cloth receptacle, and were guarded by carved figures. Among some tribal groups, the remains of the deceased were placed inside the body cavity of a carved figure.

FETISHES

The fetish was an extension of the tribal belief in spiritual forces. Consisting generally of a combination of ingredients (for example, ground bone or human blood), the fetish was thought to embody protective or destructive powers that could be wielded by the fetish owner, as long as the fetish was maintained and appeased. Fetishes were most often kept in some orifice (for example, the stomach) of a larger figure. Fetishes were believed to ensure fertility, protect against diseases, and heal illnesses.

UTENSILS

Stools, doors, spoons, boxes, headrests, and other functional objects were often symbols of prestige in tribal societies. In general, the more elaborately worked an object was, the more likely it was to have been associated with important or wealthy members of a tribal group.

Artists carved spoons that were probably used to serve food on special feast days. Stools carved with figures were associated with ancestor worship or leadership, and were reserved for ceremonial use by chiefs or other group leaders.

DIVINATION TOOLS

Divination, or the interpretation of spiritual and divine manifestations by special soothsayers, was based on a variety of techniques. Animal entrails, grain, stones, shells, bones, or palm nuts were commonly used in this process. Artists supplied a variety of other divining utensils, such as cups, bells, trays, and sticks. Magnificent examples of carved and decorated divination tools may be found in the world's museums.

JEWELRY

Among many African peoples, jewelry was considered an extension of such bodily adornments as tatooing, scarification, hairstyling, and dress. Rings, bracelets, necklaces, earrings, and ankle rings are among the many forms of tribal jewelry. Often part of a family treasure or a mark of honor and distinction, jewelry was sometimes worn to designate a person's position or occupation. Bronze and gold, combined with stones, beads, and shells, were commonly used in jewelry.

MUSICAL INSTRUMENTS

Drums are among the most important instruments in African culture, and generally take one or two forms: hollowed out wood drums with a slight opening (called slit drums), or skin- or membrane-covered drums that resonate. Depending on the region of their origin, drums could be embellished with various paints or sculpted decorations.

Bells, bows, flutes, whistles, rattles, harps, horns, trumpets, and various other devices were used to make musical sounds.

TEXTILES

Among the most beautiful products of tribal peoples are their textiles. Africa, in particular, had produced some spectacular examples of fabrics rich in color, design, and pattern. Both imported cloths and domestic materials were used to produce textiles and were dyed or woven to produce patterns. Some textiles were worn by the general populace, while other, more complex and ornate fabrics were reserved for tribal leaders.

TRIBAL ARTS: MAJOR COLLECTIONS
—————————— AFRICAN ART ——————————

Europe

Antwerp, Etnografisch Museum
Basel, Museum für Völkerkunde
Berlin, Museum für Völkerkunde
Bern, Bernisches Historisches Museum
Brussels, Musées Royaux d'Art et d'Histoire
Cologne, Kunstgewerbemuseum der Stadt
Cologne, Rautenstrauch-Joest-Museum
Copenhagen, Nationalmuseet
Delft, Etnografisch Museum
Dresden, Staatliche Museen für Tierkunde and Völkerkunde
Hamburg
 Museum für Kunst und Gewerbe
 Museum für Völkerkunde und Vorgeschichte
Leiden, Rijksmuseum voor Volkenkunde
Leipzig, Museum für Völkerkunde
Liverpool, City of Liverpool Museums
London
 British Museum
 Courtauld Institute Galleries
Louvain, Université Catholique, Africain
Lübeck, Museum für Völkerkunde
Munich, Museum für Völkerkunde
Oxford, Pitt Rivers Museum
Paris
 Musée National des Arts Africains et Océaniens
 Musée d'Ethnographie
 Musée de l'Homme

Rome
 Musei del Laterano
 Museo dell'Africa Italiana
 Museo Preistorico Etnografico Luigi Pigorini
Stuttgart, Linden-museum für Völkerkunde
Tervueren
 Musée du Congo Belge
 Musée Royal de l'Afrique Centrale
Vienna, Museum für Völkerkunde
Zürich, Museum Rietberg

United States and Canada

Baltimore, Johns Hopkins Archaeological Collection
Berkeley, Robert H. Lowie Museum of Anthropology, University of California
Bloomington, Indiana University Art Museum
Cambridge, Peabody Museum of Archaeology and Ethnology
Chicago
 Art Institute of Chicago
 Field Museum of Natural History
 Natural History Museum
Detroit, Detroit Institute of Arts
Iowa City, Museum of Art, University of Iowa
Miami, Lowe Art Museum
Milwaukee, Milwaukee Public Museum
New Haven, Yale University Art Gallery
New Orleans
 Dillard University Museum
 Louisiana State Museum
 Middle American Research Institute, Tulane Univesity

New York
 American Museum of Natural History
 Brooklyn Museum
 Metropolitan Museum of Art
 Museum of Primitive Art
Newark (NJ), Newark Museum
Normal (IL), Illinois State Normal University Museum
Oberlin (OH), Allen Memorial Art Museum

Philadelphia, University Museum, University of Pennsylvania
Portland (OR), Portland Art Museum
Seattle, Seattle Art Museum
Toronto (Canada), Royal Ontario Museum of Archaeology
Washington, D.C.
 National Museum of Natural History, Smithsonian Institute
 National Museum of African Art, Smithsonian Institute

ART OF OCEANIA

Europe

Basel, Museum für Völkerkunde
Bern, Musée d'Histoire
Bremen
 Übersee-Museum
 Museum Bremen
Brussels, Musées Royaux d'Art et d'Histoire
Cambridge, Cambridge University, Museum of Archaeology and Ethnology
Copenhagen, Nationalmuseet
Florence, Museo Nazionale di Antropologia e Etnologia
Frankfurt, Städtisches Museum für Völkerkunde
Hamburg, Museum für Völkerkunde und Vorgeschichte
Geneva, Musée et Institut d'Ethnographie
London, British Museum
Paris
 Musée des Arts Africains et Océaniens
 Musée de l'Homme

Rome
 Musei del Laterano
 Museo Preistorico Etnografico Luigi Pigorini
Stuttgart, Linden-Museum für Völkerkunde
Sydney, Australian Museum
Zürich, Museum Rietburg

United States

Baltimore, Baltimore Museum of Art
Cambridge, Peabody Museum of Archaeology and Ethnology
Chicago, Natural History Museum
College Park, University of Maryland Art Gallery
Los Angeles, University of California
New Orleans, New Orleans Museum of Art
New York
 Brooklyn Museum
 Metropolitan Museum of Art
Philadelphia, University Museum, University of Pennsylvania
Salem (MA), Peabody Museum

Mythological and Christian Figures

❧

Egyptian Mythology: Principle Deities

Ennead of Heliopsis

Atum Human form. Primeval god. God of the setting sun. Born of himself.
Nun The Ocean. Father of the gods.
Shu Human form. God of Air. Born of Atum.
Tefnut Goddess of moisture.

Shu and Tefnut begot:
Geb Human form. God of the earth.
Nut Human or bovine form. Goddess of heaven and of trees.

Geb and Nut begot:
Horus Shown as Falcon. Pharaoh is his personification on earth. Lower Egypt's major
 god in prehistoric times; national god during Old Kingdom.
Isis Human form. Wife of Osiris, mother of Horus.
Nephthys Human form. Wife of Seth, sister of Isis.
Osiris Shown as a mummy. God of the dead and of vegetation. Attributes: scourge &
 scepter.
Seth Human or animal form. Upper Egypt's national God in prehistoric times. Hostile
 brother of Osiris, and adversary over Horus's rule.

Sun Gods

Atum Human form. The setting sun.
Khepri Beetle (scarab). The rising sun.

Maat Human form. Goddess of truth and justice. Daughter of Rē. Attribute: feather.
Rē Falcon headed. Sun god; the sun at noon.
Rēhorakhty Falcon headed. Sun god at sunset and sunrise.

Ogdoad of Hermopolis

(These gods take male form in the shape of a frog and take female form in the shape of a snake.)
Amun and *Amaunet* That which cannot be seen.
Heh and *Hehet* Infinity.
Kek and *Keket* Darkness.
Nun and *Naunet* The primordial sea.

The Triad of Memphis

Nefertem Human form. God of scent.
Ptah Human form, wrapped as mummy. God of creation.
Sekhmet Takes lion head. She rules the desert, bad weather, and disease.

Triad of Thebes

Amun-Rē Human form; animal form as a ram with twisted horns or a goose. King of the gods in the New Kingdom.
Khons Human form. God of the moon. Born of Amun-Rē and Mut.
Mut Human form, or vulture. Wife of Amun-Rē. Her name includes "Mother."

Amarna

Anubis Jackal headed. God of funerary cults and mummification.
Aton Represented as a sun disc. Sun god.
Thoth Ibis-headed. God of wisdom and of the moon. His sacred animals are the ape and the ibis. Associated with funerary cults.

Local Deities

Apis Bull. God of Memphis. Used as an oracle.
Bastet Shown as Cat's head. Gives aid. Attributes: basket, sistrum, collar, and cat. Sacred animal: cat.
Bes Amalgum of creatures. God of the bed chamber.
Hathor Shown as cow. Goddess of heaven, women, and trees.
Heqt Shown as toad. Primordial mother of creation.
Khnun Ram headed. God of creation. Sacred animal: ram.
Min Human form. God of fertility.
Nekhbet Shown as vulture. Goddess of Upper Egypt.
Nile-God Human form. God of fertility as giver of the Nile. Attributes: papyrus plants, lotus buds, water jars.
Selket Scorpion. Goddess of medicine.
Sobek Crocodile. Lord of the Nile.
Thoueris Hippopotamus. Goddess of fertility and women. Aids childbirth.
Uraeus Snake. Goddess of Lower Egypt.

Greek and Roman Mythology

Achilles Greek son of Peleus and Thetis. Killer of Hector in Trojan War. Later killed by arrow shot into his heel, perhaps by Paris.

Actaeon Hunter changed to stag by goddess Diana, whom he saw bathing. Killed by his own hunting dogs.

Adonis Lover of Venus and Proserpine.

Aegeus King of Athens. Father of Theseus. Aegeus's death in the sea gave the Aegean Sea its name.

Aeneas Trojan. Son of Anchises and Venus.

Aeolus God of Wind. Son of Jupiter?

Agamemnon King of Mycene. Brother of Menelaus, whose wife Helen was abducted by Paris, thereby precipitating the Trojan War. Agamemnon led the Greeks, but was killed by his wife Clytemnestra upon his return.

Ajax Bravest Greek warrior in Trojan War.

Althaea Mother of Meleager, whose life span was determined by the length of time a log would burn. Althaea preserved the log but burned it to avenge the death of her brothers whom Meleager killed.

Amazons Warrior women.

Andromache Wife of Hector, a warrior in the Trojan War.

Andromeda A great beauty exposed on a rock to a sea monster by a jealous and vengeful Neptune. Rescued and married by Perseus. Also known as Cassiopeia.

Aphrodite See Venus.

Apollo God of the sun. Son of Jupiter and Latona. Guardian of the Muses, with whom he resided on Mt. Parnassus.

Ariadne King of Crete. Daughter of Minos, lover of Theseus, whom she saved from the labyrinth with a thread.

Atalanta Daughter of the King of Scyros. She chose celibacy over marriage and defeated all her suitors in footraces, except Hippomenes, who distracted her from the gardens of the Hesperides with three golden apples given to him by Venus.

Athena Minerva's name as goddess of Athens.

Atlas A Titan, whose main labor was to bear the globe on his shoulders.

Aurora The dawn, who pours dew on the earth.

Bacchus God of Wine and marriage. Son of Jupiter and Semele, second husband of Ariadne, father of Hymen. Connected with Dionysius.

Bellerophon Slayer of the Chimera, with the help of his winged horse, Pegasus.

Cacus Robber and son of Vulcan and Medusa. Strangled by Hercules.

Cadmus Son of Agenor, King of Phoenicia. Brother of Europa, who was abducted by Jupiter. Founder of Boeotia.

Callisto Arcadian nymph. Transformed into a bear by Jupiter. Hunted by son Arcas, who was transformed into a cub. They thereby became the constellations of the great and little bear.

Calypso Hostess for Ulysses on her island. She offered him immortality in exchange for marriage and was refused.

Cassandra Daughter of Priam and Hecuba. Loved by Hercules, who endowed her with the power to foretell the future. Given to Agamemnon at the fall of Troy and slain by his wife, Clytemnestra.

Cassiopeia See Andromeda.

Castor and Pollux Twin sons of Jupiter and Leda. Joined Jason in his quest for the Golden Fleece.

Centaur Half man, half horse.

Cereberus Dog of Pluto. Guard of entrance to the underworld.

Ceres Goddess of corn and harvests. Daughter of Saturn and Vesta.

Charon Ferryman for souls across the river Styx.

Chimera Monster slain by Bellerophon.

Clytemnestra Wife of Agamemnon, whom she betrayed with Aegisthus while Agamemnon fought the Trojan War. She murdered Agamemnon upon his return, and his death was avenged by their son, Orestes.

Cupid God of love. Son of Jupiter and Venus.

Cybele Nature goddess. Wife of Saturn. Also called Ceres, Rhea, Ops, and Vesta.

Cyclopes Race of giants with a single eye.

Cythera The island of Venus, to which she was carried on her shell.

Daedalus First artist. Maker of labyrinth for King Minos, who trapped Daedalus and his son Icarus inside. They escaped with wings of wax and feathers made by Daedalus. Icarus flew too close to the sun, his wings melted, and he plunged into the sea and drowned.

Danae One of Jupiter's loves, whom he visited in the form of a shower of gold.

Diana Greek Artemis. Huntress. Personification of chastity.

Deianira A great beauty whose suiters competed for her hand through feats of strength. Hercules won.

Deucalion Son of Prometheus, husband of Pyrrah. He built a ship to save his family from a deluge sent by Jupiter on his Kingdom of Thessaly.

Dido Queen of Carthage. Spurned by Aeneas, over whom she committed suicide.

Diomedes Thracian tyrant, who fed his horses human flesh until he was fed to them himself by Hercules.

Dionysius God of fertility and wine. Son of Jupiter. Considered a patron of the arts. Connected with Bacchus.

Echo Lover of Narcissus, over whom she died. Her voice survived to repeat sounds that reached her. Others say Juno deprived her of the ability to speak, allowing her only to repeat sounds.

Electra Daughter of Agamemnon, sister of Orestes. She convinced Orestes to slay Clytemnestra, their mother, who murdered Agamemnon, their father.

Endymion Asked Jupiter for eternal youth. Loved by Diana, who visited him at night.

Eros Greek god of love.

Europa Daughter of Agenor, King of Phoenecia. Mistress of Jupiter, who, in the form of a bull, abducted her.

Eurydice Wife of Orpheus. Her untimely death prompted Orpheus to seek her in the underworld. His attempted rescue ended in failure when he looked at her before they escaped, thereby breaking the spell.

Fates The three daughters of Necessity. Clotho held the thread of life; Lachesis turned the spindle; Atropos cut the thread with her shears.

Faun Half-man, half-goat. Attendant to Pan.

Fides Roman goddess of faith and honesty, whose temple stood on the Capitol in Rome.

Flora Goddess of flowers and gardens. Wife of Zephyrus. She had perpetual youth. Chloris was her Greek name.

Fortuna Roman goddess of fortune, who stands on a wheel with her eyes bandaged, holding a cornucopia.

Furies The three daughters of Acheron and Nox. They personify rage, slaughter, and envy and they punish wrongdoers.

Galataea A sea nymph and daughter of Nerus and Doris. She spurned the love of Polyphemus, the cyclops.

Ganymede Son of Tros, king of Troy. Abducted by Jupiter in the form of an eagle and made cupbearer to the gods.

Genii Domestic dieties. One brought happiness, the other sorrow.

Geryon Three-bodied monster whose flocks were guarded by Orthos, a two-headed dog, and Eurythion, a seven-headed dragon, both of whom were killed by Hercules.

Gigantes A race of giants, sons of Coelus (sky) and Terra (earth).

Glaucus A Trojan warrior, who foolishly exchanged his golden armor for one of iron.

Golden Fleece A ram's skin, taken by Phryxus to Colchis and returned by Jason to Ioclus.

Gordius A peasant who became king of Phrygia. His chariot was bound to its yoke by a legendary knot that was so well tied it was said that he who could untie it would become king of the Asian empire. Alexander the Great cut it with his sword.

Gorgons Three sisters: Stheno, Euryale, and Medusa, who could petrify all whom they saw. Perseus slew Medusa and gave her head to Minerva.

Graces Three attendants of Venus: Aglaia, beauty; Thalia, freshness; Euphrosyne, cheerfulness.

Halcyons Greek name for sea birds, who nested on water when the sea was calm, hence "halcyon days."

Harpies Monstrous daughters of Neptune and Terra, with heads and breasts of women, bodies of birds, and lion's claws. They poisoned all they touched.

Hebe Roman goddess of youth. Daughter of Jupiter and Juno. Cupbearer to the gods.

Hecate The goddess Diana's name in the underworld. She is known as Luna in the heavens.

Hector Son of Priam and Hecuba, husband of Andromache. Trojan chief, killed by Achilles in the Trojan War.

Hecuba Second wife of Priam, King of Troy, mother of Hector and Paris. She abandoned Paris on Mt. Ida out of fear of the prediction that he would bring ruin to his country. Paris later abducted Helen, precipitating the Trojan War.

Helen (Helena) Wife of Menelaus. The famous beauty, who fled with Paris to Troy. Her failure to return brought on the Trojan War.

Hephaestos Greek for vulcan.

Hera (Greek for Juno) Wife and sister of Zeus.

Hercules Hero. Son of Jupiter and Alcmene. Juno tried to kill Hercules as an infant with two snakes. Hercules strangled them and grew up to perform twelve impossible deeds: He: slew the Nemean Lion; slew the Lernaean Hydra; captured the elusive and swift Arcadian Stag; captured the Erymanthian Boar; cleaned the stables of King Augeas, whose 3,000 oxen had lived there thirty years; killed the Stymphalian Birds; captured the wild bull of Crete; captured the flesh-eating mares of Diomedes, which he fed to the horses; captured the girdle of Hippolyte, Queen of the Amazons; stole the meat-eating oxen of Geryon, King of Gades; obtained a golden apple from the

Garden of the Hesperides; and captured Cerberus, three-headed dog of Hades. Hercules also killed the Giant Anteus by lifting him off the ground from whence he obtained his strength; and strangled Cacus, the monster who had stolen his animals.

Hermione Daughter of Mars and Venus. Betrothed to Orestes. Abducted by Pyrrhus, son of Achilles.

Hero Priestess of Venus and beloved of Leander, who nightly swam the Hellespont to be with her. Leander drowned in a storm, causing Hero to throw herself into the sea.

Hesperides Three nymphs. Guardians of the golden apples given by Jupiter to Juno on their wedding.

Hippolyte Queen of the Amazons. Daughter of Mars. Her girdle was captured by Hercules, who then gave her to Theseus in marriage.

Hippolytus Son of Hippolyte and Theseus. Desired by Phaedra, his stepmother, whose passion drove him to the sea, where his chariot crashed among the rocks, killing him.

Horatii Three Roman brothers, triplets, who vowed to fight the Curiatii in 667 B.C. One Horatii emerged the victor.

Hyacinthus Youth loved by Apollo. Apollo caused Hyacinthus's accidental death and thus transformed his blood into a flower named after him.

Hydra Many headed monster serpent that tormented Lake Lerna until Hercules slew it.

Hygeia Goddess of health.

Hymenaeus (or Hymen) Greek god of marriage. Son of Bacchus and Venus or Apollo and one of the Muses.

Icarus Son of Daedalus. *See also* Daedalus.

Idomeneus Son of Deucalion and ruler of Crete. He vowed to sacrifice the first thing he saw to Neptune if he survived a storm at sea, and thereby was forced to kill his own son.

Io Priestess of Juno at Argus and beloved by Jupiter, who visited her in the form of a cloud. Juno transformed her into a heifer.

Iphigenia Daughter of Agamemnon and Clytemnestra. She was to be sacrificed to bring blessings from the gods before the Trojan War, but was miraculously transported away and replaced by a goat.

Iris A messenger of the gods, especially Juno. The personification of the rainbow and severer of the thread that binds the soul to the dying.

Janus Son of Apollo or Coelus. Ancient king, who knew both past and future. Presider over roads, gates, doorways, and locks.

Jason Hero who captured the Golden Fleece. Husband of Medea and later lover of Glauce, whereupon Medea revenged herself by slaying their children before his eyes.

Juno Queen of gods. Daughter of Saturn and Ops, wife of Jupiter, mother of Mars, Vulcan, and Hebe. One of the three beautiful goddesses involved in the Judgment of Paris, along with Minerva, and Venus. Venus won the golden apple.

Jupiter King of the gods. Son of Saturn and Ops, husband of Juno.

Lacoon Priest of Apollo, who opposed the admission of the Greek wooden horse inside the Trojan gates and was thereby punished by being strangled, along with his sons, by two serpents.

Laertes King of Ithaca. Father of Ulysses.

Lapithus Son of Apollo and Stilbe, whose descendents, the Lapiths, battled and defeated the centaurs during a wedding feast.

Leander Youth of Abydos, lover of Hero. *See also* Hero.

Leda Wife of Tyndareus, King of Sparta. Loved by Jupiter who visited her as a swan. She bore two eggs: Pollux and Castor issued from one, and Clytemnestra and Helen from the other.

Lucretia Roman lady, who stabbed herself rather than submit to Sextus Tarquinius and betray her husband.

Luna Diana as a celestial form—the moon.

Meander A river that wound its way through Asia Minor and emptied into the Aegean Sea.

Mars God of war. Son of Jupiter and Juno, lover of Venus. Supporter of the Trojans during the war.

Marsyas Gifted piper, whose thoughtless challenge of Apollo caused the triumphant god to tie him to a tree and flay him.

Mausolus King of Caria, whose wife erected a stupendous tomb to honor him. It became a wonder of the ancient world.

Medea Magician and wife of Jason. *See also* Jason.

Medusa The only mortal of the Gorgons. *See also* Gorgons.

Menelaus King of Sparta. Brother of Agamemnon, husband of Helen.

Mercury Messenger of the gods. God of the thieves. Son of Jupiter and Maia.

Midas King of Phrygia, who received the gift of wealth from Bacchus. Everything he touched turned to gold.

Minerva Goddess of wisdom, war, and liberal arts, who sprang full grown from Jupiter's head. Known also as Athena and Pallas.

Minotaurus Half man, half bull, who ate humans and was confined in King Minos's Labyrinth and killed by Theseus.

Morpheus God of sleep. Depicted as a corpulent, sleeping child with wings.

Muses The nine goddesses of the arts: Clio, Euterpe, Thalia, Melpomene, Terpsichore, Erato, Polyhymnia, Calliope, Urania.

Narcissus Beautiful youth, who thought his own reflection was a water nymph and fell in love with it. Finally committing suicide out of despair at failing to reach the object of his desire.

Nemesis Goddess of vengence, whom the Romans worshipped prior to war.

Neptune God of the sea. Son of Saturn and Ops, brother of Jupiter and Pluto.

Nereides Aquatic nymphs.

Nestor Homeric hero who witnessed the battle of the Centaurs and Lapithae and fought in the Trojan War.

Nike Greek goddess of victory. Daughter of Pallas and Styx. Presented in flight holding laurel wreath. Also known as Victory.

Niobe Daughter of Tantalus. Personification of grief, whose twenty children were nearly all killed by the gods.

Nymphs Lesser dieties who attended the gods and presided over springs, woods, fountains, and the sea.

Oceanids Sea nymphs. Daughters of Oceanus and Tethys. Notable among them are Amphritite and Doris.

Oceanus God of the sea. Son of Coelus and Terra, husband of Tethys.

Oedipus King of Thebes. Son of Laius. He fulfilled the prophecy that he would kill his father, although he did not know him. He triumphed over the Sphinx by solving its riddle.

Olympius Name of Jupiter at Olympia, where games dedicated in his honor took place.

Omphale Queen of Lydia. Lover of Hercules, who so succumbed to her charms that he became quite effeminite while living with her.

Ops Mother of the gods, daughter of Coelus and Terra, wife of Saturn. Her Greek name was Rhea.

Orestes Son of Agamemnon and Clytemnestra. He killed his mother to avenge his father's death.

Orion Giant. Blinded by Oenophon and later slain by Diana, who made him a star in the firmament.

Orpheus Son of Calliope. He received the lyre from Apollo. Husband of Eurydice, whom he tried to save from the underworld. *See also* Eurydice.

Palladium Statue of Pallus, owned by the Trojans and captured by the Greeks.

Pallas Name of Minerva given after she slew a giant of that name.

Pan Arcadian god of the shepherds, hunters, and peasants. Son of Mercury and Penelope. Depicted as half man, half goat.

Pandora The first female mortal, made by Vulcan. Given beauty by Venus and a famous box by Jupiter, which when opened issued innumerable evils on the world, leaving only hope inside the box.

Paris Son of Priam and Hecuba, brother of Hector. Awarded the golden apple to Aphrodite, who helped him abduct Helen, thus bringing on the Trojan War. *See also* Hecuba.

Pegasus Winged horse, sprung from Medusa's blood.

Pelias Son of Neptune and Tyro. Killed by Medea, who tricked him into believing he would obtain eternal life if she cut him up.

Penelope Wife of Ulysses, mother of Telemachus. Her patient and virtuous behavior while awaiting Ulysses's return from the war is recounted in the *Odyssey*.

Penthesilea Queen of the Amazons. Daughter of Mars. Battled in the Trojan War, where she was killed by Achilles, who fell in love with her as she died.

Perseus Son of Jupiter and Danae. Slayer of Medusa and rescuer of Andromeda.

Phaedra Daughter of Minos, wife of Theseus, whose son Hippolytus she desired and falsely accused of violating her. She drove him to his death, and in despair committed suicide.

Phaeton Generally considered the son of Phoebus (Apollo) and Clymene. Phoebus permitted him to drive the chariot of the sun. It went out of control, scorching the earth. Jupiter stopped him with a thunderbolt, which threw him from the chariot, and he drowned in the River Po.

Phyllis Beloved of Demophon, who later betrayed her. The same Phyllis(?) so enraptured Aristotle that he permitted her to ride him like a horse.

Pluto Son of Saturn and Ops. God of the underworld, who captured Proserpine (Persephone) and made her his queen.

Pollux Brother of Castor, son of Leda. Part of the Gemini constellation.

Polyphemus A cyclops. Son of Neptune, who captured Ulysses and his men on their way back from Troy. Ulysses blinded him to escape.

Pomona Roman nymph of gardens and fruit.

Poseidon Greek god of sea. Neptune to the Romans.

Priam Last king of Troy. Husband of Hecuba, father of Paris, Hector, Helen, and Cassandra.

Prometheus Father of Deucalion. He made clay figures and stole fire from the gods twice. To punish him, Jupiter chained him to a rock and had his liver eaten by a vulture every day. Hercules later saved him.

Proserpine Persephone in Greek. Goddess of the underworld. Daughter of Jupiter and Ceres, wife of Pluto. Also known as Hecate, Inferna, and sometimes Juno.

Proteus Son of Oceanus. He had the gift of prophecy.

Psyche Nymph beloved and married to Cupid. Slain by Venus, but given immortality by Jupiter.

Pygmalion Sculptor who fell in love with his perfect statue. Venus gave it life, whereupon Pygmalion married her.

Python Serpent spawned from the deluge sent by Zeus to Deucalion. Slain by Apollo.

Quies Roman goddess of rest.

Rhea Greek name for Cybele.

Romulus Founder of Rome. Son of Mars, twin of Remus, whom he slew. The twins were nurtured by a she-wolf and raised by a shepherd.

Sardanapalus Last Assyrian king, who burned himself and his legendary luxurious palace upon learning of his kingdom's revolt in c. 820 B.C.

Saturn Son of Coelus and Terra, father of Jupiter, Neptune, and Pluto, who divided his kingdom.

Satyrs Attendants of Silenus. *See also* Silenus.

Scylla A nymph of great beauty, transformed into a sea monster by the jealous Amphitrite.

Semiramis Assyrian queen in c. 1965 B.C., whose wisdom and prowess as a warrior have made her legendary. Wife of the governor of Nineveh.

Silenus Chief of the Satyrs, attendant of Bacchus. Shown as drunken old man, riding an ass and wearing flowers in his hair.

Sirens Three sea nymphs, whose singing lured sailors to their deaths on the rocks. They were thwarted by Ulysses, who passed by unhearing because of wax plugs in his ears, whereupon they threw themselves into the sea in despair.

Sphinx Monster with a woman's head and breasts, a dog's body, a serpent's tail, a bird's wings, and a lion's paws, who posed enigmas and ate all who failed to solve them. She was destroyed by Oedipus, who solved her riddle.

Styx River of the underworld.

Syrinx Nymph who escaped Pan by changing into reeds.

Tantalus Father of Niobe and Pelop, who fed his son to the gods and was therefore punished with eternal thirst.

Terra Earth, one of the most ancient Greek gods.

Theseus King of Athens. Hero who captured the bull of Marathon and sacrificed it to Minerva. He also slew the Minotaur.

Thetis Sea goddess. Wife of Peleus, mother of Achilles, whom she dipped into the river Styx upon his birth to grant him invulnerability. She forgot to dip his heel.

Titans Giants. Sons of Coelus and Terra, including Saturn.

Tithonus Aurora's husband, who was granted immortality but not eternal youth. He therefore became increasingly older, until the gods transformed him into a grasshopper, who shed his shell and became young again.

Triton Son of Neptune and Amphitrite, whose powers were such that he could calm the sea.

Ulysses King of Ithaca. Husband of Penelope. Warrior, whose travels on his return from the Trojan War are recounted in Homer's *Odyssey*.

Venus Goddess of beauty, mother of love. Wife of Vulcan, lover of Mars, from whom she had Hermione, Cupid, and Anteros. She became enamored of Adonis and caused Paris to love Helen. She is attended by Cupid and the Graces. Also known as Aphrodite (Greek).

Vesta Goddess of fire. Daughter of Saturn and Cybele.

Victory See Nike.

Vulcan God of fire. Son of Jupiter and Juno, husband of Venus. Forger of Jupiter's thunderbolts.

Zeus Greek name for Jupiter.

Christian Saints

Agatha Virgin martyr who was tortured and had her breasts cut off. Patron saint of bell founders. Invoked against fire and diseases of the breast.

Agnes (died Rome c. 350) Virgin martyr killed by sword piercing her throat. Symbolized on her feast day by the lamb.

Alban (third century?) Beheaded. Venerated in England and France.

Ann (Anna) Mother of Virgin Mary. Especially venerated in England.

Anthony the Great (Anthony Abbot) The monk, shown bearded. Regarded as healer.

Barbara Virgin martyr (?) who converted to Christianity while locked in a tower. Patron saint of miners and gunners.

Benedict (c. 480–c. 550) Founder of Benedictine order. Attributes are the broken cup and raven.

Bernardino of Siena (1380–1444) Franciscan noted for his veneration of Christ's name in the form of a plaque with IHS inscribed on it.

Bonaventure (1221–1274) Franciscan friar, bishop, cardinal.

Bridget of Sweden (1303–1373) Visionary, writer. Patron saint of Sweden.

Catherine of Alexandria (fourth century?) Tortured on wheel and beheaded.

Cecelia (third century) Martyr. Patron saint of musicians; symbolized by organ or lute.

Christopher (third century?) Giant. Patron saint of travelers. Invoked against plague and sudden death.

Cosmas and Damian Martyrs. Patron saints of doctors.

Dominic (c. 1170–1221) Founder of Dominican Friars.

Francis of Assisi (1181–1226) Founder of Franciscan order.

George (died c. 303) Martyr. Patron saint of England and of soldiers, knights, armorers, and archers. Killer of dragons. Invoked against plague, leprosy, and syphilis.

Giles (died c. 710) Patron saint of smithies, cripples, lepers, and nursing mothers.

Gregory the Great (c. 540–604) Pope. Commonly shown writing as the Holy Dove dictates.

Jerome (c. 341–420) Monk. Translater of the Bible into Latin. One of the four Latin Doctors.

Joan of Arc (1412–1431) Virgin. Second patron saint of France.

Joseph Husband of the Virgin Mary. Patron saint of families and manual laborers, especially carpenters.

Jude (first century) Patron saint of hopeless causes. Some say he's the same as Judas, the apostle.

Laurence (died 258) Deacon, martyr. Patron saint of deacons. Symbolized by grate.

Lucy (died 304) Virgin martyr killed by dagger piercing her throat following prolonged torture, which included gouging of her eyes.

Margaret of Antioch Martyr. Patron saint of childbirth.

Martin of Tours (c. 316–397) Soldier turned Christian monk. Gave his cloak to a beggar.

Mary Magdalene Anointed Christ's feet and wiped them with her hair. Symbolized by ointment jar.

Michael Archangel. Fighter against the devil. Weigher of souls, killer of dragons (the devil).

Nicholas (fourth century) Bishop of Myra. Patron saint of children, unmarried girls, merchants, pawnbrokers, apothecaries, perfumers, sailors.

Patrick (c. 390–461?) Bishop. Founder of Celtic church.

Paul Apostle, preacher. Symbolized by the sword and the book. Often replaces Matthias among the apostles.

Roch 1293–1327. Traveled about Europe nursing plague victims. Plague saint.

Sebastian Fourth century martyr shot by arrows, healed by Irene, later stoned. Plague saint.

Stephen (died c. 35) Deacon, martyr. Stoned to death in Jerusalem.

Thomas Aquinas (1225–1274) Dominican friar, theologian.

Ursula (fourth century?) Virgin and martyr. Slain by Huns along with 11,000 other virgins.

Veronica Wiped Christ's face on the way to Calvary. Symbolized by cloth on which the image of Christ's face remained.

Bibliography

GENERAL

Berenson, Bernard. *Seeing and Knowing*. London: Evelyn, Adams & Mackay, 1968.

Berger, John. *About Looking*. New York: Pantheon, 1980.

———. *Ways of Seeing*. New York: Viking, 1973.

Clark, Kenneth. *Civilization*. New York: Harper & Row, 1969.

Flemming, William. *Arts and Ideas*, 6th ed. New York: Holt, Rinehart & Winston, 1980.

Gardner, Louise. *Art through the Ages*, 7th ed. New York: Harcourt Brace Jovanovich, 1980.

Hall, James. *Dictionary of Subjects and Symbols in Art*. New York: Harper & Row, 1974.

Janson, Horst W. *History of Art*. Englewood Cliffs, N.J.: Prentice-Hall, 1971.

Mayer, Ralph. *A Dictionary of Art Terms and Techniques*. New York: Crowell, 1975.

Taylor, Joshua. *Learning to Look*, 2nd ed. Chicago: University of Chicago Press, 1981.

———. *A Visual Dictionary of Art*. Greenwich, Conn.: New York Graphic Society, 1974.

THE HISTORY OF COLLECTING

British Museum. *Collectors and Collections*. London: British Museum, 1977.

Haskell, Francis. *Rediscoveries in Art: Some Aspects of Taste, Fashion and Collecting in England and France*. London, 1976.

Lipman, Jean, ed. *The Collector in America*. New York: Viking, 1971.

Plumb, John H. *Royal Heritage: The Story of Britain's Royal Builders and Collectors*. London: British Broadcast Corporation, 1977.

Ripley, S. Dillon. *The Sacred Grove*. New York: Simon & Schuster, 1969.

Saarinen, Aline. *The Proud Possessors*. New York: Random House, 1958.

Taylor, Francis H. *The Taste of Angels: A History of Collecting*. Boston: Little Brown, 1948.

von Holst, Niels. *Creators, Collectors and Connoisseurs*. New York: Putnam, 1967.

553

ART MUSEUMS

Katz, Herbert, and Katz, Marjorie. *Museums, USA: A History and Guide.* Garden City, N.Y.: Doubleday, 1965.

Lee, Sherman, ed. *On Understanding Art Museums:* Englewood Cliffs, N.J.: Prentice-Hall, 1975.

Lewis, Ralph H. *Manual for Museums.* Washington: National Park Service, 1976.

Wittlin, Alma S. *The Museum: Its History and Its Tasks in Education.* London: Routledge & Kegan Paul, 1949.

————. *Museums: In Search of a Useable Future.* Cambridge, Mass.: M.I.T. Press, 1970.

ARCHAEOLOGY

Ackerman, James, and Carpenter, Rhys. *Art and Archaeology.* Englewood Cliffs, N.J.: Prentice-Hall, 1963.

Allen, Agnes. *The Story of Archaeology.* New York: Philosophical Library, 1958.

Daniel, Glyn. *The Origins and Growth of Archaeology.* Baltimore: Penguin, 1967.

Dimick, John M. *Episodes in Archaeology.* Barre, Mass.: Barre Publishers, 1968.

Eydoux, Henry Paul. *The Buried Past.* New York: Praeger, 1962.

Marek, Kurt W. *Gods, Graves and Scholars.* London: Gollancz, 1952.

Pallotino, Massimo. *The Meaning of Archaeology.* New York: Abrams, 1968.

EGYPTIAN ART

Aldred, Cyril. *The Development of Ancient Egyptian Art from 3200 to 1315 B.C.,* 3 vols. London: Academy Edition, 1973.

Breasted, James H. *Egyptian Servant Statues.* Bollingen Series, XIII. Washington, D.C.: Pantheon Books, 1948.

————. *History of Egypt,* 1909. Repr. New York: Scribner, 1956.

Erman, Adolf. *Life in Ancient Egypt.* Tr. by H. M. Tirard. New York: Dover Publications, 1971.

Lange, Kurt, with Hirmer, Max. *Egypt: Architecture, Sculpture and Painting in Three Thousand Years,* 4th ed. London and New York: Phaidon, 1961.

Smith, William S. *The Art and Architecture of Ancient Egypt,* 2nd rev. ed. Harmondsworth, England: Penguin, 1981.

Woldering, Irmgard. *The Art of Ancient Egypt.* New York: Crown, 1963.

————. *Gods, Men and Pharaohs: The Glory of Egyptian Art.* New York: Abrams, 1967.

AEGEAN ART

Chadwick, John. *The Mycenaean World.* New York: Cambridge University Press, 1976.

Demargne, Pierre. *Aegean Art: The Origins of Greek Art.* London: Thames & Hudson, 1964.

Higgins, Reynold. *Minoan and Mycenaean Art.* New York: Praeger, 1967.

Hood, Sinclair. *The Arts in Prehistoric Greece*. Harmondsworth, England: Penguin, 1978.

Marinatos, Spyridon, with Hirmer, Max. *Crete and Mycenae*. London: Thames & Hudson, 1960.

Matz, Friedrich. *The Art of Crete and Early Greece*. New York: Crown, 1962.

Pendlebury, John. *The Archaeology of Crete*. London: Methuen, 1967.

Wace, Allen. *Mycenae: An Archaeological History and Guide*. New York: Biblo & Tannen, 1964.

Warren, Peter. *The Aegean Civilizations*. London: Elsevier Phaidon, 1975.

GREEK ART

Arias, Paolo. *A History of One Thousand Years of Greek Vase Painting*. New York: Abrams, 1962.

Ashmole, Bernard. *Architect and Sculptor in Classical Greece*. New York: New York University Press, 1972.

Beazley, John D. *The Development of Attic Black-Figure*. Berkeley, Calif.: University of California Press, 1964.

————. *Potter and Painter in Ancient Athens*. London: G. Cumberledger, 1944.

———— and Ashmole, Bernard. *Greek Sculpture and Painting to the End of the Hellenistic Period*. New York: Cambridge University Press, 1932, 1966.

Brilliant, Richard. *Arts of the Ancient Greeks*. New York: McGraw-Hill, 1973.

Cook, Robert M. *Greek Art: Its Development, Character and Influence*. Harmondsworth, England: Penguin, 1976.

————. *Greek Painted Pottery*, rev. ed. London: Methuen, 1966.

Hooper, Finley. *Greek Realities*. New York: Scribner, 1967.

Pollitt, Jerome G. *Art and Experience in Classical Greece*. New York: Cambridge University Press, 1972.

Richter, Gisela M. *Attic Red-Figure Vases: A Survey*. New Haven, Conn.: Yale University Press, 1958.

————. *A Handbook of Greek Art*, 6th ed. New York: Phaidon, 1969.

ETRUSCAN ART

Block, Raymond. *Etruscan Art*. Greenwich, Conn.: New York Graphic Society, 1959.

Brendel, Otto. *Etruscan Art*. Harmondsworth, England: Penguin, 1978.

Mansuelli, Guido. *The Art of Etruria and Early Rome*. New York: Crown, 1965.

Pallottino, Massimo. *Etruscan Painting*. New York: Skira, 1953.

————, and Hürliman, Martin. *Art of the Etruscans*. New York: Vanguard, 1955.

Richardson, Emeline. *The Etruscans: Their Art and Civilizations*. Chicago: University of Chicago Press, 1976.

ROMAN ART

Brilliant, Richard. *Roman Art from the Republic to Constantine*. New York: Praeger, 1974.

Brion, Marcel. *Pompeii and Herculaneium: The Glory and the Grief.* New York: Crown, 1960.

Carcopino, Jerome. *Daily Life in Ancient Rome.* New Haven, Conn.: Yale University Press, 1940.

Goldscheider, Ludwig. *Roman Portraits.* London: Phaidon, 1940.

Hanfmann, George M. *Roman Art: A Modern Survey of the Art of Imperial Rome.* New York: Norton, 1975.

Hooper, Finley. *Roman Realities.* Detroit: Wayne State University Press, 1979.

Kähler, Heinz. *The Art of Rome and Her Empire.* New York: Crown, 1963.

Maiuri, Amedeo. *Roman Painting.* New York: Skira, 1953.

Strong, Donald. *Roman Art.* Harmondsworth, England: Penguin, 1976.

————, and Brown, David, ed. *Roman Crafts.* New York: New York University Press, 1976.

Wheeler, Sir Mortimer. *Roman Art and Architecture.* New York: Praeger, 1964.

EARLY CHRISTIAN AND BYZANTINE ART

Beckwith, John. *The Art of Constantinople: An Introduction to Byzantine Art (330–1453).* New York: Phaidon, 1968.

————. *Early Christian and Byzantine Art.* Harmondsworth, England: Penguin, 1970.

————. *Early Medieval Art: Carolingian, Ottonian, Romanesque.* New York: Oxford University Press, 1974.

Chatzidakis, Manolis. *Byzantine and Early Medieval Painting.* New York: Viking, 1965.

Chrichton, George H. *Romanesque Sculpture in Italy.* London: Routledge & Kegan Paul, 1954.

Demus, Otto. *Byzantine Mosaic Decoration.* London: Paul, Trench and Trubner, 1948.

Deschamps, Paul. *French Sculpture of the Romanesque Period, Eleventh and Twelfth Centuries,* 1930. Repr. New York: Hacker, 1972.

Evans, Joan. *Art in Medieval France, 987–1498.* Oxford: Clarendon Press, 1969.

Grabar, Andre. *The Art of the Byzantine Empire: Byzantine Art in the Middle Ages.* New York: Crown, 1963.

————. *The Beginnings of Christian Art, 200–395.* London: Thames & Hudson, 1967.

————. *Early Medieval Painting from the Fourth to the Eleventh Century.* New York: Skira, 1957.

Henderson, George. *Early Medieval.* New York: Penguin, 1972.

Hinks, Roger. *Carolingian Art.* University of Michigan Press, 1966.

Kitzinger, Ernst. *Early Medieval Art in the British Museum.* London: British Museum, 1969.

Morey, Charles. *Early Christian Art.* Princeton, N.J.: Princeton University Press, 1953.

Panofsky, Erwin, and Panofsky-Soergel, Gerda, eds. *Abbott Suger on the Abbey Church of St. Denis and Its Art Treasure,* 2nd ed. Princeton, N.J.: Princeton University Press, 1979.

Rice, David T. *The Appreciation of Byzantine Art*. London: Oxford University Press, 1972.

––––––. *The Art of Byzantium*. New York: Abrams, 1959.

––––––. *Byzantine Art*. Harmondsworth, England: Penguin, 1968.

Schug-Willie, Christa. *The Art of the Byzantine World*. New York: Abrams, 1969.

Swarzenski, Hanns. *Monuments of Romanesque Art: The Art of Church Treasures in North-Western Europe*. Chicago: University of Chicago Press, 1967.

––––––. *Monuments of Romanesque Art*. Chicago: University of Chicago Press, 1974.

von Simson, Otto. *The Gothic Cathedral*, 2nd rev. ed. Princeton, N.J.: Princeton University Press, 1974.

Weitzman, Kurt. *Ancient Book Illustration*. Cambridge, Mass.: Harvard University Press, 1959.

MEDIEVAL ART, 1250–1400

Cennini, Cennino. *The Craftsman's Handbook*. Tr. by D. V. Thompson. New York: Dover, 1954.

Cole, Bruce. *Giotto and Florentine Painting, 1280–1375*. New York: Harper & Row, 1976.

––––––. *Sienese Painting from Its Origins to the Fifteenth Century*. New York: Harper & Row, 1980.

Fremantle, Richard. *Florentine Gothic Painters*. London: Secker & Warburg, 1975.

Larner, John. *Culture and Society in Italy, 1290–1420*. New York: Scribner, 1980.

Male, Emile. *The Gothic Image: Religious Art in France of the Thirteenth Century*. New York: Harper & Row, 1958.

Martindale, Andrew. *Gothic Art*. New York: Praeger, 1967.

Meiss, Millard. *French Painting in the Time of Jean de Berry*. New York: Braziller, 1974.

––––––. *Painting in Florence and Siena after the Black Death*. Princeton, N.J.: Princeton University Press, 1951.

Oertel, Robert. *Early Italian Painting to 1400*. New York: Praeger, 1968.

Panofsky, Erwin. *Early Netherlandish Painting*, 2 vols. Cambridge, Mass.: Harvard University Press, 1954.

––––––, and Panofsky-Soergel, Gerda, eds. *Abbot Suger on the Abbey Church of St. Denis and Its Art Treasure*, 2nd ed. Princeton, N.J.: Princeton University Press, 1979.

Robb, David M. *The Art of the Illuminated Manuscript*. Cranbury, N.J.: A. S. Barnes, 1973.

Thompson, Daniel. *The Materials and Techniques of Medieval Painting*. New York: Dover, 1956.

White, John. *Art and Architecture in Italy, 1250–1400*. Baltimore: Penguin, 1966.

FIFTEENTH AND SIXTEENTH CENTURY ART

Ames-Lewis, Francis. *Drawing in Early Renaissance Italy*. New Haven, Conn.: Yale University Press, 1981.

Baxandall, Michael. *The Limewood Sculptors of Renaissance Germany*. New Haven, Conn.: Yale University Press, 1980.

————. *Painting and Experience in Fifteenth Century Italy.* Oxford: Clarendon Press, 1972.

Benesch, Otto. *German Painting from Dürer to Holbein.* Geneva: Skira, 1966.

Berenson, Bernard. *The Drawings of the Florentine Painters*, 3 vols. Chicago: University of Chicago Press, 1938.

————. *Italian Painters of the Renaissance*, rev. ed. New York: Phaidon, 1953.

————. *Italian Pictures of the Renaissance: The Central and North Italian Schools*, 3 vols. London: Phaidon, 1968.

————. *Italian Pictures of the Renaissance: The Florentine School*, 2 vols. New York: Phaidon, 1963.

————. *Italian Pictures of the Renaissance: The Venetian School.* New York: Phaidon, 1957.

Burckhardt, Jakob. *The Civilization of the Renaissance in Italy.* Tr. by S. G. C. Middlemore, 3rd rev. ed. London: Phaidon, 1950.

Castiglione, Baldassare. *The Book of the Courtier.* Tr. by E. Opdycke. New York: Scribner, 1903.

Cole, Bruce. *Masaccio and the Art of Early Renaissance Florence.* Bloomington: Indiana University Press, 1980.

————. *The Renaissance Artist at Work.* New York: Harper & Row, 1983.

Cuttler, Charles. *Northern Painting: From Pucelle to Bruegel.* New York: Holt, Rinehart & Winston, 1968.

Diringer, David. *The Illuminated Book.* London: Faber and Faber, 1958.

Freedberg, Sidney J. *Painting of the High Renaissance in Rome and Florence*, 2 vols. Cambridge, Mass.: Harvard University Press, 1961.

————. *Painting in Italy, 1500–1600.* Harmondsworth, England: Penguin, 1970.

Friedlaender, Max. *Early Netherlandish Painting*, 14 vols. Tr. by H. Norden. Netherlands: A. W. Sijthoff, 1967.

Hartt, Frederick. *History of Italian Renaissance Art.* New York: Abrams, 1969.

Hind, Arthur. *History of Engraving and Etching*, 3rd rev. ed. Boston: Houghton Mifflin, 1927.

Huizinga, Johan. *The Waning of the Middle Ages.* Repr. of 1924 ed. New York: Doubleday Anchor, 1970.

Ivins, William M. *Prints and Visual Communication.* Cambridge, Mass.: M.I.T. Press, 1953.

Kuhn, Charles L. *A Catalogue of German Paintings of the Middle Ages and Renaissance in American Collections.* Cambridge: Harvard University Press, 1936.

Landolt, Hanspeter. *German Painting: The Late Middle Ages, 1350–1500.* Tr. by H. Norden. Geneva: Skira, 1968.

Levenson, Jay A.; Oberhuber, Konrad; and Seehan, Jacquelyn. *Early Italian Engravings from the National Gallery of Art.* Washington, D.C.: National Gallery of Art, 1972.

Levey, Michael. *Early Renaissance.* Harmondsworth, England: Penguin, 1967.

Mather, Frank J. *Western European Painting of the Renaissance.* New York: Cooper Square Publishers, 1966.

Meder, Joseph. *The Mastery of Drawing*, 2 vols. Tr. by W. Ames. New York: Abaris Books, 1978.

Muller, Theodor. *Sculpture in the Netherlands, Germany, France and Spain, 1400–1500.* Harmondsworth, England: Penguin, 1966.

Murray, Peter, and Murray, Linda. *The Art of the Renaissance.* London: Thames & Hudson, 1974.

Pope-Hennessy, Sir John. *An Introduction to Italian Sculpture,* 3 vols., 2nd ed. New York: Phaidon, 1970–1971.

————. *Italian High Renaissance and Baroque Sculpture,* 3 vols. London: Phaidon, 1963.

————. *Sienese Quattrocento Painting.* London: Phaidon, 1947.

Ring, Grete. *A Century of French Painting.* London: Phaidon, 1949.

Saaf, Donald, and Sacilotto, Deli. *Printmaking: History and Process.* New York: Holt, Rinehart & Winston, 1978.

Seymore, Charles. *Sculpture in Italy, 1400–1500.* Baltimore: Penguin, 1966.

Shearman, John K. *Mannerism.* Baltimore: Penguin, 1967.

Steer, John. *A Concise History of Venetian Painting.* New York: Praeger, 1970.

Tietze, Hans, and Tietze-Conrat, Erica. *The Drawings of the Venetian Painters in the 15th and 16th Centuries.* New York: Augustin, 1944.

Würtenberger, Farnzsepp. *Mannerism: The European Style of the Sixteenth Century.* New York: Holt, Rinehart & Winston, 1963.

Vasari, Giorgio. *The Lives of the Painters, Sculptors and Architects,* 4 vols. Tr. by A. B. Hind. New York: Dutton, 1927.

von der Osten, Gert, and Vey, Horst. *Painting and Sculpture in Germany and the Netherlands, 1500–1600.* Baltimore: Penguin, 1969.

SEVENTEENTH CENTURY ART

Ackley, Clifford. *Printmaking in the Age of Rembrandt.* Boston: Museum of Fine Arts, 1981.

Bergström, Ingvar. *Dutch Still Life Painting.* Tr. by Christine Hedström and Gerald Taylor. New York: Joseloff, 1956.

Blunt, Anthony. *Art and Architecture in France, 1500 to 1700.* Baltimore: Penguin, 1954.

Haskell, Francis. *Patrons and Painters.* New Haven, Conn.: Yale University Press. London, rev. ed. 1980.

Held, Julius, and Donald Posner. *17th and 18th Century Art: Baroque Painting, Sculpture, Architecture.* New York: Abrams, 1971.

Hempel, Eberhard. *Baroque Art and Architecture in Central Europe.* Baltimore: Penguin, 1965.

Hibbard, Howard. *Bernini.* New York: Penguin, 1965.

Huizinga, Johann H. *Dutch Civilization in the Seventeenth Century.* Tr. by William Collins & Sons and Harper & Row. New York: Frederick Ungar Publishers, 1958.

Kahr, Madlyn M. *Dutch Painting in the Seventeenth Century.* New York: Harper & Row, 1978.

Kitson, Michael. *The Age of Baroque.* London: Hamlyn, 1967.

Kubler, George. *Art and Architecture in Spain and Portugal and Their American Dominions 1500–1800.* Harmondsworth, England: Penguin, 1959.

Lees-Milne, James. *Baroque in Italy*. New York: Macmillan, 1960.

Mahon, Denis. *Artists in 17th Century Rome*. London: Wildenstein and Co., 1955.

Metropolitan Museum of Art. *The Painterly Print: Monotypes from the Seventeenth to the Twentieth Century*. New York: Metropolitan Museum of Art, 1980.

Nicolson, Benedict. *The International Caravaggesque Movement*. London: Phaidon, 1979.

Pope-Hennessy, Sir John. *Italian Renaissance and Baroque Sculpture*, 3 vols. London: Phaidon, 1963.

Preston, Rupert. *The 17th Century Marine Painters of the Netherlands*. Leigh-On-Sea: F. Lewis, 1974.

Rose, Barbara. *The Golden Age of Dutch Painting*. New York: Praeger, 1969.

Rosenberg, Jakob; Slive, Seymour; and Ter Kuile, E. H. *Dutch Art and Architecture 1600 to 1800*. Harmondsworth, England: Penguin, 1966.

Slive, Seymour. *Dutch Painting*. New York, 1953.

Sullivan, Edward, and Malloy, Nina. *Painting in Spain, 1650–1700 from North American Collections*. Princeton, N.J.: The Art Museum, Princeton University, 1982.

Tapié, Victor L. *The Age of Grandeur: Baroque Art and Architecture*. Tr. by A. Ross Williamson. New York: Praeger, 1960.

Wilenski, Reginald H. *French Painting*. New York: Dover Publications, 1973.

Wittkower, Rudolf. *Art and Architecure in Italy, 1600–1750*, 3rd rev. ed. Baltimore: Penguin, 1973.

Wright, Christopher. *The Dutch Painters, 100 Seventeenth Century Masters*. New York: Barron's, 1978.

EIGHTEENTH CENTURY ART

Art Institute of Chicago. *Painting in Italy in the Eighteenth Century: Rococo to Romanticism*. Chicago, 1970.

Cobban, Alfred. *The Eighteenth Century: Europe in the Age of Enlightenment*. New York: McGraw-Hill, 1969.

Enggass, Robert. *Early Eighteenth-Century Sculpture in Rome*. University Park: Pennsylvania State University Press, 1976.

Fosca, Francois (Traz, Georges de). *The Eighteenth Century: Watteau to Tiepolo*. Tr. by Stuart Gilbert. Geneva: Skira, 1952.

Friedlaender, Walter. *David to Delacroix*. Cambridge, Mass.: Harvard University Press, 1952.

Held, Julius, and Posner, Donald. *17th and 18th Century Art: Baroque Painting, Sculpture, Architecture*. New York: Abrams, 1971.

Kalnein, Wend Graf, and Levey, Michael. *Art and Architecture of the Eighteenth Century in France*. Harmondsworth, England: Penguin, 1972.

Levey, Michael. *Painting in Eighteenth Century Venice*. London: Phaidon, 1959.

———. *Rococo to Revolution, Major Trends in Eighteenth-Century Painting*. London: Thames & Hudson, 1977.

Plumb, John H. *Georgian Delights*. Boston and Toronto: Little Brown, 1980.

———. *The Pursuit of Happiness: A View of Life in Georgian England*. New Haven, Conn.: The Center, 1977.

Rosenberg, Pierre. *The Age of Louis XV, French Painting, 1710–1774*. Toledo, Ohio: Toledo Museum of Art, 1977.

Rubin, James. *Eighteenth-Century French Life Drawing*. Princeton. N.J.: Art Museum, Princeton University, 1977.

Schönberger, Arno. *The Age of Rococo*. London: Thames & Hudson, 1960.

Schwarz, Michael. *The Age of Rococo*. London: Praeger, 1971.

Strobinski, Jean. *The Invention of Liberty, 1700–1789*. Geneva: Skira, 1964.

Sutton, Denys. *French Drawings of the 18th Century*. London: Pleiades Books, 1949.

Thuillier, Jacques, and Chatelet, A. *French Painting from Le Nain to Fragonard*. Geneva: Skira, 1964.

Wasserman, Earl, ed. *Aspects of the Eighteenth Century*. Baltimore: Johns Hopkins Press, 1965.

Waterhouse, Ellis. *Italian Baroque Painting*. London: Phaidon, 1962.

———. *Painting in Britain, 1530–1790*. Baltimore: Penguin, 1962.

Wilenski, Reginald H. *English Painting*. New York: Hale, Cushman and Flint, n.d.

———. *French Painting*, 3rd rev. ed. New York: Dover, 1973.

Wilton, Andrew. *British Watercolors 1750–1850*. London: Phaidon, 1977.

NINETEENTH CENTURY ART

Andrews, Keith. *The Nazarenes*. Oxford: Clarendon Press, 1964.

Canaday, John. *Mainstreams of Modern Art*. New York: Holt, Rinehart & Winston, 1959.

Champa, K. *German Painting of the 19th Century*. New Haven, Conn.: Yale University Press, 1970.

Clark, Kenneth. *The Romantic Rebellion*. New York: Harper & Row, 1973.

Clifford, Derek. *Collecting English Watercolors*. London: John Baker, 1970.

Courthion, Pierre. *Impressionism*. New York: Abrams, 1972.

Fusco, Peter, and Janson, Horst. *Romantics to Rodin: French 19th Century Sculpture from North American Collections* (Los Angeles County Museum). New York: Braziller, c.1980.

Gaunt, William. *The Impressionists*. London: Thames & Hudson, 1970.

———. *The Restless Century: Paintings in Britain, 1800–1900*. London: Phaidon, 1972.

Gernsheim, Helmut, and Gernsheim, Alison. *The History of Photography from the Camera Obscura to the Modern Era*. London: Thames & Hudson, 1969.

Goldwater, Robert. *Symbolism*. New York: Harper & Row, 1979.

Harding, James. *Artistes Pompiers: French Academic Art in the 19th Century*. London: Rizzoli, 1979.

Herbert, Robert. *Barbizon Revisited*. New York: Clarke and Way, 1962.

———. *Neo-Impressionism*. New York: Solomon R. Guggenheim Foundation, 1968.

Hofmann, Werner. *The Earthly Paradise: Art in the Nineteenth Century*. Tr. by Brian Battershaw. New York: Braziller, 1961.

Honour, Hugh. *Neo-Classicism*. Harmondsworth, England: Penguin, 1968.

———. *Romanticism*. New York: Harper & Row, 1979.

Jullian, Philippe. *The Symbolists*. New York: Phaidon, 1973.

Madsen, Steven. *Art Nouveau*. London: Weidenfeld & Nicolson, 1967.

Minneapolis Institute of Arts. *Victorian High Renaissance*. Minneapolis, 1978.

Müller-Brockman, Joseph. *The History of the Poster*. Zürich: A. B. C. Verlag, 1971.

Newhall, Beaumont. *The History of Photography*. Greenwich, Conn.: New York Graphic Society, 1982.

Nochlin, Linda. *Realism*. Harmondsworth, England: Penguin, 1971.

Novak, Barbara. *Nature and Culture, American Landscape Painting, 1825–1875*. New York: Oxford University Press, 1980.

Novotny, Fritz. *Painting and Sculpture in Europe, 1780–1880*. Baltimore: Penguin, 1960.

Rewald, John. *The History of Impressionism*. New York: Museum of Modern Art, 1961.

Sommerville, Stephen. *British Watercolors, a Golden Age, 1750–1850*. Louisville, Ky.: J. B. Speed Art Museum, 1977.

J. B. Speed Art Museum. *Nineteenth Century French Sculpture: Monuments for the Middle Class*. Louisville, Ky., 1971.

Vaughn, William. *Romantic Art*. New York: Oxford University Press, 1978.

Weisberg, Gabriel. *The European Realist Tradition*. Bloomington: Indiana University Press, 1982.

Wilmerding, John. *American Art*. Harmondsworth, England: Pelican/Penguin, 1976.

Wood, Christopher. *The Pre-Raphaelites*. New York: Viking, 1981.

TWENTIETH CENTURY ART

Adhemar, Jean. *Twentieth-Century Graphics*. London: Elek, 1971.

Alloway, Lawrence. *American Pop Art*. New York: Macmillan, 1974.

Arnason, Hjövardur H. *History of Modern Art: Painting, Sculpture, Architecture*. New York: Abrams, 1968.

Baigell, Matthew. *Dictionary of American Art*. New York: Harper & Row, 1979.

Battcock, Gregory. *Minimal Art: A Critical Anthology*. New York: Dutton, 1968.

Berger, John. *Ways of Seeing*. New York: Viking, 1973.

Cooper, Douglas. *The Cubist Epoch*. New York: Phaidon, 1971.

Dictionary of 20th Century Art. London: Phaidon, 1973.

Fry, Edward. *Cubism*. New York: McGraw-Hill, 1966.

Golding, John. *Cubism: A History and an Analysis*. New York: Harper & Row, 1968.

Hamilton, George H. *Painting and Sculpture in Europe, 1880–1940*. Harmondsworth, England: Penguin, 1981.

Jean, Marcel. *The History of Surrealist Painting*. New York: Grove Press, 1960.

Kaplan, Patricia. *Major European Art Movements, 1900–1945: A Critical Anthology*. New York: Dutton, 1977.

Lucie-Smith, Edward. *Symbolist Art*. New York: Praeger, 1972.

Martin, Marianne. *Futurist Art and Theory, 1900–1915*. New York: Hacker Art Books, 1978.

Motherwell, Robert. *The Dada Painters and Poets: An Anthology*. New York: Wittenborn, Schultz, 1951.

Richter, Hans. *Dada, Art and Anti-Art*. New York: McGraw-Hill, 1965.

Rosenblum, Robert. *Cubism and Twentieth-Century Art*. New York: Abrams, 1966.

Roters, Eberhard. *Painters of the Bauhaus*. New York: Praeger, 1969.

Rubin, William. *Dada and Surrealist Art*. New York: Abrams, 1968.

Russell, John. *The Meanings of Modern Art*. New York: Harper & Row, 1981.

Selz, Peter. *Art in Our Times*. New York: Harcourt Brace Javonovich, 1981.

————. *German Expressionist Painting*. Berkeley, Calif.: University of California, 1957.

Taylor, Joshua. *Futurism*. New York: Museum of Modern Art, 1961.

Waldburg, Patrick. *Surrealism*. New York: McGraw-Hill, 1966(?).

INDIAN ART

Archer, William G. *Indian Miniatures*. Greenwich, Conn.: New York Graphic Society, 1960.

Barrett, Douglas E. *Early Chola Bronzes*. Bombay: Bhulabhai Memorial Institute, 1965.

Kramrisch, Stella. *The Art of India*. New York: Phaidon, 1954.

————. *Indian Sculpture*. Heritage of India Series. London and New York: Oxford University Press, 1933.

Lee, Sherman. *A History of Far Eastern Art*. New York: Abrams, 1964.

Rowland, Benjamin. *The Art and Architecture of India*, 3rd rev. ed. Harmondsworth, England: Penguin, 1967.

Wheeler, Robert M. *Early India and Pakistan: To Ashoka*. New York: Praeger, 1959.

Zimmer, Heinrich R. *The Art of Indian Asia: Its Mythology and Transformations*. New York: Pantheon, 1955.

CHINESE ART

Cahill, James. *Chinese Painting*, new ed. Geneva: Skira, 1977.

Cleveland Museum of Art. *Eight Dynasties of Chinese Painting*. Ohio: Cleveland Museum of Art, 1980.

Davidson, J. Leroy. *The Lotus Sutra in Chinese Art: A Study in Buddhist Art to the Year 1880*. New Haven, Conn.: Yale University Press, 1954.

Fong, Wen, ed. *The Great Bronze Age of China*. New York: 1980.

Honey, William B. *The Ceramic Art of China and Other Countries of the Far East*. New York: Beechhurst Press, 1954.

Lee, Sherman. *Chinese Landscape Painting*, 2nd ed. Ohio: Cleveland Museum of Art, 1962.

Loehr, Max. *Ritual Vessels of Bronze Age China*. New York: Asia Society, 1968.

Rudolph, Richard. *Han Tomb Art of West China*. Berkeley, Calif.: University of California Press, 1951.

Siren, Oswald. *A History of Later Chinese Painting*, 1938. Repr. London: Medici Society, 1978.

————. *Chinese Painting: Leading Masters and Principles*. Repr. New York: Hacker, 1973.

————. *Chinese Sculpture from the Fifth to the Fourteenth Centuries*, 4 vols. 1925. Repr. New York: Hacker, 1970.

Thorp, Robert L., and Bower, Virginia. *Spirit and Ritual: The Morse Collection of Ancient Chinese Art*. New York: Metropolitan Museum of Art, 1982.

JAPANESE ART

Akiyama, Terukazu. *Japanese Painting*. Geneva: Skira, 1977.

Cahill, James. *Scholar Painters of Japan: The Nanga School*. Repr. New York: Arno Press, 1976.

Fontein, Jan, and Hickman, M. ed. *Zen Painting and Calligraphy*. Greenwich, Conn.: New York Graphic Society, 1970.

Kidder, J. Edward. *Early Japanese Art*. London: Thames & Hudson, 1969.

Lee, Sherman. *Japanese Decorative Style*. New York: Harper & Row, 1972.

Paine, Robert, and Soper, Alexander. *The Art and Architecture of Japan*. Baltimore: Penguin, 1955.

Rosenfield, John M. *Japanese Arts of the Heian Period, 794–1185*. New York: Asia Society, 1967.

———, and Shimada, Shujiro. *Traditions of Japanese Art*. Cambridge, Mass.: Fogg Art Museum, Harvard University, 1970.

Stern, Harold P. *Master Prints of Japan: Ukiyo-e Hanga*. New York: Abrams, 1969.

TRIBAL AND PRE-COLUMBIAN ART

d'Azevedo, Warren. *The Traditional Artist in African Societies*. Bloomington: Indiana University Press, 1973.

Balandier, Georges, and Maquet, Jacques. *Dictionary of Black African Civilization*. New York: Leon Amiel, 1974.

Bascom, William R. *African Art in Cultural Perspective: An Introduction*. New York: Norton, 1973.

Bennett, Wendell C. *Ancient Arts of the Andes*. New York: Museum of Modern Art, 1954.

Berg, Phil. *Man Came This Way*. Calif.: Los Angeles County Museum of Art, 1971.

Bliss, Robert W. *Pre-Columbian Art*. New York: Phaidon, 1957.

Christensen, Erwin O. *Primitive Art*. New York: Crowell, 1955.

Coe, Michael D. *The Jaguar's Children: Pre-Classical Central Mexico*. New York: Museum of Primitive Art, 1965.

Cornet, Joseph. *Art of Africa: Treasures from the Congo*. Tr. by B. Thompson. London: Phaidon, 1971.

Covarrubias, Miguel. *The Eagle, the Jaguar and the Serpent*. New York: Knopf, 1954.

Elisofon, Eliot. *The Sculpture of Africa*. New York: Praeger, 1958.

Fagg, William B. *Nigerian Images: The Splendor of African Sculpture*. New York: Praeger, 1963.

Kubler, George. *Art and Architecture of Ancient America: The Mexican, Maya and Andean Peoples*, 2nd ed. Harmondsworth, England: Penguin, 1975.

Linton, Ralph, and Wingert, Paul. *Arts of the South Seas*. New York: Museum of Modern Art, 1946.

Schmalenbach, Werner. *African Art*. New York: Macmillan, 1954.

Schmitz, Carl A. *Oceanic Art: Myth Man and Image in the South Seas*. New York: Abrams, 1971.

Sieber, Roy. *African Furniture and Household Objects*. Bloomington: Indiana University Press, 1980.

Sieber, Roy. *African Textiles and Decorative Arts.* New York: Museum of Modern Art, 1972.

Thompson, Robert F. *African Art in Motion: Icon and Act in the Collection of Katherine Coryton White.* Exhibition Catalogue. Washington, D.C., National Gallery of Art; published Los Angeles: University of California Press, 1974.

Wingert, Paul. *Art of the South Pacific Islands.* New York: Beechhurst Press, 1953.

Index